The arts of mankind

EDITED BY ANDRÉ MALRAUX
AND ANDRÉ PARROT
MEMBER OF THE *INSTITUT DE FRANCE*

EDITOR-IN-CHARGE
ALBERT BEURET

Archaic Greek Art

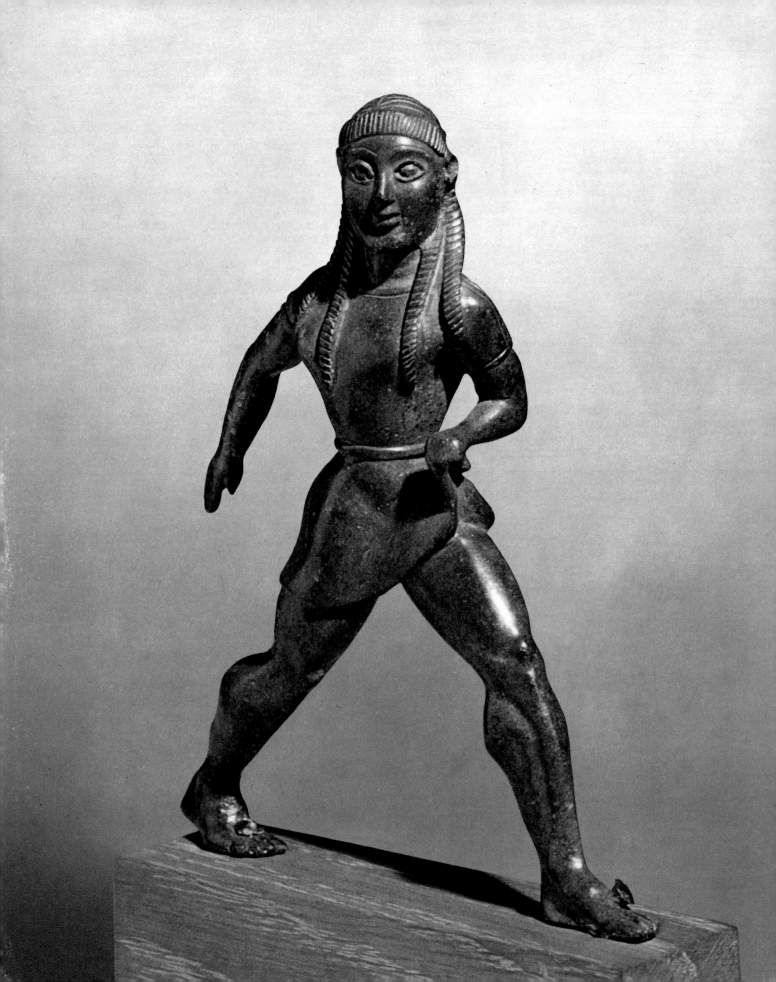

Jean Charbonneaux

Roland Martin - François Villard

ARCHAIC GREEK ART

(620-480 B C)

GEORGE BRAZILLER · NEW YORK

Translated from the French
by James Emmons; Robert Allen (Part Three)

Library of Congress Catalog Card Number: 78-136166
Standard Book Number: 0-8076-0587-5

Printed in France

Published 1971 by arrangement with Editions Gallimard.

Contents

To the memory of Christos Karouzos

Introduction

After the final collapse of the Mycenaean world in the eastern basin of the Mediterranean in the twelfth century B.C. there followed a dark age of invasions and migrations that lasted over three centuries, during which the Greek world of the mainland, the islands, and the coast of Anatolia felt its way towards a precarious balance. Yet as early as the tenth or ninth century B.C. two great creations heralded the concerted renewal of Greek life. The Geometric style, particularly in vase painting, reveals that insistence on a solid, reasoned structure which is one of the fundamental qualities of Greek art, and the epic poems assimilated, ordered, and amplified the traditions of the heroic age that folk memory had preserved. Thanks to the genius of Homer, the Greek epics were to nourish indefinitely the poetic and artistic imagination of the West. In the eighth century the cluster of independent city-states that faced the kingdoms of the Near East and Pharaonic Egypt and made up the Greek world showed the increasingly distinctive features of Hellenism. In spite of rival factions and internecine strife, the conscious pride of a racial, religious, and cultural community asserted itself clearly over and above regional differences in worship and government. The great sanctuaries, Delos, Delphi, and Olympia, quickly became Panhellenic—sacred places where delegates from the Greek city-states met periodically—and also became repositories of works of art brought from all parts of the Greek world and even from certain 'barbarian' lands. Most significant of all is the choice of the year 776 B.C., the traditional date of the first Olympic Games, as the starting point of the chronology by Olympiads unanimously adopted all over Greece.

In the same century a great movement of colonization began to carry the torch of Hellenism westwards, from South Italy to the shores of Gaul and Iberia, and northwards as far as the Tauric Chersonese (the present-day Crimea). The Greeks pushed the limits of their horizon as far as possible and multiplied their contacts with neighbouring lands, especially those with long-established civilizations. In contrast with Mycenaean expansion, which had coincided with an impoverishment of art forms, the colonization of the eighth and seventh centuries was accompanied by an exceptional development of creative

activity, not only in art but in poetry and scientific thought. In all these fields Greece owed much to the East. The Phoenicians passed on to the Greeks their momentous invention, the alphabet, and also acted as intermediaries between Greece and the Near East, while exporting the products of their art industry. But very early—as the *Odyssey* proves—there were direct contacts, chiefly by the East Greeks, with the Semitic states and neo-Hittite Syria and, no doubt slightly later, with Phrygia, Urartu, and Armenia farther to the east and northeast. In the course of the seventh century Greek traders and mercenaries, mainly Ionians, settled at Naucratis in the Nile delta.

This eager pursuit of contacts and exchanges was native to the Greek temperament. The transition from Geometric to Orientalizing art was the result of borrowings made by the 'new poor' from the 'old rich.' But just as the Greek language and alphabet, which cemented the unity of Hellenism, had brought order to the Indo-European heritage while enriching it with many subtleties of thought, so the art forms developed during the seventh century showed the same concern for organization, resulting at once in discrimination and unity. The two great orders of architecture determined the overall design and the detail of the structural elements; the ornamentation was supplied by two other art forms—painting and sculpture—but it was governed by the nature of its ambiance and the proportions of the building. Statuary worked itself free from the architecture, but because of the return to geometry brought about by the Daedalic style the structure of the human body was co-ordinated with the norms of architecture. In vase painting, through the many variations of the different styles, one can trace the search for harmony in the elaboration of shapes, in the adaptation of the decoration to the surface available, and in the schemes of composition. Filling ornaments gradually disappear. Dramatic movement animates the friezelike sequence of figure scenes, which now break away altogether from Oriental models dominated by an endless repetition of the same motifs. In these changing rhythms in vase painting, in the relationship between solid and void, between dark and light, one cannot help feeling a close kinship with the musical modes of the Aeolian and Ionian lyric poetry that followed the Homeric epics. The epics had individualized the gods and humanized the monsters deriving from the ancient East. As early as the eighth century, over a hundred years before Solon, Hesiod appealed to Dike, the personification of Justice. In the seventh century the work of artists and poets became personalized. In an expanding and spiritually unified world, in which works of art and the artists themselves circulated freely and widely, the stage was set for the great creations of archaic Greece.

The Early Achievements

620-580 B. C.

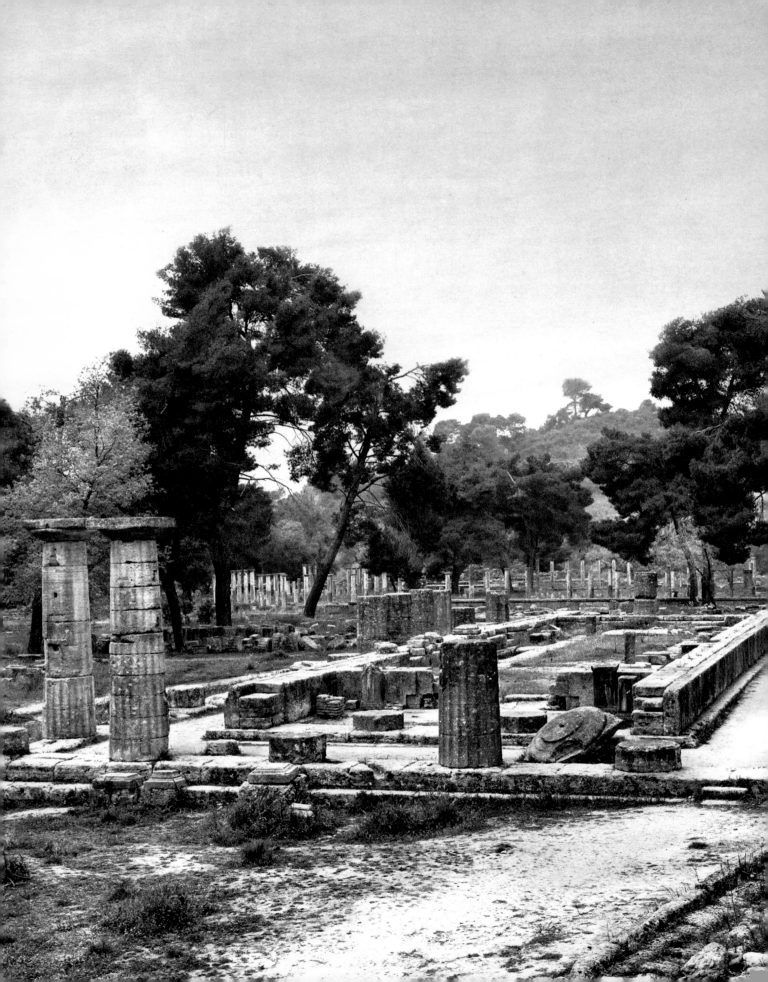

Architecture

The late seventh century was a period of fruitful advances in architecture, as the Greeks assimilated, exploited, and improved upon the legacy of all the building efforts made since the middle of the eighth century. Ventures and experiments were multiplied in two fields which, though distinct, were very closely associated through the influence each necessarily brought to bear on the other: the knowledge and mastery of materials, and the conquest of space and areas.

Techniques

We find the initial advances in the technical field, as craftsmen mastered the working of noble materials—marble and limestone. It then became possible for them to enlarge and amplify plans and areas, the better to adapt them to the function of the building. In the course of the seventh century the decisive forward step, rich in consequences, was the introduction of dressed stone for building purposes. From then on it gradually took the place of 'poor' materials like wood, sun-dried brick, pisé, stone rubble. The lessons learned from sculptors stimulated the aspirations aroused by the discovery of Syrophoenician and Egyptian architecture. In the sculptors' workshops, or circles too, stonecutters, whose proficiency was the prerequisite of all the great works of Greek architecture, were trained. Thus, wooden pillars were superseded by the slender shafts of stone columns; wooden facings at the ends and corners of walls were replaced by antae and a coigning of large blocks; the dressed stone footings of brick walls gave way to large orthostats surmounted by regular courses of blocks of soft poros, carved somewhat in the manner of bricks (and even taking over their name); lastly, in the upper part of the building, stone easily and smoothly superseded the elements of wood and terra cotta that formed and adorned the roof. Thus, by the end of the seventh century,

3

1. OLYMPIA, TEMPLE OF HERA (HERAION).

the technical resources available were sufficient to set free the creative spirit and give a fresh impetus to the tentative efforts and experiments that had already begun in the mid-eighth century in various parts of the Greek world, particularly Crete and the Cyclades.

The early temples consisted merely of a cella in the form of a plain rectangular room, in front of which was a porch with two columns. Their exterior appearance can be seen from the small votive models in terra cotta from Argos and Perachora, while the interior arrangement of two or more axial columns and sometimes an altar is illustrated by the remains cleared at Dreros, Prinias, Delos, and Thasos. The indigenous traditions going back to Helladic times had not been forgotten, and in addition to the rectangular ground plan derived from the Mycenaean mageron, the supple curves of the apsidal plan have also been traced in the strata of the Geometric period at Delphi, on the Acropolis of Athens, at Delos, Olympia, and many other holy places.

Beginning in the first half of the seventh century in both mainland Greece and Samos, the cella was considerably enlarged and surrounded, practically enveloped, by an outer colonnade that protected it while adding to its size. In fact, one cannot completely separate the peristyle colonnade from the colonnaded canopies that provided shelter for the cult statue of the deity at Samos and Didyma. Originally they had stood in the open air. Here we find an Oriental theme that had appeared in Mesopotamia as early as the third millennium and was used by the Egyptians with successful variations. Symbolic value was thus added to the protective function of the colonnade. Moreover, the peristyle's extension all round the building—as in the ancient megaron of Thermon (see p. 364, fig. 414), where the rectangular plan of the cella and the apsidal form of the portico were curiously combined, recalling the plan of the early sanctuary—marked a forward step in the working out of area and in the adaptation of two opposing structures: the ponderous mass of the closed cella and the freer, more linear design of the Ionic colonnades. The second Hekatompedon of Samos (see p. 362, fig. 410), of about 660-650 B.C., with its peristyle of 6 by 18 columns, is the best example of the efforts made in this direction. The cella here was a vast hall cleared of the interior colonnades that had stood in the way of a proper presentation of the cult statue; the interior pillars supporting the ceiling beams and the roof elements were set back against the walls and stood on a low ledge that also extended across the entrance, forming a kind of threshold. In the entrance stood two columns evenly spaced between the antae. Exactly in front of these four points of support were four additional columns, which thus enlarged the porch and formed the transition with the six columns of the façade. So at Samos in the second Hekatompedon all the elements of monumental architecture had been brought together. It was left to the builders of around 600 to exploit them more fully. They did so with a rapidity and success that varied from one part of the Greek world to another, but from the earliest temples the originality of this architecture was plain.

The First Stone Temples

From a welter of still confused and ill-guided efforts in mainland Greece the original, unique characteristics of the Doric style stand out in a few large buildings. Up to this time the distinction between the two great orders, Doric and Ionic, was still vague. The

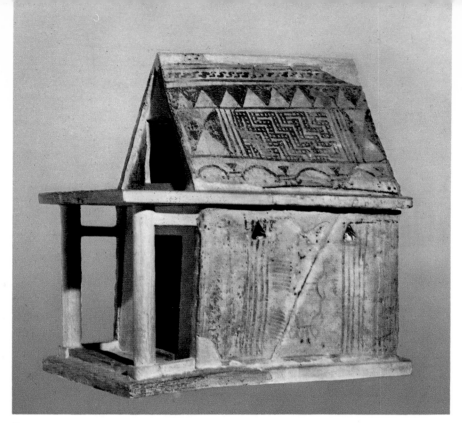

2. TERRA-COTTA MODEL OF A RECTANGULAR TEMPLE. NATIONAL MUSEUM, ATHENS.

3. THERMON, TEMPLE C. PAINTED TERRA-COTTA METOPE, DETAIL. NATIONAL MUSEUM, ATHENS.

constructions of the Geometric and Orientalizing periods were in an undifferentiated style; all that can be distinguished in it are features of local or regional origin—a few Mycenaean survivals in the Peloponnesus (Argos and Corinth) and in mainland Greece, and a more decorative tendency nearer to Creto-Aegean forms and structures in the Cyclades and on the Asia Minor coast, where the traditions of the second millennium had been less violently disrupted by the invading Dorians.

It is a moot point whether the Argives should be credited with the first temple with a regular peristyle, on the uppermost terrace of the Heraion of Argos. Only the trace of the column shafts on the large, roughly squared slabs of the stylobate reveals the arrangement of this wooden colonnade, dating from the second half of the seventh century.

At Thermon the new temple (the third) of about 620-610, which replaced Megaron B with its surrounding peristyle of wooden posts, has more to tell us about the first Doric temples with peristyles (see p. 364, fig. 414). The peripteral plan was now adopted with stronger structural features, and the quadrangular wooden posts were undoubtedly replaced by stone columns (5 by 15 columns), or at least by wooden shafts on stone bases. In the upper parts wood and terra-cotta continued to be the essential elements. The Doric frieze was already broken up by the sequence of wooden triglyphs and terra-cotta metopes, the latter consisting of painted terra-cotta plaques decorated with mythological figures and themes taken from the repertory of the vase painters and treated in a style akin to that of contemporary Corinthian vases.

The long narrow cella (23 by 105 feet) was divided into two aisles by an axial colonnade starting at the entrance where the first column, aligned on the antae, marked out two passages. At the opposite end a small room with two axial columns was separated from the main cella by a continuous partition wall. It is possible that in its original state this temple at Thermon did not have two symmetrical façades; it may have had a pediment over the entrance and a hip-roof at the back, following the arrangement of the first apsidal structure, and like the one that still remains very probably in the treasury of the Heraion at the mouth of the river Silaris (Sele) near Paestum, and doubtless in several archaic temples (for example, Neandria). The columns of the peristyle carried an architrave consisting of a double beam above which ran a Doric terra-cotta frieze of painted metopes and triglyphs that were probably set against an inner wooden framework supporting the roof.

Quite different was the plan adopted for the Temple of Hera (the Heraion) at Olympia (see p. 372, fig. 433), about 600 B.C. Of elongated proportions (6 by 16 columns), the cella was divided in what was to become the standard manner: anteroom or pronaos, and main hall with three aisles marked by two rows of columns between the antae. But, inside, the side aisles were divided into five little shrines by spur-walls at right angles to the longitudinal axis. Each shrine, except the last at the rear, was treated as exedrae were later to be, with a column in the middle of the entrance. It was complex design, betraying the hesitation the architects felt in laying out interior spaces and choosing between the two formulas at their disposal: a division into two aisles by an axial colonnade, which made for an awkward presentation of the cult statue, or a division into three aisles by two rows of columns, which reduced the space and made the central aisle into a kind

5. OLYMPIA, TEMPLE OF HERA. SOUTHWEST CORNER.

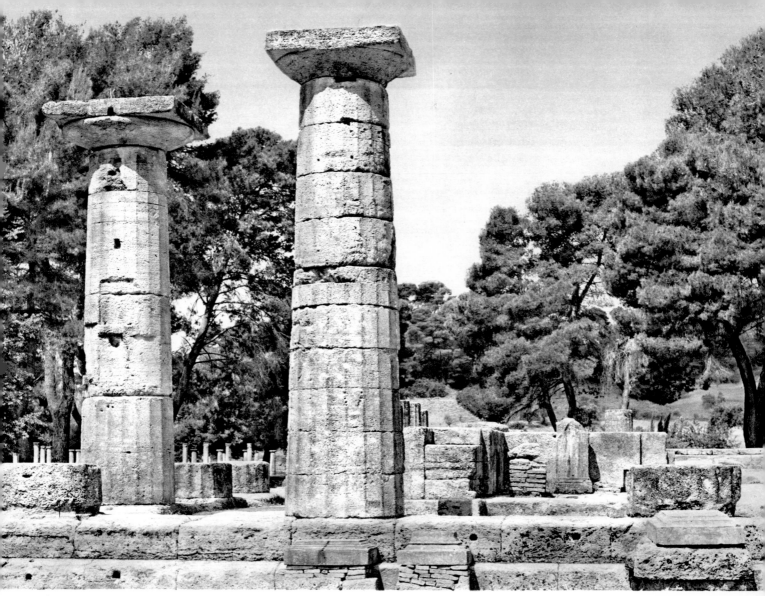

4. OLYMPIA, TEMPLE OF HERA. EAST FRONT.

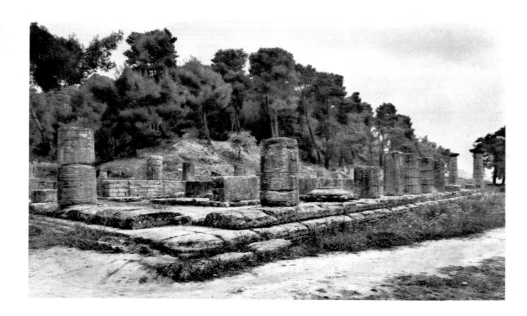

7

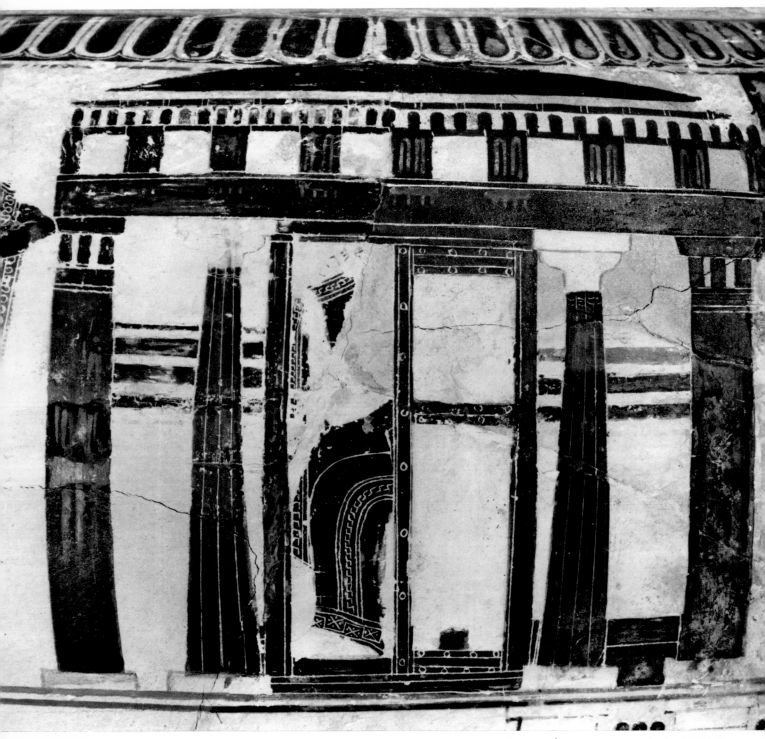

6. ERGOTIMOS AND KLEITIAS. FRANÇOIS VASE, DETAIL: TEMPLE FAÇADE WITH TWO COLUMNS 'IN ANTIS.' MUSEO ARCHEOLOGICO, FLORENCE.

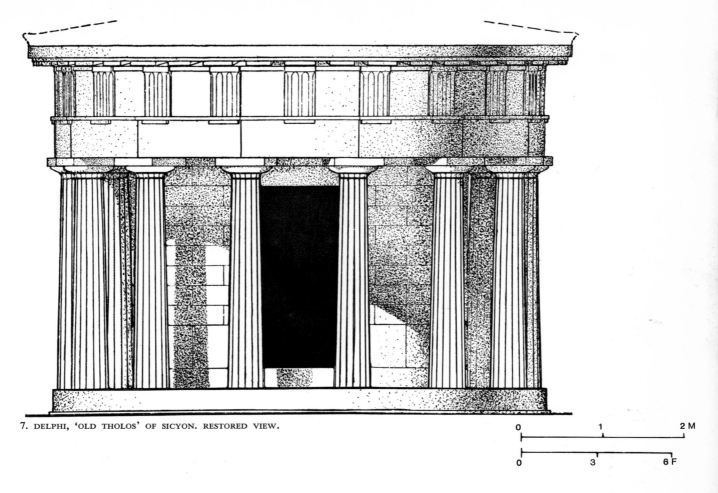

7. DELPHI, 'OLD THOLOS' OF SICYON. RESTORED VIEW.

0 1 2 M

0 3 6 F

of corridor, at the far end of which stood the divine effigy. It was not until the middle of the fifth century that architects broke with these alternatives and devised new formulas for the interior layout of temples.

The Heraion of Olympia is famous for the long history of its wooden columns, which were replaced by stone shafts only over the course of centuries. One of the old columns of oak was still in place when Pausanias visited the Panhellenic sanctuary in the second century A.D. How strange they must have been, these buildings in which wood and stone were combined, often in the same member (stone base and capital with a wooden shaft between them, stone or terra-cotta metopes alternating with triglyphs of wood, terra-cotta or stone) and, in addition, the carved and painted ornamentation, a bright polychromy serving to conceal the poorness of the materials.

It is worth looking more closely at some details of this architecture. It used to be thought that the introduction of stone brought a certain heaviness to the proportions, which then progressively gained refinement towards the end of the archaic period and resulted finally in Hellenistic constructions. Actually, the archaeological evidence and the buildings pictured in vase paintings concur in suggesting a more complex course of development. Throughout the early archaic period the practice of combining wood and stone effectually produced a greater lightness of design than has been supposed. This means that the current theories concerning the formation of the classical orders must

9

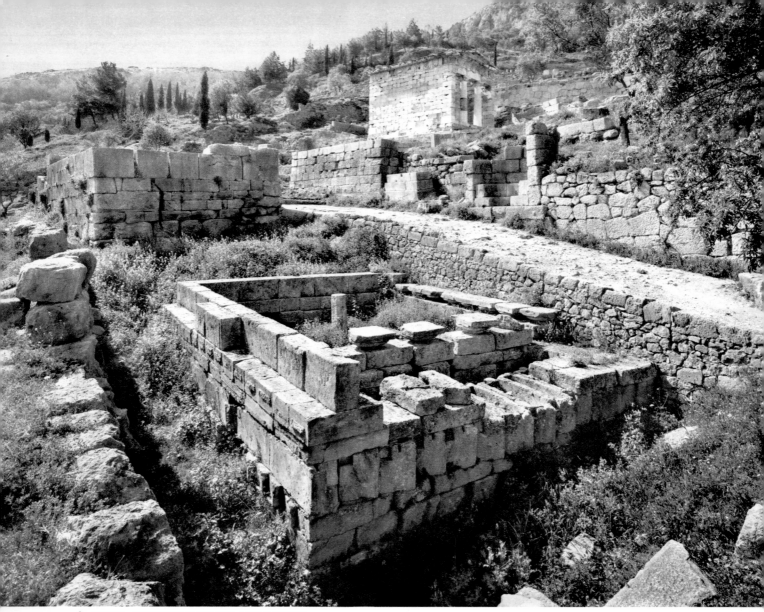

8. DELPHI, SICYONIAN TREASURY. FOUNDATIONS.

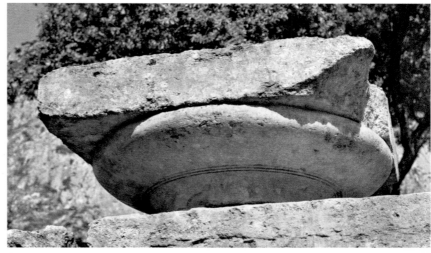

9. DELPHI, CAPITAL OF ONE OF THE SICYONIAN BUILDINGS.

10

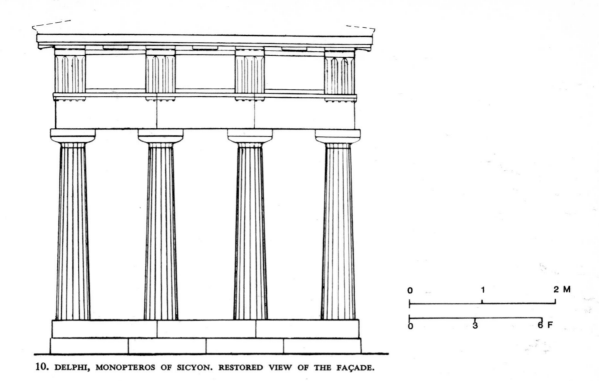

10. DELPHI, MONOPTEROS OF SICYON. RESTORED VIEW OF THE FAÇADE.

be revised more thoroughly than has yet been done. Excavations at Delphi have provided valuable evidence in this respect.

They have revealed in particular the earliest complete Doric column in stone (poros), pieced together from the drums and capitals of the first temple of Athena Pronoia, built on the Marmaria terrace at Delphi in about 600. These elements had luckily been reused in the foundations of the building erected some one hundred years later. This very slender, almost frail column (its height being six and a half times its lower diameter) was modeled after wooden columns; it was crowned by a capital whose flattened echinus showed a strong projection in proportion to its height. The temple's entablature, probably made of wood and terra-cotta, has disappeared.

More complete are the remains of the two buildings buried in the foundations of the treasury of Sicyon at Delphi. One is of circular plan, the 'old tholos' erected about 590-580, and the other, monopteral, built a little later and adorned with a fine series of carved metopes. Both designed in the manner of ancient canopies, they already show all the aspects of the Doric order with some revealing anomalies—particularly in the tholos and in the independence of the triglyphs from the columns. These columns—still very slender in the tholos, like those from the temple of Athena, but already more thickset in the monopteros—carry an architrave recessed at the back (see p. 370, fig. 429), whose outer vertical extension bore the frieze of triglyphs and metopes. Into the recess behind fitted the lower supporting elements of the roof, which were quite independent of the frieze, as is proved by the details of the carved metopes and the way they were placed.

11

We see here how stone gradually superseded wood in early sixth-century architecture. Columns and architraves were made of stone and supported the roofing, whose timber work was assembled inside like an independent element. From the finds made in the treasury of the Heraion on the Silaris, it has even been ascertained that the carved frieze was not fitted in place until the essential members of the timber roof had been installed. The identical structure of the architrave combined with variations in the layout of the frieze in several archaic temples (Ortygia at Syracuse, Temples C and D at Selinus, the Temple of Assos) confirm how this same principle was observed and developed. This is an important point, for it disposes of the theory (originating in a passage in Vitruvius) that the origin of the Doric frieze can be traced to the connection of its members with the main beams of the timber roof. The fact is that in all the early buildings in which the roof structure can be ascertained there is no connection between the timber roof and the frieze; the latter is always independent. Moreover, a close study of both early and classical timber roofs reveals that in none do any large beams come into contact with the frieze. Thus the origin of the Doric frieze must be looked for elsewhere, in a quite different direction.

The whole frieze seems to have been a facing element intended to mask the lower beams of the roof and to fill up the gap between the beam-ends, the architrave, and the edge of the roof formed by the corona and the gutters. The very independence of this element of the entablature made it well adapted for painted or carved ornamentation.

The Earliest Ionic Temples

A higher degree of technical skill, a greater ease and freedom of design, a sustained interest in decorative values are the distinguishing qualities of early architecture in the islands and on the Asia Minor coast, where Minoan traditions and contact with Egyptian and Oriental (mid-Eastern) civilization hastened its evolution and led to more varied experimentation. Though in the treatment of details the richness and vigour of Ionic architecture were revealed chiefly after 570, the main lines of development appear clearly as early as the seventh century in Crete, Delos, and Samos.

Minoan survivals are obvious in the interior arrangement of the early Cretan temples at Prinias and Dreros. Their plans are more clearly defined, and the proportions more nearly square or oblong, allowing the integration within the building of the sacrificial altar, the libation tables, and the daises on which the divine effigies were presented. The utilization of the altar led to an enlargement of the interior space and required the use of supports to carry the flat roof. The preference for pillars appears at Prinias where the façade was given a geometric design that recalls the decorative compositions around the court of the palaces at Knossos and Phaistos, a similarity strengthened by the irregular arrangement of the supports, with a single pillar in the middle. The flat roof called for the use of a protective parapet, adorned at Prinias with a frieze of horse-men—a strict, highly linear composition in which the figures are subordinated to the architectural features. Such temples stood in many sanctuaries of archaic Greece; but in most cases the remains that have come to light are too meagre to allow any more than a reconstruction of the ground plan.

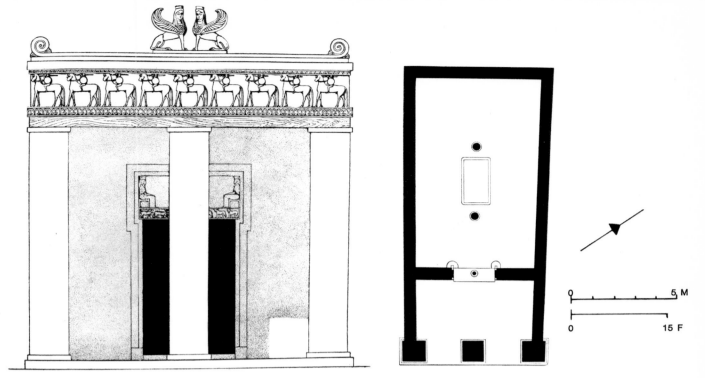

11-12. PRINIAS, TEMPLE A. RESTORED FAÇADE AND PLAN.

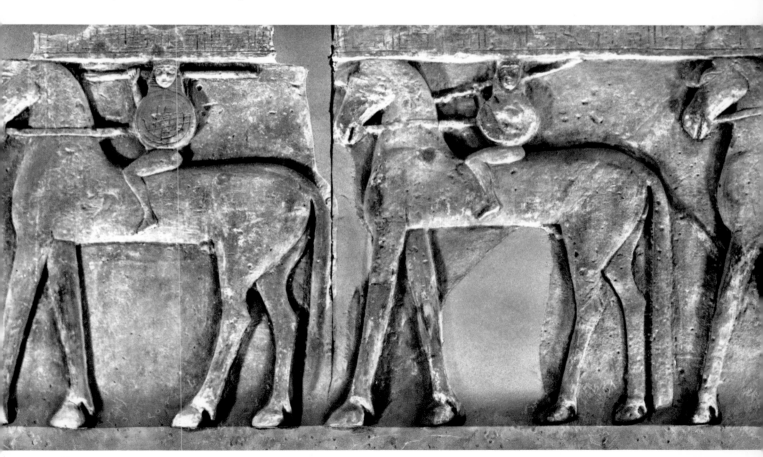

13. PRINIAS, TEMPLE A. FRIEZE RELIEFS, DETAIL. ARCHAEOLOGICAL MUSEUM, HERAKLION.

13

The Oikos of the Naxians on Delos, built in the early sixth century, shows the progress made in stone construction. The first, still highly schematic features of the Ionic order make their appearance in a fluted shaft crowned by a capital whose volutes, as in most early Delian capitals, were emphasized by painting. The use of polychromy went back to the time when the capital was a plain piece of wood intermediate between shaft and entablature and so naturally called for colouring.

The first constructions of the Heraion of Samos give a clearer picture of the main features of this early architecture. In the ancient sanctuary the wooden statue of Hera (brought by the Argonauts, according to legend) stood under a canopy amid clumps of the sacred osier on the marshy banks of the Imbrasos, beside altars set up in the open air. These primitive elements of the cult remain permanently recognizable throughout the many transformations of the sanctuary in the course of centuries, and they often exerted an influence on the mighty buildings erected by the ancient architects.

At the beginning of the eighth century appeared the first Hekatompedon on Samos (measuring 108 by 21 feet), a plain cella whose roof was supported by a row of interior pillars. Its size was increased at the end of the century by a peristyle of 7 by 17 pillars. This, with the temples of Argos and Thermon (see above), marks the first appearance of a peripteral plan. About 660 the old temple was superseded by a building (the second Heraion) in which the Samian architects completely succeeded in their attempt to create vast interior spaces while at the same time increasing and developing the exterior proportions. The new temple contained a cella 100 ½ feet long and 22 feet wide. In front was an anteroom with four columns corresponding to the extremity of each wall and to the two supports *in antis* of a peristyle with evenly spaced columns (6 on the façade, 18 on the two long sides). At the level of the stylobate this temple measured 123 ½ by 38 feet (see p. 362, fig. 410). Inside, the architect for the first time dispensed with the axial colonnade and let the roof rest on square pillars backing against the cella wall and standing on a low base that jutted out from the footing of the side walls, leaving between them a free space 18 feet wide. The pillars were arranged to correspond to the columns of the peristyle. This building is characterized by a dual innovation: first, the elements of the plan are combined in a well-unified design, of which the peristyle is made to form an integral part; second, the interior of the cella now becomes a space to be mastered and adapted to its purpose as a setting effectively enhancing the cult statue. Stone, hewn in irregular blocks, replaced brick over the whole height of the walls. The roof may have been flat or it may have been double-pitched like that of the votive models in stone found in the sanctuary.

Finally, the Samian architects began a new line of development with the construction, in about 600, of the first stoa we know of in Greece, designed to organize and to structure the sanctuary. It extended southwards (229 ½ feet long, 19 ½ feet wide), with a façade of wooden posts and a row of inner supports carrying a flat roof. Thus, by the beginning of the sixth century, the Samians had traced out the directions in which, for a considerable period, Greek architecture was to continue its efforts and achievements, developing along broad, flexible lines that allowed free scope to the creative spirit. Unhampered by strict rules and having mastered their materials, they combined exacting technical standards with a keen sense of decorative values.

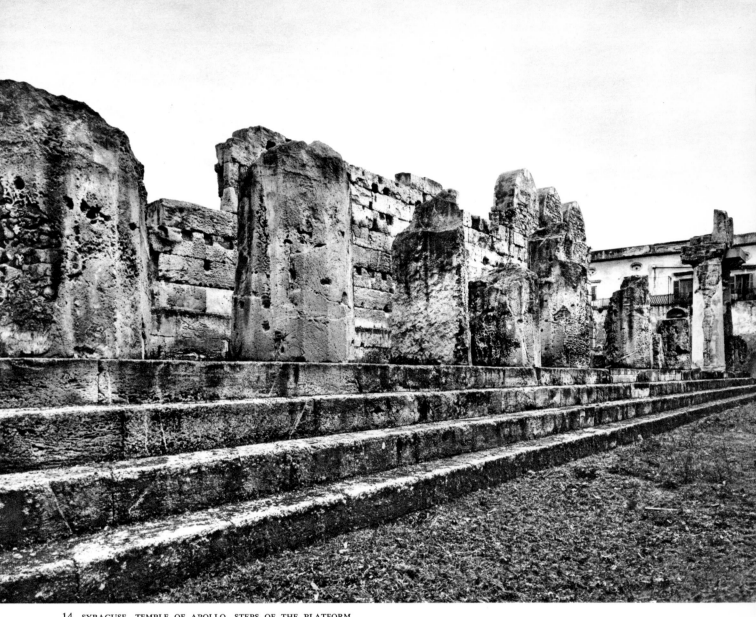

14. SYRACUSE, TEMPLE OF APOLLO. STEPS OF THE PLATFORM.

Doric in the West

We shall now consider—in contrast with the architecture of Ionia—the earliest temples erected by the western Greeks in Syracuse, the first Dorian colony founded in Sicily, by the Corinthians about 733. The oldest of the peripteral temples of Sicily is the temple of Apollo on the peninsula of Ortygia. Its bulky, ponderous forms illustrate the hesitations and misgivings felt by the western architects in their initial efforts to substitute Sicilian limestone for the timber used by the first Corinthian colonists. Their pride in

15

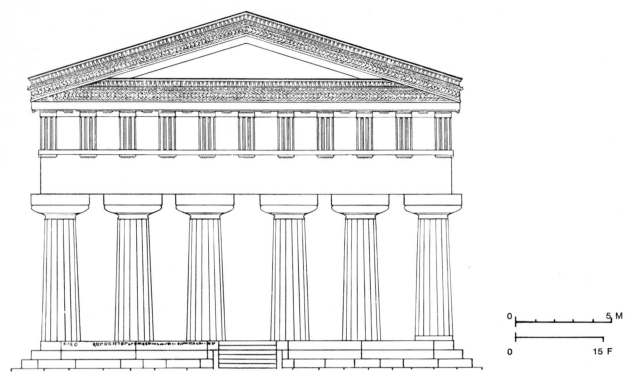

15. SYRACUSE, TEMPLE OF APOLLO. RESTORATION OF THE FAÇADE.

overcoming these technical difficulties was expressed in the inscription engraved on the enormous monolithic blocks from which the steps of the krepis were hewn: 'Cleomenes erected the temple of Apollo, son of Cnidieidas, and Epicles [carved] the columns, fine work.' With its heavy, indeed massive proportions, this temple at Syracuse combines the Corinthian tradition with certain features peculiar to Sicily: the elongated forms of the cella; the absence of an opisthodomos; the inclusion of an adyton at the back of the cella. These features also characterize the first temples of Selinus (see p. 366, fig. 420). The overall design shows a pronounced compression and contraction of the structural elements, both horizontally (in narrowness of the spans) and vertically (in squat columns and heavy, disproportionate entablature).

A more agreeable balance was achieved on Corcyra (Corfu) in the Temple of Artemis, which is one of the masterpieces of early archaic Greek art. Colonized shortly before Syracuse, Corcyra was the last port of call for the Corinthian colonists before they crossed the Adriatic on the route to the West. In the late seventh and early sixth century, when it attracted the interest of the Corinthian tyrant Periander, Corcyra enjoyed a period of great prosperity, at first reflected in its architecture by flimsy constructions, known to us chiefly from the remains of their terra-cotta decoration (lion-head antefixes and Gorgoneion from Monrepos), then, about 590, by the first of the great stone buildings of the archaic period, the Temple of Artemis. In its ground plan the classical structures are already fully worked out (see p. 364, fig. 416): a long cella (115 by 30½ feet), with pronaos and opisthodomos, divided into three aisles by two rows of ten columns each and surrounded by a vast peristyle, 21 feet deep, whose colonnade (8 by 17 columns, 156 by 73½ feet) thus has a broad spread. The façade was supported by well-balanced

16

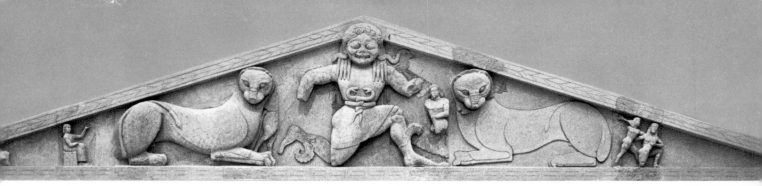

16. CORCYRA (CORFU), PALAEOPOLIS, TEMPLE OF ARTEMIS. GORGON PEDIMENT (NEW RECONSTRUCTION). CORFU MUSEUM.

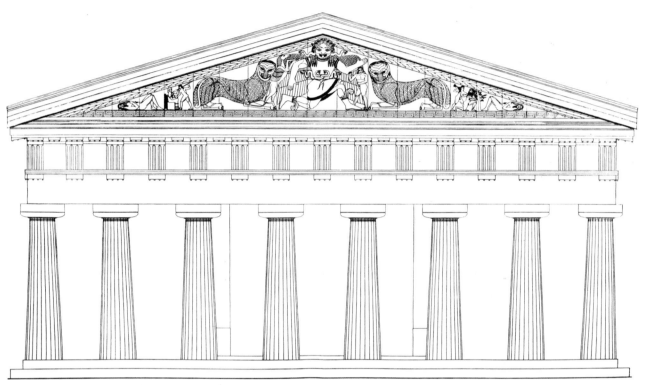

17. CORCYRA (CORFU), PALAEOPOLIS, TEMPLE OF ARTEMIS. RESTORATION OF THE FAÇADE.

columns crowned by very fine capitals, whose broadly treated, well-proportioned echinus is decorated with a necking of Doric leaf patterns (see p. 364, fig. 415).

All the elements of large-scale Doric architecture were here, and now in place: the columns of imposing proportions and the lighter, more refined entablature; the spirited rhythm of the Doric frieze with its metopes nearly square and its triglyphs prolonging the vertical pattern of the columns; the sharp line of the corona, which on the façade ended the entablature and formed the support of the pediment. Lines and areas combined and harmonized in a vigorous architectural design into which the carved and painted decorations were smoothly integrated. The colours and arabesques of spirals and leaf patterns were developed broadly in the terra-cotta sheathings of the cornices, which firmly set off the slanting lines of the pediment. The latter took its definitive form with a sequence of sculptures grouped round an imposing Gorgon.

17

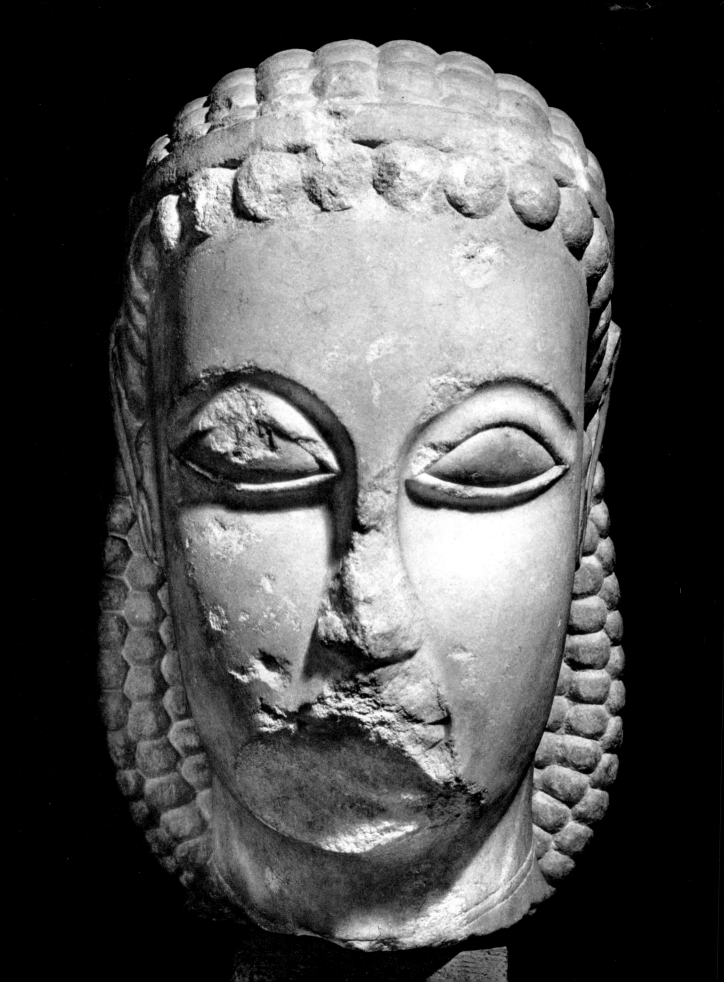

Sculpture

As we saw in the previous volume on Greece (*Aegean Art*, British edition; *The Birth of Greek Art*, American edition), large-scale statuary and architectural sculpture appeared in Greece in the second half of the seventh century B.C. From the eighth century on, the small-scale stone and marble sculpture forms that were created in imitation of precious objects imported from the Oriental world were so successful that artists were emboldened to enlarge their proportions to well beyond life size. This critical phase of overambitious growth, lasting about thirty years, prepared the way for a further evolution, or rather for a revolution that is probably unique in the history of forms. This artistic revolution, while continuing to draw upon a rich legendary and religious tradition, was influenced by a new direction in intellectual and political activity. Philosophers were trying to find rational explanations for natural phenomena, and legislators had begun the struggle to remould institutions with a view to greater social justice and cohesion.

Like painting, the decorative sculpture of religious edifices drew its subject matter from the great epic cycles, which had already figured in both Geometric and Orientalizing art. We shall see how the illustration of these legendary themes was adapted to Doric and Ionic architecture. The religious character of statuary is demonstrated not only by its presence in sanctuaries and on graves, but also by the conventions that governed it. The nudity of the *kouros* and, appearances notwithstanding, the drapery of the *kore* illustrate a peculiarly Greek mode of idealization, which was meant to give visible form to the close alliance of the worshiper with his god. But even more Greek was the statue's independence of the architecture and its affirmation of the sculptor's personality or that of the personage represented. Of this independence and personalization we have clear evidence in the many signatures and inscriptions that figure on the statues themselves, or on the bases. Even more telling perhaps is the deliberate variety of types and faces in the context of a single style. Artists were responding in their own way to the proud personal accents in the poetry of Archilochus and Sappho. In a world divided into city-states and rival factions, individual efforts and community ambitions were intensified by emulation. But are we justified in singling out, on the sculptures that have come down to us, the mark of this or that workshop? Hardly. Greek artists, like Greek poets and philosophers, were often on the move, attracted by the great sanctuaries and the more prosperous cities. Unfortunately, most of the signed bases are bereft of their statues, and even when we succeed in bringing together a small group of more or less related works, the sculptor usually remains anonymous.

19

18. ATHENS. DIPYLON HEAD. NATIONAL MUSEUM, ATHENS.

Although many assiduous and ingenious attempts have been made to trace and define the features of the main schools of Greek sculpture from the late seventh century to the opening years of the fifth, stylistic and chronological divisions are nearly always uncertain. By the eighth century, in the creative centres where its genius was manifesting itself in various ways, Greek art had absorbed and transformed its borrowings from the East. Even before the second half of the seventh century, the so-called Daedalic style, which had spread over most of the Greek world, had achieved a deliberate sobriety and spareness in the structure of forms and had set the course towards monumental sculpture. Before the end of the seventh century, the impetus in this direction was so strong, the fascination with a medium acutely sensitive to light so intoxicating, that there was an almost feverish production of colossal statues in the island marble quarries. These were not only roughed out in the quarries (chiefly at Naxos and Paros) but, it would seem, actually finished there and then shipped to their destination. The most remarkable example is the mighty figure, some four times life-size, that was dedicated to Apollo by the Naxians on Delos; the sculptor boasts in the inscription of having carved 'base and statue in the same stone.' This taste for the colossal, inspired by Egyptian statuary, seems to have waned and disappeared almost completely in the early years of the sixth century. On a more moderate scale, however, it lingered on at Samos till the time of Polycrates, and was revived in the telamones of the Olympieion at Agrigentum, pending the creation of the huge chryselephantine statues of Pheidias. The appearance of colossal statuary in the Greek world in the seventh century is in any case a spectacular illustration of the omnipotence of the landowning noble families who controlled the religious rites and usages, at a time when their domination was beginning to be contested.

From large surviving fragments of statues and reliefs, all too often worn or mutilated, we can gain some idea of the extent of the movement that spread with these itinerant sculptors through the Greek world in the last third of the seventh century and the first two decades of the sixth. It spread to Crete, the Peloponnesus, and Aegina, home of the sculptor Smilis, who is said to have worked also at Olympia and Samos; to Boeotia, in the Ptoion and at Tanagra, where workshops produced statuettes whose stylization, though deliberately conservative, is very appealing; to Thera, to Delos, where the colossal Apollo and five or six mutilated kouroi testify to the lead taken in marble carving by the Naxian sculptors; to Thasos, where the huge unfinished statue of a youth carrying a ram indicates the presence of colonists from Paros in this large island of the northern Aegean; to Samos, where fragments of colossal statues carved in the local marble have been found; to the Greek west, in Sicily, and to Cyrene in Libya.

As chance would have it, in both Attica and the Peloponnesus figure sculptures have come to light from this period which enable us to single out the distinctive qualities of an individual artist or of a human community, of fairly well-defined physical type, conditioned by its customs and institutions.

An outstanding piece from the Dipylon cemetery in Athens, one of the first of a particularly large output of works, reveals not only the hand and spirit of a great sculptor but the essential features of Attic sculpture. The marble comes from the islands, and the Dipylon Master had undoubtedly seen large-scale Naxian sculpture and to some extent modeled his work after it. (The priority of Naxian sculpture is proved by the pre-

19. ATHENS. DIPYLON HEAD, BACK VIEW. NATIONAL MUSEUM, ATHENS.

sence on Delos of Nikandre's statue in the middle of the seventh century.) Though the Attic master borrowed the elongated oval of the face from his island predecessors, he left the stamp of his personality on this over-life-size head. The facial features under the lofty luminous brow are carried to the highest degree of plastic intensity; to this is added the tactile effect of the hair, which is transformed into close-set strands of large beads enlivened by variations of size and alignment. This sculptural stylization was imitated until it became stereotyped, even after the middle of the sixth century. Because of the fascination of this face and the spell it seems to cast, it was formerly thought to be that of a sphinx, but the discovery of a related hand has restored the statue's human identity, though without lessening its daemonic character. This large head, among other pieces, appears to be an aristocratic expression of the funerary cult which, in the course

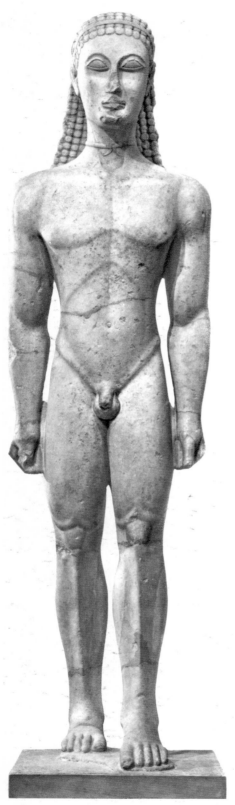

20. ATTICA. KOUROS. NEW YORK.

of the sixth century, called upon artists for other forms of sculptural representation. One can at least gain an idea of what the Dipylon statue was like from the New York kouros; there is a close resemblance between the faces, though that of the New York kouros is in a drier style, less lifelike, more geometric—possibly the work of a disciple of the Dipylon Master.

The Dipylon head in itself appears to have set a standard for Attic art, one that on an over-life-size scale maintained a beautiful harmony whose dominant note is marked by the sweeping curve of the eyebrows, which imparts a luminous clarity of design to the whole face and remains perhaps the most distinctive feature of the many masterpieces of Attic sculpture.

Half a dozen colossal statues, undoubtedly slightly later in date and in a ruder, less inspired, more detailed style, were discovered in fragments in the vicinity of the Temple of Poseidon on Cape Sounion. In the output of this local workshop, patronized by the great aristocratic families that owned the rich estates of Diacria and Mesogeia, we find a typically Greek spirit of experimentation in the rendering of certain anatomical details: the geometrically simplified grooves indicating muscles and skeleton immediately convey the essential structure of the body.

Beside these early Attic sculptures, those of the Dorian domain are all too few for this period in which artists, by now fully conscious of their technical mastery, pursued their ambitions in a series of often brilliant and even challenging works.

This paucity is surprising when we remember that Crete, even if it did not initiate Daedalic statuary, played a preponderant part in its development in the seventh century. There is little sculpture surviving now from Sparta, whereas for the sixth century we know the names of ten Laconian sculptors. There is equally little from Corinth, though we know that in this time of colonial and commercial expansion she produced much statuary in all the media used for small-scale works, and this when her colonies at Corcyra and Syracuse were producing large-scale sculpture.

22

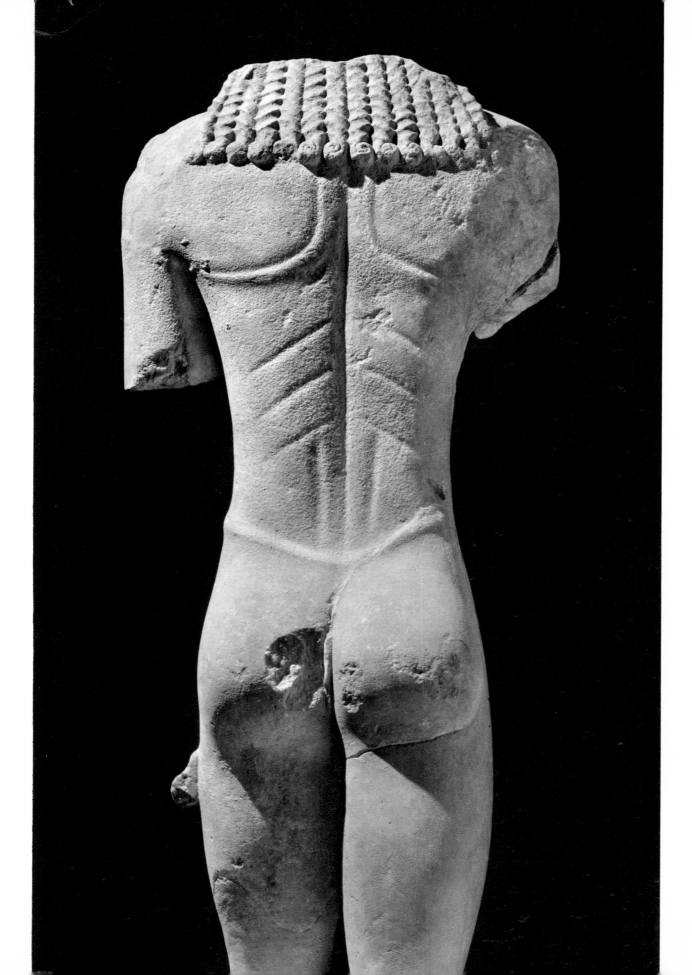

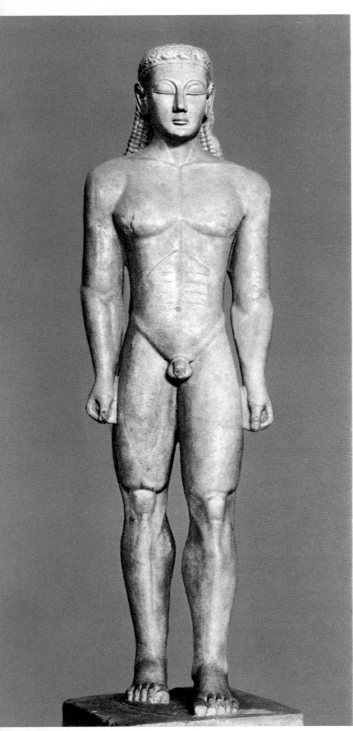

22. CAPE SOUNION. KOUROS I (CAST). ATHENS.

Because of the freshness and vivacity of the works created in this springtime of Greek art, when new life was stirring both in the mainland and the islands, the few 'Dorian' sculptures that have come down to us bear the imprint of their peculiar genius. The statues of Cleobis and Biton at Delphi, signed by Polymedes of Argos, stand at the head of a long line of works—the most extensive in the history of Greek statuary. Here the word 'statuary' takes on its full meaning. Argos never distinguished itself in monumental sculpture, as Athens and Corinth did. But in contrast with the huge Attic figures, which represent above all a conception of man, a reconstruction in lines and curves (square shoulders, flat torso grooved to indicate anatomy), the twin statues by Polymedes forcibly convey the presence of sturdy forms, of muscular bodies moving forward ready for action. There is no suggestion of thought in the low foreheads; the glow of life is in the wide-open eyes fixed on the goal ahead. The sculptor presents the twins as two athletes at the start of a race. What they actually did, as Herodotus tells us, was to draw their mother's chariot, in place of the missing oxen, to the sanctuary of Hera. On arrival they received the divine reward: they fell asleep in the sacred place, never to rise again. This edifying legend sheds light on the religious and historical import of the two statues. First, it provided the sculptor with a dramatic subject instead of an ideal image, and so gave him the opportunity to create the first surviving example of poised equilibrium in suspended action (a motif brought to classical perfection by Polycleitos, the glory of the school of Argos). Second, the two statues were dedicated by the Argives in the sanctuary of Apollo, and the death of the twins gave their exploit a legendary character, which relates it to the labours of Heracles, the Dorian hero, and presages the mythological garlands later woven by Bacchylides and Pindar in honour of the most famous victors of the Panhellenic games.

The realism achieved in the statues of Cleobis and Biton was not as pronounced in the early sculpture of Sparta and Corinth, because of the very multiplicity of outside connections and extensive artistic exchanges. This can be seen in the Spartan sculpture of

24

23. DELPHI. THE ARGIVE TWINS CLEOBIS AND BITON. DELPHI MUSEUM

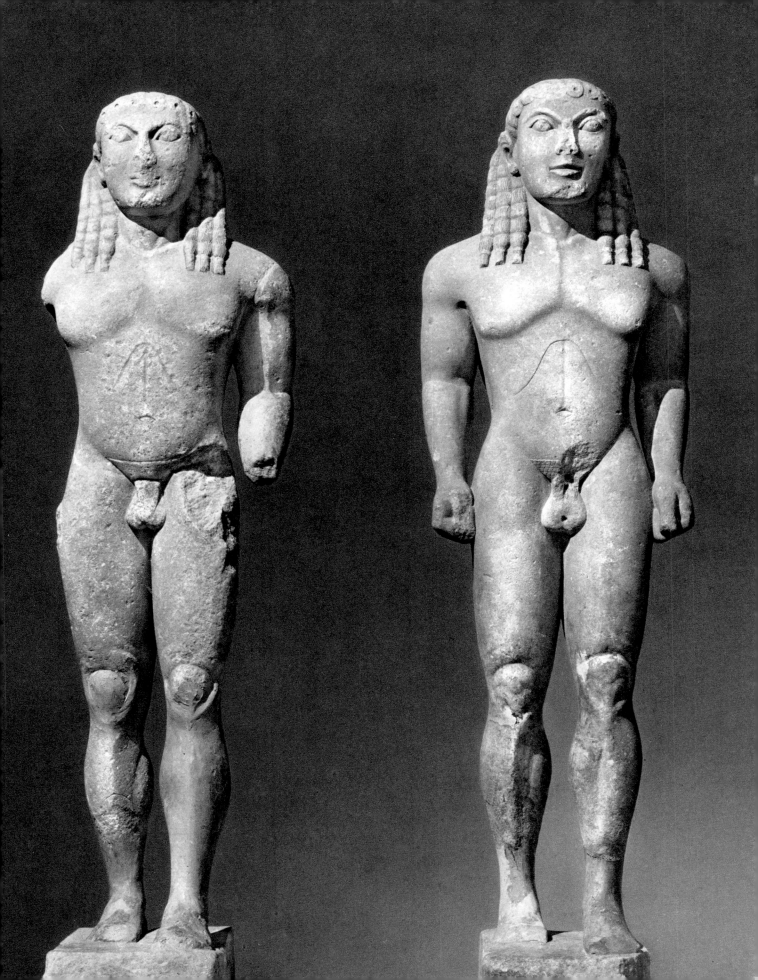

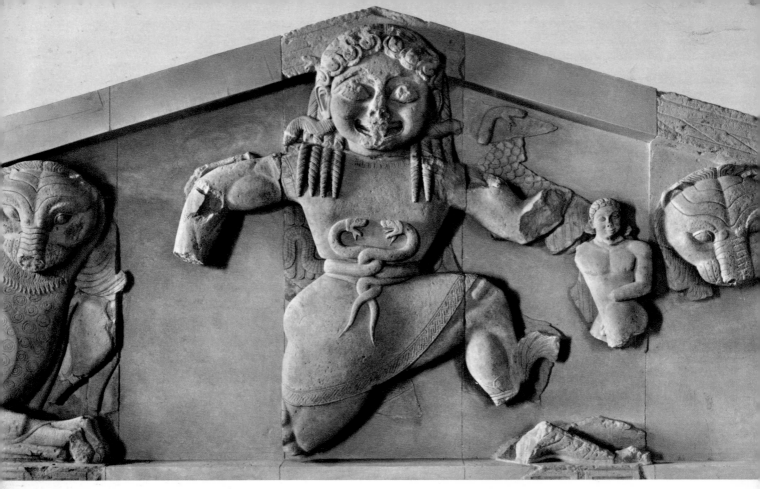

24. CORCYRA (CORFU), PALAEOPOLIS, TEMPLE OF ARTEMIS. MIDDLE SECTION OF WEST PEDIMENT. CORFU MUSEUM.

the colossal head of Hera, the only remnant of the goddess once enthroned in majesty beside a standing, helmeted Zeus in the Heraion of Olympia. The attribution of this group to the Laconian masters Medon and Dorycleidas, who with their pupils had carved other statues of divinities for the same temple, has much to be said for it. The majestic features of the goddess reflect Ionian influence, but the vigour and accents of the modeling, heightened with colour, show an expressiviness that is characteristic of the Laconian style.

Corinth was the most productive and most influential art centre of the early archaic period. Masters of architectural decoration in terra-cotta, the Corinthian sculptors produced the earliest pedimental composition in stone in the Corinthian colony of Corcyra. It stood at a height of over 30 feet in the pediment of the temple of Artemis. The central figure is a Gorgon 9 feet tall. The same motif, on a smaller scale and in gaudily painted terra-cotta, appears at Syracuse, another famous Corinthian colony. A monstrous animal deity, mother of Pegasus and Chrysaor, and mistress of wild animals (like her patroness Artemis, whose temple she protects), the Gorgon fills her role as a mythical and decorative ogre with a calculated audacity. The position of the figure, half running, half flying, balanced by two massive panthers, and the animation of the relief work, whose rich and refined design was meant to be seen from a distance, are Corinthian virtues.

26

25. OLYMPIA. COLOSSAL HEAD OF HERA. OLYMPIA MUSEUM.

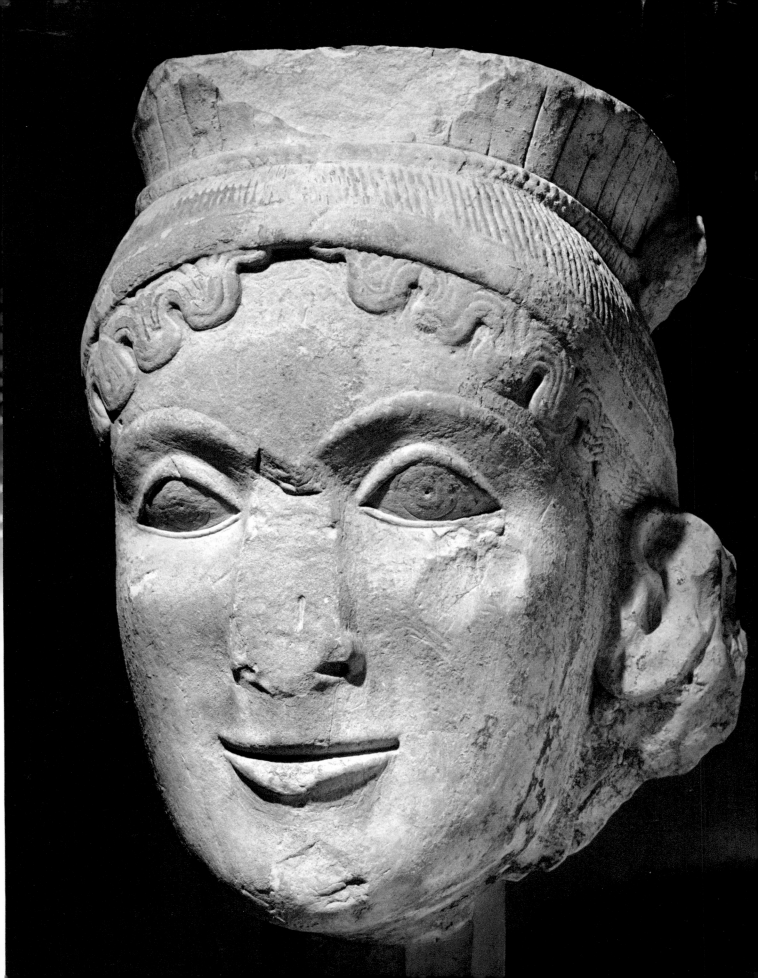

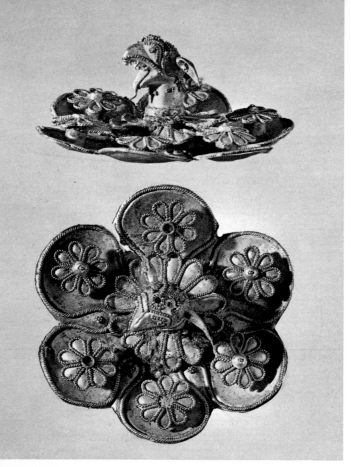

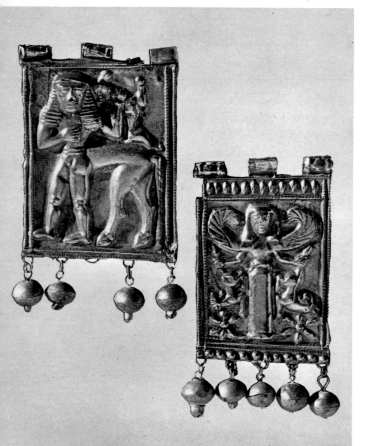

26. RHODES. ROSETTE WITH GRIFFIN. LOUVRE, PARIS.
27-28. RHODES. GOLD RELIEF PLAQUES. LOUVRE, PARIS.

The artistic and commercial links connecting Sparta and Corinth with East Greece show how careful one must be in drawing the distinction between Dorian and Ionian, which is so strikingly illustrated in architecture. For example, on Rhodes, which belongs to East Greece but whose three main cities were members of the Dorian Hexapolis, large-scale sculpture hardly appeared before the mid-sixth century, but to Rhodes's relations with Lydia we owe the most delicate jewellery of the early archaic period.

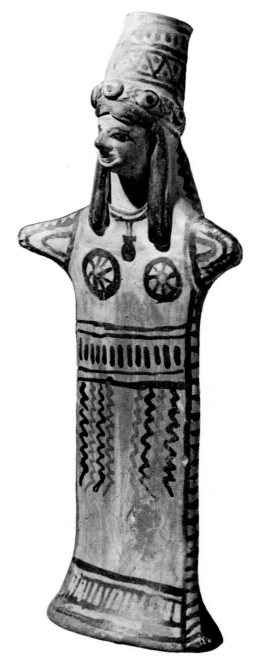

Painting and Pottery

Painting or pottery: the problem arises at the outset. Is Greek pottery of the archaic period merely a handicraft of good aesthetic and technical quality, or is vase painting a genuine reflection of the lost masterpieces of Greek painting? The ancient sources are of little help in answering this question. The only account we have of early Greek wall and panel painting is the rather confusing one of Pliny's (*Natural History*, XXXV), which may be summed up as follows. First, at Corinth and Sicyon appeared a kind of linear painting, devoid of colour, in which the painters simply outlined figures and added a few internal strokes. Then it occurred to the Corinthian Ekphantos to tint the interior of figures with a single colour made from powdered terra-cotta (this monochrome technique is the only one mentioned for the whole archaic period, except for the addition of white for women's bodies, a step taken by the Athenian painter Eumares in the mid-sixth century). Finally, torsion, anatomical details, and drapery folds began to appear in the second half of the sixth century. The subjects of these paintings were the same as those we see on painted pottery. But the resemblance extended beyond subject matter, for it has long been noticed that a similar but more complex evolution took place in the style and technique of archaic vase painting.

Although we are not in a position to reconstruct the history of early Greek painting, of which the ancient tradition itself has so little to tell us, archaeological discoveries, to an extent, have made up for the lack of written sources. Thus it now seems certain that at its beginning, after the loss of the Creto-Mycenaean inheritance, Greek painting was confined to painted pottery and that its field was very limited. The silhouetted figures drawn on the large Attic Geometric vases of the second half of the eighth century appear initially as mere accessories to the predominant decorative pattern work. But once figure scenes came to prevail over the pattern here and there, the vases of finer make became the vehicle of a nascent figure art. From the start, in keeping with a tradition that lasted as long as Greek pottery itself, the pictures were always well adapted to the shape of the vessel.

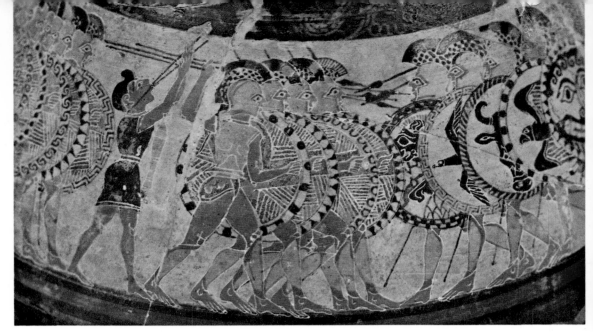

30. CORINTHIAN OLPE (CHIGI VASE), DETAIL: BATTLE OF HOPLITES. VILLA GIULIA MUSEUM, ROME.

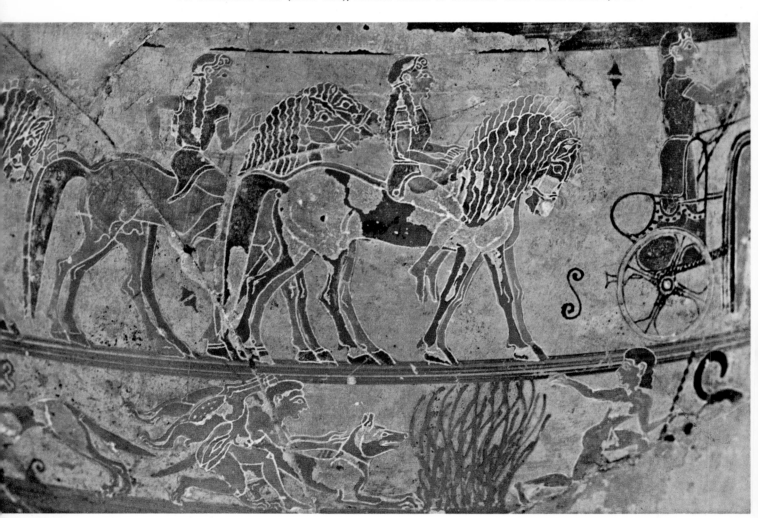

31. CORINTHIAN OLPE (CHIGI VASE), DETAIL: HORSEMEN AND HARE HUNT. VILLA GIULIA MUSEUM, ROME.

Only then, perhaps, appeared the paintings on terra-cotta plaques, the first independent pictures, which did not differ from vase paintings in technique or in style. True, other pictures were painted on wood coated with white plaster, and until the fifth century often the only decorations to figure on the walls of buildings were these wooden panels, like those executed by Polygnotos and Mikon for the Stoa Poikile and the Pinacotheca in Athens. But here again it is important to note the development, from the mid-seventh century on, of a similar white-ground technique of vase painting in East Greece. As for wall painting proper (i.e., fresco or tempera painting), it does not seem to have been practised in Greece before the end of the archaic period, for not until then were wall surfaces known to have been coated with the stucco or limewash, which served as the ground.

For the archaic period, then, vase painting may be considered more than simply a reflection of hypothetical great paintings, which in any case would have used the same means of expression. And in fact, after the Geometric phase, the evolution of vase painting led to a style based largely on outline drawing enlivened with various colours and often incised internal details. The considerable progress made, meanwhile, in the rendering of the human body enabled the archaic artist to compose scenes with many diverse figures, which often left no room on the available surface for accessories such as the numerous filling ornaments of Geometric or Orientalizing origin. So by about 640, at different places in the Greek world, we find an original, fully constituted art of painting applied to the decoration of both small clay pots and large panels which are fixed to the wall.

The Chigi vase is one of the masterpieces of this polychrome painting of the later seventh century. The anonymous Corinthian artist (the Macmillan Painter) who decorated this as well as other vases of still smaller size was truly a remarkable miniaturist. Within a space which was barely two inches high he successfully evoked a whole battle: we see opposing ranks of hoplites advance while an unarmed piper plays a martial tune. It is not only a spirited scene of real life, but a colourful composition using four basic tones (black, reddish-brown, yellow-brown, and white) and a delicate technique that, though it was at first peculiar to Corinthian pottery, became general in the sixth century: the incising of details, a fundamental element of the so-called black-figure style. Moreover, the overlapping hoplites convey a strong suggestion of spatial recession; here we find a principle of perspective that, though still rudimentary, is nevertheless a very bold innovation. This new vision of space recurs in the vase's middle zone, where the horses and riders again overlap. Finally, and no less unusual, nature has its place in the work of this interesting Corinthian painter, who has turned a commonplace hare hunt into a strenuous action scene of men and hounds dashing along among windswept bushes.

Polychrome vase painting appears at the same time in Athens, Argos, various Aegean islands, and even in outlying places of minor importance. Thus, at Megara Hyblaea in Sicily we can follow the whole evolution of a technique that in a recently discovered fragment of a dinos produced a painting undoubtedly more naïve than those on the Chigi vase but perhaps more picturesque. In this curious scene, which shows a row of heroes pulling on a heavy rope, the painter has attempted to combine tinted outline

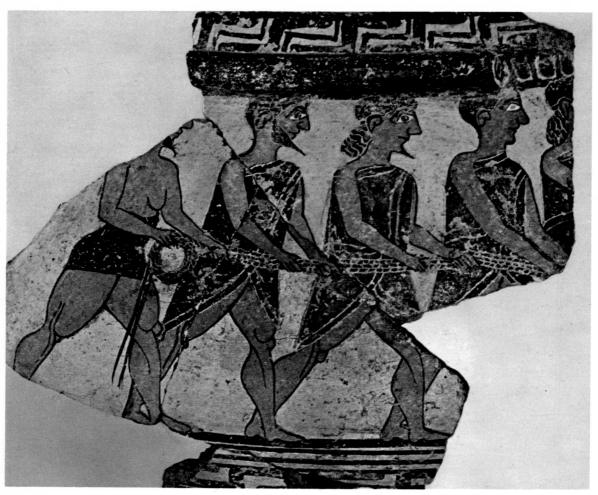

32. FRAGMENT OF A MEGARIAN POLYCHROME DINOS: HEROES PULLING ON A ROPE. SYRACUSE.

drawing with the black-figure technique borrowed from Corinth. The 'painterly' character of the scene is emphasized by the bare ground and the painter's manifest effort to individualize the figures.

The polychrome style was also used in the decoration of early buildings. The metopes from the temple of Thermon in Aetolia are terra-cotta plaques painted in the same technique as the vases.

Colours are used perhaps even more boldly on the metope representing Perseus carrying off the Gorgon's head, but this work is quite similar in spirit and style to the dinos from Megara.

Another metope from Thermon represents three seated goddesses, overlapping and receding behind each other like the hoplites on the Chigi vase. Such early works seem to have been valued by the later Greeks, for this painting was carefully restored at the beginning of the Hellenistic period.

32

33-34. THERMON, TEMPLE OF APOLLO. PAINTED METOPES: PERSEUS (ABOVE) AND GODDESSES (BELOW). ATHENS.

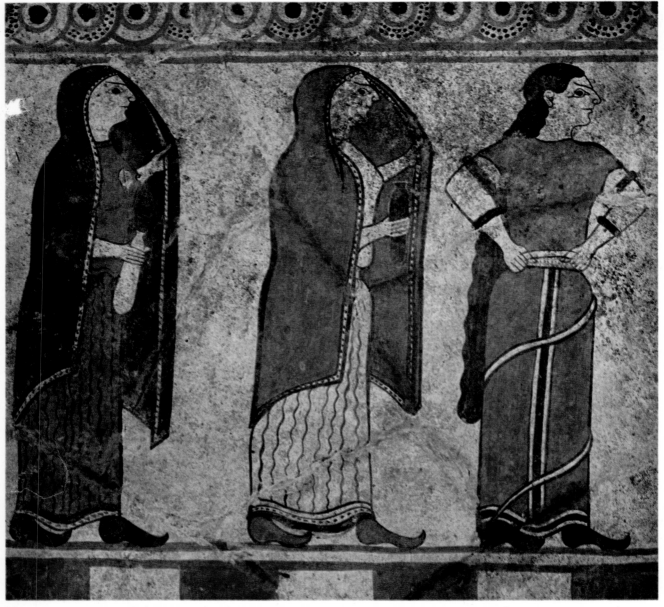

35. ETRUSCAN WALL PANEL (BOCCANERA SLAB): RELIGIOUS PROCESSION. BRITISH MUSEUM, LONDON.

Painted terra-cotta slabs were produced at least until the end of the archaic period. But probably Etruscan art provides the best examples of the use of these plaques in decorating walls in the Greek manner. The earliest Etruscan paintings were executed on terra-cotta panels, and fresco painting in the tombs did not really begin until the second half of the sixth century. The oldest group of panels, the Boccanera slabs, still show the influence of early sixth-century Corinthian vase painting in the use of incised lines and also in the combination of figure scenes and fantastic animals of Oriental inspiration, like the sphinx.

34

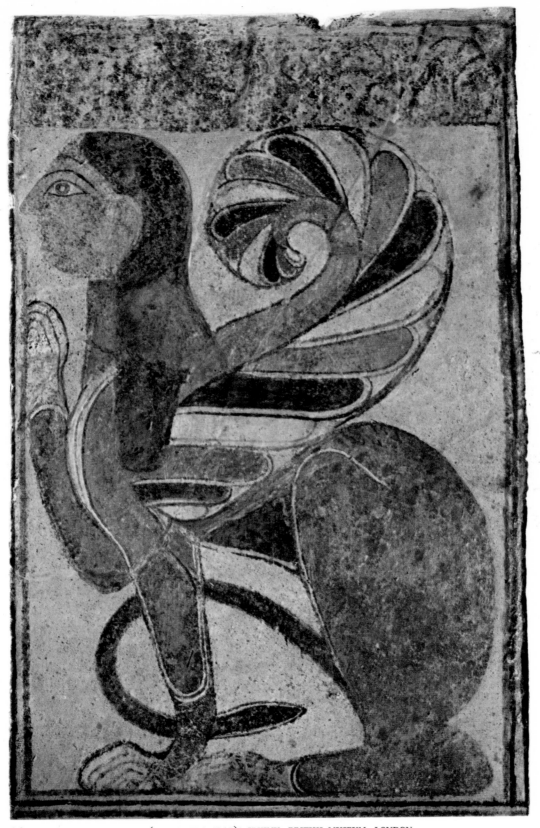

36. ETRUSCAN WALL PANEL (BOCCANERA SLAB): SPHINX. BRITISH MUSEUM, LONDON.

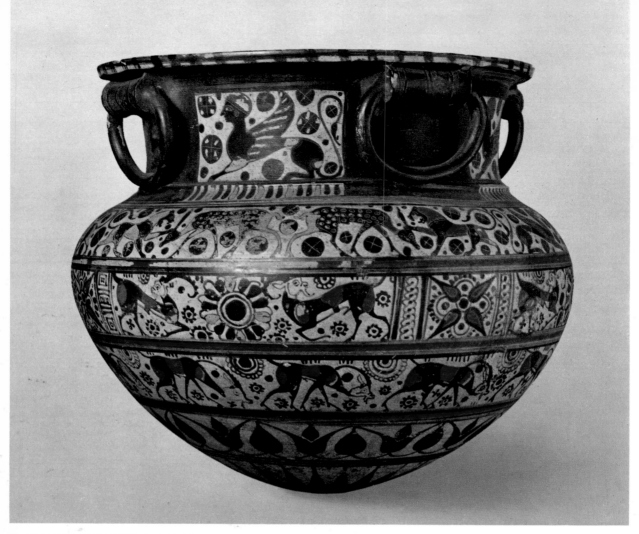

37. RHODIAN DINOS: ROWS OF ANIMALS AND DECORATIVE PATTERNS. LOUVRE, PARIS.

East and West

Despite the parallel development, we must not overemphasize the similarities between painted panels and vase paintings. The problems raised by the latter from the second half of the seventh century to the beginning of the sixth are much more complex in view of the great number of potters' workshops, the very uneven quality of the vase paintings, and the greater receptiveness to outside influences of an art whose purpose was still mainly decorative. Thus, in spite of the steady advance towards an independent art of painting centred on the human figure, there occurred at this time a new and massive penetration of Oriental influences, which had the effect of turning vase painting in the opposite direction, of plunging it into a fantastic and inhuman world wholly at variance with that rational outlook already characteristic of the Greeks.

Rhodian vase painting is typical of this new orientation. Even the rare works of 'painterly' character, like the Euphorbus plate, in which the polychrome technique lingers

36

38. RHODIAN PLATE: MENELAUS AND HECTOR FIGHTING OVER THE BODY OF EUPHORBUS. BRITISH MUSEUM, LONDON.

39. FRAGMENT OF A CHIOT CHALICE: HERACLES. ATHENS.

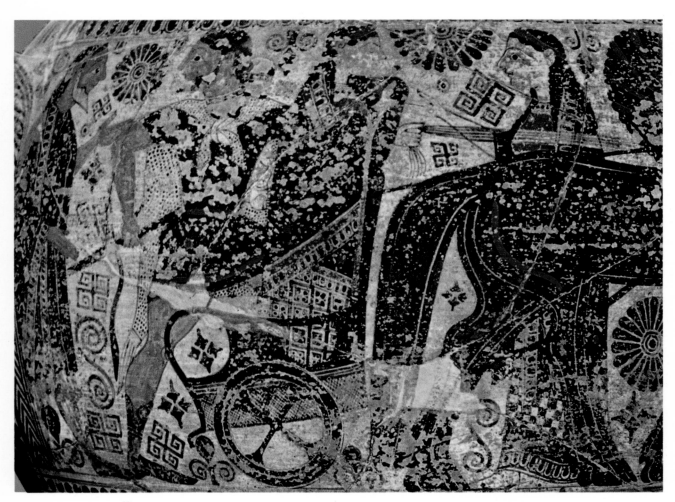

40. CYCLADIC KRATER, DETAIL: DEPARTURE OF HERACLES. NATIONAL MUSEUM, ATHENS.

41. CHIOT CHALICE: FANTASTIC ANIMALS AND DECORATIVE PATTERNS. MARTIN VON WAGNER MUSEUM, WÜRZBURG.

on, are pervaded by a host of elements quite foreign to the scene represented. Other Rhodian vases are adorned with rows of real or fantastic animals, accompanied by a profusion of ornaments and bright colours whose purpose is purely decorative.

In the Cyclades the big kraters from Melos have large figure scenes, again in a typically 'painterly' polychrome technique, although the later works already imitate the incised lines of the Corinthian black-figure technique. The most striking aspect of the composition is the many heterogeneous elements that at first baffle the eye; yet a spirited scene like the departure of Heracles is not without expressiveness. Almost the entire surface of Melian vases is covered with large stylized plant forms—spirals and palmettes—borrowed from the East.

On the island of Chios, skillfully crafted wares, of which the most popular shape was the chalice, are decorated with the same themes as Rhodian pottery: fantastic animals and large filling patterns. The composition is neat and orderly but purely ornamental. The human figure does not appear until the beginning of the sixth century, but then it is handled with a complete mastery of the polychrome technique, as is shown by the

39

figure of Heracles on a fine fragment of a Chiot chalice from the Acropolis of Athens. At Chios, too, the polychrome technique soon gave way to black-figure.

In Laconia painters kept for a long time to a purely ornamental conception of vase decoration, and Oriental influence seems to have been more limited than elsewhere. Two bowls from Tarentum (a Spartan colony), with dolphins and fish in effective patterns, mark the appearance of a naturalistic trend at the beginning of the sixth century. This gift for direct observation reappears in Laconia after 580 on black-figure cups decorated with scenes.

At Corinth, one of the leading city-states with an extensive trade, Oriental influences were strongest. Under the brilliant tyranny of the Cypselids, the potter's craft not only flourished but enjoyed an unprecedented development. Innumerable small pots were exported to many centres, but for a generation or so their decoration was limited to a monotonous repertory of animals and hybrid creatures, and a vase such as the Louvre olpe, with its sphinxes, panthers, lions, goats, and large splashes of colour, is the very antithesis of the Chigi olpe.

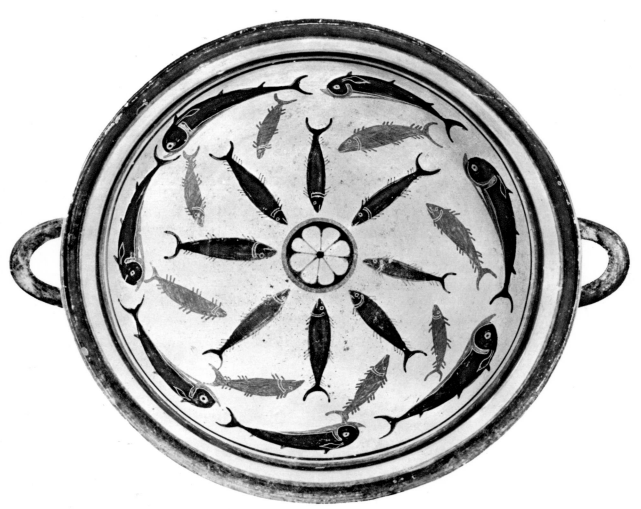

42. LACONIAN BOWL: FISH. MUSEO NAZIONALE, TARANTO.

43. CORINTHIAN OLPE: ANIMALS AND HYBRID CREATURES. LOUVRE, PARIS.

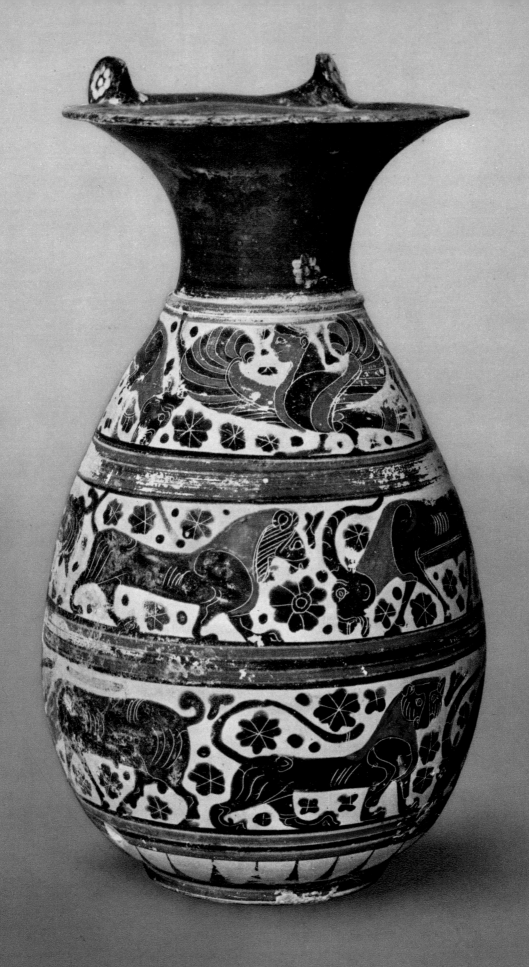

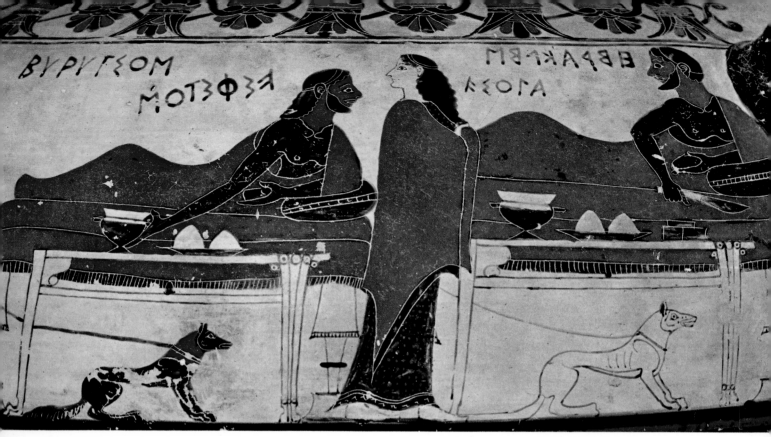

44. CORINTHIAN COLUMN KRATER, DETAIL: HERACLES AND EURYTIOS SERVED BY IOLE IN THE HOUSE OF IPHITUS. LOUVRE, PAⱤ

A Fresh Start in Corinthian Painting

But as suddenly as they had disappeared, scenes with figures reappeared in Corinthian vase painting in a new form at the beginning of the sixth century, not on small pots, which mostly continued to be decorated with fantastic motifs, but on fairly large-size pieces, particularly kraters. On these the main scene is usually one with figures, whereas rows of animals continue to serve as accessory elements of decoration. The polychrome style is superseded by fairly free line drawing without depth, in which the black-figure technique asserts itself. In the earliest examples of this new Corinthian painting, such as the Eurytios krater, some of the figures are still drawn only in outline, but the only colour is red, which covers large, arbitrarily chosen surfaces. Incisions are still used with sobriety. One feature of this vase is similar to that of wall painting: the names inscribed beside the figures, in keeping with the ancient practice of the early masters of Corinth and Sicyon as recorded by Pliny.

Sometimes certain features of polychrome painting linger on. Thus, in a banquet scene on a krater in the Louvre, women's bodies are drawn in outline and some of the clothing is painted in diluted yellow. This scene, however, compared with that on the Eurytios krater, has become conventionalized, and the background is filled with all sorts of objects. They are supposed to be hanging on the wall but are located in fact on the same plane as the revellers. The picture thus lacks any spatial recession.

42

45. CORINTHIAN SKYPHOS, DETAIL FROM BASE: HEAD OF A WARRIOR. PARIS.

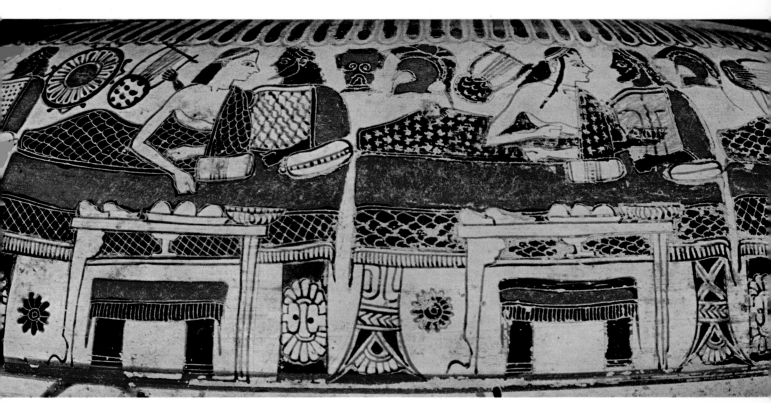

46. CORINTHIAN COLUMN KRATER, DETAIL: BANQUET SCENE. LOUVRE, PARIS.

Some smaller vases, however, following the miniaturist tradition of the Chigi vase, preserve the style of the large compositions with many figures. The painter of a skyphos in the Louvre must have amused himself and certainly demonstrated the variety of his talents by drawing on the underside of the pot a warrior's head in bright colours. But he treated the main scene almost entirely in black-figure and in a more narrative and epic style, though in size the band is less than two inches high. In overcoming the difficult problem of presenting a single theme on a continuous band, the painter contrived at once to divide his composition and to extend it all the way around. The break is marked by the cave of the good centaur Pholos, who looks on ruefully as his guest Heracles runs out in pursuit of the other centaurs who in their drunkenness are about to attack Hera.

A composition like this has nothing whatsoever in common with a wall or panel painting, since the scene circles around the side of the vase. If it were transferred to a plane surface it would lose its unity. So on this Corinthian skyphos in the Louvre we witness the birth of an original pictorial art specifically adapted to pottery and employing—a point which is worth emphasizing—a technique peculiar to pottery, the black-figure technique. The continuous band is no longer used here for an orderless massing or endless round of anonymous figures, as it was in wares of Oriental inspiration. It provides both room for a series of independent scenes, as on the Chigi vase, and a surface that lends itself to a unified single theme. No doubt such a compositional facility as this led the painter to neglect the problems of figure grouping within a picture space, for we see that the overlapping bodies of the centaurs fail to convey any suggestion of depth. Yet what appears here is perhaps a new sense of space, a subtler one, left to the spectator's imagination and produced by the volume of the vase itself. In their drunken excitement the centaurs really do form a disorderly whirl of figures round the cave of Pholos.

By comparison, one of the only two known Corinthian vases bearing a signature (that of the painter Timonidas) prefigures some more classical traditions. What the Timonidas bottle does have in common with the Louvre skyphos is the miniaturist rendering together with a certain taste for the evocation of a natural setting—in this case the bushes behind which Achilles lurks. But the zone in which Troilus, watched by Achilles, is depicted as he comes to the fountain to water his horses, can be rolled out flat and presented as a friezelike picture. The painter himself saw fit to mark off this zone by a vertical band behind Achilles. The scene can be understood easily by turning the bottle from left to right. Here, moreover, we find a much more 'painterly' handling, with the white horse in the foreground and quite an extensive use of outline drawing.

Akin to each other in the freedom and vivacity of their draughtsmanship, these two works, the skyphos and the Timonidas bottle, thus represent the parallel courses subsequently followed by the black-figure vase painters. One group devised pictures adapted to the shape of the pot but designed for a comprehensive view. This was the approach usually taken both in Corinth and Athens, where continuous bands of decoration gradually went out of use. The other and smaller group used the shape of the vase to give the figure scenes a new resonance.

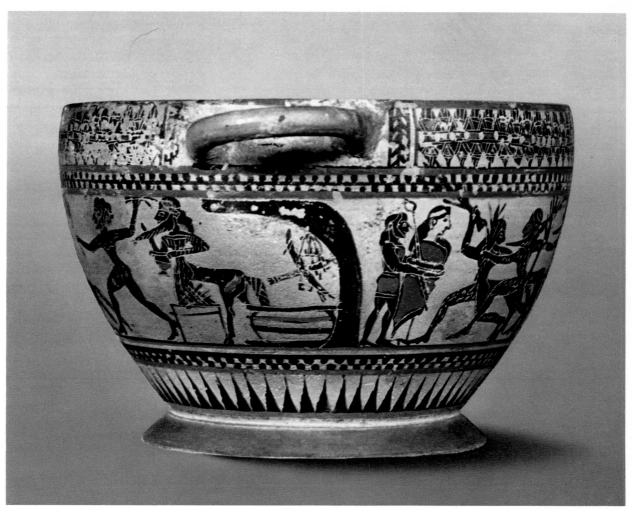

47. CORINTHIAN SKYPHOS: HERACLES PURSUING THE CENTAURS. LOUVRE, PARIS.

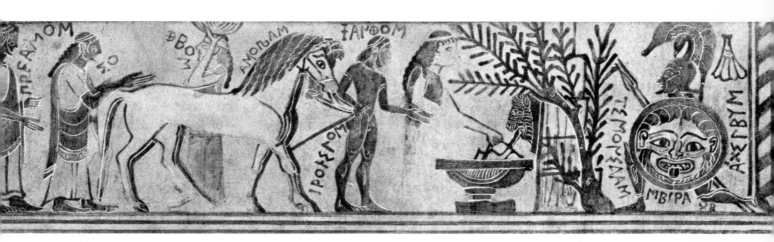

48. TIMONIDAS. CORINTHIAN BOTTLE, DETAIL: ACHILLES LYING IN AMBUSH FOR TROILUS. NATIONAL MUSEUM, ATHENS.

49. FRAGMENT OF AN ATTIC KRATER: SPHINX. KERAMEIKOS MUSEUM, ATHENS.

The Beginnings of Black-Figure in Attica

But it was not until after 580 that the great age of Greek vase painting, centred in Attica, began as a result of closer collaboration between potter and painter. Up to that time the Athenian workshops had pursued an independent course whose evolution in some respects shows a time lag; they absorbed Orientalizing trends rather belatedly, towards the end of the seventh century and especially in the early sixth. It was the influence of Corinthian pottery that led Attic painters to decorate their vases with imaginary animals. Like the Corinthians, they definitively adopted the black-figure technique, enlivening it with sizable touches of white and red. Athenian artists specialized in the production of large vases, which were set up on the graves of the well-to-do and were often decorated with pictures that, though rather naïve in style, were carefully composed.

The Nettos Painter, who represented Heracles brutally assaulting the centaur Nessos on the neck of a large amphora from the Dipylon cemetery at Athens, has not the

46

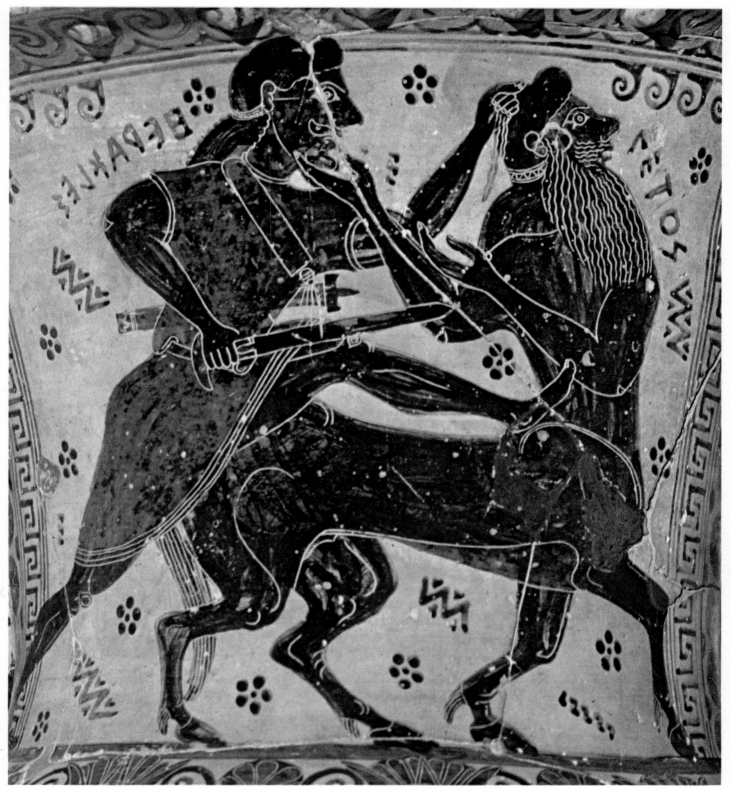

50. NETTOS PAINTER. AMPHORA, DETAIL OF THE NECK: HERACLES AND NESSOS. NATIONAL MUSEUM, ATHENS.

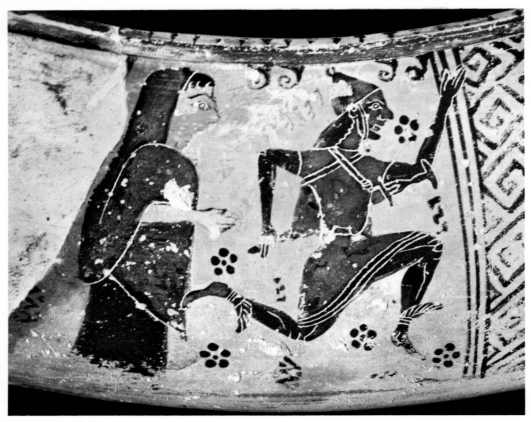

51. NETTOS PAINTER. SPOUTED KRATER, DETAIL: PERSEUS PROTECTED BY ATHENA. BERLIN.

supple freedom of line of the Corinthian vase painters, but he succeeded in composing a livelier, well-balanced picture. The two figures rise in pyramids that are reinforced by the supplicating gesture of Nessos, whose arms stretch back towards Heracles' head. The faces seem ill-proportioned and yet are as individualized and expressive as the painter's inexperienced hand can make them. The picture breaks away from the tradition of polychrome painting (which we still find, however, on a few Proto-Attic vases of the mid-seventh century). In this respect, the field patterned with filling ornaments remains characteristic of the earlier tradition.

To the Nettos Painter, too, may be attributed the decoration of a spouted krater found at Aegina (now in Berlin), on which the principal zone is divided into a series of small scenes. The artist's taste for well-delimited, sharply framed pictures is so strong that he has cut the scenes of pursuit in two, though the shape of the vase did not strictly demand such a division. In a separate panel to the left of Perseus, who is running away and protected by Athena, are the pursuing Gorgons; the two Harpies are also separated from the pursuing Boreads. In spite of the angular gestures and long strides of the Harpies and the 'kneeling' posture of the running, almost soaring, Perseus, the draughtsmanship shows unmistakable progress. Thus, in the figure of Athena the facial features are more regular, and the drapery more freely handled, with the suggestion of a fold. The compo-

48

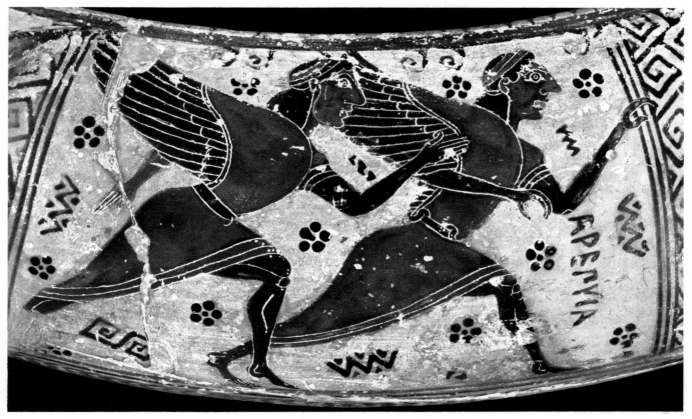

52. NETTOS PAINTER. SPOUTED KRATER, DETAIL: HARPIES PURSUED BY THE BOREADS. STAATLICHE MUSEEN, BERLIN.

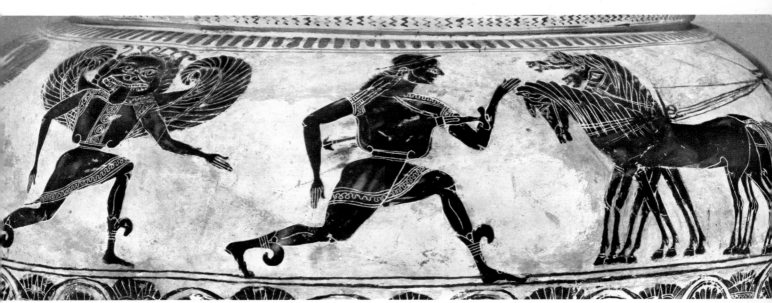

53. GORGON PAINTER. DINOS WITH STAND, DETAIL: PERSEUS PURSUED BY THE GORGONS. LOUVRE, PARIS.

49

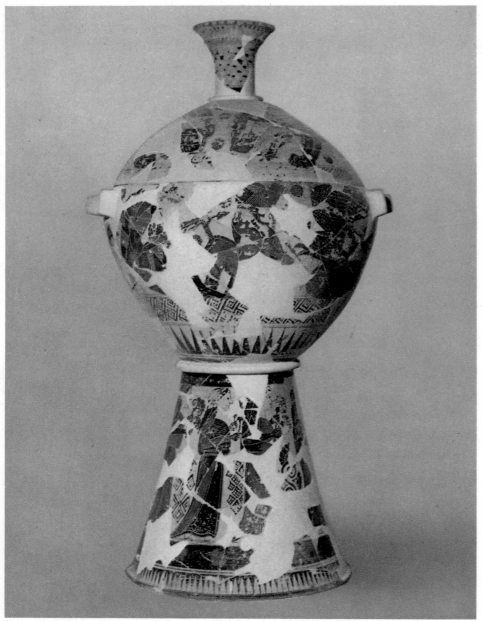

54. NETTOS PAINTER. SKYPHOS KRATER WITH LID. ATHENS.

sition, on the other hand, is less progressive, for it still relies on the device of figures set in profile, one behind the other, yet both depicted practically on the same plane. However, like the artists who painted the Chigi vase and many other vases of the last quarter of the seventh century, the painter has in part discarded the old archaic convention of representing the torso in frontal view and head and legs in profile.

One of the later works of the Nettos Painter, who stands out as the first important artistic personality in early black-figure Attic vase painting, is again a vessel of large size, a brightly painted krater (with a lid) from Vari. Here the decoration is better

50

55. GORGON PAINTER. DINOS WITH STAND. LOUVRE, PARIS.

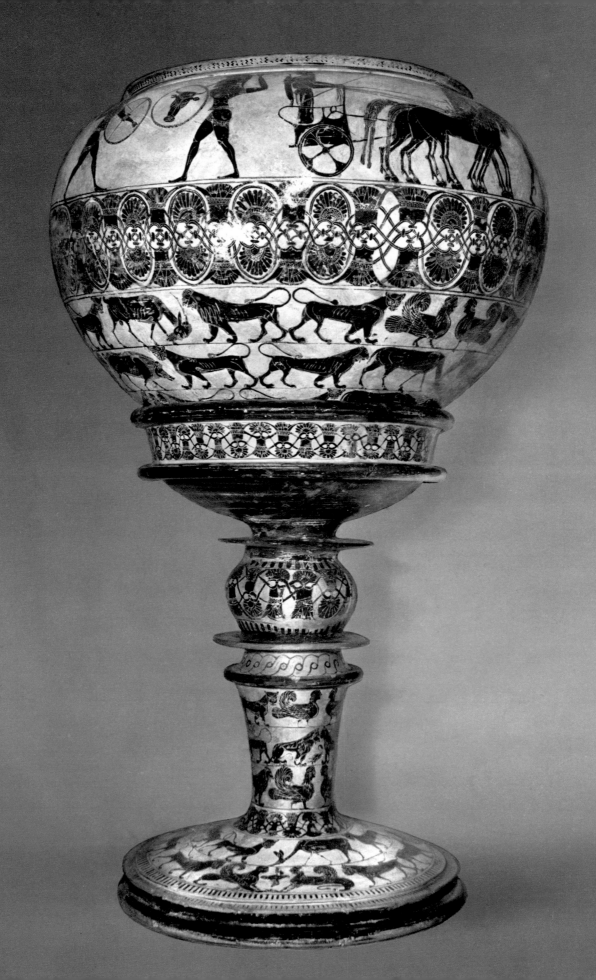

adapted to the shape than in the case of the Aegina krater. It is marked by a partial return to bands of decoration, but they are bands of Oriental inspiration, particularly the large animals on the lid, and even the procession of women on the foot, where one notes again the skillful linework already shown by the Nettos Painter in the figure of Athena on the Aegina krater. There is no warrant for attaching any precise meaning to the procession, and all the unoccupied areas are patterned with filling ornaments. Much more confused is the main scene on the body of the krater: Heracles, about to let fly an arrow at the monstrous eagle gnawing at the vitals of the bound Prometheus, is squeezed into a corner and is out of all proportion to the rest of the scene.

This fresh influx of Oriental currents that began to mark the work of the Nettos Painter grew stronger in Attica in the first two decades of the sixth century as a result of the then predominant influence of Corinthian vase painting. During this time Athens suffered the social and economic crisis that Solon's reforms were designed to obviate, and Attic black-figure declined. There were no more monumental pieces, but pots of medium size; no more figure scenes, but bands of animals devoid of meaning; no outstanding artistic personalities, but decorators who, like the Gorgon Painter, rarely painted figure scenes.

It is from his masterpiece, the Louvre dinos, that the Gorgon Painter takes his name. This dinos, with its long stem, testifies to the progress made by the potter in the study of harmonious proportions and of balance between areas, here framed by fine mouldings. The shape of the vase seemed to call for decoration in bands, but nearly all of them are filled with rows of animals or ornamental friezes. Figure work is limited to the uppermost band, where two subjects are awkwardly arranged, unseparated and yet presented so that neither scene can be understood at a glance. Space is used much less skillfully than in contemporary Corinthian vases and Perseus pursued by the Gorgons comes right up against one of the quadrigas that frame the combat between two Homeric heroes. The running figures are simply strung out one behind the other, whereas the symmetrical grouping of the two fighting men and the two chariots heralds the well-ordered pictures on black-figure vases after 580.

In spite of the absence of outstanding works, Attic painted pottery began to be exported at the beginning of the sixth century, and to places far from Athens. The stemmed dinos decorated by the Gorgon Painter, for example, is one of the earliest large pieces of Attic pottery found in Etruria; after 580 most of the finer Athenian wares were shipped overseas to the western markets. This practice, resulting from the measures taken by Solon to encourage handicrafts and trade, is significant: it vouches for the popularity of these Attic vases, soon to be valued as works of art, among the rich and civilized peoples of the sixth century like the Etruscans.

Equilibrium and Progress

580-525 B. C.

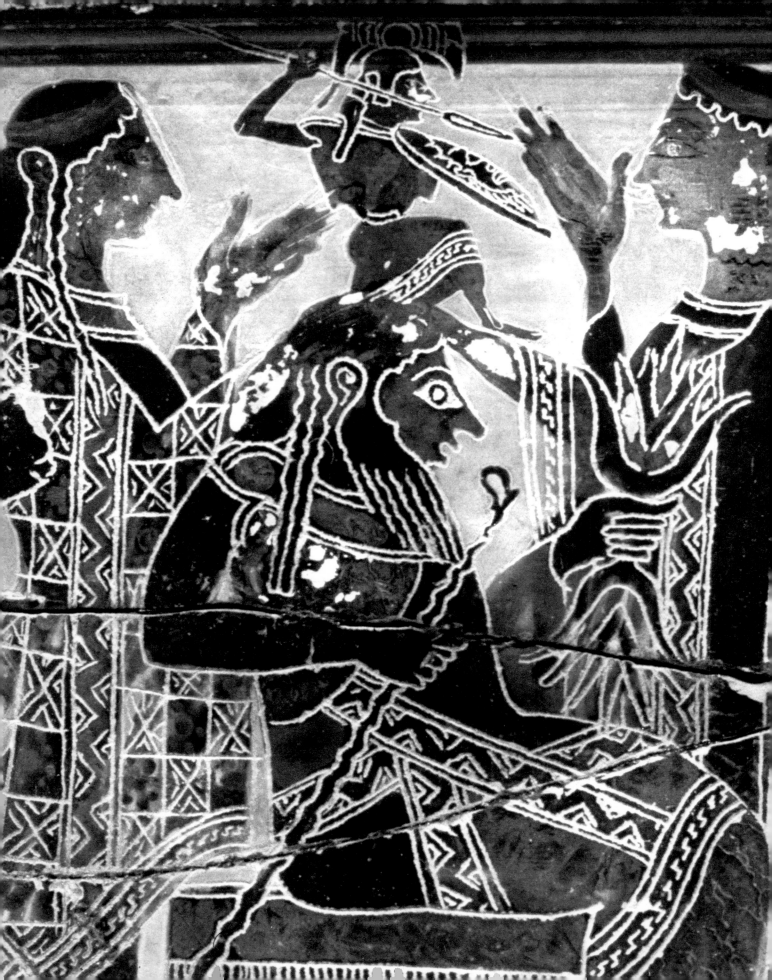

Painting and Pottery

Cleitias

Black-Figure Vases

By the beginning of the sixth century Greek art had a somewhat chaotic aspect. The techniques had been largely mastered by then, the various schools had assumed their characteristic features, and the leading artists can be singled out. And yet, amid all the interacting trends, currents, and sources of inspiration that went into the making of this art, it is sometimes difficult to define a prevailing style at any given moment in the early sixth century; the convenient label 'Orientalizing style' covers in practice a rather complex blend of ingredients.

In vase painting, however, after about 580, the focus is clearer and until about 525 a certain unity of style prevailed, which owed its uniformity, it would seem, to the peculiar technique of black-figure and the adoption of a set of conventions. We can trace a distinct evolution, but it affects details of draughtsmanship rather than the structure of the figures or scenes represented. Since no wall paintings have survived from this period, it is impossible to follow this art's development before the end of the sixth century, when we again find a polychrome style of flat tints, whose technique has scarcely changed at all in the intervening years. But there do survive from the early sixth century some small pictures on terra cotta plaques painted in black-figure, and there can be no question that this technique fostered the rise of a style peculiar to vase painting. Thus, as we have seen, procedure came into general use that was neither true painting nor mere line drawing but that proved well suited to pottery decoration: figures painted in black silhouette on the natural clay surface of the vase, with inner details incised and touches of white and red discreetly added.

The black-figure style inherited a system of conventional features, such as the combination of profile and frontal views in figures. These conventions, however, gradually disappeared. The kneeling position used to depict running figures gave way to a more natural representation of movement. Inner details were multiplied and treated with greater realism. Drapery folds appeared and began to convey an impression of volume. Finally, but by slower degrees, body structure was rendered more accurately, and movement suggested with greater ease and freedom. In a word, the black-figure style tended steadily towards a less conventional rendering of the human figure and a closer approximation of an ideal reality.

55

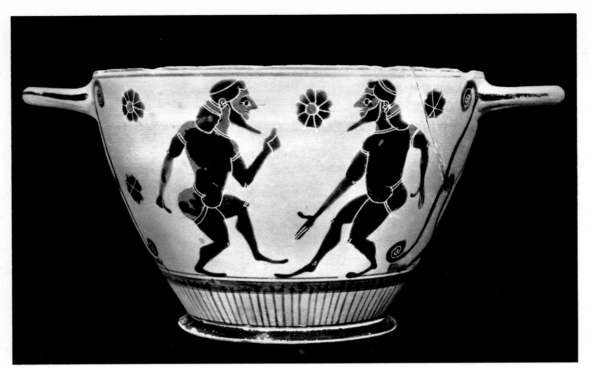

57. ATTIC SKYPHOS: REVELLERS EXECUTING A COMIC DANCE. NATIONAL MUSEUM, ATHENS.

The First Generation of Attic Painters

Very appreciable advances were made in Attic vase painting in the second quarter of the sixth century. They were due both to the influence of Corinthian black-figure on most of the workshops active around 580 and to the sharp reaction of the leading Attic vase painters against the effects of that influence. As it turned out, within a few years the situation was reversed, and it was then the Corinthian painters who had to cope with the artistic and commercial ascendancy of Attic pottery. At first, however, certain groups of Attic painters followed Corinthian models quite closely in animal patterning and especially in figure scenes on characteristic themes. The Attic skyphos, with a pair of dancing revellers, illustrated above, might pass for Corinthian work, even in its details.

Sophilos, the first Attic vase painter to sign his works, was the first to depict scenes with many figures from epic themes and also initiated in Attica the use of the frieze for continuous compositions forming a unified whole. On the dinos from Pharsalus, Sophilos painted a lively picture of a massed crowd watching the funeral games held in honour of Patroclus. It is naïve, still rather clumsy painting, in which there is much use of white and red. Bordered by traditional animal friezes, it is nevertheless one of the earliest efforts to give the figure-work scene a dimension worthy of the Homeric epic. It also presents, again for the first time, a background (the stands in side view) whose recession in space is suggested by the reduced size of the figures. By contrast, in another large composition representing the gods and goddesses invited to the wedding of Peleus, Sophilos treated the picture field on more traditional lines. Yet here, too, in the suppleness of the moving figures, in the taste for architectural detail, and the concern for pictorial effect, with the

58. SOPHILOS. FRAGMENT OF A DINOS: FUNERAL GAMES OF PATROCLUS. NATIONAL MUSEUM, ATHENS.
59-60. SOPHILOS. FRAGMENTS OF A DINOS: PROCESSION AT THE WEDDING OF PELEUS. NATIONAL MUSEUM, ATHENS.

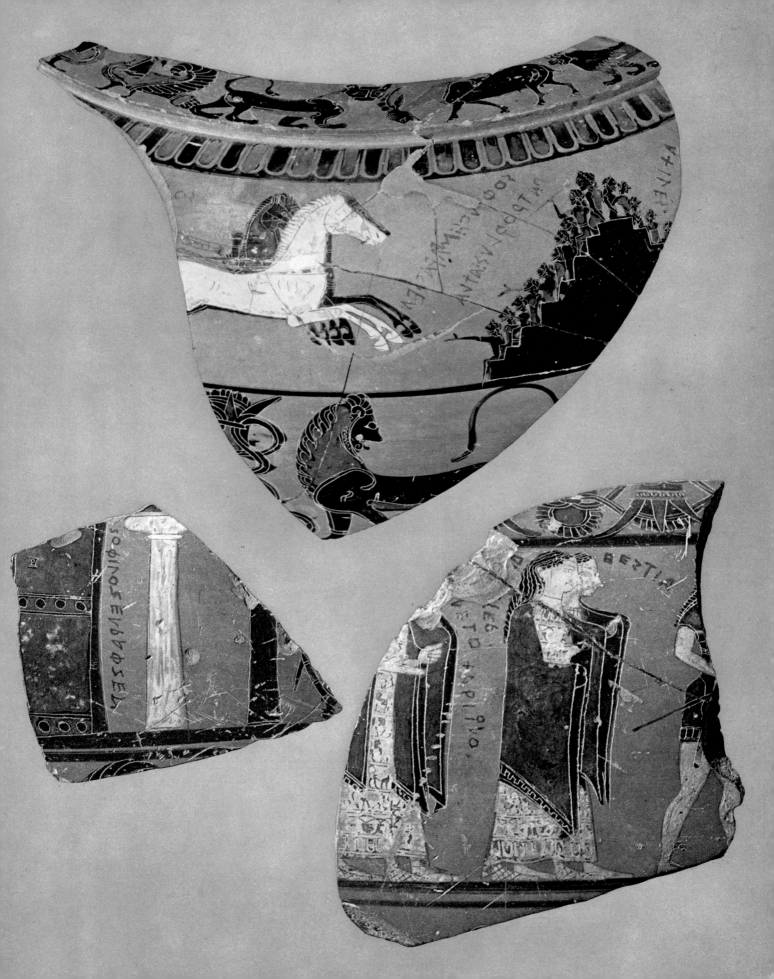

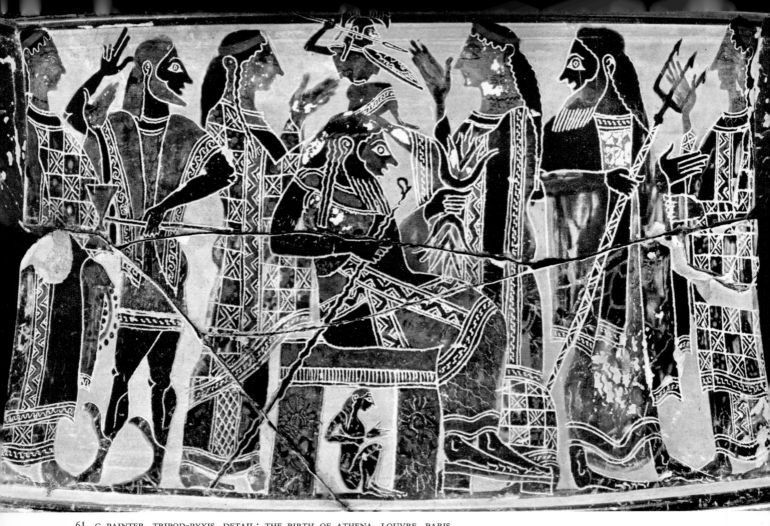

61. C PAINTER. TRIPOD-PYXIS, DETAIL: THE BIRTH OF ATHENA. LOUVRE, PARIS.

62. C PAINTER. LID OF A LEKANIS, DETAIL: THE SLAYING OF ASTYANAX AND PRIAM. MUSEO NAZIONALE, NAPLES.

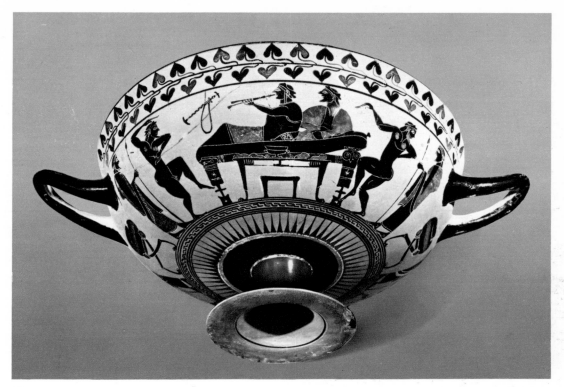

63. HEIDELBERG PAINTER. CUP: BANQUET AND REVELLERS. MUSEO NAZIONALE, TARANTO.

white flesh of the women outlined in red, can be seen the advances made over a few years.

At the very time when these original features were becoming prominent, about 580-570, other Attic painters still conformed to Corinthian fashions. But these fashions prevailed much more in details of the drawing than in the overall composition, which was now Attic in spirit. We need only consider certain works by the C Painter (the initial refers to the 'Corinthianizing' character of his style). This painter of cups and small pots does indeed seem to hark back to the miniaturist design of Corinthian wares, and a detail like the row of hoplites on the lekanis lid from Cumae recalls the battle scene on the Chigi vase. But to this the painter added a new dramatic conception of the black-figure picture, which is evident either within the traditional setting of the narrow frieze, as in the slaying of Priam on this lekanis lid, or in the form of a rectangular panel-like picture, as in the birth of Athena on the Louvre tripod-pyxis. The latter scene is Attic in its theme and untraditional in its conception—the symmetrical grouping which makes all eyes converge on the goddess as she springs from the forehead of Zeus. But the figures are still stiff, with heads slewed round sharply and bodies encased in heavy garments.

Scenes taken from daily life are portrayed on a whole series of cups and bowls from the second quarter of the sixth century, the work of the C Painter or a colleague of his, the Heidelberg Painter. In these, all trace of Corinthian influence has disappeared. This spirited and engagingly unpretentious style was to find its fulfillment in the work of the Amasis Painter (see pp. 87-89).

But the outstanding artistic personalities of the period 570-560 were the painters of large vases and large compositions, of which the famous François vase is the masterpiece.

59

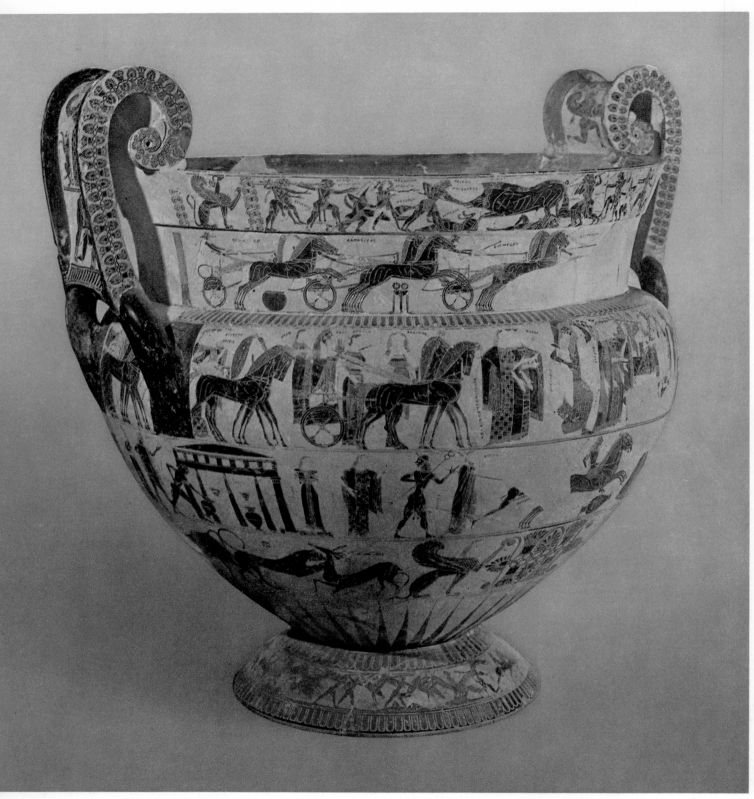

64. ERGOTIMOS AND KLEITIAS. VOLUTE KRATER (THE FRANÇOIS VASE). MUSEO ARCHEOLOGICO, FLORENCE.

60

This volute krater of exceptional size (it stands 26 inches high) is signed by both the potter Ergotimos and the painter Kleitias, a fact which seems to show that in the eyes of contemporaries the work of the potter (that is, the shape of the vase) was also import- ant. From this time on in Athens, potters' and painters' signatures became more and more frequent, and all the evidence suggests that the social standing of these workshop owners or managers was by no means negligible. They dedicated rich offerings on the Acropolis, their output found a ready market overseas at prices that are known to have been high, and the very fact that they signed their work proves that they regarded them- selves and were regarded by others as more than mere artisans.

The very large number of figures on the François vase are for the most part grouped in scenes from the Greek epics. One entire side of the krater is devoted to the story of Achilles and his father Peleus: the Calydonian boar hunt, with Peleus in the forefront; the wedding of Peleus and Thetis, with the procession of gods and goddesses who attended the wedding extending all around the vase; the slaying of Troilus by Achilles; the funeral games in honour of Patroclus, bosom friend of Achilles (we have seen this theme and the wedding of Peleus already treated by Sophilos); and, on the handles, the death of Achilles, with Ajax carrying the hero's body. On the other side are two of Theseus' exploits: the deliverance of the young Athenians who had been handed over to the Mino- taur, their dance in a ring, and the joy of Theseus' companions; and the battle of the Cen-

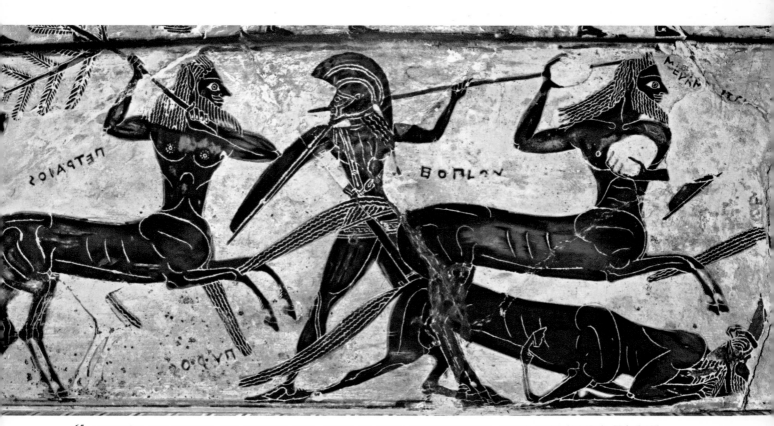

65. ERGOTIMOS AND KLEITIAS. THE FRANÇOIS VASE, DETAIL OF NECK: CENTAUROMACHY. MUSEO ARCHEOLOGICO, FLORENCE.

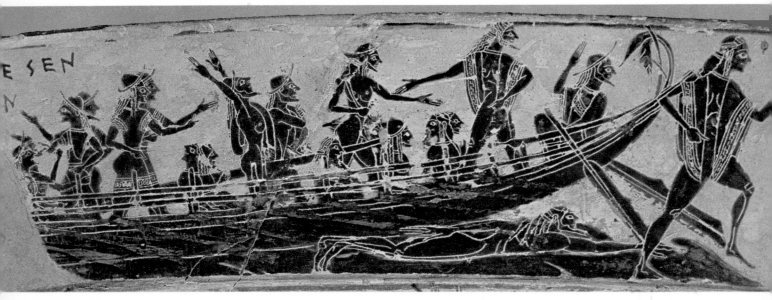

66. ERGOTIMOS AND KLEITIAS. THE FRANÇOIS VASE, DETAIL OF NECK: LANDING OF THESEUS' COMPANIONS. FLORENCE.

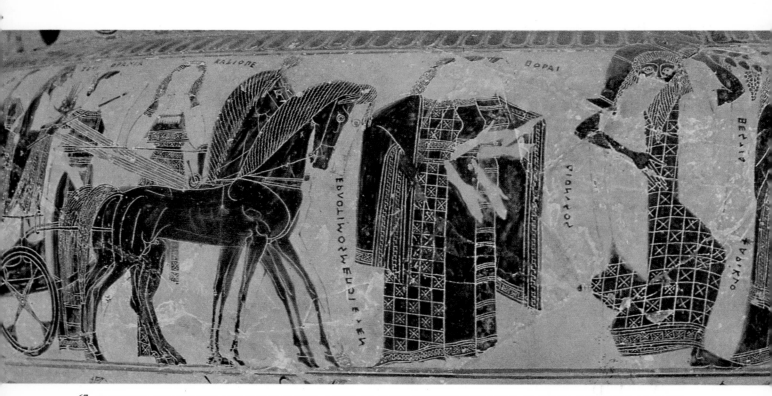

67. ERGOTIMOS AND KLEITIAS. THE FRANÇOIS VASE, DETAIL OF BODY: WEDDING PROCESSION OF PELEUS AND THETIS. FLORENCE.

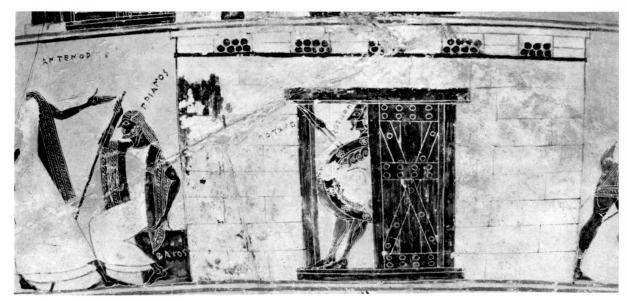

68. ERGOTIMOS AND KLEITIAS. THE FRANÇOIS VASE, DETAIL OF BODY: PRIAM AND ANTENOR BEFORE TROY. FLORENCE.

taurs and the Lapiths, with the Athenian hero fighting on the side of the latter. Apart from these subjects taken from the epic cycles, there is only a single scene from the mythology of the gods, and this, in singular contrast with the epic themes, is treated in a spirit of parody: the return of Hephaestus to Olympus, led by Dionysus and his thiasos, or entourage. On the foot unfolds a kind of burlesque, exotic epic—the battle of the pygmies and the cranes. Finally, a few secondary themes in the Orientalizing tradition remain: the lowest frieze on the body, decorated with sphinxes, palmettes, and fighting animals; and on the handles, two winged figures of Artemis as mistress of wild animals, and two Gorgons.

This brief list of the pictures indicates the compositional scheme and variety of the subject matter. The pictures, each a self-contained unit and sometimes framed by buildings, are set out in elongated friezes, which with one exception do not extend beyond one side of the vase. Though the ample, measured gestures of certain figures give a touch of solemnity, the scenes are still full of life when examined in detail. The battle of the centaurs may seem banal, but the different episodes are carefully composed, and the interknit bodies convey a sense of spatial depth. The long procession of gods at the wedding of Peleus and Thetis is enlivened here and there by figures like Dionysus carrying a gold amphora, his wedding present, or Calliope, both represented in front view. What could be more vivid and droll than the high-spirited gesturing of Theseus' sailors as their boat touches the shore? And what could be more dramatic than the anxious figure of Priam vainly awaiting the return of Troilus before Troy's gate, or the beautifully composed picture of Ajax carrying the stiff corpse of Achilles? The work of Kleitias thus seems to contain all the tendencies that were to inspire the Attic black-figure painters. Moreover, these remarkable qualities, along with the finesse and sureness of the incisions, appear in many other contemporary vases.

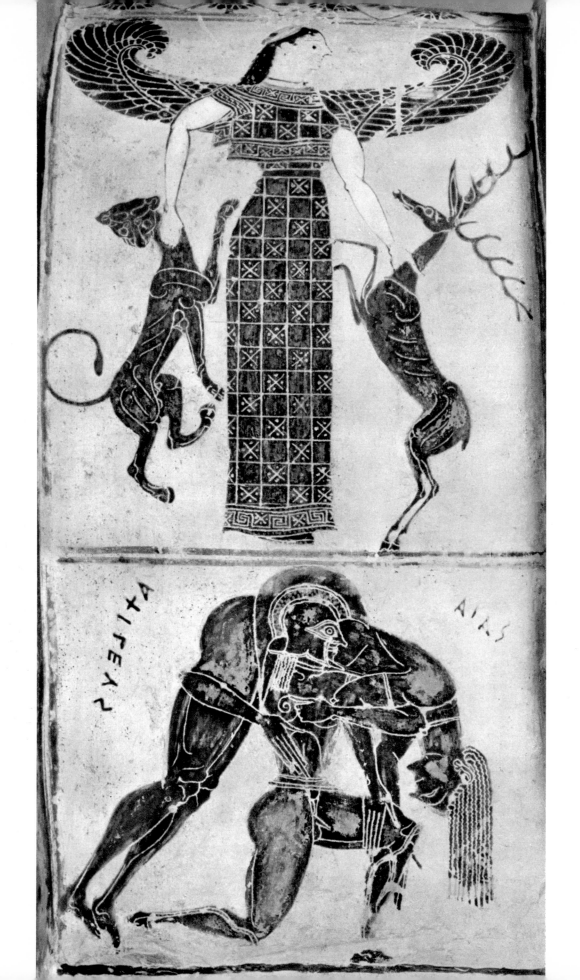

The Painter of Acropolis 606 is a good example of an artistic personality who, though less creative than Kleitias, is perhaps a more typical master of the epic and monumental style that prevailed in the years 570-560. The main frieze on his dinos in Athens is given over to a single battle scene; the two groups of antagonists are engaged in heroic combat, for in the Homeric manner they have jumped from their chariots and challenged each other to fight. Although the composition is only apparently symmetrical, it nevertheless emphasizes a harmonious grouping of the two front-line chariots in the foreground. The placement of the warriors on the far side of the horses creates a new effect of density, even more strongly than on the François vase, but there is no feeling of depth, for the overlappings are not clearly marked. The incised details are hardly less meticulous than on the François vase, but the white and red are more elaborately used and better adapted, too, to the black-figure technique. Whereas Kleitias still applied the white directly on the clay and added outline, as did Sophilos, the colours of the Painter of Acropolis 606 are only enlivening touches added over the black paint, thus enabling him to balance his masses freely and to emphasize certain details.

The epic style served not only large compositions with many figures; in the hands of some Attic painters, it even led on occasion to an early expression of individual feelings. Nearchos, who was both painter and potter, is known only from a few fragments, the most important of which come from a kantharos found on the Acropolis. They are enough to vouch for this artist's mastery. He was a draughtsman whose skill in incision work is astonishing. He was a keen observer of animals and portrayed them realistically. As a painter he tellingly conveys the emotions of the hero, and in spite of certain archaic

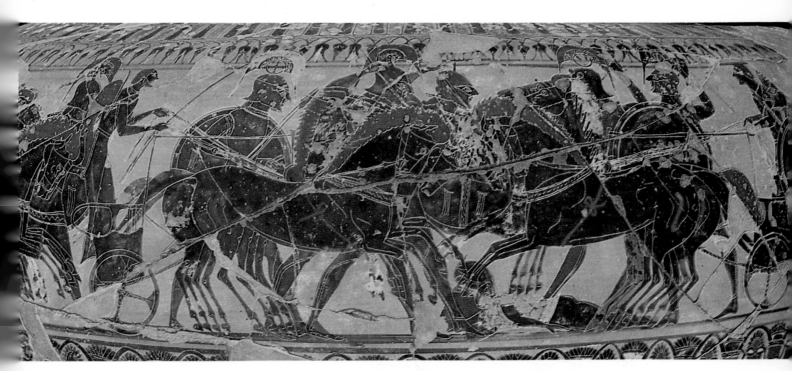

70. PAINTER OF ACROPOLIS 606. DINOS, DETAIL: WARRIORS FIGHTING BETWEEN THEIR CHARIOTS. NATIONAL MUSEUM, ATHENS.

◄ 69. ERGOTIMOS AND KLEITIAS. FRANÇOIS VASE, DETAIL OF HANDLE: ARTEMIS—AJAX CARRYING THE BODY OF ACHILLES. FLORENCE.

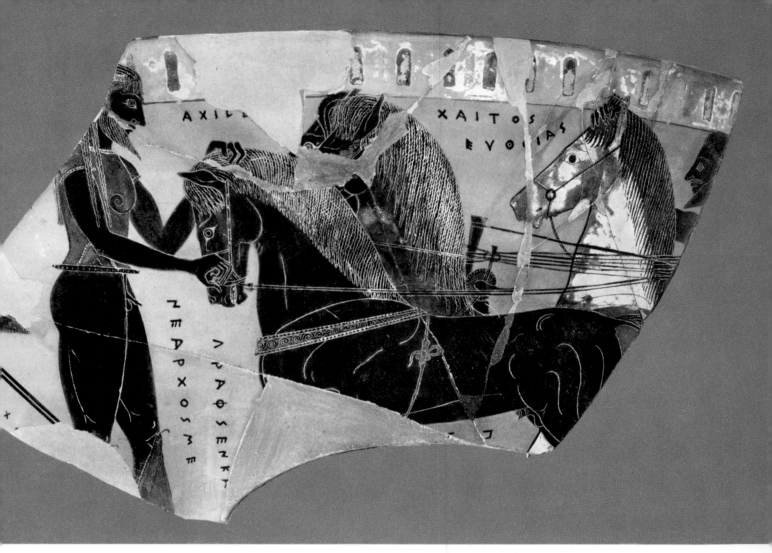

72. NEARCHOS. FRAGMENT OF A KANTHAROS: ACHILLES WITH HIS TEAM OF HORSES. NATIONAL MUSEUM, ATHENS.

conventions, the pensive figure of Achilles stroking one of his horses evokes the misgivings of the hero as he arms himself for a decisive encounter.

The last great figure of Attic vase painting in the second quarter of the sixth century is Lydos, whose career extended beyond the middle of the century. His work is more uneven than his contemporaries'. Besides his large output of undistinguished vases, Lydos painted some scenes of great dramatic effectiveness. He sometimes reminds one of Nearchos in the sensitive expressiveness of certain figures, like the mourners on a fragment of a large funerary plaque. Above all, he was one of the first to decorate a large vase with two separate, well-framed panels instead of scenes laid out in several friezes.

It is a significant fact that by about the middle of the sixth century the panel amphora had become the most common type of Attic vase, while all varieties of krater became less popular. These panels, which became the standard form of vase decoration, were adapted to the curving body of the amphora and presented dramatic or amusing scenes that were always well balanced. Working on a rather restricted surface in the epic style of

71. LYDOS. FRAGMENT OF A TERRA-COTTA PLAQUE: MOURNERS SINGING A DIRGE. FORMERLY VLASTO COLLECTION, ATHENS.

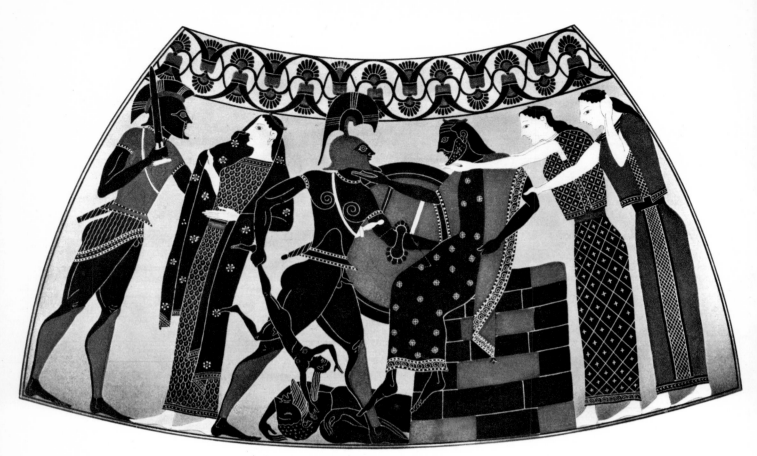

73. LYDOS. PANEL AMPHORA, DETAIL: THE FALL OF TROY. STAATLICHE MUSEEN, BERLIN.

the time, Lydos proved his skill in recording a dramatic moment whose expressive intensity is focused on a small figure group. On the Berlin amphora, eight figures convey the drama of the fall of Troy, and if we compare the slaying of Priam here with the same theme treated a few years before by the C Painter, we can measure the progress made in the command of dramatic expression. This was the vein in which Exekias was soon to excel.

Boeotian Pottery

Even in Attica, alongside such outstanding artists as Kleitias, Nearchos, and Lydos, a large number of craftsmen turned out routine wares, technically competent but devoid of artistic merit. But from 570 on, Athens, it is important to emphasize, occupied a very special position in the production of painted pottery, a position steadily reinforced with the passage of time. Over a period of generations and in response to the demand of overseas markets, Athens alone achieved and maintained a high output. Over nine-tenths of the vases painted by Greeks during this time came from the workshops of Athens. So it is understandable that the Attic vase painters were more sensitive than

68

74. BOEOTIAN CUP WITH BIRD PATTERNS. STAATLICHE ANTIKENSAMMLUNGEN, MUNICH.

others to the trends that stimulated archaic Greek art and impelled artists to seek out new forms and designs.

Other regions, some of them quite close to Attica but self-governed and remote from the main routes of sea-borne trade, produced ceramics that appear singularly poor and commonplace compared with Attic wares. Boeotian pottery is typical of the kind produced for local consumption, for its style evolved so slowly that it never overcame its initial provincialism. In the sixth century its 'bird cups' were still being decorated in the Subgeometric tradition. The black-figure technique scarcely appears at all before the second quarter of the century, and then only on small groups of vases whose decoration is often in a caricatural vein. On a kantharos, a vase shape common in Boeotia, the artist has

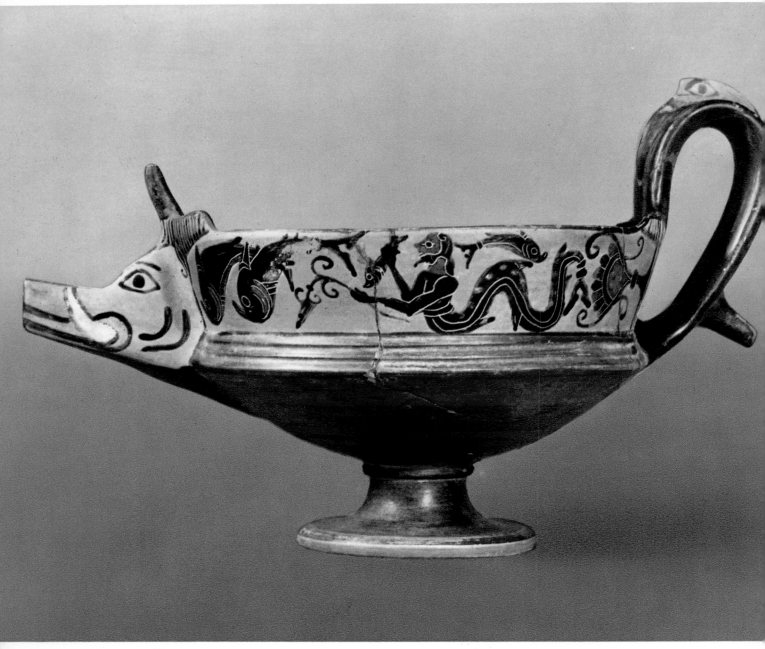

75. BOEOTIAN KANTHAROS WITH HANDLE IN THE FORM OF A BOAR'S SNOUT. LOUVRE, PARIS.

given one handle the form of a boar snout and decorated the side with the coiling body of a sea god surrounded by a random assortment of dolphins, a fish, and palmettes. At the top of the other handle he has even painted an eye. Here we can no longer speak of Orientalizing traditions; this is rather a spontaneous creation, possibly of folk inspiration, which aims at a purely decorative effect.

The End of Vase Painting in Corinth

The painters of large Corinthian vases in the second quarter and middle years of the sixth century nursed higher ambitions, for they aspired to the epic style that was then the glory of Attic painting. At a time when the bulk of minor Athenian wares was still influenced by small Corinthian vases, the Corinthian painters, who were trying to maintain a pictorial tradition of broader sweep, fell under the spell that was beginning to be cast by Attic black-figure vases. Thus, in order to conform to fashion, the potters of Corinth began to cover the pale clay they had formerly used with a second coat of clay, an orange slip that gave the surface pretty nearly the same warm tint as Attic vases. In spite of this, Attic wares won out in the competition for the main overseas market, Etruria. Corinthian exports, up to then plentiful, fell off, and practically ceased by the mid-sixth century. The loss of overseas markets dealt a death blow to the production of quality wares in Corinth.

It is easy to draw a parallel between the François vase and one of the outstanding pieces of Corinthian pottery, the Amphiaraus krater in Berlin. They have the same monumentality of form (admittedly less elaborate in the case of the Corinthian vase), the same epic themes with psychological implications (the seer Amphiaraus, as he leaves to make war on Thebes, knows that he is doomed by the treachery of his wife Eriphyle), the same presentation of a large figure scene on a broad frieze occupying only one side of the vase, a similar use of background buildings. The Corinthian vase painting, however,

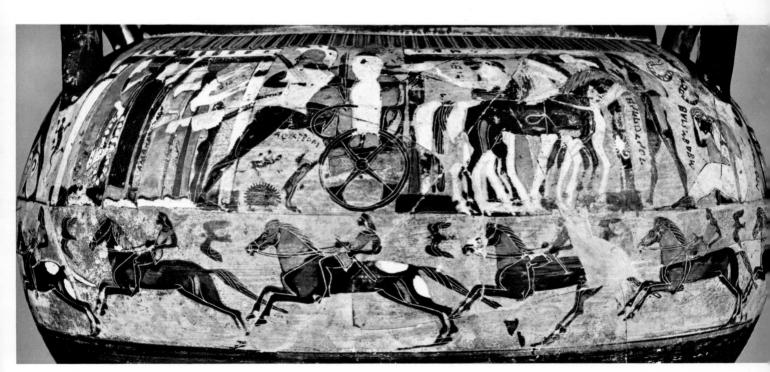

76. CORINTHIAN COLUMN KRATER, DETAIL: DEPARTURE OF AMPHIARAUS FOR THEBES. FORMERLY STAATLICHE MUSEEN, BERLIN.

71

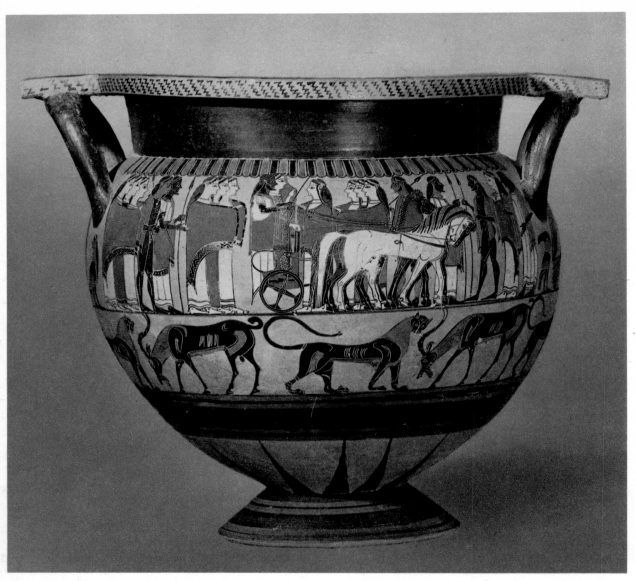

77. THREE MAIDENS PAINTER. CORINTHIAN COLUMN KRATER: WEDDING PROCESSION. VATICAN CITY.

is both more colourful and more commonplace; the figures are stereotyped, and the animation comes above all from the large areas of added colour. There are even some filling elements introduced in the form of domestic animals, and the row of horsemen in the lower frieze has a purely decorative value.

This rather lifeless drawing becomes more noticeable in the work of less talented painters (it should be noted, moreover, that no Corinthian vase painter of this period saw fit to sign his work). A krater in the Vatican, with its flawless technique and its large, well-balanced touches of colour, is agreeable enough to look at, but it lapses into the triteness of an anonymous subject (a wedding procession) and conventional motifs (the quadriga in the centre is a repetition of that of Amphiaraus). What new elements there are—the more massive form given to the column krater and the close-knit groups of

72

78. CORINTHIAN AMPHORA: TYDEUS KILLING ISMENE BEFORE THEBES. LOUVRE, PARIS.

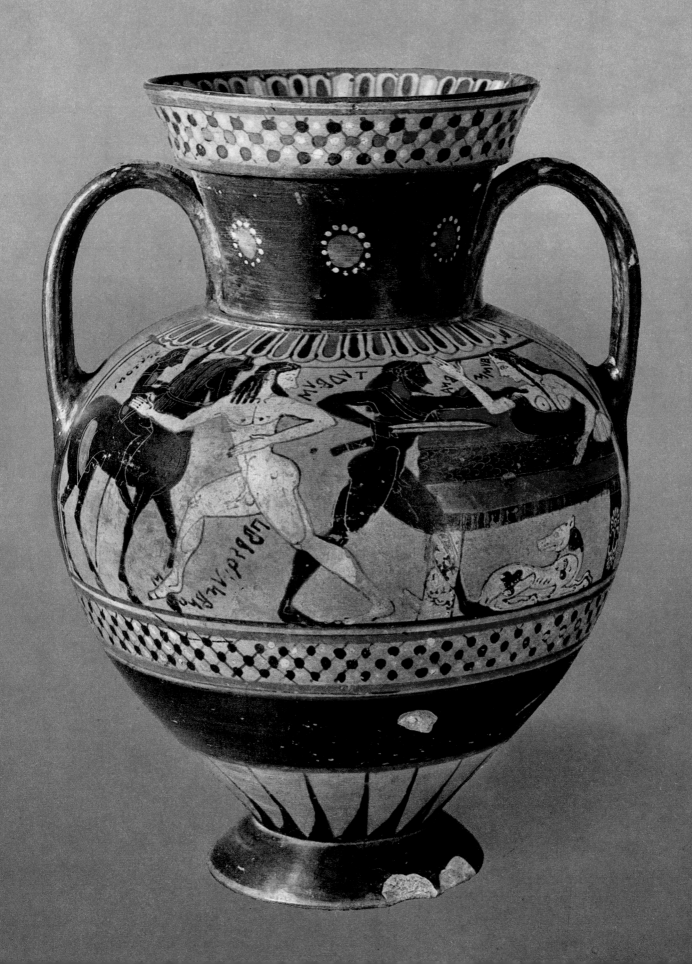

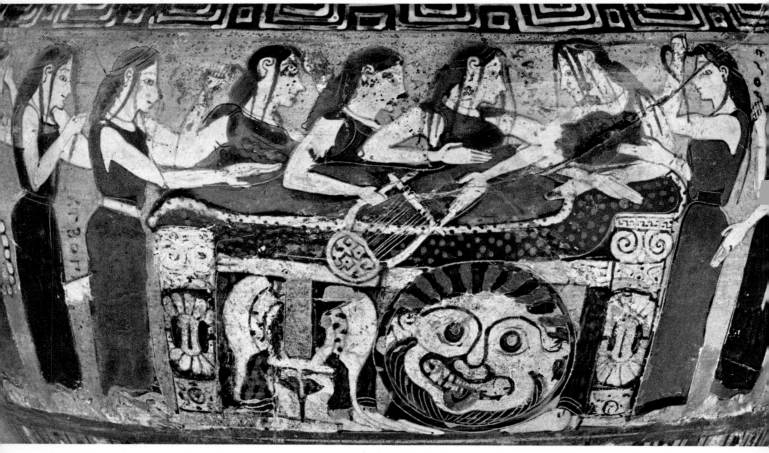

79. CORINTHIAN HYDRIA, DETAIL: NEREIDS MOURNING OVER THE BODY OF ACHILLES. LOUVRE, PARIS.

women three by three—are all paralleled in Attic pottery. But on the François vase the group of the three Horae in the wedding procession of Peleus and Thetis is vividly rendered, quite unlike the stereotyped groups thrice repeated on this Corinthian krater by the Three Maidens Painter.

Yet, as in Attica, a few isolated works from Corinth of about the mid-sixth century testify to a fresh attempt to compose dramatic pictures within a restricted framework. On an amphora in the Louvre, Tydeus is about to slay Ismene, while her naked lover runs away. An extensive use of white—applied, contrary to the usual practice, even to the man's body—brightens up a skillfully composed and soberly executed picture, framed by the arrival of a quiet horseman on one side and the impassive presence of a pet dog on the other. The drawing, though free and spirited, cannot match the quality of that of the Attic painters, who were now unrivaled in the delicacy of their incision work, formerly a Corinthian speciality.

The picture on a hydria in the Louvre is much more coherent and balanced. The supple gestures of the Nereids mourning over the body of Achilles, their pensive faces, and interlacing arms convey a sense of harmony and subtle emotion that is quite

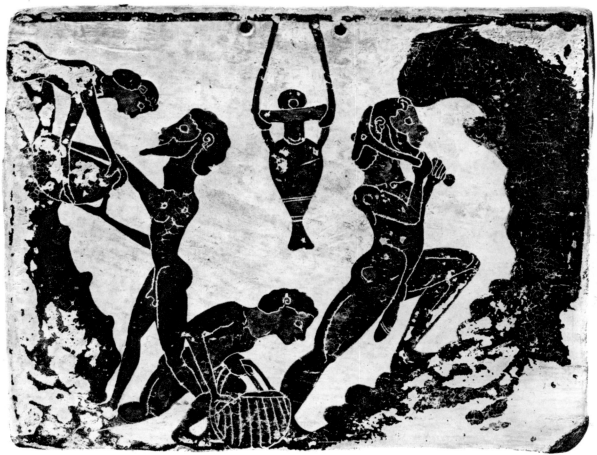

80. CORINTHIAN TERRA-COTTA PLAQUE: EXTRACTING CLAY FROM THE PIT. STAATLICHE MUSEEN, BERLIN.

unusual in Corinthian pottery. The composition and proportions of this scene suggest that it may be a reduced version of a larger painting, and one cannot help conjecturing whether the end of Corinthian vase painting may not have been to some extent compensated for, on the artistic plane, by the development of wall painting from about the middle of the sixth century on. Ancient tradition refers to wall paintings and, as we shall see presently, a few remnants of them have survived.

Before this time, however, one can hardly assume the existence of any Corinthian painting evolving independently of vase decoration. There are a quantity of Corinthian paintings on terra-cotta plaques, made as votive offerings, but all of them are executed in black-figure with a minimum of added colour. Some represent gods. Others depict Corinthian craftsmen at work, which confirms their connection with vase painting. For the vase painters themselves were fond of caricaturing the activity of their workshops, and they painted many scenes direct from life that recorded the successive stages of their work, from the extraction of clay from the pit to the shaping and firing of the pots. This is a far remove indeed from pictures inspired by any supposed form of large-scale painting.

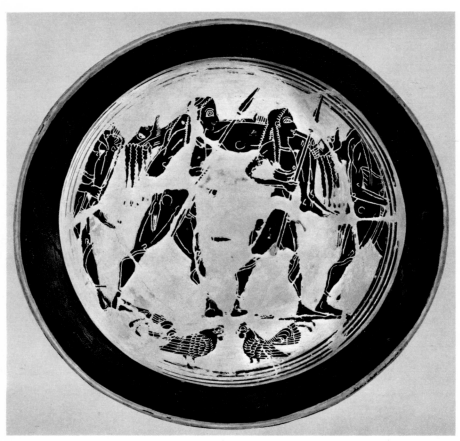

81. LACONIAN CUP: RETURNING WARRIORS. STAATLICHE MUSEEN, BERLIN.

Laconian and Chalcidian Vase Painting

Attempts have been made to trace the influence of contemporary wall painting on Laconian pottery, as well as on other archaic wares. It is true that Laconian black-figure vases are painted on a white ground and that the figure scenes inside cups are not always well adapted to the circular medallion formed by the bottom of the bowl, sometimes seeming to derive from a picture of rectangular format. On the Berlin cup the procession of warriors carrying on their shoulders their dead companions had to be sharply cut off on either side to fit in a tondo. Similarly, on the Louvre cup evoking the murder of Troilus, Achilles alone is represented lurking behind the fountain, thus making the subject barely intelligible. But many other Laconian cups are decorated in a more logical manner; the punishments of Atlas and Prometheus on the Vatican cup and the large picture on the Arcesilas cup are better adapted to the circular field of the bowls. It should be noted that Laconian pottery used no one particular effect of polychromy. Certain scenes evoke daily life or actual events, not only on the Berlin cup with its characteristic glorification of a Spartan warrior who died for his country, but also on the Arcesilas cup, showing the king of Cyrene seated on his throne in a peculiarly African setting

76

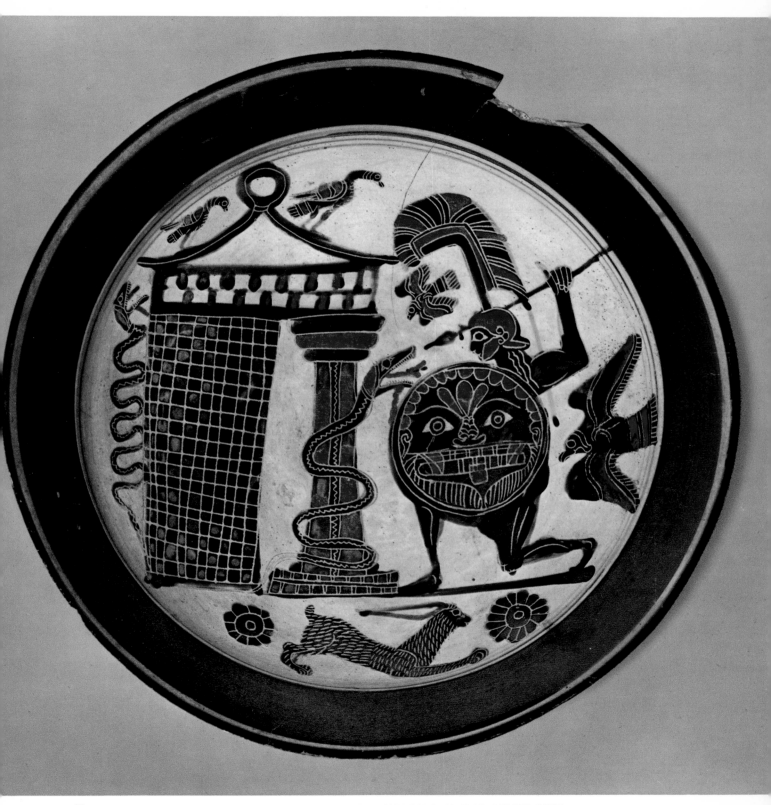

82. LACONIAN CUP: ACHILLES BEHIND THE FOUNTAIN LYING IN AMBUSH FOR TROILUS. LOUVRE, PARIS.

83. LACONIAN CUP. CABINET DES MÉDAILLES, BIBLIOTHÈQUE NATIONALE, PARIS.

(with birds, monkey, lizard, and feline). In these two cases there is no reason to suppose that outside models were imitated.

Laconian potters, however, enjoyed neither the social standing nor the artistic recognition of the Athenian potters. In Laconia craftsmen belonged to the lowest class of society, the citizens of Sparta being debarred from any form of manual labour. The production of pottery, moreover, seems to have been rather limited, the bulk of it spanning about half a century and shared among several painters. Yet a considerable quantity of cups, including the best of Laconian black-figure painting, was exported in all directions. These tall-stemmed cups, of delicate and elegant make, are generally decorated on the outside with bands of floral designs. The pictures on the inside of the bowl are vivid and spirited, but somewhat loose in design and not so carefully executed as the Corinthian paintings from which they derive. For instance, the incised outlines of the figures do not always coincide with the painted area of the body.

The most important surviving piece of Laconian pottery is the Arcesilas cup: Seated under an awning out of the sun, Arcesilas II, king of Cyrene, watches his workmen weighing and storing bales of that mysterious and sought-after medicinal plant that the ancients called silphium, and which was a source of wealth for Cyrene. The figures of the busy men bringing in and carrying off the bales, or calling out the weight registered,

78

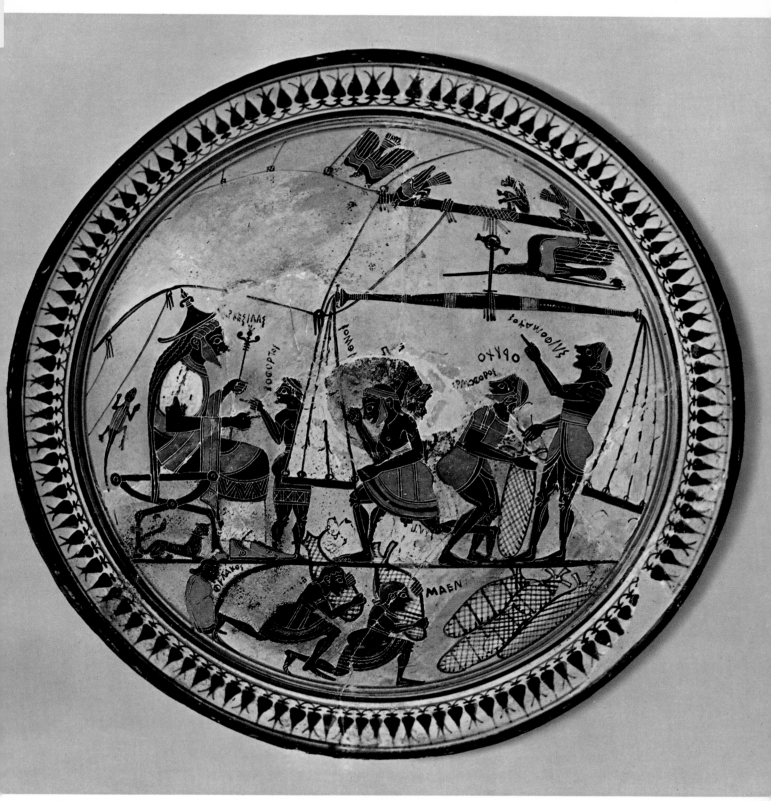

84. LACONIAN CUP: KING ARCESILAS WATCHING HIS WORKMEN WEIGHING BALES OF SILPHIUM. CABINET DES MÉDAILLES, PARIS.

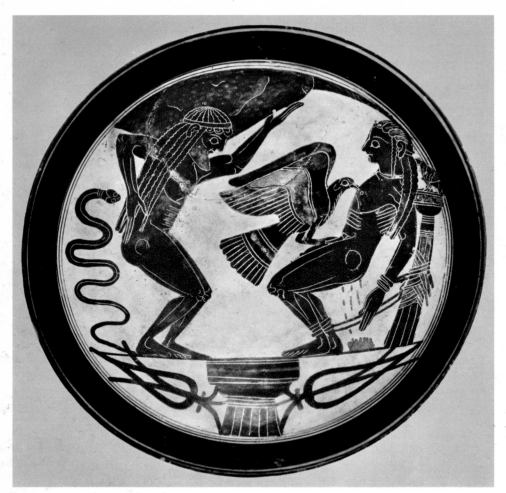

85. LACONIAN CUP: PUNISHMENTS OF ATLAS AND PROMETHEUS. VATICAN CITY.

and the bonhomie of the king surrounded by his African pets all contribute to a lively and appealing picture, though one whose design is perhaps a little too strictly confined to a single plane. On the Berlin cup, also, where the feeling expressed is unusual for a Laconian work, the painter avoided any overlapping of the warriors' legs, thus lessening the scene's depth.

The Louvre cup is still more typical of the average output of the Laconian painters. The kneeling figure of Achilles is disproportionate to the lopsided building, surrounded by snakes and birds, behind which he is hiding. Corinthian influence is evident in the extensive touches of red and in the design of the exergue. On the Vatican cup, too, the composition is on a single plane; it is perhaps more animated but no less naïve. Prometheus is awkwardly bound to an undersized column, and the blood dripping from his wounds forms not a pool but a heap on the ground. The anatomy of the sky-bearing Atlas departs noticeably from physical reality at the very time when Attic painters were taking inspiration more and more from nature. One can thus easily account for the rapid decline of Laconian painting after the middle of the sixth century.

Conversely, Chalcidian vase painting did not appear until the mid-sixth century, and

80

86. INSCRIPTION PAINTER. AMPHORA, DETAIL: HERACLES FIGHTING GERYON. BIBLIOTHÈQUE NATIONALE, PARIS.

in the space of some forty years it had run its course. Here, too, the output was limited but, like Laconian vase painting, it was exported and widely diffused in the West (South Italy, Sicily, and especially Etruria). The Chalcidian alphabet used by the painters and the distribution of the find-places indicate that this pottery was probably made in a Chalcidian colony in Italy—Rhegium (present-day Reggio di Calabria), where particularly large quantities of it have been found. Chalcidian ware seems to have been the only one of any importance in the Greek West, and this circumstance would explain why its decoration is sometimes rather provincial and conservative and follows in particular certain trends of Corinthian vase painting, for example the animal friezes and rosettes dotted in the picture field. But at the same time it was strongly influenced by Attic pottery, especially in the shapes and decorative system of amphorae (although Chalcidian ware allowed more room for secondary ornamentation applied with a keen

81

87. INSCRIPTION PAINTER. AMPHORA, DETAIL: GERYON'S CATTLE. BIBLIOTHÈQUE NATIONALE, PARIS.

sense of general decorative effect). Indeed, Chalcidian black-figure is the only such ware that can rival the best Athenian vases in the second half of the sixth century, not only because of its excellent technique and draughtsmanship but also because of its original compositions, which continued the grand style of Attic painting until—like part of Attic vase painting itself—they were pervaded by influences from Ionia.

The Geryon amphora in the Bibliothèque Nationale keeps to the tradition of pictures inserted in a broad zone extending over more than half the circumference of the vase. But this picture of Heracles fighting Geryon is composed with great skill; it is an original creation, not an imitation of Attic models, for the figure of the three-bodied winged monster is borrowed from an epic poet of the Greek West, Stesichorus of Himera. The lithe figure of Heracles drawing his bow is posed with easy freedom, and the lifeless bodies of the dog and the herdsman Eurytion emphasize the overlapping of planes. Geryon's herd of cattle, which Heracles was fighting to obtain as one of his Twelve Labours, forms a magnificent piece on the other side. More than an example of direct observation of nature, it is an interesting attempt to present the animals in the background in a view other than profile.

The Würzburg krater is more straightforwardly decorative in spirit. Yet the couples represented, Helen and Paris, Andromache and Hector, have a certain power of evo-

82

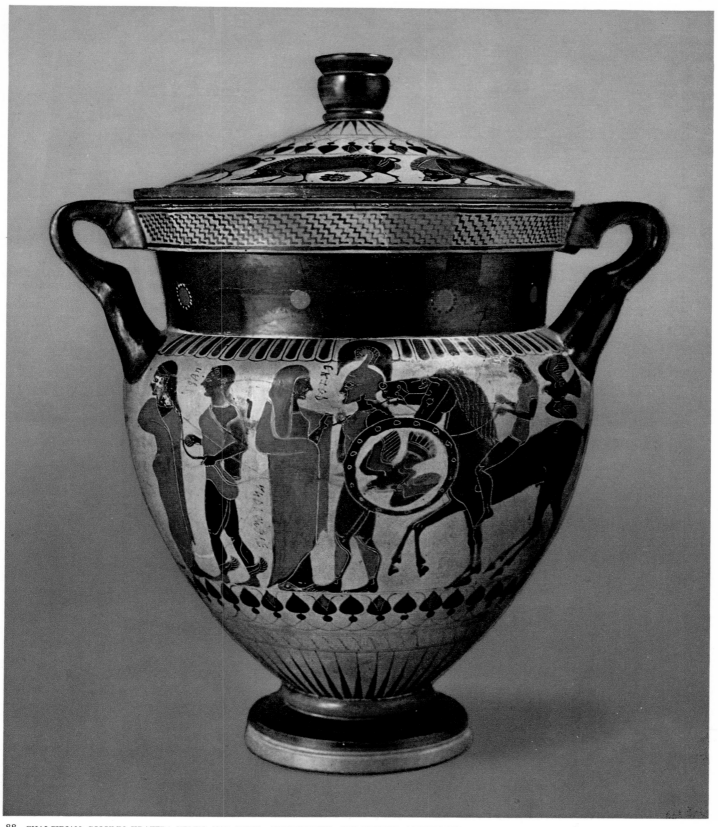

88. CHALCIDIAN COLUMN KRATER: HELEN AND PARIS, ANDROMACHE AND HECTOR. MARTIN VON WAGNER MUSEUM, WÜRZBURG.

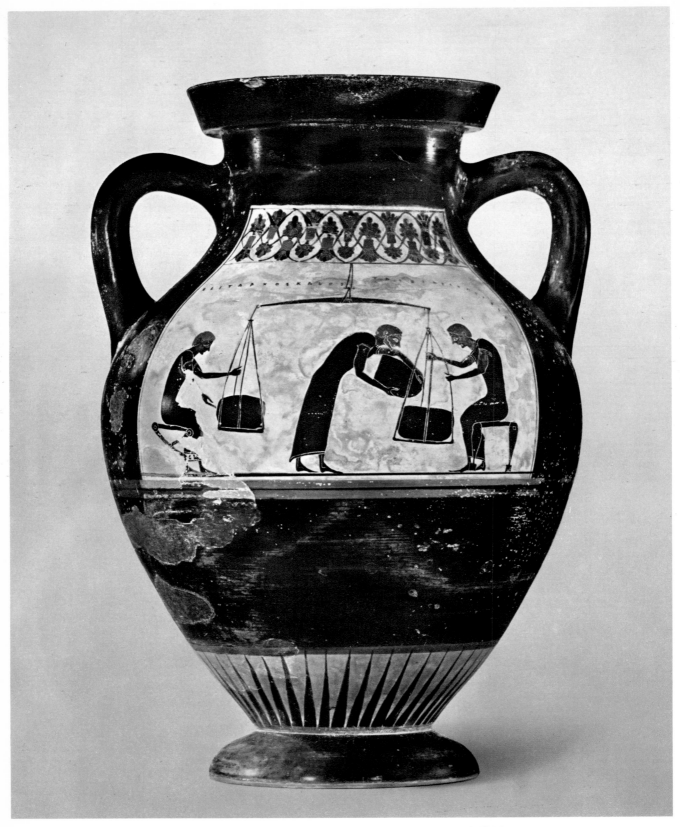

89. TALEIDES PAINTER. AMPHORA: WEIGHING GOODS. THE METROPOLITAN MUSEUM OF ART, NEW YORK.

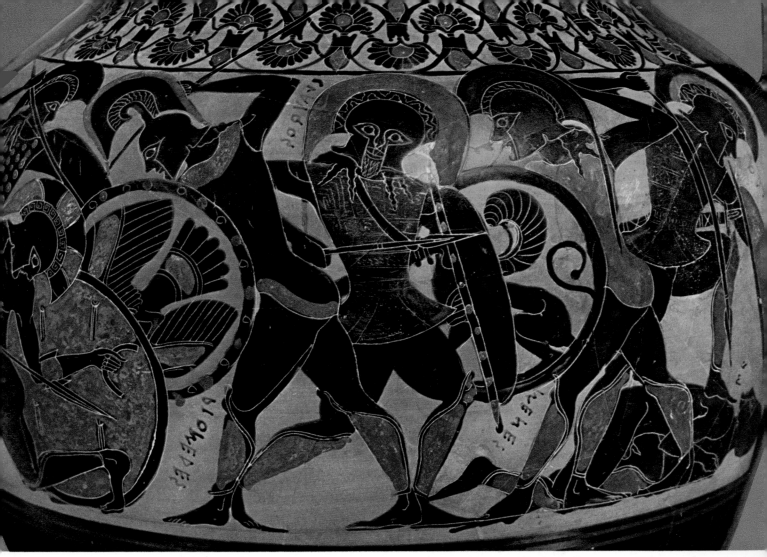

90. INSCRIPTION PAINTER. CHALCIDIAN PSYKTER AMPHORA, DETAIL: GREEKS AND TROJANS FIGHTING. NATIONAL GALLERY OF VICTORIA, MELBOURNE.

cation. The animal frieze on the lid and the liberal use of red recall the Corinthian tradition, but the graceful curves of Helen's figure and the rather sharp angle of the faces reflect the new Ionian influences. The psykter amphora in Melbourne is in appearance much closer to Attic pottery; the broad picture occupies the same position on the vase and is framed in the same way as on an Attic amphora decorated by the Taleides Painter (see below). Yet, while the Attic Painter sparely and soberly records a scene of daily life—three men weighing goods—the Chalcidian amphora in Melbourne maintains the tradition of the epic grand style. The Greek and Trojan warriors are designated by name, and their overlapping figures staggered from left to right produce a new feeling of oblique recession; the effect of movement in space is further emphasized by the slewing round of the central figure, whose face is seen in front view. The Inscription Painter, who decorated both the Geryon and the Melbourne amphorae and who probably founded the Chalcidian workshop, thus appears in some respects as a forerunner, even by the standards of contemporary Attic vase painting.

91. AMASIS PAINTER. AMPHORA, DETAIL. STAATLICHE MUSEEN, BERLIN.

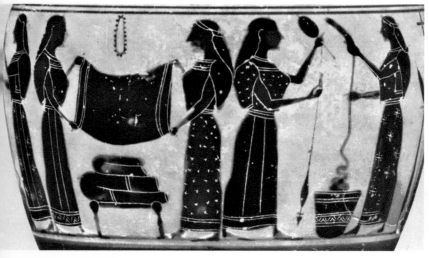
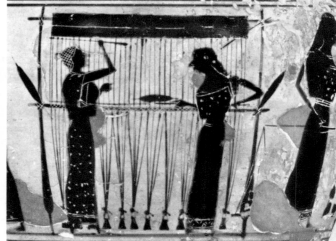

92-93. AMASIS PAINTER. LEKYTHOS, DETAIL: WOMEN SPINNING AND WEAVING. THE METROPOLITAN MUSEUM OF ART, NEW YORK.

86

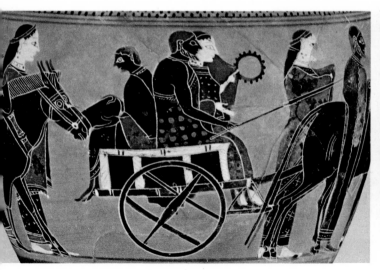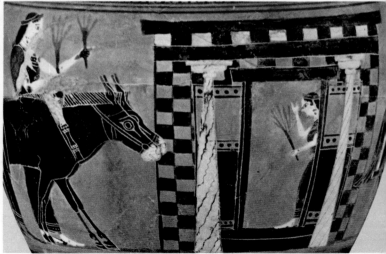

94-95. AMASIS PAINTER. LEKYTHOS, DETAIL: WEDDING PROCESSION. THE METROPOLITAN MUSEUM OF ART, NEW YORK.

The Amasis Painter and the Athenian Miniaturists

In the third quarter of the sixth century, two main tendencies appear in Attic black-figure vase painting. One took over the previous generation's nobility and grandeur, to which Exekias—the best representative—added a new, wholly classical serenity that was purely Athenian in spirit. The other tendency was towards more familiar themes, more freely handled, and often of small-scale design.

We shall examine this latter trend first, because it was more receptive to outside influences and more responsive to Ionian tastes. It also has its antecedents in certain Attic vase decorations of the second quarter of the sixth century, not only on cups like those of the Heidelberg Painter, but also on the François vase, which includes several scenes of revelry on a miniaturist scale.

This whole school centres on one outstanding personality, the Amasis Painter, whose oeuvre includes over a hundred vases of various shapes: amphorae, often of fairly small size; small vessels such as the oinochoe, the olpe, and the lekythos; and lastly a series of small cups. But other painters of the same circle produced pieces of equal finesse and inventiveness: the Taleides Painter, for example, whose oeuvre is almost as varied as that of the Amasis Painter, or the decorators of the Little Master cups, like the Phrynos Painter or the Tleson Painter.

It should be noted, however, that these latter were in every case anonymous painters employed by potters who alone had the right to sign the work produced in common, thus proving that in this circle of Little Masters the painting of the pots was considered less important than the shaping of them.

The general characteristics of this group of painters' work are small, minutely delineated figures, always lifelike but not devoid of mannerism (elongated bodies, studied and sometimes rather affected poses), and well-spaced-out pictures, in which the figures are usually placed side by side and are taking part in scenes of revelry, dancing the Bacchic komos

87

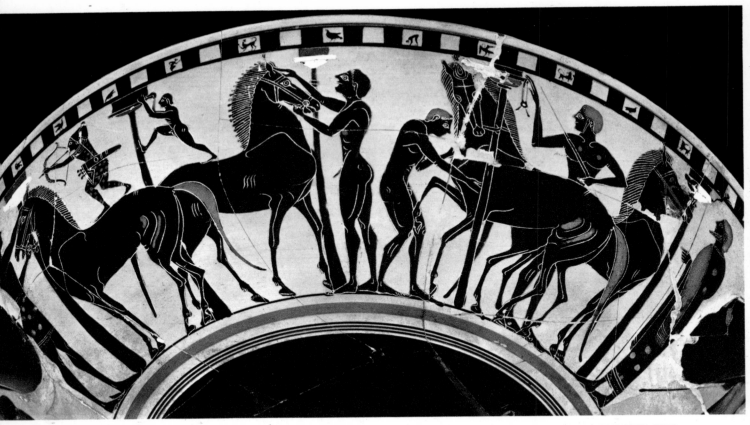

96. AMASIS PAINTER. CUP, DETAIL: BALANCING TRICKS IN A RIDING SCHOOL. PRIVATE COLLECTION, NEW YORK.

with an abandon often verging on indecency. Other scenes are of daily or household life, whereas mythological themes are much rarer. The amphora of the Taleides Painter in the Metropolitan Museum, already referred to, is characteristic in this respect: three small, slender figures, somewhat lost in a picture space too large for them, are shown carefully weighing bales of goods.

In the same way, two matching lekythoi by the Amasis Painter give us extremely instructive, lifelike glimpses of ancient Athens. On one, women are shown spinning, weaving, and folding up cloth; on the other the artist has represented a picturesque wedding procession. In democratic fashion the wedding party is seated in mule-drawn carts moving by torchlight towards the nuptial house. This colourful, friezelike picture conveys no sense of depth. Even more fanciful is a cup in a private collection in New York: the slender portico, its metopes decorated with tiny animals, and the horses with small figures balancing on their backs give this riding-school scene a curious atmosphere of unreality.

But it is in Dionysiac scenes that the Amasis Painter displays to the full his gifts as a draughtsman. In these sileni and maenads, and in the figure of Dionysus on the amphorae in Berlin and in the Bibliothèque Nationale, there is no trace of divine ecstasy; there is an unerring mastery of line, whether painted or incised. The line-drawn bodies

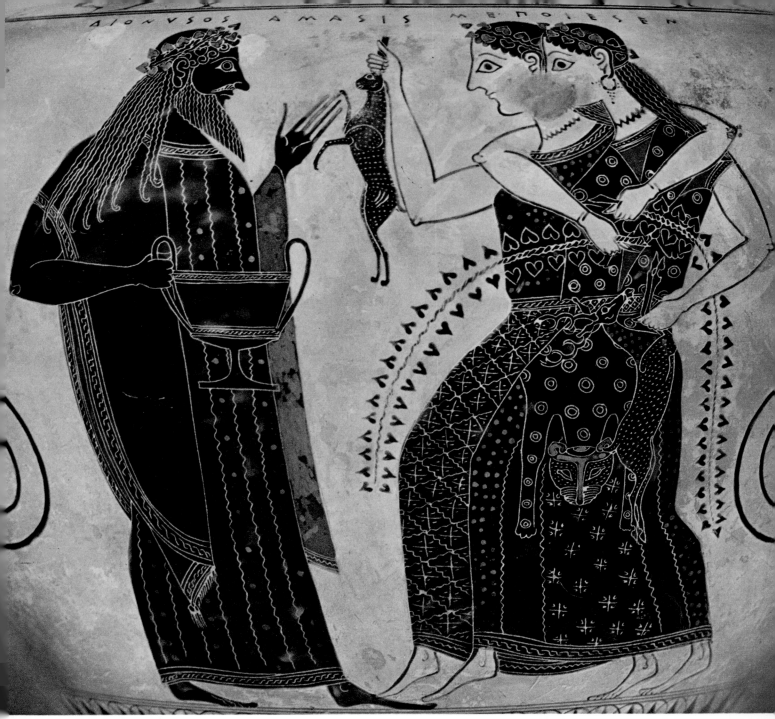

97. AMASIS PAINTER. AMPHORA, DETAIL: DIONYSUS AND TWO MAENADS. CABINET DES MÉDAILLES, BIBLIOTHÈQUE NATIONALE, PARIS.

of these dancing maenads, which already anticipate red-figure work, also testify to a diffuse influence of Ionian art that is especially noticeable in the facial structure. The female heads with receding foreheads that sometimes form the entire decoration of Little Master cups revert to a tradition inaugurated a century before on a series of Orientalizing vases from Melos.

89

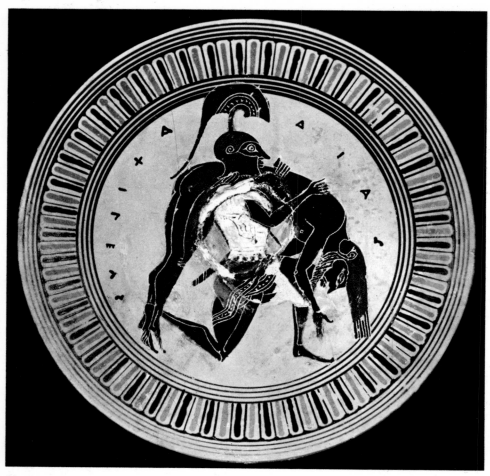

98. PHRYNOS PAINTER. CUP: AJAX CARRYING THE BODY OF ACHILLES. VATICAN CITY.

One of the Little Masters, however, the Phrynos Painter, sometimes tackles loftier themes. On the inside of a cup in the Vatican he takes up the theme of Ajax carrying the body of Achilles, already treated by Kleitias, and renders it in an even more spirited way. The motif is well adapted to the tondo, but to fit it in, the painter was forced to revert to the kneeling posture for the running figure of Ajax; the same holds true for the inside of the Tleson cup in the British Museum, which represents a brightly coloured scene of everyday life. The broad yet detailed use of white and red, the skipping step and smiling faces of the figures, the receding forehead, and even the intricate pleating of Ajax's loincloth reveal in both cases Ionian influence. But, in keeping with the best Attic tradition, the colour does not conceal the incision work, which is applied with a sweep and a sureness of hand all the more remarkable since these tondos are only a few centimetres in diameter. One marvels, too, at the scene on the outside of another cup by the Phrynos Painter, with its design so small of scale yet grandiose, its extreme finesse of line and incision, which conveys with a mixture of solemnity and humour the peculiar character of each of the three divinities.

90

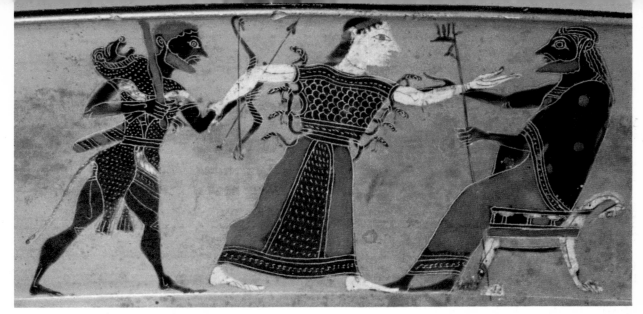

99. PHRYNOS PAINTER. CUP, DETAIL: INTRODUCTION OF HERACLES INTO OLYMPUS. BRITISH MUSEUM, LONDON.

100. TLESON. CUP, DETAIL: HUNTER WITH HOUND AND GAME. BRITISH MUSEUM, LONDON.

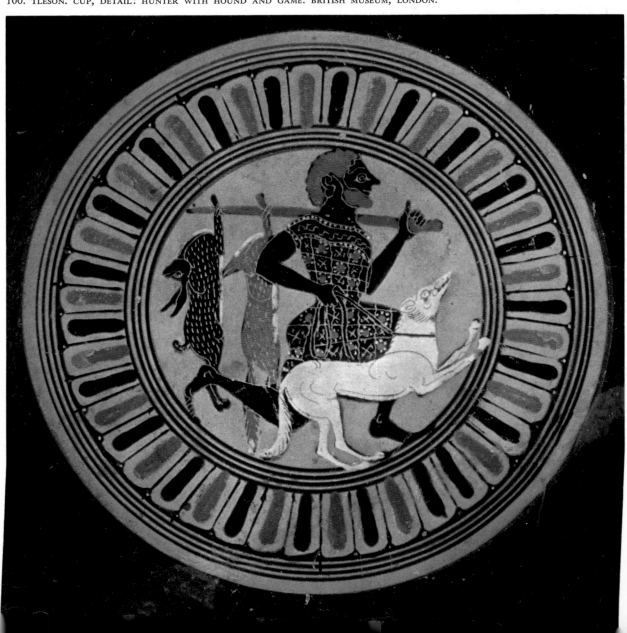

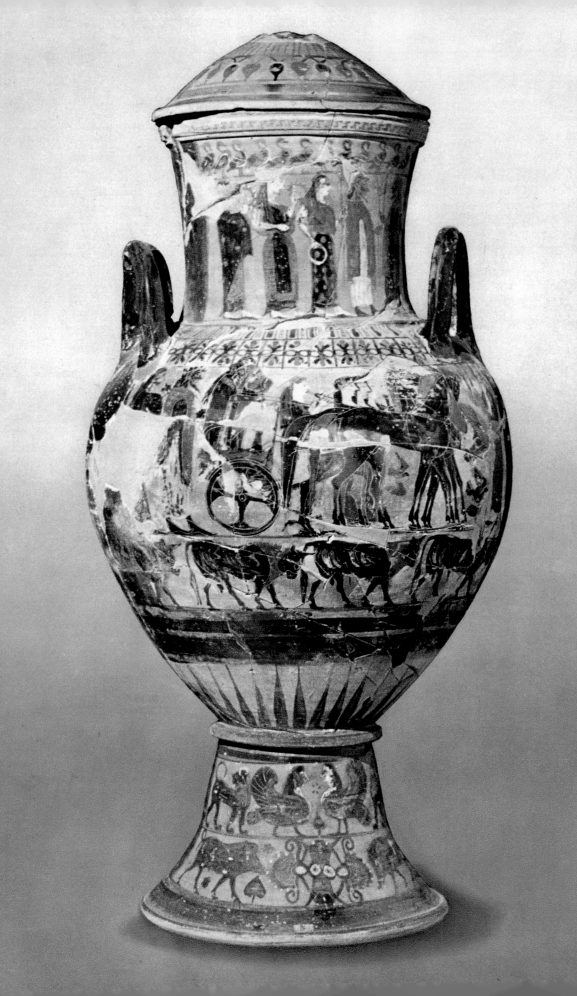

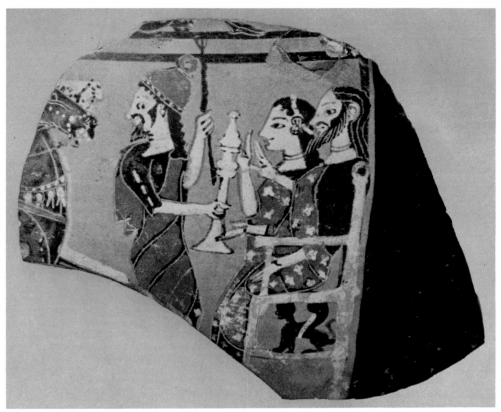

102. FRAGMENT OF AN IONIAN HYDRIA: HERALD APPROACHING AN ENTHRONED COUPLE. ATHENS.

The Ionian School

Instead of a rather severe grandeur, sprightliness and humour are the distinctive traits in black-figure vase painting of the Ionian school. Ionian painted pottery of the second half of the sixth century is not the work of a single centre; it was produced by a string of small workshops extending from Asia Minor to Etruria. The products were not widely diffused, but among them all there is an unmistakable likeness. There are no grounds for supposing that there was any direct Ionian influence on Attic pottery. On the contrary, certain Ionian wares were obviously inspired by Attic models. Such is the case with Eretria, in Euboea, which began turning out black-figure work under the dual influence of Corinth and, above all, Athens. Several very large funerary vases stand out as the masterpieces of the Eretria workshop, whose provincial character remained very marked. The belated Corinthian influence appears in the rows of secondary animals and in the groups of three overlapping female figures. Both the themes and the overall design, however, are Attic, and the figures have a smiling grace that shows clearly enough the handiwork of Ionian artists. Also, the extensive use of added white, in preference to red, is characteristic of the black-figure pottery of Asia Minor.

Clazomenae seems to have been one of the most flourishing centres of Ionian black-figure wares in the second half of the sixth century, catering chiefly to the eastern and

93

103. IONIAN HYDRIA FROM ITALY, DETAIL: SACRIFICE TO DIONYSUS. VILLA GIULIA MUSEUM, ROME.

Egyptian markets. Its vase paintings are almost purely decorative, and even the figure scenes are usually devoid of meaning, consisting for the most part of graceful arrays of girls and processions of women in flowing drapery. Mythological themes are rare and generally difficult to interpret, as in the case of the fragment of a hydria representing a herald who, holding a torch in his hand, approaches a couple seated on a throne. Whatever the subject may be, this is a good example of Ionian painting, typified by the smiling faces, the rather affected gestures, the forms stressed by emphatic curves, the many small details, and the liberal use of white.

Only two Clazomenian fragments have been found in Athens, and it may be concluded that Ionian influences did not reach Attic pottery by way of Ionian black-figure vases. Indeed, these influences extend far beyond the field of vase painting and the region of Attica, for Ionian fashions were adopted at the same time by most of the Greek schools of sculpture. So it was rather the fundamental character of Ionian art—its easy, smiling, mannered graciousness, its focus on outward appearances—that was for a time to modify the aesthetic vision of Greek artists. The appeal of Ionian art was no doubt intensified by Ionia's luxury-loving culture, whose fashions in dress tempted the artist to concentrate on the billowing of finely pleated garments rather than the structure of the body; its art was also transmitted by the emigration of artists who were driven from Asia Minor by Persian encroachments, some of whom, ceramists in particular, settled in Italy.

By about 540-520, therefore, the workshops of the best Ionian vase painters are to be found in Caere, a city in southern Etruria, whose harbour town, Pyrgos, was inhabited by Greeks. Here it has been possible to identify a workshop employing two or three

94

104. IONIAN CUP: BIRD-NESTER BETWEEN TWO TREES. LOUVRE, PARIS.

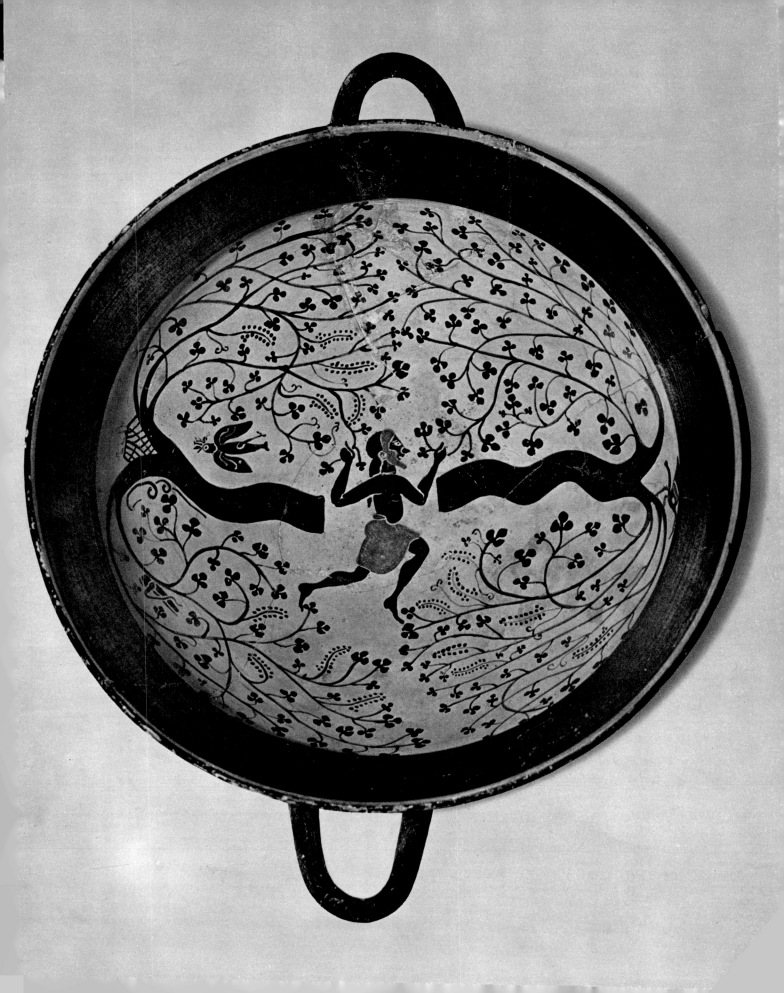

105. PAINTER OF THE CAERETAN HYDRIAI. HYDRIA. LOUVRE, PARIS.

different painters who specialized in the decoration of dinoi and hydriai. The finest piece, a hydria in the Villa Giulia Museum in Rome, brings us directly into contact with one of the most original aspects of Ionian painting, the use of a natural setting for everyday scenes. The solemn sacrifice has become a *fête champêtre*: in a vine arbour chunks of meat are being barbecued on the flaming altar, and cups are being filled. The antecedents of such a scene can be found in Ionia itself, for example, the Louvre cup with a bird-nester. Here the bulk of the picture space is given over to two trees filled with birds; the man is grasping a branch of each. On this cup of the mid-sixth century the technique uses not incision for details but reserved lines, which, in fact, merely separate the painted areas. The painters who settled in Etruria were not slow to acquire greater mastery, but they maintained the same separation between parts of the body and treated each as a mass with rounded contours.

But the artistic personality of the Painter of the Caeretan Hydriai overshadows that of all other Ionian vase painters in Etruria. His personal contribution was remarkable and is shown by his use of wide-ranging mythological themes, sometimes directly inspired

96

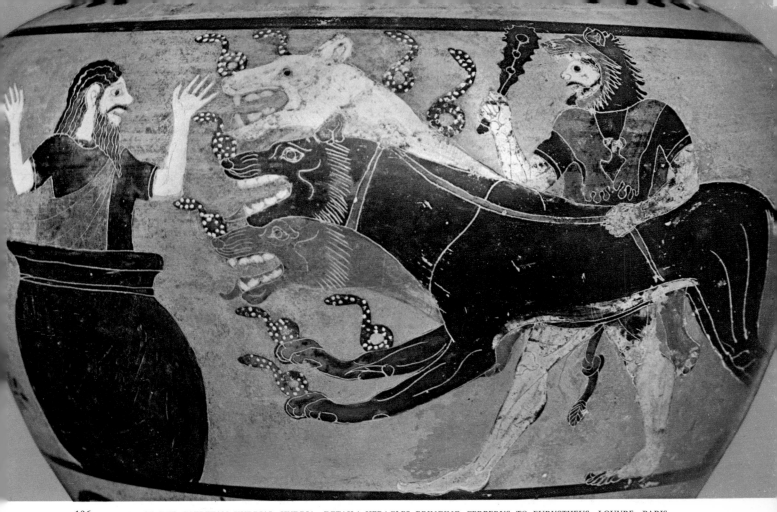

106. PAINTER OF THE CAERETAN HYDRIAI. HYDRIA, DETAIL: HERACLES BRINGING CERBERUS TO EURYSTHEUS. LOUVRE, PARIS.

107. PAINTER OF THE CAERETAN HYDRIAI. HYDRIA, DETAIL: HERACLES SLAYING BUSIRIS. KUNSTHISTORISCHES MUSEUM, VIENNA.

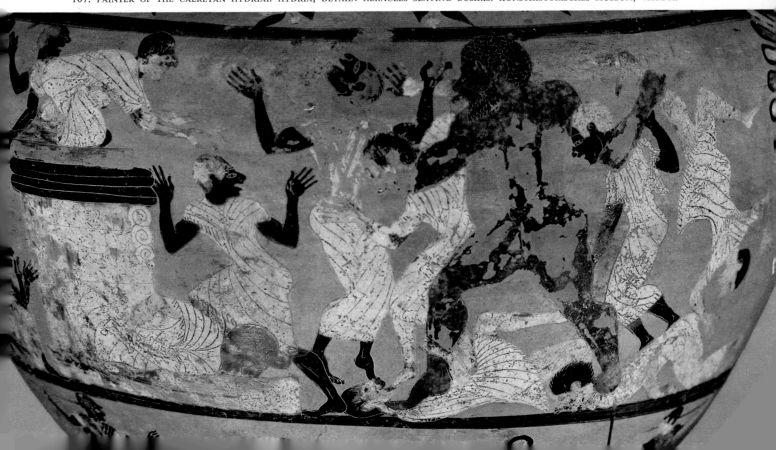

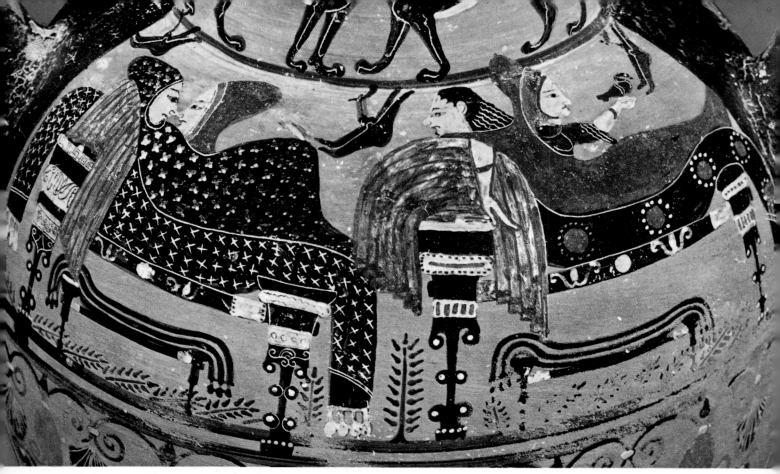

108. ETRUSCAN 'PONTIC' AMPHORA, DETAIL: WOMEN BANQUETING. THE METROPOLITAN MUSEUM OF ART, NEW YORK.

by literary works, his impressive handling of compositions with many figures, and above all his knack of treating certain espisodes with a humorous, light-hearted touch. Eurystheus, terrified by Cerberus whom Heracles has brought to him from Hades, hides in a pithos; Heracles, about to be sacrificed at the altar of Zeus by the Egyptian king Busiris, turns on his captors in a lusty free-for-all in an exotic setting. Colour is skillfully used to give a 'painterly' value to these highly linear compositions. In addition to white and red, a third colour appears on the Busiris hydria, a bistre yellow used for the less swarthy Egyptian priests.

So flourishing a school must have found imitators in Etruria itself. The influence exerted by the Ionian wares of Caere gave a distinctly Ionian flavour to Etruscan painting in the second half of the sixth century. Although also adopted by the tomb painters, the Ionian style was above all the immediate source of the Etruscan black-figure style of the 'Pontic' vases. These are characterized by their Greek subject matter, their Ionian style, their draughtsmanship with its emphasis on curves, and their colourful ornament and plant forms.

In the long term, however, this powerful current of Ionian influences did not progress any further; these painters preferred picturesque detail to the realistic study of anatomy, gay clusters of colourful figures to any serious attempt at figure composition in space, the set smile or smirk to any effective expression of feelings. Attic vase painting alone,

and then only in part, maintained the spirit of experiment and research in a solemn and refined atmosphere inherited from the previous generation—a phase, so to speak, of black-figure classicism that prepared the way for the new inventions of the last quarter of the sixth century.

Exekias and Black-Figure Classicism

It cannot be said, however, that all trace of the Ionian spirit is absent from the large black-figure Attic vases decorated by the school of Exekias. On an Attic amphora in the Vatican, for example, the background is patterned with plant forms. But here the natural setting is not intended merely to please the eye. At the foot of the trees lies the corpse of Memnon, sorrowfully watched by his mother Eos (Dawn); the crow perched on a branch adds a funereal note to the scene. To a certain extent the trees produce an impression of depth, for some are in front of and some behind the weapons and body of the Attic dead warrior. One marvels at the skill with which this anonymous painter composed a complete and perfect picture adapted to the bulging shoulder of the amphora. Though it is perhaps not immediately apparent, progress has been made in the direction of realism: Eos is wrapped in a himation with overlapping folds, and the anatomical details of Memnon's body have on the whole been accurately observed.

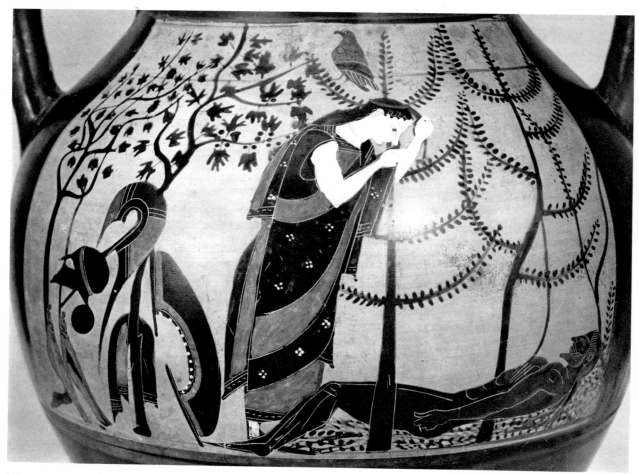

109. ATTIC AMPHORA, DETAIL: EOS BESIDE THE BODY OF MEMNON. VATICAN CITY.

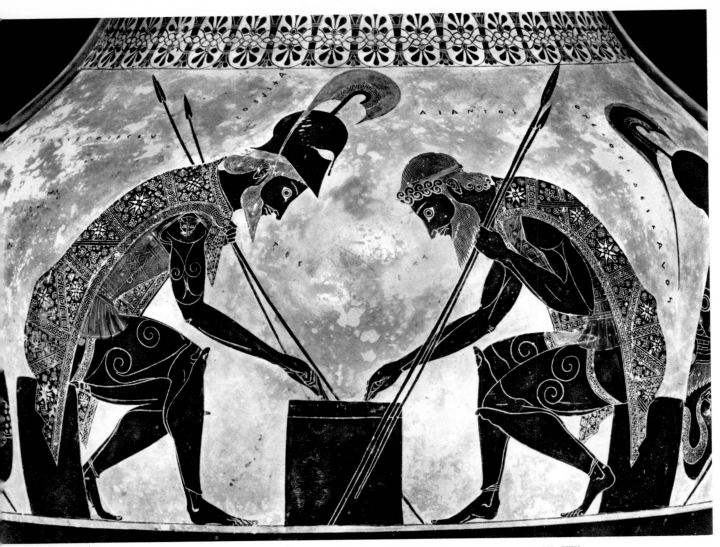

110. EXEKIAS. AMPHORA, DETAIL: ACHILLES AND AJAX PLAYING DRAUGHTS. VATICAN CITY.

One can perhaps better appreciate the progress in the work of an artist of the first order like Exekias. Signing as both potter and painter, he worked chiefly on amphorae, among which the grandeur and exquisite finish of the Vatican amphora is unsurpassed.

The scene showing Achilles (helmeted) and Ajax playing draughts is admirable in its simplicity. The triangular effect produced by the two seated heroes bending forward symmetrically, which could have been too emphatic, is neatly compensated for by the diverging diagonals of the spears. The symmetry itself is tempered by subtle variations in the position of the legs, for example, and above all by the slightly sharper bend of Ajax's body. The design may seem flat at first sight; yet the spears placed on either side of the gaming board, one heel tilted in front of one seat and one behind the other, and the hems of the garments falling on either side of the seats may have been meant to impart relief to the scene. The theme seems quite clear, since both heroes in spite of their

100

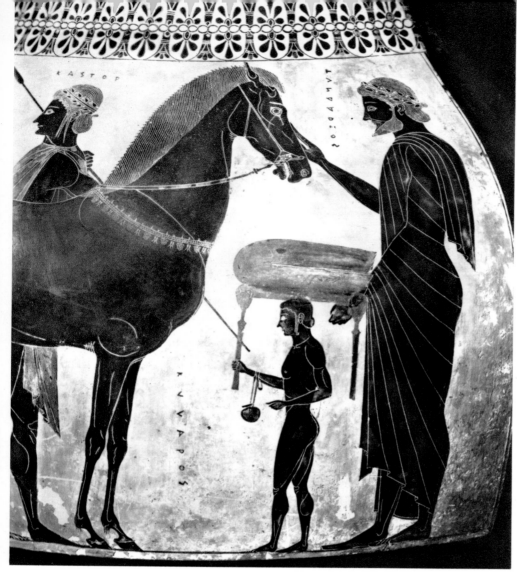

111. EXEKIAS. AMPHORA, DETAIL: RETURN OF THE DIOSCURI. VATICAN CITY.

princely mantles are in battle dress. The implication is that, intent on their game, they have let the Trojans break into their camp before answering the call to arms and running out to relieve the hard-pressed Achaeans. Thus, all is classical in this work, the spirit as well as the style and the perfection of the incised drawing.

On the other side, the return of the Dioscuri conveys a tremor of emotion that is perhaps a shade more perceptible. The twins are welcomed home by their parents, while a slave boy and a pet dog come forward to meet them. It is a family scene quite devoid of the picturesque touches in which an Ionian painter would have indulged. Here, one can appreciate even more the progress made in the realistic treatment of details, in the easy, lifelike rendering of attitudes. True, Castor's head turns round completely; its position remains conventional. How admirable, on the other hand, are such details as the horse's head, the anatomy of the slave boy, and the draped himation of Tyndareus, in whose garment the folds bring out so well the volume of the body.

101

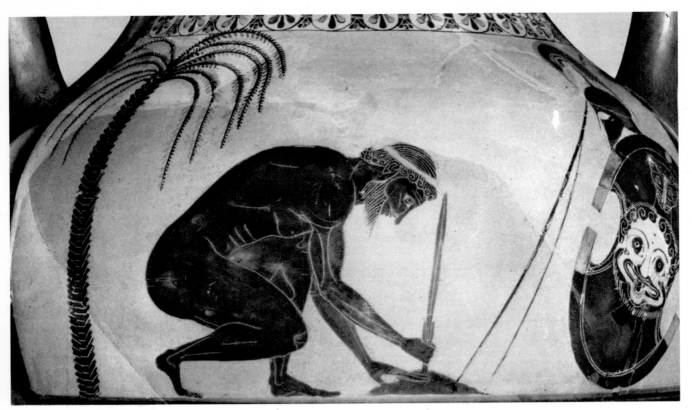

112. EXEKIAS. AMPHORA, DETAIL: AJAX PREPARING FOR HIS SUICIDE. MUSÉE MUNICIPAL, BOULOGNE-SUR-MER.

Even when Exekias tackled more dramatic subjects elsewhere, the mood and design remain classical. On the Boulogne amphora he preferred to represent the hero preparing for his suicide with resolute fortitude rather than showing the frenzied Ajax savagely taking his own life. The palm tree on the left (which looks like a concession to Ionian taste) helps to fill out a composition that otherwise would seem rather empty. Although the hero's legs are out of all proportion to the rest of his body, this unusual portrayal of Ajax nevertheless illustrates the painter's innovating spirit.

Other works by Exekias seem better designed and, on that very account, more ordinary. One is the amphora in the British Museum, sparingly decorated with a scene of combat. The presentation of the two figures is still highly archaic—torso in frontal view, head and legs in profile. The theme of the beaten enemy running away, sinking to the ground, and turning towards his adversary had occurred as early as the second quarter of the sixth century. Still, this composition is less conventional than it seems. Its subject is Achilles bending grimly over the queen of the Amazons, who straightens to face him; their tightly knit grouping is accentuated by their sharp exchange of glances. And indeed there is even an intimation here of hidden feelings—the love for Penthesilea with which Achilles was smitten at the very moment he transfixed the brave queen. This delicacy of expression is particularly noteworthy in a scene of violent death. The theme was to be taken up again in classical painting.

102

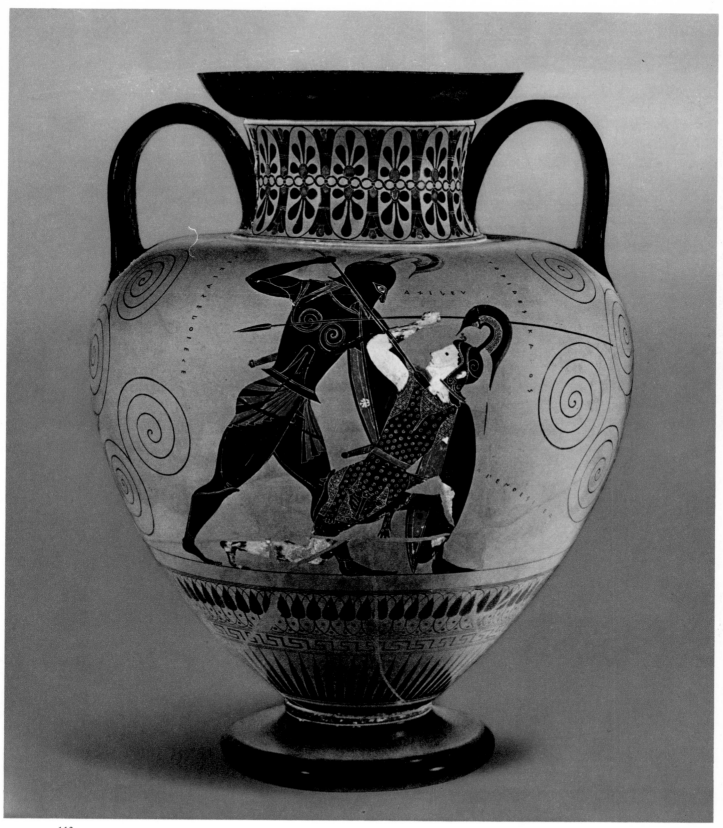

113. EXEKIAS. AMPHORA: ACHILLES SLAYING PENTHESILEA. BRITISH MUSEUM, LONDON.

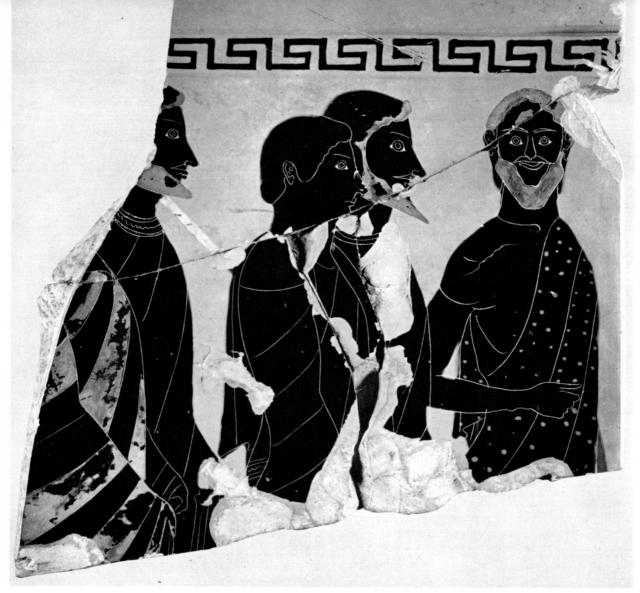

114. EXEKIAS. FRAGMENT OF A TERRA-COTTA PLAQUE: FUNERAL PROCESSION. STAATLICHE MUSEEN, BERLIN.

Exekias also painted a series of terra-cotta plaques, now reduced to fragments, that originally adorned an Athenian funerary monument. These plaques are of special interest, for they show that around 530 in Athens a painted decoration could still be made by the same procedures as those used for vase painting, and by one of the foremost vase painters. The funerary scenes depicted are remarkable for their sobriety of expression. The faces are grave, some of them pensive, and there is none of that gesturing that is so commonly found in works of this kind, for example in those of Lydos that we have seen. On the other hand, the personality of Exekias comes across strongly in these fragments: the upright bodies are wholly in profile and are stiff only in appearance; the faces are intelligent, with high, straight foreheads; the draperies suggest volume; and there is an experimental touch in the case of the strange face turning to gaze straight at us.

104

115. EXEKIAS. FRAGMENT OF A TERRA-COTTA PLAQUE: FUNERAL SCENE. STAATLICHE MUSEEN, BERLIN.

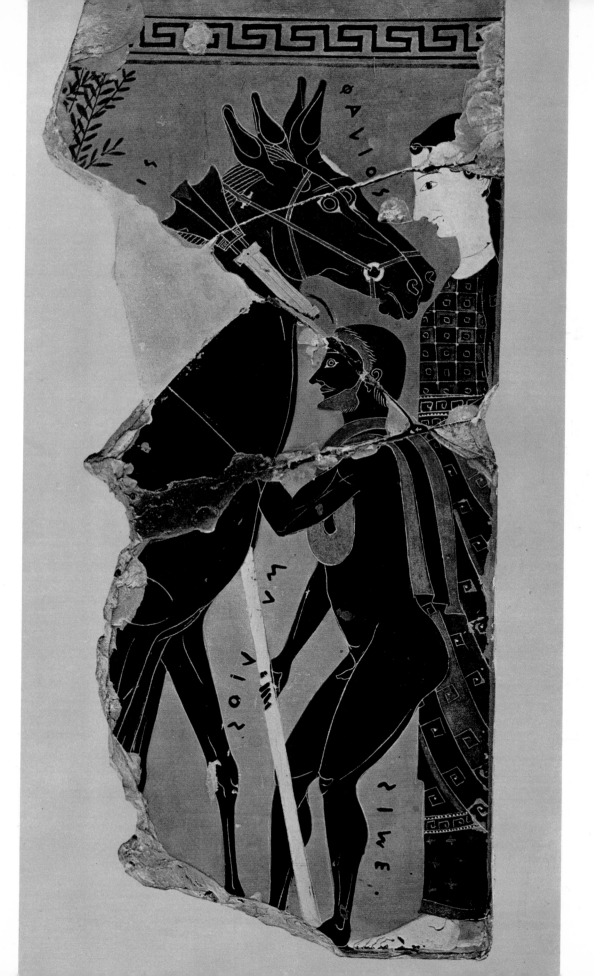

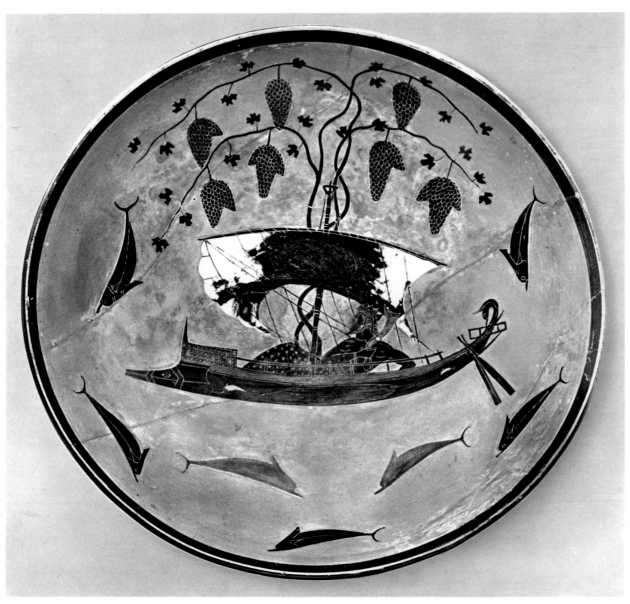

116. EXEKIAS. CUP: DIONYSUS ON A BOAT. STAATLICHE ANTIKENSAMMLUNGEN, MUNICH.

To the end of his career Exekias proved himself a genuine creator. To him we owe the invention of the calyx krater, which became one of the standard vase shapes of the red-figure style. He also devised a new type of cup, often decorated with eyes on the outside. But the Munich cup, which is its prototype, remains in many ways unique of its kind. On a special red glaze (the 'coral' red or 'intentional' red technique, which was to be used later by some of the red-figure painters) glides the boat of Dionysus, with dolphins sporting around it, and from the mast sprouts a vine with clustered grapes —a mysterious scene that may prefigure the Dionysiac mysticism of the late sixth century.

Sculpture

Advances in Attic Statuary (575-540)

The achievements of the early archaic period constituted a rich heritage that had freed Greek art from its subservience to the East and set it moving along the new paths it was to follow. The main types of statuary and the essential elements of architectural decoration had taken form: the acroteria, antefixes, and metopes of Calydon and Thermon, the Prinias frieze, the Corcyra pediment. In Greece, moreover, from the very beginnings of large-scale statuary, artists represented the human figure—especially the male nude—with less concern for rendering the static volumes of the body, as in Egypt, than for conveying the pliant action of limbs and muscles. Hence, arms and legs were disengaged, a step taken regardless of the resulting fragility. This accounts for the preference shown everywhere for bronze statuary once the technique of hollow casting was mastered in the fifth century. Also, a desire to capture sentient, active life led artists to single out the organs of sense on the face and represent them with maximum intensity. First they enlarged the eyes and the ears, then relaxed the lips into a smile. This expressive stylization, so arresting at first, became gradually attenuated with the passage of time, but it was maintained till about the end of the sixth century.

The almost complete disappearance of colossal statues in the last two decades of the sixth century is a fact of considerable historical and aesthetic importance. This course was set by Athens, which was now establishing its primacy in the arts. In 594, at a time of acute social tension in Athens, Solon became archon. Sage, poet, and man of action, he spoke out against violence in words that took effect. 'Like a wolf held at bay by a pack of hounds, he faced them all'; he freed 'the black Earth, mother of the Olympian divinities,' from the monopoly of the rich landowners; he recalled the exiles and abolished imprisonment for debt; he proclaimed the rule of law in accordance with Dike (Justice), thus making for 'order and harmony.' On Mytilene, the island of Alcaeus and Sappho, another sage and leader of men, Pittacus, was carrying out similar reforms. Inordinate ambition was being opposed by that sense of moderation that is so profoundly Greek. Art was becoming humanized; the two earliest Attic statues from the Acropolis—the Calf-Bearer, shown here in a photograph taken at the time of its discovery in 1864, and the Rampin Horseman—attest to this.

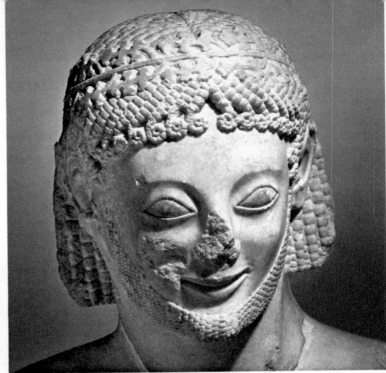

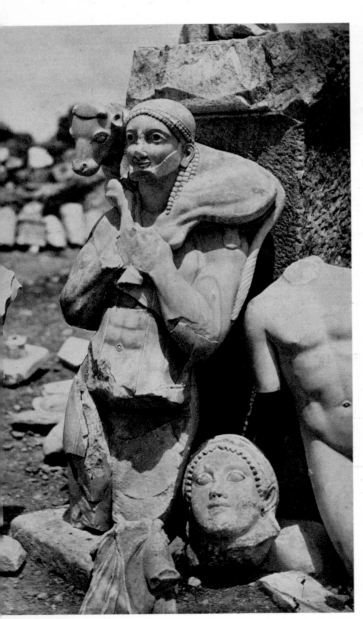

117. THE CALF-BEARER AS EXCAVATED ON THE ACROPOLIS IN 1864.

The theme of the animal-bearer, already treated in small carvings, here avoids abstraction. The statue is designed for frontal presentation, but its geometric stylization is enlivened by slight asymmetries (which, on the Horseman, are bolder and more accentuated). Above all, its volumes emerge and expand; the pleasing contrast between the passiveness of the animal and the firm grip of the bearer evokes the pastoral poetry deriving from the last books of the *Odyssey* and conveys the warmth of an actual presence. In about 560 the statue of the winning horseman at the Pythian games was dedicated on the Acropolis. A bold, wonderfully varied play of light, subdued on the nude torso, vibrant on the face and in the granulations of the hair, transposes this new image into a world where the real and the imaginary are united. One would give a great deal for further works by these two anonymous masters, whose temperaments are unmistakably different. No other work can be convincingly related to the Calf-Bearer. On the other hand, Humfry Payne's attribution of the Peplos Kore to the Rampin Master is indisputable. It helps us to appreciate the genius of one of the

108

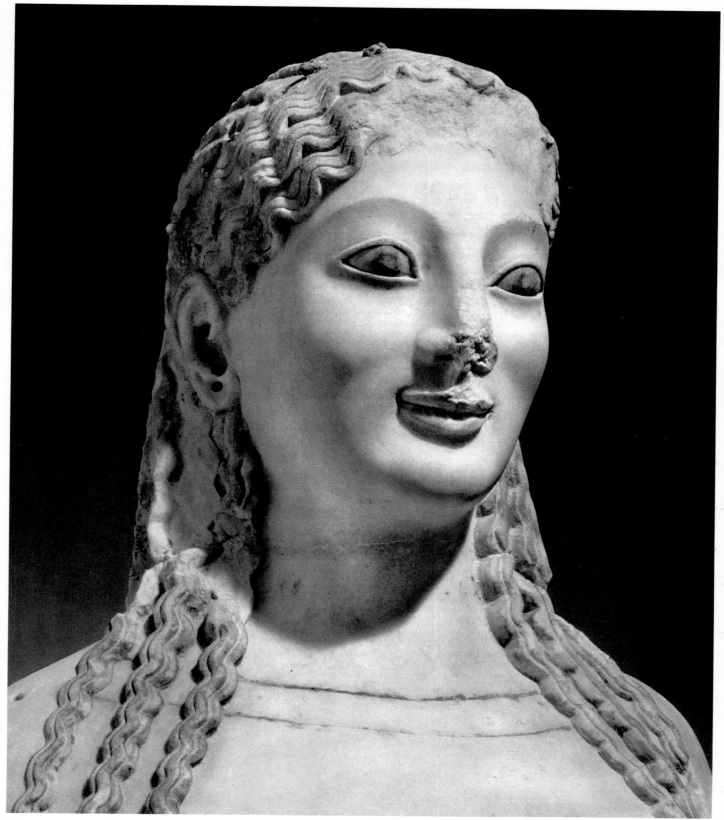

119. ATHENS. KORE 679 OR PEPLOS KORE, DETAIL. ACROPOLIS MUSEUM, ATHENS.

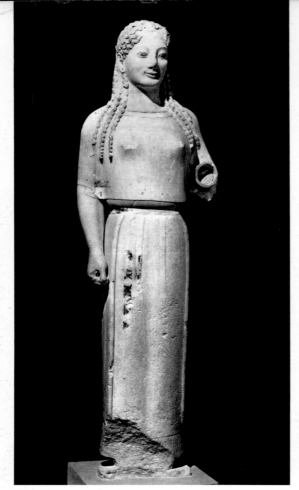

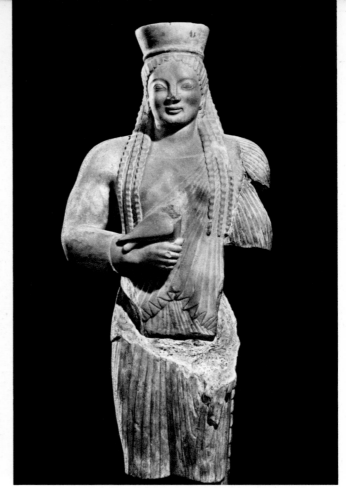

120. ATHENS. 'PEPLOS KORE.' ACROPOLIS MUSEUM, ATHENS. 121. ATHENS. KORE. MUSÉE DES BEAUX-ARTS, LYONS.

greatest Greek sculptors and to see how, in this decisive period, he was at the forefront of the general movement of Greek art towards the rendering of forms in their organic reality.

Twenty years after the Horseman, in about 540, the Rampin Master carved for the sanctuary of Athena the Peplos Kore, a girl clad in the strict Dorian peplos. This was at a time when the robust and fleshy Lyons kore, of the Ionian fashion that was destined to hold sway for the next half-century, had already been standing on the Acropolis for at least ten years. The artist's choice of the peplos does not imply a stubborn attachment to the Daedalic tradition, but rather is an innovating attempt to emphasize the plastic values of a woman's body under the clinging sheath of cloth. The many folds of the Ionian drapery, cascading in both straight and slanted pleats, mask the body, hiding its lines and proportions.

In the Peplos Kore the body dominates the drapery; its vibrations animate a covering whose abstract rigour, in return, strengthens and idealizes the body beneath. In the Horseman, presumably an earlier work, there is a certain indulgence in decorative refinements inspired by jewellery, ivories, or textiles imported from the Ionian East; the smooth face emerges from the surrounding granulations like a gem from its setting. On the face of the kore we find the same curves, the same swellings and hollows, but

110

122. ATHENS. THE RAMPIN HORSEMAN. LOUVRE, PARIS (HEAD), AND ACROPOLIS MUSEUM, ATHENS (BODY).

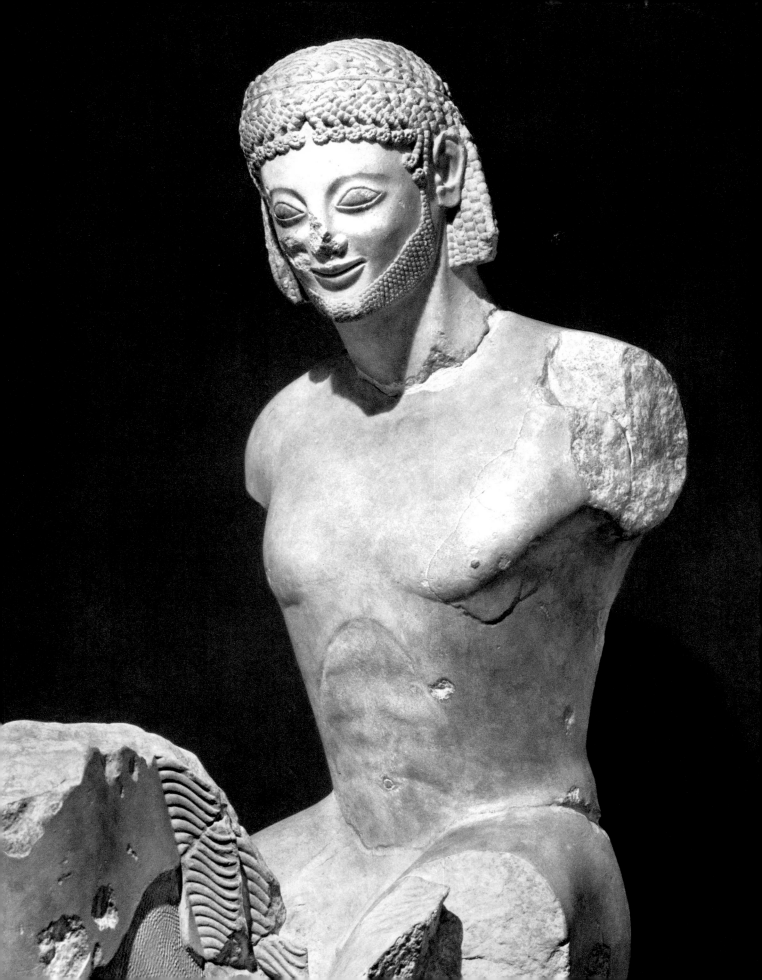

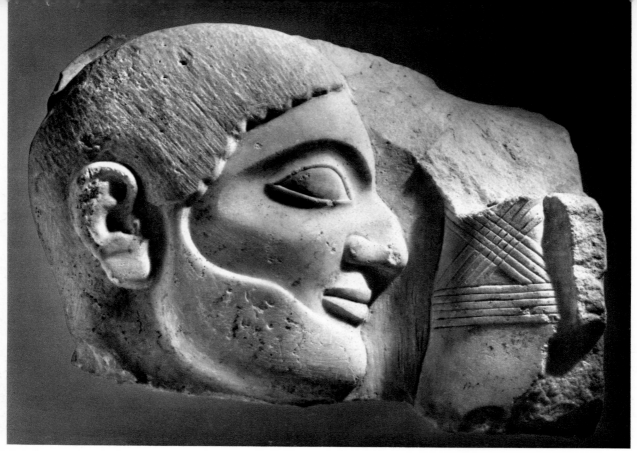

123. ATHENS, THEMISTOCLEAN WALL. STELE WITH THE HEAD OF A BOXER. KERAMEIKOS MUSEUM, ATHENS.

modeled in a more radiant light; the geometric harmony of the structure remains, but it has been transfigured by keen observation of living, sensuous forms.

We return to the Calf-Bearer and the Horseman, which do not belong to the same family as the abstract kouroi. The representaion of a definite action gives these figures identity. We have already noted this in the case of the Argos twins Cleobis and Biton, as in that of the Horseman, even though neither his name nor that of his companion has come down to us (surviving fragments show that there were two riders forming a group). We know that the Calf-Bearer's name was [Rh]ombos. True, these are not yet portraits, as we understand the word, but are they so very far from it? We shall have occasion to come back to this difficult question. What is certain is that Greek sculptors, especially perhaps before the middle of the century and the growth of Ionian influence, became more and more responsive to the diversity of faces, as they observed with ever keener curiosity the people and things around them. Striking examples of this response have come to hand in two mid-century funerary reliefs, one with the profile of a boxer with a large hook nose, the other with a discus thrower delicately individualized in the aureole of his discus. At the same time began another movement, whose source, like that of numbers, music, and geometry, lay in the profoundly Hellenic sense of harmony. It is exemplified by the Kerameikos sphinx, whose spirited elegance is typically Attic, and whose fine, regular features resemble those of a Corinthian sphinx made twenty or thirty years earlier as an acroterium for the temple of Calydon.

112

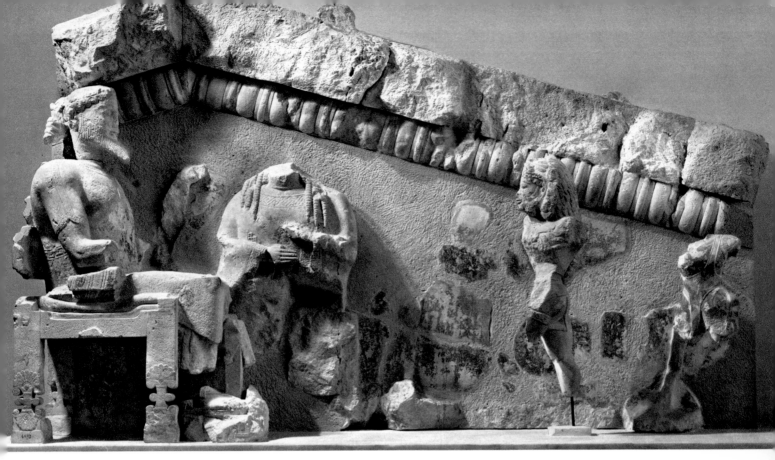

124. ATHENS. PEDIMENT: HERACLES INTRODUCED INTO OLYMPUS. ACROPOLIS MUSEUM, ATHENS.

The Rise of Large-Scale Decorative Sculpture (580-540)

In the field of monumental sculpture, it may have been the Corinthian example of the Temple of Artemis in Corcyra that prompted Attic sculptors to detach pediment figures from the wall against which they had been set. This seems possible, for the very early small pediment in flat relief of Heracles attacking the Hydra was followed in the first half of the century by three pedimental groups in which the figures were given more body as the building grew larger. At the same time, sculptors ceased to treat the figures like a frieze, with all of them moving in the same direction a treatment in fact ill-suited to the shape and dominating position of the pediment. It was more natural for the figures to converge. On the so-called Introduction Pediment, showing Heracles arriving in Olympus, Zeus and Hera are majestically enthroned under the apex of the triangle. Escorted by Athena and her divine retinue, the hero is solemnly welcomed by the king of the gods who, in pose and stature, anticipates the Zeus of Pheidias on the east pediment of the Parthenon.

Much more original than the early heraldic group on the Corcyra pediment, this composition may well reflect the didactic verse of Solon, but it is also tinged with the Orientalizing glamour of the epic. The influence of painting asserts itself in the wealth of ornaments painted over a light-coloured plaster that smoothes the rough surface of the soft limestone in which the figures were carved. Indeed, the figure types, the costumes, and even the subject are closely connected with the main scene on the François vase.

113

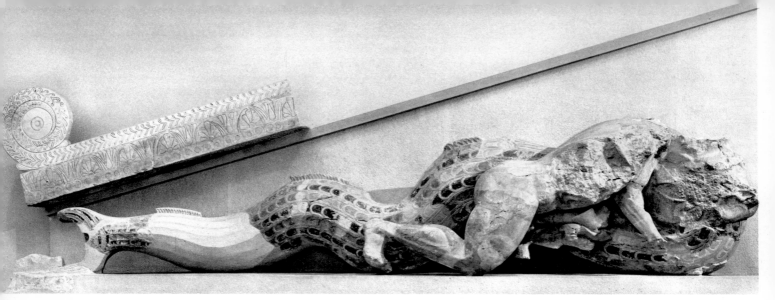

125. ATHENS, OLD TEMPLE OF ATHENA. PEDIMENT, DETAIL: HERACLES WRESTLING WITH TRITON. ACROPOLIS MUSEUM, ATHENS.

At about the same time, but in a very different spirit, a sculptor of more striking originality carved a pediment group for a temple dedicated to Athena, very probably by Pisistratos during his first period of rule (beginning 560). Here the sculptor adopted a solution that avoided a diminishing scale of figures within the triangular space. The three-bodied monster, designed for the right side of the pediment, ends in a series of coils, corresponding to the long fish tail of the merman Triton with whom Heracles is grappling on the left side. Even more than in his invention of the three-bodied monster, this sculptor's talent can be seen in the skill—worthy of a film or stage director—with which he places and presents his 'actors': the monster's first two faces turn at different angles towards the heroic duel; the third looks out at the spectator, thus prefiguring the role of the chorus in Greek tragedy. Centred and astonishingly spirited, the composition departs from epic narration; it shows the action at its climax and thus reveals the dramatic genius of Hellenism, which was to find in Athens its consummate literary and theatrical expression. The pediment's style of powerful, fully rounded forms is emphatically plastic and deliberately rugged. The washes of colour—black, blue, red, green, and yellow—do not serve to accentuate the decorative design, but extend over broad surfaces.

In comparison with the humanized mythology of the Introduction Pediment, that of Heracles and Triton betrays the survival of that daemonic world to which the Gorgon pediment in Corcyra belongs. In the two Athenian pediments, there is not only an opposition between two styles but a demonstration of the fundamental dualism of the Greek religion. Heracles, the hero who overcame monsters and was protected by Athena, is glorified on three of the oldest pediments from the Acropolis. And some thirty years after those we have just described, the pediment group of the Hecatompedon was to represent the battle of the gods and giants.

Like the stained-glass windows of Gothic cathedrals, the metopes running round the Doric temple illustrated a series of legendary episodes intended to render homage to divinity and to edify the faithful. As early as the seventh century and throughout the sixth, subjects similar to those on the metopes occur in small-scale sculpture—in reliefs

130. DELPHI. GOLD GRIFFIN. NATIONAL MUSEUM, ATHENS.

129. OLYMPIA. BRONZE SHIELD STRAP, DETAIL. OLYMPIA MUSEUM.

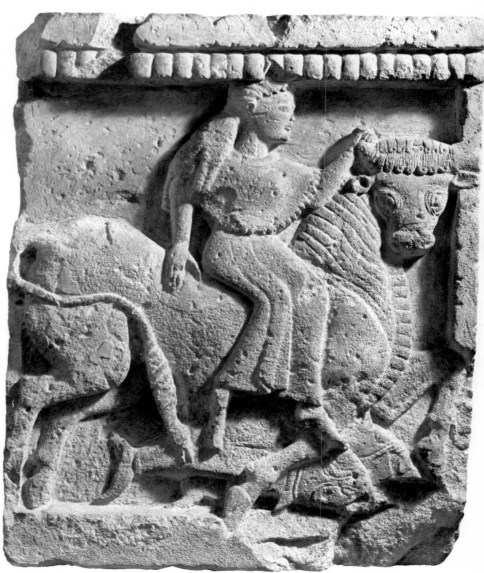

131. SELINUS. METOPE: THE RAPE OF EUROPA. MUSEO NAZIONALE, PALERMO.

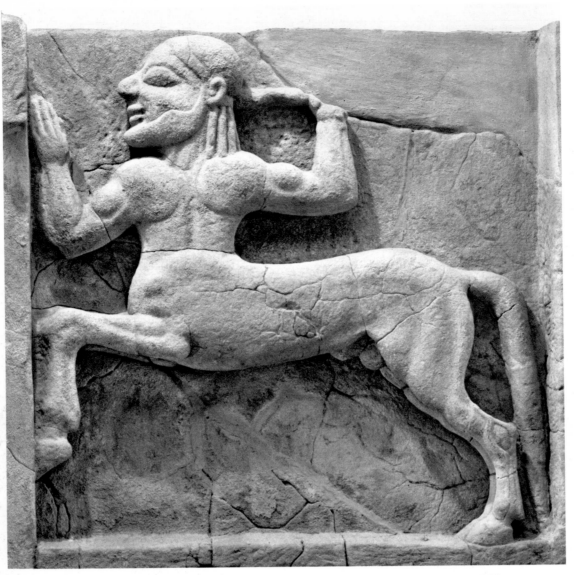

132. POSEIDONIA (PAESTUM), SILARIS TREASURY. EAST METOPE: GALLOPING CENTAUR. PAESTUM MUSEUM.

of pedimental sculptures (except for fragments recently discovered at Metapontum), have provided us with a long series of archaic and classical metopes. On the earliest, the imitation of jewellery is revealed by the chiseling of the frame and the clumsiness of some decorative details; but the frontal presentation in the early Selinus metopes became, twenty years later, more ponderously insistent in its appeal to the spectator.

There seems to have been no real unity of design in the sequence of metope reliefs on a given building until we come to the Athenian Treasury at Delphi, at the beginning of the fifth century. Towards the middle of the sixth, however, there had been an interesting move in this direction in the Heraion Treasury on the Silaris (near Paestum). Nearly all its metopes have been found, about half of which (seventeen or nineteen out of thirty-six) illustrate the legend of Heracles. Others among them represent episodes

133. SELINUS, TEMPLE C. METOPE, DETAIL: PERSEUS SLAYING THE GORGON. MUSEO NAZIONALE, PALERMO.

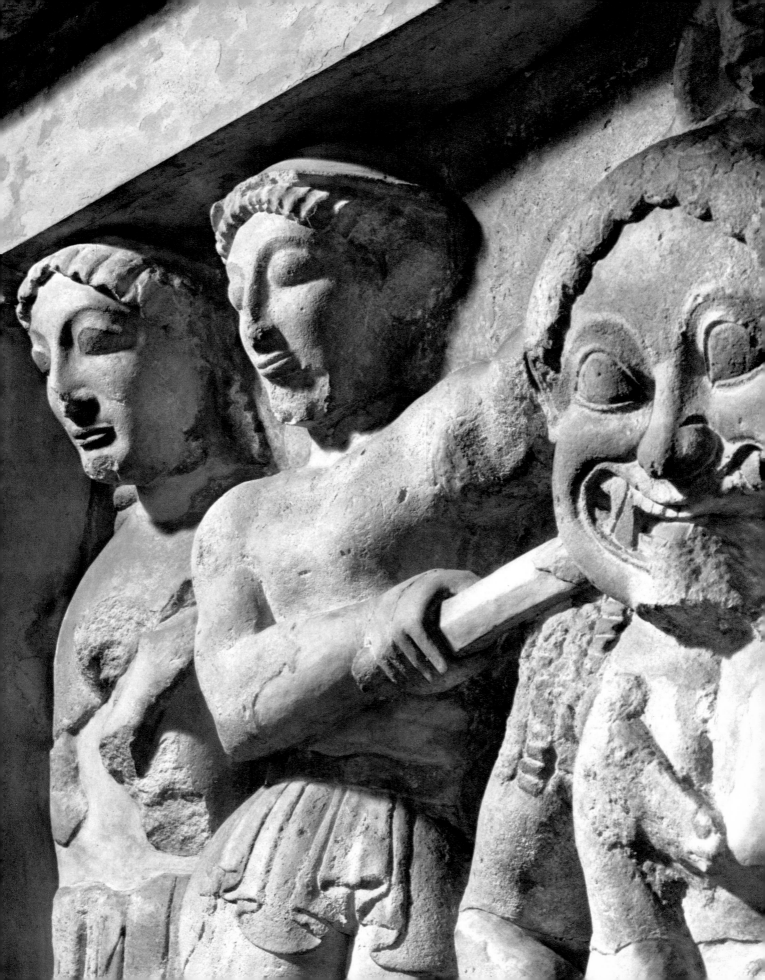

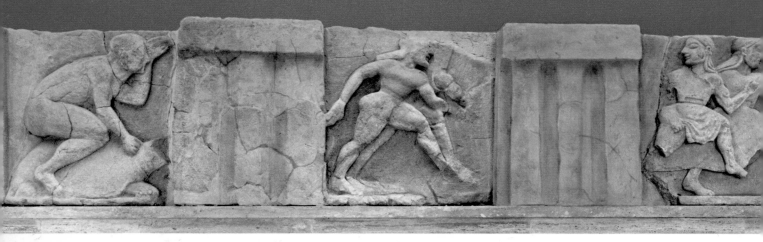

134. POSEIDONIA (PAESTUM), SILARIS TREASURY. WEST METOPES: HERO BESTRIDING A TORTOISE—DIOSCURI—LEUCIPPIDES. PAESTUM.

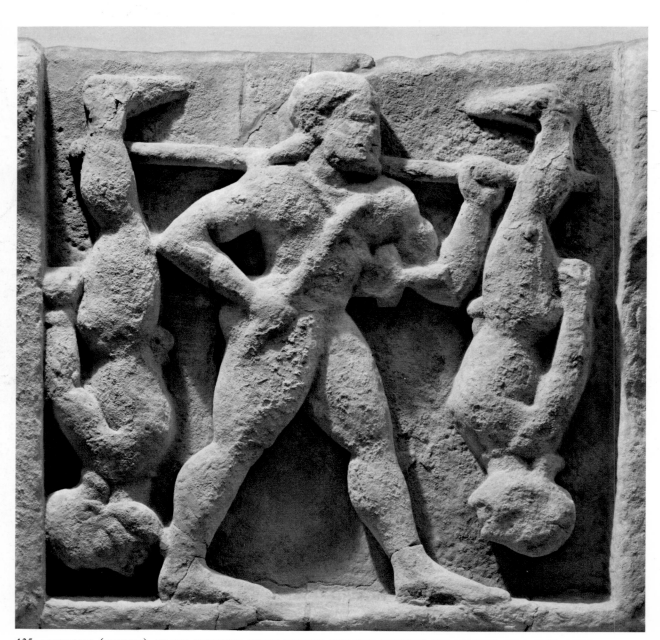

135. POSEIDONIA (PAESTUM), SILARIS TREASURY. NORTH METOPE: HERACLES CARRYING THE CERCOPES ON A POLE. PAESTUM.

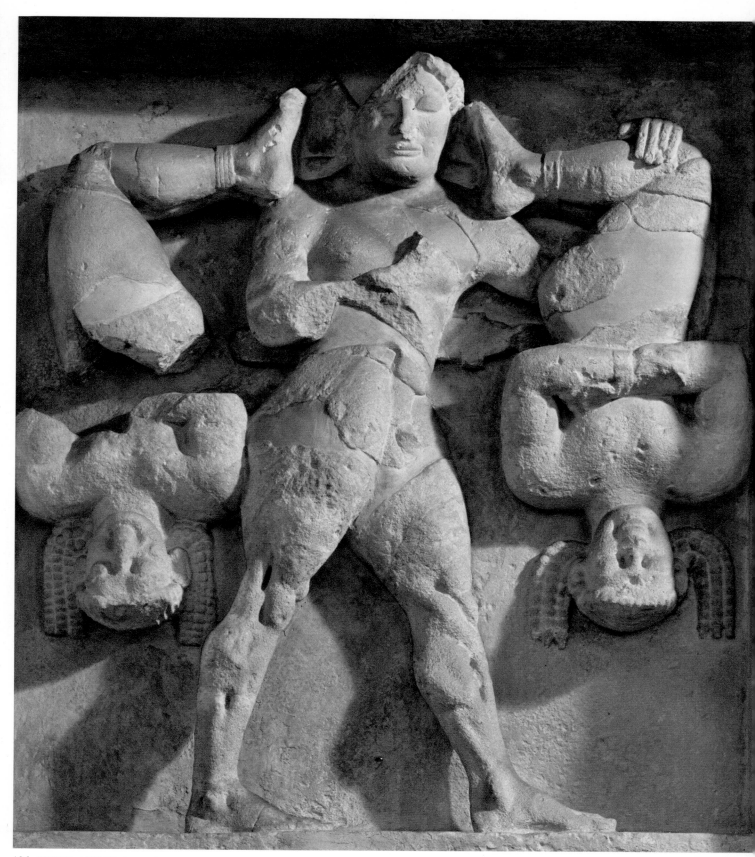

136. SELINUS, TEMPLE C. METOPE: HERACLES AND THE CERCOPES. MUSEO NAZIONALE, PALERMO.

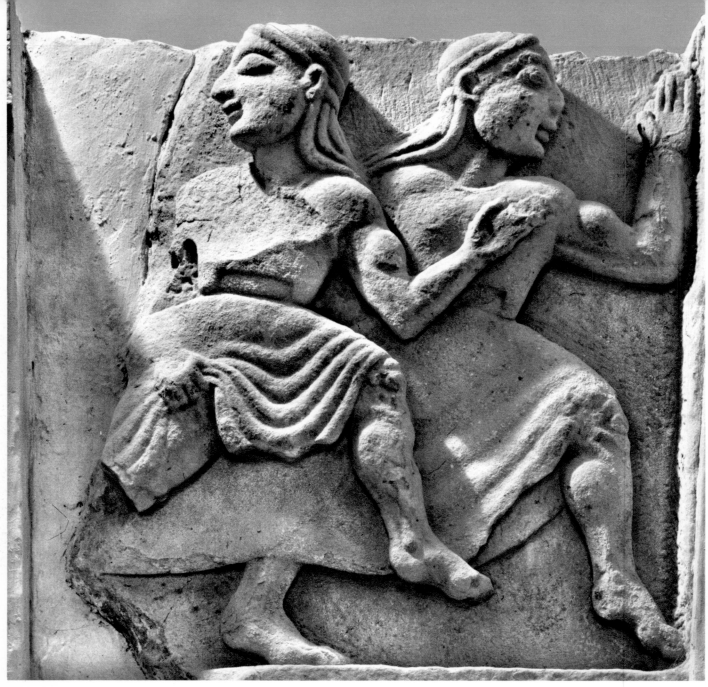

137. POSEIDONIA (PAESTUM), SILARIS TREASURY. WEST METOPE: TWO GIRLS RUNNING AWAY. PAESTUM MUSEUM.

of the Trojan cycle taken from the Achilles legend, scenes from the Oresteia, and a sile-nomachy. The choice of these unusual subjects, undoubtedly taken from the *Hymns* of Stesichorus, is interesting because it denotes a taste for dramatic action that was parti-cularly strong in the colonial world of Magna Graecia. This taste is further revealed in the way in which even the commonest themes of the legendary repertory are treated —with a naïve but robust and spirited realism in which the comic and the tragic often appear side by side.

122

The Ascendancy of Ionia

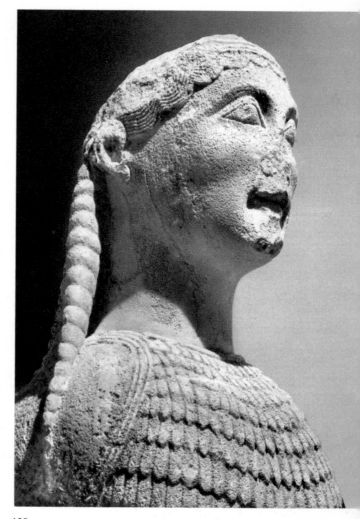

138. DELPHI. NAXIAN SPHINX, DETAIL. DELPHI MUSEUM.

The evolution of Greek sculpture towards naturalism during the sixth century varied according to the genius or skill of the artist and to the traditions and norms of the school or workshop in which he was trained. Moreover, apart from a few historical landmarks and a small number of inscriptions and literary texts, the differentiation of styles is largely based on the find-place, and the dating of extant works on the progressive degree of accuracy in the rendering of proportions and anatomical detail. In both respects there remains a margin of uncertainty or error. Here one can fully appreciate the valuable evidence provided by a masterpiece like the Dipylon sphinx. It is illuminating to compare it with the only slightly earlier Naxian sphinx at Delphi, whose large, set features hark back to the aesthetic of the seventh century. In viewing the Dipylon sphinx, one is struck at once by the lifelike suppleness of the winged feline body, the pronounced bone structure of the face, and the large gazing eyes suggestive of a living presence. The sphinx on top of the Megacles stele in the Metropolitan Museum, coming some twenty years later, seems stereotyped, despite the less rigid bearing of its head.

These three examples are characteristic. The innovating artist outdistanced others but, consciously or unconsciously, he kept to the contemporary interpretation of certain organs, like the eye and the ear, which were both expressive and decorative. Their

123

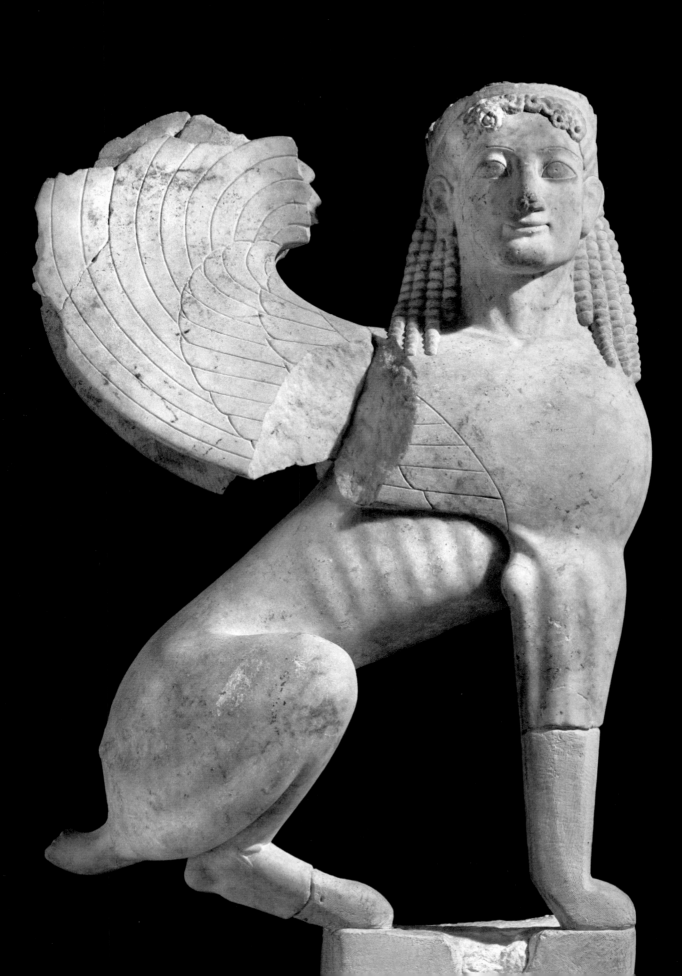

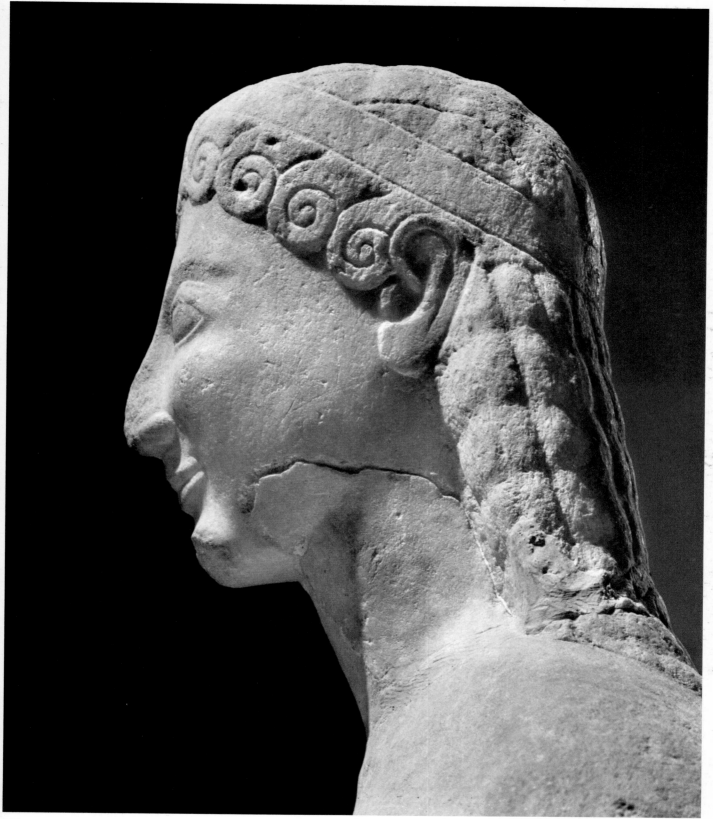

140. THERA. KOUROS, DETAIL. NATIONAL MUSEUM, ATHENS.

139. ATHENS. SPHINX. KERAMEIKOS MUSEUM, ATHENS.

141. SAMOS. HEAD OF A KOUROS. ARCHAEOLOGICAL MUSEUM, ISTANBUL.

142-143. SAMOS. BRONZE KOUROS, TWO VIEWS. SAMOS MUSEUM.

form was stylized and magnified to emphasize their receptive or quickening power, and their accuracy of design was not equalled until the last two decades of the sixth century. The same is true of aristocratic men's hair (to say nothing of women's), whose ornamental treatment continued even after the end of the sixth century, with many variant patterns of beads, spirals, flakes, flutings, wavelets, and scalloping. But from the 530's on, as we shall see, Attic art set the example of sobriety. The ceremonial archaic smile, symbolizing man's likeness to the gods and borrowed from Anatolian Ionia at the beginning of the sixth century, had spread throughout the Greek world by about 560-550. Thus, the stamp of the Ionian spirit, moving westwards, superseded that of the eastward-moving Daedalic spirit. The curve of the lips answered by the slant of the eyes, combined with the refinements of headdress and Ionian draperies, already marveled at in the previous century by the author of the Homeric hymn to the Delian Apollo, was a style that held Greece in its spell for over fifty years, in spite of the clumsiness of its early exponents like the sculptor of the Thera kouros, and in spite of mechanical repetition by later imitators.

Successors of the nude colossi of the early archaic period, the kouroi of the generation of 570-540, rarely exceed life size and then only by little. The workshops of the West realized the male ideal with more athletic vigour than did those of East Greece. In the East two great art centres, Samos and Miletus, left their imprint on most of the kouroi produced after the mid-sixth century, from Keramos and Mylasa in Caria to Istria and Olbia on the Pontus Euxinus, and to Naucratis in Egypt and Cyrene in Libya. What we have to deal with, unfortunately, are nearly always headless bodies or bodiless heads. Recent research, however, has enabled the finest kouros head of the Ionian East, hitherto thought to be Rhodian, to be reassigned to the Samian school of the mid-sixth century; it belongs to a colossus found in fragments in the Samian Temple of Hera. This is an important discovery, for the harmonious design of the face, the full volumes, the discreet smile, and the neat divisions of the hair reveal this head as

126

the prototype of a very extensive series, and demonstrate the close stylistic similarity between Samos and Miletus. Another proof of this, among others, is provided by the almost complete kouros found at Artake (a Milesian foundation on the peninsula of Cyzicus), which plainly derives from a Samian model. From Samos, moreover, we have a whole series of bronze statuettes, in default of the bronze statues with which Rhoikos and Theodoros—architects and sculptors who are traditionally credited with the introduction of the hollow-casting technique into Greece—doubtless adorned the Temple of Hera. These small bronzes show a great variety of attitudes. The simplest is the frontal figure; other types are the offering-bearer, the horseman, the banqueter, and the flute player. Recognizable in these are the touch and fancy of the individual modeler. The oldest Samos bronze goes back to the great building period of Rhoikos and Theodoros, before 550. Except for an attenuation, it represents a characteristic male type that remained unchanged. Its narrow chest, fully rounded lower body, large head with full cheeks, greedy lips, salient eyes, and nose denoting an eager lust for life suggest, one feels, the climate of the times in that fertile island enriched by trade.

The heads and torsos of which we have just spoken belong to the years between 560 and 540 (these dates are of course approximate and open to discussion), when an artistic community took form in which East-West currents were mingled. By 'community,' however, we mean common experiments and growth rather than a common style, for the leading personalities left their mark on their works.

In Athens, as we have seen, the Rampin Master carved the Peplos Kore in about 540, twenty years after the Horseman. Other sculptors, too, born in the early sixth century, undoubtedly continued their work into the 540's and beyond. A striking image of Attic youth of this period, the Volomandra kouros marks the rise of a new generation; its size, broad shoulders, and large beads of the hair testify to the influence of the Dipylon and Sounion Masters. The ideographic grooves marking its musculature are almost smoothed away by the firm, supple, unifying modeling, but their

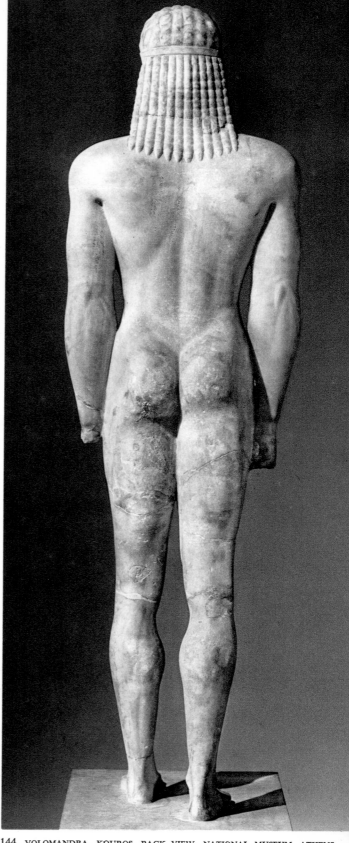

144. VOLOMANDRA. KOUROS, BACK VIEW. NATIONAL MUSEUM, ATHENS.

127

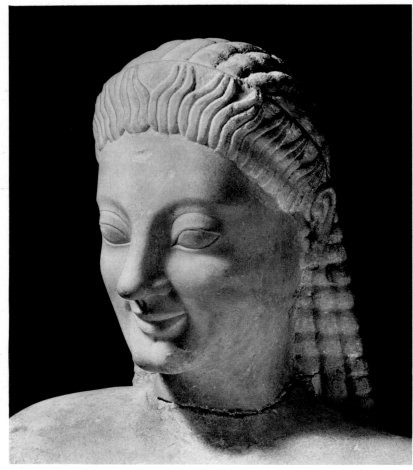

145. VOLOMANDRA. KOUROS, DETAIL. NATIONAL MUSEUM, ATHENS.

underlying presence reveals a typically Attic tracery of long undulating lines. The Ionian smile has come over the face, whose charm is enhanced by the glowing expanse of the forehead, and one cannot but wonder if the flamelike wisps of hair crowning the forehead may not symbolize, like the *Iliad*, the fire of ardent youth overtaken by death. Here, in any case, we are in the presence of a poetic creation. The long line of kouroi took their forms from life, from a reality ever more closely observed, but those forms were raised to another level by the grace and rhythm of a transfiguring lyricism.

The effects of Roman looting at Corinth are to some extent compensated for by the finds made elsewhere in Corinthian colonies and trading stations. It is instructive to compare the earlier of the two Corinthian torsos found at Actium with the kouros from Tenea, near Corinth, and to compare the latter with the Attic kouros from Volomandra. Carved about 570, as indicated by the plain, incised arc designating the thorax, the compact forms of the Actium kouros are still close to the Corcyra Chrysaor of about twenty years before; but the shoulder blades and hip bones now show through under

146. ACTIUM. KOUROS. LOUVRE, PARIS.

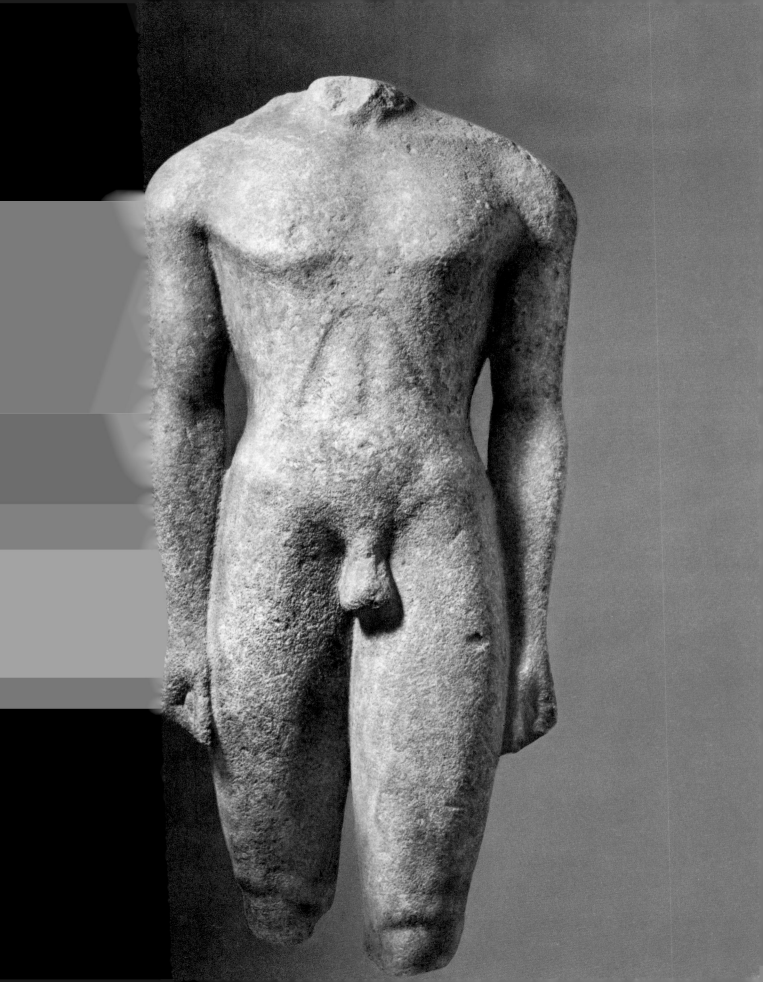

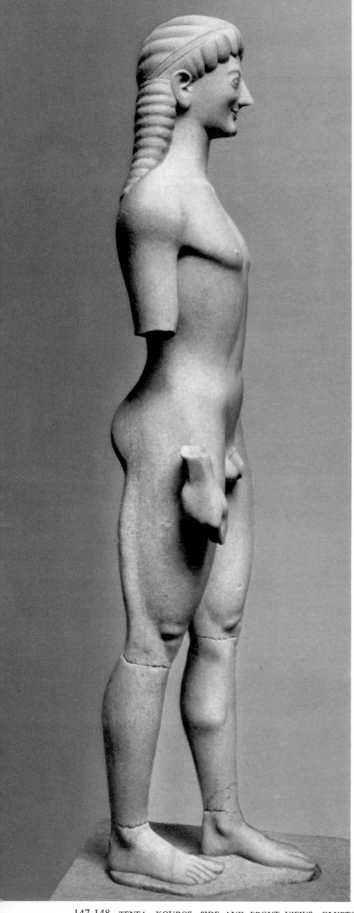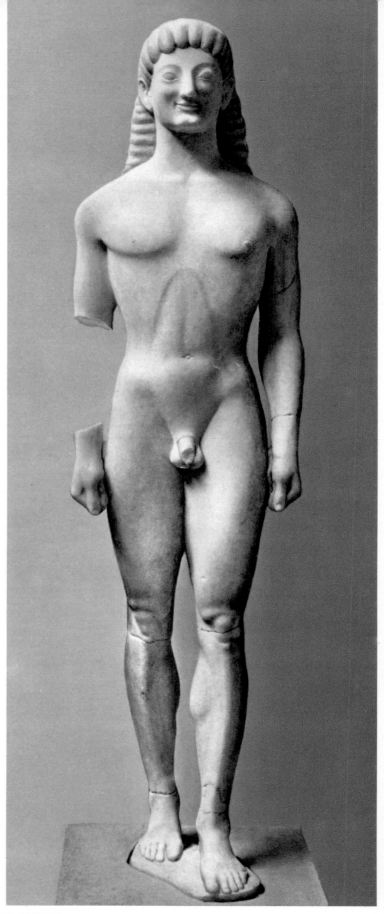

147-148. TENEA. KOUROS, SIDE AND FRONT VIEWS. GLYPTOTHEK, MUNICH.

the skin. The Tenea kouros of about 550 is in the same lineage. Here we see a type conceived in the previous generation and brought now to perfection of form and outline by subtler, more rounded modeling systematically controlled by calculations based on foot lengths. This, in short, is a masterpiece beyond the reach of an artisan, although it is one in which vivifying inventiveness had no part. This Corinthian youth, whose smile conveys the satisfaction of success, exemplifies the advances made towards naturalism and balance during the decade that separates it from the Volomandra kouros, but it lacks the *élan vital* that quickens its Attic predecessor, a shortcoming that is emphasized by the disproportions of its ungainly large body.

Unfortunately, there is little to choose from among these parallel ranks of young men, nearly all of them mutilated, which represent, each in its own lineage, the ideal of male beauty current just before and just after mid-century. Examining the structure and evolution of the forms of these kouroi, one seems to distinguish two main tendencies: the analytic one seeks to emphasize the significant organ or muscular detail; the other expresses the body structure in a well-knit unity of volume. Observant curiosity had led the carvers of the Sounion kouroi to render the muscular divisions of back and abdomen by well-marked linear patterns; these have spread over the whole body of the Volomandra kouros, but according to the sculptor's intention he uses them either to attenuate or to stress the detail of the modeling. The first direction is clearly predominant in Attic sculpture that arose among an Ionian population, but it was to maintain the balance between the Ionian genius and the Dorian genius. It is equally clear that the Argive twins Cleobis and Biton belong to the second direction, as does the Tenea kouros, however refined by the Ionian countercurrent. The statuary of the mid-sixth century perhaps best illustrates the fruitful opposition of these two aesthetics, which balanced, followed, or combined each other. Hence the nuances, cross currents, and apparent contradictions to be found, for example, in three works which, though

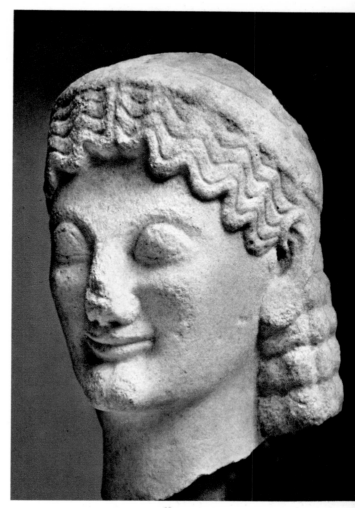

149. THASOS. HEAD OF A KOUROS. COPENHAGEN.

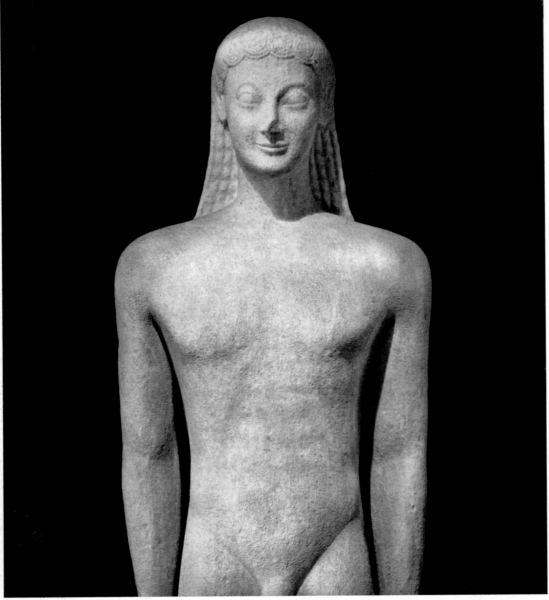

150. MELOS. KOUROS, DETAIL. NATIONAL MUSEUM, ATHENS.

perhaps secondary, are thereby all the more characteristic of Cycladic Ionianism. From the front, the silhouette of the Melos kouros is very close to that of the slightly earlier Volomandra kouros, but the waist is narrower and the chest flatter. The delicacy of the facial features brings to mind that 'sweet Naxian melody' (to use Ernst Buschor's phrase), which is exemplified by several torsos from Delos and which contrasts with the sturdiness of the young athlete from Paros—one of the few sculptures found on the island where the finest marble was quarried. This sturdiness would seem Dorian, were it not for the full modeling of the torso and the full curves of the face, which suggest a connection with the Anatolian Ionianism of Miletus, which maintained close relations with Paros. We find a sharper, firmer accent in the facial features of the head from Thasos; here we probably have a Parian model transposed into the local dialect and marble.

132

151. PAROS. KOUROS. LOUVRE, PARIS.

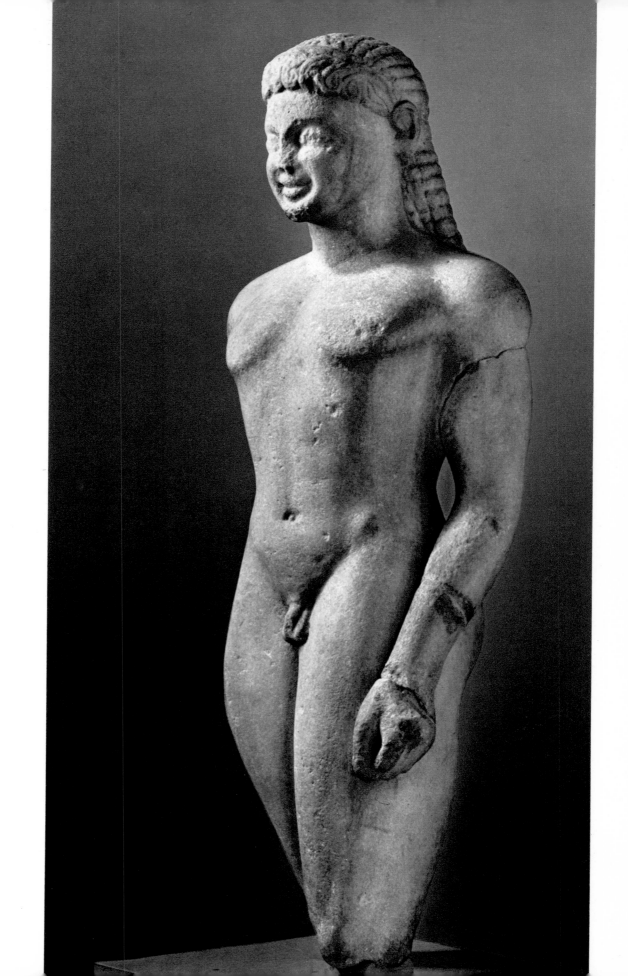

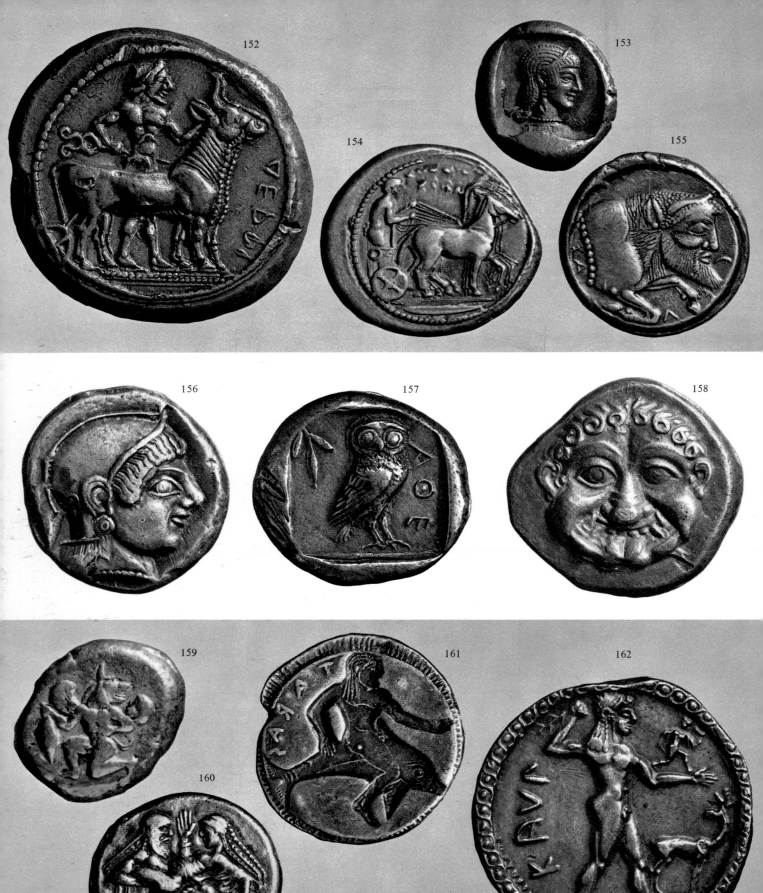

The author of the Homeric hymn to the Delian Apollo describes the god receiving in his sacred grove 'the long-robed Ionians . . . who gladden [him] with boxing, dancing, and song' and who seem so godlike that 'a man might think them ageless and deathless.' However much idealized, this description of aristocratic life in East Greece in the seventh century, when the great families were still supreme, evokes a community enriched both commercially and artistically by its connections with the Oriental world and especially with the kingdom of Lydia. A land of gold and electrum, in which the first coins were struck and the first pieces of jewellery bearing the Hellenic mark were made, Lydia took on in the Greek imagination an aura of legend. Croesus, who reigned from 561 to 546, succeeded by the middle of the century in bringing the Greek cities of the Anatolian coast under Lydian domination, but like Rome four centuries later, he fell under the spell of the conquered. The latest of the ivory statuettes found at Ephesus, a priestess from about 570, is one of the first and most charming tokens of the triumphant Ionianism of Asia Minor. The purity of its design is Greek, but the refinement of the cutting owes much to the technique of the Lydian ivory carvers. This little masterpiece precedes and heralds the imposing series of female statues from Samos. Indeed, the Hera dedicated by Cheramyes, standing like a column on its round base, appears like a large-scale transposition in marble of the ivory priestess. What is miraculous here is that, instead of blurring the lifelike inflections of the modeling, the architectural stylization actually enhances the majestic femininity of the goddess's body under the suggestive variations of the drapery. Probably never in Greek statuary has an artist better expressed a great religious idea by a union of the real and the arbitrary, of observation and invention.

Beside this outstanding master, his associate or disciple, the sculptor Geneleos, is less of an innovator, but he too is capable of subtle variations in the handling of forms and draperies. For the Temple of Hera in Samos he carved a family group, the first we know of from this period. The six frontal statues

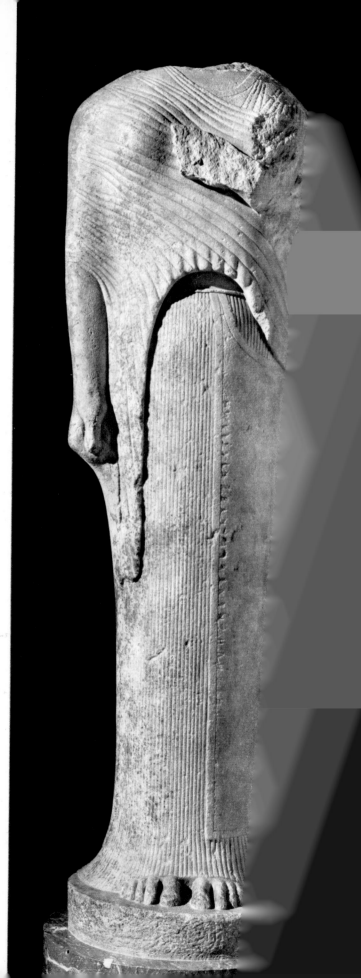

135

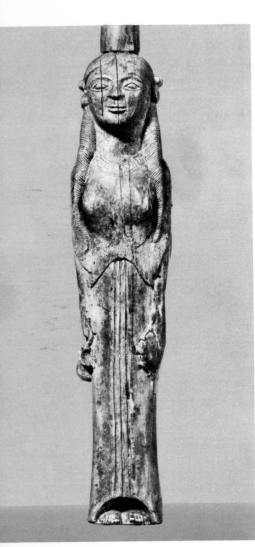

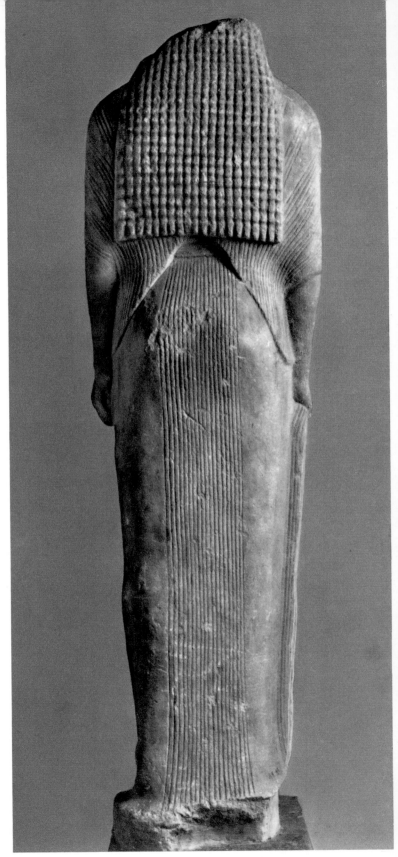

164. EPHESUS. IVORY PRIESTESS. ISTANBUL.

165. SAMOS. ORNITHE, BACK VIEW, FROM A GROUP BY GENELEOS. BERLIN

136

stood in a row on a low base. The arrangement of the group reflected both a religious and a family hierarchy: two women, one seated on the left, the other reclining at the right, and between them a draped man and three standing girls. The survival of Asiatic matriarchy is evidenced here by the predominant position and attitudes of the two women, especially the reclining woman—mother, head of the family, and no doubt a priestess too. It was she who dedicated the group to Hera, who was herself the heiress of the great Asiatic goddess, and whose treasury (according to the inscribed inventory found in the ruins of the temple) contained a prodigious quantity of trinkets, jewellery, and fine clothes. The sculptural composition of the group can only be judged from the three surviving statues, all headless. The architectural significance lies above all in their differentiation of forms—the mother matronly and stout, the girls slender, youthful, small-breasted, with their aristocratic long, heavy hair. The straightforward realism of their strict vertical design is characteristic of the Samian style. The loss of the heads in this series of female statues, whose style was to blend with that of the Cyclades and spread throughout the Hellenic world, deprives us of an important criterion of appreciation. It is partly compensated for by a statuette found at Olympia, which probably formed the support of a bronze bowl—one of the many offerings marking the presence of Samos in the Panhellenic sanctuaries. The deliberately oversized face has one feature that was common at Samos and Miletus: the broad span of the brow and the elongated eyes. But the lack of charm in this face is evident from a comparison with the smiling lips and elongated eyes of another, slightly later, female figure, of which only the head and

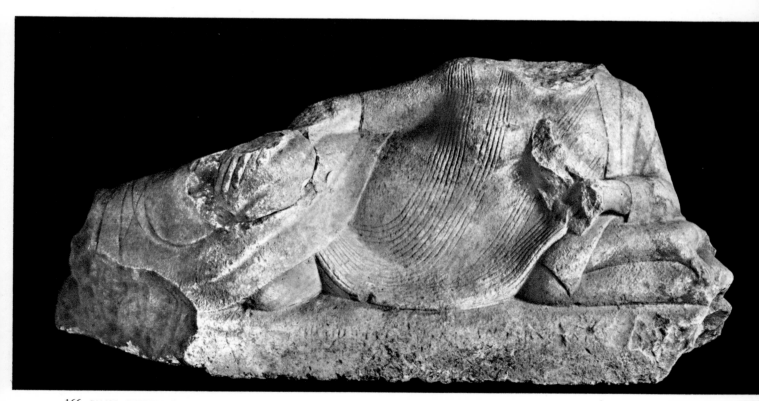

166. SAMOS. RECLINING WOMAN, FROM A GROUP BY GENELEOS. VATHY MUSEUM, SAMOS.

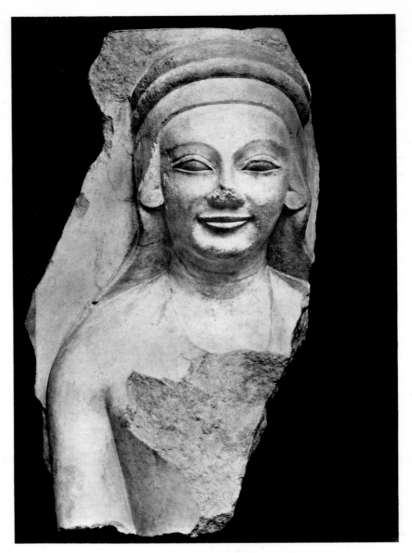

167. OLYMPIA. APHRODITE (?). ATHENS. 168. DIDYMA. RELIEF ON A COLUMN BASE. STAATLICHE MUSEEN, BERLIN.

right shoulder remain on a fragment of a column base (from the Temple of Apollo at Didyma near Miletus).

This head is a valuable remnant, since all the seated statues of the sixth century discovered in East Greece, mostly at Miletus, are headless, except for one from the series of the Branchidae, the priestly clan that ministered to the Temple of Apollo at Didyma. As late as 1821, seventy of these statues could still be seen lining the sacred way leading to the temple. The most complete of those that survive is the earliest in date; it is also the most majestic and most representative of this Oriental motif of an enthroned personage. The body, in its solemn, rigid position, forms a block enveloped in a foldless drapery; the cloth of the mantle is indistinguishable from that of the tunic it covers, but in the undulations of the modeling emphasized by the outlined skirt of the mantle the Greek imprint is already unmistakable. In the following period and down to the closing years of the sixth century, draperies became more animated and diversified, but the attitude

138

169. DIDYMA. SACRED WAY OR AVENUE OF THE BRANCHIDAE. SEATED MAN. BRITISH MUSEUM, LONDON.

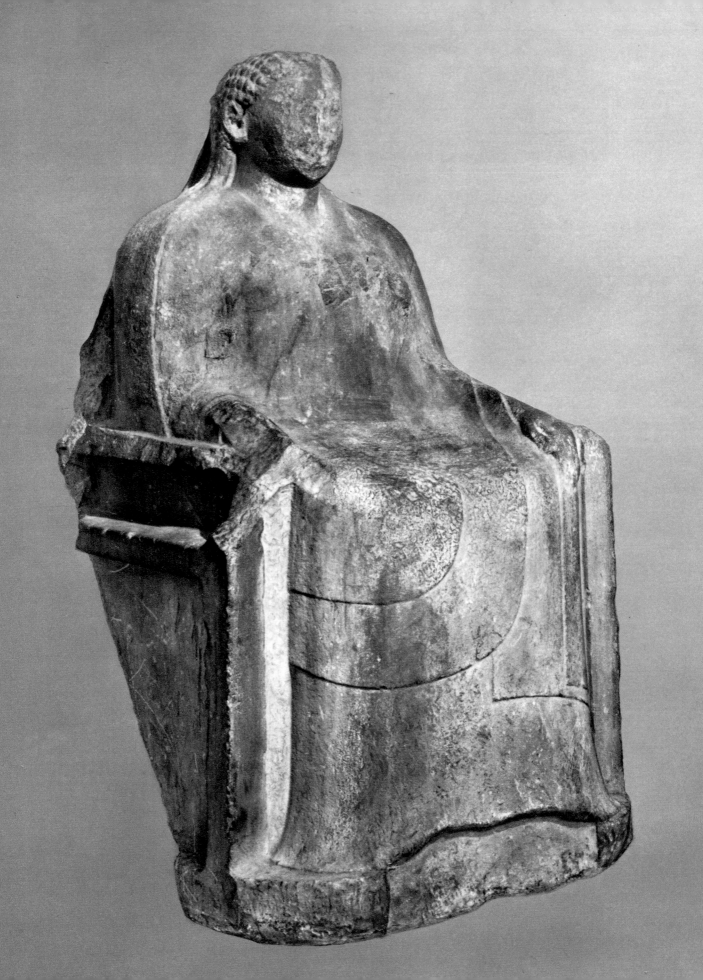

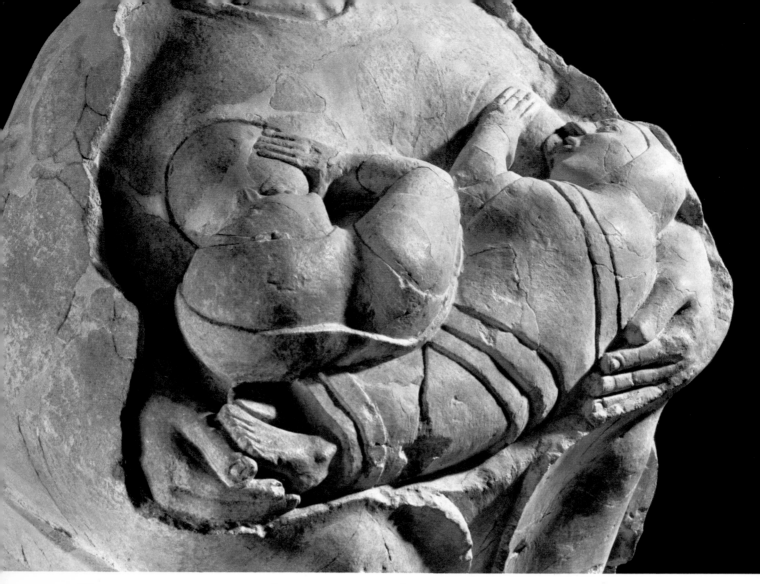

170. MEGARA HYBLAEA. KOUROTROPHOS (GODDESS SUCKLING TWINS), DETAIL. MUSEO ARCHEOLOGICO NAZIONALE, SYRACUSE.

140

172. MEDMA. ENTHRONED GODDESS. MUSEO ARCHEOLOGICO NAZIONALE, REGGIO.

of seated figures, whether male or female, with hands resting on their knees, did not change—a noticeable instance of religious conservatism in the homeland of Thales, where Greek science and philosophy took their rise. The motif of the enthroned figure also occurred in the statuary of the Dorian world as soon as the Daedalic phase had ended, notably in Crete and the Peloponnesus. And in Sicily about 560 we find an original example of it in a small limestone group depicting a goddess suckling twins (Kourotrophos) from Megara Hyblaea, in which a realistic subject is set off by the possibly symbolic stylization of the mantle, which cups the children like a shell.

171. MEGARA HYBLAEA. KOUROTROPHOS (GODDESS SUCKLING TWINS). MUSEO ARCHEOLOGICO NAZIONALE, SYRACUSE.

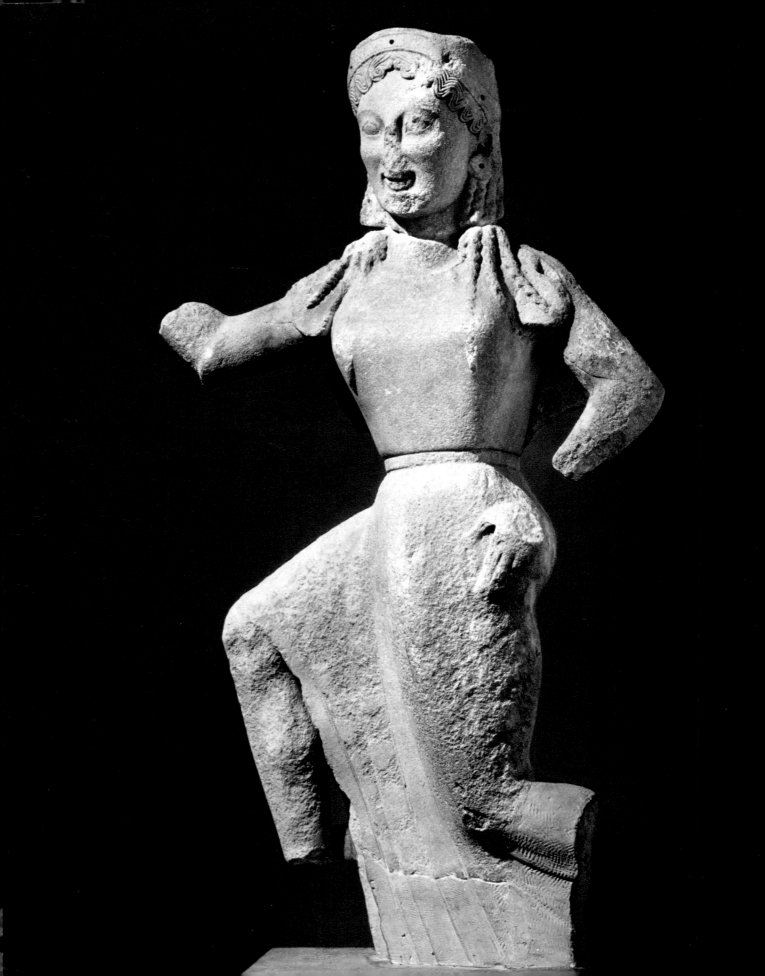

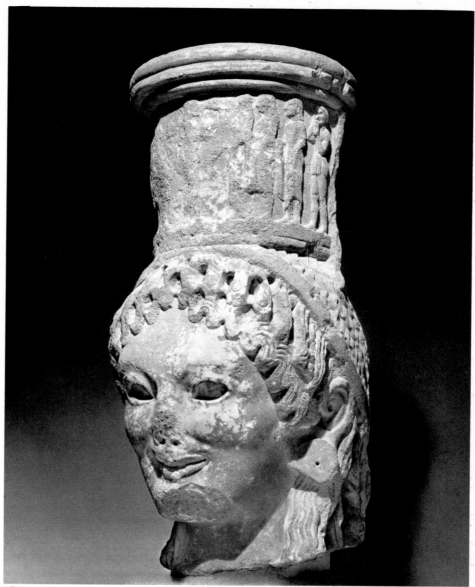

174. DELPHI. HEAD OF A CARYATID. DELPHI MUSEUM.

We have noted that the Ionian costume, marking a change in feminine fashion, appeared in Athens towards the mid-sixth century with the Lyons kore, whose Atticism has in fact been questioned. This kore had been preceded on the Acropolis by two statues apparently imported from Samos and Naxos. The great current of influence flowing from Eastern Ionia soon spread through Western Greece. It naturally affected Delos, where the flying Nike gives a hint of it; the distinctive smile is there, but the garment clinging to the bust fails to join smoothly with the curving folds draping the lower body. The attribution to Archermos of Chios, even if this figure does not actually belong to the base inscribed with his name, seems well founded. In any case, the contour of the face, the features, and the hair are similar to those of the pseudo-Cnidian caryatid at Delphi, an obviously later work.

143

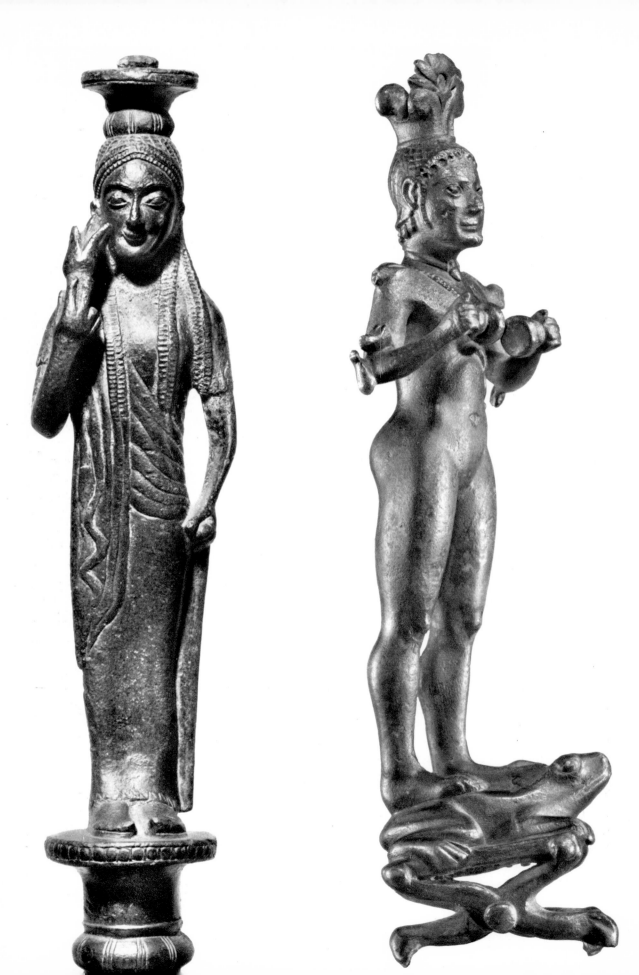

About 550, Theodoros of Samos and Bathycles of Magnesia, both of them sculptors and architects, were invited to Sparta, which had maintained relations with Asiatic Greece since the seventh century. So it comes as no surprise to find at Sparta, from about the mid-sixth century, a bronze statuette in simplified Ionian costume, with scarf and tunic. This handmaid of Aphrodite, holding a lotus flower, seems earlier than the Laconian Artemis from Mazi which, like its contemporary, the Attic kore by the Rampin Master, still wears the Dorian peplos. It would be rash to assume that this coexistence of two styles in Laconian art of 550-540 reveals the opposition of two cults, as in the *Hippolytus* of Euripides. But the lady with a lotus certainly bears the Spartan imprint of elongated skull and vigorously expressive features, and the statuettes of running girls and nude mirror-bearers (two Laconian specialities) show that the girls of Sparta combined a frank sensuality with their almost masculine devotion to outdoor games. Sparta, moreover, was able to indulge in Ionian pleasures with no detriment to the military ideal glorified in the poems of Tyrtaeus and reflected in many statuettes of helmeted and armoured figures and, in the early fifth century, the fine marble statue of the pseudo-Leonidas (fig. 338).

Spartan interest in the heroes of epic poetry is revealed by Pausanias' description of the works of art decorating their oldest temples and by the rich finds of Spartan bronzes at Olympia. The most remarkable are two facing statuettes from the lip of a large bowl: a warrior in peacetime dress, wearing the short mantle typical of Sparta, steps towards an older, bald-headed man who is more fully dressed. One thinks at once of the heroes of the *Iliad*, Menelaus and Agamemnon, or Nestor and Phoenix. What is so novel and attractive about this group is not only its unique subject or the fine workmanship, but the scrupulous realism with which the two mid-sixth century actors are so well differentiated in physical appearance, attitude, and clothing. In addition to realism we find a taste for the theatre, which was no

145

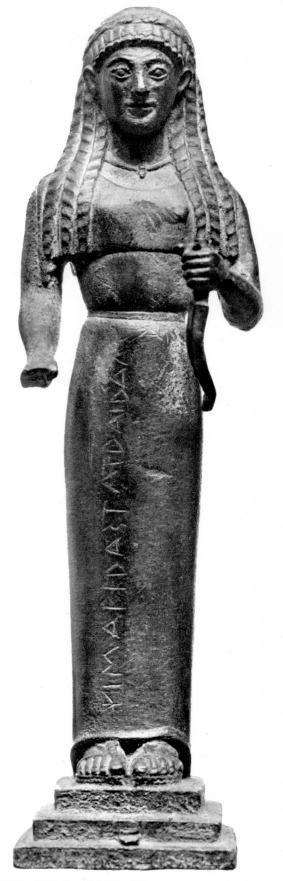

175. SPARTA. APHRODITE (?) WITH LOTUS FLOWER. STAATLICHE MUSEEN, BERLIN.
176. SPARTA. GIRL WITH CROTALA. METROPOLITAN MUSEUM OF ART, NEW YORK.

177. MAZI. ARTEMIS DAIDALEIA. MUSEUM OF FINE ARTS, BOSTON.

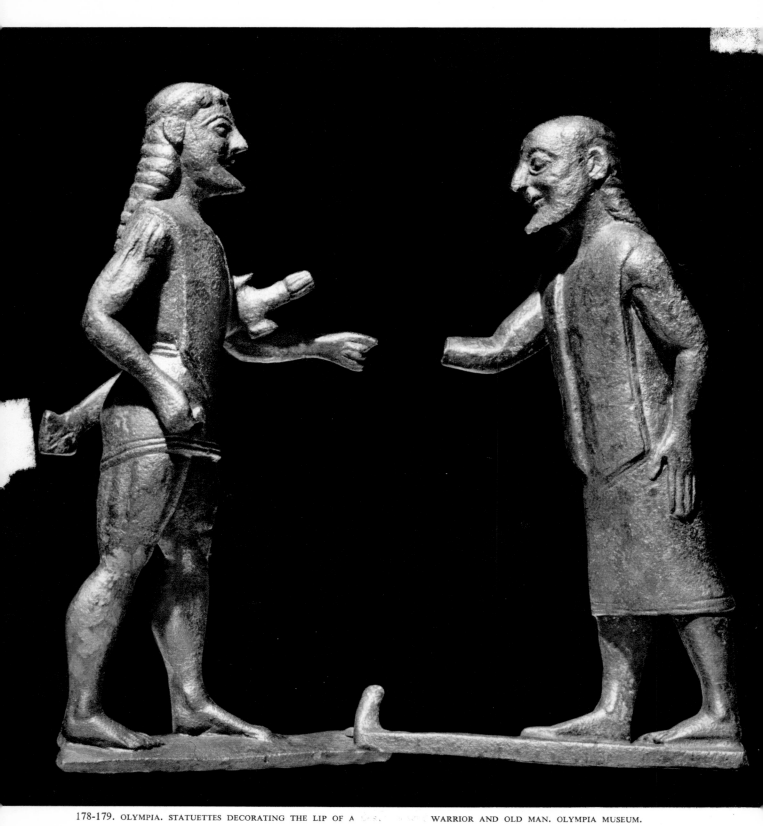

178-179. OLYMPIA. STATUETTES DECORATING THE LIP OF A WARRIOR AND OLD MAN. OLYMPIA MUSEUM.

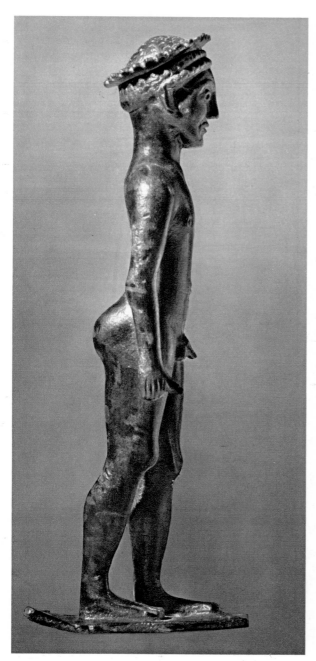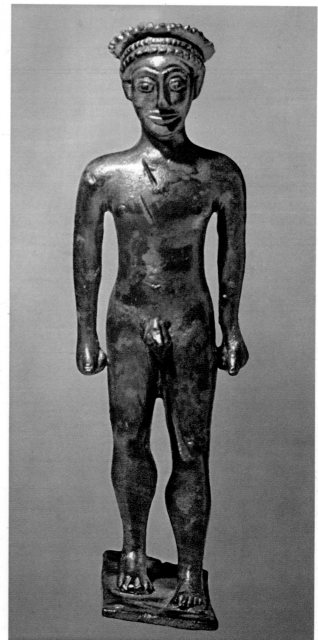

180-181. OLYMPIA. YOUNG SPARTAN WITH REED CROWN, SIDE AND FRONT VIEWS. OLYMPIA MUSEUM.

Athenian monopoly; the violently expressive terra-cotta masks found at Sparta in the temple of Artemis Orthia evoke the games held there in the goddess's honour. At Olympia another Laconian festival has left a token of the dances that commemorated the victory of Thyrea: the bronze statuette of a choir leader, wearing a crown of reeds like the Athenian youths described by Aristophanes. The rustic sturdiness of this thick-featured

Laconian athlete adds a note of naïve truthfulness to the imagery of the 540's and 530's. It makes us regret all the more keenly the disappearance in Laconia of the more representative works of large-scale bronze or marble statuary, whose existence may be inferred from the funerary relief from Chrysapha, near Sparta. This compelling work illustrates a cult of the hero and family imbued with an otherworldly mystery. Despite its rather uncouth design it shows the adaptation of Ionian models for the hair and clothing into the local style around 540.

The bronze industry that flourished in the Peloponnesus in the second half of the sixth century, chiefly at Corinth and Sparta, found in Magna Graecia some active competition, as is proved by the growing number of finds made in recent years, of which the most remarkable is the large bronze krater discovered at Vix on the upper Seine, some hundred miles from Paris. It is uncertain whether it was actually made at Tarentum or Rhegium, but the warriors on its neck are based on Laconian models, and the chariot horses beside them are clearly related to those of a horseman found at Dodona, of Peloponnesian type. Comparison of the Gorgon on the handles with that on the Corcyra pediment and with a Syracusan gorgoneion of about 500 shows the progress made over a period of a century in the humanization of this figure type.

182. TARENTUM. TERRA-COTTA BANQUETER HOLDING A CUP AND A LYRE. MUSEO NAZIONALE, TARANTO.

148

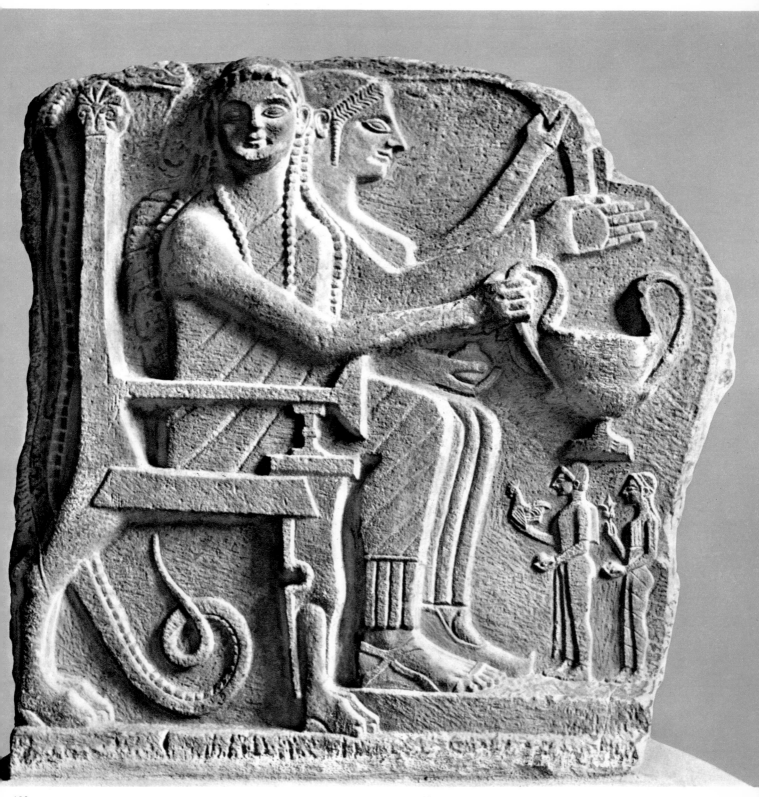

183. CHRYSAPHA. HERO RELIEF: OFFERING OF A COCK AND FLOWER TO HEROICIZED (?) DEAD COUPLE. STAATLICHE MUSEEN, BERLIN.

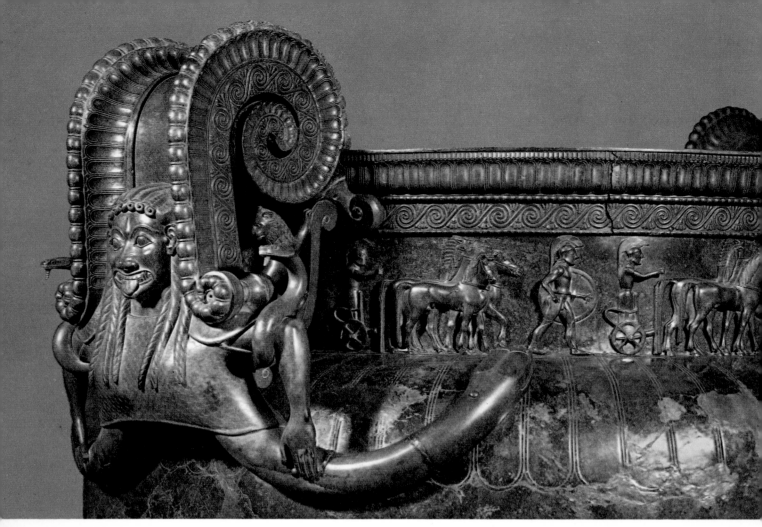

184. VIX. HANDLE AND NECK OF A BRONZE KRATER, DETAIL: GORGON, WARRIORS, AND CHARIOTS. MUSÉE ARCHÉOLOGIQUE, CHÂTILLON-SUR-SEINE.

185. SYRACUSE. TERRA-COTTA GORGONEION. SYRACUSE.

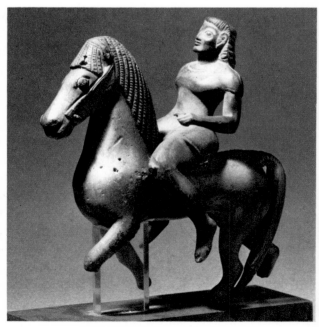

186. DODONA. BRONZE HORSEMAN (CAST). ATHENS AND PARIS.

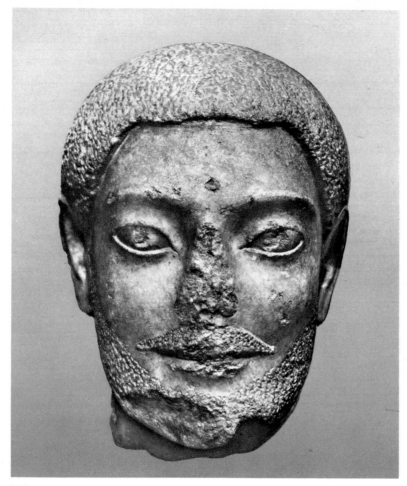

187. AEGINA OR ATHENS. SABOUROFF HEAD. STAATLICHE MUSEEN, BERLIN.

The Growing Exchange
Between Eastern Greece and Western Greece (540-525)

During the 530's, after Pisistratos returned to Athens from exile and regained power, a triple alliance was formed between the Athenian tyrant, Polycrates of Samos, and Lygdamis of Naxos, the masters of three prosperous and enterprising cities that were then the leading art centres of the Greek world, each with a long tradition behind it. The fresh stimulus given to the arts, if not by Lygdamis, who was soon banished, at least by Pisistratos and Polycrates, is well attested. The work of Pisistratos, intelligently conducted and continued by his son Hippias until 510, proved the most enduring, and in sculpture we have some precious remnants of it. One of the earliest, from about 540, is also the most singular and most enigmatic: the so-called Sabouroff Head, a marble head whose hair, moustache, and beard were carved in low relief with hammer and point and then covered with painted stucco, a rather unusual procedure. Equally unusual for a sixth-century Greek are the short hair, moustache, and beard. On the basis of these features, it has been suggested that this was a portrait, possibly of Pisistratos himself.

151

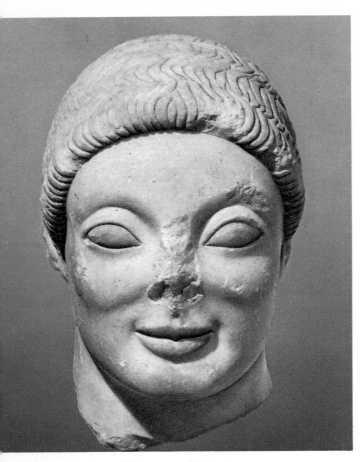

188. ATHENS (?). JACOBSEN HEAD. COPENHAGEN.

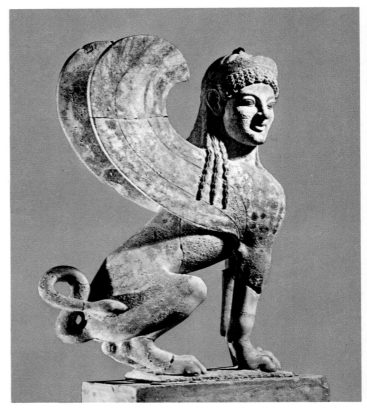

189. ATHENS. SPHINX FROM A GRAVE MONUMENT. NEW YORK.

There is in fact at least one other individual feature: the eyebrows, which instead of arching, as is the rule in contemporaneous sculpture, are almost rectilinear. Another unusual detail is the faint smile, which is more pronounced on the right side of the mouth, thus imparting a slight upward slant to the right eye and eyebrow. On the face of the Peplos Kore the same slight movement occurs, reinforcing the impression of a living presence. The obvious conclusion is that the Sabouroff Head, with its strong touch of individuality, may well be the work of the Rampin Master. True, one cannot really speak of a portrait in the present sense of the term. But the inscriptions accompanying certain grave monuments refer, in the nominative or the genitive, to the presence of the deceased in his likeness. And it was in this period that, according to tradition, the sculptors Boupalos and Athenis, sons of Archermos of Chios, made a caricature of their contemporary, the poet Hipponax. So, presumably in certain cases a particular detail sufficed to make a known person recognizable. The Sabouroff Head invites comparison with that of a short-haired athlete that was carved a few years later in a different style by another great artist, whose use of broad curves sweeping the face in a single move-

152

ment kept closer to the Attic tradition. It is a more open and sensual face, bursting with vitality, powerfully representing a type rather than revealing a secret life, as in the earlier work. The difference of design and expression between the Sabouroff Head and the Jacobsen Head conveys, at this time of continuous growth in Attic art, something of the passionate interest awakened in sculptors as they came to realize that the human face and body were capable of great diversity and variety of expression. This is a significant distinction between archaic and classical art, for the latter in the next century aimed to define and perfect the lineaments of an ideal form.

Yet, as we have noted, even early archaic art pursued harmony and gave a foretaste of the classical conception.

Further evidence of that foretaste is provided by the largest of extant Attic grave monuments. Among the stelae of this kind scattered over the Greek world, those of Attica form by far the most extensive series. The New York-Berlin stele is one of the last of the early group, whose characteristic feature is the sphinx surmounting the shaft. The more modest stelae of the later group are crowned simply by a palmette finial. It may be that by some antiluxury decree Pisistratos put a stop to the making of these elaborate and imposing gravestones. This seems plausible in view of the fact that the New York-Berlin monument was dedicated by a man whose name began with the letters 'ME' (here the inscription breaks off), presumably Megacles of the Alcmaeonid family, enemies of Pisistratos. The youth's delicate profile, his chilly elegance, and the affected grace of his gesture mark a new stage in the search for an aristocratic ideal. But the stele seems overelaborate with its shaft relief surmounted by an engraved capital and a statue in the round, the whole heightened with bright colours. Most remarkable is the highly effective bas-relief technique, which by imperceptible transitions suggests the full thickness of the youth's body without actually undercutting the volumes. We shall meet further examples of this technique, which Greek art carried to perfection, especially in the coins.

153

190. ATHENS. GRAVE MONUMENT. NEW YORK AND BERLIN.

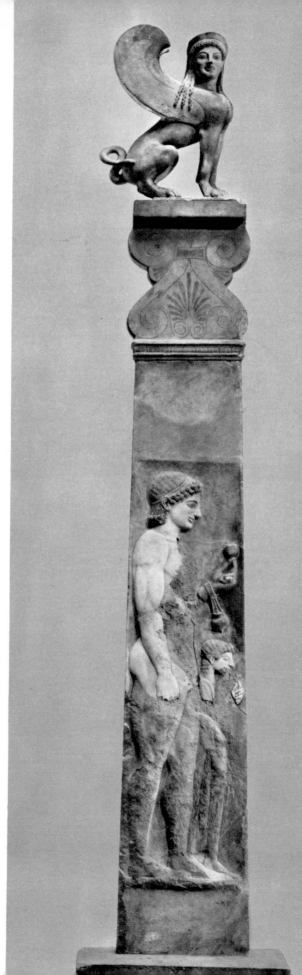

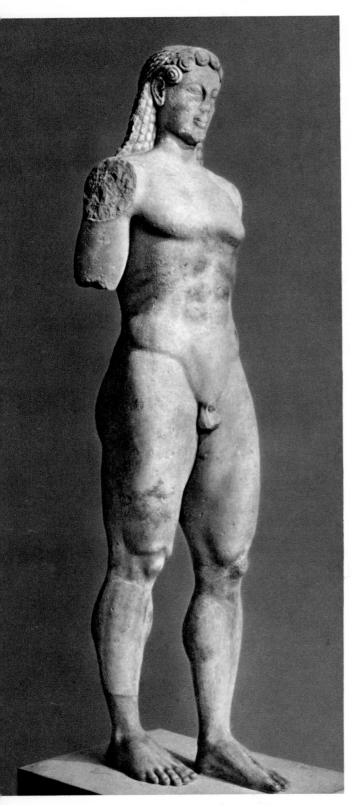

191. CEOS. KOUROS. NATIONAL MUSEUM, ATHENS.

The progress made in the study of the male body during this time can be seen in the accuracy of proportions and even more in the relief patterning of an athletic musculature. The 'Croisos' from Anavyssos in Attica, of about 525, has in my opinion been overestimated. Presented like an anatomy lesson, the figure is surprisingly motionless and heavy for the work of an Attic master.

The Ceos kouros, on the other hand, is an original example of a form in which all the muscular areas ripple with life yet without relinquishing their autonomy. The face, of the Naxian type, forms an elongated oval; like the curling locks of hair, it has the puffy air of a vegetal growth and shows no intellectual radiance. The body, poised for movement, suggests the healthy sturdiness of a peasant rather than an athlete and represents quite impressively the small quiet island where Aristaeus, god of husbandry, was worshiped, the island of honey, wine, and milk. But we must not exaggerate the provincialism of this statue, for it is the work of a master. Ceos, moreover, lies close to Attica. It was the birthplace of the great lyric poet Simonides, who, before his patronage by Pisistratos, led the choirs of young people at the festivals of Apollo in Ceos, about the time this statue was carved.

Of the fine series of statues from the Ptoion in Boeotia, the earliest are of rather primitive local workmanship. But by the middle of the century the influx of pilgrims had enriched the sanctuary of Apollo, where two offerings were dedicated, one by an Alcmaeonid, the other somewhat later by a Pisistratid. A fair number of kouroi, in island marble or even in Pentelic, bear the imprint of sculptors foreign to Boeotia—Naxians or Athenians. One statue is probably contemporary with the Ceos kouros; it has the same proportions, the same movement of the arms disengaged from the body. Its softer, smoother, freer modeling harmonizes with the careful design of the face and the smiling lips, whose affected grace contrasts with the more solidly constructed faces and more virile headdresses of other statues found in the same sanctuary. If, after consulting the oracle, visitors went on to Thebes, they could admire on the

154

192. PTOION, NEAR THEBES. KOUROS. NATIONAL MUSEUM ATHENS.

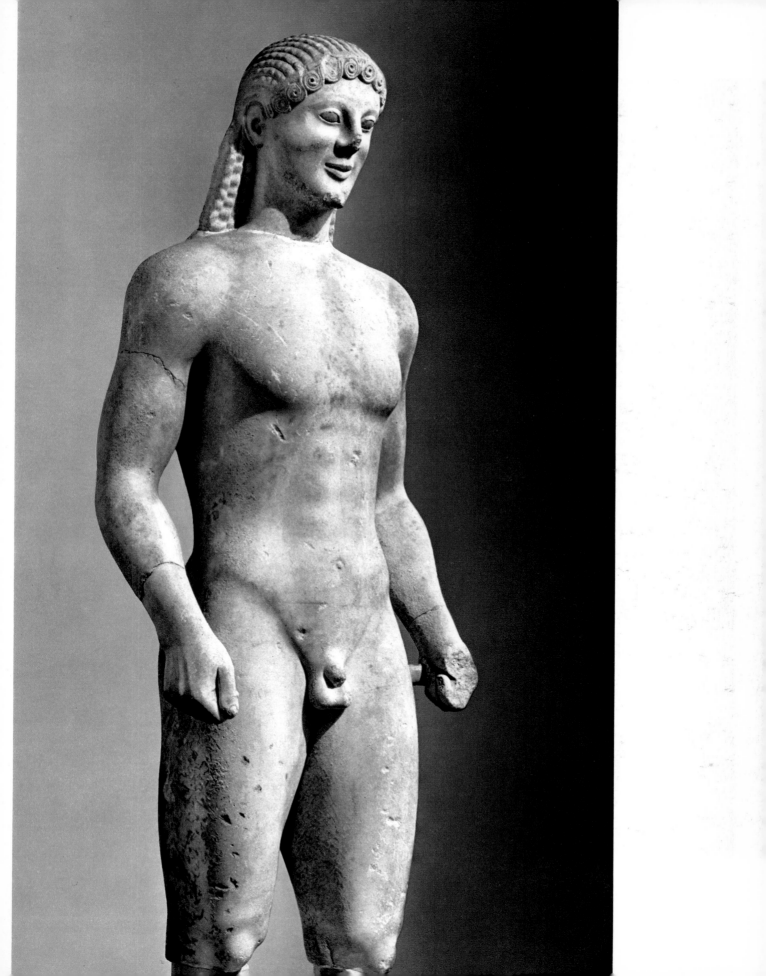

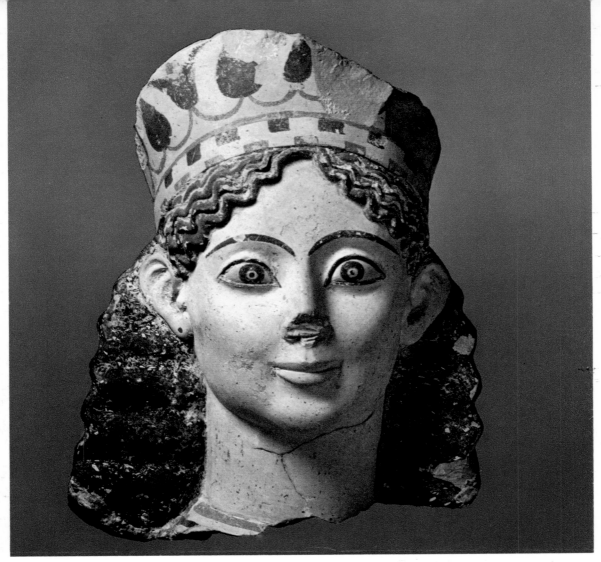

193. THEBES, TEMPLE OF APOLLO ISMENIOS (?). ACROTERIUM FRAGMENT: HEAD OF A SPHINX. LOUVRE, PARIS.

Temple of Apollo Ismenios a Corinthian terra-cotta sphinx with the head of a woman, whose beaming face is closely akin to that of the Apollonian kouros from the Ptoion. These kouroi are a few examples chosen from among the best preserved of this simple type—the young Greek male in the perfection of his nudity—ranging in date from the 550's to the 520's. One is struck by the expansive vitality that quickens them, the studied dissymmetries of body and face, the pent-up eagerness to act and assert themselves, which they exhibit in the frontal stance that tradition imposed on them. Indeed, the concept of religious and civic discipline, which sought to lift art above reality and actual experience and make it independent of history, is the very basis of the classical doctrine. Although frontalism was abandoned in the fifth century, the concept continued to hold sway while artists assimilated the naturalistic advances of the sixth century.

But archaic art continued to express its creative power and receptivity to life in many works besides kouroi; its output includes a variety of figures characterized by their gesture, their clothing, their action. In marble statuary the Rampin Master gave currency to the

156

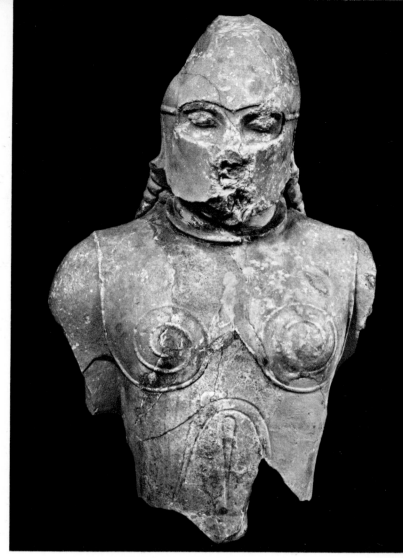

194. SICYON (?). HERMES CRIOPHOROS. ATHENS. 195. SAMOS. WARRIOR TORSO. STAATLICHE MUSEEN, BERLIN.

horseman, which had its successors on the Acropolis in the last quarter of the sixth century. A great many statuettes were modeled on other standard types, and presumably some are imitations of lost bronzes. This may well be the case with one of the best of the Ram-Bearers and one of the earliest of a numerous, well-characterized, and localized series. Made in the northern Peloponnesus, probably at Sicyon, it represents Hermes himself, patron of the Arcadian shepherds, whose distinctive costume he wears. Other examples from Sparta reflect city manners and customs.

On Samos the taste for tangible reality, for a diversity of types, attitudes, and appearances found expression even before the middle of the century in the group by Geneleos, a family votive offering that we have seen proudly transposed into large-scale statuary. Polycrates came to power there about 533 and, as a luxury-loving demagogue, he surrounded himself with artists and poets. Marble statues, including an armoured warrior reflecting the tyrant's military ambitions, were dedicated to Hera in her reconstructed sanctuary.

157

196. SAMOS. OFFERING-BEARER. STAATLICHE MUSEEN, BERLIN.

Several statuettes of particularly fine workmanship from this native island of the first Greek bronze founders give some idea of the large bronzes, long since melted down. Most remarkable is an offering-bearer, possibly one of Polycrates' favourites (another of whom was his cithara player Bathyllos). Though it belongs in the line of Ionian kouroi, it is in some ways very distinctive and even unique. The inordinate volume of the head, with its mass of hair and thick facial features, seems at first sight ill-adjusted to the lithe body, which has none of the usual athletic musculature. And yet a strange charm emanates from this bronze. Is it Asiatic indolence, sullen assent to the ritual gesture, or the ambiguity of adolescence? In the formal design the artist has contrived to blend an eye-pleasing realism with the ceremonial ideogram of the Samian tradition.

The decorative sculpture of Ionic architecture most clearly distinguishes the Ionian aesthetic from its rival. The metope reliefs and pediment sculptures fit logically into the structure of a Doric building, whereas the continuous frieze of Ionic temples and treasuries, as well as the figures in high relief on certain column bases, like those of the Artemision of Ephesus or the Didymeion of Miletus, theoretically contradict the statics of the architecture. In fact, the column-base relief and the continuous frieze were taken over from Oriental art and had to be adapted to the specific conception and proportions of a Hellenic type of building. In a relief from Cyzicus the posture of the charioteer and the design of the horses stem from an Assyrian prototype, evidently hellenized at Miletus, whence it passed to this Milesian colony. The only large Doric temple built on the Asia Minor coast, at Assos in Aeolis, about 540, became oddly naturalized Ionian with the addition of a frieze carved in low relief on the architrave. One scene on it represents Heracles wrestling with Triton in a manner similar to the one we have seen on one of the Acropolis pediments in Athens. Another, a banquet scene, also belongs to the legend of the Dorian hero, as do several metopes.

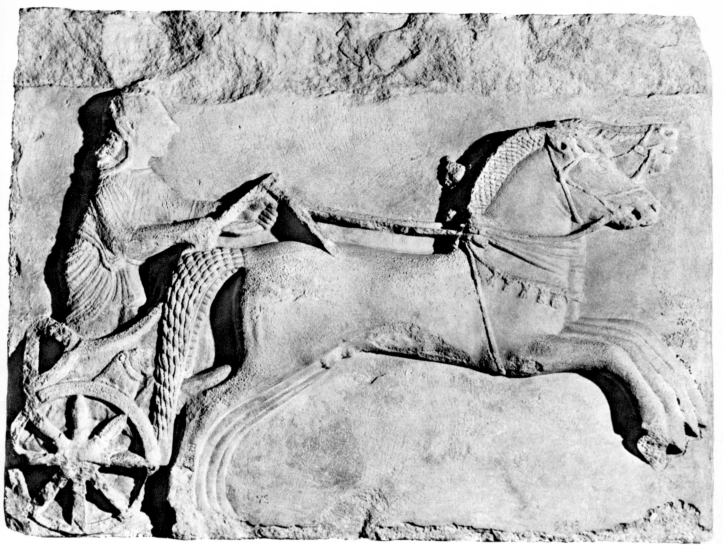

197. CYZICUS. RELIEF: CHARIOT. ARCHAEOLOGICAL MUSEUM, ISTANBUL.

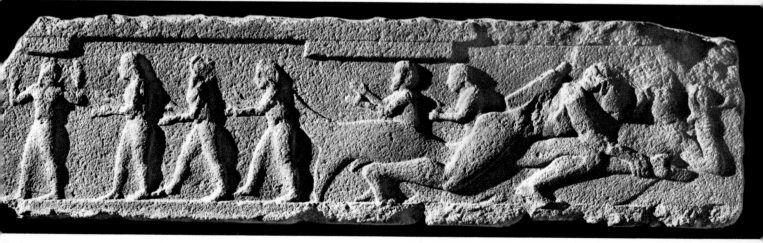

198. ASSOS, TEMPLE. ARCHITRAVE FRIEZE, DETAIL: HERACLES WRESTLING WITH TRITON IN THE PRESENCE OF THE NEREIDS. LOUVRE, PARIS.

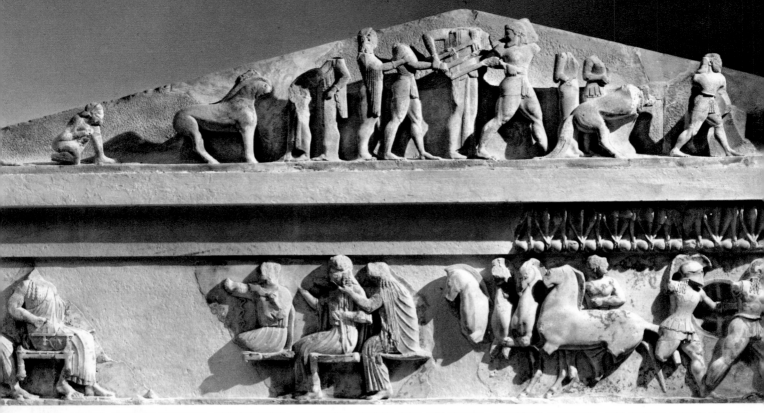

199. DELPHI, SIPHNIAN TREASURY. EAST PEDIMENT AND FRIEZE: DISPUTE OVER THE TRIPOD—DIVINITIES, QUADRIGA, AND HEROES. DELPHI MUSEUM.

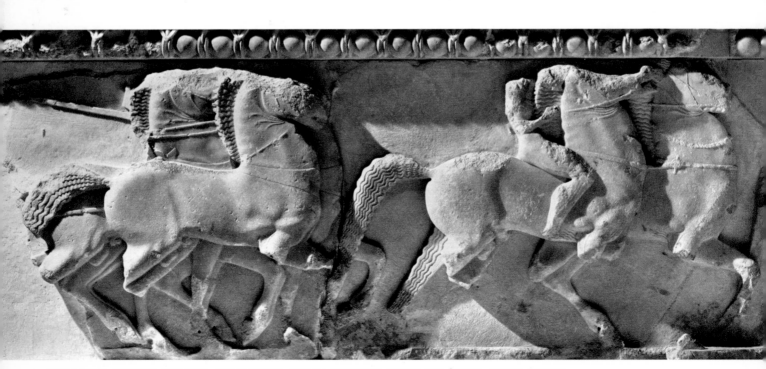

200. DELPHI, SIPHNIAN TREASURY. SOUTH FRIEZE, DETAIL: HARNESSED HORSES AND RIDERS. DELPHI MUSEUM.

These two examples suggest an extremely widespread repertory of highly varied images illustrating the legends sung by the poets, whose works were read or recited in all the Greek communities of East and West.

The exploits of Heracles loom large in this imagery. Two episodes figure in the most typically Ionian series of architectural sculptures that we have, those of the Siphnian Treasury at Delphi, which can be almost exactly dated (530-525). We are fortunate in thus being able to assign a definite date to the female type represented by the caryatid with her characteristic drapery (mantlet falling obliquely over a fine-pleated tunic). Several variants of this type occur among the Ionian and Attic korai of the Acropolis. Several sculptors worked on the Siphnian Treasury. Siphnos itself had no artistic tradition; the islanders, newly enriched by their gold mines, undoubtedly secured the services of famous artists. In any case, two masters with their associates shared the execution of the friezes. The head sculptor, undoubtedly the elder of the two, probably acted also as master of the works; he executed the west frieze above the façade and the south frieze. Presumably he was both architect and sculptor, as was often the case at that time, and in planning the decoration he achieved a new harmony by integrating the myths with the architectural setting. Thus he chose as the subject of the west frieze the Judgment of Paris and renewed its presentation by depicting each of the three goddesses with her chariot. On page 167 we see Athena impetuously getting into hers and Aphrodite complacently alighting and slipping on a necklace. In spite of the deterioration and partial destruction of this frieze, its three-part rhythm clearly corresponded to that of the pronaos in accordance with the spirit of Doric architecture. The fragments of the abduction scene from the top of the south wall render the tempo of a cavalcade, the pace slackening in the centre and speeding up at the far side; the variations are carried to the point of mythical hyperbole in the sweeping, quivering curves delineated by a passionate admirer of good

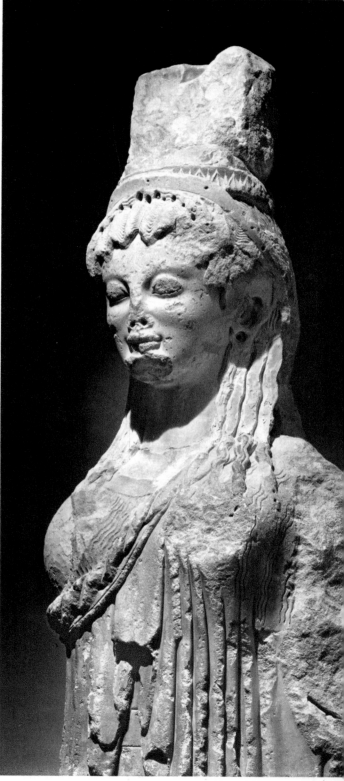

201. DELPHI, SIPHNIAN TREASURY. CARYATID, DETAIL. DELPHI.

161

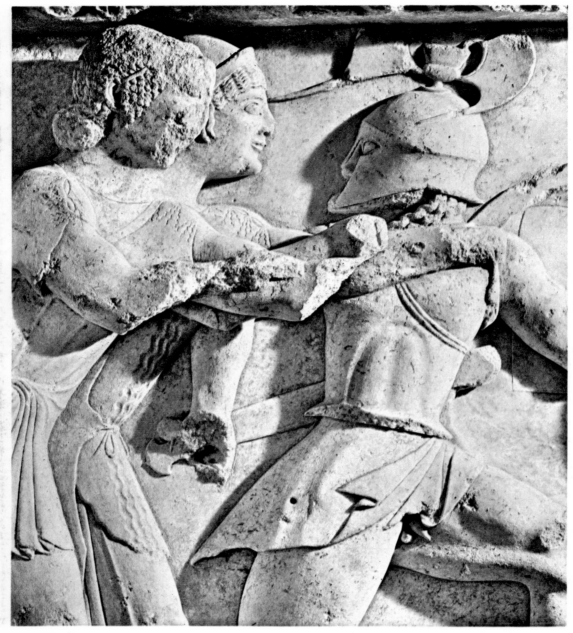

202. DELPHI, SIPHNIAN TREASURY. NORTH FRIEZE: GIGANTOMACHY, DETAIL. DELPHI MUSEUM.

horses. On this geometric patterning, quickened by a strong lyrical inspiration, all the resources of archaic stylization have been brought to bear. The other two friezes are much better preserved. The one on the east side represents scenes from the *Iliad*, the one on the north a gigantomachy—both subjects well suited to a younger artist, less powerful, less original than his elder, but capable of gracefully or vigorously renewing imagery borrowed from vase paintings or from the metal reliefs that by now were sold throughout

162

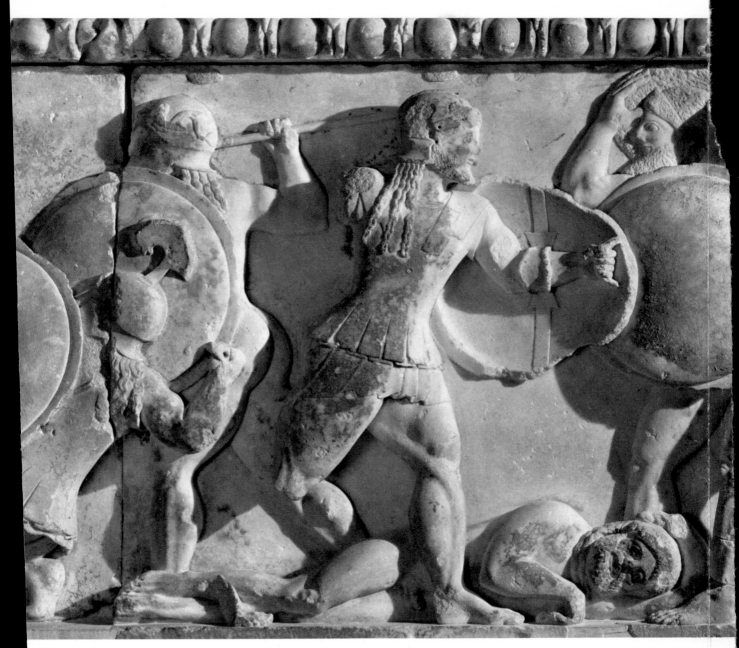

204. DELPHI, SIPHNIAN TREASURY. NORTH FRIEZE: GIGANTOMACHY, DETAIL. ARES AND HERMES FIGHTING AGAINST GIANTS. DELPHI MUSEUM.

The two sculptors who carved the frieze can be distinguished from each other by temperament and technique. The master sculptor kept to the monumental tradition of early archaism (like the later Athenian sculptor Antenor, who resembles him in the controlled power of his work); hardly rounding off the angles, he carved his figures in broad surfaces broken only by modeled or incised details that were conceived as both ornaments and signs rendering the movement and solemnity of the sacred drama. On

165

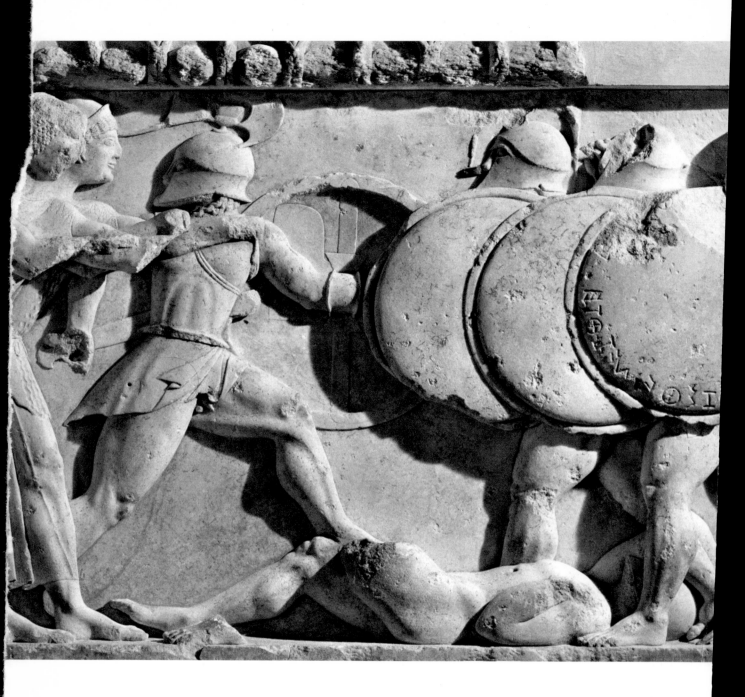

ting, thus obtaining a rich play of light and shadow over the fully modeled figures.

What were the intentions behind the choice of subjects? One at least can be inferred. Represented on the east pediment is the dispute between Heracles and Apollo over the Delphic tripod, settled by Zeus in favour of Apollo. This was the first scene glimpsed by visitors as they came up to the Treasury, and this homage to the Delphian Apollo may have had a Siphnian Aphrodite as its pendant on the west façade.

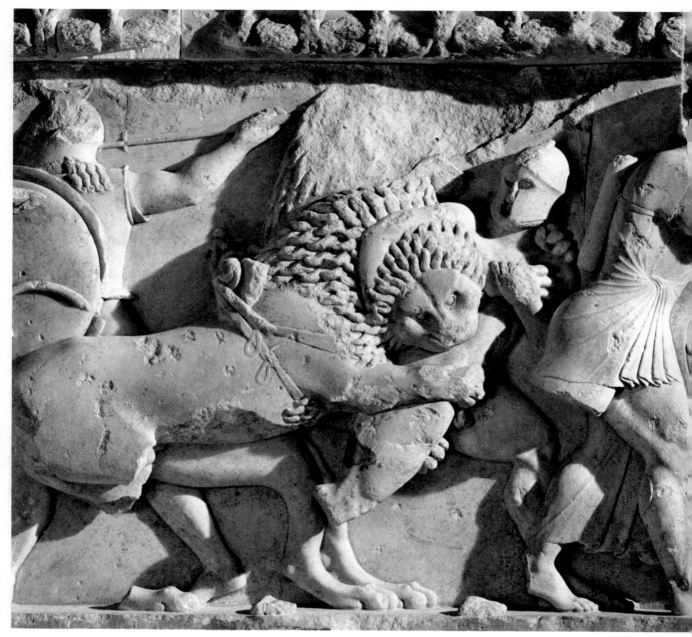

203. DELPHI, SIPHNIAN TREASURY. NORTH FRIEZE: GIGANTOMACHY, DETAIL. DELPHI MUSEUM.

the Greek world. The four-part composition of his *Iliad* scenes keeps to a rather over-simple symmetry, but he avoids the danger of monotony by the finesse of the details and, especially in the assembly of the gods, by the ingenuous grace and variety of attitudes, gestures, and draperies. Here he conjures up the familiar vivacity of the epic poem. In the north frieze his virtuosity is strongly felt. He effectively renders the dense welter of battling gods and giants by his technique of relief sculpture with extensive undercut-

163

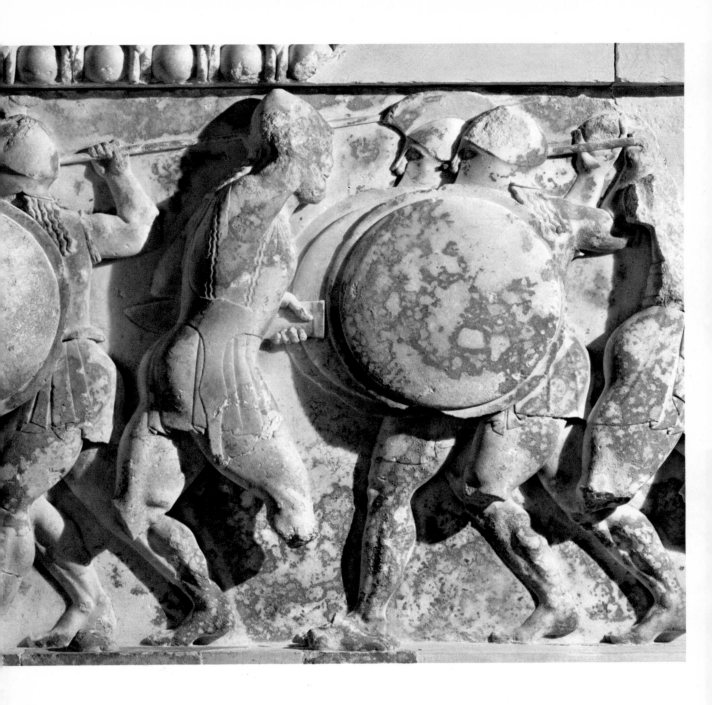

the north and east the figures of the younger sculptor are more down to earth—they talk, gesticulate, fight, run, fall, and thus set a very different rhythm. This artist owes much more to his models than his great rival does, but he neverthess incorporated them with unfailing skill and a new wealth of detail into the graded thickness of the relief. From the two opposing styles can one infer that the two masters had different backgrounds? Actually the short stocky type of male figure that is common to both—though

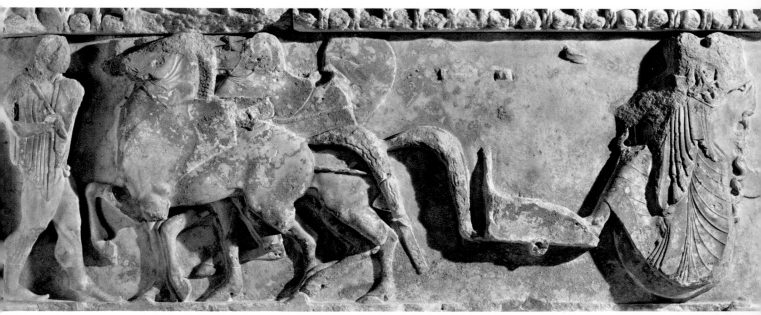

205. DELPHI, SIPHNIAN TREASURY. WEST FRIEZE: JUDGMENT OF PARIS, DETAIL. HERMES AND QUADRIGA OF ATHENA. DELPHI MUSEUM.

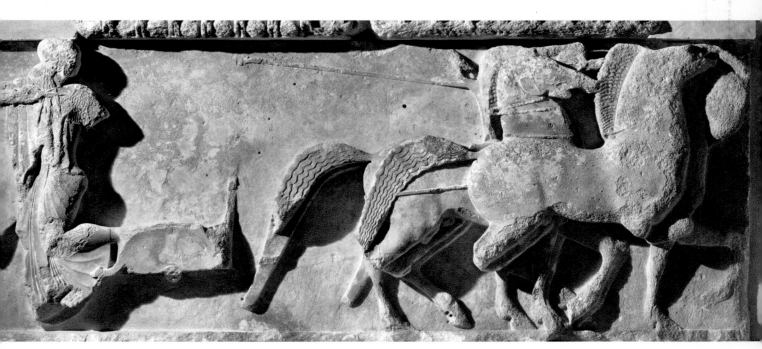

206. DELPHI, SIPHNIAN TREASURY. WEST FRIEZE: JUDGMENT OF PARIS, DETAIL. APHRODITE ALIGHTING FROM HER CHARIOT. DELPHI MUSEUM.

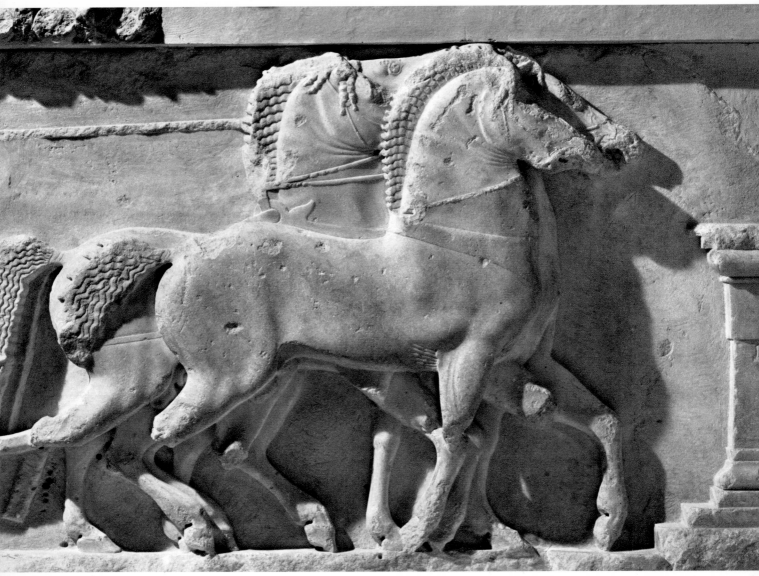

207. DELPHI, SIPHNIAN TREASURY. SOUTH FRIEZE, DETAIL: QUADRIGA. DELPHI MUSEUM.

they treat it quite differently—belongs to East Greece. The horses of the master sculptor resemble those painted on sarcophagi from Clazomenae, which were also imitated by Attic vase painters. In exchange, these vase painters provided the master of the north and east friezes, who was doubtless a Parian but responsive to Attic influence, with a whole repertory of motifs deriving from large-scale painting. Quite apart from their artistic quality, the carvings of the Siphnian Treasury are of special interest because they show, on the one hand, the unconstrained freedom with which two artists could collaborate on the same work and, on the other, the rapid evolution of the relief technique and the variety of exchanges between art centres.

Architecture

Having mastered their materials and taken the decisive steps in the direction of monumental architecture during the half-century extending from 625 to 575 B.C., Greek builders entered a phase of vigorous creation.

Asia Minor and the Islands

This architecture is particularly well illustrated in Ionia and the islands, where the rich coastal cities were enjoying a prosperous period of political and economic growth. Open to foreign influence through their extensive trade relations, stimulated by contacts with the Oriental civilizations and such princely dynasties as those of Lydia and Phrygia, and living in the midst of an intense intellectual life stimulated by poets and philosophers, they devoted much of their talents to works of embellishment and the building of temples. Each city tried to outdo the other with an almost Oriental ostentation. At about the same time, around 570-560, work began on two large temples of the first rank, the Heraion of Samos and the Artemision of Ephesus, which resemble each other closely. The design probably originated with the two Samian architects Rhoikos and Theodoros, for according to tradition Theodoros was summoned to Ephesus to give the benefit of his engineering and architectural experience to the builders of the Artemision, the Cretan Chersiphron and his son Metagenes. These architects were interesting personalities, and we are fortunate in knowing something about them from later chroniclers like Vitruvius and Pliny. Theodoros was an architect, sculptor, engineer, and eager traveler (both Samians had visited Egypt, where Naucratis had much of interest to show them), who, Pliny tells us, 'designed the labyrinth of Samos and made a statue of himself in bronze; he was famous not only for the astonishing likeness of this statue, but also for the great refinement of his art.' He specialized in building solid foundations in marshy ground and owed his high reputation chiefly to his achievement in erecting the Temple of Hera—known from its forest of columns as the 'labyrinth of Samos.' Here at one stroke Greek architecture attained a monumental scale, comparable to that of the great Egyptian

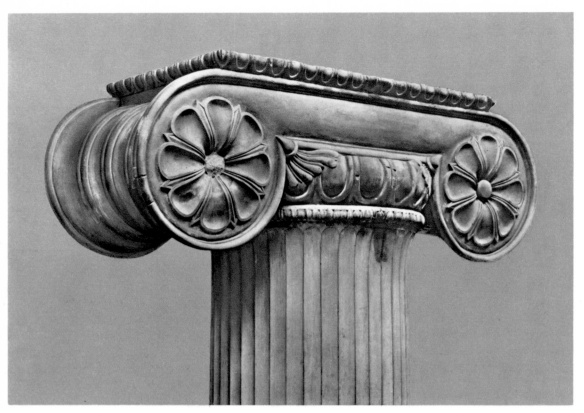

208. EPHESUS, ARTEMISION. CAPITAL. BRITISH MUSEUM, LONDON.

ensembles (see p. 362, fig. 411). The peripteral scheme became dipteral: the 104 columns of the peristyle stood in a double row on a platform measuring 344 by 172 feet and raised only slightly above ground level (the stepped platform was little used in Aegean and Ionian architecture). Entered through a deep pronaos (which remained the rule in the temples of Ionia), the cella was divided by two rows of columns into three aisles of about equal width. This interior division was repeated outside on the façade, where the three central spans corresponding to the interior colonnades were much wider (26 $^1/_2$ feet) than the spacing of the side colonnades (17 feet). This connection between the spans of the peristyle and the interior plan gave rise to a pattern of eight columns in front of the temple, whereas at the back there were ten columns evenly spaced. Through the monumental mass of the Samian Heraion ran an internal rhythm that unified and animated the overall design.

The Artemision of Ephesus was more richly and elaborately decorated than the Heraion of Samos. It, too, was a dipteral temple, with a peristyle comprising a double row of columns and a different pattern at each end: eight columns in front (with a spacing from axis to axis of 28 $^1/_2$ feet in the centre and 20 feet at the sides), and nine columns at the back, according to the most convincing reconstructions. It was slightly larger in size (377 $^1/_2$ by 180 $^1/_2$ feet on the stylobate) and had a larger number of columns, though the cella was no doubt open to the sky, for the Artemision, like the later temple

170

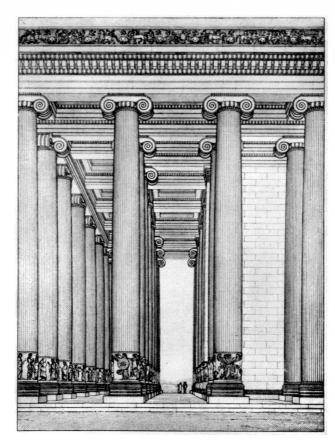

209. EPHESUS, ARTEMISION. RESTORATION OF THE COLONNADES.

at Didyma, combined cult requirements with a unified architectural design. Chersiphron made a point of integrating into the temple the altars successively erected on the site since the ninth century. At Samos they remained outside; here at Ephesus they formed the nucleus of the temple. Thus the sacred area, as at Didyma, was enclosed within a monumental structure. At Ephesus the Ionic order reached its full splendour and elegance: the deeply fluted column shafts rose to a height of 62 feet (twelve times the average lower diameter of slightly over 5 feet); they rested on elaborately carved bases with double scotia and torus; in addition, the lowest drum of every column at the front was carved with figures in high relief, some remnants of which are in the British Museum. There, too, is preserved the magnificent capital with wide-spreading, firmly designed volutes, replaced on some examples by eight-petaled rosettes occupying all the available surface. Unusually elongated and still a little rigid in the central portion (which represents the wooden block from which it originally derived), the capital is enlivened by the decorative patterning at each end. The fusion between these two elements, one architectonic, the other decorative, is not yet perfectly harmonized. So splendid a temple, built entirely of marble even to the high, carved gutter crowning the entablature, deserved to be associated with the name of Croesus, king of Lydia, who after extending his rule to Ephesus in 560 had made a point of offering to Artemis some of the sumptuous columns from the façade of her temple.

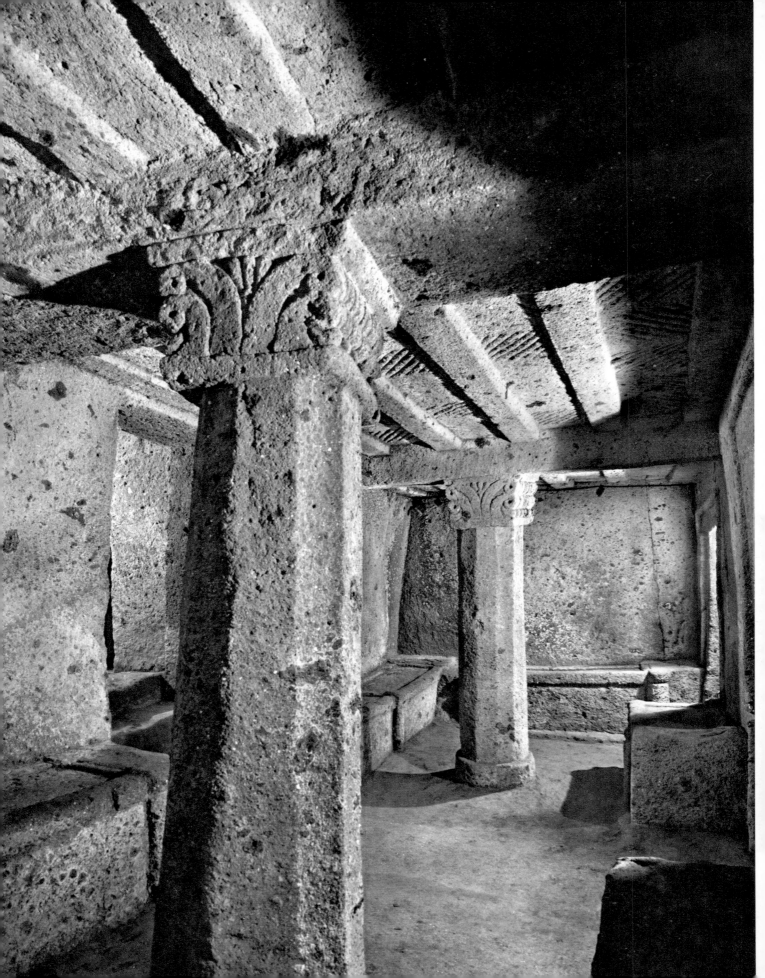

In Sardis, Croesus' capital, a temple in the same style was erected to the local goddess Cybele, and the Milesians also built a comparable temple in the sanctuary of Apollo at Didyma. Apart from a few sparse remains, we know only the fourth- and third-century versions of these two temples.

Buildings like these, in which the decorative values dear to the Ionians were skillfully integrated in mighty architectural structures, were beyond the means of any but the large wealthy cities just mentioned. These temples, moreover, by no means exhausted the creative powers of the Ionian architects.

The Aeolic Order

An interesting variant of the volute capital appears in a series of buildings that began with the Temple of Neandria, erected about 580-570, and included the buildings of Larisa on the Hermos in the middle of the century and the two slightly later temples at Klopedhi on the island of Mytilene. Though in the classical Ionic order this Aeolic capital was superseded by the Ephesian type, it lingered on in minor monuments to the end of the Hellenistic period, not only in East Greece but at Alexandria and in South Italy. It was also used by the Etruscans in the pilaster capitals and interior pillars of their monumental tombs, where its floral design was well suited to the decorative setting of the tomb chambers.

The Aeolic capital consists of two large volutes springing upwards and curling outwards. The central space between them is decorated with a fanlike palmette. Its lower stems seem to shoot from a ring of leaves at Neandria and from a coiling spiral at Larisa,

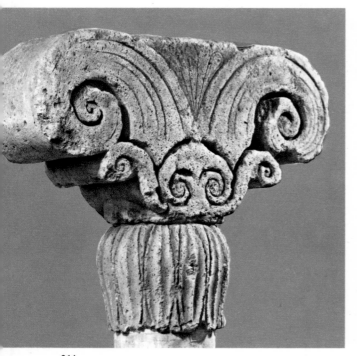

211. LARISA ON THE HERMOS. AEOLIC CAPITAL. ISTANBUL.

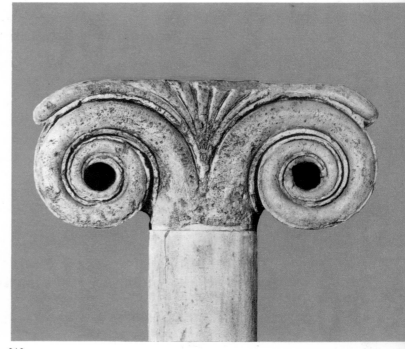

212. NEANDRIA. AEOLIC CAPITAL. ARCHAEOLOGICAL MUSEUM, ISTANBUL.

210. CAERE (CERVETERI). TOMB WITH AEOLIC CAPITALS.

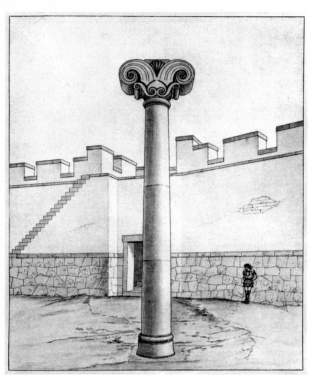

213. LARISA ON THE HERMOS. AEOLIC COLUMN. RESTORATION. 214. CAPE MONODENDRI. ALTAR OF POSEIDON. RESTORATION.

whereas at Mytilene they are tightly bound by a thick fillet. Though similar in spirit to Egyptian capitals with floral patterns, this design seems to have originated in Syria and Phoenicia. The earliest examples, treated as applied ornaments on pilaster capitals, have been found at Megiddo; they next appear in Cyprus and on tomb façades in Phrygia and Paphlagonia. They have been variously designated, but since their architectural use is chiefly confined to Aeolis they are best called Aeolic. This is definitely an independent type of capital and cannot be considered an early stage in the formation of the Ionic capital with horizontal volutes. Each corresponded to a different kind of wooden supporting shaft. Necessarily slender because of the shape of its decorative motifs, the Aeolic capital did not lend itself to the enlargement called for by later architectrual development. It was therefore superseded by the forms of the Ephesian capital, but it gave rise to some very elegant creations.

A type of leaf capital was designed in imitation of those that occur frequently in Assyrian reliefs, where they support light canopies, and even more commonly in fine furniture, where they decorate the legs of chairs and beds. The leaf capital was experimented with in some votive columns and in small-sized buildings—the Temple of Athena at Phocaea, a sanctuary in Old Smyrna, and on Delos and Thasos—where it consists of a thick crown of overhanging leaves. These became contracted over a time, and the crown became the echinus of the classical capital, carved with the egg-and-dart ornament. This leaf capital can be seen on the Naxian votive columns at Delphi and at Delos, where the abacus was hollowed out to receive the base of a seated sphinx.

Thus, a repertory of decorative forms was developed, of which volutes, palmettes, and the egg-and-dart moulding became the distinctive features of the Ionic style and prevailed in constructions of various types, in particular the large sacrificial altars on a high podium. One of the best known examples is the altar of Poseidon on Cape Mono-dendri near Miletus. From this simple plan were developed the great colonnaded altars of the Ionian cities of the Hellenistic period.

As so constituted, the Ionic order spread beyond the coastal towns where it had originated. Its forms were adopted in the islands of the northern and central Aegean and in the Ionian colonies. At some points it penetrated into the Dorian domain in the wake of the colonizing movements. Thus, Ionic temples were built at Naucratis in Egypt and at Locri in South Italy.

Conversely, an example of the Doric order appears at Assos in the Troad, where a temple of Athena was raised on the acropolis. The material was a dark, hard basalt, difficult to carve. The influence of the movement and linear rhythm of the Ionic order led to the introduction here of a peculiar feature paralleled only in later buildings: the continuous relief frieze on the architrave, with mythical figures taken from the repertory of the Ionian decorators and no doubt from the terra-cotta sheathing plaques that at this time decorated the wooden epistyles at Sardis, Gordion, and Pazarli.

The Doric Order in Greece and the West

The architecture of mainland Greece and the Greek colonies of Sicily and Italy, though perhaps less spectacular, reveals an equally varied pattern of experiment in the progressive elaboration of the rules and structures of the Doric style. Whereas decoration and polychromy were limited to the upper parts of the temple (frieze, corona, pediment), the plans and forms show considerable variety in the working out of details.

Not much is known about the Temple of Apollo at Delphi, which was destroyed in 548. The main lines on which Doric architecture developed in the middle years of the sixth century are revealed in the Temple of Apollo at Corinth. Built about 540, it replaced a seventh-century temple, of which only some roofing elements have been preserved (as also in the case of the early Temple of Poseidon in the Isthmian sanctuary). The heavy columns still stand, sharply silhouetted against the dark, bleak slopes of Acrocorinthus. Their massiveness speaks eloquently (as do those of the Temple of Apollo at Syracuse) of the architect's concern to make them solid enough to support a structure built entirely of stone. Each shaft is a monolith 20 feet high, crowned by a massive capital whose echinus is now better designed, its upward curve being well adapted to its function as a transitional member between the verticality of the shaft and the horizontality of the abacus; the overall height is just a little over four times the lower diameter of the column. These columns stand solidly on a stone platform with four steps, which is higher and more extensive than the overly thin archaic krepis. Lines and volumes have fullness that avoids heaviness and combines them in harmonious relationships. Here at Corinth, for the first time, the steps of the krepis are given a slight curvature to counteract the monotony of a purely horizontal design. The rhythm of the colonnade (6 by 15 columns) is

attuned to the rhythm of the Doric frieze itself, which never ceased to set problems for Greek architects because of the contradictory demands of its two imperative rules: the triglyph above each column had to be centred on the axis of the column shaft, yet at the corners the frieze necessarily ended with a triglyph whose centre was displaced out wards from the centre of its column. To avoid an unsightly extension of the last metope (as in the Temple of Athena at Paestum), or a widening of the angle triglyph (Temple C at Selinus), architects preferred to reduce the spacing between the two outermost columns. Often, indeed, this reduction was spread over the distance between the last three columns. At Corinth the architect has already adopted this solution and reduced the width of the two outermost metopes. Here the reproportioning is more subtle, and differences are less perceptible. The plan reveals the same preoccupations (see p. 371, fig. 431). Framed by the pronaos and the opisthodomos, with two columns between the antae, the cella is divided into two rooms separated by an interior wall; each room opens onto its porch. The larger room is divided into three aisles by two rows of four columns; the rear room is square in plan with four columns—the same scheme later used by Ictinos in the Parthenon.

Of the buildings that preceded the great temples of Athena on the Acropolis of Athens, we know little apart from the decorations, notably the pediments carved in tufa, which belong to the history of sculpture. The same is true of the Laphrion at Calydon, where the sixth-century temples—one dedicated to Apollo, the others to Artemis—have revealed only the terra-cotta decorations of their entablature. The first, Temple A, built about 570-560, was crowned by an elaborate painted sima. Beneath it ran a frieze, whose square metopes consisted of large painted panels notable for an impressive gorgoneion. The uppermost acroterium took the form of a Gorgon, and at the corners of the roof stood sphinxes, one of which is an outstanding masterpiece of terra-cotta sculpture in the first half of the sixth century. The Calydonian antefixes with female heads, from the edge of a roof, are thought to come from the earliest temple of Artemis (Temple B1), which is roughly contemporary with Temple A.

In the fourth century these early temples at Calydon were replaced by a large temple of peripteral plan standing conspicuously on a high terrace, whose disposition and wall were at first strictly conditioned by the temple.

For this period the finest extant examples of temple architecture in the Doric style are to be found in Sicily and Magna Graecia. Because of the wealth of their territories and the volume of their trade with Italy and other parts of the Greek world, the colonial cities flourished and were soon able to vie with the mother cities in the number and size of their constructions. Here, of course, it was a question of prestige; hence, the monumentality of these temples and the massing of them in groups within the sacred areas majestically sited in the rolling Sicilian landscape. Such are the acropolis and the Marinella hill at Selinus and the sacred ridge at Agrigentum, as well as the more or less artificial mounds at Paestum.

The temples prominently sited in the urban landscape are brilliant manifestations of the prosperity and independence of these cities. They undoubtedly testify to local piety, although there is no textual evidence of any particular religious fervour, and no sanctuary in Sicily ever acquired Panhellenic renown. But to an even greater extent these temples

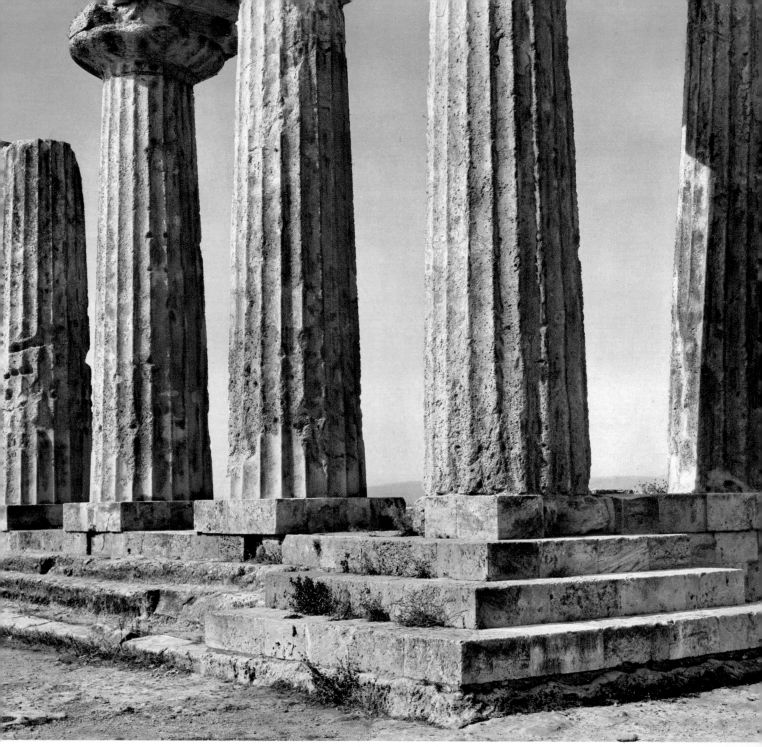

215. CORINTH, TEMPLE OF APOLLO. NORTHEAST CORNER. STEPPED PLATFORM AND COLUMNS.

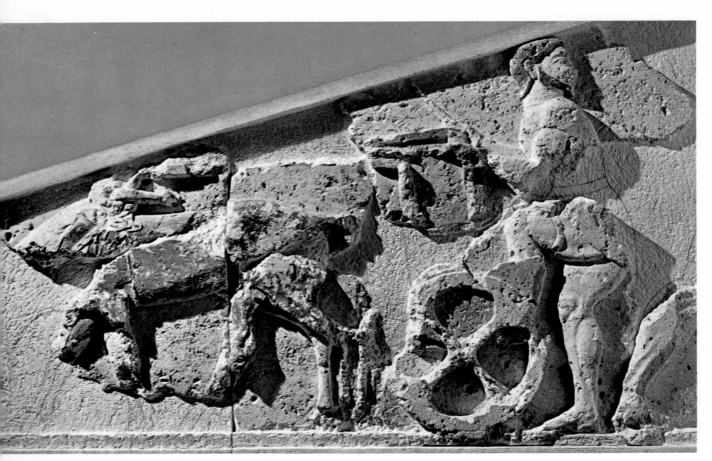

216. ATHENS, ACROPOLIS. HYDRA PEDIMENT. ACROPOLIS MUSEUM, ATHENS.

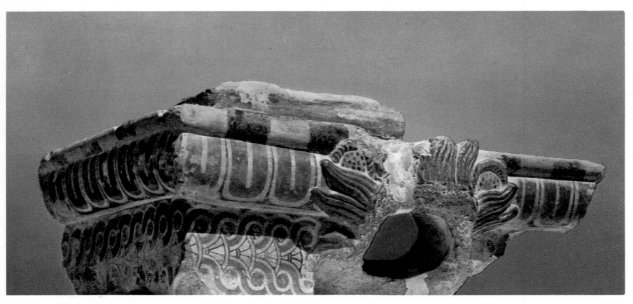

217. CALYDON, LAPHRION, TEMPLE A. TERRA-COTTA SIMA. NATIONAL MUSEUM, ATHENS.

218. CALYDON, LAPHRION, TEMPLE A. TERRA-COTTA ACROTERIUM SPHINX. NATIONAL MUSEUM, ATHENS.

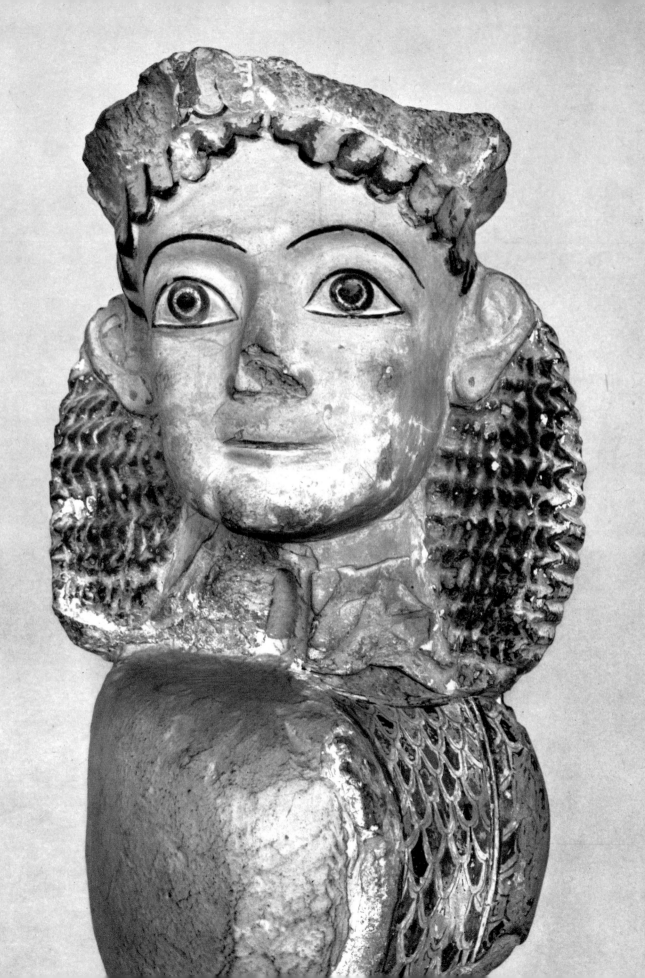

219. SYRACUSE. THE ANCIENT QUARRIES, DETAIL.

are an expression of civic pride. They also reflect the rivalry between the largest of these cities and their competing assertions of power.

Even when they are wrecked and reduced to scattered ruins, as at Selinus, or half preserved, as at Agrigentum, the Sicilian temples testify to the creative power and abundance of this architecture. Their materials, however—local limestone, rough, conchitic, and difficult to polish—had to be smoothed with a coating of stucco. The quarries of Syracuse—notorious as the place where part of the Athenian expeditionary force was exterminated in 413—testify to the scope of these building activities, which continued without interruption from the middle of the sixth century to the end of the fifth.

The earliest temple erected on the acropolis of Selinus, Temple C (about 540), reveals something of the youthful enthusiasm, the free and independent spirit of the Sicilian

180

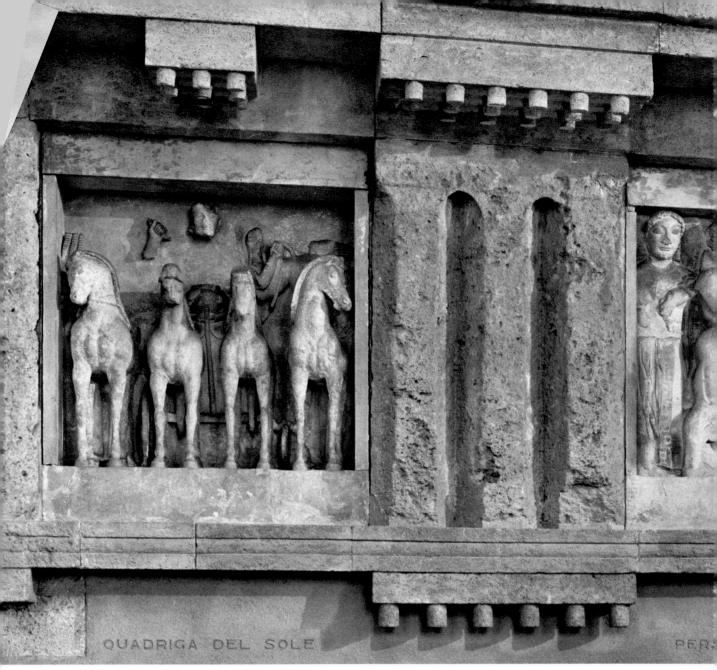

QUADRIGA DEL SOLE PERS

221. SELINUS, TEMPLE C. DORIC FRIEZE WITH SCULPTURED METOPES. MUSEO NAZIONALE, PALERMO.

The same vigour and luxuriance appear in the upper parts of Temple C. The columns, taller and slimmer than at Syracuse and crowned by a more highly developed capital, carried a spirited and colourful entablature. The frieze and the corona were strongly modeled by the projection of the triglyphs in front of the metopes and by the vigorous volumes of the overhanging mutules and guttae. The monumental character of the entrance, already noticeable in the ground plan, was even more strikingly emphasized in the elevation. The well-spaced layout of the columns contrasted with the profuse decoration above them. The ten metopes on the façade were carved in high relief; each was framed above and below

183

here the monumentality of the design was emphasized by a flight of eight steps occupying the whole width of the façade; on the other three sides the platform had only four steps, as at Corinth, and this remained the standard arrangement in Sicily. The colonnade is handled with great freedom. In front the interaxial distance is nearly 14 $^1/_2$ feet; on the sides it is reduced quite noticeably to a little over 12 $^1/_2$ feet. Even the diameter of the columns is variable (from 70 to 75 inches). These touches of fantasy, which break up the uniformity of design, make free with the rules of the Doric order already hard and fast, in mainland Greece.

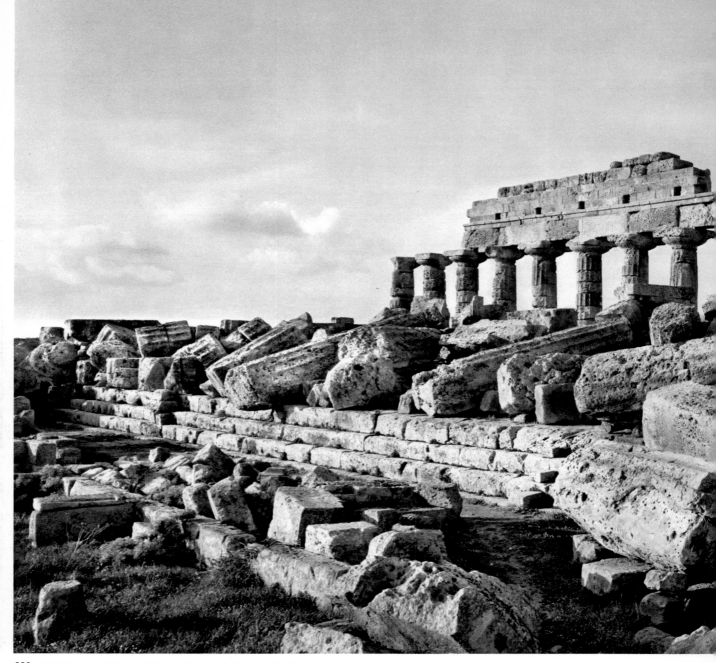

220. SELINUS, TEMPLE C. LEVELED COLUMNS OF THE SOUTH SIDE AND RESTORED COLUMNS OF THE NORTH PERISTYLE.

architects, and also their immediate concern with monumental effect. The plan of Temple C (see p. 366, fig. 421) shows it to be one of the earliest naoi of Selinus. It is an unusually elongated building, with an anteroom, a long narrow cella, and an adyton at the back, surrounded by a magnificent colonnade (6 by 15 columns) designed without any relation to the interior construction. Externally, the long sides and the back formed a broad gallery or covered walk (measuring 13 $^1/_2$ feet from the cella wall to the inner side of the columns, and 20 $^1/_2$ feet to the edge of the stylobate); in front of the entrance, on the east side, stood a double row of columns, which doubled the depth of the gallery. And

181

EO E LA MEDUSA ERCOLE E I CERCOPI

by plain bands of stone, which emphasized the vigour of the relief. The very presentation of the subjects—the quadriga of Apollo boldly shown in front view, Perseus and the Gorgon standing out sharply against the ground plane, Heracles and the Cercopes passing by as if on a stage—resorts to theatrical effects that are well in keeping with the architectural structure of the frieze and with its original function, which seems to have been that of an ornamental course placed in front of the timber work and not closely associated with it. Working in exactly the same spirit that is found in the treasury of the Heraion on the Silaris, the Selinus sculptor made effective use of the original architectural purpose of the frieze.

184

222. SELINUS, TEMPLE C. METOPE: QUADRIGA OF APOLLO. MUSEO NAZIONALE, PALERMO.

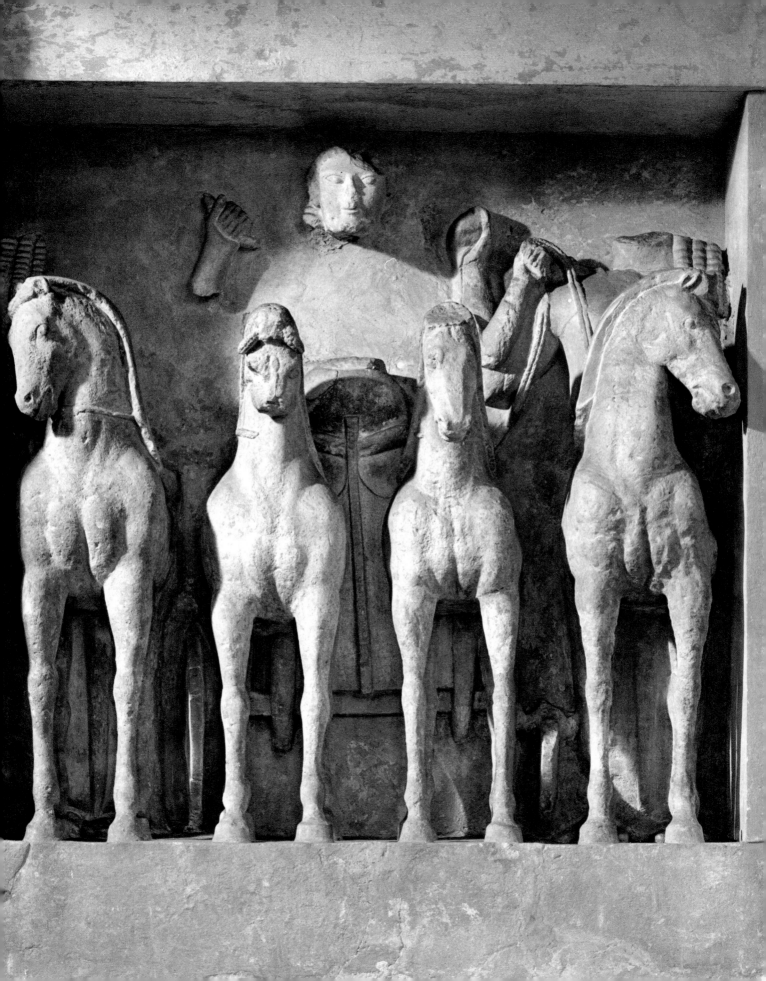

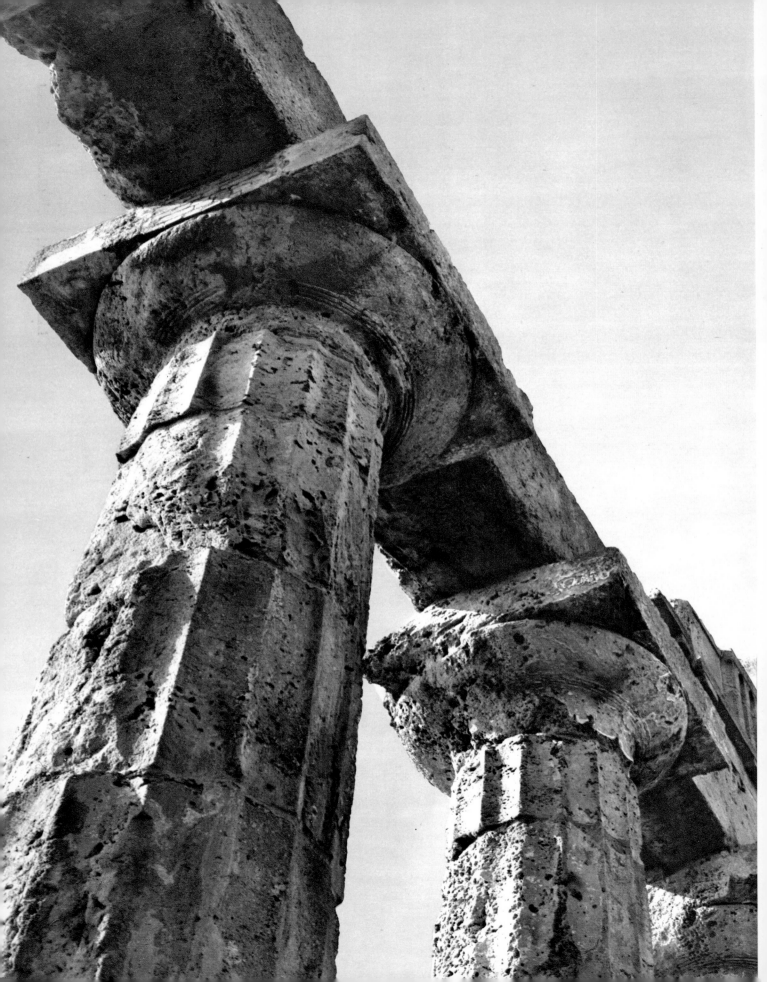

224. POSEIDONIA (PAESTUM), TREASURY AT THE MOUTH OF THE SILARIS. ORNAMENTAL COURSE. PAESTUM MUSEUM.

Crowning Temple C at Selinus was a rich terra-cotta revetment that ran along the edge of the roof on the long sides, and in front framed the pediment, in the centre of which was fixed a large terra-cotta Gorgon's head. Terra-cotta sheathings were also used here to protect the roof beams at the crowning of the entablature. These are the first examples of a facing technique that, though by no means confined to Sicily, was particularly well developed in Sicilian workshops. For when the people of Gela had a treasury built in the Panhellenic sanctuary at Olympia, they sent out their own artisans to manufacture and install the elaborate scheme of terra-cotta sheathings on the cornices and gutters.

The characteristics of sixth-century Doric architecture in Sicily consist of notable freedom of design and a concern for adapting the newly established forms and rules of the Doric style to the traditions and demands of the older plans, vigour and fantasy in carrying out the design, a marked striving for monumental effects, and an accurate understanding of architectural structures nicely emphasized by the treatment of the decorative scheme and its adaptation to the building. Thus, the builders avoided monotony and gave each temple a styling of its own in architectural complexes where quantity might easily have detracted from quality.

Temple D on the acropolis of Selinus, built a few years later in the same temenos, beside Temple C, has a quite different aspect. Though designed on the same plan, it introduced some variants: its proportions were less elongated (6 by 13 columns); the entrance was treated differently, the façade consisting of a row of four columns (the outer two engaged in the ends of the cella walls), thus re-echoing the peristyle, which had a greater harmony in the arrangement of its columns owing to more uniformity of spacing.

At about the same time, in the mid-sixth century, the Syracusans erected outside their city a temple dedicated to the Olympian Zeus, in which the heaviness and clumsiness

223. SELINUS, TEMPLE C. COLONNADE, DETAIL.

225. POSEIDONIA (PAESTUM), TREASURY AT THE MOUTH OF THE SILARIS. PRESENTATION OF THE FRIEZE. PAESTUM MUSEUM.

of the earlier Temple of Apollo were rectified by means similar to those revealed by Temple C at Selinus. The plan was similar, with a double row of columns in the entrance peristyle; the columns in front were more widely spaced than those on the sides; the scheme of terra-cotta sheathings was more systematic; but the columns were still monoliths and very thickset. An evolution was under way, and the progress made hereafter is plain to see in the fine buildings of the end of the century.

The Greek colonies in Italy, which because of their different origins were more directly associated with Ionian traditions, showed a keener appreciation of decorative values in their handling of the Doric style. This is noticeable at Poseidonia (Paestum) and particularly in the sanctuary of Hera on the Silaris.

The fruitful excavations carried out by Paola Zancani Montuoro and Umberto Zanotti

226-227. POSEIDONIA (PAESTUM), SILARIS TREASURY. CAPITALS.

Bianco between 1933 and 1938 revealed the main buildings of the Silaris sanctuary. In particular they yielded the entablature with sculptured metopes (now in the Paestum Museum) from a small shrine or treasury built shortly after the middle of the sixth century, probably about 540. Of very plain rectangular plan, this building had a Doric façade with two columns *in antis*. The column capitals, firmly but freely shaped and stressed at the base of the echinus by three well-marked fillets, are very different from the Ionic anta capitals. Treated as a kind of applied ornament at the end of the wall, the top of each anta capital curves outwards to support a thick abacus delicately carved with a garland of palmettes and lotus flowers. The base of the capital is marked by a meander pattern; its upward curve ends in a rosette-faced cylinder under the corner of the abacus. The rosette motif is repeated and developed on the uppermost course of the wall.

The frieze of the Silaris Treasury, which has no architectonic function, stood in front of the timber work that supported the roof. The massive triglyphs are set well forward, as in Temple C at Selinus, and they are nearly as wide as the metopes. The sculptured metope blocks were fitted between the triglyphs, and the masons' marks, still visible on the back, show that they were mounted when the timber work of the roof was already in position. The subjects of the metope reliefs (labours of Heracles, battle of Pholus and the Centaurs, etc.) are characterized by the Western aspects of these mythological

189

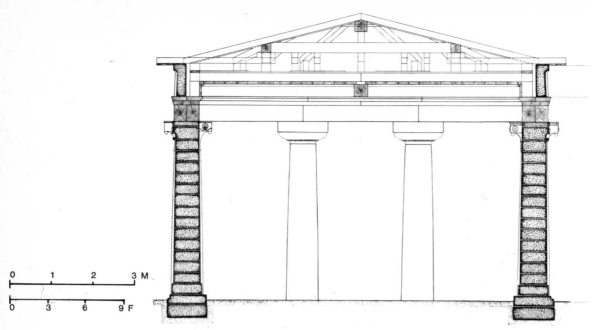

228. POSEIDONIA (PAESTUM), SILARIS TREASURY. CROSS SECTION.

themes: a continuous movement, set up by the play of gestures and lines, runs through the frieze on each side of the treasury, unchecked by the pauses marked by the triglyphs.

The cuttings made on the back of the metopes to fit the ends of roof beams enable us to reconstruct the curious, revealing arrangement of the timber roof of the Silaris Treasury. Behind the frieze a system of vertical and horizontal supports forming a rigid framework was erected to carry the horizontal beams on which the ceiling rested. These beams supported the props that bore the weight of the upper crosspieces supporting the rafters. But this quite usual arrangement here extended back only as far as the two interior wooden pillars (the stone base of one of them was found still in position). Between this point and the back wall of the treasury, the timber work consisted of a series of rafters forming a radiating scheme reminiscent of the hip roof that was normally used to cover archaic buildings of apsidal plan. This radiating structure, at the level of the ridge pole, called for a crownpiece where the rafter ends met and were tied together. One would hesitate to believe that such a device was used, were it not for the fact that it is represented in some Etruscan tombs, notably in the Tomb of the Painted Animals at Cerveteri. Here the entrance chamber has a ceiling whose radiating lines represent a series of rafters fitting into a crownpiece that ends the ridge pole normally running over the other chambers of the tomb. This is a far cry from the theoretical reconstructions of archaic timber roofs, which allegedly account for the different elements of the Doric entablature.

It should be noted, however, that whereas the existence of this radiating scheme at the rear of the Silaris Treasury is attested by the cuttings made on the metopes for the ends of rafters, there is no such evidence on the façade. Here there was probably a wooden pediment, perhaps sheathed with terra-cotta, like those of many earlier buildings of apsidal or quadrangular plan, such as the shrines on the Acropolis in Athens. Sculptured elements of such pediments have also been found on several sites in Asia Minor.

190

229. CAERE (CERVETERI). TOMB OF THE PAINTED ANIMALS.

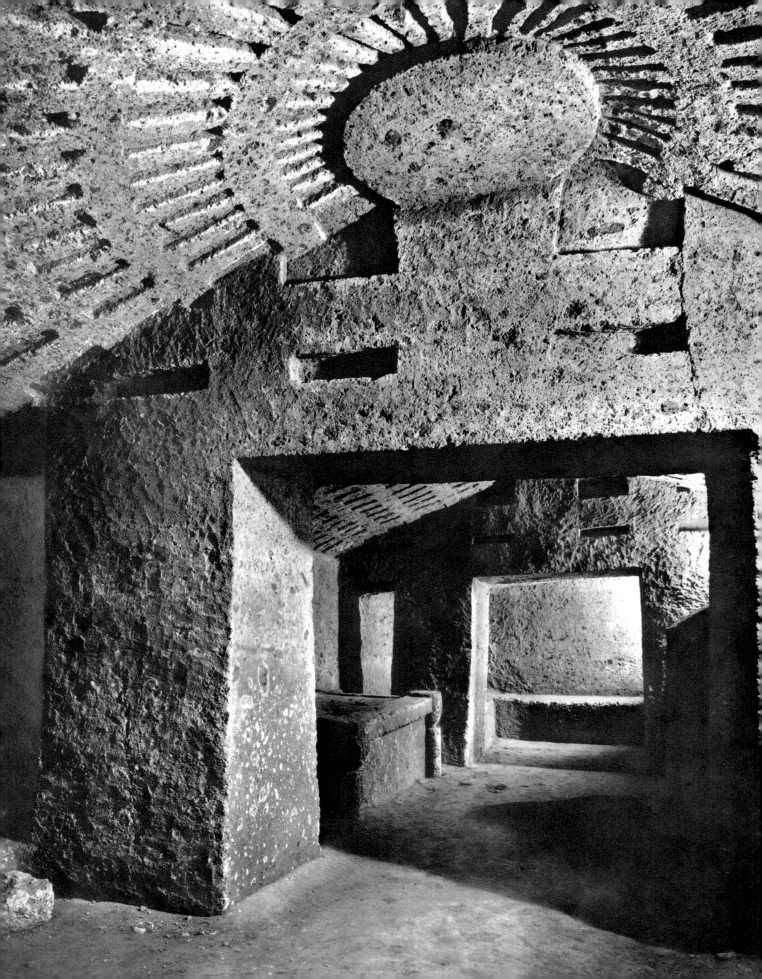

More will be said about Paestum and Sicily, where in the last quarter of the sixth century the various tendencies we have just noted came to fruition. First, however, it is necessary to return to Greece and trace there the development and extension of those 'treasuries' that represent an original aspect of Greek architectural design throughout the second half of the sixth century. Since they were offerings dedicated by the different cities in the Panhellenic sanctuaries, often in token of a victory or a success of some kind, the treasuries bear the mark of their place of origin and testify conspicuously and sometimes ostentatiously to the rivalries that pitted the Greek cities against one another. Because no expense was spared, and since they were often of a political character, the treasuries were grouped together in *topoi epiphanestatoi* or privileged places, such as the terrace overlooking the approach to the stadium at Olympia and along the sacred way at Delphi, with no regard for harmonious or ordered siting. The builders of each treasury were intent solely on making it as conspicuous as possible and eclipsing the others. The result is an extreme diversity of design, a wide sampling of all the architectural inventions and tendencies of the archaic period.

At Olympia, on the terrace of the treasuries, which was bordered by a stepped embankment from which the spectators could watch the procession of athletes at the stadium entrance, there stood a row of twelve buildings, including an altar dedicated to Heracles. Pausanias mentions ten, of which the third was probably in ruins at the time of his visit. From west to east on the way to the stadium he names the treasuries of Sicyon, Syracuse, Epidamnus, Byzantium, Sybaris, Cyrene, Selinus, Metapontum, Megara, and Gela. The most famous is the treasury of Gela, for it was adorned with the finest group of architectural terra-cottas found in the Olympia excavations. Originally it was only a single rectangular room with its front on the long south side, which was open so that one could see the statues and offerings displayed on the monumental base that the building enclosed. This layout indicates clearly the function of most of these treasuries. In the fifth century a porch (6 by 2 columns) was added to the front. To show off the fine workmanship of their local terra-cottas, the donors brought with them from Gela the architectural revetments, for instead of a frieze these brightly painted terra-cottas bordered the roof and the pediment. In accordance with the early technique of applying sheathings to wood, the terra-cotta plaques were fixed with dowels to the course of tufa that was roughly shaped to form the projecting part of the corona. The plaques forming the gutter and the facing of the geison had been moulded into the appropriate shape and decorated with geometric motifs: meanders, leaves, and lozenges above, interlaces edged with an astragal below. On the pediment the terra-cottas even covered the foot of the tympanum, though no protective sheathing was needed there. In view of the width of the façade (since the entrance was on the long side of the treasury), they produced an effect of mass and vigorous polychromy that emphasized the monumentality so often sought after in Western buildings. This effect was further stressed by a circular acroterium similar to the one that adorned the top of the façade of the neighbouring Heraion of Olympia. It consisted of a series of concentric rings standing out in black, brownish-red, and bright yellow on a cream-coloured ground.

Whereas at Delos the treasuries, reduced now to the merest fragments, were arranged in a harmonious semicircle north of the temples of Apollo and Artemis, at Delphi they

230. OLYMPIA, TREASURY OF GELA. DISK ACROTERIUM, DETAIL. OLYMPIA MUSEUM
(NEW RESTORATION).

231. DELPHI. HEAD OF A CARYATID. DELPHI MUSEUM.

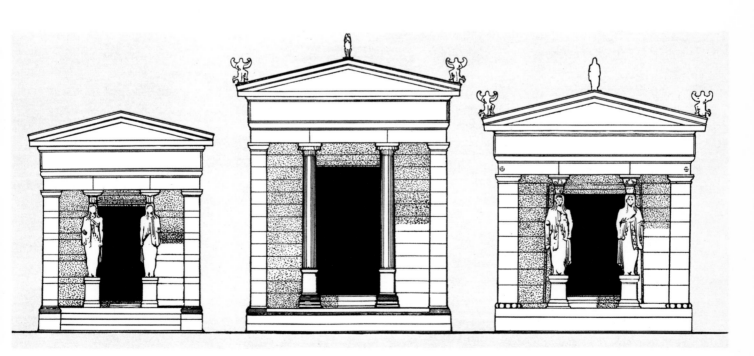

232. DELPHI, TREASURIES OF CNIDUS, MASSALIA, AND SIPHNOS. RESTORATION OF THE FAÇADES.

193

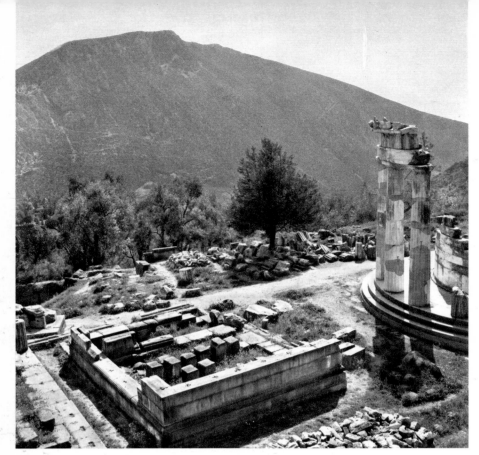

233. DELPHI (MARMARIA), SANCTUARY OF ATHENA. TREASURY OF MASSALIA AND THOLOS.

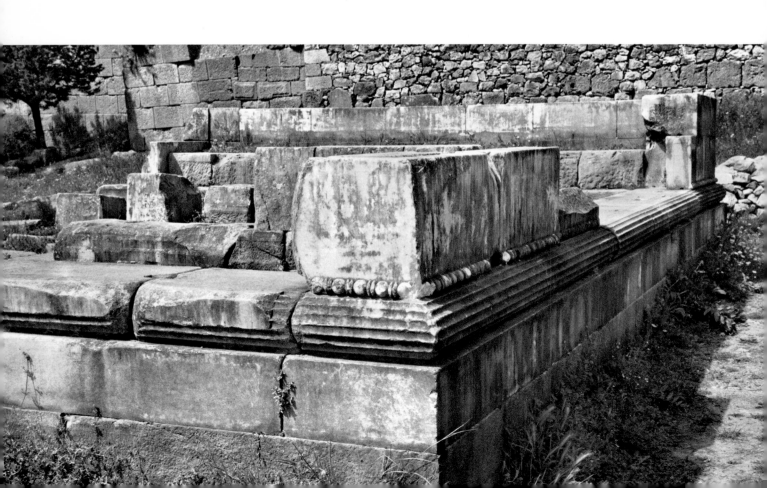

234. DELPHI, SIPHNIAN TREASURY. PALMETTE AND LOTUS-FLOWER ORNAMENT, DETAIL.

were scattered over the sanctuary and represented a wide variety of designs ranging from the late seventh century (treasury of Corinth) to the fourth (treasury of Thebes). These two treasuries were the most original monuments at Delphi, both in the sanctuary of Apollo and in that of Athena on the Marmaria terrace. Built of poros, limestone, and marble, they belong to different styles, often showing original variants that were destined to have far-reaching repercussions, such as the introduction of the sculptured frieze on the Ionic entablature.

They were sometimes hardly more than canopies, like the monopteros of Sicyon, whose remains were found buried, with those of the tholos, in the foundations of the later Sicyonian Treasury. Apart from the importance of the monopteros in the history of archaic monumental sculpture, its arrangement provides valuable evidence for the transition from a wooden to a stone entablature. Many other nameless buildings of the same type, some of them buried in the earthworks that went to form the terraces at Delphi at the end of the sixth century, have yielded elements that have much to tell us about archaic Doric friezes and coronas. But it is the Ionic treasuries at Delphi that, from 550 to 525, provide the richest materials and the most instructive variants. On their façades the taste for sculptured decoration found free expression. In the treasuries of Clazomenae and Massalia the volute capital was replaced by the palm capital, derived originally

195

235. DELPHI (MARMARIA), SANCTUARY OF ATHENA, TREASURY OF MASSALIA. PLATFORM, DETAIL.

from Egypt but already used in Crete at Arkhades. The body of the capital consists of elongated leaves, forming a round basket; they curl outwards at the top to support a square abacus. The columns (with eighteen flutings in the Clazomenian and twenty-two in the Massalian treasury) may have rested on bases like those of Ephesus and Samos, with two scotiae and a thick filleted torus, or possibly on a plinth analogous to the one of the caryatids (see p. 370, fig. 427-428). For the Cnidians about 545 and the Siphnians in 525 replaced the columns in front of their treasuries by caryatids carved in a style akin to that of the korai. The capital of the Siphnian columns has a sculptured calathos set between two pairs of vigorously profiled fillets, thus providing a happy solution to the problem raised by the architectonic role of the korai.

The walls, treated in the Cycladic manner with alternating courses of coupled stretchers and headers running through the wall, stood on a moulded base: a fluted torus in the Cnidian and Massalian treasuries, a thick egg-and-dart in the Siphnian. The builders of each treasury at Delphi tried to outdo the others in ornate embellishments, and they introduced relief carving everywhere. Instead of having the three bands or fasciae that were usual at this time, the architrave is adorned with rosettes. Along the top runs an egg-and-dart moulding, which is repeated above in the form of leaf-and-dart on a course separating the frieze from the corona. The soffit of the corona is occupied by a garland

236. DELPHI, SIPHNIAN TREASURY. ENTABLATURE, DETAIL. DELPHI MUSEUM (NEW RESTORATION).

196

237. DELPHI, THE SACRED WAY AT THE CORNER OF THE SIPHNIAN TREASURY.

of palmettes and lotus flowers carved in a dense, expressive style. But above all, the Siphnians took over and extended the motif of the sculptured frieze that the Cnidians had timidly introduced on the façade alone. The sculptured frieze reappears in the treasury of Massalia.

The sculptured frieze proved to be a fruitful innovation, one whose originality should be emphasized. Two types of Ionic entablature are traditionally recognized. That of

197

Asia Minor had an architrave with three fasciae, at the top of which ran a moulding with an egg-and-dart pattern. On this rested the wooden part of the entablature consisting of horizontal beams connecting the columns with the ends of the joists supporting the early flat roof. The edge of the roof was held in position and protected by a sort of terra-cotta parapet, various examples of which have come to light in excavations in East Greece, in particular at Larisa on the Hermos, Gordion, and Pazarli. In the Artemision at Ephesus, this parapet was transformed into a high gutter (25 $\frac{1}{2}$ inches high). The second type of Ionic entablature was that of the Attic architects who, in taking over the innovations of the Cnidians and Siphnians at Delphi, generalized the use of the sculptured frieze, eliminating the dentils so as not to exaggerate the height of the entablature. The combination of the two types, with frieze and dentils, did not appear until the fourth century. But the earliest Ionic buildings on Delos, the Oikos of the Naxians, had a smooth frieze whose upper edge was decorated with an astragal and which was surmounted, as in the Delphian treasuries, by a Lesbian cymatium. And the same is true of the Cnidian treasury at Delphi, where the sculpture was undoubtedly reserved for the entrance, in the same spirit that had led there to the substitution of caryatids for columns in order to enrich and enliven the façade. The Siphnians, in their eagerness to achieve a sumptuous effect, not only set up caryatids at the entrance but continued the frieze all around their treasury. The smooth frieze, or frieze treated as a thick cymatium, thus appears to be unique to island architecture if not to Asia, and was an original part of the structure of the Ionic entablature. It is architectonic and not merely a decorative element.

When we recall the original features of the treasury of the Heraion on the Silaris, the elaborate polychrome terra-cottas on the treasury of Gela at Olympia, the variety of forms in the entablatures of the Doric treasuries at Delphi, the quality and interest of the decorative carvings on the monopteros of Sicyon and the Ionic treasuries at Delphi (that of Siphnos in particular), we can fully appreciate the part played by the treasuries in the history of archaic architecture. Because of their small size and the freedom of design they afforded the builders, they provided a favourable testing ground for all the experiments that could not easily be tried in larger buildings. Many solutions worked out in the treasuries were later adopted in large-scale architecture. The role of the treasuries thus deserves to be better known and more carefully studied.

PART THREE

The Late Archaic Period

525-480 B. C.

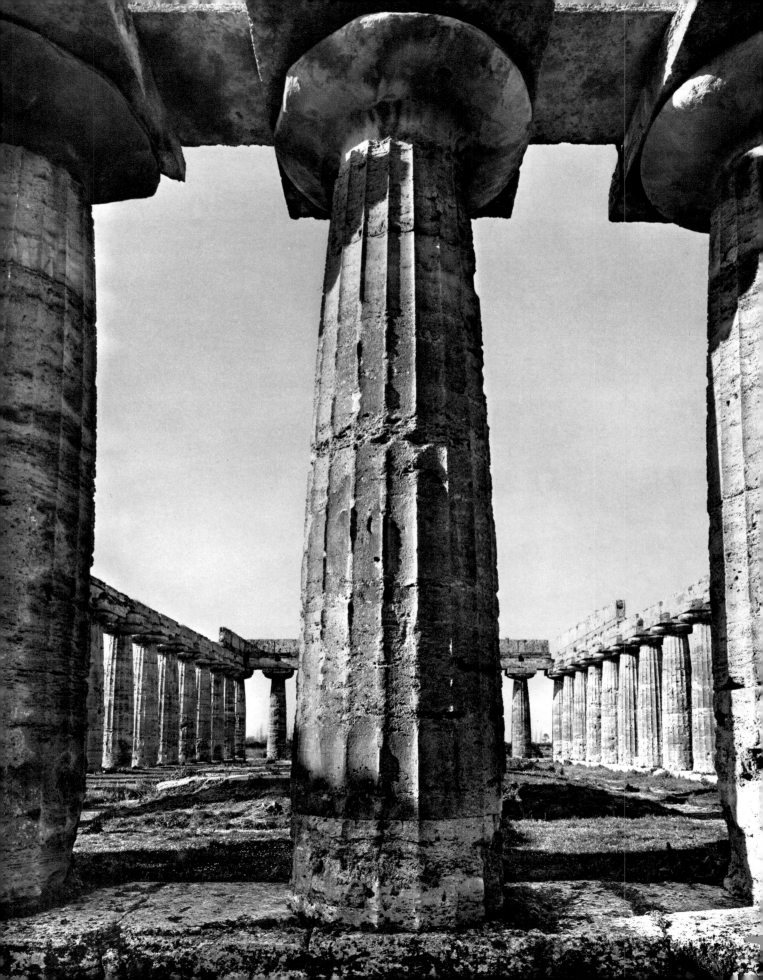

Architecture

During the last decades of the archaic age, after a phase of rapid growth and creative experimentation, architecture entered a period of codification. This settled phase of consolidation did not mean a slowing down of building activity. On the contrary, it produced a large number of edifices in which the forms and structures became refined to the point where they were ready to achieve realization in the classical style. The developments in architecture reflected the progress of the city-states, which, after the violent, even savage, struggles of the seventh and sixth centuries and the turbulent period of colonization, enjoyed the enlightened influence of the law-givers. This resulted in the compilation of codes and constitutions incorporating political and social advances. The towns were renovated and took on a more precisely defined character through the concordant actions of the newly installed rulers and the architects, who erected buildings that reflected the regimes and the changed political, economic and social conditions. In every field archaism became less turbulent, accepted rules and regulations, and achieved a new maturity.

The End of Archaic Ionic

This phenomenon of consolidation is clearly seen in the eastern part of the Greek world, where it stood out against the restlessness and insecurity caused by the first inroads of the Persian Empire, which finally extended its sovereignty over the whole Aegean coast by the capture of Miletus in 494. The building sites opened at the beginning of the sixth century were so vast and involved such expenditure that work there was still progressing in the fifth century. Proof of this is provided by the advanced style of some parts of the sculptured gutter at the Artemision at Ephesus. The Milesians took Ephesus as a model for their first great temple at Didyma where, as at Ephesus, a sacred area was enclosed for the purpose of preserving the oracular spring and the laurel sacred to Apollo. Recent excavations have laid bare the foundations of the naiskos, a little shrine that was added at the end of the sixth century to house the statue of the god, a handsome bronze by the Sicyonian sculptor Canachos. Externally, the Didyma temple closely resembled its Ephesian model. The peristyle consisted of two rows of columns over 50

238. POSEIDONIA (PAESTUM), TEMPLE OF HERA I ('THE BASILICA').

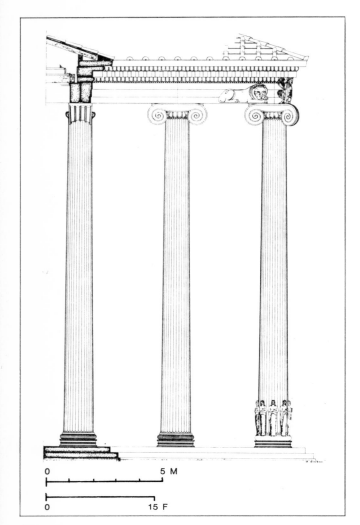

240. SAMOS, HERAION, POLYCRATES TEMPLE. COLUMN BASE.

241. SAMOS, HERAION, RHOIKOS TEMPLE. COLUMN BASE.

239. DIDYMA, FIRST TEMPLE OF APOLLO. ENTABLATURE.

feet high, and the lowest drums of the façade columns were decorated with figures of korai in high relief. The plan of this peristyle was derived from that which Rhoikos had adopted on Samos (see p. 368, fig. 424): eight columns on the front with a wider spacing in the centre, nine at the back, and twenty-one on each side. The ample volutes of the Didyma capitals are better assimilated than those at Ephesus. The architrave comprised three fasciae surmounted by a series of mouldings—dentils between two sharply designed egg-and-dart cymatia—which were only slightly less extensive than the architrave itself and took the place of a frieze. A curious innovation, of which no other instance has been found, is the guardian image of the Gorgon flanked by couchant lions at the corner of the entablature. Are they the sole remnants of a more extensive sculptured decoration on the architrave of the façade? The traces that remain are too meagre to answer that question.

The building site of the Heraion on Samos was never idle, for no sooner was the Temple of Rhoikos finished than it was destroyed, probably by fire. After Polycrates had seized

power, he began in about 530-525 to rebuild the vast dipteral structure. But in order to satisfy the new taste, which, as we shall see below, forced architects to take into consideration the layout of the whole area, the new building was shifted towards the west to make room for an esplanade around the main altar. A great deal of material from the old temple was incorporated in the foundations of the new one. The ground plan (see p. 363, figs. 412-413) remained virtually unchanged (368 by 181 feet on the stylobate). The arrangement of the original cella was maintained, with two rows of eleven columns each (instead of ten), as was the varying rhythm of the columns of the peristyle (eight for the pronaos and nine at the back), but a third row was added at each end—a scheme copied from the Artemision at Ephesus— and the lateral spans were distinctly narrower than those at front and rear. In this way perfect unity was preserved in the general proportions of the new Samian Heraion and in the mutual relations between its various parts, while at the same time it was rendered more lively and animated by the variety of the decorative elements. This is particularly evident in the column bases, where cylinders banded with mouldings are combined with fluted tori; these mouldings, too, are vigorously executed (see p. 369, fig. 425). The upper part of the shaft is decorated with a wide necking band on which a motif of lyre-shaped spirals is combined with a compact garland of palmettes and lotus flowers. This same design is repeated between the volutes of the capitals.

The capitals of the peristyle are remarkably well balanced. They have lost the rigidity originally inherited from the wooden model. The middle section of the volutes has become thicker, reducing the cymatium to a purely ornamental function, and the volutes themselves, solidly joined by the curving line of the channel (canalis), form two regular spirals edged by a thin fillet that stresses the convex profile of the coils (see p. 369, fig. 426). Inside the cella the capitals retained the archaic design similar to some early capitals on Delos; they were reduced to a single element, the cymatium with egg-and-dart pattern, on which rested a square abacus. This form solved one of the problems of the volute capital, which was designed to be viewed from two sides only and was ill-suited to corner columns and interior colonnades.

Thus Ionic architecture attained its apogee, ironically, at the very moment when the building sites of the Ionian cities were reduced to silence by the Persian conquest, which ushered in a lengthy period of extremely slack civic activity. It was not until the fourth century that on the coast of Asia Minor architecture experienced a new phase of creative achievement in which the great architects of the period played a part.

The Flowering of Archaic Architecture in the West

But Ionic influence was soon felt in the Greek colonies in the West, which formed the very heart of the Doric domain. In some temples at Locri and Massalia (Marseilles), cities still close to their origins, an Ionic style similar to that of Samos and Ephesus was adopted at the end of the sixth century. At Syracuse, where the Dorian style was strictly observed, recent finds show that an edifice of the same Ionian style was erected in the temenos of Athena. More important and signifying a greater potential for development were the efforts made at Paestum to lighten and loosen the rigid lines and areas of the

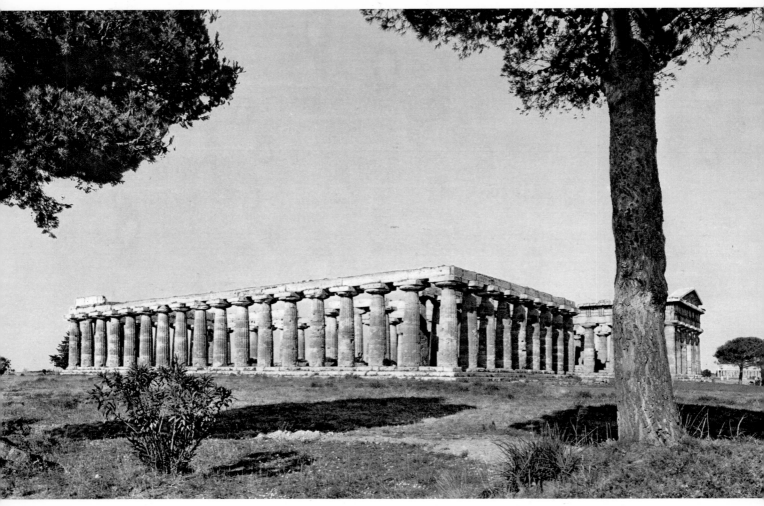

242. POSEIDONIA (PAESTUM), TEMPLES OF HERA I ('THE BASILICA') AND HERA II ('TEMPLE OF POSEIDON'). EAST FRONTS.

Doric order by the introduction of Ionic forms in both colonnades and entablatures.

At Paestum the first temple of Hera, known as the 'Basilica,' was erected about 530 B.C. It is a curious building with an unusual layout and proportions. The peripteral colonnade, which has lost part of its entablature—only the architrave is still in place—as well as the cella, whose walls have almost entirely disappeared, develops like a garland without a structure to cling to. At first glance it gives the impression of an overextended geometrical area, but when we endeavour to analyze the components of that area they elude our grasp, remain ethereal and dissolve, so to say, in light and space. The external rhythm of the colonnade is rather indeterminate, with nine close-set columns on the façades and eighteen more widely spaced on each side. These unusual proportions appear to be lacking in vigour, and the elements of the colonnade are juxtaposed rather than unified. This is partly due, no doubt, to the architect's concern with certain plastic effects. The column shafts, though actually not very slender are made to appear more so by the contraction of the entasis, which reduces the diameter very rapidly along the upper third and makes the column thinnest directly under the capital. The capital is still very wide and has

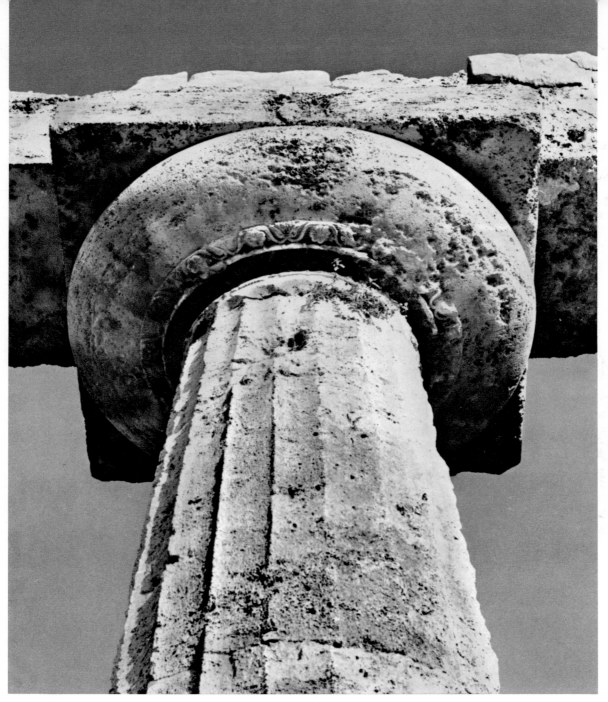

243. POSEIDONIA (PAESTUM), TEMPLE OF HERA I ('THE BASILICA'). COLUMN AND CAPITAL, DETAIL.

an echinus whose function is ornamental rather than architectonic. Each column strikes us as a plastic achievement, but we miss a bold expression of functional unity. What we have here is a cluster of pleasant forms and lines that do not join in a common effort.

The inner area gives the impression of a perfectly symmetrical composition with respect to an axis defined by the central column of each façade. The architect of the 'Basilica' aimed at introducing into a Doric plan the relations his Samian colleagues had worked

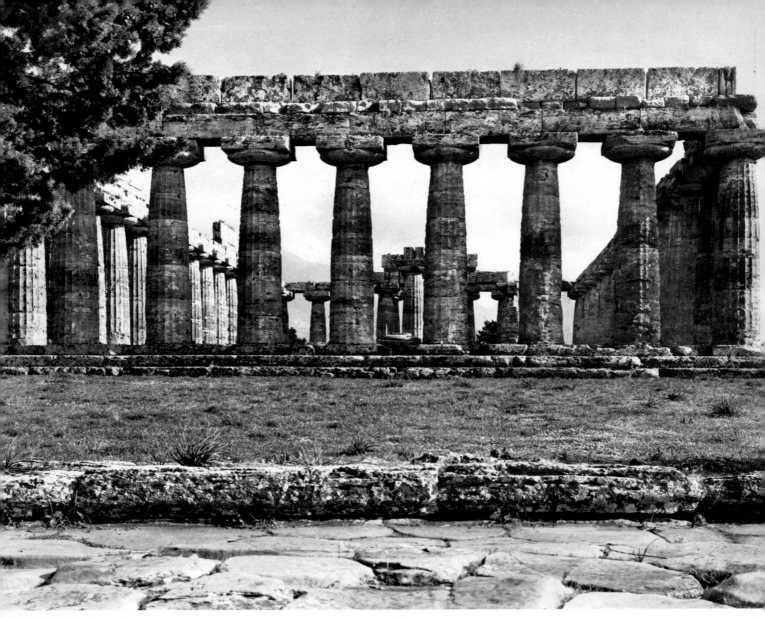

244. POSEIDONIA (PAESTUM), TEMPLE OF HERA I ('THE BASILICA'). EAST FRONT.

out between the inner divisions of the edifice and the rhythm of the outer colonnades (see p. 375, fig. 438). This explains his choice of a nine-column scheme at the front and back, framing an axial colonnade that divided the cella into two equal aisles whose width corresponded to two intercolumniations of the façade. Thus the cella walls are aligned with the third and seventh columns. Consequently, each of the lateral galleries of the peristyle also corresponded to the two outermost intercolumniations, and the entire space enclosed by the peristyle was divided into four equal parts. These strict proportions were broken up, however, by the need to make room for the cult statue, so the inner columns are set closer together towards the east front to leave more room at the back of the cella. As a result, there is no relation between them and the external columns. The same propensity for Ionic forms is displayed in the composition of the entablature.

206

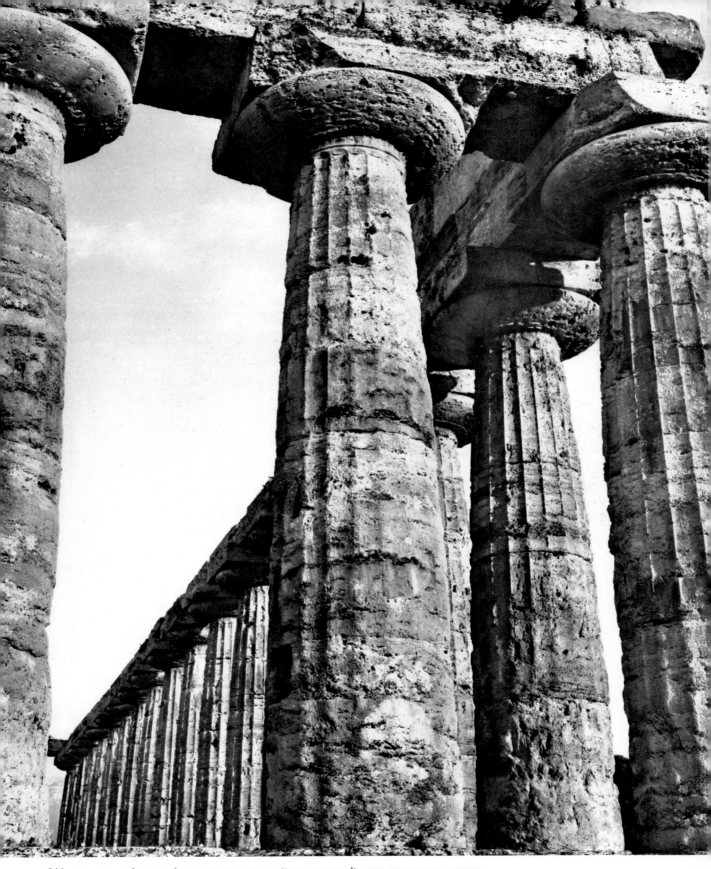

246. POSEIDONIA (PAESTUM), TEMPLE OF HERA I ('THE BASILICA'). THE COLONNADE, DETAIL.

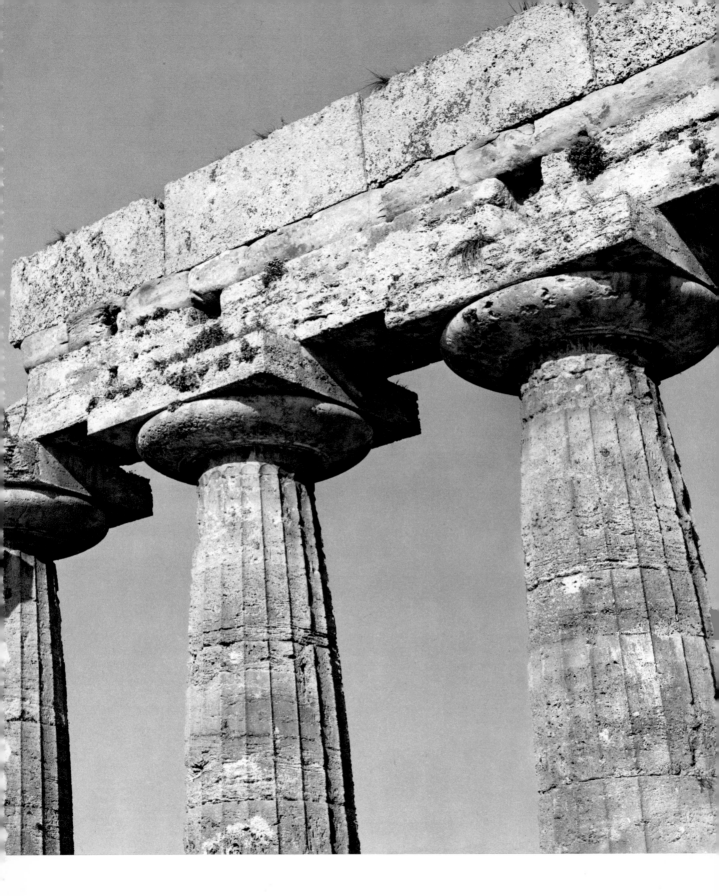

208

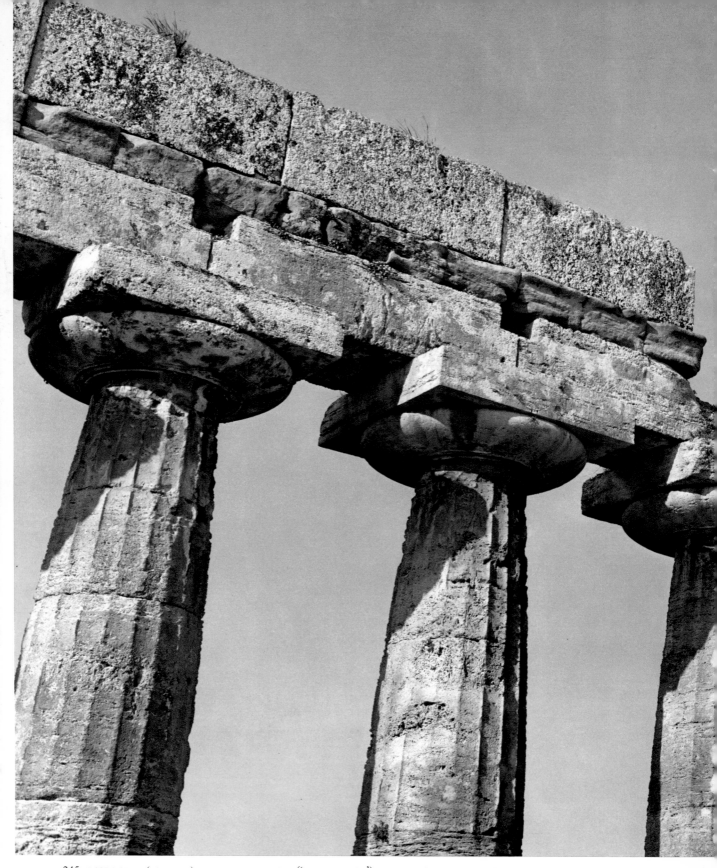

245. POSEIDONIA (PAESTUM), TEMPLE OF HERA I ('THE BASILICA'). THE COLONNADE, DETAIL.

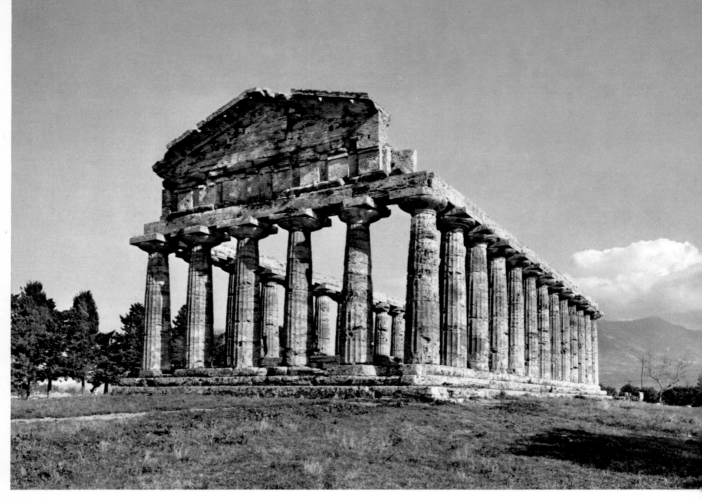

247. POSEIDONIA (PAESTUM), TEMPLE OF ATHENA.

The Doric taenia of the architrave was replaced by a cymatium with Lesbian leaf moulding, while another moulding adorned with egg-and-dart probably surmounted the triglyph frieze, as in the Temple of Athena. All that remains of the cornices are a few handsome fragments of their terra-cotta sheathing.

Towards the end of the century another temple was built on the north of the site, in honour of Athena. The novel features of the ground plan of the 'Basilica' were omitted, and the architect reverted to the traditional peripteral plan with 6 by 13 columns. This resulted in a structure that is at once more balanced and harmonious and stands out clearly on the low mound that emphasizes the importance of each temple in relation to the buildings in the vicinity (particularly those of the forum, which occupied a shallow depression). A platform with three high steps completes the monument and supports the peristyle, whose proportions harmonize well with the lines of the landscape.

The columns have a less pronounced entasis and a more massive, robust appearance. The capitals are heavier, the echini more rounded, and their plastic values better suited to their architectonic function. Nonetheless, the architect kept to the trend typical of what we may call the Paestum workshops: in the outer entablature he retained the carved and moulded courses inserted between the architrave and the frieze and between the frieze

210

and the corona. To stress the decorative motifs of the upper part of the building, he omitted the traditional Doric corona with its mutules and guttae and replaced it with a coffered soffit; its edges were painted, and each coffer was adorned with a bronze rosette.

While adopting the type of cella peculiar to the Sicilian temples, the architect emphasized the monumental character of the entrance. The cella had a prostyle (4 by 2 columns) and, as in Temple D at Selinus, the ends of the cella walls took the form of half columns. Another important feature is the choice of the Ionic order for these inner columns. This is the first occurrence of two orders in the same building. The Ionic order was adopted because of its ornamental value and slender proportions, which were considered to be better suited to the layout of inner rooms. The capitals are not absolutely identical with those of Asia Minor or the Cyclades. The central section has expanded, and the overall proportions are more compact; the volutes are better developed and keep closer to the column shaft. The Western architects, who were accustomed to the strictly architectonic lines of the Doric order, retained that style, while accepting the ornamental style proposed by the East and adapting it better to its structural function. Lastly, it is worthy of note that the Temple of Athena at Paestum, like several other temples in Italy and Sicily, had two staircases inside the cella, one on each side of the entrance. From the temples erected at Agrigentum in the fifth century it has been possible to establish the true purpose of this arrangement, which was peculiar to Western temples. A harmonious interplay of forms and volumes, a pleasing use of ornamental motifs, a balanced combination of the two orders, each of which is given a function of its own, in the same edifice are the novel characteristics of this temple of Athena, whose impact did not make itself felt until some time later.

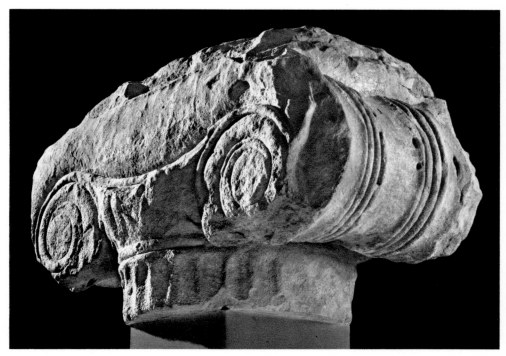

248. POSEIDONIA (PAESTUM), TEMPLE OF ATHENA. IONIC CAPITAL. PAESTUM MUSEUM.

211

249. POSEIDONIA (PAESTUM), SILARIS HERAION, TEMPLE. ORNAMENTAL COURSE. PAESTUM MUSEUM.
250. POSEIDONIA (PAESTUM), SILARIS HERAION, TEMPLE. RESTORATION OF THE ENTABLATURE.

During about the same period the Heraion on the river Silaris, to the north of Paestum, was enlarged by the construction of a big peripteral temple beside the existing treasury. This edifice confirms the originality of the Paestum builders, who were receptive to novelties but remained strongly influenced by earlier forms and designs. The ground plan (see p. 374, figs. 436-437) is conceived on a grand scale, with eight columns on the façade and seventeen on each side. Noteworthy here is the uniform intercolumniation, which remains unchanged throughout the colonnade, except at the corners, where the position of the triglyphs involved the narrowing of the span between the last three columns on the sides and between the last two alone on the façade. The cella is of the Sicilian type, elongated (about 82 by 23 feet), with no inner columns, and completed by an adyton that takes the place of the opisthodomos. There is a classic pronaos with two (perhaps Ionic) columns between the antae, which may have reflected the layout of the Temple of Athena. The entablature displayed a wealth of ornamentation. The frieze, while maintaining the alternate rhythm of triglyphs and metopes, is adorned with a procession of dancing maidens, whose unbroken movement is in the manner of the Ionic friezes: the dancers advance in a continuous line up to the corner metope, where the motif ends with a single figure that turns back. The ornamental courses that crown the frieze are decorated in the Ionic fashion with double mouldings—egg-and-dart and overturned leaves below, egg-and-dart and leaf-and-dart above. In the museum at Paestum there is a block of the entablure; a close examination reveals the robust vigour of this ornamentation, which is carved in

212

high relief with forms closely akin to those of the classical style. Instead of a corona there is a high gutter with lion-head rain spouts that recalls the early parapets of Oriental roofs and is similar in design to the gutter that crowns the Artemision at Ephesus. These innovations reveal a thorough knowledge of ancient Ionic architecture, but they could not be further developed at a time when the general trend, particularly in mainland Greece, aimed on the contrary at establishing stricter rules and more severe structures.

Temples F and G at Selinus were the last attempts made in Sicily to resist the hard-and-fast rules of Doric architecture. The former still displays the characteristics of the ancient megaron; it is elongated (about 131 by 30 feet), divided into three rooms one behind the other (pronaos, cella, and adyton), and enclosed by a colonnade to which it is unrelated (see p. 367, fig. 423). The colonnade already demonstrates the evolution towards the classical layout. There are only fourteen columns on each side instead of seventeen, but there is still the prostyle façade with four columns. These are not suited to the broad gallery, which measures just over 19 feet in breadth and is therefore almost as wide as the cella. The size of the gallery is stressed by the contrast, or contradiction, between a greatly elongated archaic cella and a peristyle influenced by recent buildings. These discrepancies are obvious in the mutual relations between the various parts of the edifice. Very 'modern' too are the proportions of the order in Temple F. The inter-columniation is exceptionally wide for the period (14 feet 7 inches in front, 15 feet 5 inches at the sides) in relation to the diameter of the columns (70 1/2 inches), which makes the colonnade surprisingly light and airy. Similar proportions do not occur again until well into the fifth century. The only typical feature of the Sicilian archaic mode is the large size of the triglyphs on the frieze. These produce a halting rhythm in the development of the metopes and set off with unusual emphasis the metopes on the main façade, which were decorated with reliefs. The predominance in the peristyle of empty spaces over solids may also have been due to the presence of a stone curtain wall between the columns, which enclosed the temple completely and isolated it from the outside. This wall has sometimes been viewed as the mark of a temple devoted to the celebration of mysteries.

To the north of Temple F the ruins of Temple G, which was dedicated to Apollo, form an impressive mass. The building was started about 520 probably under the tyrant Peitha-goras, who, like his fellow tyrants in East Greece, wanted to demonstrate his power in a vast architectural conception. The people of Selinus found difficulty in finishing the job, for they were still at it about 470. Temple G is still the finest example of the vigour, origin-ality, and technical virtuosity of architectural design in Sicily. It shows us how the grandiose plans and monumental conceptions of the Ionian architects were adapted to the traditional indigenous structures through the spirited interpretation of the Doric order.

The proportions of Temple G—the peripteral colonnade measured 164 by 361 feet—show a close relationship to the famous temples at Ephesus, Samos, and Didyma, but their tightly packed ornamental columns were replaced here by a masterly organization of space. In fact, the Doric peristyle (8 by 17 columns) left room for a gallery almost 40 feet wide, which is a considerable span for a timber roof that had to cover a gap wider than the main room of the Parthenon (see p. 367, fig. 422). The cella constitutes a clever modernization of the ancient megaron. It is positioned so as to be perfectly integrated in the peristyle: the walls, antae, and columns of the prostyle anteroom are in exact agree-

251. SELINUS, TEMPLE G (THE APOLLONION). RUINS.

ment with the rhythm of the outer columns. These precise relations between the various elements result in a harmonious balance between the masses inside the colonnade.

The importance of the entrance to the cella is stressed, traditionally, by a prostyle porch with four columns in front, two on each side and two *in antis*, which are treated in an Ionianizing style. But the porch does not 'drift' inside the peristyle; all the columns are aligned with those of the pteron, as are the antae themselves. The large chamber, which measured almost 56 feet in width, was divided by two rows of columns into three almost equal aisles. This arrangement is conclusive proof that the cella was covered, or at least was meant to be. Thus the hypothesis of an unroofed central court is difficult to sustain. This hypothesis forms part of a theory that was widely accepted at the beginning of this century. It was based on an erroneous generalization of a statement by Vitruvius, which the facts do not bear out. The original ground plan of the Apollonion comprised the traditional adyton. This was replaced, under the influence of classical design, by an opisthodomos, and the adyton was transformed into a sort of niche at the end of the central nave.

214

It is interesting to examine the elevation as a means of tracing the evolution of taste and ideas of proportion through the long period when the edifice was under construction. The colonnades on the east and north and part of the colonnade on the south still display the archaic features of Sicilian Doric; the slender columns are surmounted by a very wide echinus separated from the shaft by a necking band with a leaf moulding. In the columns dating to the middle years of construction (the western half of the south side) the echinus rises up more sharply and stiffly. Finally, the elevation has been given a supple classical profile in the column capitals of the west front. These columns have more massive shafts than the relatively slender older ones (diameter at the foot 10 feet 8 inches compared with 9 feet 9 inches).

The Apollonion at Selinus contrasts with the exuberance of the Ionian temples it was intended to rival. The technical skill and daring experiments of its designers make it one of the most outstanding products of architectural invention in Sicily and a triumphant assertion of the possibilities inherent in the Doric order. Freed from the constraint of set rules and often trying to lighten and render more flexible the strict relationships of forms and lines by the introduction of ornamental motifs and elements typical of East Greece, the Doric order in Sicily offers variety, suppleness, and charming details. In mainland Greece discipline was more strictly imposed, and it is only in the relations and interplay of the various parts of the plan that an evolution towards the classical rules of the Doric order is clear.

The Prelude to Classicism

In Athens divergent trends were in evidence. On the Acropolis the peripteral colonnade and the ornamentation of the Temple of Athena Polias were in the pure Doric tradition, whereas the sanctuary of Zeus to the south of the sacred rock was surrounded by an enclosure in which rose the mighty masses of a temple conceived in the manner and according to the plans of Ionian architects, if not in the Ionic style. The peristyle of Athena was modeled on that of Apollo in Corinth. The colonnade has the same rhythm, though it is slightly shorter (6 by 12 columns), with the intercolumniation wider on the façade (13 feet 3 1/2 inches in Athens, 13 feet 2 3/4 inches in Corinth) than on the sides (12 feet 6 inches in Athens, 12 feet 3 inches in Corinth), and the contraction at the corners is still more pronounced. As in Corinth the cella was divided into two rooms. But the use of Parian marble to crown the edifice (the tiles, the sima, and the cornice of the pediments), the sculptured ornamentation of the pediment and metopes, and the unbroken frieze on the façade of the cella mitigated the severity of the Corinthian model.

Pisistratos' sons wanted to challenge the Ionian tyrants on their own ground and began work in the sanctuary of Zeus—where their father had apparently already erected a peripteral Hecatompedon—on a building whose proportions and plan were inspired by the large dipteral temple that Polycrates had dedicated to Hera on Samos. This was the Temple of Olympian Zeus. The size (134 by 353 feet on the stylobate) and the conception of the colonnade (108 columns arranged in two rows on the sides and three rows of eight columns each at the ends) obviously derive from Ionian models. However, there are details that leave some doubt as to the actual intentions of the architects selected by Pisistratos, who, according to Vitruvius, were four in number: Antistates, Callaeschros,

252. DELPHI (MARMARIA), TEMPLE OF ATHENA. COLUMN, DETAIL.

Antimachides, and Porinos. In fact, if the irregularities in the intercolumniations of the façade, which recall those of Asian temples, do not seem to be in keeping with the rhythm of the Doric frieze, the proportions of the columns (lower diameter 7 feet 10 1/2 inches) and their closeness do not answer to the supple lightness of an Ionic entablature.

If the Athenian architects, like their colleagues, who designed Temple G at Selinus, attempted to transpose into the Doric style the great achievements of the Ionian masters, their efforts were not crowned with the same success, for the fall of the Pisistratid tyranny in 510 halted building operations when the first drums of the columns had been put in position and it is doubtful whether the finished edifice would have achieved the beauty and harmony of the magnificent masterwork at Selinus. It was not until the Hellenistic period, under the Seleucid kings, that work on the Temple of Olympian Zeus was resumed in the Corinthian style, to be completed still later in the time of Hadrian.

When the Delphians rebuilt the Temple of Apollo that had been destroyed in 548, they looked to Corinth for their model, as had the Athenians. But the plan of the interior had to be adapted to the oracular function of the sanctuary and the traditional cella altered to include the two essential natural elements, the crevice in the rock and the

216

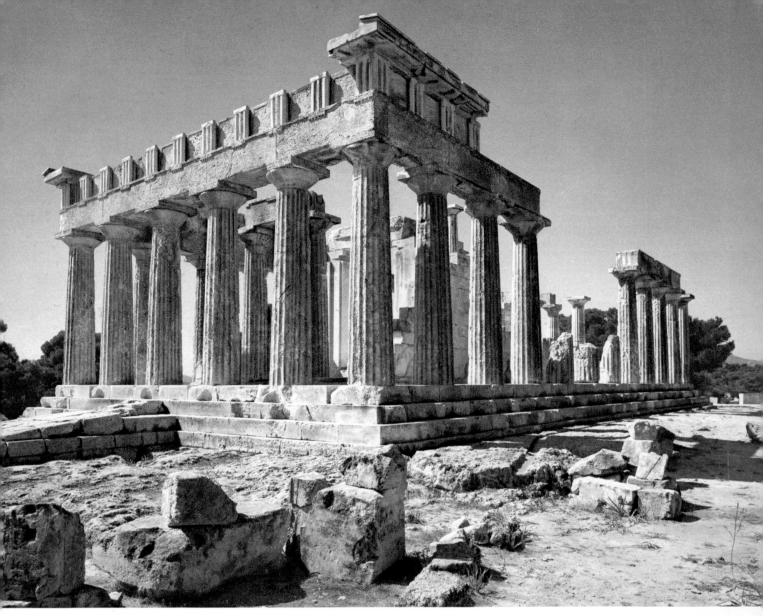

253. AEGINA, TEMPLE OF APHAIA. OVERALL VIEW.

sacred spring, which had been present at the birth of the Delphic oracle. Later transformations make it impossible to determine the solutions adopted at that time. The best we can do is to imagine the outer appearance of the temple. As in that of Apollo in Athens, marble cornices were associated with columns in tufa. The vigorous, full forms marked an evolution towards the classical style. This is also true of the new Temple of Athena at Delphi, which was built before the end of the century on the Marmaria terrace.

But the edifice whose state of preservation best enables us to grasp the most characteristic features of the late archaic style stands on a rocky spur on the island of Aegina. Surrounded as it is by a typical island landscape, it still sings the glory of Athena Aphaia in a colour harmony in which the pale gray conchitic limestone mirrors the green hues of the pines and is illuminated by the pale blue horizons of the Saronic Gulf.

217

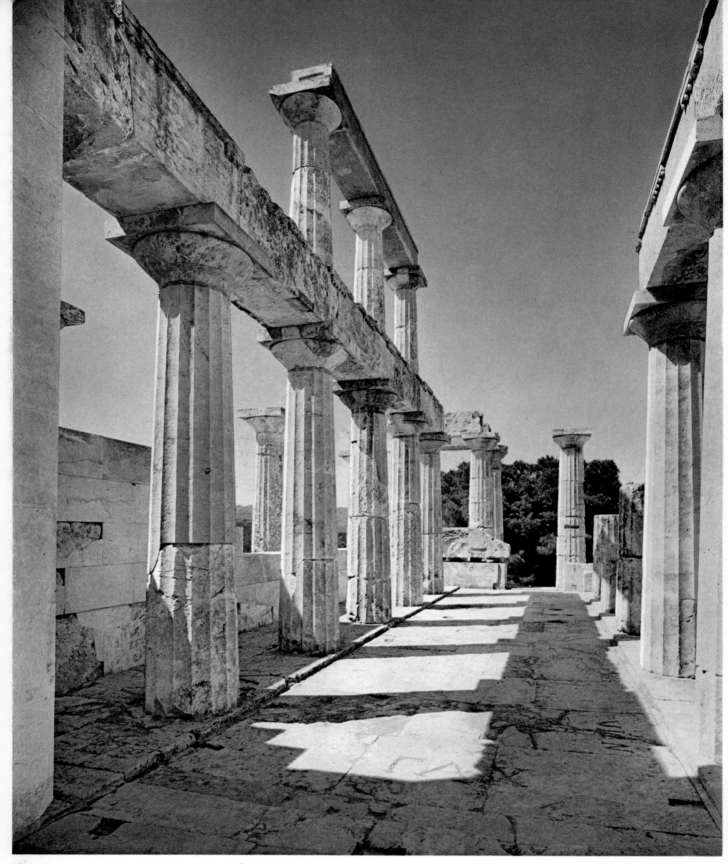

254. AEGINA, TEMPLE OF APHAIA. INTERIOR OF THE NAOS.

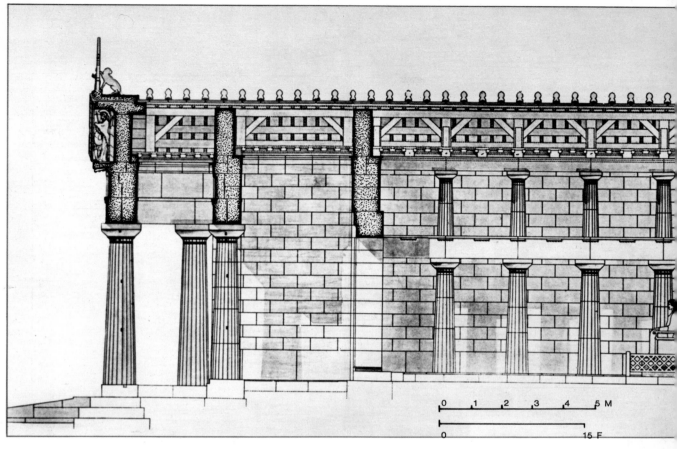

256. AEGINA, TEMPLE OF APHAIA. RESTORED SECTIONAL VIEW.

The brilliant light and the beautiful scenery of Aegina seem to have inspired the proportions of the temple and the elegance of its forms. Though relatively small (45 by 94 feet, with a peristyle of 6 by 12 columns), its harmonious proportions and full-bodied areas make it look more massive than it really is. The platform differs from the natural rock on which it stands only in the regular pattern of the joints between the squared stone blocks that form the stepped courses rising one above the other. The columns are tall and slender and still largely covered by the pale stucco that sheathed and protected the porous local limestone, besides offering the possibility of a sharper, more precise execution of the fluting. The heaviness or overemphatic sturdiness of some archaic columns has given place here to lighter shafts with soaring lines. In fact, the ratio of the height of the columns to the diameter at the foot of the shaft has greatly increased (from 4.15 at Corinth to 5.32 on Aegina; it will be 5.48 in the Parthenon). The supplely profiled capitals achieved a balance between architectonic function and plastic values, which was so short-lived that in the Parthenon we look for it in vain. The architect of the Temple of Aphaia declined to borrow a single element from the Ionic style. Here all is line and the regular interplay of surfaces and areas (see p. 373, fig. 434).

The cella was treated in the same spirit. Its classical plan includes pronaos and opisthodomos, each of which was entered between two columns *in antis*. It is divided into three

221

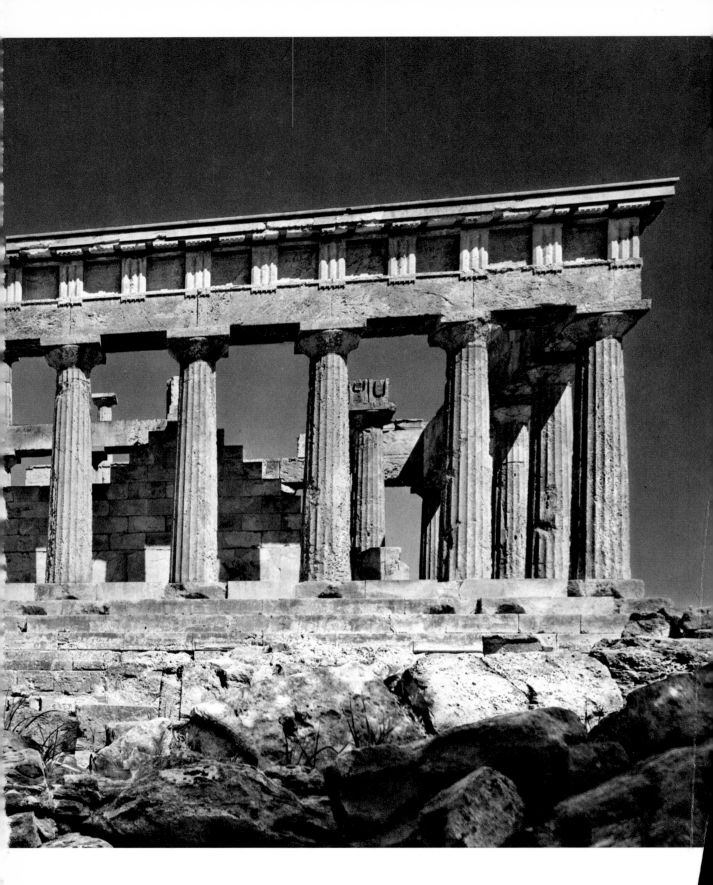

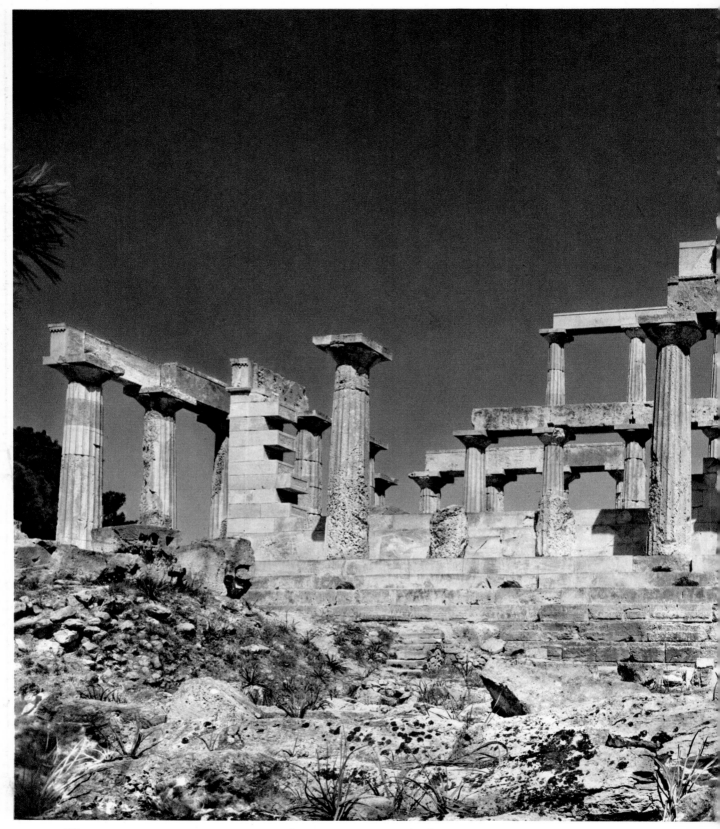

255. AEGINA, TEMPLE OF APHAIA. SOUTH SIDE (AFTER RECENT RESTORATIONS).

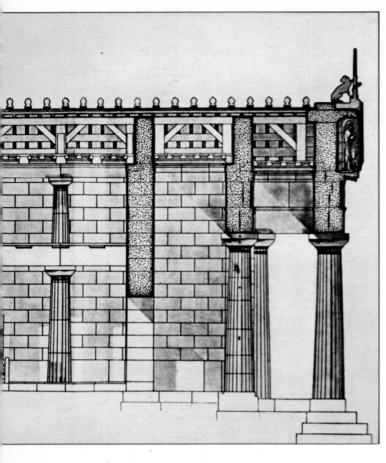

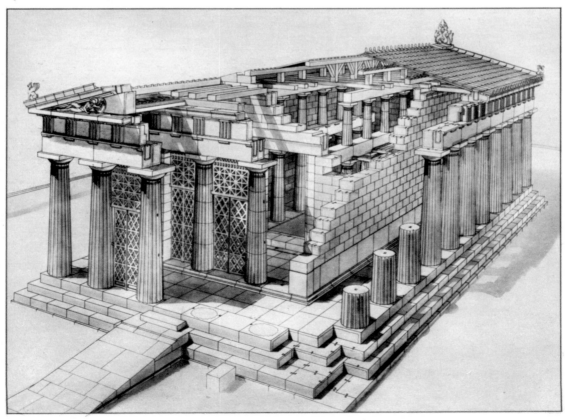

257. AEGINA, TEMPLE OF APHAIA. RESTORED CUTAWAY VIEW.

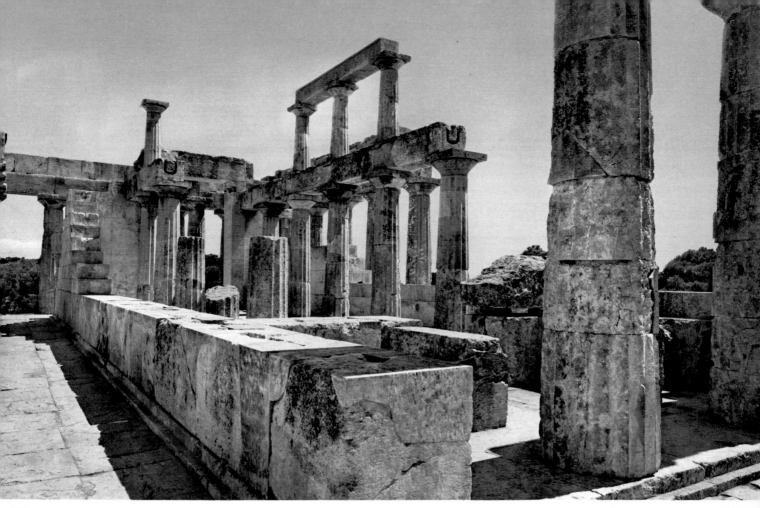

258. AEGINA, TEMPLE OF APHAIA. WALL OF THE NAOS, DETAIL.

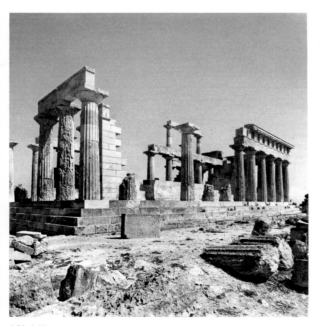
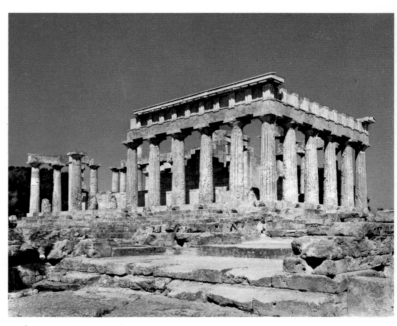

259-260. AEGINA, TEMPLE OF APHAIA. SOUTHWEST CORNER AND FRONT (AFTER RESTORATION).

223

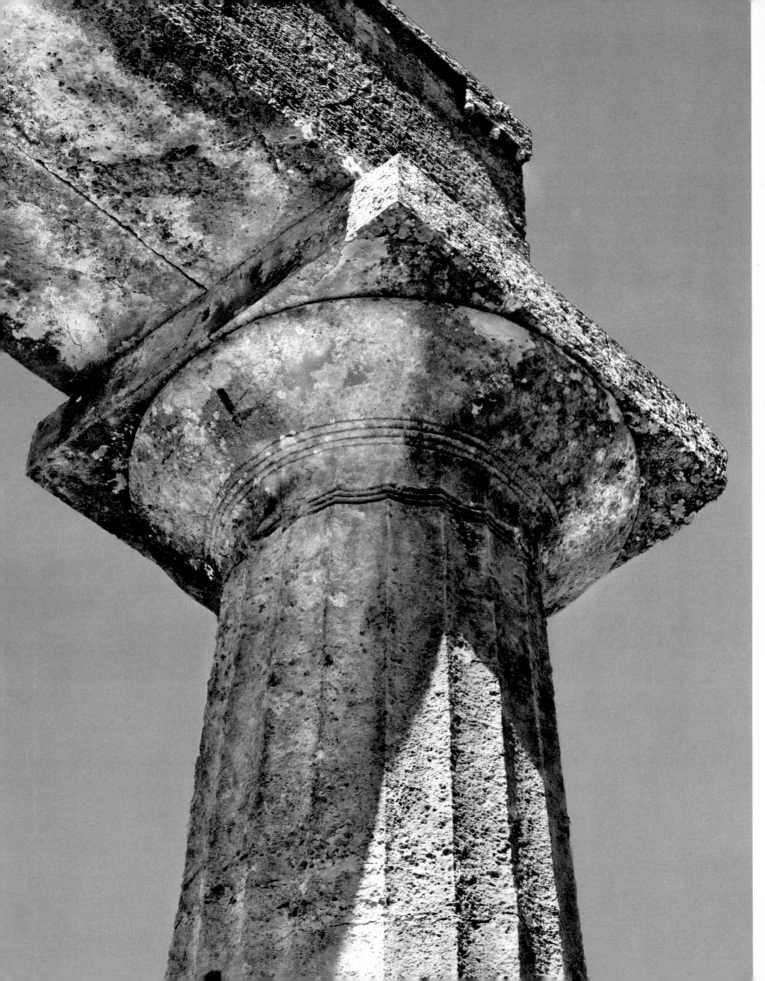

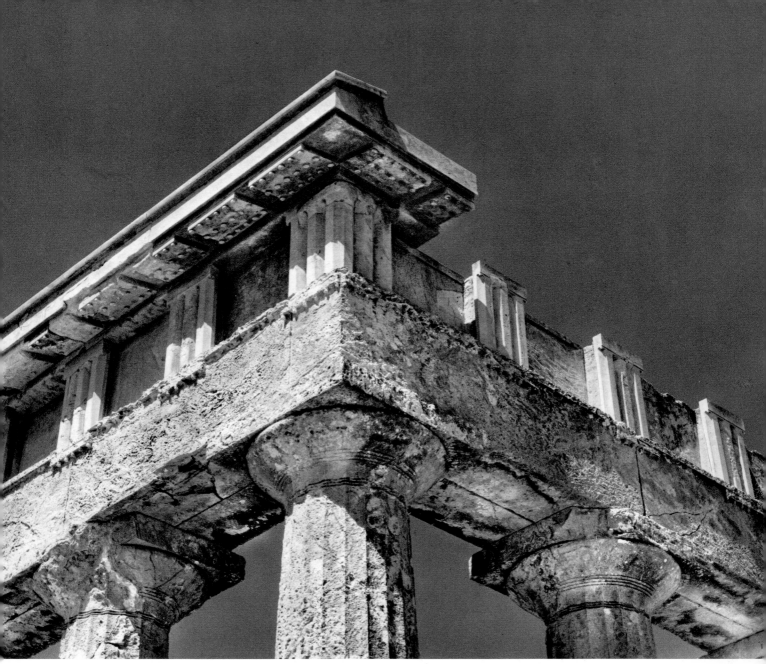

262. AEGINA, TEMPLE OF APHAIA. ENTABLATURE, DETAIL.

aisles, a surprising arrangement in so small a structure (see p. 373, fig. 435). In fact, the total inside width of the cella is 12 feet 11 inches—a narrow span that could have supported a simple timber roof. Why, then, were the two rows of five Doric columns each arranged in two stories in accordance with a rule that was followed without exception till the end of the fifth century? The function of the columns was less architectonic than ornamental: they developed and enriched the setting for the cult statue that occupied a central position in this handsome layout—in the central nave (10 feet wide)—and its importance was emphasized by a canopy calculated to break up a space whose proportions were too narrow.

225

261. AEGINA, TEMPLE OF APHAIA. CAPITAL.

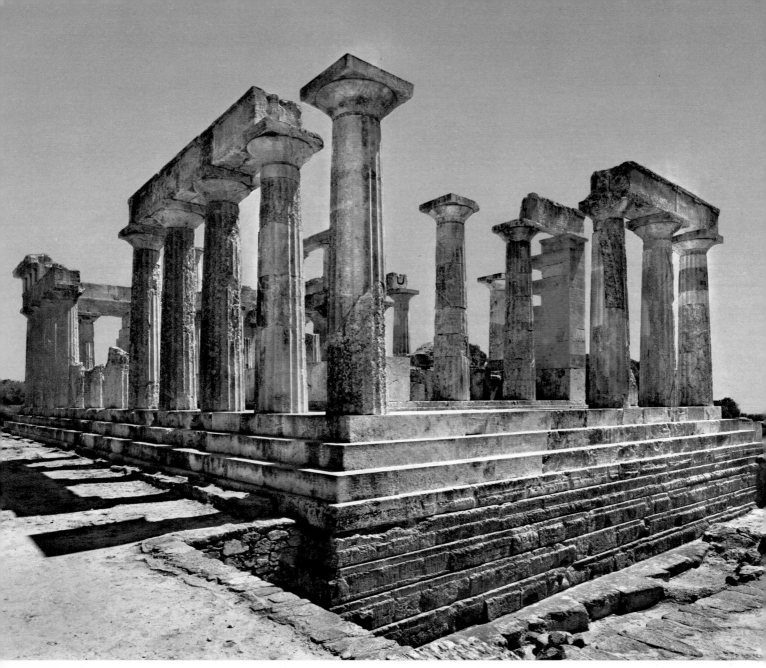

263. AEGINA, TEMPLE OF APHAIA, WEST SIDE. FOUNDATIONS AND PLATFORM (KREPIS).

Architectural and plastic values were closely associated and harmonized both outside, where the approaching visitor was greeted by the image of Athena on the tympanum of the pediment amid combats engaged in by vigorously modeled figures sculptured completely in the round, and within, where the cult statue was enveloped in an arabesque of columns.

The Temple of Aphaia on Aegina, like the treasury of the Athenians erected at Delphi immediately after the battle of Marathon, is a splendid example of the definitive achievements of the archaic Doric style. It has harmonious purity of lines and areas, a balance,

264. DELPHI, SANCTUARY OF APOLLO, ATHENIAN TREASURY. FAÇADE.

265. DELPHI, THE SACRED WAY DESCENDING TOWARDS THE ATHENIAN TREASURY.

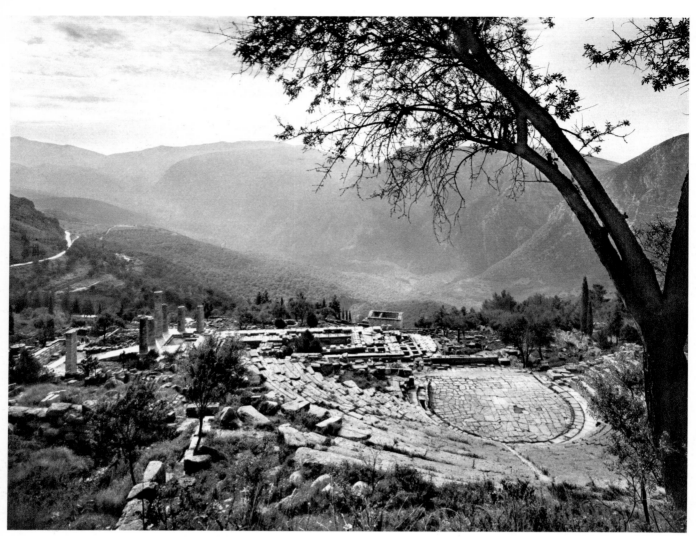

266. DELPHI, VIEW OF THE SANCTUARY FROM THE TOP OF THE THEATRE.

seldom attained elsewhere, between the proportions of the various elements of the order, and supple, vigorous capitals that have lost all archaic ponderousness but have not yet lapsed into the set patterns of an exaggeratedly geometrical classicism.

The extraordinary balance of grace and strength found in the major works of architecture at the end of the archaic period is a result of a feeling for plastic values that architects must have acquired by associating with sculptors. In that way they obtained a technical skill and a control of their materials which eliminated the clumsiness that can still be observed in the buildings erected during the period of research and experiment. Its harmonious lines make the Athenian Treasury at Delphi the best example of the late archaic style.

The development of these values and the taste for transposing plastic elements into an architectural context brought about the first experiments in design that marked the transition from the archaic to the classical age. On Aegina the lines of the landscape had

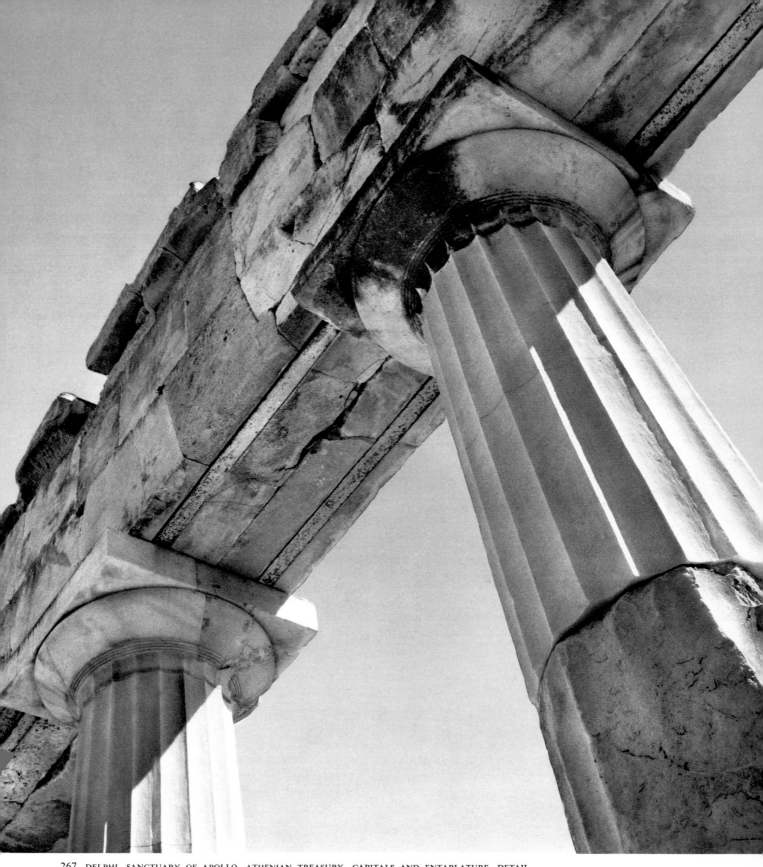

267. DELPHI, SANCTUARY OF APOLLO, ATHENIAN TREASURY. CAPITALS AND ENTABLATURE, DETAIL.

229

268-269. DELPHI, SANCTUARY OF APOLLO. POLYGONAL WALL OF THE TERRACE: SOUTHEAST CORNER OF THE POLYGONAL WALL ON THE SACRED WAY.

270. DELPHI, SANCTUARY OF APOLLO. POLYGONAL WALL AND INSCRIBED MANUMISSION RECORDS, DETAIL.

already suggested how the temple should best be sited and had fixed its relationships with the other structures, notably the propylaea and the altar. It was at this time that in the sanctuaries the entrance to the sacred precinct was given a monumental aspect as a foretaste of the more sumptuous quarters reserved for the deity. The temple was rendered conspicuous and singled out from the ancillary structures by its mass, its volume, and, in many cases, its ornamentation. At Delphi, where a number of minor constructions— treasuries, votive offerings, memorials, and trophies—had already encroached upon the sanctuary, large-scale works were undertaken with a view to integrating in the landscape the monumental platform on which the Alcmaeonid Temple of Apollo was to rise. Buildings were razed, terraces were laid out and linked with the contours of the terrain. They were designed in relation to the shape and even the colour of the grandiose backdrop formed by the Phaedriades through the construction of a long wall of polygonal masonry. We must try to imagine the wall as it was in all its massive strength before the arabesques of its joints and the bold effect of its blocks were concealed by the Athenian Colonnade, which later impaired both its value and its function.

In the Panhellenic sanctuary of Zeus at Olympia, the interplay of masses and areas is impressive enough without any reference to the landscape. The monumental masses of the buildings are arranged in great apparent disorder in an almost square enclosure bordering on the Cladeos at the foot of Mount Cronion. As everywhere else, one enters at a corner and as one follows the winding processional way, the impressive areas of the ancient Heraion, the Temple of Zeus, the terrace of the treasuries, and the antique installations of the Pelopion emerge one after the other from the medley of altars and votive offerings in bronze and terra-cotta. Areas, lines and colours, architecture and sculpture, mingle and jostle each other in an assemblage where each element lends importance to the others, demonstrating the force and vigour of the splendid burst of original creation and varied experiment that characterized the archaic period in Greece.

The movement thus brought about by a certain love of order and the urge to make the most of structures and areas was in the end fostered and accelerated by the political development of the city-states, which induced the first stirrings of the new-born art of town planning on the threshold of the classical age. Architecture, as a symbol of prestige, which at the end of the sixth century had provided rival tyrants with a means of self-expression, was not replaced but merely expanded by the public buildings that reflected the main trends of the new political and social forces now at work. That is how in Athens, about the year 500, the first features of the agora took shape on the west side of the vast hollow north of the Acropolis, and by degrees filled it completely. Temples and meeting halls, the Prytaneum, the enclosures consecrated to the new eponymous heroes installed by Cleisthenes, the first mint, and the monumental fountain houses were assembled in an architectural complex. Like the sanctuaries, it preserved its diversity yet formed at the foot of the rock sacred to Athena (henceforth exclusively devoted to religious purposes) the first collection of civic and sacred buildings that mirrored the political functions of the nascent Athenian democracy. Thus a novel type of architectural composition rose in the very heart of the city, forming its first monumental centre and focal point.

Side by side with religious architecture, civic architecture asserted its claims and extended the field in which the classical age was to reach the height of its achievement.

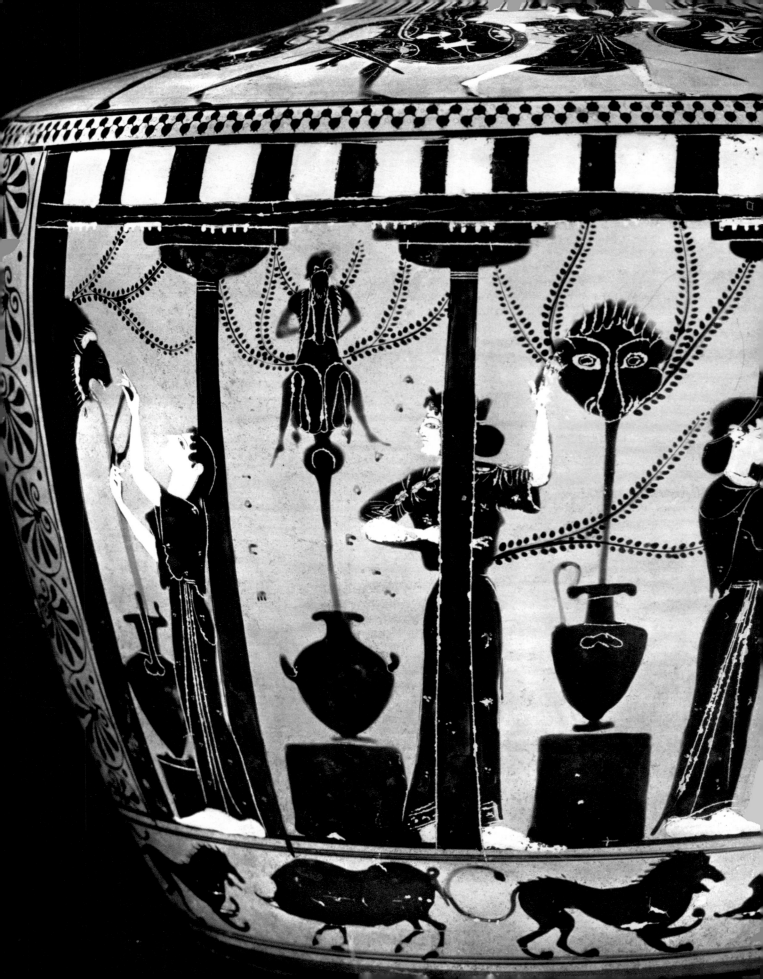

Sculpture

The Predominance of Attica

Athens asserted her artistic supremacy during the period from about 525 to the end of the sixth century, first under the Pisistratids and, after the two years of domestic struggles that followed their fall, under the democratic government set up by Cleisthenes. The threat of a Persian invasion in East Greece caused several sculptors from that region to seek refuge in Athens. Their presence and the works they produced there made such an impact on Attic art, right up to the closing years of the century, that it is no easy matter to distinguish among the host of seductive korai on the Acropolis those of Athenian from those of Ionian origin. The manner in which the sculptors treated the Ionian costume adopted by the ladies of Athens may help us to do so.

The study of the Ionian costume worn by the korai has given rise to lengthy discussions from which a few essential observations may be extracted. Like hair styles, both masculine and feminine, archaic drapery was first and foremost adornment and decoration aimed at stressing women's beauty and, second, a set of variations on a sartorial theme borrowed from real life, which may be attributed partly to fashion and partly to the sculptor's personal interpretation. In accordance with the same principle, the colours applied to the marble were not imitative but ornamental. Most of the korai wear a mantle and a tunic. The mantle may be arranged in different ways; it is seldom long and more usually takes the shape of a wide stole.

Let us compare two of the statues from the Acropolis that are both equally characteristic: Kore 682, which is undoubtedly a later copy of a model produced in the 520's, and Kore 671. The parallel commonly drawn between the face of the pseudo-Cnidian caryatid at Delphi (fig. 174) and that of Kore 682 makes us realize what is mannered in the latter's smile, which perfectly matches the refined artifice of her dress. In contrast to the provocative, almost caricatural Ionianism of Kore 682, the undoubtedly Attic style of Kore 671 is so firmly anchored in the previous period that she has been attributed to the Master of the Volomandra kouros. The rather unusual detail of the long mantle thrown over both shoulders, the vertical folds of the drapery, the simple hair style, all the signs of the plastic language combine to express the soberly elegant dignity of an Athenian lady, whose only concession to fashion is her smile.

233

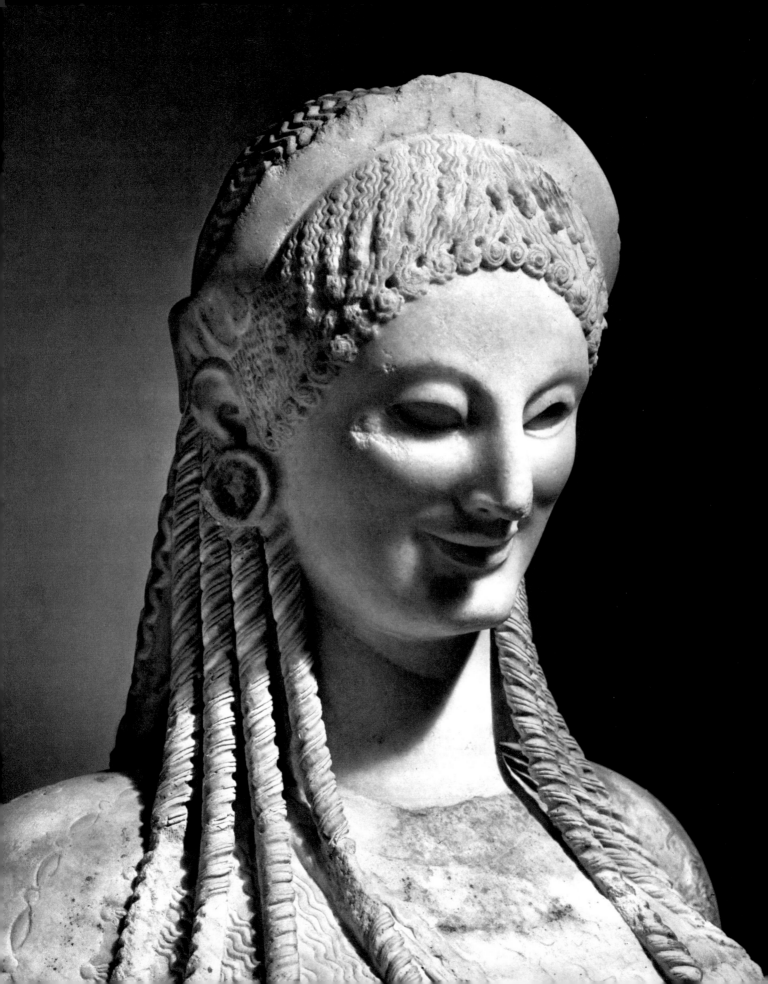

The same search for sobriety occurs again about 520, this time in Kore 681, Antenor's Kore, a figure whose authority and amplitude are unequaled in archaic statuary. Its height, about 6 feet 8 inches, gives it a permanent place in an aristocracy that had not renounced its privileges. The name of its illustrious author, which has luckily come down to us, confirms its significance. (Antenor, who worked in both marble and bronze, was called to Delphi a few years later by the Alcmaeonids to design the decoration of the tympanum of the new Temple of Apollo. And it was he who, after the fall of the Pisistratids, erected the statues of the Tyrannicides on the Acropolis.) By her matronly build, Antenor's Kore dominates her youthful companions. The display of such majesty demanded the use of Ionian dress. But the intentional archaism asserted in the hair style, the shape of the face, and the rendering of the drapery enabled the artist to proclaim the pre-eminence of the vigorously rounded body and the unity of its structure. Even the goffered folds of the mantle stress the living form by echoing the cluster of rippling folds raised by the left hand. Thanks to this splendid balance, a figure whose gestures are dictated by a convention at once mundane and ritualistic achieves the quality of a monumental composition.

About this time the sculptor of the Acropolis pediment—a pupil of the Rampin Master, perhaps—solved the problem of adapting human figures to a triangular space without resorting to animals or monsters to fill the corners. The choice of the subject, the battle of the gods and giants, enabled the artist to pay homage in the centre to both Athena and her father Zeus, as well as to vary the attitudes of the victorious gods and vanquished giants to suit the slant of the space available. Originally there were probably ten figures on the pediment, but only four have been preserved—Athena and three naked giants. Transposed to sculpture in the round, they demonstrate the progress that representation of movement had made in painting and relief. In addition, the asymmetry of the goddess's face, whose features have an almost classical design, reveals the study of the three-quarter view.

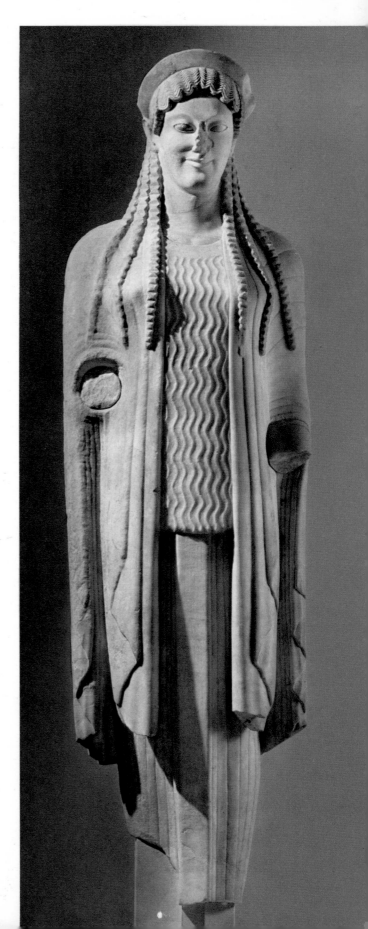

235

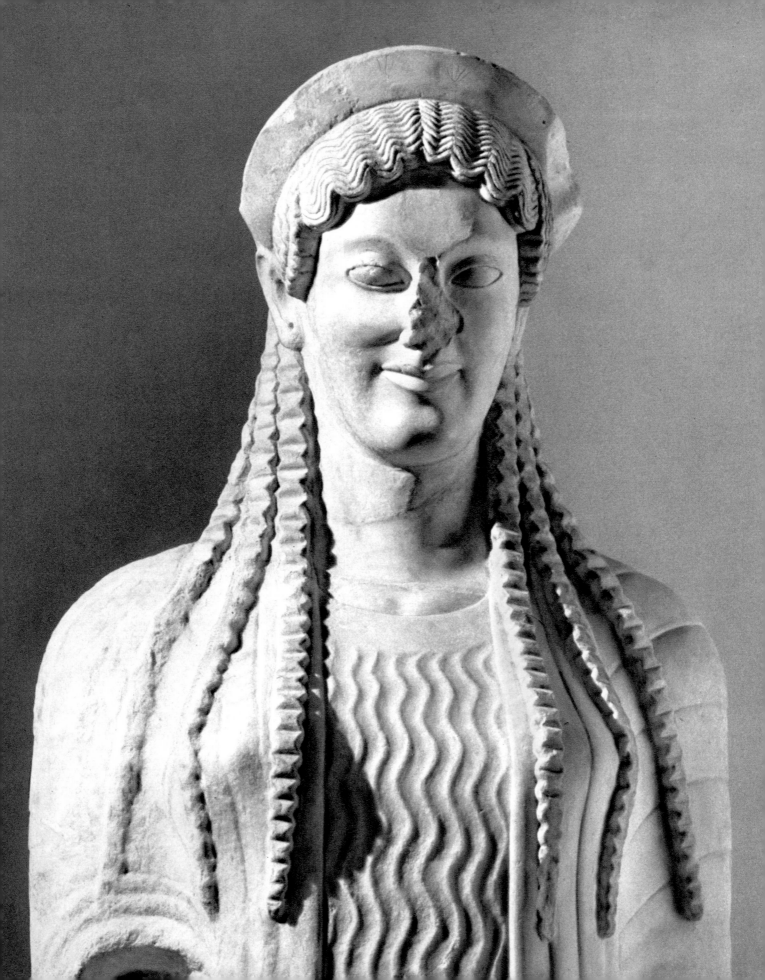

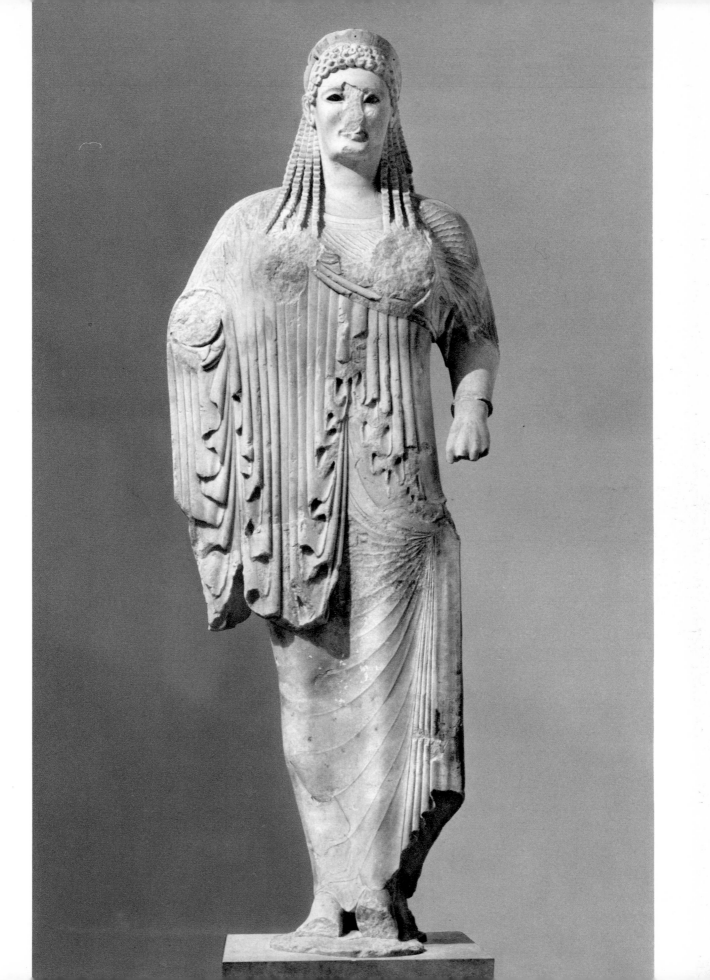

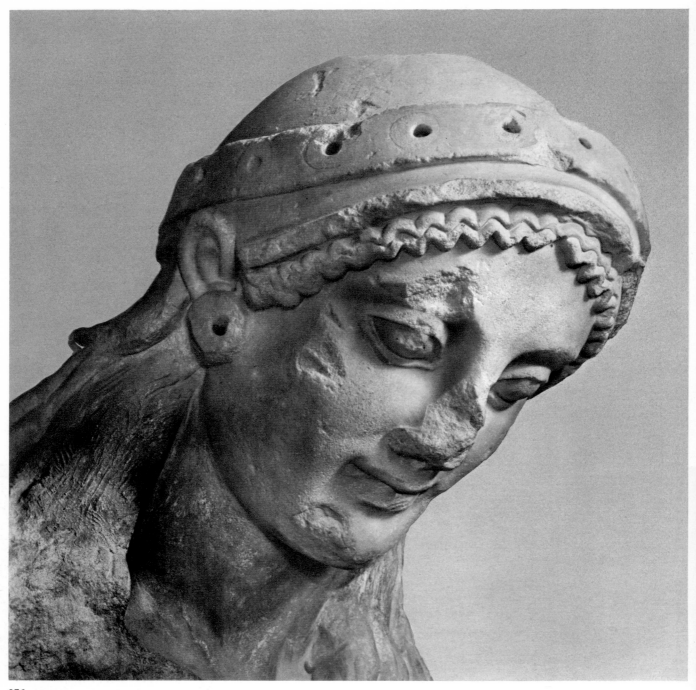

276. ATHENS, HECATOMPEDON. EAST PEDIMENT: ATHENA ATTACKING A GIANT, DETAIL. ACROPOLIS MUSEUM, ATHENS.

Another version of the Gigantomachy was represented on a larger scale on the west pediment of the Temple of Apollo at Delphi. Very little remains of these sculptures, which were executed in high relief in a friable stone. However, the goddess's impetuous stride, which creates an extraordinarily dynamic effect, has been preserved and enables us to form an idea of what the mythical melee must have looked like. On the pediment of

238

the main façade, Antenor, who may have designed the relief, has left his mark. The static composition here is in direct contrast to that on the west. It shows the epiphany of the deity—the frontal, pacific presentation of the Apollonian triad. Apollo, Leto, and Artemis are mounted on a quadriga surrounded by their attendants of both sexes—Charites and Curetes. The superbly stylized animals fighting in the corners are a deliberate survival from the decoration of the older temples on the Acropolis; their function was to stress the Alcmaeonids' loyalty to aristocratic traditions. Antenor conveyed the religious and political views of his patrons by the deliberately archaizing style of the large marble figures he sculptured in the round. Some of them have been partially reconstructed. The big kore, despite her different drapery, is a sister of the great lady on the Acropolis. She has the same ample curves set off by the tautly arranged, simplified drapery, which is conceived as an architectural element to be viewed from below and afar. In like manner, the Nike from the acroterium, solidly set atop the building, displayed her broad, stocky silhouette against the sky.

The west pediment of the Temple of Apollo at Eretria, which was erected about the same time or slightly later, is decorated with a battle of the Greeks and Amazons. A new, original detail makes the composition very interesting: instead of fighting a heroic duel, Theseus simply carries off Antiope. The sculptor thus had an opportunity to treat in the round a subject frequently represented in the past in vase paintings and to make a study of dramatic psychology in its various aspects. The two tightly clasped figures display at different angles the young woman's sad face and the hero's triumphant smile.

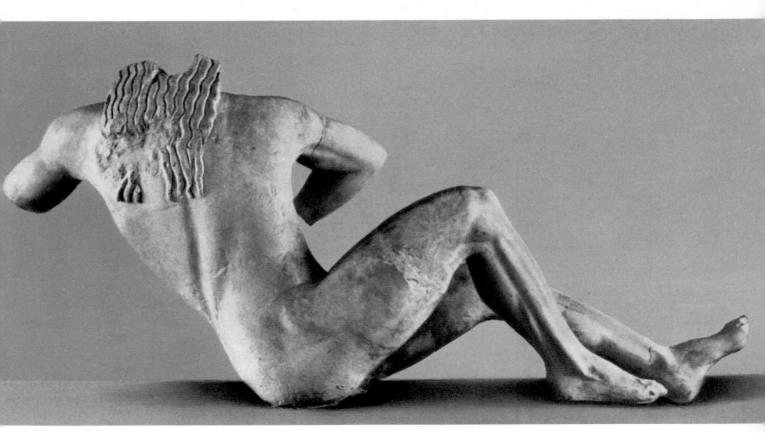

277. ATHENS, HECATOMPEDON. EAST PEDIMENT, DETAIL: A GIANT. ACROPOLIS MUSEUM, ATHENS.

278. DELPHI, TEMPLE OF APOLLO. EAST PEDIMENT, DETAIL: LARGE KORE. DELPHI MUSEUM.

240

279. DELPHI, TEMPLE OF APOLLO. ACROTERIUM: NIKE. DELPHI MUSEUM.

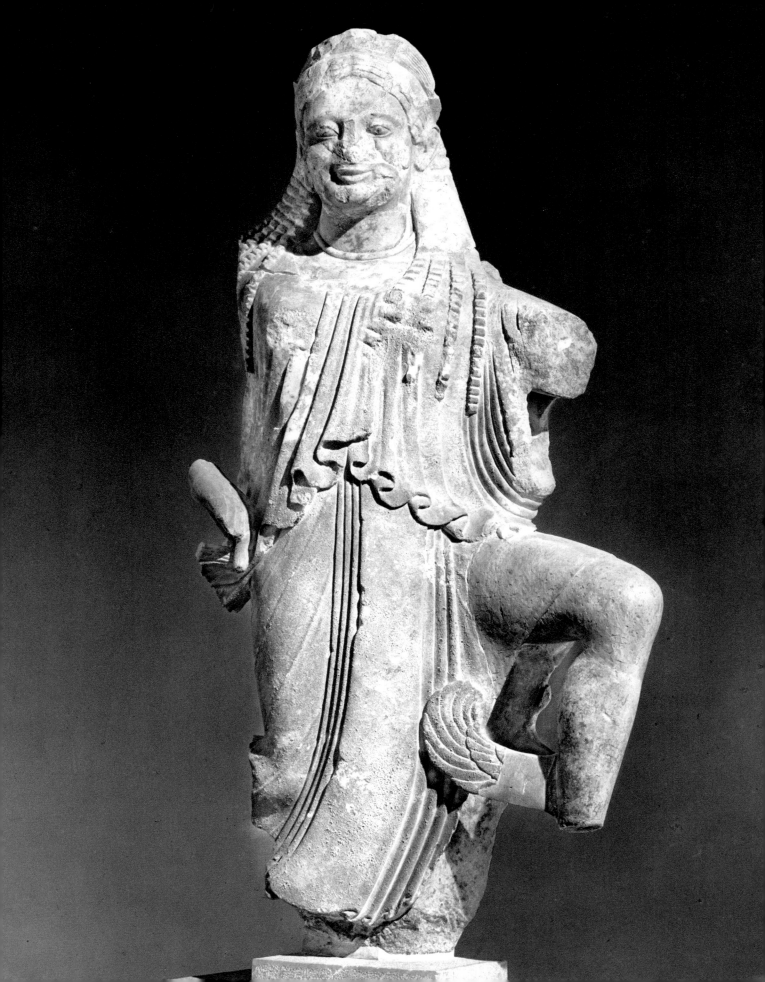

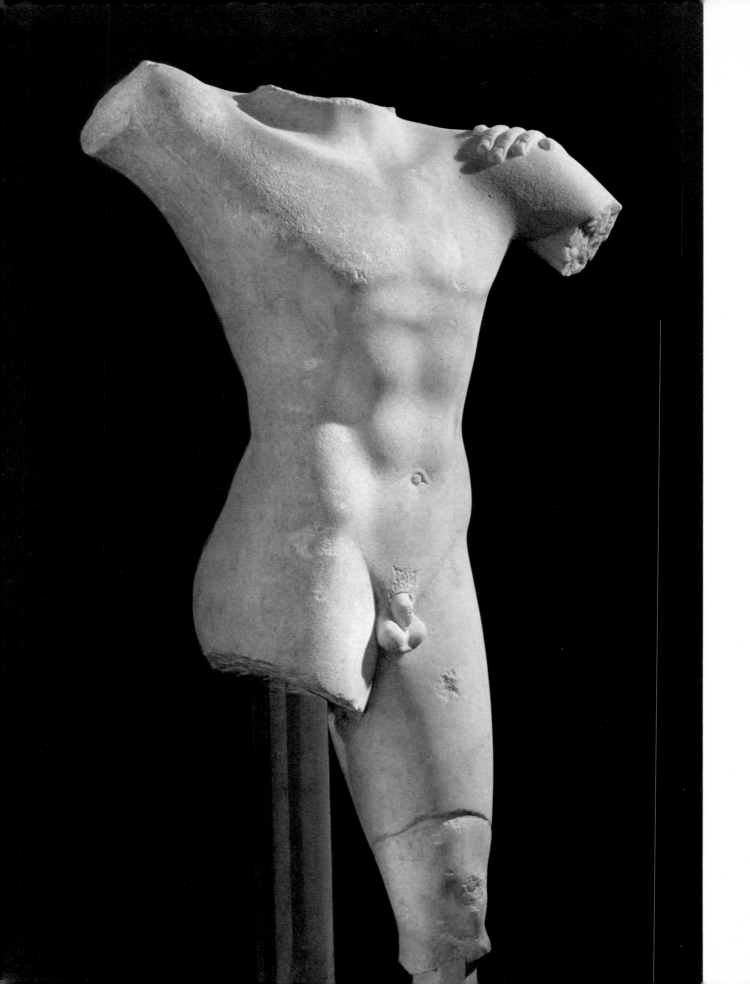

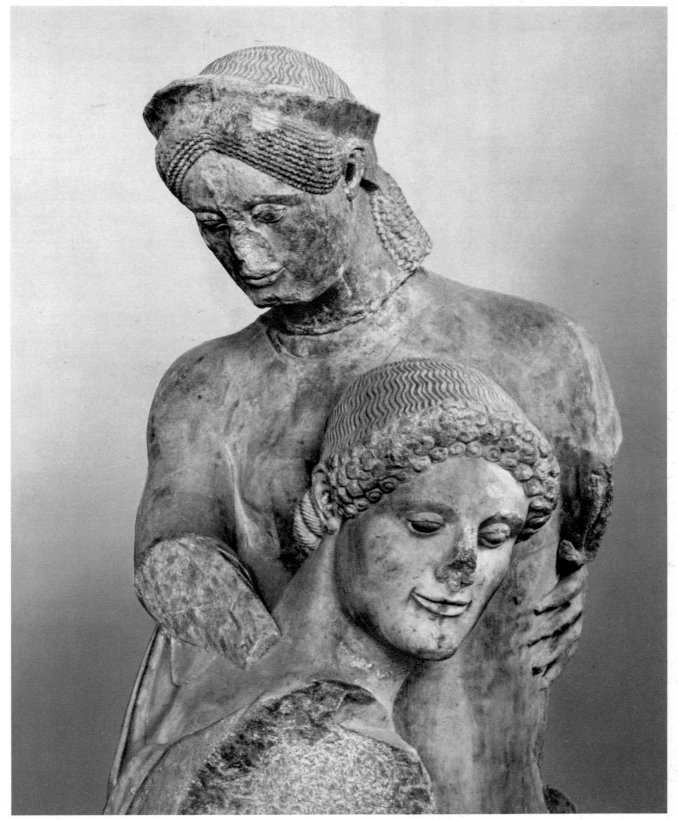

281. ERETRIA, TEMPLE OF APOLLO. WEST PEDIMENT: THESEUS AND ANTIOPE, DETAIL. CHALCIS MUSEUM.

243

280. ATHENS. NUDE MALE TORSO. ACROPOLIS MUSEUM, ATHENS.

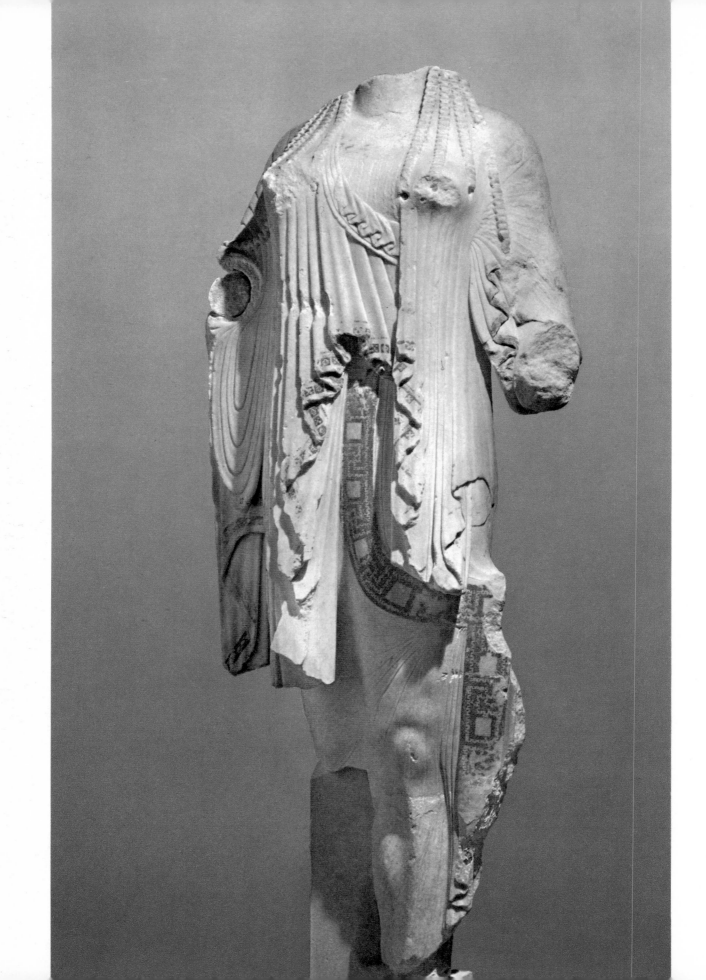

The daring arrangement of the group and the accuracy of the ornamental details suggest a connection with the north and east friezes of the Siphnian Treasury at Delphi. But other parallels may also be drawn, notably with the latest kouroi from the Ptoion. And Attic influence makes itself felt in the modeling of Theseus' torso, which closely resembles that of a fragment from a statue of the same hero found on the Acropolis, originally part of a free-standing group. In fact, the group from the Eretria pediment adds its invaluable testimony to that of the tympanum sculptures which bear the mark of two different Attic styles. It exemplifies the composite idiom that evolved from the repeated contacts, under the aegis of Athens, among artists who gathered in Eretria from every point of the compass during the last quarter of the sixth century.

But let us return to Athens, where one of the Acropolis korai, 675, contemporary no doubt with the Eretria pediment, affords the finest example of the survival of Ionianism in the sanctuary of Athena a decade or so before the end of the century. By a lucky chance this little statue still displays all its colours virtually intact. The sculptor probably came from Chios, like the marble for the statue. It sometimes happened that the wealth of ornamentation of Ionian drapery was so overwhelming that the shrouded body beneath it served merely as a support. What gives Kore 675 her peculiar quality is that, despite the bright colours, we can feel the presence of the body under the drapery, whose curved or slanting folds encircle the arms, mould the rounded breasts, and tighten to mark the slender waist. What is lacking here is the most precious achievement of Attic art—the expression of inner life. Kore 675 is a pretty, charming young fashion model and nothing more. Let us compare her with the Peplos Kore, which dates from twenty-five or thirty years earlier (figs. 119-20), or with Kore 670 of ten years before, simply dressed in a pleated tunic. The latter is all the more typical because it is not a very original work. The artist borrowed his vocabulary—the hair style, the almond eyes, the smile—from Ionian exemplars, but modified these elements in contour

245

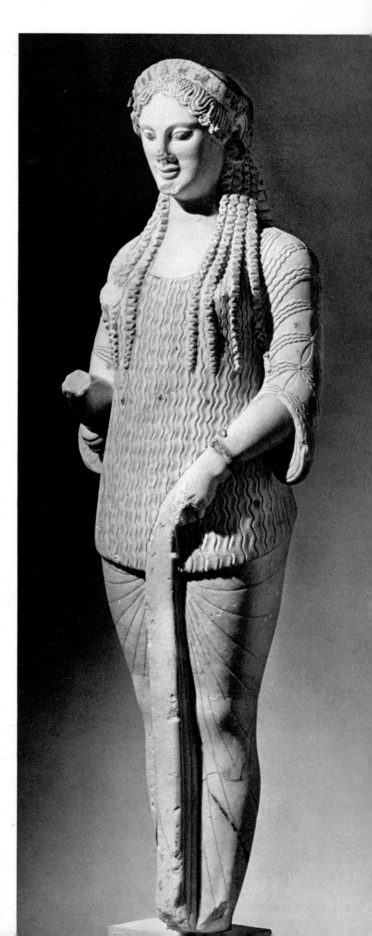

282. ATHENS. KORE 594. ACROPOLIS MUSEUM, ATHENS.

283. ATHENS. KORE 670. ACROPOLIS MUSEUM, ATHENS.

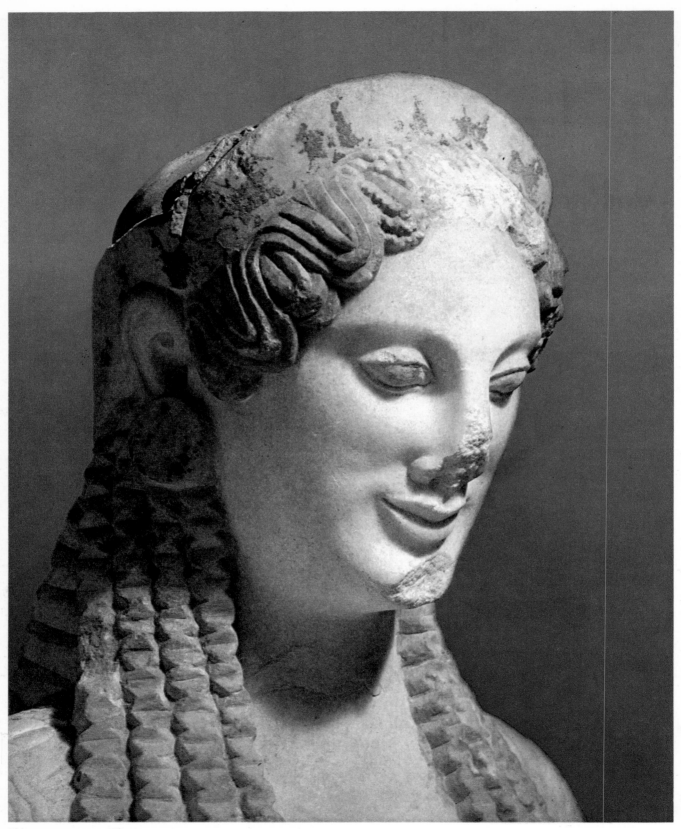

284. ATHENS. KORE 670, DETAIL. ACROPOLIS MUSEUM, ATHENS.

285. ATHENS. KORE 675. ACROPOLIS MUSEUM, ATHENS.

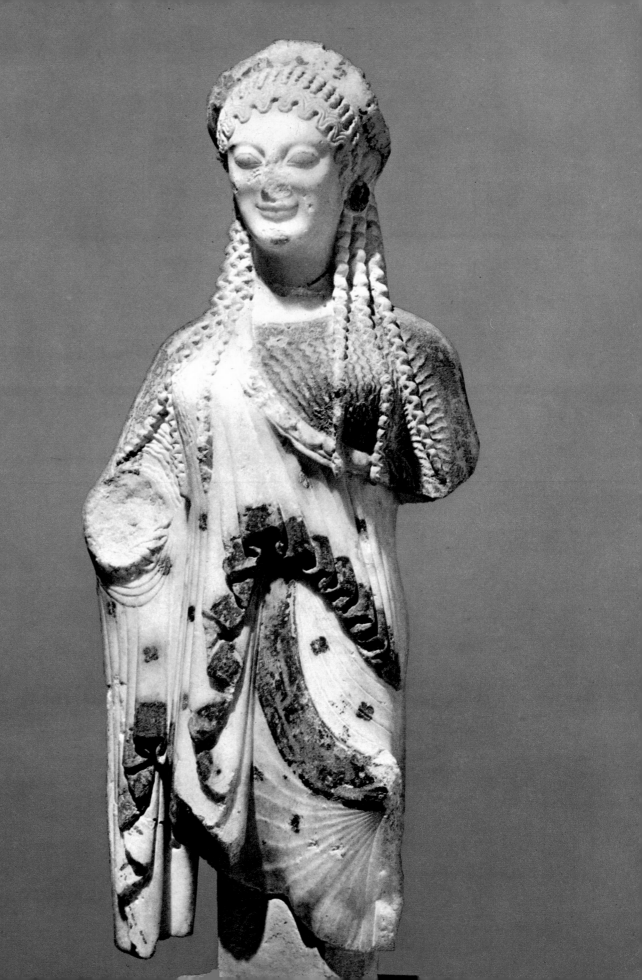

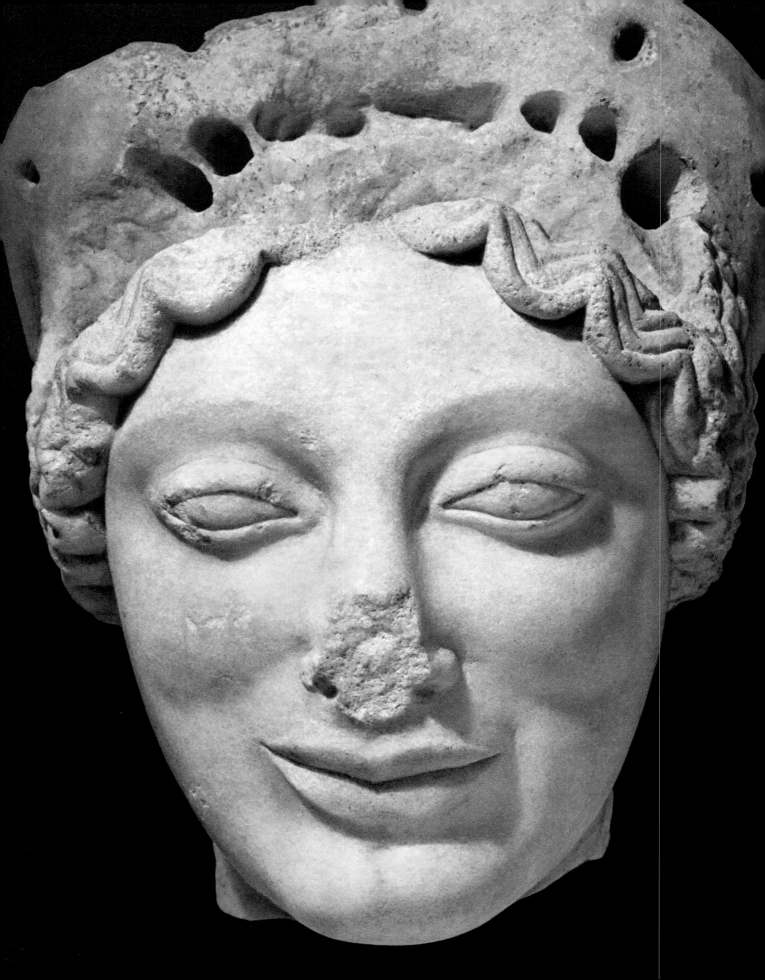

and thickness and set them in the oval of the face in such a way that their mutual relationships produce an ideal and mysterious harmony. It has been suggested that this image of a modest young girl, which prefigures the Ergastinai on the Parthenon, was a more or less direct portrait of a living model. And it is true that the most beautiful faces of Attic korai— those which are not, like some others, merely mediocre copies of genuine masterpieces—present, despite their superficial resemblance, a variety of shapes and expressions that is not merly the fruit of the sculptor's imagination. An exceptional instance of this is Kore 643. The face, under the loops of hair that crown it like two folded wings, seems imbued with poetry like a distant echo of Sappho's verse. So typically Attic in its openness to the light, so spiritually and physically individual with its slightly crooked smile, this face refuses to be considered simply a member of a stylistic family and rebels against the dawning severity of the age. This sobriety asserted itself not only in the disappearance of smiling lips, but also in the strict simplicity of drapery and ornamentation, thus paving the way for the aesthetic revolution that took place during the first twenty years of the fifth century.

The many korai produced by the Athenian workshops between 520 and 500 are only part—though indeed the most attractive part—of an output whose abundance and variety, particularly after the fall of Hippias in 510, was unequaled by any other centre of Greek art. There seems to have been a gradual disappearance of the kouroi more or less generally throughout the Greek world. One of the last was the Athenian Aristodikos, whom we shall meet at the beginning of the late archaic period. But a young man in festal apparel appears about 510 among the korai in the sanctuary of Athena. Wearing a tunic and long cloak, he is draped more simply than the others, but in a similar style. The appearance of a masculine type, often encountered in paintings and reliefs but not in statuary, in the religious environment where the kouroi still held sway, seems unusual. This event takes us back, at least in Athens, to the days of the Calf-Bearer (fig. 117). Eastern Ionia

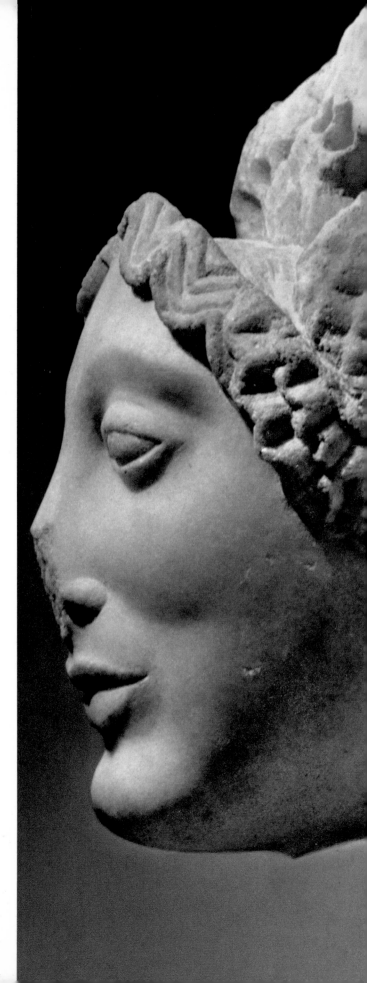

249

286. ATHENS. HEAD OF KORE 643. ACROPOLIS MUSEUM, ATHENS.

287. ATHENS. HEAD OF KORE 643, SIDE VIEW.

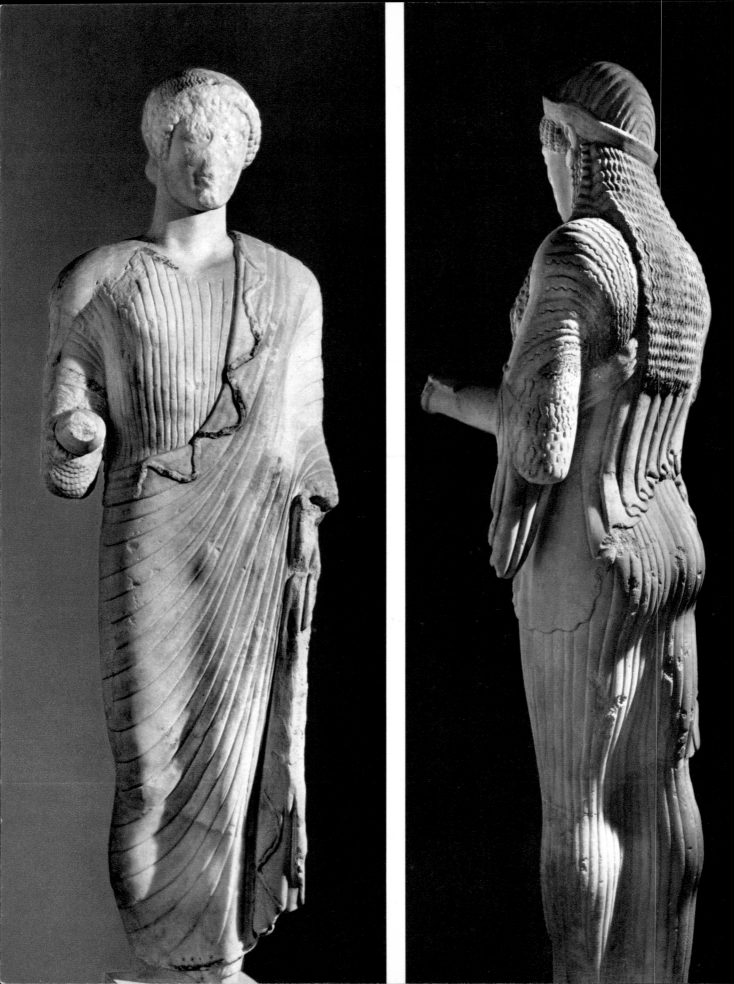

offers a suitable comparison and perhaps an explanation. Some statues of men, erect and draped, from Samos and the region of Miletus and Pergamon, as well as the seated statues of the Branchidae from Didyma and Aiakes from Samos, show greater individuality than do even those kouroi whose bases are marked with a name and an epitaph. A good example of this is the statue of Dionysermos, probably a Samian noble. Not only the Levantine, rather than Hellenic, facial type, but also the processional attitude, the heavy features and puffed cheeks, the air of self-satisfaction, prove that this was meant to be a portrait. This is not true of the distinguished young Athenian who, in the matter of style, has much in common with Kore 671. It is quite likely, however, that by presenting himself draped before Athena he was conforming to an Ionian fashion and wanted to mark his identity as distinct from the kouroi dedicated in the sanctuary of the goddess.

Of the many statues of seated gods and goddesses, all severely mutilated or almost totally destroyed, the most important and best preserved is one attributed to Endoios, a famous sculptor and traveler who worked in Athens notably during the last quarter of the sixth century. In the statue of Athena that he carved about 530 he abandoned the static pose that was traditional for statuary of that type. The withdrawn left foot, the movement of the arms, the bent head are indications of imminent action. To understand the novelty of this image one has only to compare it with the seated statues of Athena and Hera from the east frieze of the Siphnian Treasury at Delphi. Endoios was not only a sculptor but a painter and probably also designed reliefs. Undoubtedly the simultaneous progress made in the various techniques and the emulation that was one of the characteristics of the Greek temperament speeded up the advance of an art that was impatient to render the movement of life.

The reserve of power latent in archaic stylization, the forceful patterning that overflows and stabilizes the living element—Antenor exploited it with signal success—can sometimes be sensed in a minor work. For instance, there is the small bearded head of

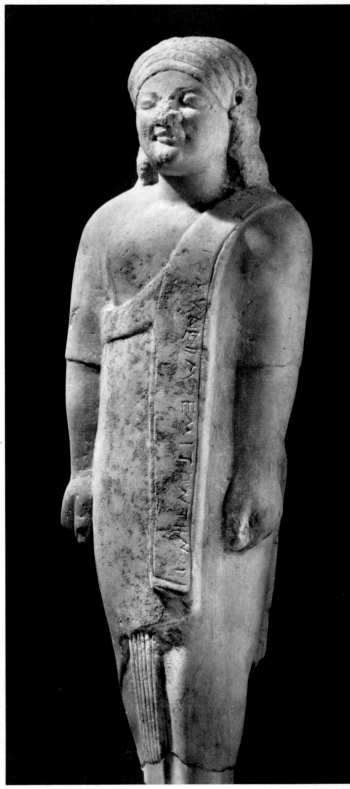

290. DIONYSERMOS. LOUVRE, PARIS.

251

288. ATHENS. CLAD FIGURE OF A YOUNG MAN. ACROPOLIS MUSEUM, ATHENS.
289. ATHENS. KORE 685, THREE-QUARTER VIEW. ACROPOLIS MUSEUM, ATHENS.

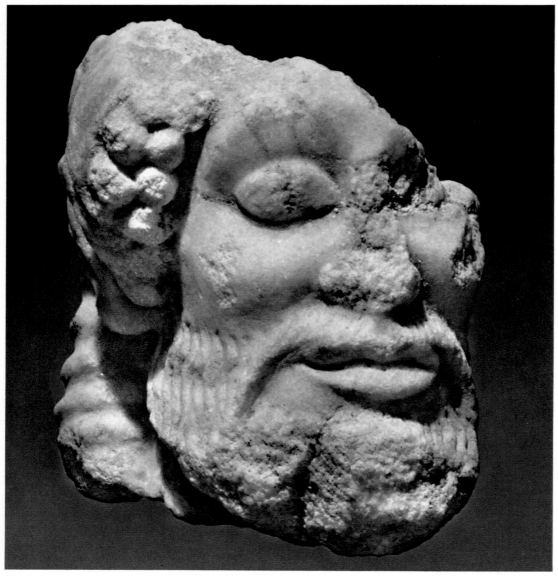

291. ATHENS. HEAD OF A BEARDED HERMES. ACROPOLIS MUSEUM, ATHENS.

Hermes, once placed atop a pillar on the Acropolis, whose features were designed to express the tutelary presence of the god. That, in fact, was the purpose of these modest monuments, which were scattered throughout town and countryside and even during the classical period preserved an archaic type intensely charged with elemental life.

Conversely, the power of observation was constantly renewed and enriched in representations of the horse which, whether bare, mounted, or harnessed, was a favourite subject with Attic painters and sculptors and interested the East Greek workshops no less than those in the Peloponnesus and Magna Graecia. In the Acropolis Museum we can trace the progress of research on this theme in Attic statuary from the early days of

252

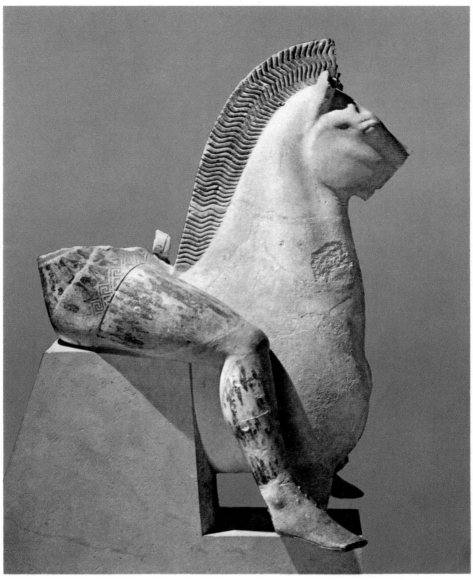

292. ATHENS (?). ATHENIAN HORSEMAN IN SCYTHIAN COSTUME. ACROPOLIS MUSEUM, ATHENS.

the Rampin Master to the beginning of the fifth century. When an artist studied the horse with a view to reproducing its image in a drawing or sculpture, he was far less inhibited by social or ritual conventions than in the case of the human figure. Ornamental stylization was confined almost exclusively to the design of the mane. Where the style makes its mark, as we have seen in the Siphnian Treasury, is in the choice of attitudes and the accentuation of the forms that express the animal's qualities. These latter may, indeed, be rendered in the same terms as human virtues, all the more so because it is the rider who passes them on to his mount. In fact, in the close union of horse and rider, realized with increasing precision in Attic sculpture, not only the attitudes but also physical forms harmonize:

253

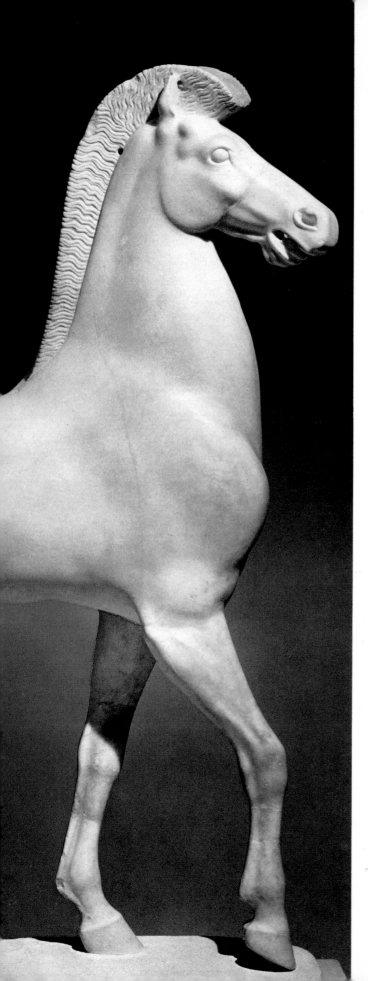

the man's limbs and muscles are integrated with those of the beast. Horse 697, neither harnessed nor mounted and better bred than the Scythian horseman's steed, is portrayed bare and unconstrained. The head, whose bone structure can be glimpsed under the rippling muscles, is designed with a knowledge inspired by the perfect understanding between man and beast. This horse is the ancestor of those of the Parthenon. It even excels them, because it possesses the same strength and spirit that quicken the splendid torso of Theseus on the Acropolis, even if it was not carved by the same hand.

In this series of sculptures dedicated to the glory of the horse we look in vain for a rider worthy of his mount. This lack is a result of acts of vengeance perpetrated by barbarians and by the Athenians themselves. Sole survivor is a small torso which, like Kore 673, has quality though it is a minor work. The long almond eyes drawn out towards the temples and the smiling lips reveal the hand of an Ionian artist, while the movement of the head and upper body shows us two things. In the Rampin Horseman's face we observed a slight asymmetry due to the movement of the head towards the left shoulder. Here, clearer and more marked, the face is linked with a contraction of the shoulder and the muscles on the left side of the chest. This indicates that the figure belonged to a group of two riders and is a very clear example of one of the major inventions in Greek art. Formerly, faces had always been represented either frontally or in profile. Here the daring deformation has created an intermediate form halfway between the two; it conveys an angled view of the inclination caused by movement.

The horses on the Acropolis were imitated far and near. For instance, the forepart of a winged steed on the island of Thasos proves that Attic influence was felt there before 510. But the horse was not the only animal that held the attention of Athenian sculptors; other species were attempted, too. About 520 and immediately after, the Hecatompedon workshop excelled in animal sculpture. The lion-head waterspouts of that temple were not treated as mere conventional ornaments but with the

254

293. ATHENS. LED HORSE 697. ACROPOLIS MUSEUM, ATHENS.

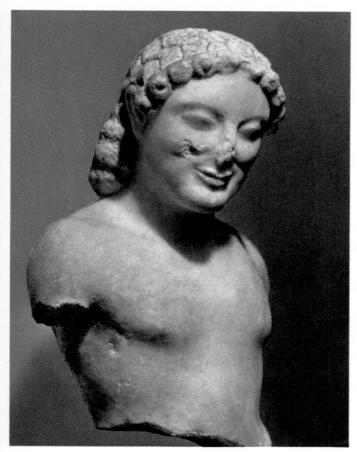

294. ATHENS. TORSO OF A HORSEMAN. ACROPOLIS MUSEUM, ATHENS.

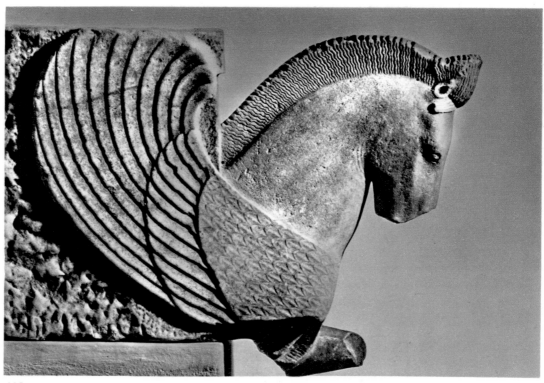

295. THASOS, HERACLEION. FOREHAND OF A WINGED HORSE. THASOS MUSEUM.

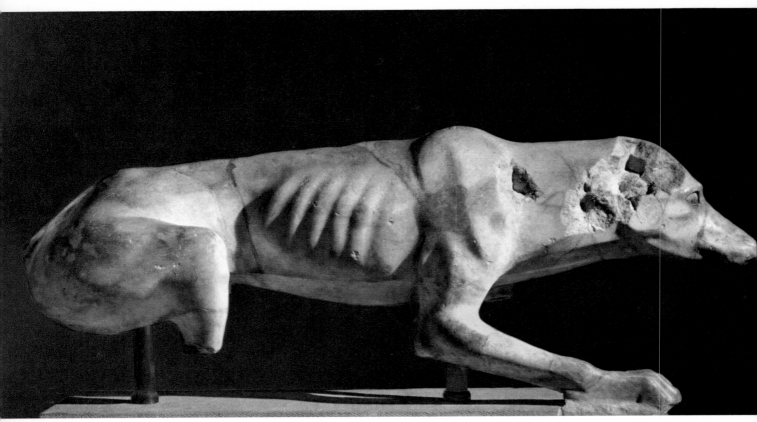

296. ATHENS. HOUND. ACROPOLIS MUSEUM, ATHENS.

same care and in the same style as the male nudes of the Gigantomachy on the pediment. And it has also been noted that the same method of working and polishing marble was employed for the pair of hunting hounds that were very likely an offering to Artemis Brauronia, the mythical bear transformed into a huntress, in her sanctuary on the Acropolis. Though dogs and horses were familiar animals in Greece and their movements and anatomy could be observed daily, this was not true of the lion, whose symbolic and ornamental image had reached the Greek world from the East in pre-Hellenic times. In the numerous representations of lions in archaic sculpture, including the traditional group of the lion devouring its still living prey, the artist's imagination, assisted by his observation of domestic animals, renovated motifs borrowed from abroad. There is reason, however, to believe that in Asia Minor the proximity of hunting grounds and the residences of kings or satraps offered the possibility of studying and rendering the natural attitudes and expressions of wild beasts in captivity.

In Attica during the last ten or fifteen years of the sixth century the technique of relief sculpture attained an unequaled degree of perfection. This was partly because of the example set by artists from other centres of artistic activity, particularly the islands where the finest marble was worked. Nonetheless, virtually all the reliefs discovered on the Acropolis and in the Kerameikos cemetery seem to bear the imprint of an Attic origin.

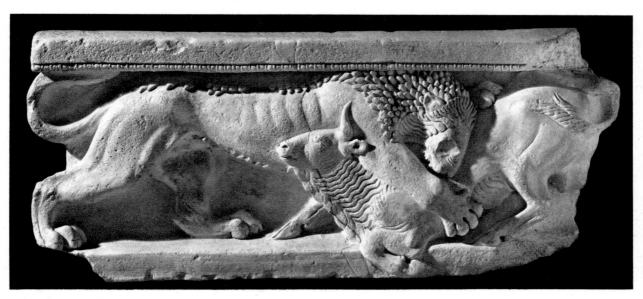

297. CENTURIPE. ARULA: LION ATTACKING A BULL. MUSEO ARCHEOLOGICO NAZIONALE, SYRACUSE.

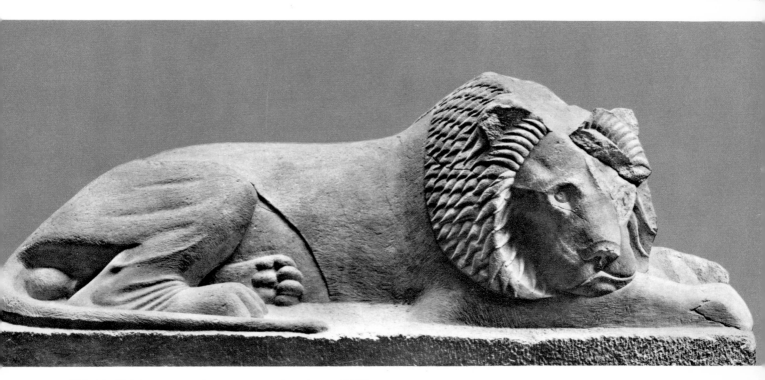

298. MILETUS. RECUMBENT LION. STAATLICHE MUSEEN, BERLIN.

257

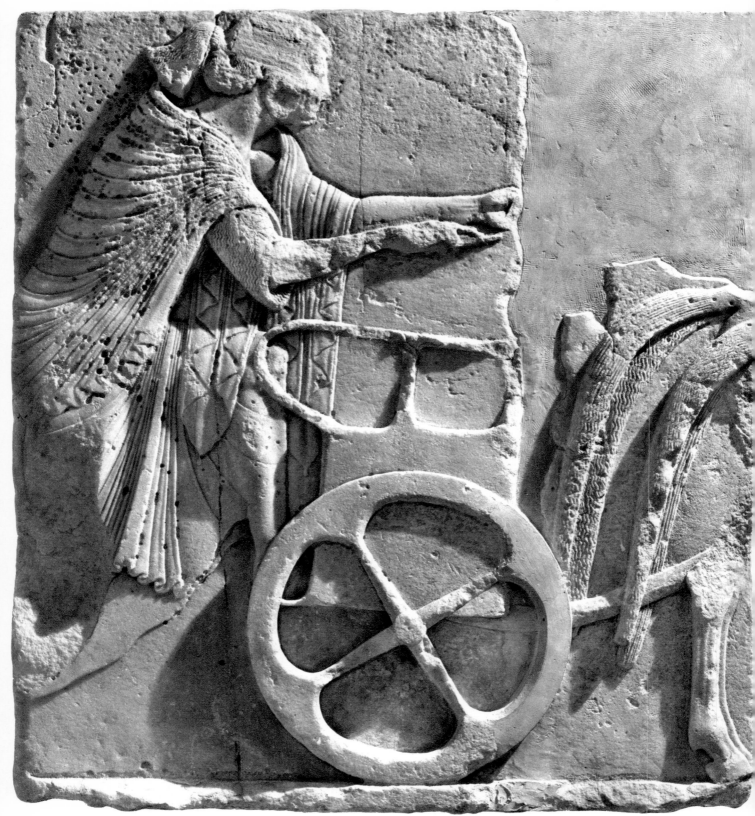

299. ATHENS. RELIEF: GODDESS STEPPING INTO A CHARIOT. ACROPOLIS MUSEUM, ATHENS.

This is proved by comparing style and detail with the red-figure vases painted by the masters of Attic pottery. These comparisons, together with the evidence of technique, disprove the theory that some fragments of a frieze which seemingly prefigured that of the Parthenon can be attributed to the Hecatompedon. In fact, this frieze with the splendid figure of a goddess mounting a chariot came from an edifice we know nothing about. The relief of the goddess, which dates from the last decade of the sixth century, is admirable for its amazing delicacy of design and for the impression it gives of drapery waving in a real space, divided into four distinct planes, when in reality its recession is only a matter of inches. Less skillfully graduated, partly because of their simpler subject matter, are the reliefs on gravestones, which were the heirs to a long tradition. The quality of the Aristion stele, the most famous of them all, has undoubtedly been overrated because it is both well preserved and signed by an artist named Aristocles, who is known from two other signatures. The work cannot be faulted from the technical viewpoint. The placing of the silhouette, the depth of the carving, the meticulous design of the details have been very carefully calculated. The alignment of the fingers and ringlets is perfect; not a hair of the beard or a pleat of the tunic is missing. But there is neither unity nor life here; each element was treated separately in accordance with the workshop recipe. For all the fame he seems to have enjoyed among his contemporaries, the artist is not of primary interest here; it is the danger, which threatens an overrefined art, of finding satisfaction in perfection.

When we examine the slightly earlier hoplitodromos stele or the slightly later palaestra reliefs from the Dipylon, we feel that freedom of invention and the joy experienced in a genuine contact with life had not entirely disappeared. The carver of the votive relief of the hoplitodromos, winner of a race for armed men, invented a type of stele that widens out from top to bottom in order to make room for the runner's outspread legs. The broad crescent of the helmet crest is framed by the coiling volutes of an Ionic capital, while the ideogram of the running

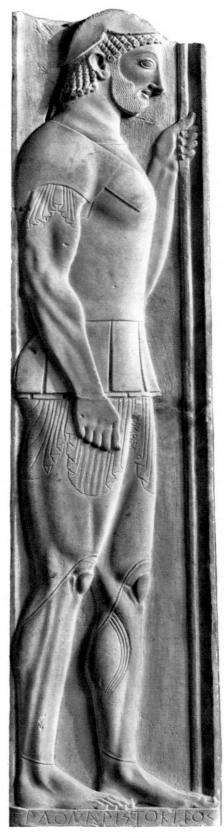

300. ATTICA. ARISTION STELE. NATIONAL MUSEUM, ATHENS.

259

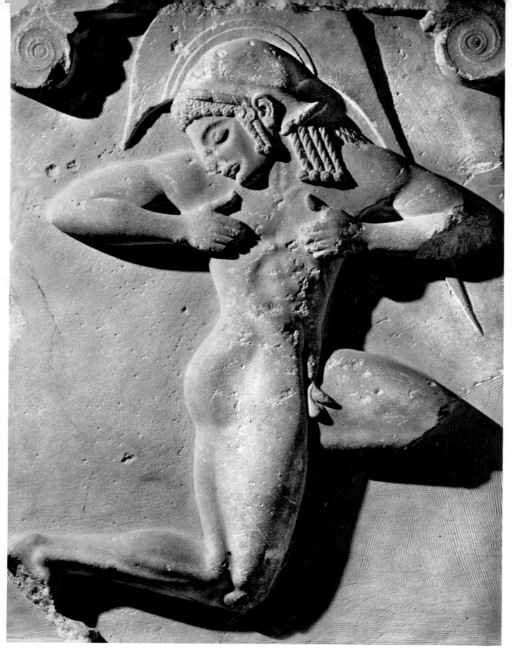

301. ATHENS. HOPLITODROMOS STELE. NATIONAL MUSEUM, ATHENS.

figure exhibits frontally the rhythmic swing of arms and legs. It is hazardous to attribute this composition to Antenor, as has been done, but only a great sculptor could have adopted a conventional design whose import was obvious and breathed life into it for the purpose of harmoniously filling the cramped surface of a stele. It would have been a mistake to imitate the runner's actual movements—though that was done during the classical period—for that would have made him run out of the frame. An example of this can be seen in the figure of one of the athletes on the relief with the ball game, the third man from the right. Rushing towards the left, he stops in his tracks and looks back over his shoulder. The attitude, though more realistic, is the same as on the hoplitodromos

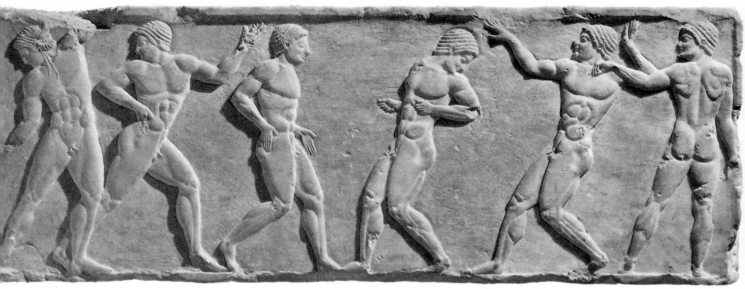

302. ATHENS. STATUE BASE: BALL GAME. NATIONAL MUSEUM, ATHENS.

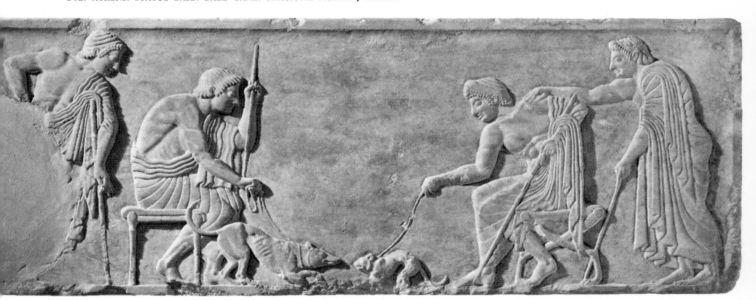

303. ATHENS. STATUE BASE: CAT AND DOG FIGHT. NATIONAL MUSEUM, ATHENS.

stele, but the intention is entirely different. The difference between the stele and the reliefs on the statue base can be compared to that between an epigram and a lyric poem. On the base the athlete's life is evoked in three stanzas, in honour of Athenian youth, modulated on the rhythm of the day's hours. The lost statue must have portrayed a young aristocrat carried off before his time. The movements of the ball players are governed by an extremely lively rhythm, and their positions are faithfully rendered. Here again we find the archaic formula of showing torso in front view and legs in profile, but some of the figures are presented in three-quarters view or in virtually total profile. Though the bodies of these athletes are depicted in all their muscular vigour, their lissom grace makes

261

the game look more like a ballet than a sporting contest. This should not surprise us, for the flute player too had his place in the palaestra. Some of the gestures are portrayed with an elegance that borders on mannerism. We can see the result when carried to extremes in some vase paintings from the period of the Leagros group.

It will be noticed that in the ball-game relief, as in the diverting picture of four young men amusing themselves during the rest interval by setting a dog at a cat, the perfectly balanced, convergent composition is enclosed in a frame like those on pediments. The ease with which the actors in these little scenes move about and enjoy themselves without a thought of the spectator reflects a cultivated society that displayed its poetically idealized image quite unselfconsciously. The charm that emanates from these reliefs owes much to the surviving traces of the archaic style in an art that was tending more and more towards a direct vision of reality but had not yet given up graceful smiles, almond eyes, beaded strands of hair, and formal postures.

The hockey players who adorn another statue base executed some ten years later reveal scarcely a trace of this late archaic charm. The flatness of the silhouetted figures betrays an unsuccessful attempt to project on a flat surface a vision too theoretically realistic. On the other hand, the cleverly calculated empty space in the centre and the overlapping of two figures at each side of the panel denote a bold effort to render spatial depth. I am inclined to think that the sculptor found his inspiration for the players on the left in the group of Tyrannicides executed by Antenor about 506 and carried off by the Persians twenty-five years later. These works enable us to form a good idea of the artistic activity in Athens during the fruitful years just before and just after the turn of the century.

Incidentally, there is a votive relief on the Acropolis that may perhaps be viewed as

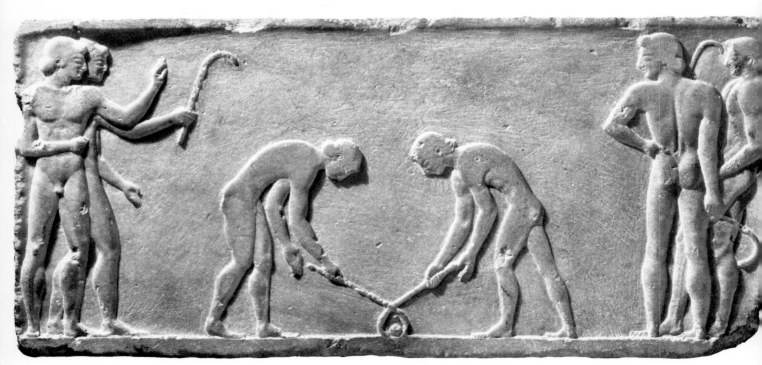

304. ATHENS. STATUE BASE: HOCKEY GAME. NATIONAL MUSEUM, ATHENS.

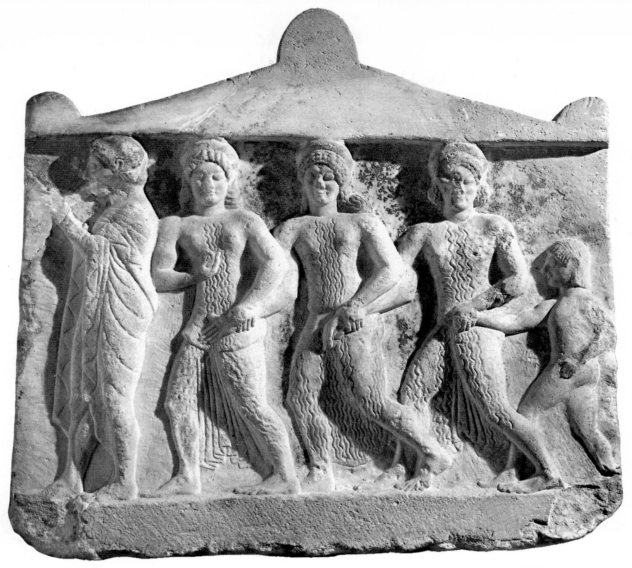

305. ATHENS. RELIEF: HERMES, THE CECROPIDES, AND THE BOY ERICHTHONIUS. ACROPOLIS MUSEUM, ATHENS.

the counterpart of the elegant, aristocratic palaestra scenes. It represents a ritual dance accompanied on the flute: three rather thick-set women in close-fitting tunics step hand in hand together with a little boy. The flute player might be Hermes attended by the daughters of Cecrops and the young Erichthonius. But the family character of the group and the frontal presentation, which calls on the spectator to take part in the rite, open the door to a different world—the world of popular worship, which finds naïve expression in many votive offerings dedicated in the sanctuaries during the ensuing centuries.

We must now return to Magna Graecia in order to find a monumental sculpture that is the sequel, after an interval of thirty or forty years, to that on the temples erected during the third quarter of the sixth century. Towards the end of that century the rugged, severe style that had suited the temperament of the heirs to a race of Dorian pioneers lost much of its rigour upon contact with influences from Ionia. At Selinus those influences made themselves felt very slowly and never affected the firmly entrenched qualities of the local

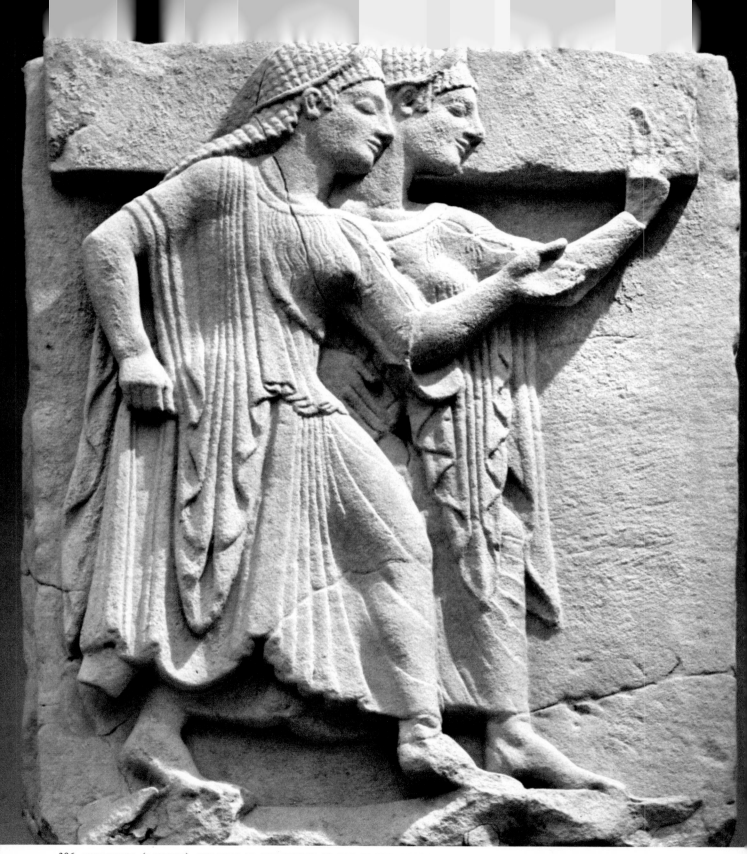

306. POSEIDONIA (PAESTUM), HERAION AT THE MOUTH OF THE SILARIS. METOPE: TWO GIRLS RUNNING OR DANCING. PAESTUM MUSEUM.

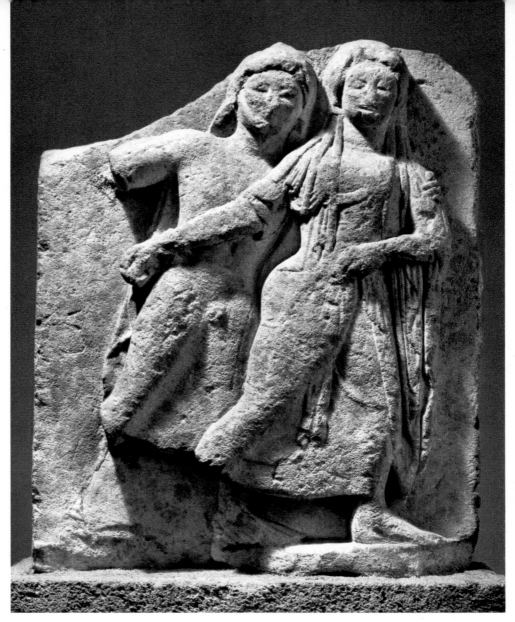

307. SELINUS, SANCTUARY OF DEMETER MALOPHOROS. RELIGIOUS DANCE. MUSEO NAZIONALE, PALERMO.

character. This can be clearly seen in two dance scenes, one on a relief from the Demeter Malophoros sanctuary at Selinus itself, where a mystery cult of fertility was celebrated, the other on a metope from the second Heraion on the Silaris, executed about the same time. In the Selinus relief the two dancers dressed in the Ionian fashion are united and swept up in an undulatory rhythm, but the forms have retained their earthy peasant sturdiness. Though the stone is severely weathered we can still appreciate the earnest facial expressions and candid gestures that are typical of the early metopes and the same way of associating the spectator in the ritual celebration, of which we have just examined another example in Athens. From the Silaris temple there are several metopes on which pairs of maidens carved in profile enact a carefully ordered mythical flight or dance. Here the luxurious elegance of the costumes, the archaizing meticulousness of the hair, the

265

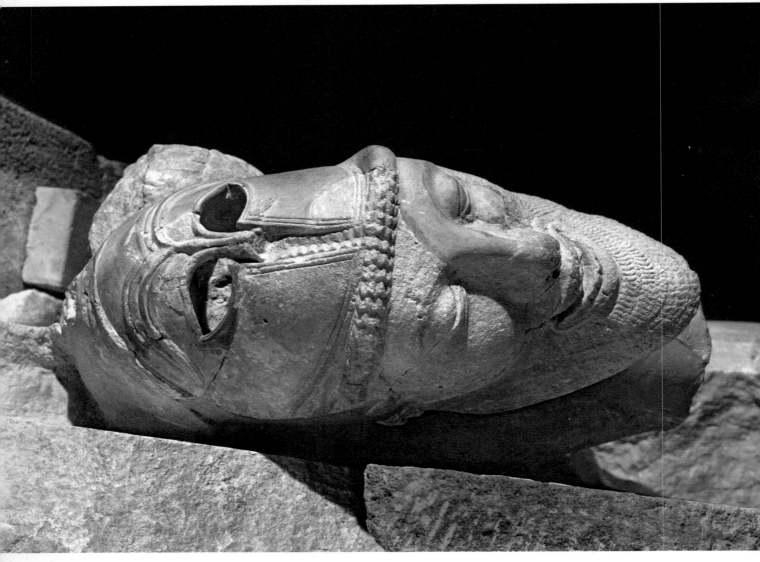

308. SELINUS, TEMPLE F. METOPE, DETAIL: HEAD OF A DYING GIANT. MUSEO NAZIONALE, PALERMO.

studied grace of the gestures are a triumph of the Ionian spirit—but an Ionianism so obviously borrowed and flaunted that the attribution of the second Silaris temple to the Sybarites, who had taken refuge in the vicinity of Paestum after the destruction of their city, is amply justified.

That Attic style made itself felt very strongly in Sicily at the beginning of the fifth century is proved by the fine head of a terra-cotta kore discovered at Agrigentum. The kore is not lacking in spirited individuality, but in this helmeted head of a giant struck down by a goddess the striking portrayal of the death throes is typical of a certain Sicilian realism that persisted well into the fifth century. Its survival is demonstrated by the severe style of the metopes of Temple E at Selinus towards the middle of the fifth century.

The New Spirit

In 500 B.C. Aeschylus entered a play in the tragedy competition. In 498 Pindar wrote his first ode, the tenth *Pythian*. He was a member of the Theban aristocracy but had gone to Athens to finish his education. There he moved in the circle of poets and artists who were soon to bring about a decisive change in Greek art. It was precisely during that brief span at the turn of the century that the statue of Aristodikos, which Christos Karouzos has so searchingly analyzed, was executed. The beautiful Parian marble in which it was carved has not suffered much from weathering, because the statue was probably pulled down by the Persians some twenty years later. It was an important discovery, for the statue was the ultimate achievement of a type that sculptors had been developing and refining for one hundred and twenty years.

Aristodikos still belongs unmistakably to the family of archaic kouroi. Frontality is maintained despite divergencies that are hardly perceptible at first sight and in any case are less obvious than those in the Strangford Apollo and more especially the Agrigentum kouros, both of which are clearly later works. Yet this funerary statue of a young aristocrat of the Mesogeia is the first to represent realistically and faithfully the naked body. Why is there an essential difference between Aristodikos and other kouroi? Because the sculptor conceived the living organism as a unified, integrated entity and treated it as such. The body is well-knit instead of relaxed; the smooth modeling involves the entire muscular system. In this respect the three-quarter views of the back are especially eloquent; they reveal the thickness of the body and call attention to slight movements that depend, as their very subtlety proves, on a posture that is no longer conventional but real. Viewed from the same angle, the Agrigentum kouros affords a countercheck to this. The exaggerated curve of the loins stresses the break between the buttocks and the trunk, which is made to seem still broader by the outstretched arms. This robust athlete is a work that is only just beginning to break away from the archaic pattern. The

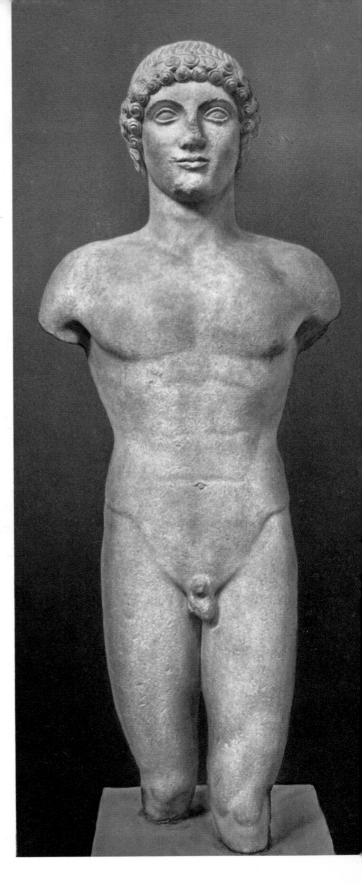

267

309. ANAPHE (?). KOUROS KNOWN AS THE STRANGFORD APOLLO. BRITISH MUSEUM, LONDON.

sturdy Dorian temperament is revealed in the lines of force and the architectural structure, whose basic principle was to be given a new lease of life in a novel balance by Polycleitos half a century later. In contrast, the Strangford Apollo is archaizing rather than archaic: it is visibly the last of its line, an end product of Ionianizing eclecticism, and its calligraphic grace fades in the banality of the facial features.

It has been said that the Aristodikos statue 'ushers in a new age, the age of tragedy.' The display of charm and strength has given way to an awareness of individual destiny, a sort of meditation involving the whole of this very real body, whose stance harmonizes with the slight inclination of the head. And here an important observation should be made. The precise measurement of the statue has proved that its proportions are governed by the law of numbers. The length of the foot, taken as the unit of measure, is equal to the length of the head and is contained seven times in the overall height; the genitals occupy the centre of this latter dimension. Equally, although the rounded oval of the face, sadly disfigured, shows all the fullness of youth and may well preserve an idealized memory of the dead man, there is no reason to doubt that it was regularized in the same spirit as the body.

This was the period when the new orientation of Attic art was decided, and it marked the conclusion of researches carried out from east to west in the privileged cities where creative activity flourished. From the end of the seventh century onwards, despite the many and diverse impulses and discoveries, we can discern a fundamental unity that is most clearly visible in the parallel evolution of two statuary types—the kouros and the kore. Thanks to historical circumstances and the advantage of a more freely ranging genius, Athens succeeded in grouping and directing the plastic values that arose out of the great cultural developments in the Greek world. The outstanding discovery, so signally exemplified by the Aristodikos statue, was that of the human body's organic unity, both physical and spiritual. The author of a work so carefully considered and well thought out cannot have been a novice. It has been suggested, quite plausibly, that he got his training with the team that carved the Hecatompedon pediment, namely, in the most typical Attic tradition—that of the Rampin Master. The crown of little curls that frames the forehead and the curious design of the pubic hair are the last traces of an aristocratic convention. Otherwise, the acceptance of both objective truth and the arithmetic of a canon of beauty is complete. These two conditions are by no means contradictory. As Pindar says in the tenth *Pythian*, '... I hope even more to make with songs for the garlands' sake Hippokleas honored among the youth and his elders, and to young maidens a troubled thought...' (Lattimore). But that was also the time when Cleisthenes the law giver made all men equal before the law. Pindar praised the common virtues and, like Aeschylus, insisted on the danger of all excess.

The most original Acropolis korai executed between 500 and 480 match this climate of political and moral reform. The persistence of Ionian spirit reflected in the hair style and the arrangement of the drapery represented a resistance of the new spirit, which embarrassed Athenian sculptors, who were obviously more at ease when rendering the male nude. But their efforts to break free from those bonds reveal the diversity of their individual temperaments. It is these later Attic korai that show most clearly where the two great currents that constantly nurtured the achievements of the archaic period were in accord or disaccord. The importance of the first is not so much its attachment to ar-

268

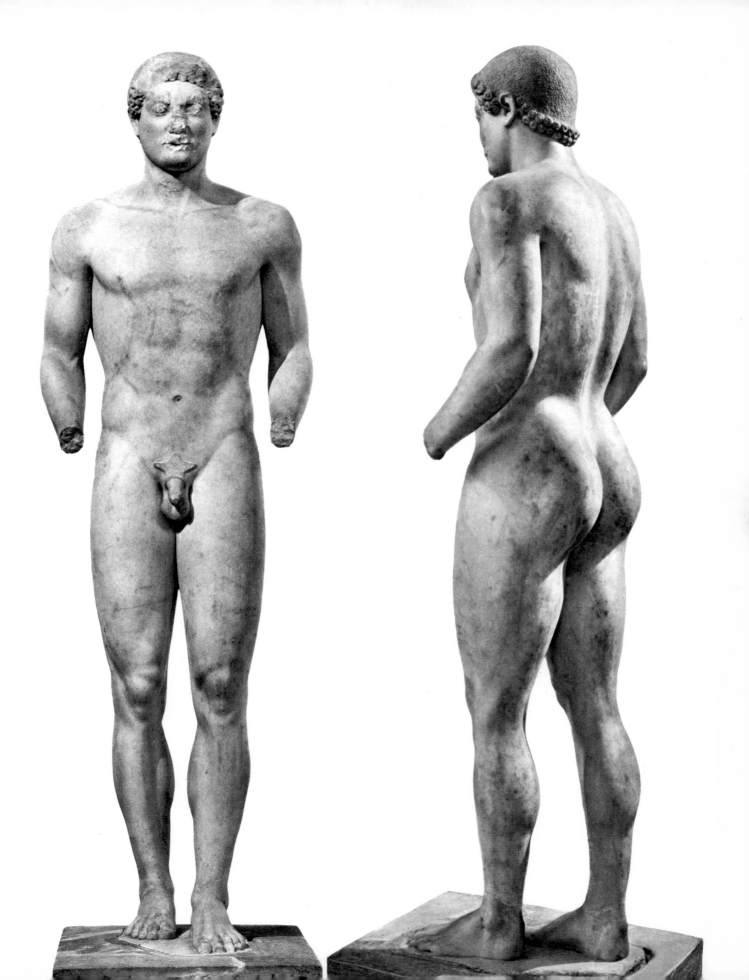

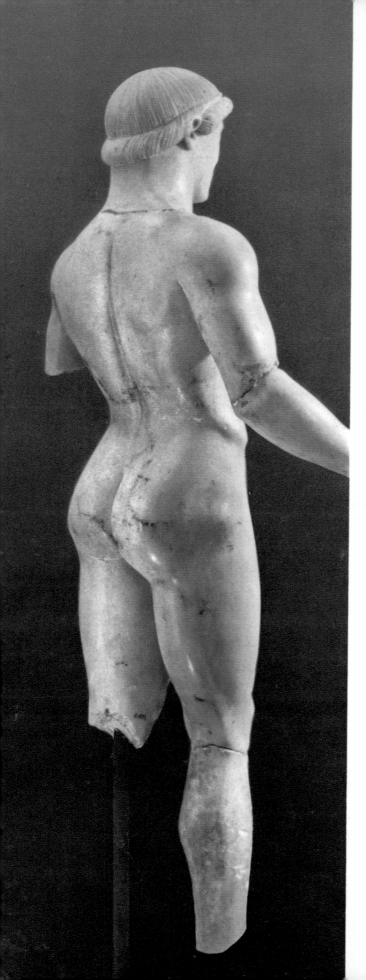

chaic tradition as its awareness of the style's values, that is to say, the interpretation of real forms with a view to bringing out their grandeur or their delicacy, their decorative character or their expressive force. The second current is progressive, open to observation and analysis, stimulated by an urge towards experiment and innovation.

To what extent did the two currents merge? The answer provided by Kore 696 is all the more interesting because the polos she wears distinguishes her from the other Acropolis korai. This towering divine or priestly headdress, similar to that worn by caryatids at Delphi, gives the statue a religious character, as does its larger-than-life size. The rounded cheeks and delicate modeling show that the sculptor was unusually sensitive to womanly grace. Yet none of the many other heads that have come down to us gives such an impression of majesty, except perhaps those of the Dipylon kouros and the Olympian Hera. This is because each feature is based on a solidly structured volume and benefits from the extra force inherent in the deliberate maintenance of archaic stylization. Here we are at the limit of overgeometrization. The merging of the old and new currents can also he seen in Korai 674 and 686, of which the first voices regret for the past, whereas the second looks towards the future. Both are clad in the Ionian fashion, but the vertical folds of the mantle repudiate all decorative effect, and attention is centred on the face. In Kore 674 all the plastic elements of the face belong to the archaic repertory, but the disappearance of the smile—only the barest shadow is left at the corners of the lips— has relaxed the curves of the cheeks, forming an oval framed in shadow by the arching ripples of the hair. In a harmony that is almost too perfect the expressive values of the archaic idiom, stripped of all artifice, are imbued with the still timid breath of real life. The slight inclination of the head expresses to perfection that maidenly reserve and composure of which Kore 670 gave but a superficial impression. Kore 686, dedicated by Euthydikos ten years later, represents the new generation. Here archaic convention is but a gossamer web that barely veils the

270

312. AGRIGENTUM. KOUROS. MUSEO ARCHEOLOGICO, AGRIGENTO.
313. ATHENS. KORE 674. ACROPOLIS MUSEUM, ATHENS.

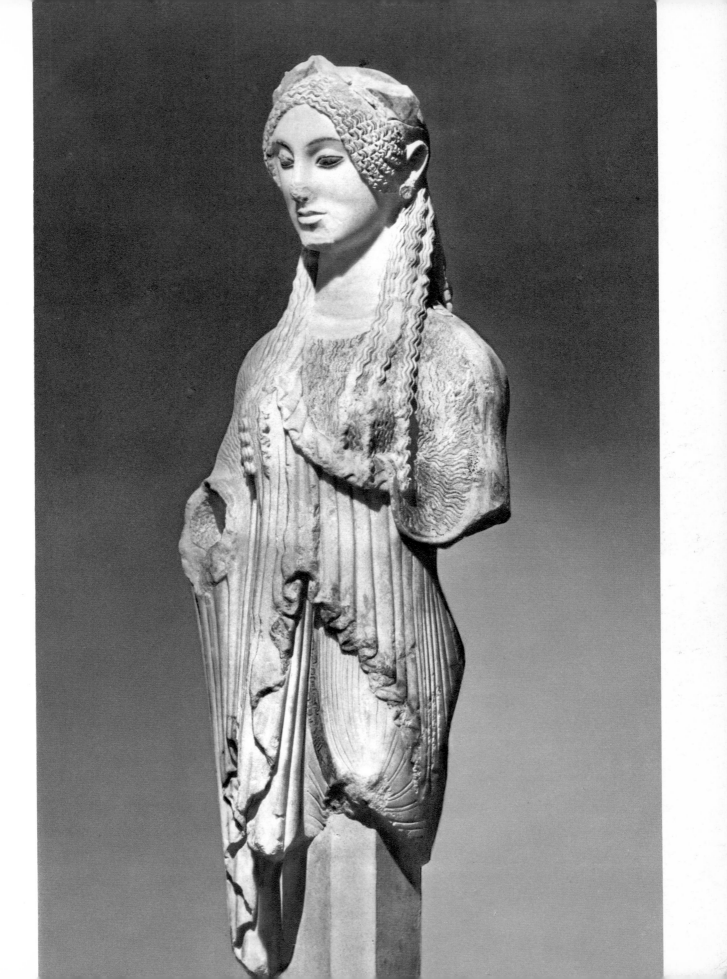

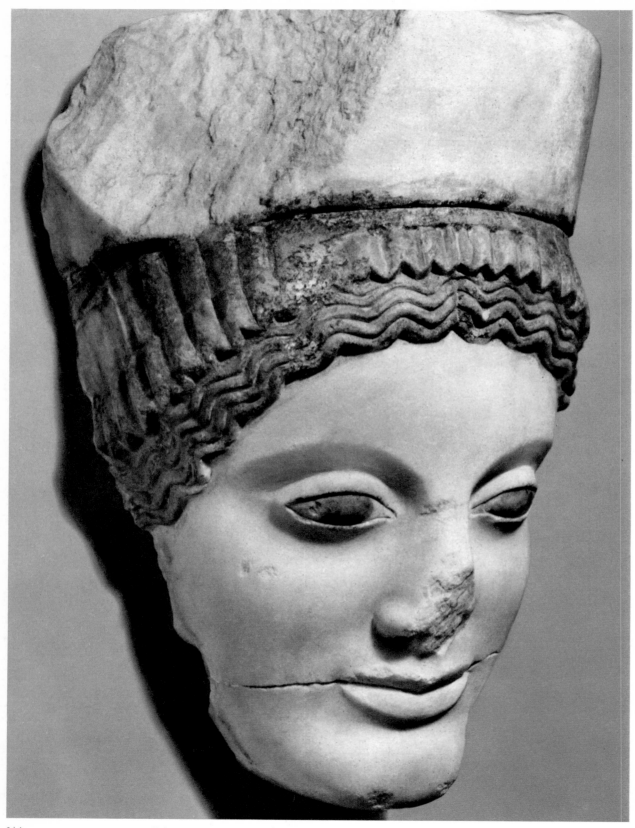

314. ATHENS. HEAD OF KORE 696. ACROPOLIS MUSEUM, ATHENS.

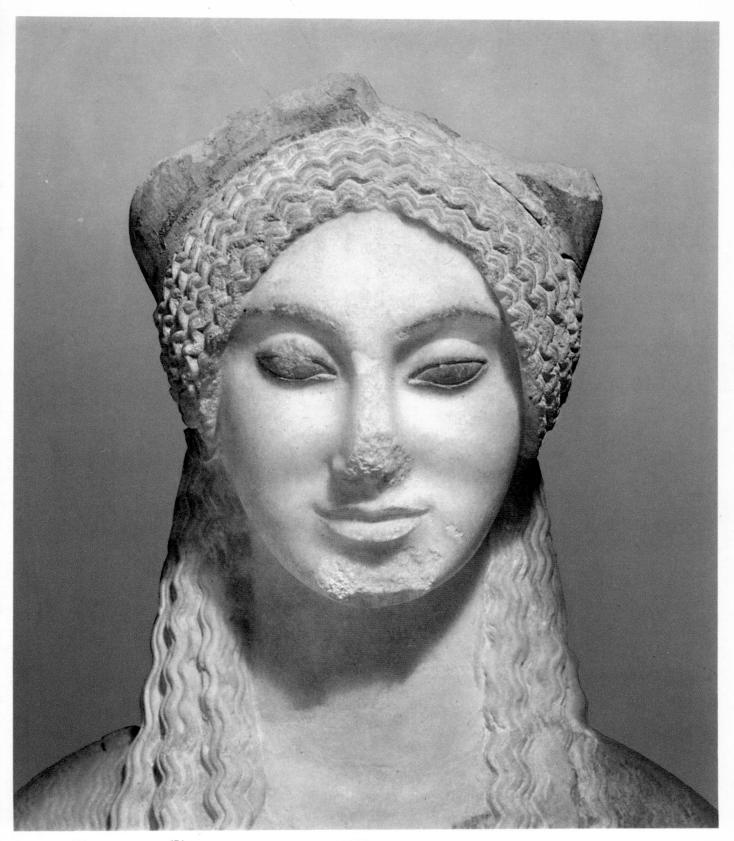

315. ATHENS. KORE 674, DETAIL. ACROPOLIS MUSEUM, ATHENS.

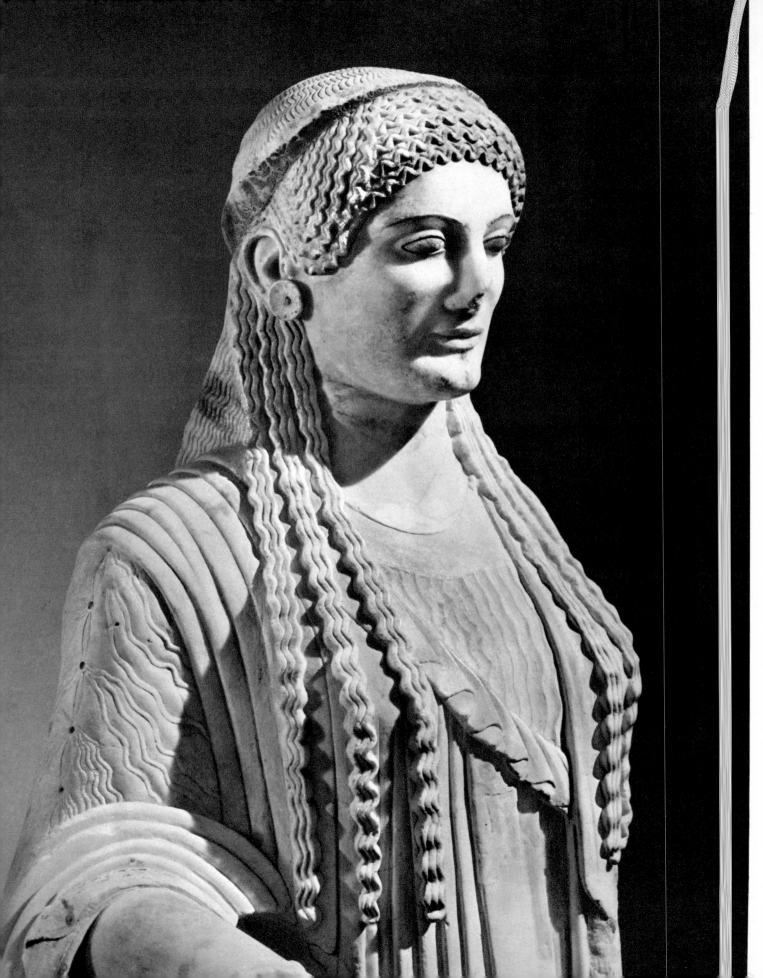

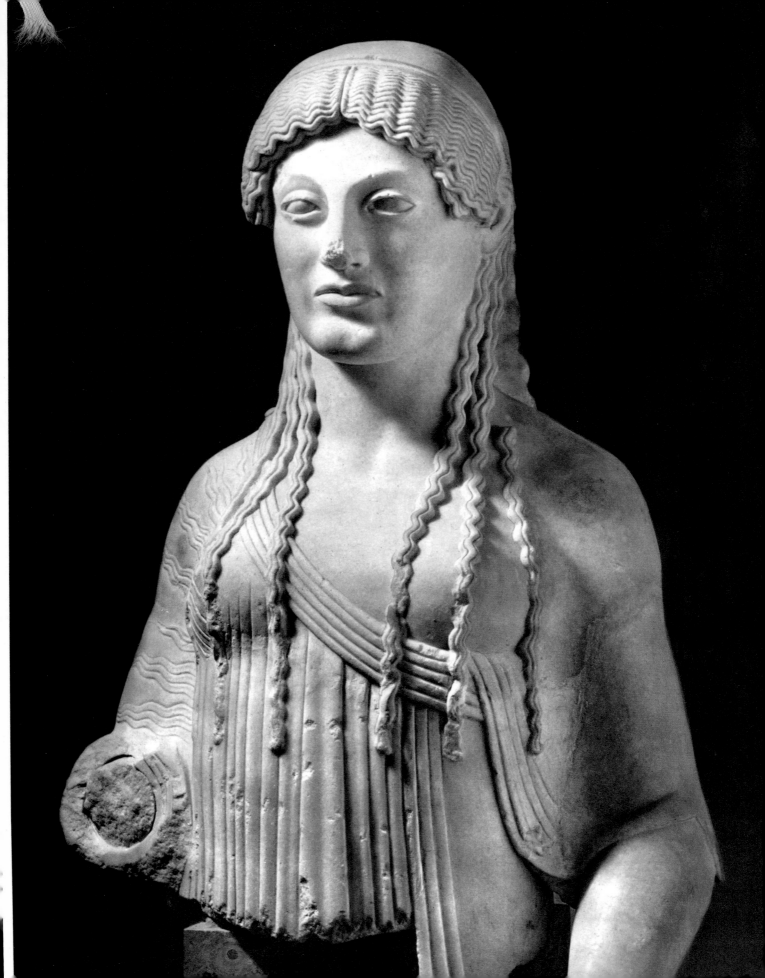

reality of the firm, fleshy body. The cubic skull and vertical profile prefigure the forms and proportions of the classical style even more clearly than the similar structure of the head of Kore 696. The hair no longer weaves an unreal network around the face; a parting divides it. The corners of the closed lips turn down in a pout that, on the face of a girl whose brothers fought at Marathon, is the symbol of a revolution at once ethical and aesthetic. The severe style has arrived.

Is it sufficient to compare the ancient Attic ideal, as embodied by Antenor, with the virtues of the new regime ('Freed from the tyrants,' Herodotus says, 'the Athenians far outstripped the rest') in order to account for this reaction against the seductions of a quite recent past? We must question a work that goes beyond the hesitations of the 'Euthydikos kore,' namely, the Blond Boy. The sculptor has retained the heavy eyelids and underlip of the archaic mode, as well as the thick hair with curls that cover the forehead, but these elements no longer give the impression of being survivals or deliberate borrowings. They are apparently the natural product of a strong yet curbed vitality. Only a misleading presentation and deceptive lighting could disguise the boy's youthful reserve as romantic melancholy.

The life-giving breeze that blew on the Acropolis before the battle of Salamis originated in the West. The most famous sculptors of that age, those whose memory has survived through literary tradition, came from the Peloponnesus. Canachos of Sicyon excelled in every medium—wood, ivory, marble, and bronze. His statue of Apollo Philesios spread his fame throughout the Greek world. At Sicyon he had already worked on a group of Muses with Hageladas of Argos. This Argive master enjoyed so great a reputation in ancient times that he was credited with having taught Myron and Pheidias. At Olympia, before the end of the sixth century, he had signed three statues of victorious athletes. About 490, at Delphi (like Olympia, a vast repository of gods, heroes, men, and beasts in marble and in bronze), he erected the votive monument of the Tarantines, which consisted of a row of chained Messapian women and hobbled horses. It is worth noting that the permanent rivalry and frequent wars between the Greek cities do not seem to have done much to keep artists from moving about. Thus we find the signatures of two Aeginetan bronze workers, Callon and Onatas, on the Acropolis, though Athens never ceased proclaiming her hatred of Aegina all through the sixth century and finally conquered it in the fifth. What a pity that all the works of these Dorian sculptors mentioned in texts or localized by unattached signatures have been lost. All we possess is a number of anonymous works bearing the stamp of those masters' style, which asserted its influence more and more strongly at the time of the Persian wars.

One of these works is a splendid head of Athena in terra-cotta, which was unearthed during the excavations of the stadium at Olympia in 1940. It belonged to a free-standing group of at least four figures, of which only a few fragments remain. The massive volume of the head and in particular the broad, square face find an extraordinarily close echo on the Acropolis in Kore 684, which, even before the excavations was believed to have been carved by a Peloponnesian master. The Olympian Athena is a work of outstanding technical quality, lavishly decorated in keeping with the Corinthian tradition. Similar ornamental motifs occur on a statuette of a priestess produced in a workshop at Sicyon of Corinth, whose face displays the same vigorous fullness.

276

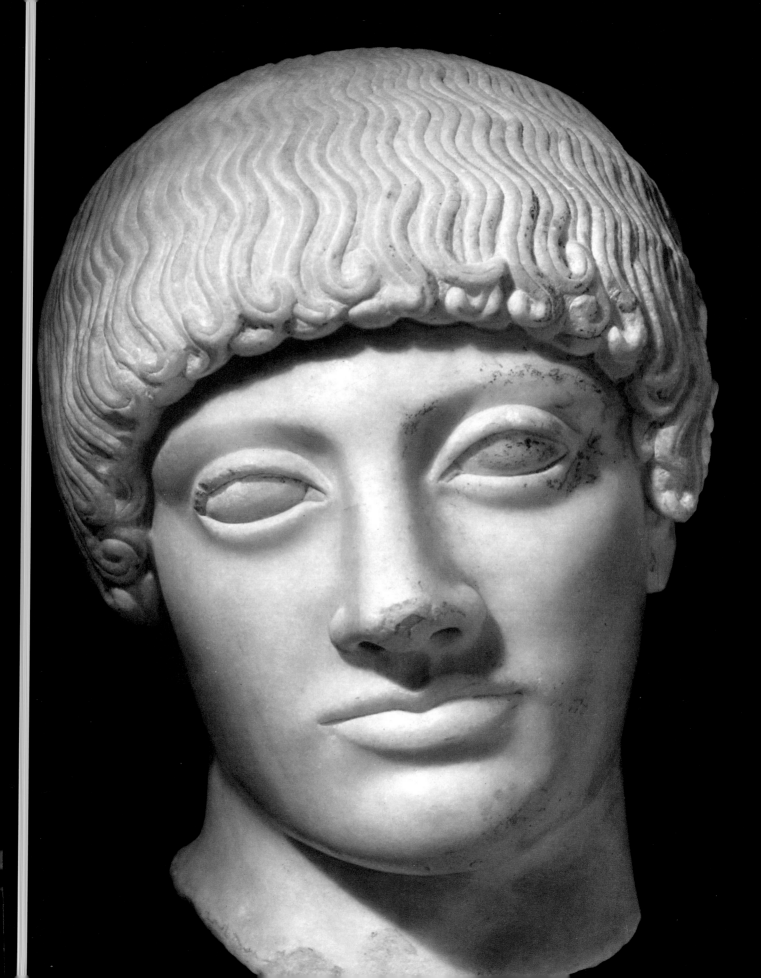

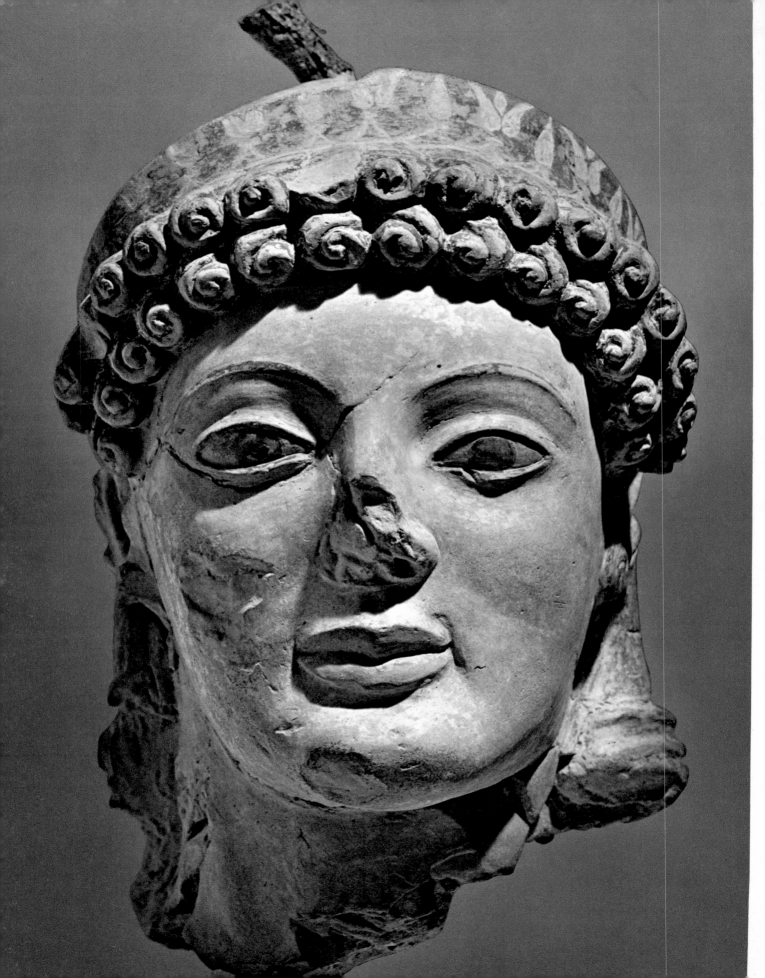

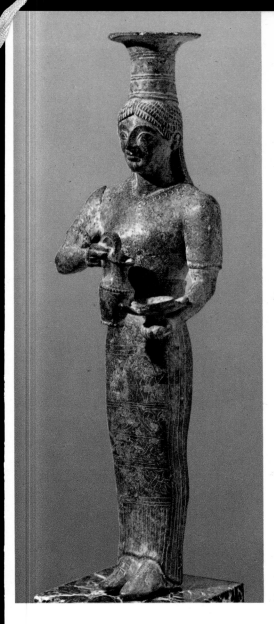

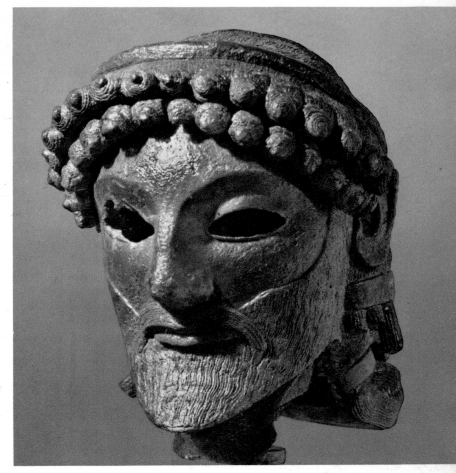

321. OLYMPIA. BRONZE HEAD OF ZEUS. NATIONAL MUSEUM, ATHENS.

320. DODONA (?). BRONZE PRIESTESS. LOUVRE, PARIS.

The most impressive demonstration of the transition from the Ionianizing to the severe style is provided, as we shall see later, by the two pediments of the temple at Aegina. That on the west side was carved about 500; that on the east some ten years later. It is interesting to compare the Blond Boy with a bronze head of Zeus, which dates from the same period, bears the mark of Aeginetan workmanship, and displays a deliberately archaic character dictated by the model's divine nature. Advances in metal-working techniques enabled the sculptor to give the form its fullness and strength. And the dry tautness of the severe style is stressed on the bare areas of the face by the precision of the ornamental details added with a burin after casting. This makes us appreciate all the more the difference in both style and spiritual quality between this work by a master sculptor in bronze and the Acropolis marble. No matter how closely the author of the Blond Boy followed the 'Dorian reaction,' the harmony that prevails in the composition of the features, in the musical accord of the facial reliefs, in the sober, refined rendering

279

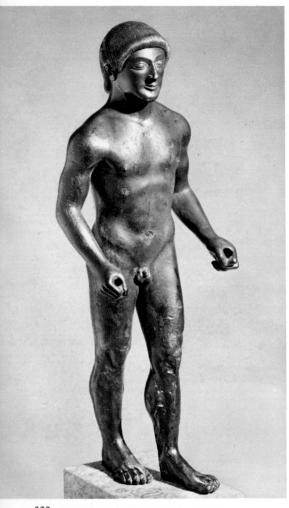

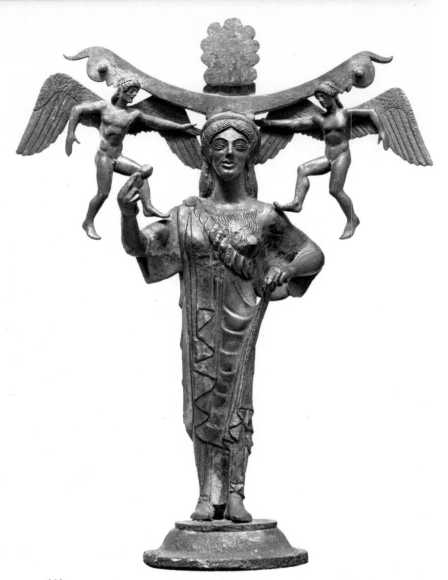

322. ATHENS. BRONZE ATHLETE. ATHENS.

323. AEGINA. BRONZE MIRROR STAND. MUSEUM OF FINE ARTS, BOSTON.

of the hair is hardly conceivable outside Athens. Also, there is a kinship between this marble and a standing athlete, one of the finest Attic bronzes from the Acropolis, dating from about the same time. The two faces are similar in structure and features, but they differ in expression. The inwardness of the Blond Boy contrasts with the young athlete's obvious, though restrained, love of action, which is in the lineage of the Jacobsen Head. Among the masterpieces produced by Athenian bronze workers about 500 there is an Athena Promachos, in which both trends are present, though the first predominates. This is not surprising, because the very young maiden in martial attire is a sister of Kore 674. The Athena Promachos offers further evidence of the link between bronze and marble and is of invaluable assistance in our comparison of the two media. The number and quality of the statuettes, either free-standing or serving as mirror stands, which were produced by the Athenian workshops about the turn of the century, presuppose that bronze statues were executed there after Antenor's and before the Tyrannicides cast by Critios

280

324. ATHENS. BRONZE FIGURE OF ATHENA PROMACHOS. NATIONAL MUSEUM, ATHENS.

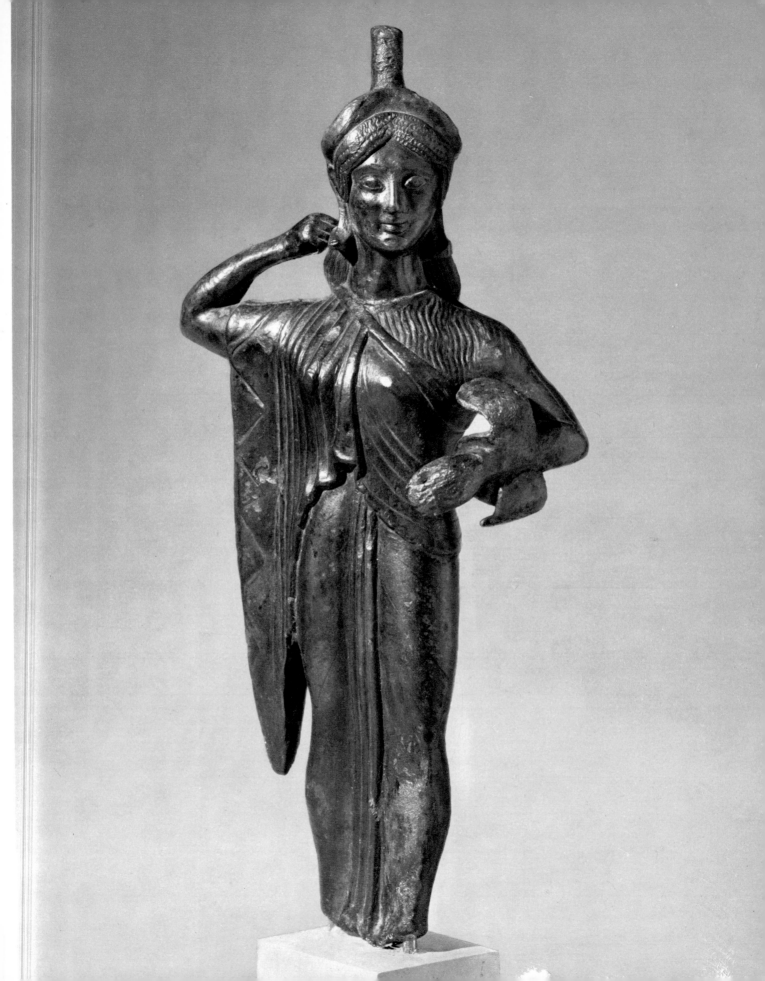

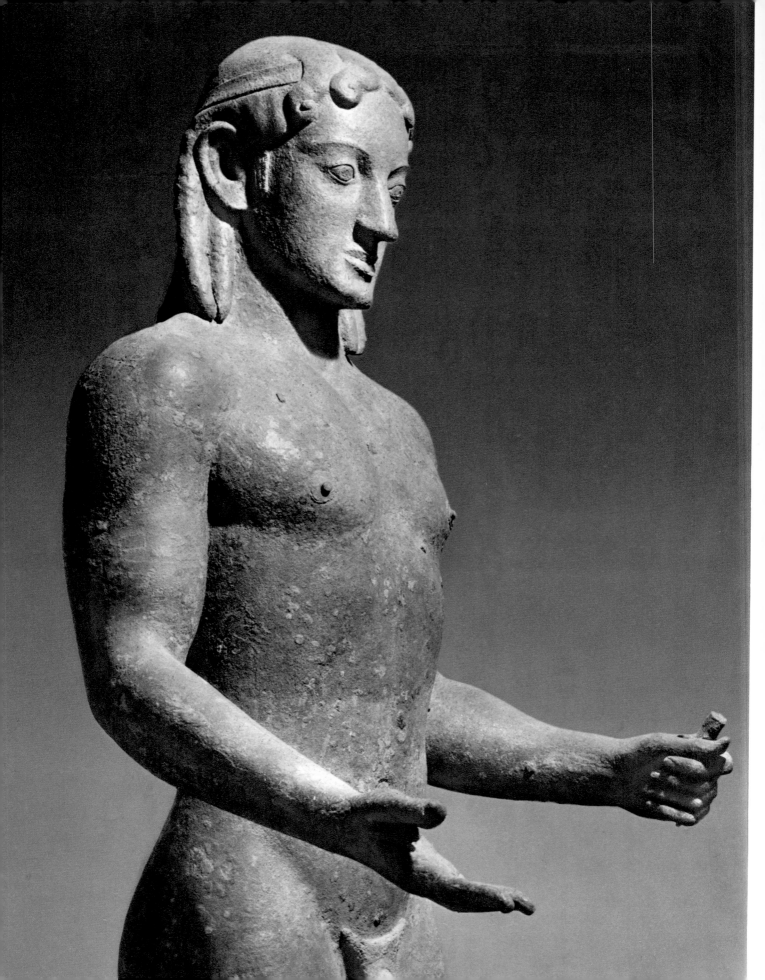

and Nesiotes in 477. All of them have disappeared.

However, the important discovery of a large bronze Apollo at Piraeus shows the skill attained by Greek sculptors in bronze during the last quarter of the sixth century. It is difficult to fit the work into the series of kouroi, even with the help of extant bronze statuettes. A rather surprising aspect of this work is that the full, supple modeling of the body reveals so few muscular details, even allowing for a certain abrasion of the surface. The same is true of the face and even more of the hair, whose stiff locks resemble lumps of wax rolled in the palm of the hand. The fact that so few retouches were made after casting may indicate that for some reason the statue was never finished. The overall design and the proportions point to a date around 520, and it seems to me that the closest comparison can be made with a statuette of Apollo dedicated by Deinagoras of Naxos but unfortunately unsigned. Is it the work of a Naxian sculptor trained, as has been supposed, in the Peloponnesus? We cannot be sure;

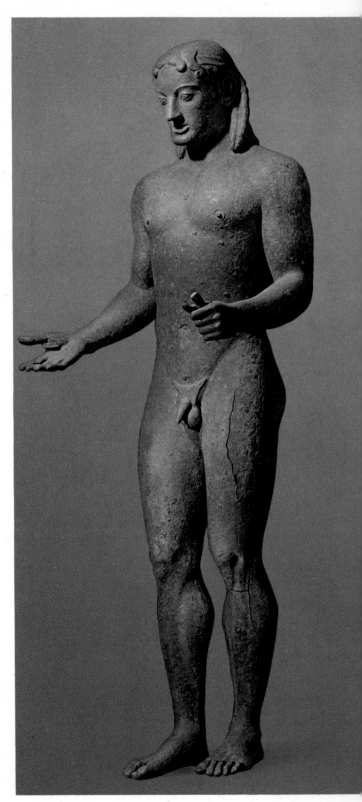

327. PIRAEUS. BRONZE APOLLO. NATIONAL MUSEUM, ATHENS.

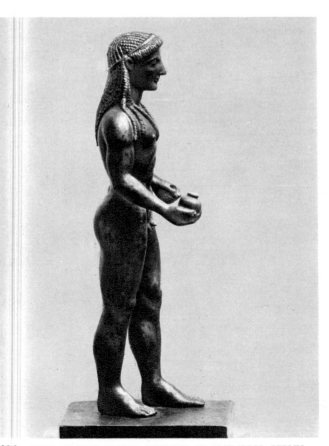

283

326. NAXOS. BRONZE KOUROS HOLDING AN ARYBALLOS. BERLIN.

◄ 325. PIRAEUS. BRONZE APOLLO, DETAIL. NATIONAL MUSEUM, ATHENS.

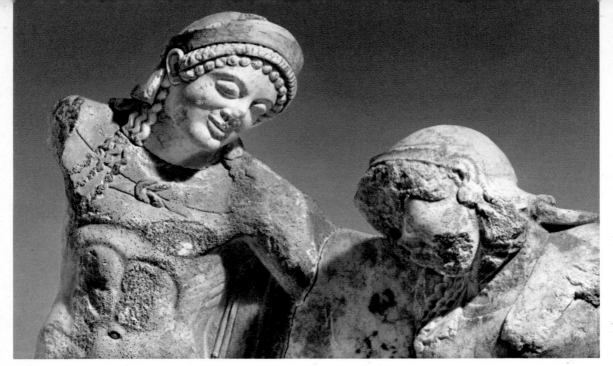

328. DELPHI, ATHENIAN TREASURY. SOUTH METOPE: THESEUS AND ANTIOPE, DETAIL. DELPHI MUSEUM.

yet the welcoming attitude of the Piraeus Apollo corresponds to that of Athena receiving the homage of a group of devotees on a votive relief from the Acropolis carved about the same time.

For the transition in monumental sculpture from archaic Atticism to the severe style, important evidence of quality and historical interest is offered by the Athenian Treasury at Delphi. Its date has long been and still is under discussion. But analyses of the architecture and the sculptural decoration agree in assigning this typically Attic monument to the period immediately after the battle of Marathon. Here for the first time we find perfect unity in the sculptural decoration. Only fragments of the pediments remain, but that on the east must have represented the meeting between the Panhellenic hero Heracles and Theseus, legendary king of Athens, who embodied the city's destiny. That on the west showed a battle scene. The two heroes' exploits were divided up among the metopes. The south frieze, the most conspicuous, was reserved for Theseus mastering the bull of Marathon. The war against the Amazons, in which both Heracles and Theseus played leading parts, was illustrated on the metopes of the east façade and by the horsewomen of the acroteria. The metopes, like those on the north side of the Parthenon half a century later, were clearly executed by sculptors of whom some were *retardataire* or archaic, others progressive or preclassical, and others between the two. The first were inferior to the second, not in invention and workmanship but in the naturalistic rendering of the attitudes. Heracles' acrobatic leap over the stag is contained in a harmoniously geometrical curve, and all the resources of archaic calligraphy have been employed here in order to make the plastic interpretation of the exploit as meaningful and decorative as possible. In the same style, if not by the same hand, Theseus, with his cloak and body thrown back, is about to kill the collapsing Antiope. With torsos executed frontally and faces in three-quarter view, the group is represented in maximum breadth,

284

329. DELPHI, ATHENIAN TREASURY. NORTH METOPE: HERACLES AND THE HIND. DELPHI MUSEUM.

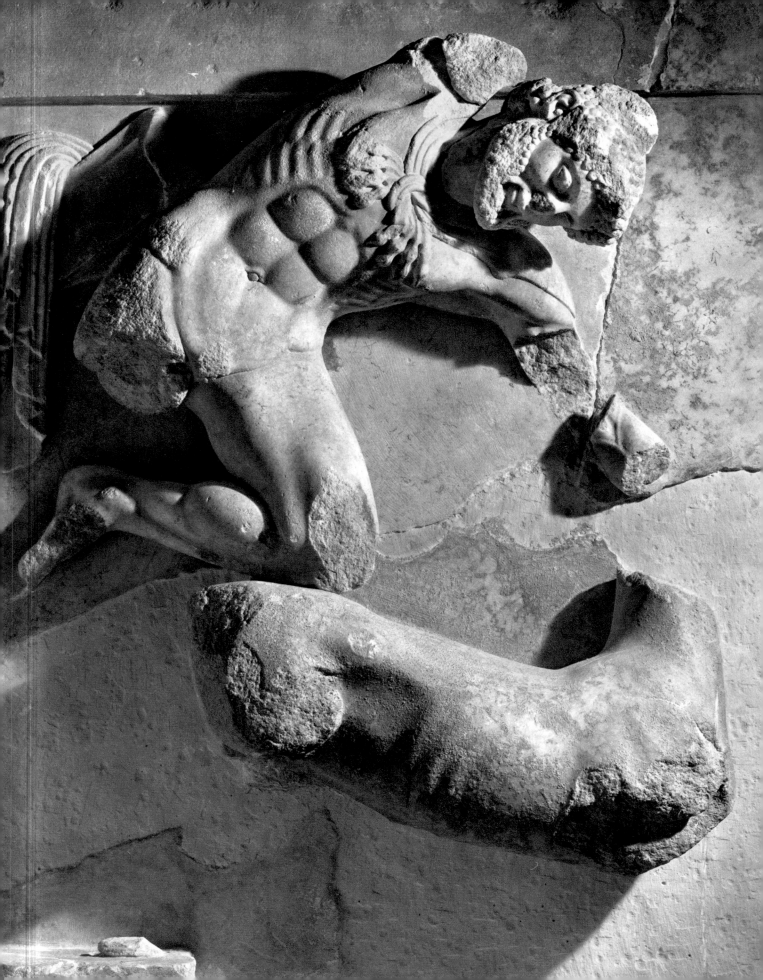

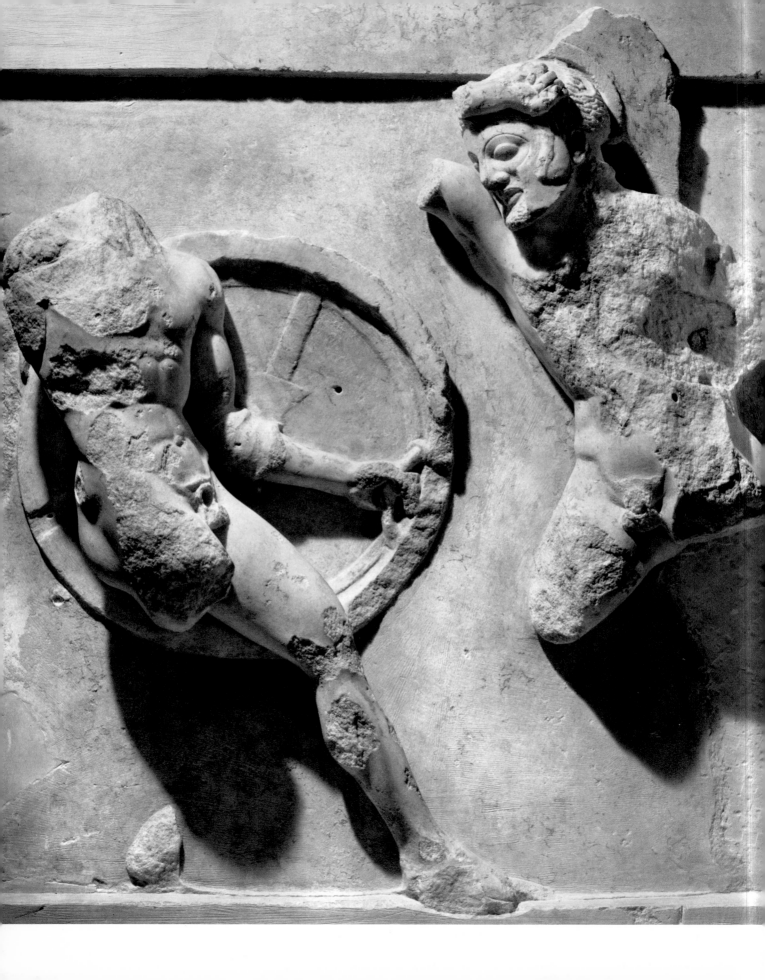

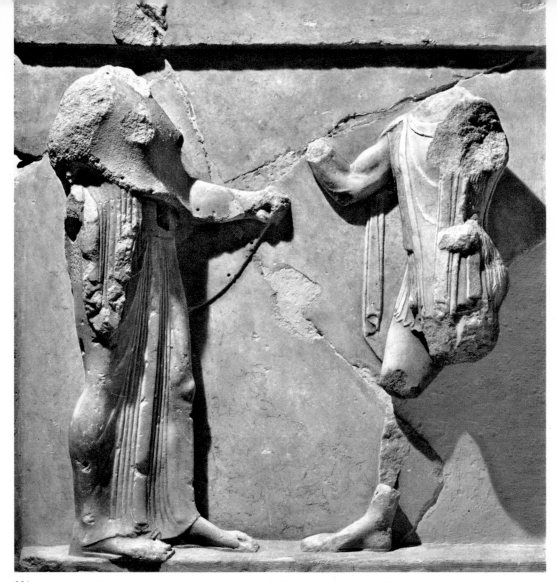

331. DELPHI, ATHENIAN TREASURY. SOUTH METOPE: ATHENA AND THESEUS. DELPHI MUSEUM.

but at the same time the figures detached from the background break away from the conventions of archaic design and are balanced by their own weight. However, it is in the duel between Heracles and Cycnus that the decisive step is taken towards the classical rendering of movement. Cycnus is on the point of falling limply, in keeping with the rhythm imposed by his adversary's well-aimed thrust. The elegant, natural play of the muscles transforms his fatal fall into a dance movement, thus foreshadowing all the combat scenes that were to unfold on classical friezes right up to the mid-fourth-century mausoleum at Halicarnassus and beyond. But the severity of the new aesthetic finds its most telling expression in the meeting of Theseus and Athena rather than in representations of action. The heads are missing but because of the tautness of the forms, which stresses the distance between the human and the divine, the hero's controlled yet eager pace and the goddess's simple gesture of welcome, sanctified by her outstretched aegis, mark this image with the radiance of Attic spirituality.

287

330. DELPHI, ATHENIAN TREASURY. NORTH METOPE: HERACLES AND CYCNUS. DELPHI MUSEUM.

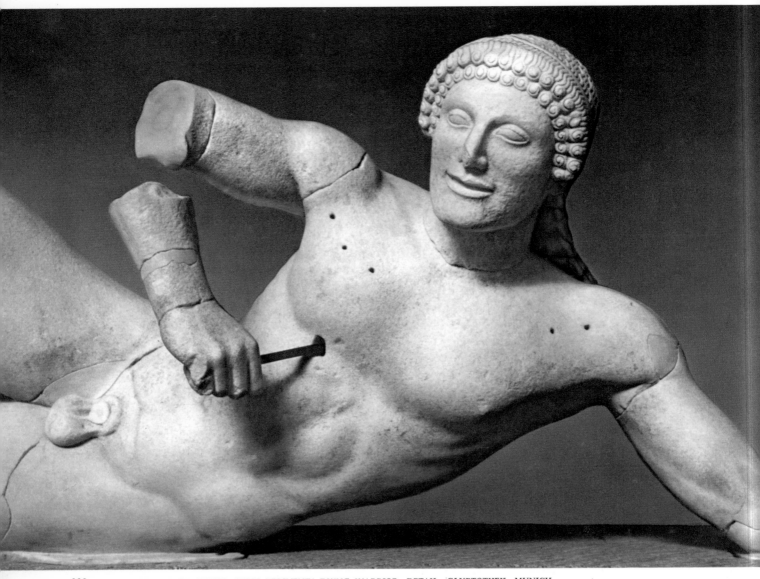

332. AEGINA, TEMPLE OF APHAIA. WEST PEDIMENT: DYING WARRIOR, DETAIL. GLYPTOTHEK, MUNICH.

The typically Greek rivalry between Athens and Aegina is illustrated by the decoration, executed between 500 and 480, on the pediments of the Temple of Aphaia. The island took pride in the exploits of its heroes. Those of the first Trojan War, led by Heracles, were portrayed on the east façade; those of the second, Ajax, Teucer, and their comrades, on the west. Their combats were idealized in accordance with the concept of Hellenic humanism that became still more strictly adhered to in the classical period. Here form is revered for its own sake, particularly on the west pediment, which is a sort of eclectic summing up of the archaic style. Aeginetan sculptors were famous for their bronze work, as we have seen and as is proved by a statuette closely related to the Athena on the west pediment. The marble figures, which were in fact adorned with metal ornaments, were treated individually with a meticulous precision and a sense of balance that resorted to

288

333. AEGINA, TEMPLE OF APHAIA. EAST PEDIMENT: DYING WARRIOR, DETAIL. GLYPTOTHEK, MUNICH.

no adventitious devices, despite the variety of attitudes. This statuary conception makes itself felt in the overall composition in which unity of action is entirely lacking. Athena, motionless in the centre, divides the combatants into two groups, each of which faces outwards and is made up of two trios fitted together with clockwork precision. The Homeric motif of the duel over the body of a wounded man is repeated four times.

The sculptor of the east pediment came to grips with the same subject ten or twelve years later. Not enough figures have been preserved to enable us to reconstruct the composition with any certainty. But, unlike the one on the west, it is convergent, and Athena in the centre takes part in the fight. Dynamic action replaces static presentation. The drama has become human. New attitudes, like that of the warrior bending down to catch the body of his falling comrade, render the pathos of the melee in the movement of the muscles. On the face of the wounded warrior in the corner, who is making a

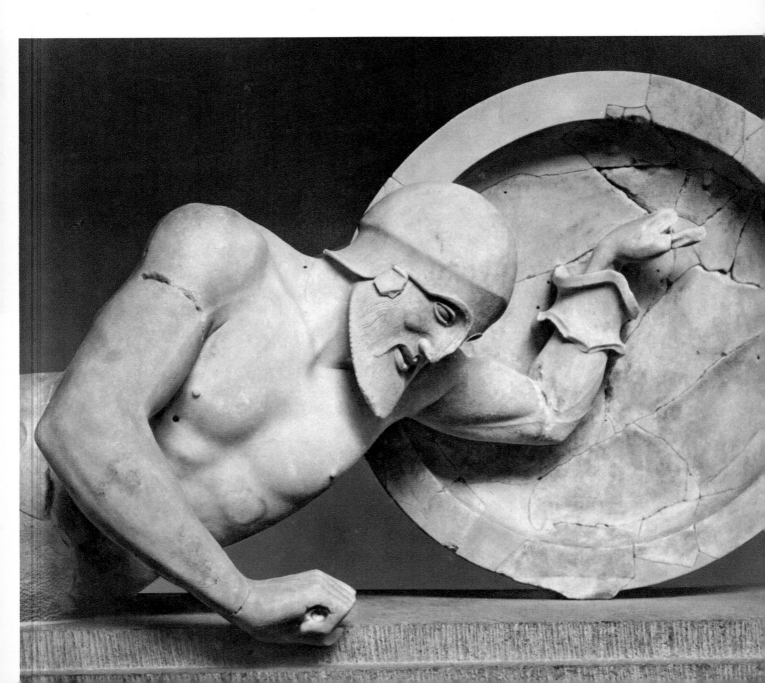

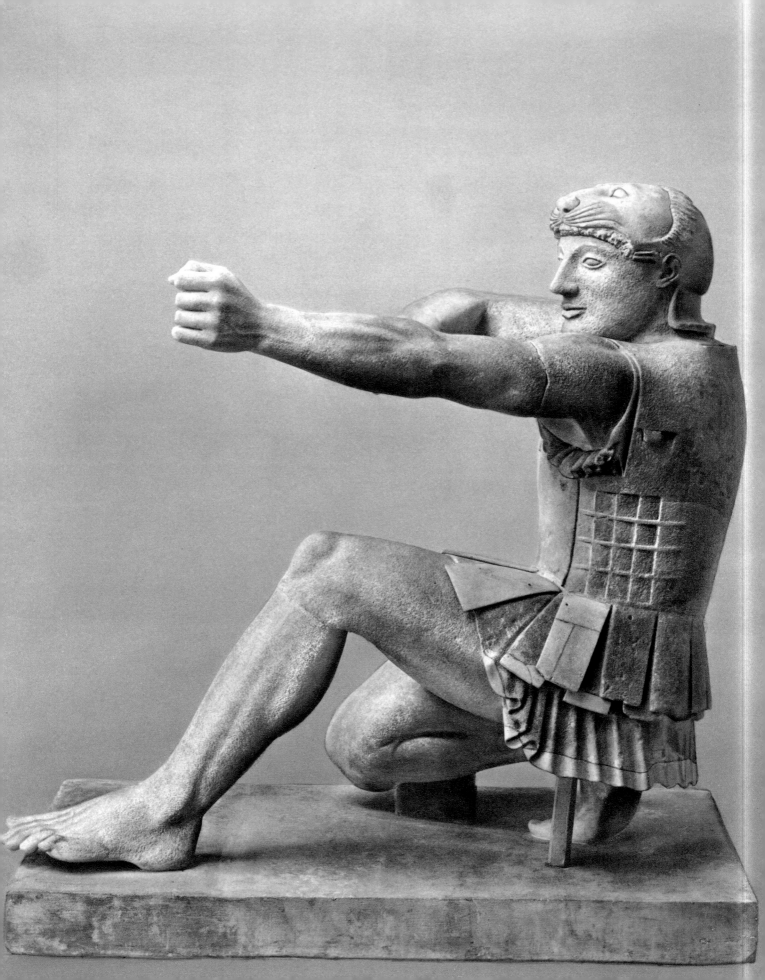

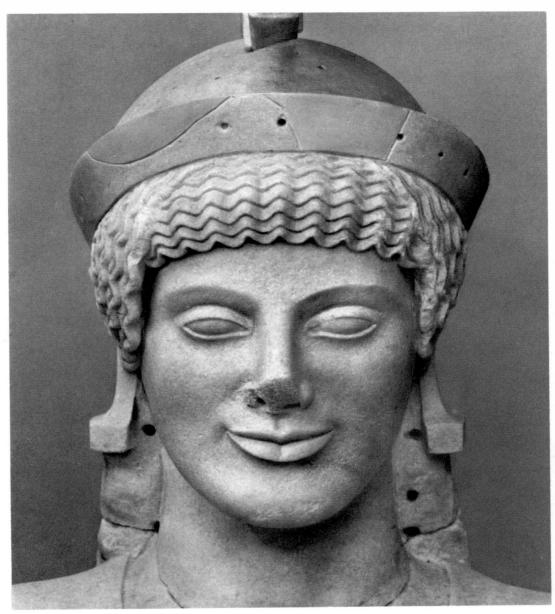

335. AEGINA, TEMPLE OF APHAIA. WEST PEDIMENT, DETAIL: HEAD OF ATHENA. GLYPTOTHEK, MUNICH.

last effort to rise, a grimace of pain has replaced the conventional smile. This figure, whose circular shield enhances the plastic effect of his magnificent torso, should be compared with its counterpart on the west pediment, which is petrified in its frontal pose, with the sternly imperious Aeginetan Zeus at Olympia (fig. 321), and with the contemporary Spartan warrior muscle-bound in his thick-set strength, who throws all his weight into the fray (fig. 338). Only then can we realize to the full—despite the persistence of a rather abstract perfection—the new life that pervades the composition on the east pediment. Undoubtedly the wind which brought this new life blew in from Athens, breathing a whiff of the Aeschylean drama into this picture of the Trojan epic.

334. AEGINA, TEMPLE OF APHAIA. EAST PEDIMENT, DETAIL: HERACLES DRAWING HIS BOW. GLYPTOTHEK, MUNICH.

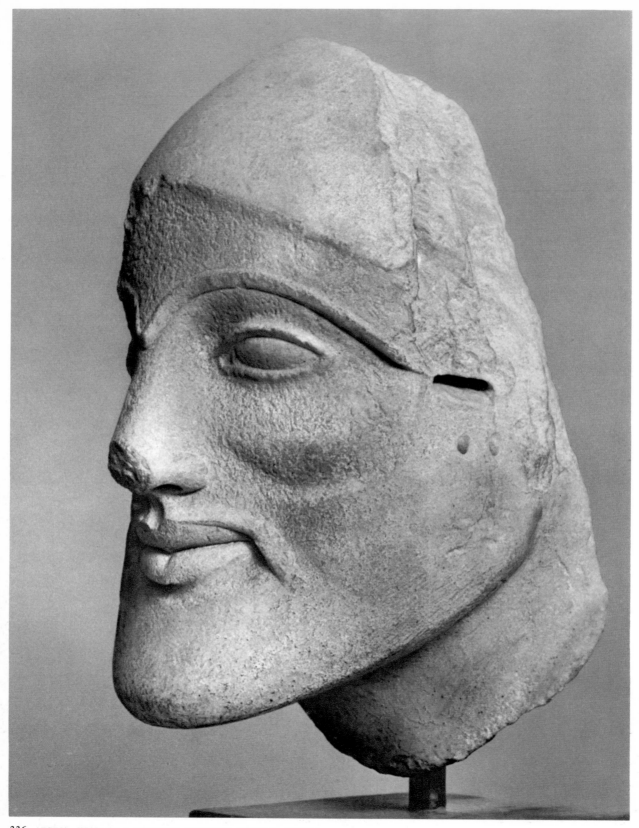

336. AEGINA. HEAD OF A WARRIOR. NATIONAL MUSEUM, ATHENS.

337. AEGINA, TEMPLE OF APHAIA. EAST PEDIMENT: HERACLES DRAWING HIS BOW, DETAIL. GLYPTOTHEK, MUNICH.

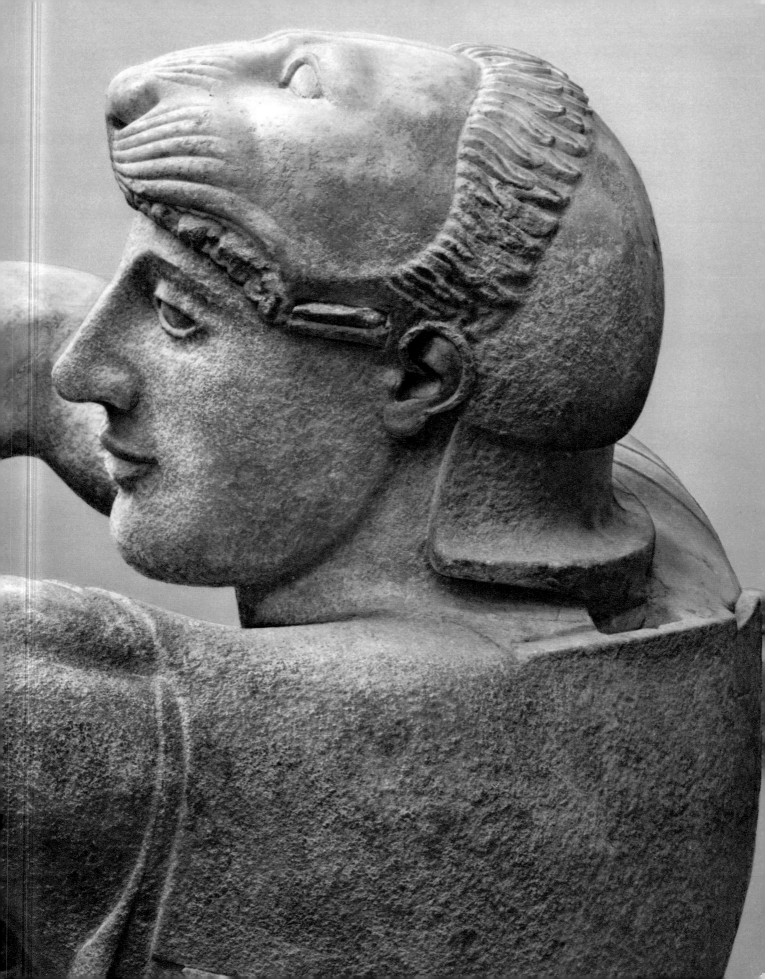

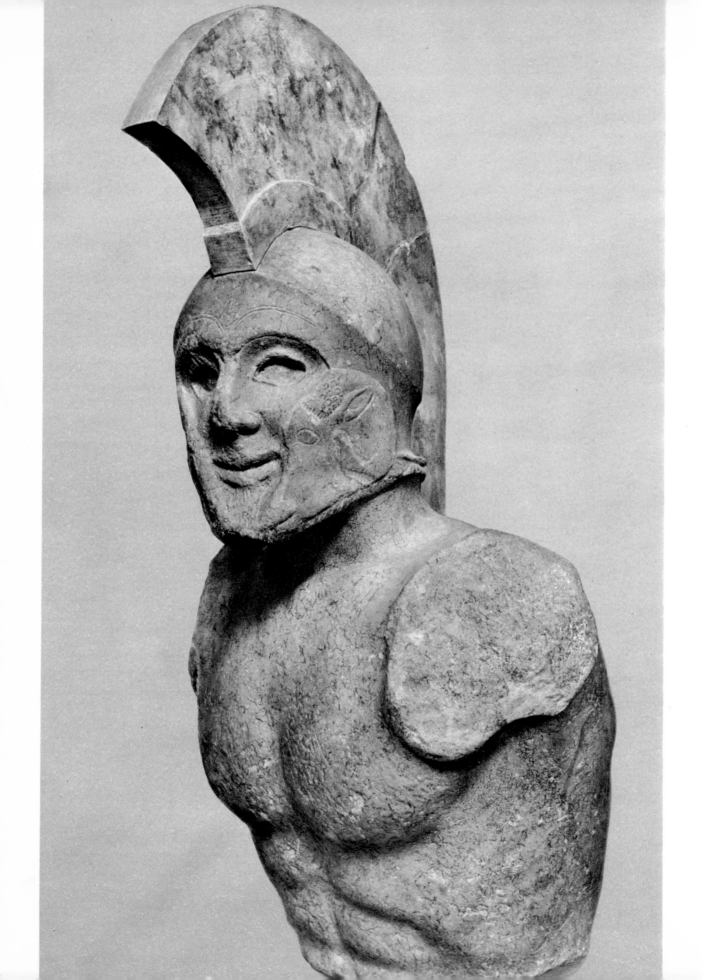

Painting and Pottery

Red-Figure Vase Painting

Athens was unrivaled in the production of painted Greek vases during the late archaic period. For many years after about 525, no vase painting of any artistic value was produced outside Attica. This supremacy, which was already striking, was sustained by the success of a new technique invented in Athens itself—red-figure painting. As in the case of black-figure, the appearance of this technique led to the development of an original style, but one based on an entirely different principle. Before, the figures had been painted in black silhouette against the natural clay surface. Now the process was reversed: the background was painted in black, leaving the figures reversed in the light red colour of the clay. The painter began by sketching the contours and the main features of his subject, then outlining the figures with a broad band or 'stripe' of paint. The most delicate operation, probably done with a very fine brush, consisted in adding the inner details by means of drawing lines that are extremely thin but have a marked relief. For further anatomical detail—filling out the figure without emphasizing its particularities—the artist used a diluted paint that gave an effect of soft, shaded strokes. Here there was no need for the added touches of colour that heighten black-figure pottery, and, in fact, they were very seldom used in red-figure.

The result is a sort of two-colour drawing that is far more closely linked with the specific technique of the potter than was the black-figure style. The red-figure method made it much easier to render attitudes and breathe life into drapery, muscles, and faces. The black-figure painter began with a silhouette, which he endeavoured to bring to life with incised details that were often difficult to execute. The red-figure painter, contrastingly, was free to multiply his lines to suit his fancy and to concentrate his efforts on achieving genuine realistic effects. Thus the freedom of expression that characterized red-figure pottery of the severe style, produced between 525 and 480, led to the development of a larger number of outstanding masters than Greek pottery of any other period. At the same time, it paved the way for the rise of truly great painting after 480 B.C. Nonetheless, the new technique was not generally accepted at first: some fifteen years elapsed before the new style finally asserted itself and realized to the full its great potential. During those years the Athenian workshops continued to produce mostly black-figure ware of excellent quality.

295

338. SPARTA. SPARTAN WARRIOR. SPARTA MUSEUM.

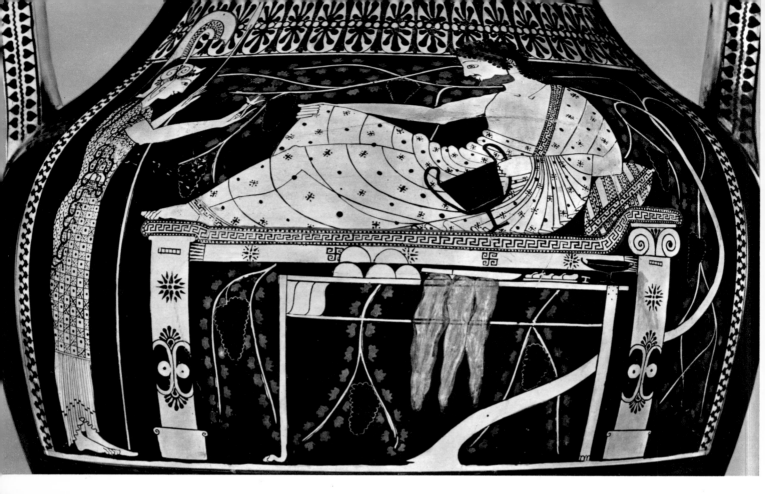
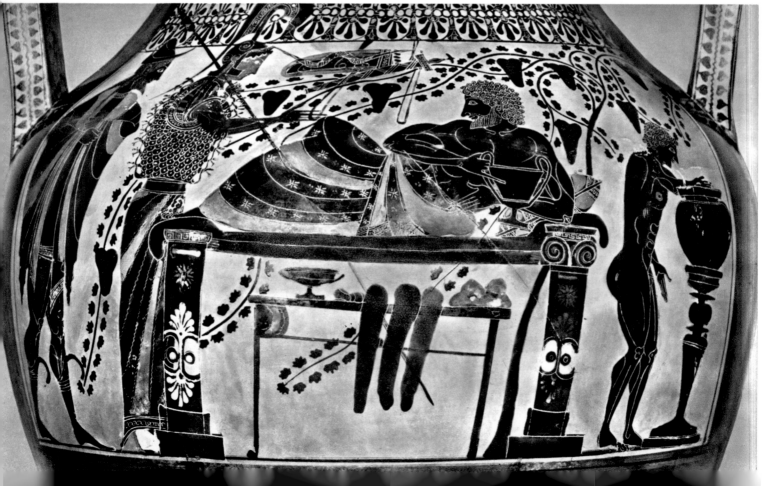

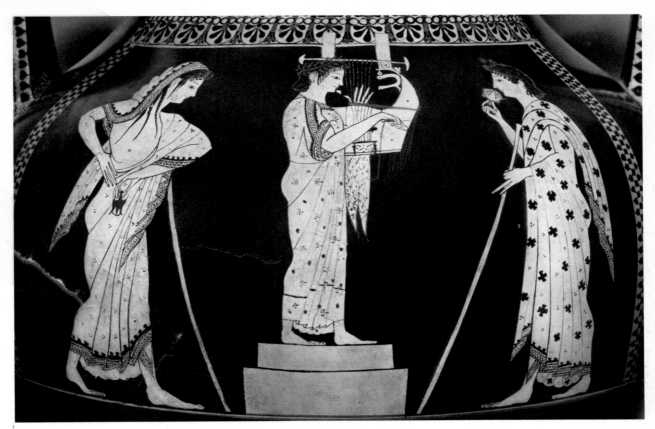

341. ANDOKIDES PAINTER. AMPHORA, DETAIL: MUSICAL CONTEST. LOUVRE, PARIS.

Early Red-Figure (530-515)

It was in all probability the Andokides Painter who invented the red-figure technique about 530, but he did not exploit the full scope of his innovation all at once. At first he collaborated with a black-figure painter known as the Lysippides Painter, who, like himself, was a pupil of Exekias. Thus red-figure is linked with the Attic tradition of noble, stately style. It is interesting to compare the two sides of an amphora in Munich (opposite), one of which is painted in red-figure, the other in black. The same subject is depicted in both (hence the term 'bilingual'). The black-figure panel below is richer, the bodies and drapery are supple, the gestures unconstrained. In the red-figure panel the Andokides Painter retained the essential figures, but their attitudes are still rather awkward and Athena's costume, though pleated, seems quite stiff. There are still some touches of added red, and the panel has a black-figure frame. Paradoxically, it is the red-figure section that gives the impression of a less advanced style.

There is an amphora in the Louvre, however, entirely in red-figure technique, that displays greater freedom. The drapery hangs loose, forming folds and moulding the bodies. The composition is classical, and its very symmetry recalls the Exekias amphora in the Vatican, but the picture is enhanced by a mannered grace of Ionian fashion. The

339. ANDOKIDES PAINTER. AMPHORA, DETAIL: BANQUET OF HERACLES WITH ATHENA. STAATLICHE ANTIKENSAMMLUNGEN, MUNICH.
340. LYSIPPIDES PAINTER. AMPHORA, DETAIL: BANQUET OF HERACLES WITH ATHENA. STAATLICHE ANTIKENSAMMLUNGEN, MUNICH.

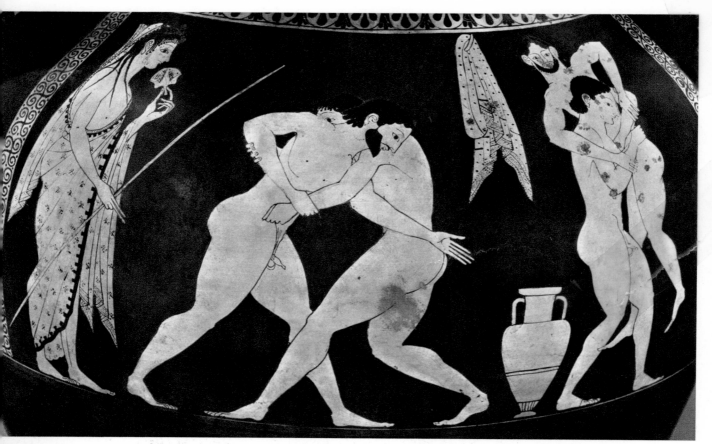

342. ANDOKIDES PAINTER. AMPHORA, DETAIL: WRESTLERS. STAATLICHE MUSEEN, BERLIN.

smart young Athenians who belonged to the circle of the sons of the tyrant Pisistratos wore long Ionian chitons that were rather effeminate. From now on these handsome youths provided painters with one of their major sources of inspiration.

In those days athletic contests were one of the most popular pastimes of young men and boys. They offered artists a unique opportunity to observe bodies in strenuous action and to make realistic sketches of anatomical details. The wrestling scenes on the Berlin amphora, also by the Andokides Painter, reveal this research. The red-figure technique enabled the painter to render different postures without making the whole design less clear. The second group is more original: the painter did not hesitate to render the torsion of the vanquished athlete's body while showing his face in front view.

In spite of this, the black-figure style still exerted considerable influence, even on the Andokides Painter, some of whose works display a curious attempt to achieve a compromise between the two techniques. His amphora depicting Amazons arming, also in the Louvre, is in a special technique. It is like red-figure, but the figures are reserved on a white slip applied over the panel before the black paint. On these white figures the painter has drawn several details in matte lines besides elaborating and enlivening them with incision and touches of added red.

298

343. ANDOKIDES PAINTER. AMPHORA: AMAZONS ARMING FOR BATTLE. LOUVRE, PARIS.

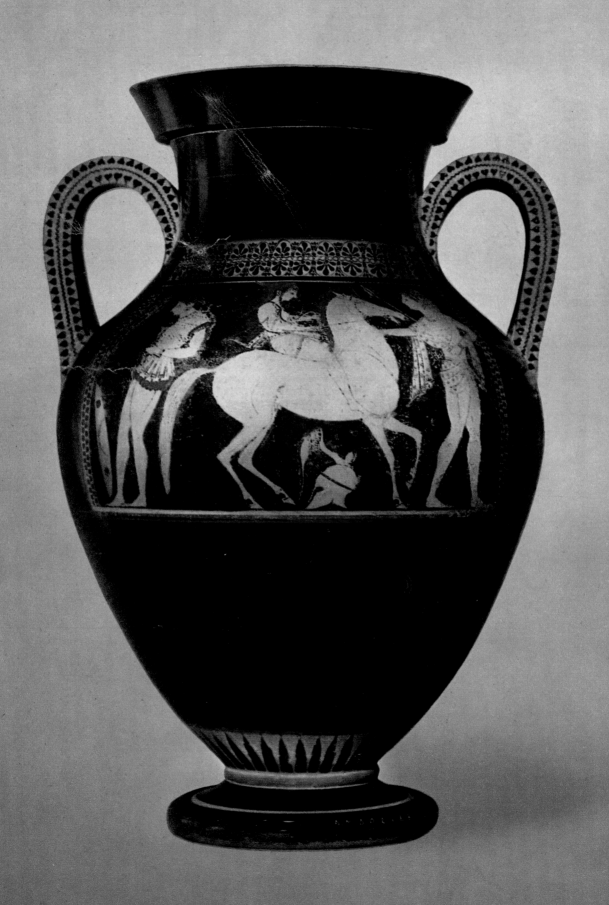

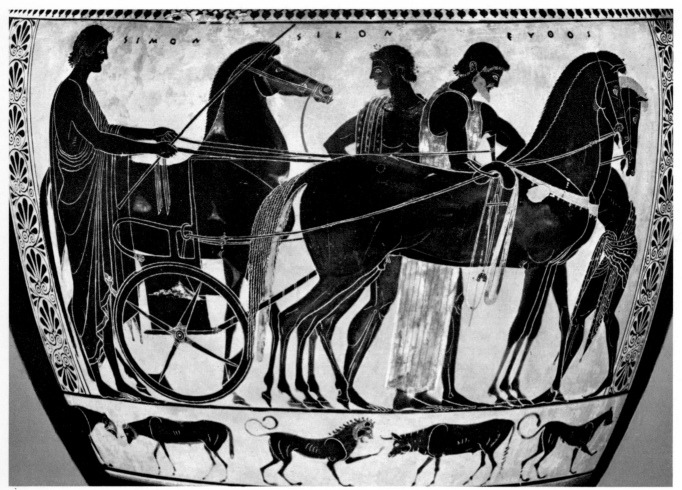

344. PSIAX. HYDRIA, DETAIL: HORSES BEING HARNESSED TO A QUADRIGA. STAATLICHE MUSEEN, BERLIN.

Late Black-Figure

It was not long, however, before the red-figure painters, too, felt the impact of the new style and endeavoured to transfer the advances made in draughtsmanship to a less entirely suitable medium. Psiax, who seems to have been slightly younger than the Andokides Painter, employed both techniques side by side. But sometimes his black-figure work is like a transcription of his red-figure work. For instance, in the panel of a hydra in Berlin the silhouettes are designed with a clarity that implies the existence of a preliminary sketch no less elaborate than those required for red-figure vases. In addition, the incised details are so fine and numerous, particularly in the drapery, that, viewed in negative, they form a network which seems made up of painted lines. As for the touches of added colour, they are reduced to a minimum and serve chiefly to distinguish the charioteer from the young man by his side. The layout of the panel remains classical in character—Psiax, like the Andokides Painter, still followed the tradition of Exekias—

300

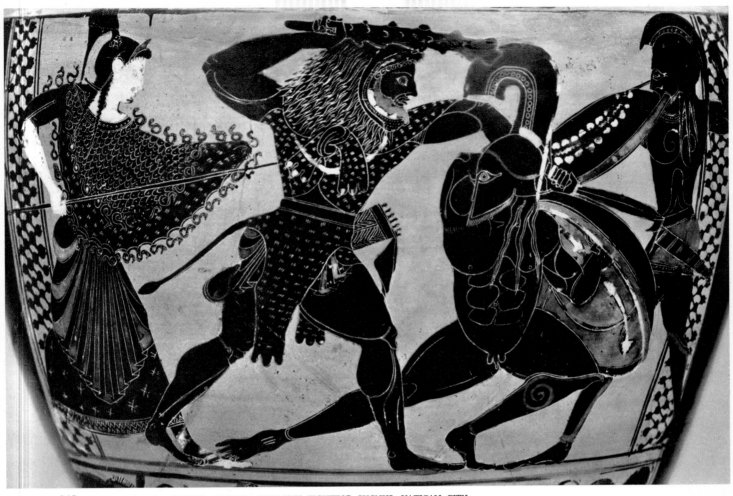

345. MADRID PAINTER. HYDRIA, DETAIL: HERACLES FIGHTING CYCNUS. VATICAN CITY.

but the structure of the figures has noticeably evolved. The faces, for instance, have the new shape that we find in the red-figure paintings of the severe style: the head is better proportioned, the nose is short, the eyes are smaller and placed approximately in the correct position.

As so often happens, artists whose personalities were less strong kept closer to tradition. Thus the Madrid Painter still used the black-figure technique and made lavish use of touches of added colour. Nonetheless, his handling of a commonplace subject like the fight between Heracles and Cycnus reveals a liveliness and a sense of movement that are quite exceptional. Athena, forgoing her customary impassibility, rushes at Heracles. The crisscrossing legs of the four figures, and still more, Cycnus's twisted body and foreshortened left leg, bear witness to a spatial vision that was completely new and unique in black-figure work. In fact, it is among the red-figure painters that we must seek the origin of this new trend. Here the drawing of the abdomen, in particular, is obviously—though awkwardly—transferred from the red-figure vases of the period.

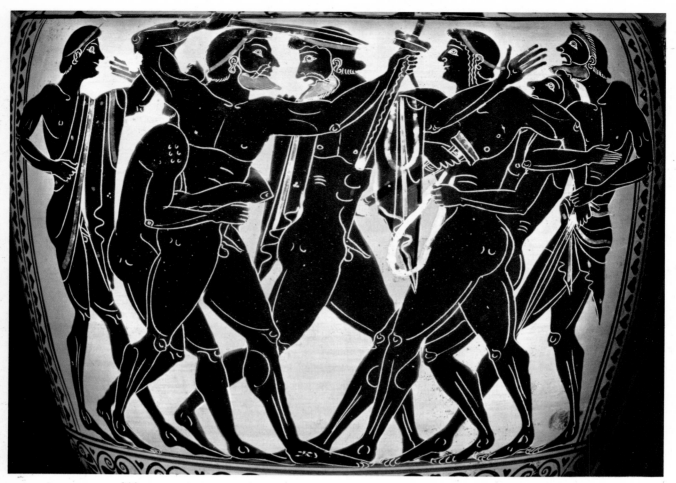

346. PAINTER A OF THE LEAGROS GROUP. HYDRIA, DETAIL: HEROES QUARRELING. LONDON.

Liveliness, vigour, and realism in the rendering of attitudes are the essential charac-
teristics of a black-figure hydria of about 520-510, now in the British Museum. The almost
cylindrical hydria has the shape used by a number of anonymous painters who make
up the Leagros group. The chief element in the decoration of these vessels was a large
rectangular panel whose proportions encouraged well-balanced composition, whereas
the shoulder was frequently adorned with a secondary subject. Scenes taken from everyday
life are as common as the traditional mythological themes. Both are depicted with a
profusion of figures and movements, even with a certain exaggerated expressionism,
which are in no way related to the classicism of Exekias and his school.

On the British Museum hydria a quarrel has blazed up, and the antagonists, whose
friends are trying to keep them apart, have already drawn their swords. The movement
of the interlocking legs suggested to the painter a V-shaped composition, in which the space
between the slanting uprights is occupied by the man with outstretched arms, who is
endeavouring to separate the adversaries. Each figure has an individuality of his own,
expressed by his gestures and facial expression. The dispute is violent but will not end in

302

347. PAINTER A OF THE LEAGROS GROUP. HYDRIA, DETAIL: ACHILLES CARRYING THE BODY OF PENTHESILEA. LONDON.

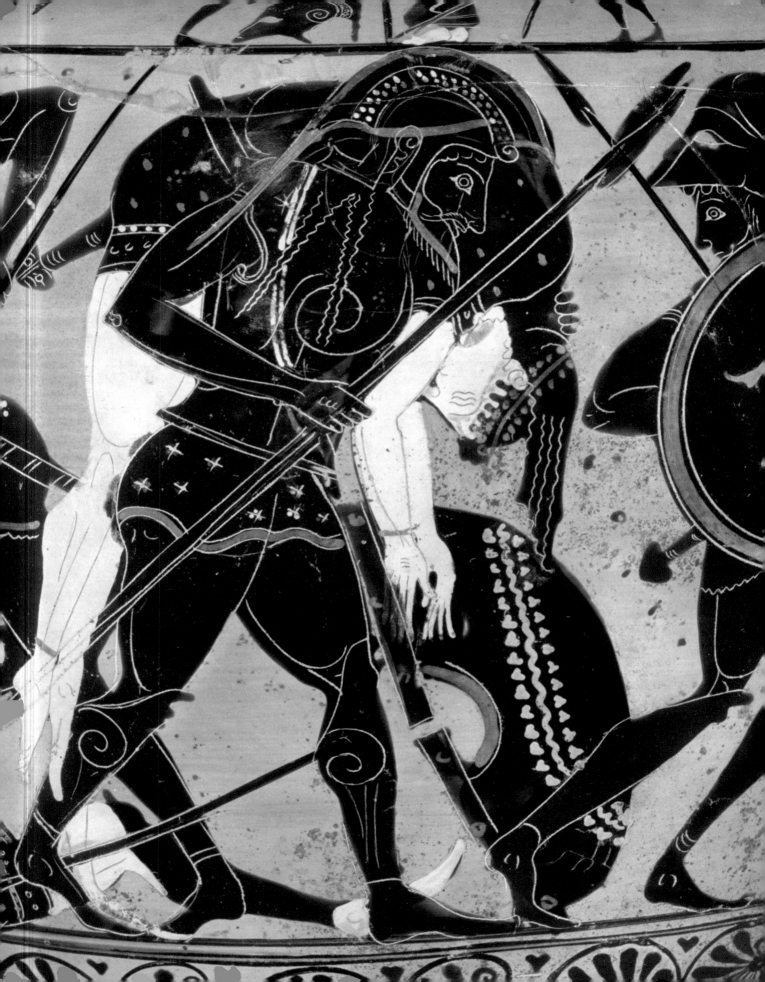

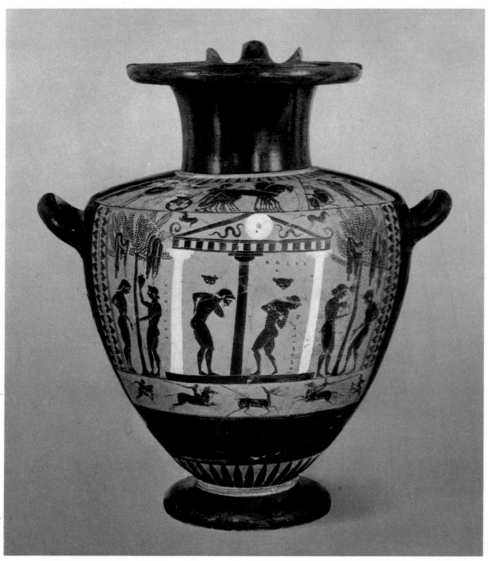

348. ANTIMENES PAINTER. HYDRIA: MEN AT A FOUNTAIN. RIJKSMUSEUM VAN OUDHEDEN, LEYDEN.

a tragedy. That, at least, is the impression the artist has succeeded in conveying in a work where, for the first time perhaps, the liveliness of the whole makes us overlook the lingering traces of archaic conventions. The expression of feelings is equally clear in a more dramatic scene on another hydria, also in the British Museum. There the theme of Penthesilea's death is treated by the same painter, one of the outstanding members of the Leagros group. Unlike Exekias (fig. 113), he has preferred to evoke the sorrow of Achilles, who, refusing to be consoled for the crime he has committed, bears away the body of the Amazon queen with measured steps, unmindful of the battle still raging round about.

Painters were attracted not only by psychological aspects but also by more easily grasped details of daily life. One of the themes that occurs most frequently, and is particularly

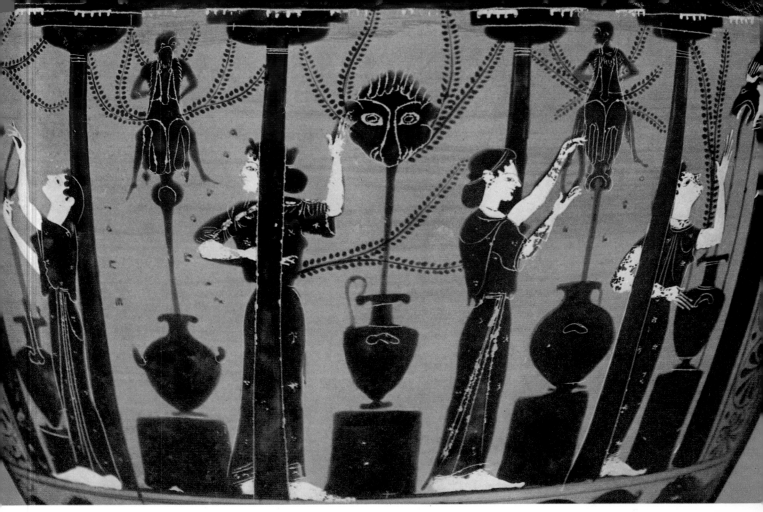

349. ATTIC HYDRIA, DETAIL: WOMEN DRAWING WATER AT A FOUNTAIN. BRITISH MUSEUM, LONDON.

well suited to the purpose for which the hydriai were used, is that of women fetching water. The women are seen filling their jars at the spouts in the monumental fountain houses that the Athenians, who formerly had been forced to make do with wells and cisterns, had received from their tyrants' bounty. On occasion the fountain houses were visited by young men who used them as showers. A vividly coloured hydria by the Antimenes Painter depicts the men washing alongside others who are oiling their bodies in the shade of the trees on which they have hung their clothes. The fountains where the women replenish their hydriai are adorned with leafy boughs. The background of these scenes is increasingly filled with different schematic foliage patterns, which provide a facile filling ornament for a style that on the whole declined to a very mediocre level after 510.

However, at the beginning of the late black-figure period, about 520-510, some black-figure painters display a taste for natural setting that is almost as highly developed as in Ionia. Black-figure is more suited than red-figure for representing nature. The delicate foliage of the trees in archaic paintings stands out clearly against the pale clay. In the red-figure style, however, leaves can appear as touches of added colour on the black ground.

305

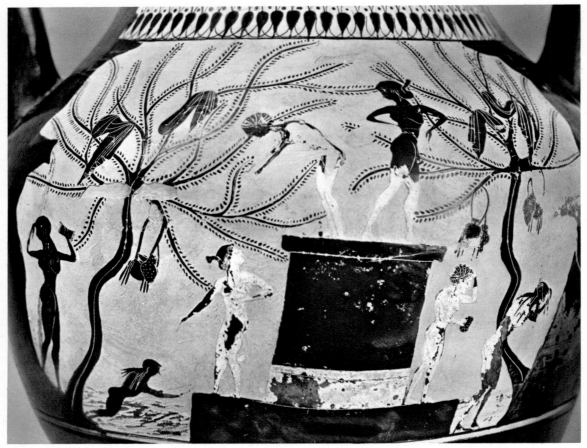

350. PRIAM PAINTER. AMPHORA, DETAIL: WOMEN BATHING. VILLA GIULIA MUSEUM, ROME.

An amphora by the Priam Painter recently found in Etruria proves that Attic artists were not totally devoid of a feeling for nature. Indeed, it afforded some of them a chance to attempt to save black-figure in some measure by renewing their themes and sources of inspiration. There is perhaps no other archaic painting in which the Greeks' love of water is expressed so delicately as in this scene. At the mouth of a grotto whose rocky walls form the frame of the panel seven naked girls disport themselves in a watery landscape. One is diving into a pool that is overshadowed by two trees on whose branches hang garments and perfume jars. Two others are taking a shower and washing themselves under the jets of water that gush out of the rock. The white added to the girls' bodies, which has partly disappeared, gives a bright tonality to a picture that is no longer, in effect, made up of black silhouettes. The large pedestal, which is set, no doubt on purpose, slightly off centre, serves as axis and focus of a composition that, though in appearance loosely designed, is in fact carefully thought out. Thus the arms of the two girls who stand one above the other point to the one diving into the water, whose body prolongs the line formed by those arms. There is more than one novelty in this pleasant and original work: for instance, the detail of water splashing on a lovely lissom body and—a still more surprisingly impressionistic effect—the reflection of light on water in front of the grotto.

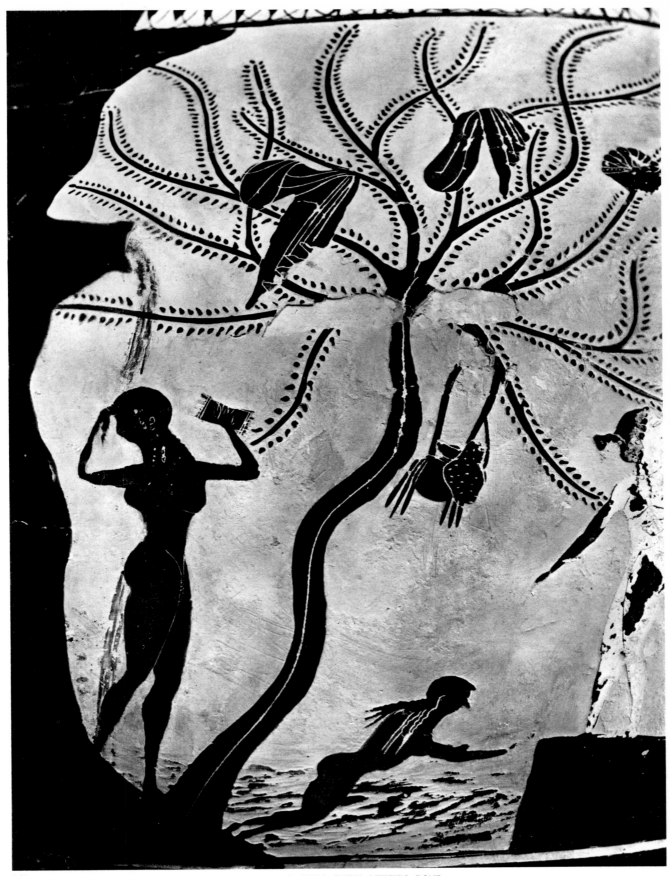

351. PRIAM PAINTER. AMPHORA, DETAIL: WOMEN BATHING. VILLA GIULIA MUSEUM, ROME.

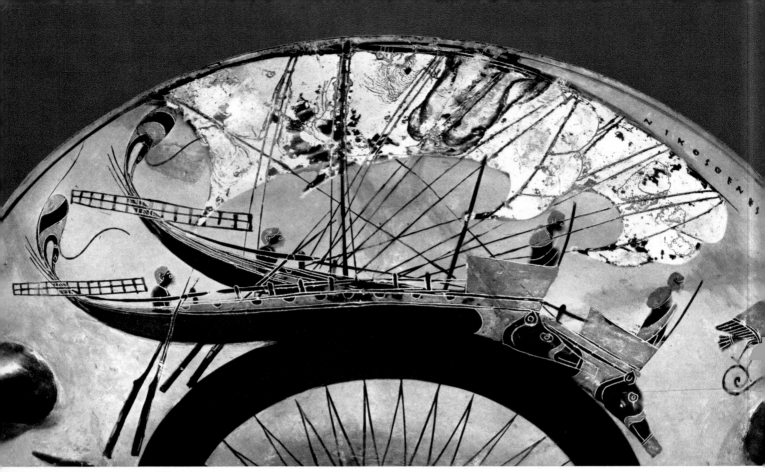

352. NIKOSTHENES PAINTER. CUP, DETAIL: SHIPS. LOUVRE, PARIS.

Other black-figure painters sought to renovate their technique while following the same naturalistic trend. One of their most characteristic procedures was the extensive use of white both in the painted decoration or, better still, as a background for the figures. A good example of the first method occurs on a cup in the Louvre with the signature of Nikosthenes, who owned a thriving workshop that chiefly produced ware for export to Etruria. Nikosthenes signed as potter a quantity of amphorae, oinochoai, and cups, some of which display very original shapes. But some of the painters he employed were rather mediocre. The cup in the Louvre differs from the general run in the painter's inventive spirit and decorative skill. Two boats, whose huge white sails belly with the wind, are curved to fit the roundness of the cup. The miniaturist style of the preceding generation is evident but the inspiration is new, for here the human figure plays a purely secondary role.

Nikosthenes' workshop also produced a series of white-ground vases. Indeed, it was probably responsible for an oinochoe in Brussels of exquisite shape and well-proportioned decoration. The naturalistic inspiration of the theme is clear, but the execution does more than merely reflect an accurate observation: it is already almost a genre scene. The appearance of this rather precious white-ground technique calls for a few comments. First of all, it is striking that white-ground was still in use among the few good black-figure painters of the early fifth century. The Sappho Painter uses it, for instance, on a krater with a

353. PAINTER OF THE NIKOSTHENES WORKSHOP. OINOCHOE: COW SUCKLING HER CALF. BIBLIOTHÈQUE ROYALE, BRUSSELS.

354. SAPPHO PAINTER. COLUMN KRATER: ODYSSEUS ESCAPING FROM POLYPHEMUS' CAVE. KARLSRUHE.

representation of the trick that Odysseus and his comrades used to slip past Polyphemus and escape from his cave. The technique was also used, though infrequently, by some red-figure painters when they wanted to give their compositions a more 'painterly' appearance. Lastly, the polychromy of the Attic white-ground lekythoi during the fifth century provides obvious proof of the influence of fresco painting. Indeed, the question arises whether the appearance of the Attic white-ground technique does not perhaps tally with a progressively increasing importance of wall painting.

Painting Towards the End of the Archaic Period

Meanwhile, the vogue for pictures painted on terra-cotta plaques continued up to the end of the archaic period. They were always executed in the black-figure technique. For instance, the Sappho Painter, at the beginning of the fifth century, decorated plaques with funerary subjects that were well drawn and extremely lively, but quite traditional in composition. Even a red-figure painter like Skythes signed on the Acropolis two fine plaques with black figures. Vase painting made its influence felt in some quite unexpected quarters. At the end of the sixth century, a series of Attic stelae was painted in a manner

310

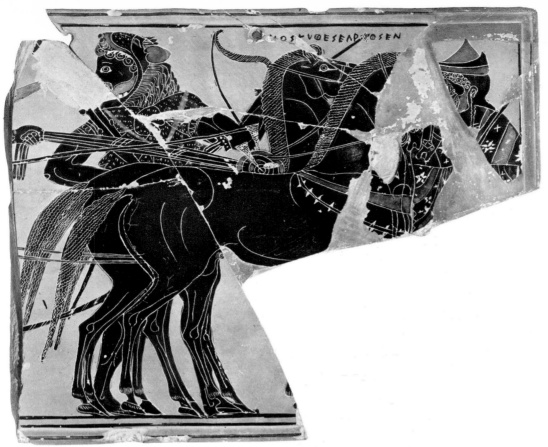

355. SKYTHES. TERRA-COTTA PLAQUE: HERACLES AND HERMES BESIDE THE CHARIOT OF ATHENA (?). NATIONAL MUSEUM, ATHENS.

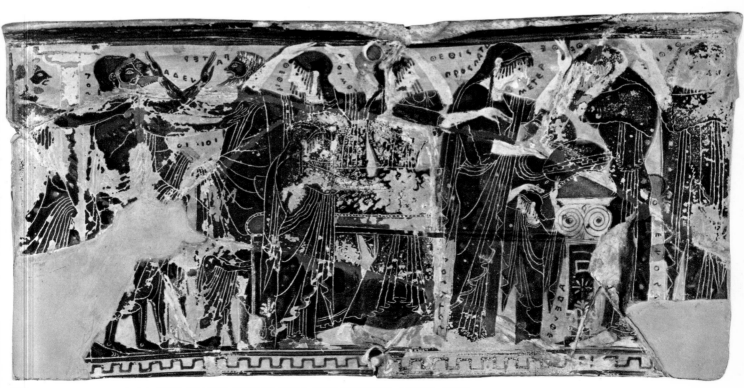

356. SAPPHO PAINTER. TERRA-COTTA PLAQUE: FUNERAL SCENE WITH MOURNERS. LOUVRE, PARIS.

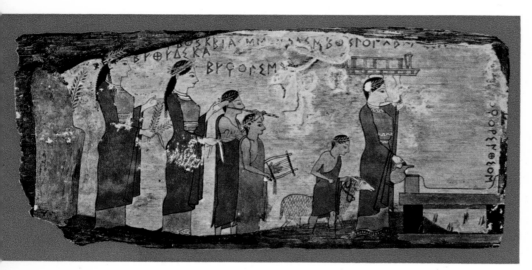

357. PITSA. CORINTHIAN PLAQUE: SACRIFICIAL SCENE. NATIONAL MUSEUM, ATHENS.
358. ATTIC GRAVESTONE OF LYSEAS: DIONYSUS WITH KANTHAROS. NATIONAL MUSEUM, ATHENS.

that recalls the red-figure style. The figures on the Lyseas stele stand out against a dark ground, and the inner drawing lays bare the pale colour of the marble. The colour range is of course broader than in vase painting, but the basic procedures are the same in both.

On the other hand, a terra-cotta plaque from the Acropolis—it may perhaps have adorned a building—breaks free to some extent from the black-figure influence. The hoplite's flesh is painted brown and outlined in black as on the Thermon metopes, though the black-figure technique is still used in a number of details.

But it is outside Athens that we must look for the first evidence of a genuine mural painting whose existence is now well established by literary tradition. The precious wooden panel paintings discovered at Pitsa, to the west of Sicyon, can give us, on a smaller scale, an idea of the frescoes of that period. The best preserved of these small pictures, a sacrificial scene, was apparently signed by a Corinthian painter. The composition is simple

312

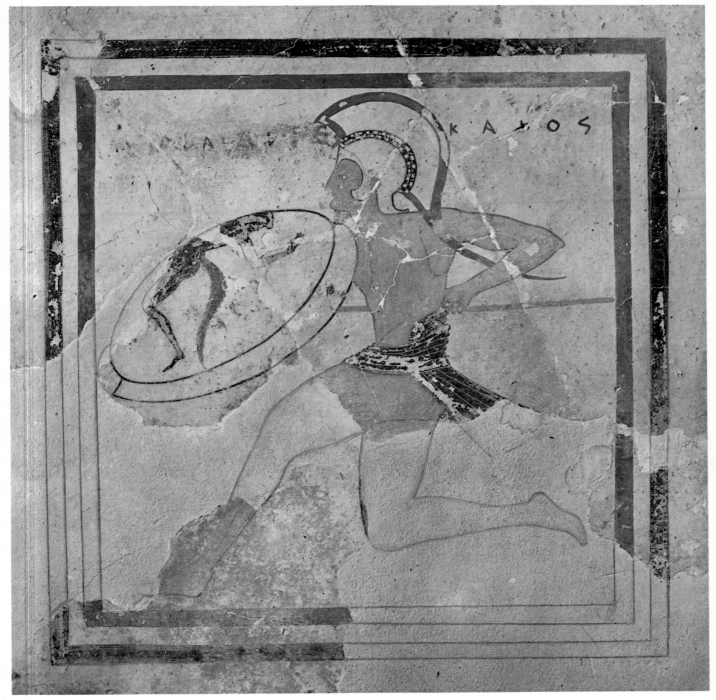

359. ATTIC TERRA-COTTA PLAQUE: RUNNING HOPLITE. ACROPOLIS MUSEUM, ATHENS.

but the linework is delicate and graceful. The technique, in particular, is that of fresco painting: the figures coloured in flat tints stand out against a white ground prepared with gesso. We can distinguish six or seven different colours; some of them—notably the blue and the red—are clear and bright. There is, of course, no depth, no trace of

313

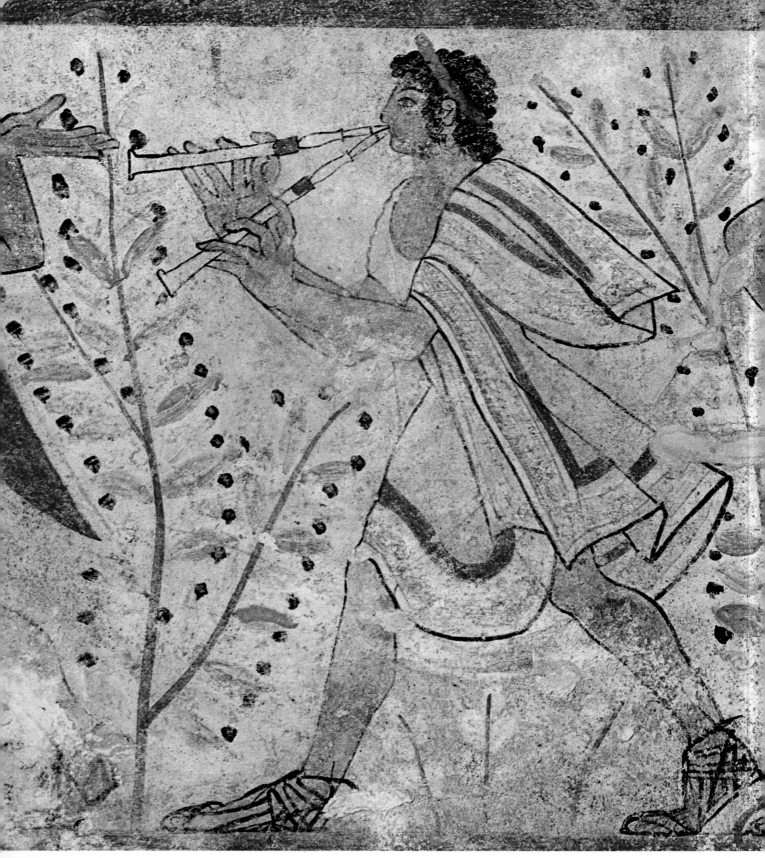

360. TARQUINIA, TOMB OF THE LEOPARDS. FLUTE PLAYER. MUSEO NAZIONALE, TARQUINIA.

314

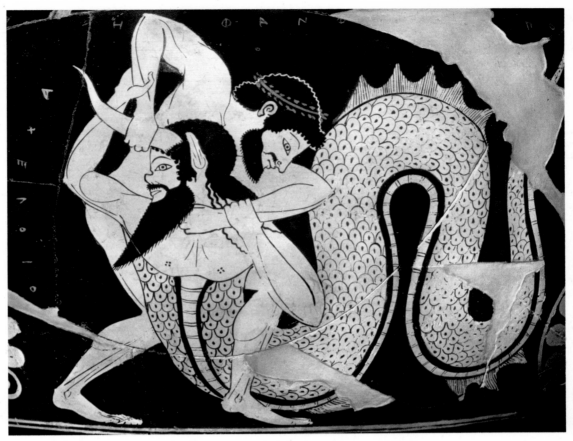

361. OLTOS. STAMNOS, DETAIL: HERACLES AND ACHELOUS. BRITISH MUSEUM, LONDON.

rounded volumes that might have been suggested by the use of graded tints. At the end of the archaic period, fresco painters still endeavoured to render the modeling of bodies and the volume of drapery by drawing alone. In the Etruscan paintings at Tarquinia, where Greek influence was strong, the drawing is very highly developed but the colours are still used in the same way.

The First Generation of the Severe Style (520-500)

After 520 or thereabouts the archaic red-figure style, the so-called severe style, asserted itself in all its rigour with a unity of conception and inspiration that is quite remarkable. The only differences are due to the marked individuality of the major artists. There is still no clear distinction between painters of large vases and painters of cups; the best artists took pleasure in displaying their talents on vessels of the most diverse shape and size.

This is true, for instance, of Oltos, whose noble style, derived from the Andokides Painter, can be appreciated even on many of his cups. The large cup at Tarquinia depicting an assembly of the gods has a rather stately aspect, but the superposed folds of

315

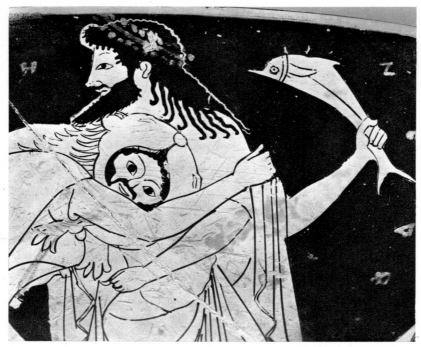

362. OLTOS. CUP, DETAIL: HERACLES AND NEREUS. VILLA GIULIA MUSEUM, ROME.

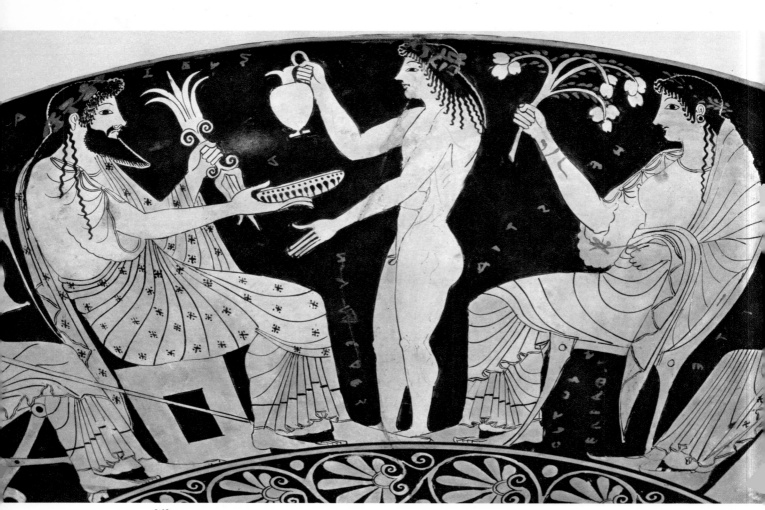

363. OLTOS. CUP, DETAIL: ASSEMBLY OF THE GODS, WITH ZEUS, GANYMEDE, AND HESTIA. MUSEO NAZIONALE, TARQUINIA.

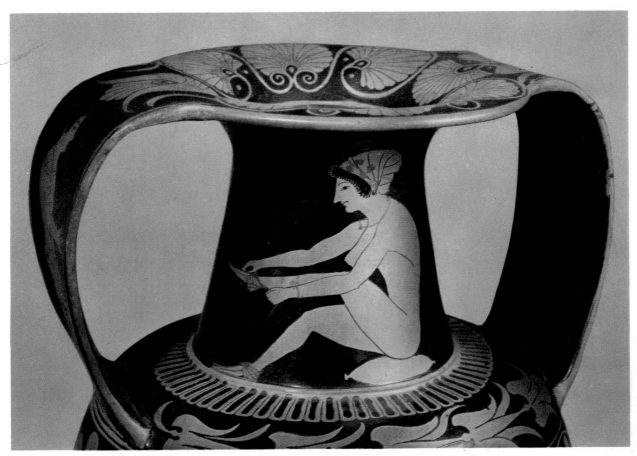

364. OLTOS. AMPHORA, DETAIL OF THE NECK: NUDE GIRL TYING ON HER SANDALS. LOUVRE, PARIS.

the garments and their full sleeves give the draped figures a plastic volume that we see here for the first time. Oltos was more interested in anatomic reality than the Andokides Painter. The Ganymede on the Tarquinia cup and the Heracles and Achelous on the London stamnos show the difference between a body at rest and one whose muscles swell under an effort. Oltos was also the first artist to make a tentative study of facial features. The nose comes to life, the lips still more. He even succeeded at times in achieving the correct frontal representation of a face. A genius in every field, he did not scorn genre scenes. The girl tying on her sandals is a delightful picture in the Ionian spirit. Noteworthy is the use of red in the drawing of the sandals and the awkward rendering of the female nude. At that time realistic observation was still restricted to the male anatomy.

Epictetos resembled Oltos in his tendency to align the figures on his cups. His first concern was to render each form correctly, but that did not make him neglect the composition. The scene of Theseus slaying the Minotaur is composed with the utmost care: the antagonist's gestures reveal the artist's search for balance. All the figures, however small, are drawn with a liveliness and an accuracy that recall the Little Masters of black-figure work. But in a quarter of a century draughtsmanship had made great progress. Here for the first time a painter has deliberately resorted to foreshortening, as in the Minotaur's right leg, which is viewed frontally while his body is turned slightly to one side, and also

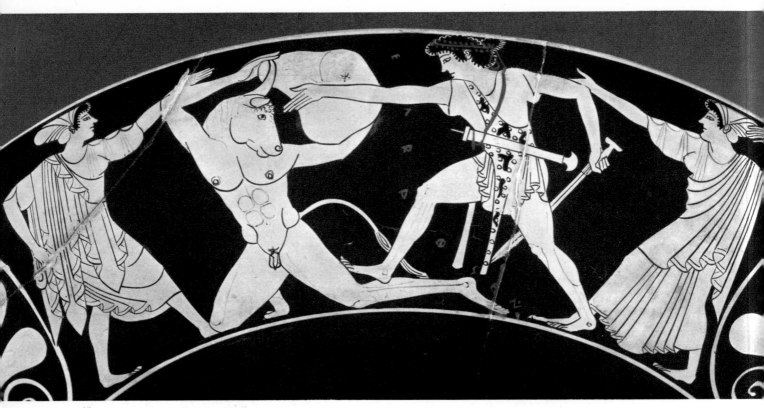

365. EPICTETOS. CUP, DETAIL: THESEUS SLAYING THE MINOTAUR. BRITISH MUSEUM, LONDON.

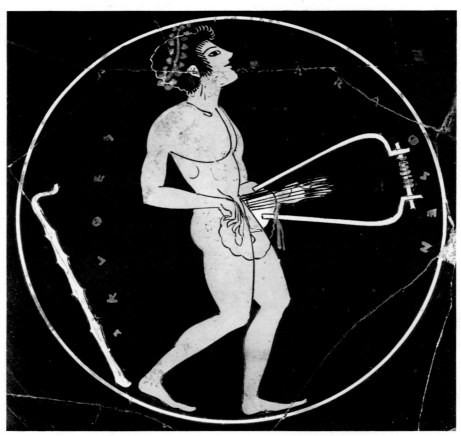

366. SKYTHES. CUP, DETAIL: LYRE PLAYER. VILLA GIULIA MUSEUM, ROME.

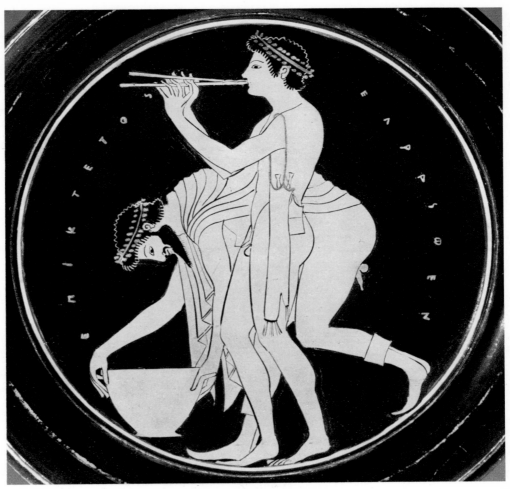

367. EPICTETOS. PLATE: REVELLERS. BRITISH MUSEUM, LONDON.

in the torso of Theseus, who is viewed from the back with his shoulder concealing the lower part of his face.

Scenes of drunken revelry were Epictetos' favourite theme. A number of plates bearing his signature are decorated with lively paintings whose composition is felicitously adapted to the shape of the vessel. There is a plate in the British Museum on which the painter superimposed one figure upon another in deliberately contrasted attitudes. Also worthy of note are the superposition of the young flute player's arms and the foreshortening entailed by the action of the reveller picking up the skyphos. Epictetos displays his gifts in the supple, yet rigorous contour lines of every one of his works.

Skythes, who worked with Epictetos and, like him, was a cup painter, produced tondos in a similar manner. The lyre player on a cup in Rome fills a roundel no less harmoniously. The movement of the legs balances that of chest and head; the latter is bent back slightly in a pose calculated to express the feelings of a musician enthralled by his instrument. Here, as with Epictetos, one admires the delicate rendering of the hands, each finger of which is drawn separately. Skythes, however, is far more concerned than Epictetos with anatomical detail and has rendered the abdomen with a network of faint lines.

319

There were many other cup painters of the same generation, but their names have not come down to us. The quality of their work varies widely, and even the best pieces are less perfect in conception and execution than those of the above artists. The Nikosthenes Painter, for instance, decorated a number of cups and small vases, some of which bear the signature of this master potter, whose output was extremely abundant. One of the anonymous painter's most original works is a cup in Melbourne with an infrequently represented theme: Hypnos, the tutelary spirit of sleep, is perched on the body of the sleeping Alcyoneus when he is surprised by Heracles. The painting is lively, but the overall composition and the positions of the figures are still rather naïve, while the drawing, even of their garments, is flat. The artist has made some attempts at foreshortening by drawing in front view the face of the sleeping giant and rendering the details of his abdomen. But in all probability he merely reproduced on a smaller scale what had already been done by the great contemporary masters.

Of these latter Euphronios stands in the first rank. He was the typical craftsman of genius. While continuing to use all the forms lately invented for red-figure, he added others of his own making, and his work has nothing in common with the black-figure style that was still practised by Oltos and Epictetos. At the start, between about 520 and 500, he was first and foremost a painter. But at the end of the century he gave up painting and from 500 to 480 devoted the end of his long career to working as a potter and managing a prosperous workshop that employed many young painters.

For Euphronios the accurate observation of the human body was an absolute law. It is a commonplace to view the krater of Heracles and Antaeus as a sort of anatomical

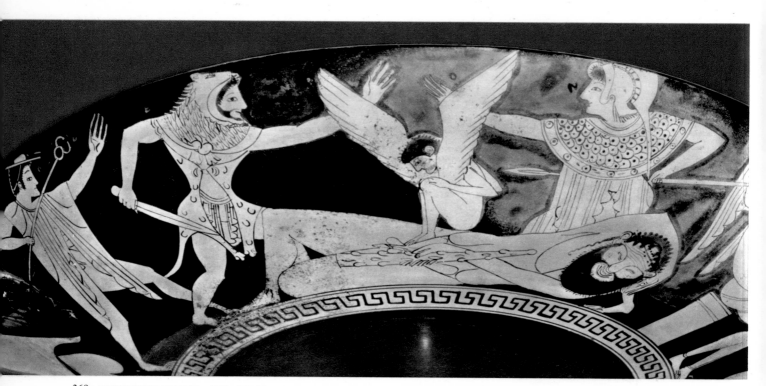

368. NIKOSTHENES PAINTER. CUP, DETAIL: HERACLES AND ALCYONEUS. NATIONAL GALLERY OF VICTORIA, MELBOURNE.

320

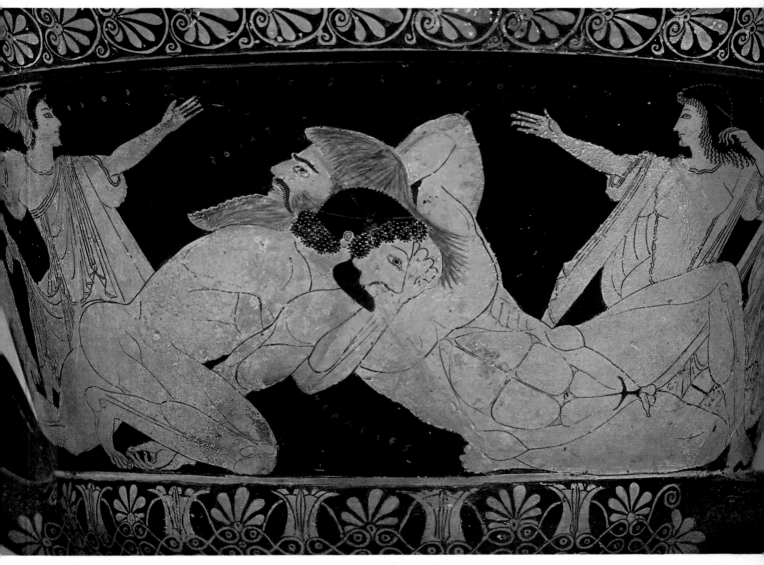

369. EUPHRONIOS. CALYX-KRATER, DETAIL: HERACLES AND ANTAEUS. LOUVRE, PARIS.

table complete with every detail, even those invisible to the naked eye. Certainly Euphronios, like the artists of the Renaissance, made a systematic study of the human body. But the realism he practised, down to the figures' hair, does not consist simply in accurately observing and positioning numerous anatomical details. He aimed also at creating an overall impression, breathing life into a body, conveying facial expressions rendering movements in space. Needless to say, there are still some archaic traits—Antaeus' frame is too violently twisted, and the eyes are still depicted frontally—but foreshortening is more frequent in the arms and legs; the mouths and eyes are livelier. All these details fuse in a felicitous whole, and the composition of the scene agrees with the canons of classical harmony while avoiding overstrict symmetry.

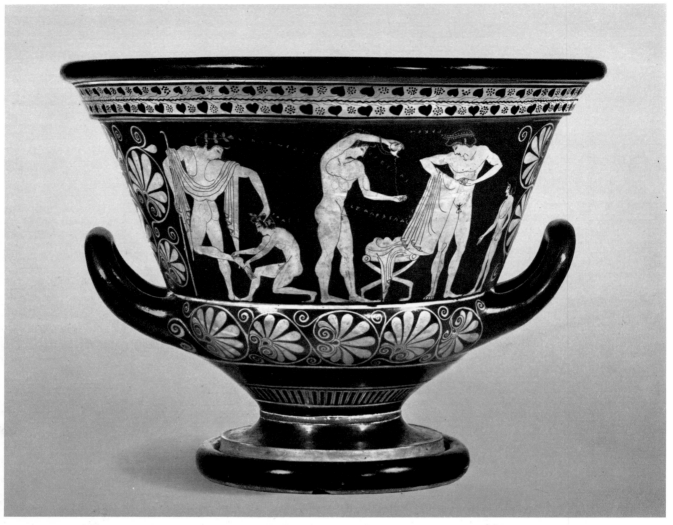

370. EUPHRONIOS. CALYX-KRATER: YOUNG MEN OILING AND GROOMING THEMSELVES. STAATLICHE MUSEEN, BERLIN.

The calyx-krater in Berlin is not decorated with pictures in the proper sense of the term, though the figures are pleasantly framed in the general architecture of the vase. The young men's toilet offered the artist a pretext for observations of figures in movement with twisted gestures and foreshortened limbs.

Here Euphronios deliberately attempted to record unusual attitudes that raised difficult problems, for instance, a young man viewed from the rear, precarious by balancing, with one foot lifted behind him and one shoulder much higher than the other. The general asymmetry of the body is well caught, and the graceful details of the drapery over the shoulders and the hand resting on the slave boy's head transform a dry anatomical study into a very charming group. The young man holding the raised aryballos is drawn in an equally asymmetrical pose but is viewed in profile and his body is less twisted. Still more remarkable is the novel statuesque posture of the young man on the right,

whose whole body is viewed from the front with one leg in frontal and the other in three-quarter view.

Nothing is second-rate in Euphronios' work. An equal skill and spirit of experiment is displayed on an unsigned amphora in the Louvre, where the decoration is limited to a seated reveller depicted on the neck of the vase. Arms and legs are foreshortened in a way that, combined with the body's torsion and the garment's stacked folds, gives the figure an unusual depth, especially towards the left. Euphronios was very fond of depicting young men, but he never repeated the same figure. His inventiveness is as unfailing as the quality of his workmanship.

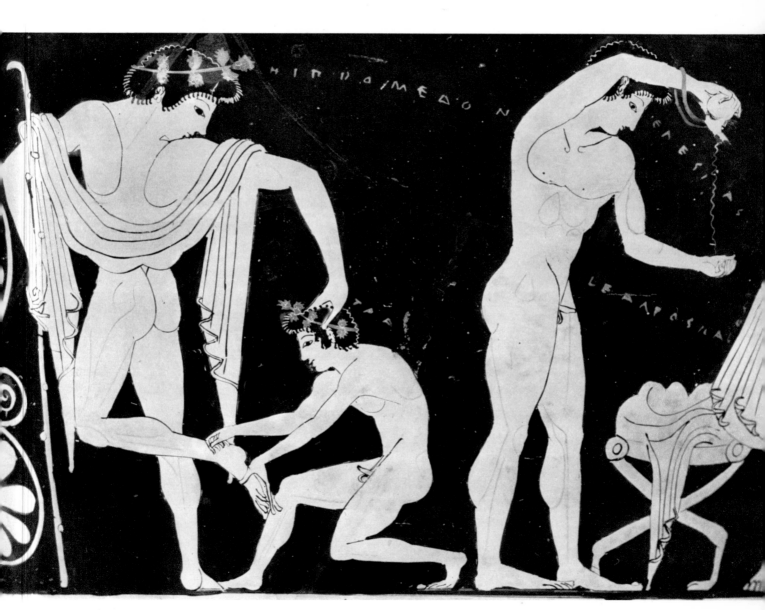

371. EUPHRONIOS. CALYX-KRATER, DETAIL: YOUNG MEN OILING AND GROOMING THEMSELVES. BERLIN.

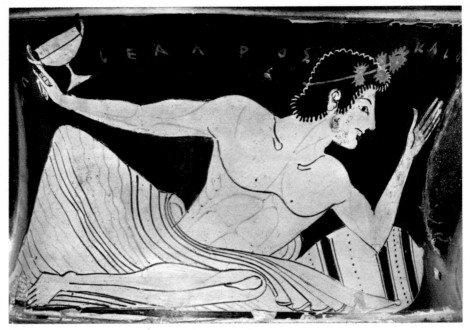

372. EUPHRONIOS. AMPHORA, DETAIL: BANQUETING REVELLER. LOUVRE, PARIS.

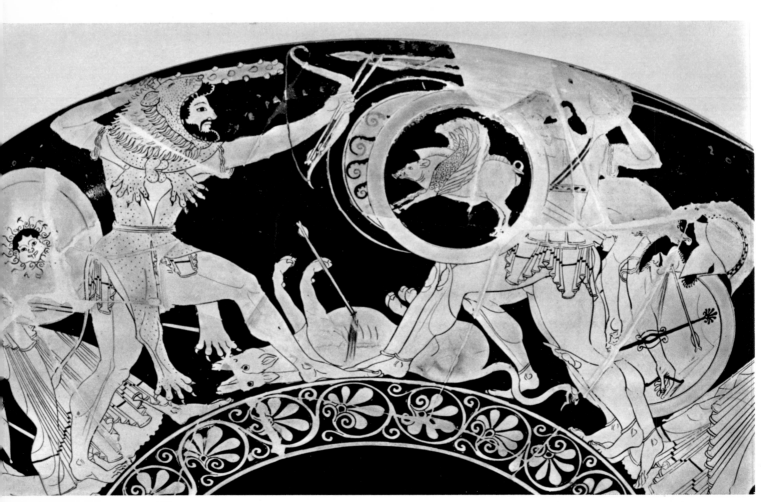

373. EUPHRONIOS. CUP, DETAIL: HERACLES AND GERYON. STAATLICHE ANTIKENSAMMLUNGEN, MUNICH.

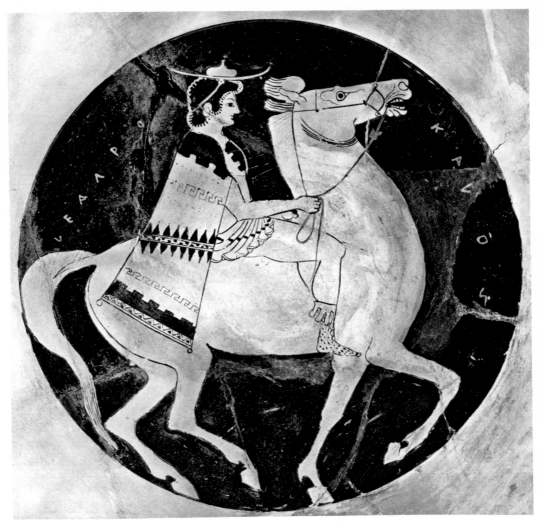

374. EUPHRONIOS. CUP, DETAIL: YOUTH ON HORSEBACK. STAATLICHE ANTIKENSAMMLUNGEN, MUNICH.

Further proof of Euphronios' many-sided talent is provided by the magnificent cup in Munich. Can we doubt that the artist deliberately contrasted the sober tondo inside the cup with the large dynamic composition that adorns the outside? On the lookout for novelty, as was his wont, he ringed the tondo with a broad band of 'coral' red, reverting to a technique already employed by Exekias in his Dionysus cup (fig. 116). The figure of Euphronios' young man on horseback has an admirable elegance. The horse's feet, tail, and head seem so naturally arranged that one does not notice the fact that they were designed to fit the circumference of the tondo. The cup's outer decoration is one of the first instances of a complex, agitated scene adapted to the difficult shape of a large shallow cup. Heracles, the three-headed, three-bodied Geryon, and the terrified woman on the right present a carefully designed balance of advancing and receding masses filling up the empty spaces that unavoidably occur between the figures. Heracles' hand grasping bow and arrows is thrust out until it well-nigh touches two of Geryon's shields; these latter, in turn, act as counterweight to the mortally wounded body of the monster.

325

375. EUTHYMIDES. AMPHORA: HECTOR ARMING, BETWEEN PRIAM AND HECUBA. MUNICH.

'As never Euphronios [painted]': this defiant inscription can be seen alongside Euthymides' signature as painter of an amphora in Munich decorated with the figure of Hector donning his armour. This is clear proof that Euphronios was considered by his contemporaries as a master who was far from easy to surpass. Many details on the Munich amphora bring him to mind: first and foremost the taste, common to both artists, for realistic observation of the anatomy and positions of bodies in movement enclosed in a limited space. Like Euphronios, and for the same reason, Euthymides markedly preferred athletes and revellers. But he was less concerned with avoiding static presentation, and his figures even in strenuous movement do not seem to vibrate with as much intense vitality. The lines of his figures, though drawn with flawless accuracy, are more supple and fluent. One is surprised to see how close the principal panel of the Munich amphora is to the classical spirit of Exekias' day, for Euthymides was before all else a painter of panel

376. EUTHYMIDES. AMPHORA, DETAIL: DANCING REVELLERS. STAATLICHE ANTIKENSAMMLUNGEN, MUNICH.

(one-piece) amphorae. This picture of Hector flanked by his parents Priam and Hecuba shows the same restraint in the barely suggested expression of feeling. Needless to say, there are great stylistic differences between Euphronios and Euthymides. The statuesque frontal posture of Hector is virtually the same as that of one of the athletes on Euphronios' krater in Berlin. But the drapery, which Euthymides perhaps studied in greater detail than Euphronios did, gives the three figures a monumental quality that the latter sought to achieve with foreshortening.

It is in the scene of revelry on the other side of the Munich vase that Euthymides wrote his challenge to Euphronios. Was he alluding to the more balanced (but at the same time more commonplace) grouping of the figures or to the torsion and foreshortening of the reveller in the centre? Whatever the reason, this rear view of an excessively foreshortened torso and the exaggerated slant of the spine cannot bear comparison with Euphronios'

327

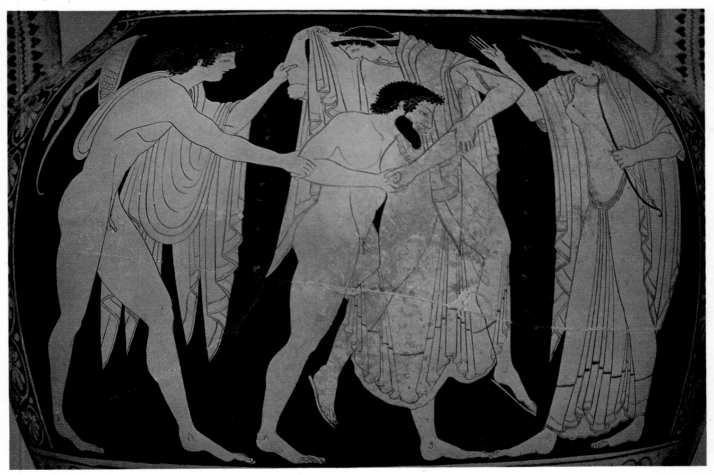

378. PHINTIAS. AMPHORA, DETAIL: LETO CARRIED OFF BY TITYUS. LOUVRE, PARIS.

effortless solution of a similar problem on the Berlin krater. What Euthymides has added as his personal contribution is a mannered, rather feminine grace that Euphronios, a painter of male bodies, lacked. In Munich there is another amphora decorated by Euthymides, representing Helen carried off by Theseus—the nonviolent abduction of a willing maiden who caresses her ravisher. The smiling faces, the affected drawing of the hands with their slender, up-turned fingers, the elaborate hair styles, and the formal attire seem to echo an Ionian trend: the girl Theseus clasps in his arms is a kore from the Acropolis. But even so the artist has not neglected his study of the male nude. How sharp is the contrast between the hero's muscular strength and Helen's naïve grace!

Another vase painter of the first importance is Phintias, who resembled both Euthymides and Euphronios, but was closer to the former. Their kinship is evident when we compare the abduction of Helen by Theseus with that of Leto by Tityus on an amphora by Phintias in the Louvre. The grouping is similar and the figures have the same smiling grace, although here the circumstances might seem more dramatic because Leto was carried off against her will and the ravisher was subsequently pursued and slaughtered

329

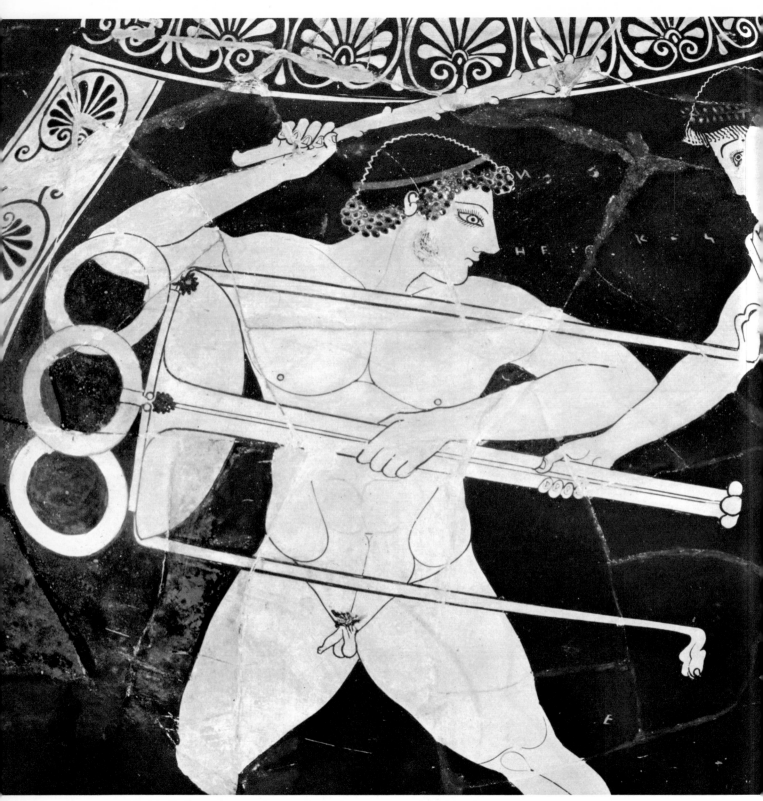

379. PHINTIAS. AMPHORA, DETAIL: HERACLES CARRYING OFF APOLLO'S TRIPOD. MUSEO NAZIONALE, TARQUINIA.

380. PHINTIAS. AMPHORA, DETAIL: SATYR EMBRACING A MAENAD. MUSEO NAZIONALE, TARQUINIA.

by Leto's children, Apollo and Artemis. Phintias showed the two deities present at the abduction, but they put up only a token resistance with the ghost of a smile upon their lips. Nonetheless, despite the rather mannered grace of their portrayal, the figures display a more athletic vigour than those of Euthymides. There is also a difference of accent: whereas Helen was simply borne away in her ravisher's arms, Leto is lifted off the ground, almost as if torn up by the roots.

To appreciate Phintias' spirited drawing fully we must examine certain details in isolation. He is even more meticulous than Euphronios in portraying the anatomy of some of his figures. For instance, he drew the fingernails in one by one. This wealth of detail in no way detracts from the overall design. Like Euthymides' Theseus, the figure of Heracles carrying off Apollo's tripod is presented frontally on the Tarquinia amphora, with a strenuous movement of the legs and a marked foreshortening of the arms. Apollo, too, is presented frontally, with the result that the entire picture faces the spectator. The details do not preclude a concern for psychological expression. The other side of the same amphora is adorned with a Dionysiac comos in which a satyr has thrown his arms around a maenad and is about to kiss her. The expression of lust on his tormented features, which are also shown full-face, is a first tentative communication between the image and the spectator.

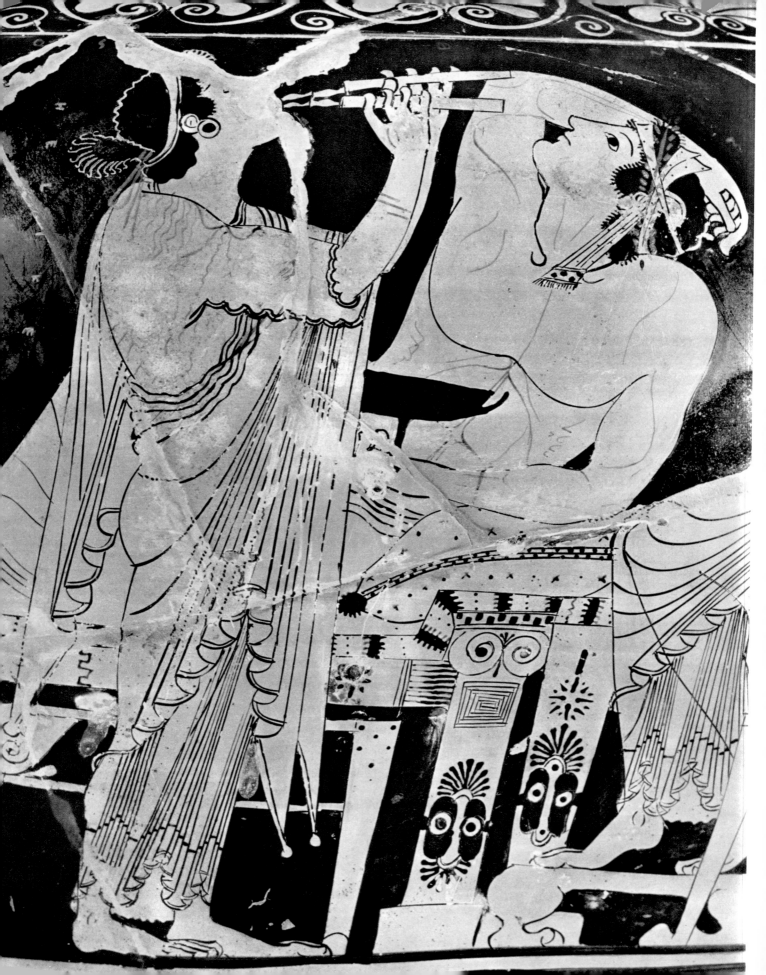

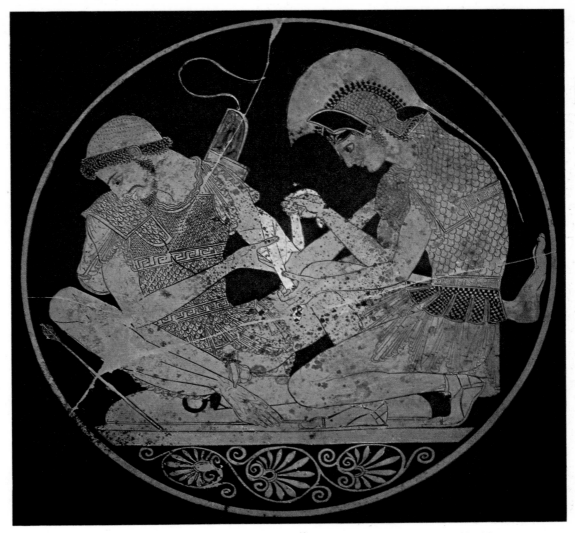

382. SOSIAS. CUP, DETAIL: ACHILLES BANDAGING PATROCLUS' WOUND. STAATLICHE MUSEEN, BERLIN.

Besides Euphronios, Euthymides, and Phintias, there were other excellent painters who may have had less inventive talent but seldom lapsed into the commonplace. One of them was Smikros, who painted his own portrait as a reveler enraptured by the music produced by a girl playing a double flute. The ecstatic pose prefigures some masterpieces of the next generation.

The state of red-figure vase painting about the turn of the century is best shown in two cups preserved in Berlin, which stand rather apart from the general run but are no less characteristic. One, signed by the potter Sosias, exploits all the latest achievements in foreshortening; the painter even outdid Euphronios in the precision and refinement of certain details. The picture of Achilles bandaging Patroclus' wounded arm is composed in a masterly fashion in its tondo and reveals two striking innovations: the notion of a group veritably conceived in space and the complete departure from conventional devices

333

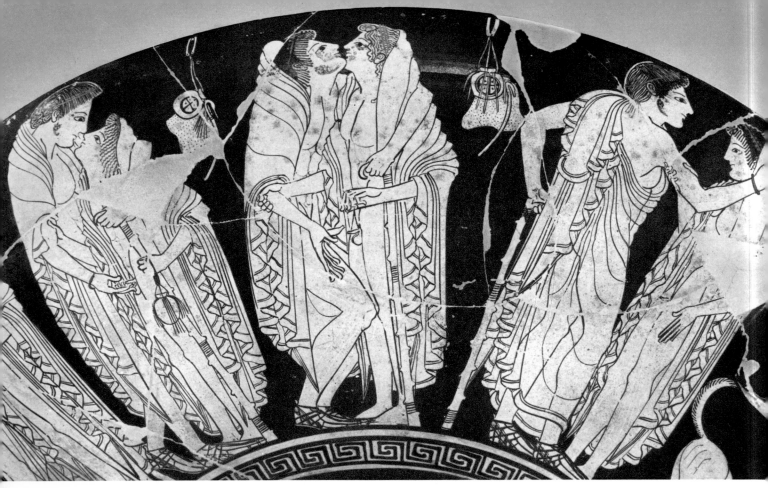

383. PEITHINOS. CUP, DETAIL: AMOROUS COUPLES. STAATLICHE MUSEEN, BERLIN.

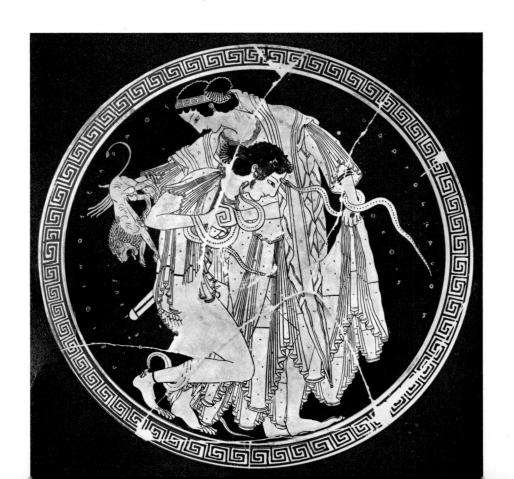

385. KLEOPHRADES PAINTER. CALYX-KRATER, DETAIL: ATHLETES. MUSEO NAZIONALE, TARQUINIA.

in the rendering of facial expression. Even the eye is now drawn in side view. The other cup, which is signed by Peithinos, seems more archaic at first glance, but the intricate, lavish, almost mannered interplay of the transparent draperies is already in the spirit of Macron (p. 351), or the Brygos Painter (p. 346), as is the erotic theme represented on the outside band surrounding the centrepiece.

The Second Generation of the Severe Style (500-480)

By the early fifth century, vase painters had a highly developed technique. In a quarter of a century anatomical observation had made such gigantic strides that drawing a figure in movement now raised few if any problems. Thus it is all the more surprising to see that the traditions and conventions of archaic art were still in part observed. Painters still preferred to draw their figures in profile rather than in front or three-quarter view. Faces depicted frontally were even less frequent than during the sixth century, and another twenty years passed before the eye was generally drawn in side view though that occurred, as we have seen, in works produced as early as about 500. If the truth be told, Attic painters were not in the least inhibited by the continued existence of those conventions. In fact, what they wanted was to make pictures that were expressive in themselves or stressed the beauty of a single figure. A distinction was made between artists who painted large vases and those

335

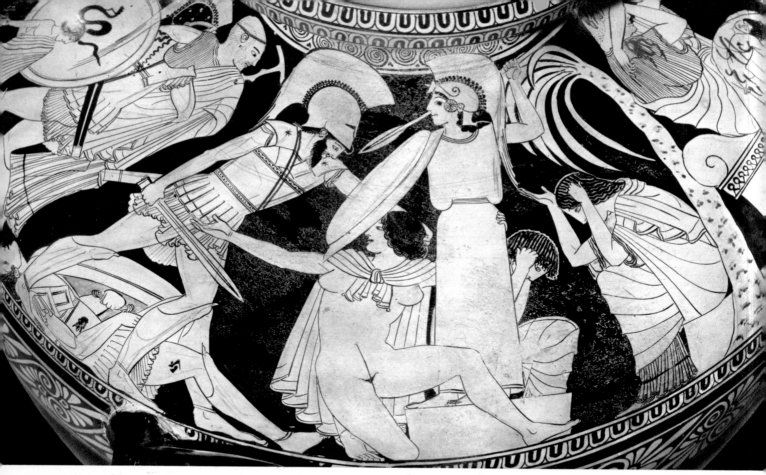

386. KLEOPHRADES PAINTER. HYDRIA: THE FALL OF TROY, WITH AJAX AND CASSANDRA. MUSEO NAZIONALE, NAPLES.

who painted cups, but in practice specialization in the matter of size and shape did not involve any great difference in inspiration. Painters of the first rank took no less pleasure in illustrating themes with great dramatic power than in depicting the jollities of revellers or the exercises of athletes. The differences lie rather in the artists' personal style.

The Kleophrades Painter was apparently a pupil of Euthymides. In fact, the athletes on the Tarquinia calyx-krater display the rather languid animation and the stacked folds typical of that master of the previous generation. The younger artist had learned well his lessons about rendering of anatomical detail, presentation of figures in front or back view, torsion and foreshortening. But he also contributed something of his own: the sculptural solidity of the two figures and the establishment of a link between them through the glances they exchange and through the composition of the scene. The group is situated, so to say, in space, for the black paint spreads freely and unrestrictedly on both sides.

But it is in grand epic compositions like the fall of Troy on the shoulder of the Naples hydria that the Kleophrades Painter displayed his genius to the full. Faced with problems still more complicated than those involved in the decoration of a large shallow cup, he composed a scene of heretofore unrealized breadth and unity. The outstretched corpses and the kneeling or seated figures of the vanquished give the picture rhythm and fill the empty spaces between those that stand erect. Here—and this is where a vase differs from a cup—the heads are close together while the bodies diverge. The scene is composed as

336

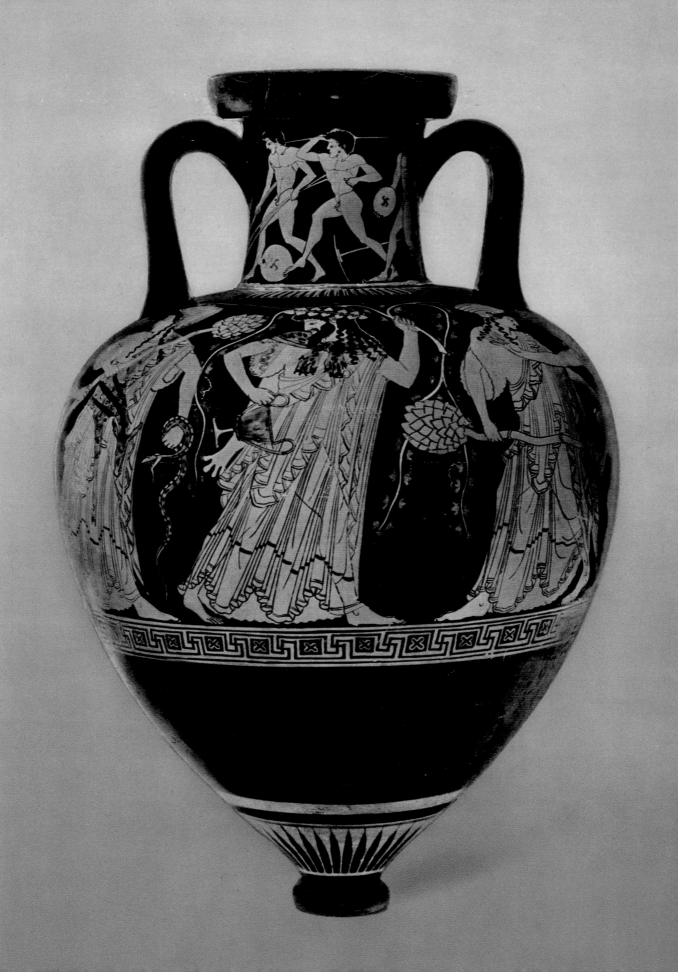

388. KLEOPHRADES PAINTER. AMPHORA, DETAIL: DANCING MAENAD. STAATLICHE ANTIKENSAMMLUNGEN, MUNICH.

in the reliefs on a classical pediment: the dramatic action reaches its paroxysm in the centre while calmer episodes are depicted at each end. Thus on the left is Aeneas in flight, carrying old Anchises in his arms; in the middle, the two crucial scenes of the murder of Priam, who had taken refuge on the altar with the blood-stained body of Astyanax on his knees, and the rape of Cassandra, who had placed herself under the protection of the image of Athena. This latter scene is a novel example of realistic observation of the female nude combined with a skillful exercise in the rendering of overlapping planes.

Though its inspiration is different, the monumental amphora in Munich provides no less significant evidence of the Kleophrades Painter's gift for composing a harmonious overall decoration. Here the theme of Dionysus surrounded by his thiasos, so trite in other works, is given new breadth and resonance. The figures of the god and the maenads clad in transparent chitons, which stress the volumes while hinting at the structure of the bodies they clothe, are characterized by their noble aspect. Noteworthy, in particular, are two of the bacchantes who are in the throes of a mystic frenzy induced by the music of pipes and lyre. Their arched bodies, their heads flung back, their half-open mouths, their fixed, inspired gaze vividly express their feelings. Added to this is the realistic drawing of the eyes, shown

338

389. BERLIN PAINTER. AMPHORA, DETAIL: CITHARA PLAYER. METROPOLITAN MUSEUM OF ART, NEW YORK.

almost in side view, and a partial reversion to polychromy that is rather unusual: the hair of one maenad and the pelts they wear are coloured with a diluted brown paint. This revival of polychromy may be an indication of the growing importance of mural painting.

The Berlin Painter, a contemporary and rival of the Kleophrades Painter, employed far more sober means to render an emotion that approaches very close to musical ecstasy. But on his amphora in the Metropolitan Museum, as on the earlier Skythes cup in Rome, it is the musician who is carried away by his own music. The overall conception of the figure is quite remarkable. The lissom grace of the forms is stressed by the stole that hangs down below the cithara and accompanies the movement, but the linework is extremely firm. Though clothed in a very simple garment, the figure possesses perhaps greater plastic value than do those of the Kleophrades Painter, for there is a closer relationship between the body and the fabric. The latter moulds the forms quite distinctly, whereas in many other works the transparent garments, whose intricate folds become almost an end in themselves, are divorced, so to say, from the body that is visible under them. In fact, the plain short cloak hanging from the cithara player's shoulders in a series of broad stacked folds has far more genuine relief than a profusion of folds hunched closely together. The Berlin Painter's sober style is already very much in the spirit of the classical period.

Another significant feature is that these bodies, whose elongated forms prefigure to some extent the mannerism of the early classical style after about 480 stand out against a plain black background without a frame of any kind or even a ground line beneath their feet. This procedure, which the Kleophrades Painter employed only on occasion and then incompletely, for instance on the Tarquinia calyx-krater, became an almost constant feature of the Berlin Painter's work. Like the cithara player in the Metroplitan Museum, the figure of Heracles on an amphora in Würzburg stands out with a strong sculptural effect against the unrelieved black surface of the vase. In order to show more clearly that what counts plastically is the isolated figure and nothing else, the artist divided the scene of Heracles carrying off the Delphic tripod into two parts: Apollo, equally isolated, is represented on the other side. In this way the Berlin Painter reconstructed on the bodies of his vases a peculiarly ceramic space that recalls how some Corinthian painters a century before had used the whole periphery of the vase as a single open space, a self-contained whole. But the figure that stands out in splendid isolation against a dimensionless surface might also call to mind the Pythagorean doctrine of contrasting values—light opposed to darkness, form to void, limited to infinite.

Not all the Berlin Painter's work was conceived so deliberately as a vision in space. It is nonetheless true, however, that the great majority of his vases are adorned with isolated figures and only very few with scenes grouping several figures. The Basel amphora, which, despite its unusual size, displays a marvelous balance between the proportions of the figures and the shape of the vessel, is a sort of compromise between the two types of composition. There is a single figure on each side, each relating to the other: Heracles proffers his kantharos to Athena, who holds an oinochoe in her outstretched hand. The overall unity of the motif is suggested by the row of palmettes that serves as a base for the figures on both sides. Athena, her head slightly bowed in a pensive pose, has a graphic rather than a plastic quality, and the painter clearly took pleasure in adding detail to detail with a linework whose firmness deserves our admiration. Though adorned with

340

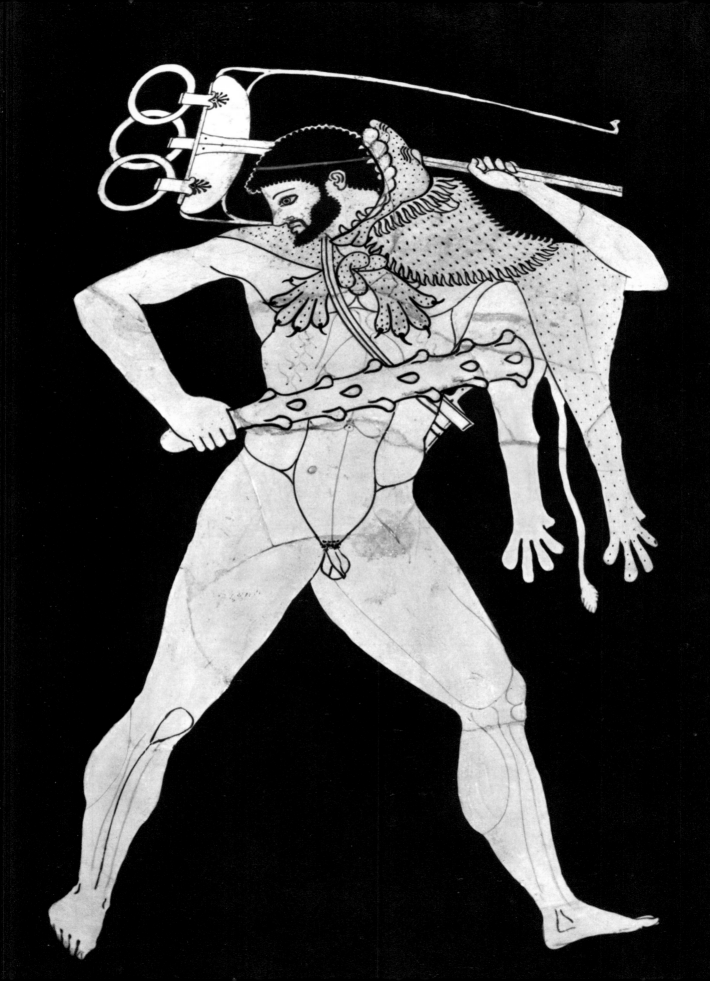

391. BERLIN PAINTER. AMPHORA: ATHENA. ANTIKENMUSEUM, BASEL.

342

392. ONESIMOS. CUP, DETAIL: DISCUS THROWER. MUSEUM OF FINE ARTS, BOSTON.

cobweb-fine embroideries, her apparel is not overloaded with folds; the chiton falls perfectly straight and allows the legs to show through wherever there are no folds. The work of the Berlin Painter displays a logical clarity of design that is essentially classical and is far less evident in many other artists.

Cup painters also used isolated figures, although not with the same intention, to decorate the tondo. Onesimos, one of the painters Euphronios preferred in his capacity as a potter, utilized the procedure after the manner of the preceding generation. His aim was to enclose a lifelike, realistically observed figure within the tondo. The discus thrower in action on the Boston cup is a very successful effort in this respect. But Onesimos did not shrink from more complex scenes in which realistic observation extended beyond isolated figures. In many of his works he took for his theme aspects of a life of pleasure, which he handled with a novel realism not only in the grouping of the figures but also in the numerous objects of common use that surround them. For instance, on his cup in the

343

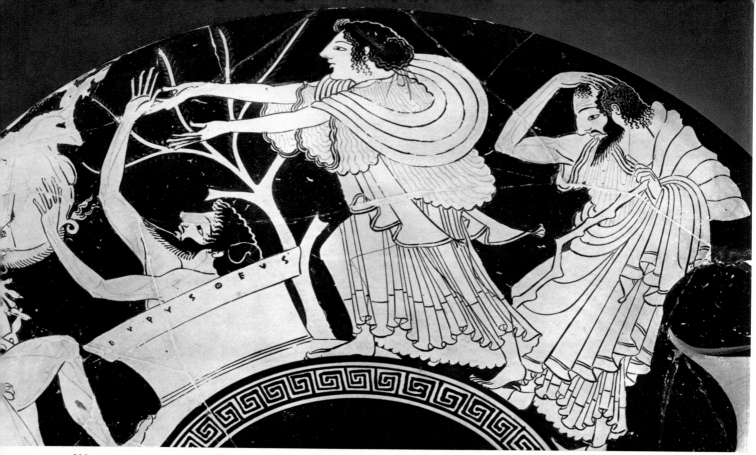

393. ONESIMOS. CUP, DETAIL: HERACLES AND EURYSTHEUS. BRITISH MUSEUM, LONDON.

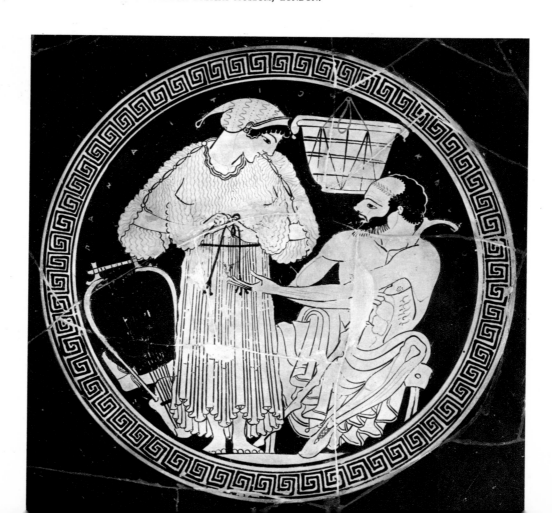

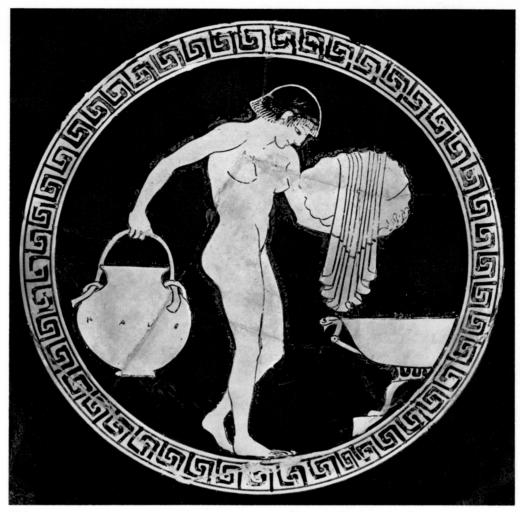

395. ONESIMOS. CUP, DETAIL: GIRL GOING TO WASH. MUSÉES ROYAUX D'ART ET D'HISTOIRE, BRUSSELS.

British Museum he has realistically caught a courtesan with her paramour in a familiar setting. Worthy of note is the skillful placing of the figures, both viewed from the front, with the seated man neatly foreshortened. Also notable is the quantity of detail: the woman's headdress, the man's shoes, and above all his balding forehead and pimply nose. This latter is one of the earliest examples in Greek vase painting of realistic portrayal of individual features. Onesimos sought to please and amuse people rather than to move them; he preferred the light side of mythological themes. On the cup in the British Museum he reverted to the scene of Eurystheus hiding in his pithos, which had already been treated in a similar spirit by the Ionian painter of the Caeretan hydriai. The lively composition fits the shape of the cup perfectly, and the drapery, which is drawn with consummate skill, is used to give the figures a perceptible volume by the massing of folds in several planes.

But what Onesimos liked best was to depict familiar subjects—a young man on horseback or, as on a cup in Brussels, a graceful young girl at her toilet. The time had come

394. ONESIMOS. CUP, DETAIL: COURTESAN UNDRESSING. BRITISH MUSEUM, LONDON.

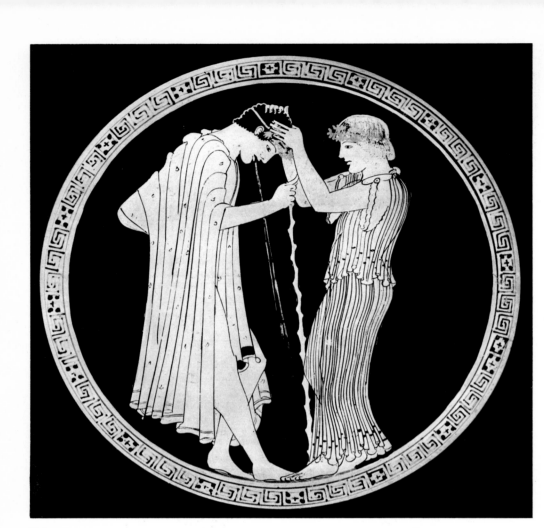

396. BRYGOS PAINTER. CUP, DETAIL: REVELLER VOMITING. WAGNER MUSEUM, WÜRZBURG.

when the female nude was considered worthy of observation for its own sake and was no longer treated merely as a frequently quite superfluous adjunct in erotic scenes.

It was, however, in the works of the Brygos Painter, the most eminent cup painter at the end of the archaic period, that the female form was first assigned its rightful place. In the rather trivial picture on the Würzburg cup of a young man vomiting after drinking too much, it is the woman who is given the most attractive role, one in which she can display all her grace and tenderness. The supple, rhythmic movements of the two figures seem to be produced by a tensed spring. This tension of the bodies, whose forms are stressed and enveloped by the sober lines of the drapery, is particularly striking in dance scenes as well. The Brygos Painter was fond of portraying maenads dancing alone in the throes of a frantic ecstasy that forced them to whirl dizzily round and round, still more wildly mystic perhaps and more overcome by the sacred frenzy than those depicted by the Kleophrades Painter. Like the latter, the Brygos Painter did not hesitate to employ certain 'painterly' procedures. The tondo of the Munich cup is in the white-ground technique, encircled by a black and white frame, and the painter made great play with brownish-yellow paint, as he did with a diluted brown for certain details on the

398. BRYGOS PAINTER. CUP, DETAIL: MAENAD. STAATLICHE ANTIKENSAMMLUNGEN, MUNICH.

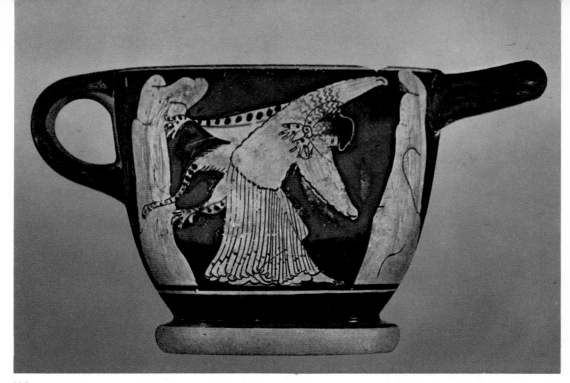

397. BRYGOS PAINTER. SKYPHOS: MAENAD DANCING. METROPOLITAN MUSEUM OF ART, NEW YORK.

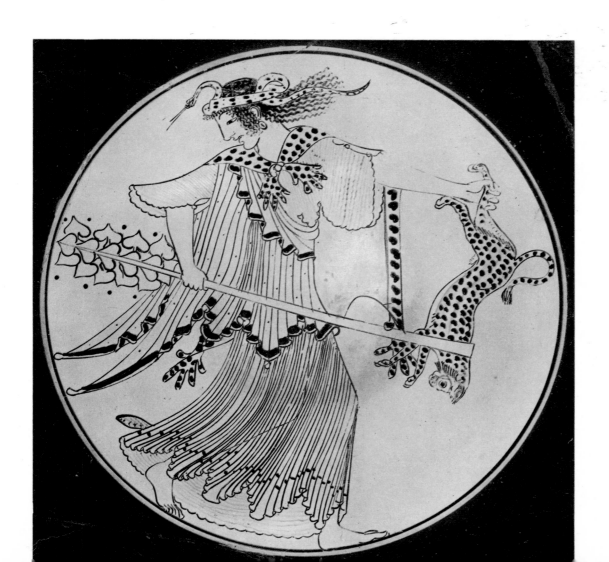

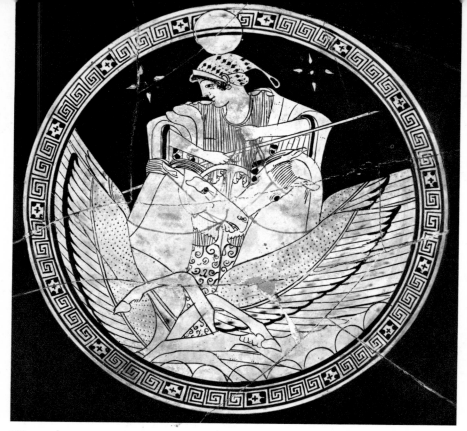

399. BRYGOS PAINTER. CUP, DETAIL: SELENE IN HER CHARIOT. BERLIN.

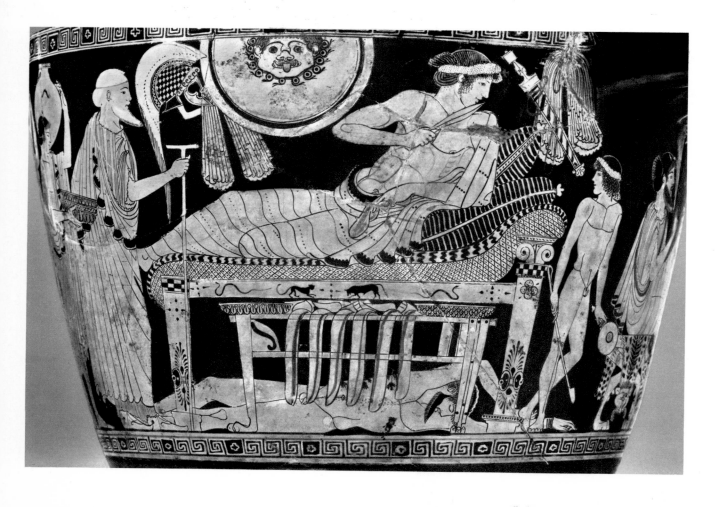

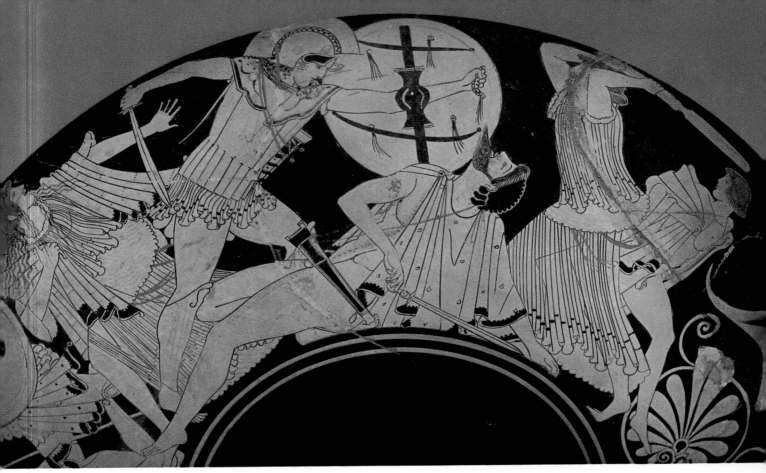

401. BRYGOS PAINTER. CUP, DETAIL: SCENE FROM THE ILIUPERSIS. LOUVRE, PARIS.

skyphos in the Metropolitan Museum. But the most noteworthy feature of the latter is that the dancing maenad is framed by two contorted rocks. This picturesque and unusual detail is emphasized by the patches of shadow on the rocks' surface, which are also found on some of the artist's human figures.

On a cup in Berlin the Brygos Painter depicted Selene's chariot amidst a wealth of symbols that were further developed during the classical age. It rises from the waves drawn by a pair of winged steeds with crossed legs. The full moon shines above, flanked by stars and bisected by the edge of the tondo.

But it is in his grand heroic compositions that the Brygos Painter showed his real skill. On the Vienna skyphos, Achilles celebrates the death of Hector, whose corpse lies stretched out at his feet; he has yet to catch sight of Priam, who approaches in the hope of ransoming his son's body. Details that display a pictorial realism, such as Priam's snowy hair and beard, and the rectangular shape of the composition, resemble authentic painting in the modern sense. But here we have rather the end result of a long evolution that began with the Corinthian Eurytius krater (fig. 44). For nothing here foreshadows the new lines of research that were to mark the birth of large-scale classical painting.

The scene from the *Iliupersis* on a cup in the Louvre is designed in strict accordance with the vessel's shape. The dramatically agitated figures that frame the dying Trojan are arranged in a double V-shaped composition. Quite unforgettable is the splendid,

349

400. BRYGOS PAINTER. SKYPHOS: PRIAM COMING TO RANSOM HECTOR'S BODY FROM ACHILLES. KUNSTHISTORISCHES MUSEUM, VIENNA.

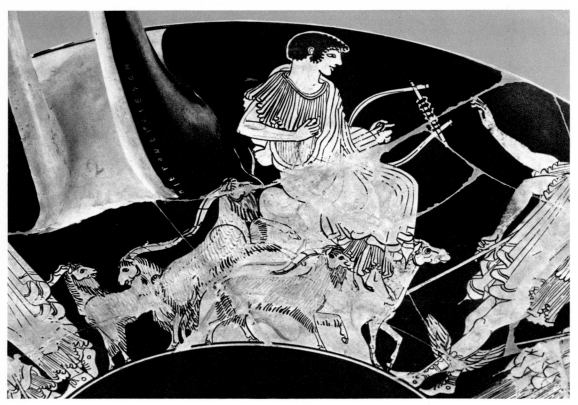

402. MACRON. CUP, DETAIL: THE JUDGMENT OF PARIS. STAATLICHE MUSEEN, BERLIN.

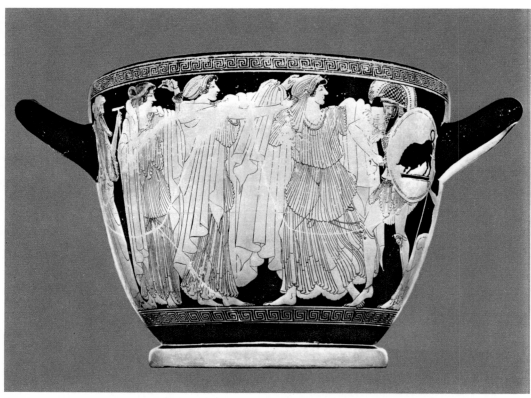

350

403. MACRON. SKYPHOS: MENELAUS RECOVERING HELEN AT TROY. MUSEUM OF FINE ARTS, BOSTON.

404. MACRON. CUP, DETAIL: MAENADS BEFORE THE IDOL OF DIONYSUS. STAATLICHE MUSEEN, BERLIN. ▶

energetic figure of Andromache who runs forward armed with a pounder in defence of her son Astyanax. Here, too, a discreet 'painterly' note is provided by the details in diluted yellowish-brown, the red splashes of blood, and the few shadows cast on the bodies. But the general conception is that of a vase painter, in particular a painter of red-figure ware.

Macron brings us into contact with a different form of traditionalism: the traditionalism of refined and graceful pictures designed first and foremost for the spectator's entertainment. In his work he also reserved a place for female figures, but not in the manner practised by the Brygos Painter. Macron was pre-eminently a painter of swelling transparent drapery that stressed the female form rather than concealed it. Between the battles of Marathon and Salamis he painted nothing but scenes of jollity, and even when he tired of revellers he would use a myth as a pretext for a display of graceful details. An example of this is the Judgment of Paris on a cup in Berlin, where for the first time Aphrodite is surrounded by fluttering erotes or cupids. The charming portrayal of Paris as a goatherd is a delicate genre picture that reveals an unusual feeling for nature. The dance of the bacchantes around the idol of Dionysus on the outside of another cup in Berlin has nothing ecstatic about it; what the painter has rendered is the gaiety of a group of women clothed in flimsy garments, who are celebrating a festive occasion on their own.

In some of his works, however, Macron treated the theme with greater breadth and resonance, though never with a truly dramatic tone. When Menelaus recovered possession

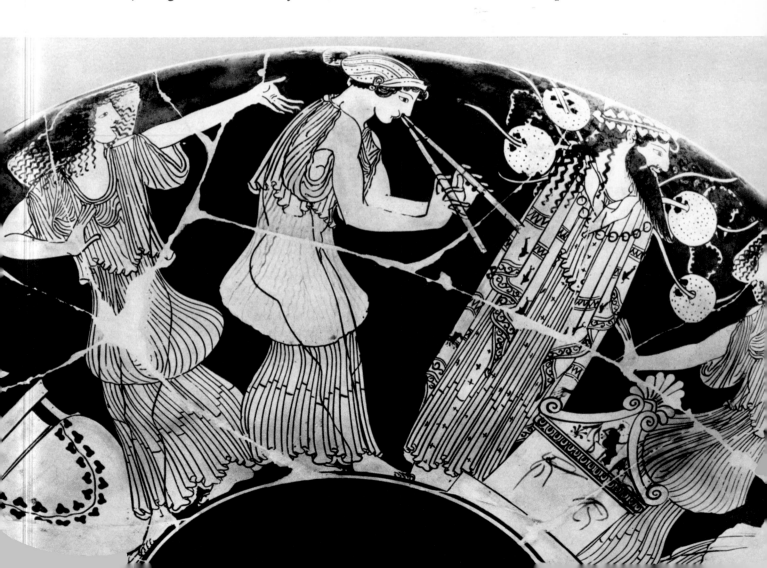

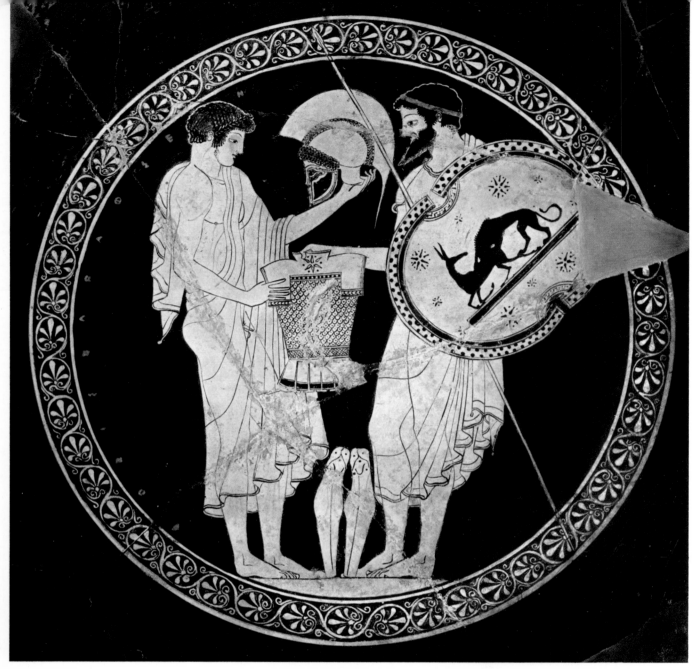

405. DOURIS. CUP, DETAIL: ODYSSEUS RECEIVING FROM NEOPTOLEMUS THE ARMS OF ACHILLES. KUNSTHISTORISCHES MUSEUM, VIENNA.

of Helen after the fall of Troy his intention was to punish her for her infidelity; but Aphrodite shielded her and with her beauty dispelled his wrath. The Boston skyphos that shows the scene has a doubly sinuous grace, the rhythm of the figures is echoed by the wavy horizontal line of the arms. Behind the three women Macron has spread a sort of screen of thick, voluminous material that sets off the transparency of their chitons and the bodies.

Douris illustrates better than any other artist the transition to the classical age, for some of his work was undoubtedly produced shortly after 480. Yet perhaps no vase painter of the early fifth century maintained so strong a link with the past. He was a draughtsman

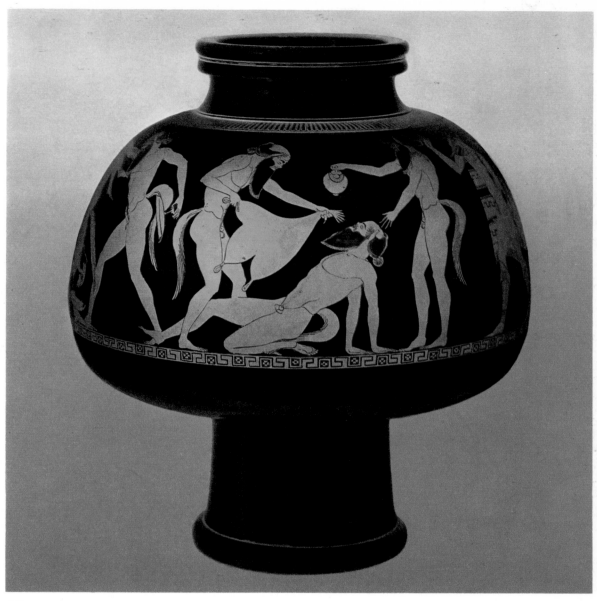

406. DOURIS. PSYKTER: SILENI FROLICKING AROUND DIONYSUS. BRITISH MUSEUM, LONDON.

rather than a painter. He very seldom used added colour; his linework has an exemplary tautness, and his figures are strung out with hardly a thought of grouping them in space. And yet, despite the rather archaizing stiffness of some figures, the drapery falls more loosely and the eyes are drawn almost in side view, even in his early works, like the Vienna cup on which Odysseus is depicted receiving the arms of Achilles from Neoptolemus.

A psykter in the British Museum is a good example of the juxtaposition of lifelike, even burlesque, figures drawn with a perfect mastery of movement and foreshortening, well suited to the vessel's shape but arranged in a purely linear order. Douris returned

353

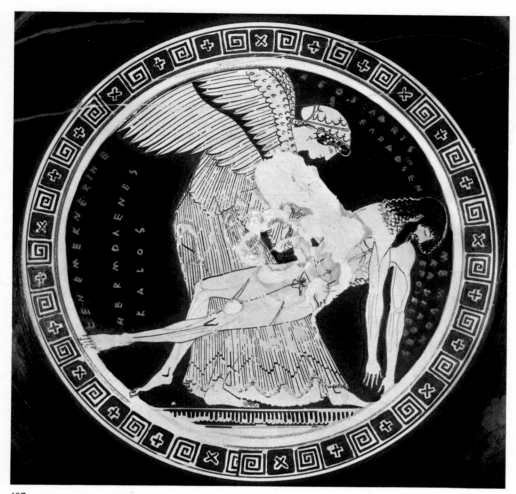

407. DOURIS. CUP, DETAIL: EOS WITH THE BODY OF HER SON MEMNON. LOUVRE, PARIS.

quite naturally to the principle of applying the decoration in a continuous frieze, for the
vase has no handles. One sometimes gets the impression that he drew flawless figures
for the simple pleasure of overcoming a difficulty and for no other purpose. This, too,
links him with the tradition of the great masters of the previous generation. In some cups,
however, the tondo gave him an opportunity to compose pictures of great expressive force.

One of these is the famous cup in the Louvre on which Eos carries the dead body of
her son Memnon in her arms. This pagan *Pietà*, which so admirably fits into the shape
of the tondo, expresses a pathos at once muffled and intense. Douris attenuated the taut-
ness of his line to render the garment of Eos, a plain chiton that accompanies the bending
movement of her body and whose close-set pattern of multiple pleats contrasts with Mem-
non's stiff naked corpse, the anatomical details of which are starkly stressed. But there
is no other sign of emotion. The controlled sentiments reveal a classical taste, like that
of Exekias or the Berlin Painter, but this is not yet a painting of the classical age.

It is curious to observe how in the early years of the fifth century Attic vase painting
tended to deviate from real life. The painters of the previous generation had moved with
the current of contemporary Attic art and life. They were concerned chiefly with eager

354

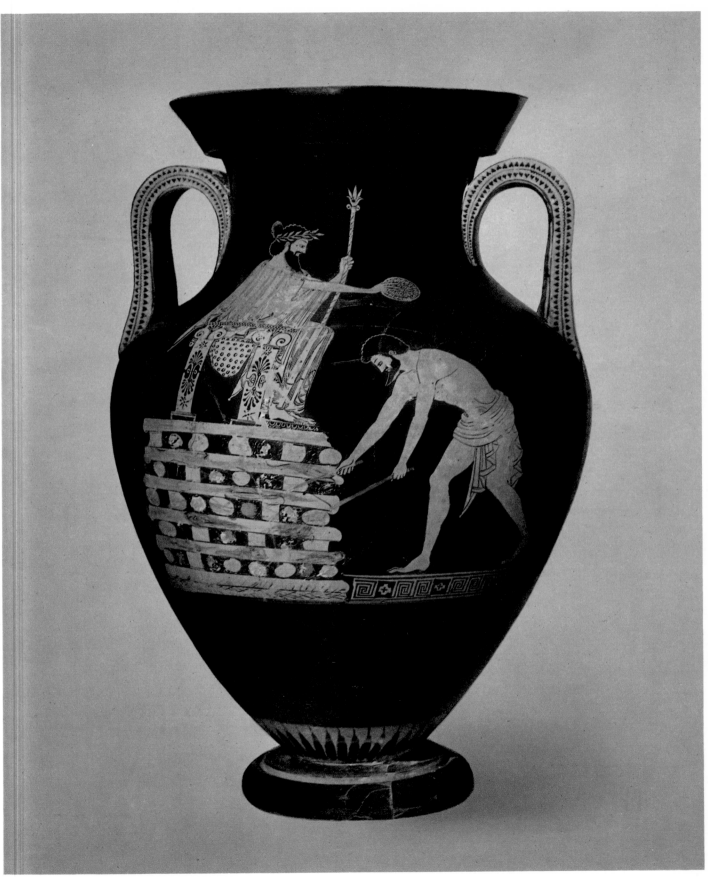

408. MYSON. AMPHORA: CROESUS ON THE PYRE. LOUVRE, PARIS.

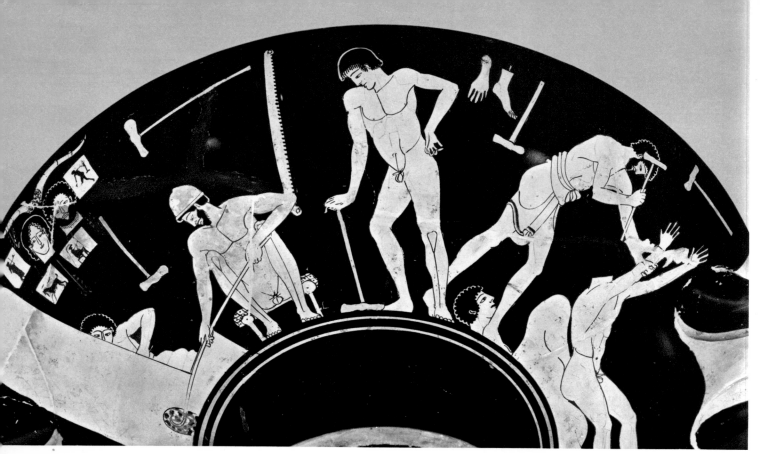

409. FOUNDRY PAINTER. CUP, DETAIL: BRONZE FOUNDERS' WORKSHOP. STAATLICHE MUSEEN, BERLIN.

experimentation, parallel to that of the sculptors, and with the delineation of a society that was still aristocratic, although its rich young men were agitated at a time when the tyranny was drawing to a close and new political institutions were being established.

What a contrast with the painters who represent the last phase of the severe style! In their work one looks in vain for the slightest echo, even in the shape of indirect mythological allusion, of the Greeks' grandiose struggle, focused in Athens, against the Persian Empire. An isolated indication of the relations with the East occurs on an amphora decorated by Myson representing Croesus, king of Lydia, seated on his funeral pyre. One cannot help asking oneself whether the innumerable scenes of revelry do not give a rather distorted and stereotyped picture of a society that, in that eventful period, can hardly have consisted exclusively of debauchees, pederasts, and courtesans.

It is symptomatic that at the very time when Athenian craftmanship reached perhaps the peak of perfection and Athens built the great fleet which after 479 made her a political power, vase painters took far less interest than before in the tasks and occupations of daily life. A cup like that on which the Foundry Painter, who learned his trade from the Brygos Painter, has left us a very lively representation of a bronze foundry is the exception rather than the rule. We have seen that in Attic vase painting stylistic evolution had slowed down very noticeably. This is a striking contrast with the new and rapid developments taking place in Greek art as a whole, the interest of the few isolated attempts in vase painting, like the Brygos Painter's, to discover new sources of inspiration.

Conclusion

The great process of colonization, which extended the maritime limits of the Greek world to the shores of the Black Sea and the western Mediterranean, came to an end at the close of the seventh century. After the phase of territorial expansion, Hellenism turned towards the establishment of political institutions, the study of scientific principles and their application.

During the period that ended with the Persian wars the abundance and diversity of Greek art were due, on the one hand, to the particularism of city-states jealous for the glory of their tutelary deities and, on the other, to the religious sentiments of the community, whose generosity was spurred by rivalry to load the Panhellenic sanctuaries with precious gifts. Despite clashes and setbacks the great artistic achievements marked an unwavering progression that owed its orientation to the wisdom of the lawgivers and its acceleration to the demagogy, often at once cunning and enlightened, of the tyrants.

Colossal statuary, the manifestation of a decadent feudal aristocracy, had disappeared almost entirely by the end of the first quarter of the sixth century. In architecture the ambitious urge to erect mighty buildings made itself felt only in the great cities of Anatolia and the dominions of the Sicilian tyrants. As the sixth century advanced, the instinct for moderation developed. This trait, so specifically Greek, expressed itself in the observation, at once rational and imaginative, of living forms and in the calculated harmony of proportions. In architecture the opposition of Dorian and Ionian styles led merely to the establishment of two orders after the brief efflorescence of the Aeolic order had been absorbed by the Ionic.

Following the creative impulse received from the Aegean islands and the Ionian continent, Attic predominance asserted itself in the gradual renunciation of graceful costumes, smiling faces, and shimmering colours. In Attic vase painting the onset of this evolution can be seen as early as 530 in the transition from black-figure to red-figure. The shock of the Persian wars speeded up the conversion of Greek art to the severe style, and the battle of Salamis in 480 was the signal for the prelude to the classical age.

JEAN CHARBONNEAUX

PART FOUR

General Documentation

SCIENTIFIC ADVISER MADELEINE DANY

Plans

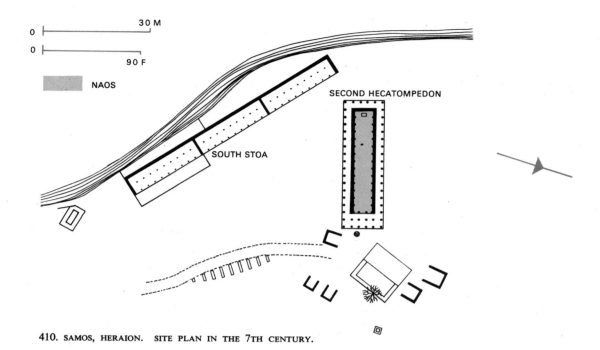

NAOS

30 M

0

0

90 F

SECOND HECATOMPEDON

SOUTH STOA

410. SAMOS, HERAION. SITE PLAN IN THE 7TH CENTURY.

411. SAMOS, HERAION. SITE PLAN IN THE MID-6TH CENTURY.

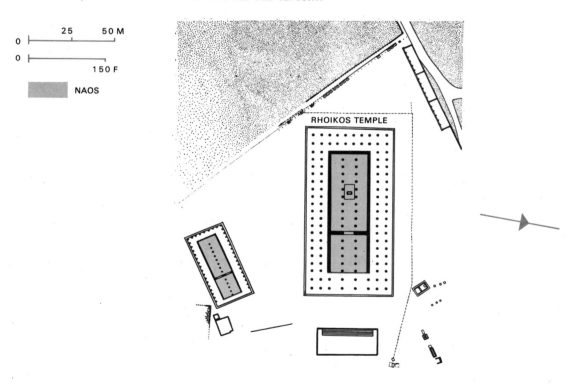

25 50 M

0

0

150 F

NAOS

RHOIKOS TEMPLE

For some buildings it has not been possible to indicate the exact orientation.
Further details concerning the plans will be found in the corresponding entries of the List of Illustrations.

412. SAMOS, HERAION. POLYCRATES TEMPLE.

10 20 30 M

30 60 90 F

NAOS

413. SAMOS, HERAION. POLYCRATES TEMPLE. RESTORATION OF THE FAÇADE.

363

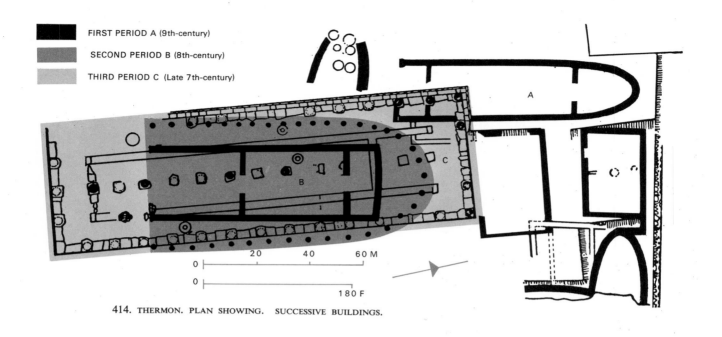

20 40 60 M

0

0

180 F

414. THERMON. PLAN SHOWING. SUCCESSIVE BUILDINGS.

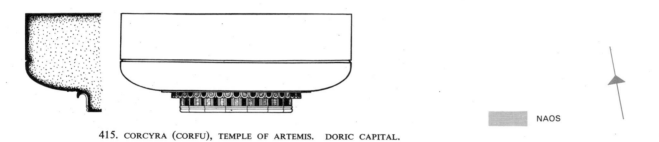

NAOS

415. CORCYRA (CORFU), TEMPLE OF ARTEMIS. DORIC CAPITAL.

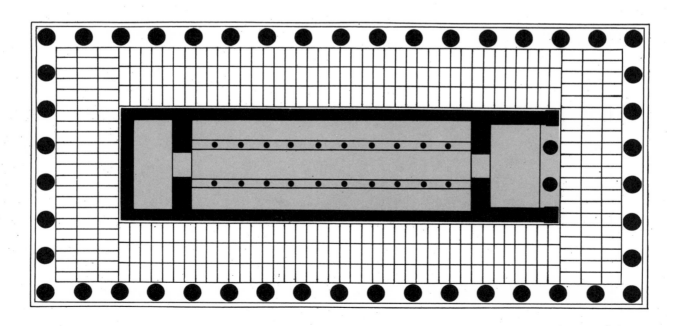

416. CORCYRA (CORFU), TEMPLE OF ARTEMIS.

417. CALYDON, LAPHRION, TEMPLE C. RESTORATION OF THE ENTABLATURE.

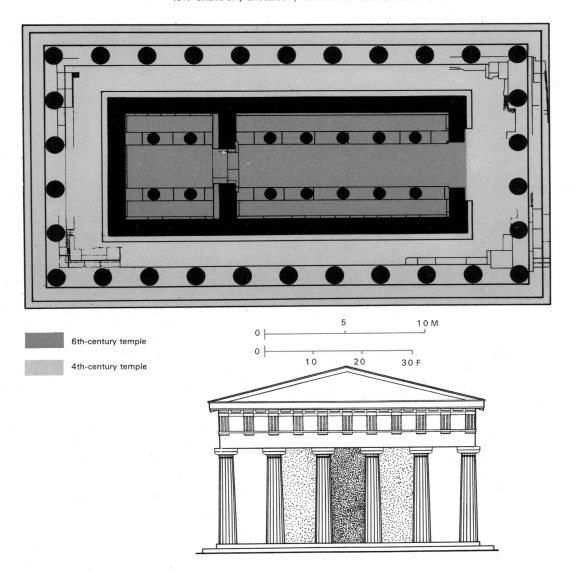

6th-century temple

4th-century temple

418. CYRENE, TEMPLE OF APOLLO. PLAN SHOWING SUCCESSIVE STATES.

419. CYRENE, TEMPLE OF APOLLO. RESTORATION OF THE FAÇADE.

365

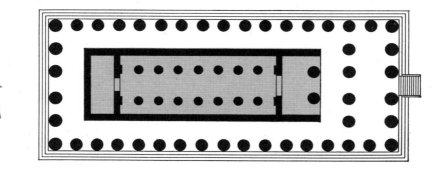

420. SYRACUSE (ORTYGIA), TEMPLE OF APOLLO.

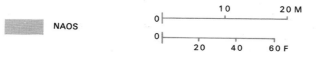

NAOS

0 |————————|———10———|———20 M
0 |————|————|————|————|————|
 20 40 60 F

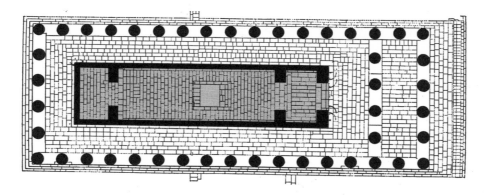

421. SELINUS, TEMPLE C.

366

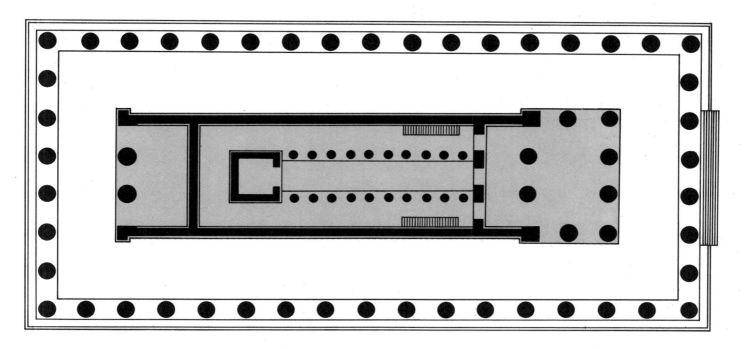

422. SELINUS, TEMPLE G (THE APOLLONION).

NAOS

0 ⊢———————⊣ 10 20 M

0 ⊢———————⊣ 20 40 60 F

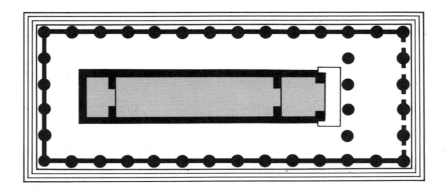

423. SELINUS, TEMPLE F.

367

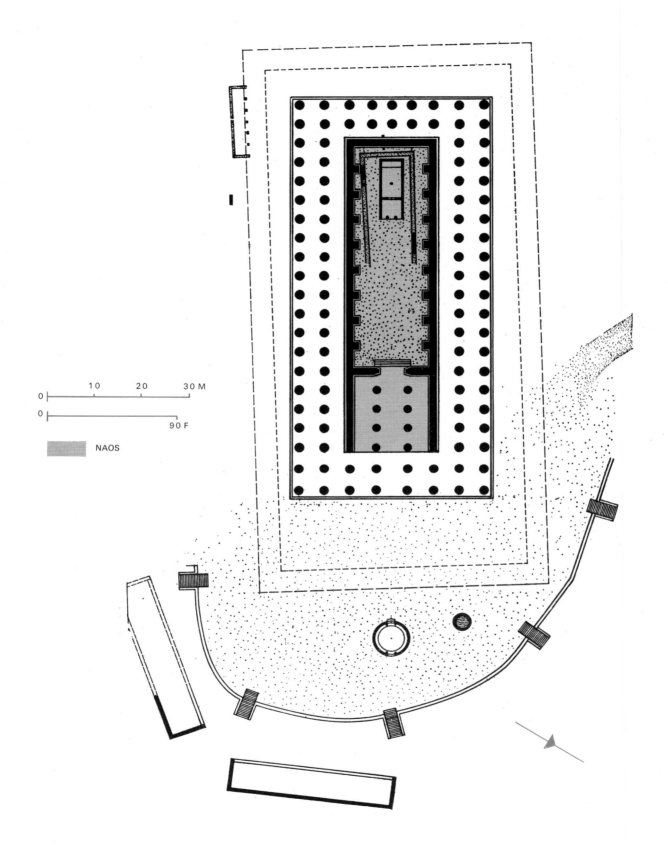

10 20 30 M
0

0
90 F

NAOS

424. DIDYMA, FIRST TEMPLE OF APOLLO AND LIMITS OF THE SANCTUARY.

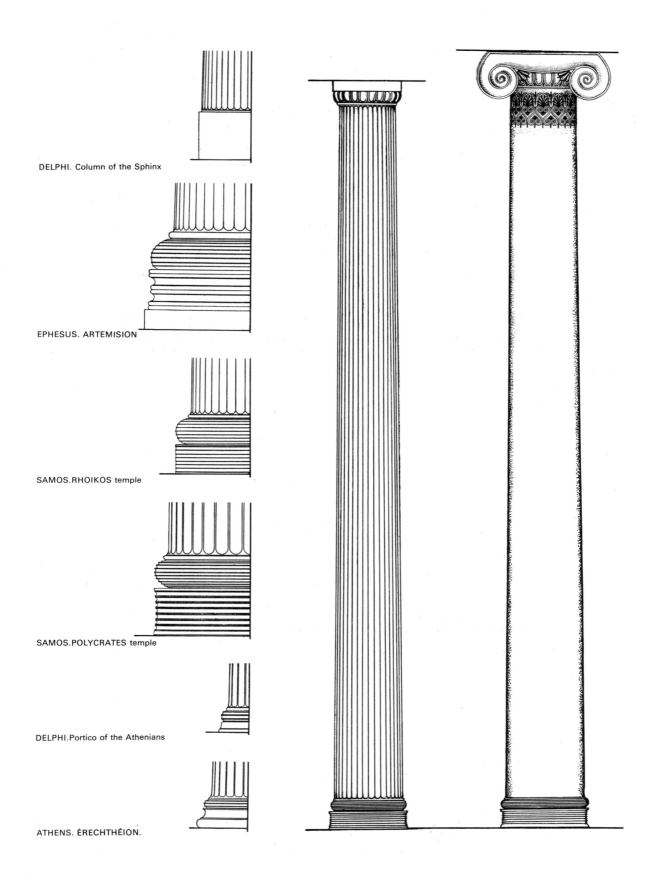

DELPHI. Column of the Sphinx

EPHESUS. ARTEMISION

SAMOS.RHOIKOS temple

SAMOS.POLYCRATES temple

DELPHI.Portico of the Athenians

ATHENS. ÉRECHTHÉION.

425. TYPES OF IONIC COLUMN BASES.

426. SAMOS, POLYCRATES TEMPLE. IONIC COLUMNS.

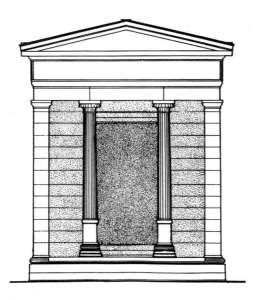

427. DELPHI (MARMARIA), TREASURY OF MASSALIA.
RESTORATION OF THE FAÇADE.

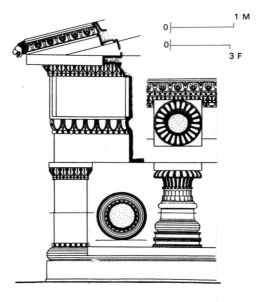

428. DELPHI (MARMARIA), TREASURY OF MASSALIA.
DETAILED RESTORATIONS.

429. DELPHI, MONOPTEROS OF SICYON.
BACK AND JOINT OF A CORNER BLOCK OF THE ARCHITRAVE.

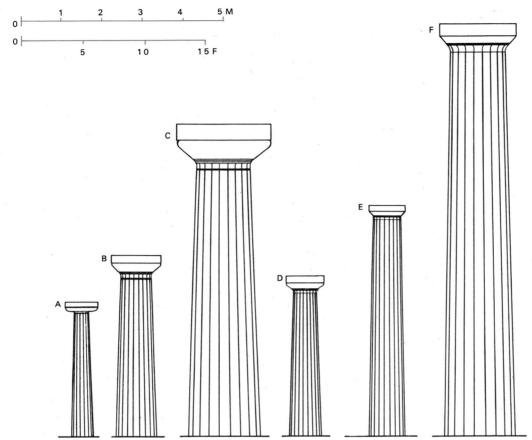

430. DELPHI. CHANGING PROPORTIONS OF THE DORIC COLUMN: A. TEMPLE I OF ATHENA, B. TEMPLE II OF ATHENA, C. TEMPLE OF APOLLO (6TH C.), D. ATHENIAN TREASURY, E. MARMARIA THOLOS, F. TEMPLE OF APOLLO (4TH C.).

NAOS

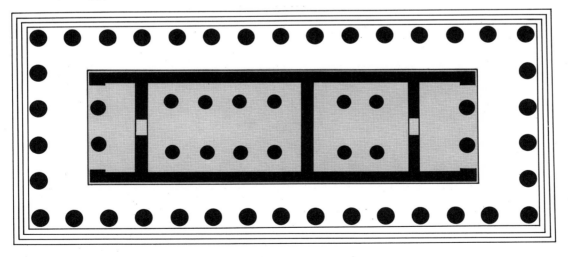

431. CORINTH, TEMPLE OF APOLLO.

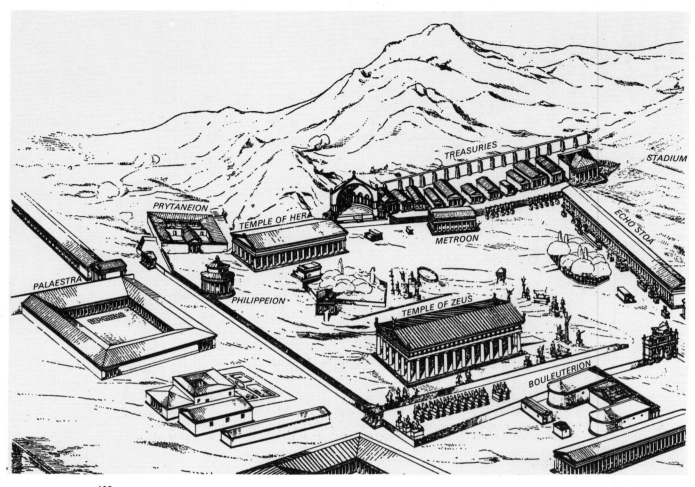

432. OLYMPIA, MAIN BUILDINGS OF THE SANCTUARY.

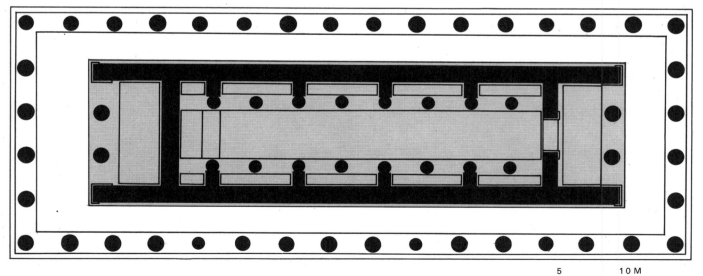

433. OLYMPIA, HERAION.

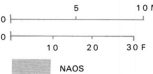

NAOS

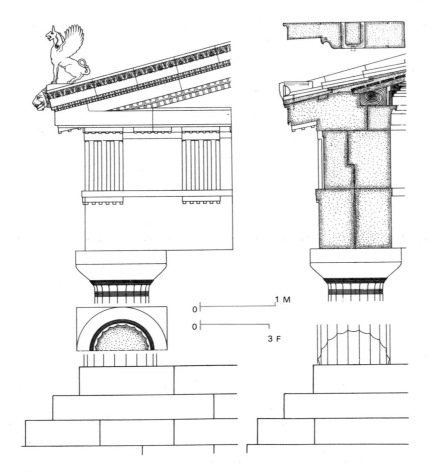

434. AEGINA, TEMPLE OF APHAIA. DETAILS OF THE ORDER.

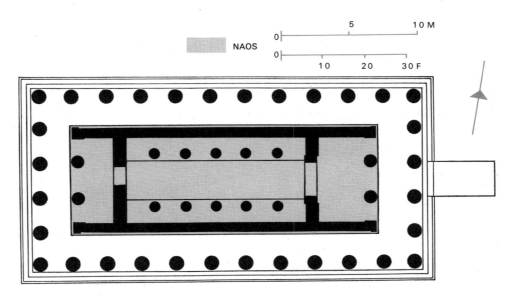

435. AEGINA, TEMPLE OF APHAIA.

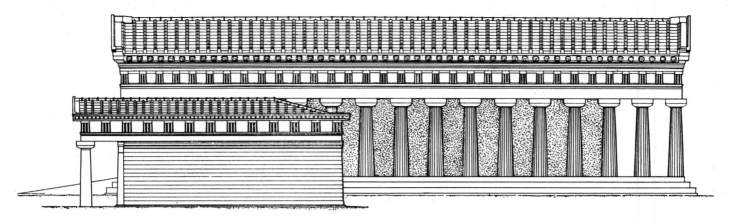

436. POSEIDONIA (PAESTUM), HERAION AT THE MOUTH OF THE SILARIS. ELEVATIONS.

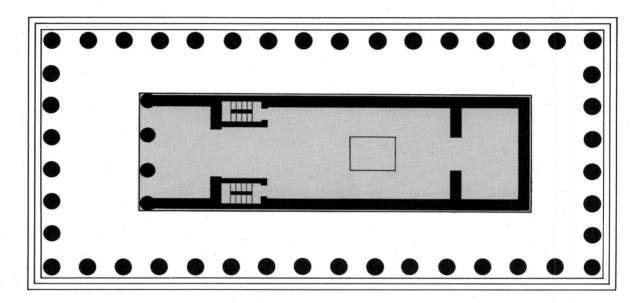

437. POSEIDONIA (PAESTUM), HERAION AT THE MOUTH OF THE SILARIS. PLANS.

NAOS

374

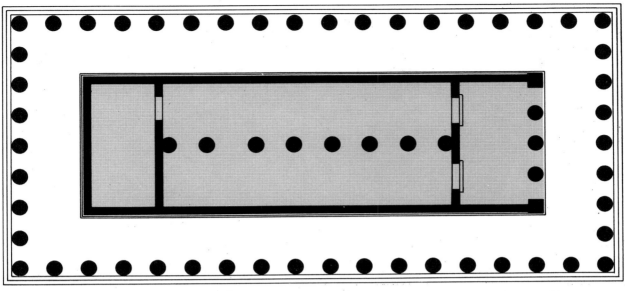

438. POSEIDONIA (PAESTUM). TEMPLE OF HERA I ('THE BASILICA').

NAOS

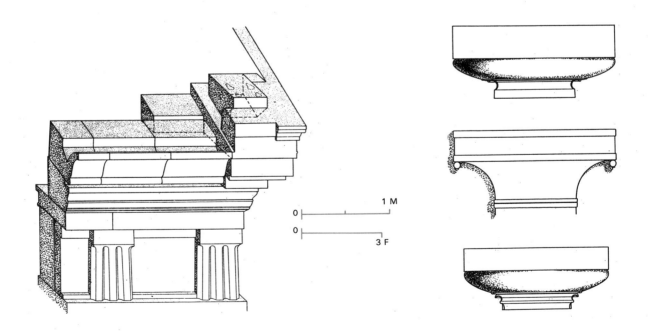

439. POSEIDONIA (PAESTUM), SILARIS HERAION.
RESTORED ENTABLATURE OF THE TEMPLE.

440. POSEIDONIA (PAESTUM), SILARIS TREASURY. CAPITALS.

Plans drawn by Claude Abeille.

375

Chronological Table

	EVENTS	EAST GREECE AND ISLANDS	MAINLAND GREECE
650	Foundation of Selinus. Cypselus, tyrant of Corinth.	Hecatompedon II of Samos. Beginning of Orientalizing pottery in Rhodes.	
640	Death of Archilochus of Paros. Foundation of Naucratis in Egypt.	Beginning of 'Melian' pottery.	
630	Colaios of Samos and the Phocaeans sail to southern Spain. Foundation of Cyrene. Law code of Draco in Athens.	Temple of Hera on Delos. Temple of Old Smyrna. Temple A at Prinias (Crete).	Chigi vase (Proto-Corinthian polychrome style). Temple C of Thermon and painted metopes.
620	First coins struck in Greece.	Orientalizing pottery of Chios. Naxian sculptors on Delos.	Treasury of Corinth at Delphi. First ivories of Sparta (Artemis Orthia).
610		Temple of Dreros (Crete). Rhodian jewellery. Euphorbus plate (Rhodes).	First temple of the Isthmus of Corinth.
600	Foundation of Massalia (Marseille). Alcaeus and Sappho in Lesbos. Solon's reforms in Athens.	Oikos of the Naxians on Delos. Beginning of polychrome pottery on Chios. Sculptors from Paros on Delos and Thasos.	Heraion of Olympia. Beginning of Laconian black-figure pottery. Eurytios krater (Corinth). Temple of Athena at Delphi. Laconian sculptors at Olympia.
590	Thales of Miletus.	First kouroi on Thera and Samos. South Stoa of the Heraion of Samos.	Temple of Artemis on Corfu with pedimental sculptures. Polymedes of Argos at Delphi.
580	Foundation of Agrigentum.	Temple of Neandria. Temple of Athena at Phocaea. First statue of the Branchidae on the Sacred Way leading to the first temple of Apollo at Didyma (Didymeion).	The painter Timonidas at Corinth. Old Tholos at Delphi. Column and Sphinx of the Naxians at Delphi. Beginning of Boeotian black-figure pottery. Colonnades of the Heraion of Argos.
570	Creation of the Greater Panathenaea (566/565).	Rhoikos and Theodoras introduce hollow casting on Samos. Rhoikos temple on Samos.	Monopteros of Sicyon at Delphi. First kouros in the Ptoion.
560	Pisistratos becomes tyrant of Athens (561/560).	Artemision D on Ephesus (Croesus temple). Master of the Hera of Cheramyes, and Geneleos on Samos. Series of Samo-Milesian kouroi from Caria to the Pontus Euxinus.	Amphiaraus krater (Corinthian). Arcesilas cup (Laconian). Temple of Apollo in the Laphrion (Calydon). Temple of Apollo at Amyclae. Chryselephantine statues in the Rhodian style at Delphi.
550	Conquest of Lydia (Croesus) by the Persians (Cyrus).	Buildings of Larisa on the Hermos. Archermos of Chios on Delos. Stoa of the Naxians on Delos. Beginning of Clazomenian pottery and the Ionian Little Masters.	Apollo of Tenea, near Corinth. End of Corinthian black-figure pottery. Treasury of Gela at Olympia. Black-figure pottery of Eretria. West edifice of the Heraion of Argos. Treasury of Cnidus at Dephi. End of Laconian black-figure pottery.

ATHENS AND ATTICA	THE GREEK WEST	AFRICA	
			650
	Polychrome pottery of Megara Hyblaea.		640
Beginning of Early Proto-Attic pottery.			630
Nettos Painter.			620
The Dipylon Master.			
			610
The Sounion workshop.	So-called 'megaron' of Selinus.		600
	Colossal head from Laganello (Syracuse).	Kouros of Cyrene.	
Hydra pediment (Acropolis of Athens).			
Buildings in tufa on the Acropolis. Gorgon Painter.		First temple of Apollo at Cyrene.	590
The painter Sophilos.			
Laying out of the Agora in Athens.			580
Introduction pediment (Heracles brought to Olympus).	Kourotrophos (goddess suckling twins) of Megara Hyblaea.		
Pediment of Heracles and Triton. Old Temple of Athena. Kleitias: The François vase. The Calf-Bearer (Moschophoros). The painter Nearchos.	Etruscan paintings on terra-cotta (Boccanera slabs). Temple of Apollo at Syracuse.	Temple of Apollo at Naucratis.	570
The Rampin Master. The painter Lydos. The Rampin Horseman.	Temple C at Selinus. Metopes of Temple Y at Selinus.		560
	Temple of Zeus at Syracuse.		
The kouros of Volomandra.	Beginning of the Chalcidian pottery of Rhegium (Inscription Painter).		550
Amasis Painter.	Megaron of Demeter (Malophoros) at Selinus.		
The painter Exekias. Tleson Painter and the Attic Little Masters.	Silaris Treasury and its metopes.		

	EVENTS	EAST GREECE AND ISLANDS	MAINLAND GREECE
540	Defeat of the Phocaeans at Alalia. Instituting of the tragedy competition in Athens (534). Polycrates, tyrant of Samos. Pythagoras at Croton.	Figure reliefs for the column bases of the first temple of Apollo at Didyma (Didymeion) near Miletus. Temple of Assos with sculptured friezes. Porinos naos on Delos. Bronze founders active in Samos.	Temple of Apollo at Corinth. Treasuries of Olympia (Byzantium, Metapontum).
530	Birth of Aeschylus. End of the tyranny of Polycrates.	First temple at Didyma. Oikos of the Andrians and Hieropoion on Delos. First temple of Cybele at Sardis. Polycrates temple on Samos.	Sculptures of the Ionian treasuries at Delphi. Siphnian Treasury at Delphi. Massalian Treasury at Delphi.
520	Birth of Pindar.		Antenor at Delphi. Alcmaeonid temple and polygonal wall at Delphi.
510	End of the Pisistratid tyranny in Athens. Sybaris destroyed by Croton. Democratic reforms of Cleisthenes in Athens (508/507). Athenian victory over the Boeotians and Chalcidians (506).		Amazonomachy on the Eretria pediment. Temple of Athena at Marmaria.
500	Travels of Hecataeus of Miletus. Ionian revolt (499/494). Pindar's first ode (498). Fall of Miletus (494). Archonship of Themistocles in Athens (493). War between Athens and Aegina.	Temple of Athena Aphaia at Aegina.	Stele of Orchomenos (Boeotia) by Alxenor of Naxos.
490	Battle of Marathon. Archonship of Aristides in Athens (489). Gelo, tyrant of Syracuse (485). Construction of the Athenian fleet.		Athenian Treasury at Delphi. Doric treasury of Marmaria.
480	Second Persian War: Destruction of Athens by the Persians. Battles of Salamis and Himera.		

ATHENS AND ATTICA	THE GREEK WEST	AFRICA	
Peplos Kore by the Rampin Master. Phrynos Painter. Agora of Athens: Building preceding the tholos (Building F).	Temple D at Selinus. Metopes of Temple C at Selinus.		540
Beginning of red-figure pottery. Seated Athena by Endoios. Andokides Painter. Grave monument of Megacles. The painter Psiax. Peripteral temple of Athena. Bronze Apollo of Piraeus. Ionian sculptors in Athens.	Temple of Hera I at Paestum ('Basilica'). Ionian vase painters in Etruria (Caere). Temple of Artemis at Massalia (capital). Temple F at Selinus. Temple of Apollo Lykeios at Metapontum.		530
Work begins on the Olympieion. The painters Oltos, Epictetos, and Skythes. The painter Euphronios. The Gigantomachy pediment of the Hecatompedon. Pisistratid Telesterion at Eleusis. The painters Euthymides and Phintias.	Work begins on the Apollonion (Temple G at Selinus).		520
The Antenor Kore. Aristion stele by Aristocles. Palaestra reliefs. Statue of Aristodikos.	Work begins on the Olympieion at Agrigentum. Temple of Athena at Paestum. Temple of Hera at the mouth of the Silaris.		510
Kleophrades Painter. Relief with hockey players. The painter Onesimos. Old Temple of Poseidon at Sounion. Berlin Painter. Brygos Painter.	Temple of Hera at Metapontum. Temple of Heracles at Agrigentum. Temple of Athena at Syracuse. Temple of Demeter at Agrigentum.	Temple of Zeus at Cyrene.	500
Kore of Euthydikos. Parthenon I (?). Douris and Macron. Kouros by Critios.	Metopes of Temple F at Selinus. Kouros of Agrigentum. Temple of Himera.	Korai of Cyrene.	490
The painter Myson.			480

Bibliography

ABBREVIATIONS USED IN THE BIBLIOGRAPHY

AA	Archäologischer Anzeiger, Beiblatt zum Jahrbuch des deutschen archäologischen Instituts, Berlin, W. de Gruyter.
AJA	American Journal of Archaeology. The Journal of the Archaeological Institute of America.
AM	Mitteilungen des deutschen archäologischen Instituts, Athenische Abteilung, Berlin, Gebr. Mann.
Annuario	Annuario della scuola archeologica italiana di Atene.
BCH	Bulletin de correspondance hellénique (École française d'Athènes), Paris, E. de Boccard.
BSA	The Annual of the British School at Athens, London, Macmillan.
Eph. Arch.	Ephemeris archaiologiki, Athens.
GBA	Gazette des Beaux-Arts, Paris, Presses universitaires de France.
Hesperia	Hesperia, Journal of the American School of Classical Studies at Athens.
Istanb. Mitt.	Mitteilungen des deutschen archäologischen Instituts, Abteilung Istanbul.
Jahrb.	Jahrbuch des deutschen archäologischen Instituts, Berlin, W. de Gruyter.
JHS	The Journal of Hellenic Studies, London, Macmillan.
JOEAI	Jahreshefte des österreichischen archäologischen Instituts, Vienna, Rohrer.
M. A. Lincei	Monumenti antichi pubblicati per cura dell' Accademia dei Lincei, Rome.
MDAI	Mitteilungen des Deutschen archäologischen Instituts, Berlin, F. H. Kerle Verlag.
Mon. Piot	Monuments et mémoires publiés par l'Académie des Inscriptions et Belles-Lettres (Fondation Eugène Piot), Paris, Presses universitaires de France.
RA	Revue archéologique, Paris, Presses universitaires de France.
RA.n.s.	Revue archéologique, nouvelle série, Paris, Presses universitaires de France.
REA	Revue des Études anciennes, Bordeaux, Féret et fils éditeurs.
REG	Revue des Études grecques, Paris, Les Belles Lettres.
RIA	Rivista dell'Istituto Nazionale di Archeologica e Storia dell'Arte, Rome, 'L'Erma' di Bretschneider.

Except for the general works listed at the beginning of the three main sections (Architecture, Sculpture, Painting and Pottery), the bibliography follows the order of the text.

Architecture

A │ GENERAL WORKS

1. PERROT (G.) and CHIPIEZ (C.), *Histoire de l'art dans l'Antiquité*, VII, *La Grèce de l'épopée, la Grèce archaïque (le temple)*, Paris, Hachette, 1898.

2. DURM (J.), *Die Baukunst der Griechen*, 3rd ed., Stuttgart, A. Kröner, 1910.

3. CHOISY (A.), *Histoire de l'architecture*, Paris, G. Baranger, 1929, 2 vols.

4. WEICKERT (C.), *Typen der archaischen Architektur in Griechenland und Kleinasien*, Augsburg, Filser, 1929.

5. HANELL (K.), *Zur Entwicklungsgeschichte des griechischen Tempelhofes*, in *Corolla Archaeologica*, II, Lund, Gleerup, 1932, pp. 228-237.

6. WREDE (W.), *Attische Mauern*, Athens, Deutsches archäologisches Institut, 1933.

7. ANTI (C.), *Teatri greci arcaici*, Padua, Le tre Venezie, 1947.

8. LAPALUS (E.), *Le Fronton sculpté en Grèce des origines à la fin du IVᵉ siècle*, Paris, E. de Boccard, 1947.

9. SCRANTON (R.L.), *Group Design in Greek Architecture*, in *The Art Bulletin*, XXXI, 1949, pp. 247-268.

10. YAVIS (C.G.), *Greek Altars. Origins and Typology*, St. Louis University Studies, Monogr. Series Humanities, 1, St. Louis (Mo.), 1949.

11. DINSMOOR (W.B.), *The Architecture of Ancient Greece*, 3rd ed. London, Batsford, 1950.

12. PHILIPPSON (A.), *Die griechischen Landschaften, eine Landeskunde*, I-IV, V, Frankfurt/Main, V. Klostermann, 1950-1959.

13. MARTIN (R.), *Recherches sur l'agora grecque. Étude d'histoire et d'architecture urbaines*, Paris, E. de Boccard, 1951.

14. KIRSTEN (E.), *Die griechische Polis als historisch-geographisches Problem des Mittelmeerraumes*, Bonn, F. Dümmler, 1956.

15. MARTIN (R.), *L'Urbanisme dans la Grèce antique*, Paris, A. & J. Picard, 1956.

16. LAWRENCE (A.W.), *Greek Architecture*, chap. 6-12, Harmondsworth, Middlesex, Penguin Books, 1957.

17. ORLANDOS (A.K.), *The Building Materials of the Ancient Greeks* (τὰ ὑλικὰ δομῆς τῶν ἀρχαίων Ἑλλήνων) in *Library of the Archaeological Society*, No 37, Athens, I, 1955; II, 1959-1960 (French translation of Vol. I, under the title *Les Matériaux de construction et la technique architecturale des anciens Grecs*, Paris, E. de Boccard, 1966).

18. GERKAN (A. von), *Von antiker Architektur und Topographie. Gesammelte Aufsätze*, edited by E. BOEHRINGER, Stuttgart—Berlin, W. Kohlhammer, 1959.

19. ROBERTSON (D.S.), *A Handbook of Greek and Roman Architecture*, 3rd ed., Cambridge, University Press, 1959.

20. *Neue deutsche Ausgrabungen Mittelmeer und vorderer Orient*, Berlin, Gebr. Mann Verlag, 1959.

21. BERVE (H.) and GRUBEN (G.), *Greek Temples, Theatres and Shrines* London, Thames and Hudson, 1963; New York, Abrams, 1968.

22. SCULLY (W.), *The Earth, the Temple and the Gods. Greek Sacred Architecture*, New Haven—London, 1962.

23. WYCHERLEY (R.E.), *How the Greeks Built Cities*, 2nd ed., London, Macmillan & Co., 1962.

24. KIRSTEN (E.) and KRAIKER (W.), *Griechenlandkunde*, 4th ed., Heidelberg, 1962.

25. BOARDMAN (J.), *The Greeks Overseas*, Harmondsworth, Middlesex, Pelican Books, 1964.

26. MARTIENSSEN (R.D.), *The Idea of Space in Greek Architecture*, 2nd ed., Johannesburg, University Press, 1964.

27. SCRANTON (R.L.), *Aesthetic Aspects of Ancient Art*, Chicago—London, University Press of Chicago, 1964.

28. BIROT (P.) and DRESCH (J.), *La Méditerranée et le Moyen-Orient*, II, *La Méditerranée orientale*, Paris, Presses universitaires de France, 1956.

29. MARTIN (R.), *Manuel d'architecture grecque*, I, *Matériaux et techniques*, Paris, A. & J. Picard, 1965.

30. PRITCHETT (W.K.), *Studies in Ancient Greek Topography*, I, Berkeley, University of California Press, 1965.

31. GRUBEN (G.), *Die Tempel der Griechen*, Munich, Hirmer Verlag, 1961.

32. MARTIN (R.), *Monde grec*, in *Architecture universelle*, Fribourg, Office du livre, 1966.

33. BERGQVIST (B.), *The Archaic Greek Temenos. A Study of Structure and Function*, in *Acta instituti Atheniensis regni Sueciae*, XIII, Lund, Gleerup, 1967.

B │ 1. THE ORDERS

34. WURZ (E. and R.), *Die Entstehung der Säulenbasen des Altertums unter Berücksichtigung verwandter Kapitelle*, in *Zeitschrift für Geschichte der Architektur*, fascicule 15, Heidelberg, C. Winter, 1925.

35. DEMANGEL (R.), *La Frise ionique*, Paris, E. de Boccard, 1933.

36. *Sur l'origine de la frise dorique à triglyphes*, R. DEMANGEL, in *BCH*, LVI, 1931, pp. 117-163; LXI, 1937, pp. 421-438; LXII, 1938, pp. 180-193; M.L. BOWEN, in *BSA*, XXXXV, 1950, pp. 113-125; R. COOK, in *BSA*, XXXXVI, 1951, pp. 50-53.

37. RIEMANN (H.), *Zum griechischen Peripteraltempel. Seine Planidee und ihre Entwicklung bis zum Ende des 5. Jahrhunderts*, Frankfurt/Main, Düren, 1935. (Thesis).

38. RIEMANN (H.), *Die Bauphasen des Heraions von Olympia*, in *Jahrb.*, LXI-LXII, 1946-1947, pp. 30-54.

39. DEMARGNE (P.), *La Crète dédalique*, Paris, E. de Boccard, 1947, pp. 150-158. (On the origin of the orders.)

40. GERKAN (A. von), *Die Herkunft des dorischen Gebälks*, in *Jahrb.*, LXIII-LXIV, 1948-1949, pp. 1-13.

41. KÄHLER (H.), *Das griechische Metopenbild*, Munich, F. Bruckmann Verlag, 1949.

42. MARTIN (R.), *Problèmes des origines des ordres grecs à volutes*, in *Études d'archéologie classique*, I, Paris, E. de Boccard, 1958, pp. 117-132.

43. AKURGAL (E.), *Vom äolischen zum ionischen Kapitell*, in *Anatolia*, V, 1960, pp. 1-7.

44. RIEMANN (H.), *Studien zum dorischen Antentempel*, in *Bonner Jahrbücher*, CLXI, 1961, pp. 183-200.

45. NYLANDER (C.), *Die sogenannten mykenischen Säulenbasen auf der Akropolis in Athen*, in *Opuscula archeologica Athen.*, IV, 1963, pp. 31-77.

46. LA COSTE-MESSELIÈRE (P. de), *Chapiteaux doriques du haut archaïsme*, in *BCH*, LXXXVII, 1963, pp. 170-218.

2. MOULDINGS

47. SHOE (L.T.), *Profiles of Greek Mouldings*, Cambridge, (Mass.), Harvard University Press, 1936, 2 vols.

48. SHOE (L.T.), *Profiles of Western Greek Mouldings*, in *Papers and Monographs of the American Academy in Rome*, XIV, Rome, American Academy in Rome, 1952, 2 vols.

49. WEICKERT (C.), *Das lesbische Kymation*, Leipzig, 1913.

3. TIMBER ROOFS AND ARCHITECTURAL TERRA-COTTAS

50. HODGE (A.T.), *The Woodwork of Greek Roofs*, Cambridge, Cambridge University Press, 1960.

51. VAN BUREN (E.D.), *Greek Fictile Revetments in the Archaic Period*, London, Murray, 1926.

52. VAN BUREN (E.D.), *Archaic Fictile Revetments in Sicily and Magna Graecia*, London, Murray, 1923.

53. AKERSTRÖM (A.), *Die architektonischen Terrakotten Kleinasiens*, in *Acra instituti Atheniensis regni Sueciae*, XI, Lund, Gleerup, 1966.

54. RHOMAIOS (K.A.), *The Calydon Terracottas*,) (κέραμοι τῆς Καλυδῶνος), in *Library of the Archaeological Society*, XXXIII, Athens, 1951 (in Greek).

55. LE ROY (C.), *Fouilles de Delphes*, II, *Topographie et architecture, Les Terres cuites architecturales*, Paris, E. de Boccard, 1967.
Cf. Corinth, Sardis.

C | 1. GREECE AND THE EAST

56. DUNBABIN (T.J.), *The Greeks and their Eastern Neighbours*, London, The Society for the Promotion of Hellenic Studies, 1957.

57. FRANKFORT (H.), *The Art and Architecture of the Ancient Orient*, Harmondsworth, Middlesex, Penguin Books, 1954.

58. AKURGAL (E.), *Orient und Okzident. Die Geburt der griechischen Kunst*, in *Kunst der Welt*, Baden-Baden, Holle Verlag, 1966.

59. NAUMANN (R.), *Architektur Kleinasiens von ihren Anfängen bis zum Ende der hethitischen Zeit*, Tübingen, E. Wasmuth Verlag, 1955.

60. DRERUP (H.), *Griechische Architektur zur Zeit Homers*, in *AA*, 1964, col. 180-219.

2. ASIA MINOR

Troy

61. BLEGEN (C.W.), *Troy. The Sixth Settlement*, Princeton, University Press, 1953.

62. BLEGEN (C.W.) *et al.*, *Troy*: I, *General Introduction, The First and Second Settlements*; II, *The Third, Fourth and Fifth Settlements*, Princeton, University Press, 1950-1951.

Gordion

63. Recent excavations: reports by R. S. YOUNG in *AJA*, since 1955.

Neandria

64. KOLDEWEY (R.), *Neandria*, in *Berliner Winkelmannsprogramm*, LI, Berlin, Programm zum Winkelmannsfeste, 1891.

65. GERKAN (A. von), *Zum Tempel von Neandria. Neue Beiträge zur klass. Altertumswiss.*, in *Mélanges B. Schweitzer*, 1954, pp. 71-76.

Assos

66. CLARKE (J.T.) and BACON (F. H.), *Report on the Investigations at Assos* 1881, Papers of the Archaeological Institute of America, Classical Series, I, Boston, 1882; *Report on the Investigations at Assos 1882-1883*, Papers of the Archaeological Institute of America, Classical Series, II, Boston, 1898.

67. BACON (F.H.), CLARKE (J.T.), and KOLDEWEY (R.), *Investigations at Assos*, Cambridge (Mass.), Harvard University Press, 1902-1921.

68. SARTIAUX (F.), *Les Sculptures et la restauration du temple d'Assos en Troade*, Paris, Leroux, 1915.

Larisa on the Hermos

69. *Larisa am Hermos. Die Ergebnisse der Ausgrabungen 1902-1934*. J. BOEHLAU and K. SCHEFOLD, I, *Die Bauten*, 1940; A. AKERSTRÖM, II, *Die architektonischen Terrakotten*, Stockholm, Publications of the Academy, History and Antiquity Section, 1940.

Smyrna

70. AKURGAL (E.), *Bayrakli*, in *Zeitschrift der philosophischen Fakultät der Universität Ankara*, VIII, 1, 1950, pp. 1-97.

71. COOK (J.M.), *Old Smyrna*, in *BSA*, LIII-LIV, 1958-1959, pp. 1-34.

72. NICHOLLS (R.V.), in *BSA*, LIII-LIV, 1958-1959, p. 30 *sq.*

Sardis

73. BUTLER (H.C.), *Sardis*, II, *Architecture*, 1, *The Temple of Artemis*, Leyden, E.J. Brill, 1925.

Ephesus

74. HOGARTH (D.G.), *Excavations at Ephesus: the Archaic Artemisia*, London. The British Museum, 1908.

75. LETHABY (W.R.), *Greek Buildings represented by fragments in the British Museum*, London, B.T. Batsford, 1908. (Temple of Artemis at Ephesus, pp. 1-37.)

76. BENNDORF (O.), *Forschungen in Ephesos*, I, Vienna, Österreichisches archäologisches Institut, 1906.

77. LOEWY (E.), *Zur Chronologie der frühgriechischen Kunst. Der Artemistempel von Ephesos*, Vienna, Sitzungsberichte der Akademie, 1931, pp. 1-41.

78. TRELL (B.L.), *The Temple of Artemis at Ephesus*, coll. *NNM*, CVII, New York, 1945.

Miletus, Didyma

79. KLEINER (G.), *Alt-Milet*, Wiesbaden, Franz Steiner Verlag, 1966.

80. DRERUP (H.), *Bericht über die Ausgrabungen in Didyma 1962*, I, *Die Grabung im Adyton*, in *AA*, 1964, col. 334-368.

81. WIEGAND (T.), *Didyma*, I, H. KNAKFUSS, *Die Baubeschreibung*, Berlin, Deutsches archäologisches Institut, 1941, 3 vols.

82. GRUBEN (G.), *Das archaische Didymaion*, in *Jahrb.*, LXXVIII, 1963, pp. 78-177.

83. HAHLAND (W.), *Didyma im V. Jahrhundert vor Chr.* in *Jahrb.*, LXXIX, 1964, pp. 142-240.

Xanthos

84. METZGER (H.), *Fouilles de Xanthos*, II, *L'Acropole lycienne*, Paris, Klincksieck, 1963.

3. ISLANDS AND CYCLADES

Crete

85. DEMARGNE (P.), *La Crète dédalique*, Paris, E. de Boccard, 1947.

86. PERNIER (L.), *Tempi arcaici sulla Patela di Prinias*, in *Annuario*, I, 1914, pp. 18-111.

87. PERNIER (L.), *New Elements for the Study of the Archaic Temple of Prinias*, in *AJA*, XXXVIII, 1934, pp. 171-177.

88. MARINATOS (S.), *Le Temple géométrique de Dréros*, in *BCH*, LX, 1936, pp. 214-285.

89. DEMARGNE (P.) and VAN EFFENTERRE (H.), *Recherches à Dréros*, in *BCH*, LXI, 1937, pp. 5-32 and 333-348.

90. SAVIGNONI (L.), *Il Pythion di Gortina*, in *M.A.Lincei*, XVIII, 1907, pp. 35 sq.

Delos

91. GALLET DE SANTERRE (H.), *Délos primitive et archaïque*, Paris, E. de Boccard, 1958.

92. VALLOIS (R.), *L'Architecture hellénique et hellénistique à Délos jusqu'à l'éviction des Déliens (166 av. J.-C.)* : I, *Les Monuments*, Paris, E. de Boccard, 1944; II, 1, *Grammaire historique de l'architecture délienne*, *ibid.*, 1966.

93. PLASSART (A.), *Exploration archéologique de Délos*, XI, *Les Sanctuaires et les cultes du mont Cynthe*, Paris, E. de Boccard, 1918.

94. GALLET DE SANTERRE (H.), *Exploration archéologique de Délos*, XXIV, *La Terrasse des lions, le Letôon et le monument de granit*, Paris, E. de Boccard, 1959.

Samos

95. BUSCHOR (E.), *Heraion von Samos. Frühe Bauten*, in *AM*, LV, 1930, pp. 1-99.

96. BUSCHOR (E.), *Ein frühdädalischer Ringhallentempel*, in *Festschrift für A. Rumpf*, Krefeld, 1950, pp. 32-37.

97. GRUBEN (G.), *Die Südhalle*, in *AM*, LXXII, 1957, pp. 52-64.

98. JOHANNES (H.), *Die Säulenbasen vom Heratempel des Rhoikos*, in *AM*, LXII, 1937, pp. 13-37.

99. REUTHER (O.), *Der Heratempel von Samos. Der Bau der Zeit des Polykrates*, Berlin, Gebr. Mann Verlag, 1957.

Chios

100. BOARDMAN (F.S.A.), *Chian and Early Ionic Architecture*, in *Antiquaries Journal*, XXXIX, 1959, pp. 170-218.

Thasos

101. LAUNEY (M.), *Études thasiennes*, I, *Le Sanctuaire et le culte d'Héraclès à Thasos*, Paris, E. de Boccard, 1944.

Samothrace

102. LEHMANN-HARTLEBEN (K.), *Excavations at Samothrace (Anaktoron)*, in *AJA*, XXXIV, 1940, pp. 328-358.

4. ATHENS AND ATTICA

103. THALLON HILL (I.), *The Ancient City of Athens*, London, Methuen & Co., 1953.

104. PLOMMER (W.H.), *The Archaic Acropolis. Some Problems*, in *JHS*, LXXX, 1960, pp. 127-159.

105. WIEGAND (T.), *Die archaische Porosarchitektur der Akropolis zu Athen*, Kassel-Leipzig, W. de Gruyter, 1904.

106. DINSMOOR (W.B.), *The Hekatompedon on the Athenian Acropolis*, in *AJA*, LI, 1947, pp. 109-151.

107. SCHUCHHARDT (W.H.), *Archaische Bauten auf der Akropolis von Athen*, in *AA*, 1963, col. 797-824.

108. RIEMANN (H.), *Der pisistratidische Athenatempel auf der Akropolis zu Athen*, in *MDAI*, III, 1950, pp. 7-39.

109. WELTER (G.), in *AM*, XXXXVII, 1922, pp. 60-71; XXXXVIII, 1923, pp. 182-189. (Archaic Olympieion in Athens.)

110. Agora excavations in Athens. Reports and studies in *Hesperia* since 1933.

111. NOACK (F.), *Eleusis. Die baugeschichtliche Entwicklung des Heiligtums*, Berlin, W. de Gruyter, 1927.

Aegina

112. FURTWÄNGLER (A.), FIECHTER (E.R.) and THIERSCH (H.), *Ägina. Das Heiligtum der Aphaia*, Munich, von Straub, 1906, 2 vols.

5. CENTRAL GREECE

Thermos

113. KAWERAU (G.) and SOTIRIADIS (G.), *Der Apollotempel zu Thermos*, *Antike Denkmäler*, II, Berlin, A. G. Reimer, 1902-1908, pl. 49-53.

114. DRERUP (H.), *Zu Thermos B*, *Marburger Winckelmannsprogramm*, 1963.

Calydon

115. DYGGVE (E.), *Das Laphrion. Der Tempelbezirk von Kalydon*. Copenhagen, Ejnar Munksgaard, 1948.

Delphi

116. LA COSTE-MESSELIÈRE (P. de), *Au musée de Delphes*, Paris, E. de Boccard, 1936.

117. DEMANGEL (R.), *Fouilles de Delphes*, II, *Topographie et architecture, Le Sanctuaire d'Athéna Pronaia*, fascicule 1, *Les Temples de tuf*, Paris, E. de Boccard, 1923.

118. DAUX (G.), *Fouilles de Delphes*, II, *Topographie et architecture, Le Sanctuaire d'Athéna Pronaia*, fascicule 1, *Les deux Trésors*, Paris, E. de Boccard, 1923.

119. DINSMOOR (W.B.), *Studies of the Delphian Treasuries*, in *BCH*, XXXVI, 1912, pp. 439-493; XXXVII, 1913, pp. 5-83.

120. POUILLOUX (J.), *Fouilles de Delphes*, II, *Topographie et architecture*, XII, *La Région nord du sanctuaire, de l'époque archaïque à la fin du sanctuaire*, Paris, E. de Boccard, 1960.

121. COURBY (F.), *Fouilles de Delphes*, II, *Topographie et architecture, Le Sanctuaire d'Apollon, La Terrasse du temple*, Paris, E. de Boccard, 1915-1927, 3 fascicules.

122. AUDIAT (J.), *Fouilles de Delphes,* II, *Topographie et architecture, Le Trésor des Athéniens,* Paris, E. de Boccard, 1935, 2 vols.

123. AMANDRY (P.), *Fouilles de Delphes,* II, *Topographie et architecture, La Colonne des Naxiens et le Portique des Athéniens,* Paris, E. de Boccard, 1953.

124. BOURGUET (E.), *Monuments et inscriptions de Delphes,* VIII, *Le Trésor de Corinthe,* in *BCH,* XXXVI, 1912, pp. 642-660.

125. HANSEN (E.), *Les abords du Trésor de Siphnos à Delphes,* in *BCH,* LXXXIV, 1960, pp. 387-433.

126. LA COSTE-MESSELIÈRE (P. de), *Les Alcméonides à Delphes,* in *BCH,* LXX, 1946, pp. 271-287.

127. LA COSTE-MESSELIÈRE (P. de), in *BCH,* LXXVII, 1953, pp. 346-376, and *RA,* XI, 1940, pp. 104-110. (On the attribution of the caryatids to the Ionian treasuries.)

128. DINSMOOR (W.B.), *The Athenian Treasury as Dated by Its Ornament,* in *AJA,* L, 1946, pp. 86-121.

Perachora

129. PAYNE (H.), *Perachora. The Sanctuaries of Hera Akraia and Limenia,* I, Oxford, Clarendon Press, 1940.

Corfu

130. RODENWALDT (G.), *Korkyra-Archaische Bauten und Bildwerke,* I, *Der Artemistempel,* Berlin, Gebr. Mann Verlag, 1940.

131. RIEMANN (H.), *Zum Artemistempel von Korkyra,* in *Jahrb.,* LVIII, 1943, pp. 31-38.

6. PELOPONNESUS

Corinth

132. *Corinth. Results of Excavations Conducted by the American School of Classical Studies at Athens,* I et sq. Cambridge (Mass.), Harvard University Press, since 1932.

133. WEINBERG (S.), *On the Date of the Temple of Apollo at Corinth,* in *Hesperia,* VIII, 1939, pp. 191-195.

134. BROONER (O.), *Isthmian Excavations,* in *Hesperia,* XXII, 1953, pp. 182-195; XXIV, 1955, pp. 110-141.

Argos and Argolis

135. FRÖDIN (O.) and PERSSON (A. W.), *Asine. Results of Swedish Excavations, 1922-1930,* Stockholm, Generalstabens litografiska Anstalts Förlag, 1938.

136. WACE (A.J.B.), *Mycenae. An Archaeological History and Guide,* Princeton, University Press, 1949.

137. MÜLLER (K.), *Tiryns,* III, *Architektur der Burg und des Palastes,* Augsburg, Filser, 1930.

138. WALDSTEIN (C.), *The Argive Heraeum,* Boston—New York, Houghton, 1902-1905, 2 vols.

139. AMANDRY (P.), *Recherches sur les monuments de l'Héraion d'Argos,* in *Hesperia,* XXI, 1952, pp. 222 sq.

140. VOLLGRAFF (I.W.), *Le sanctuaire d'Apollon Pythéen à Argos,* in *Études péloponnésiennes,* Paris, Vrin, 1956.

141. ROUX (G.), *Le sanctuaire argien d'Apollon Pythéen,* in *REG,* LXX, 1957, pp. 474-488.

Sparta

142. DAWKINS (R.M.), *The Sanctuary of Artemis Orthia at Sparta,* London, Macmillan, The Society for the Promotion of Hellenic Studies, Supplementary Papers, V, 1929.

143. BOARDMAN (J.), *Artemis Orthia and Chronology,* in *BSA,* LVIII, 1963, pp. 1-7.

144. KIRSTEN (E.), *Heiligtum und Tempel der Artemis Orthia zu Sparta in ihrer ältesten Entwicklungsphase,* in *Bonner Jahrbücher,* CLVIII, 1958, pp. 170-176.

Olympia

145. CURTIUS (E.), ADLER (F.) *et al., Olympia. Die Ergebnisse der von dem deutschen Reich veranstalteten Ausgrabungen,* II, *Die Baudenkmäler von Olympia,* Berlin, A. Ascher, 1892.

146. DÖRPFELD (W.), *Alt-Olympia,* Berlin, Mittler, 1935.

147. RIEMANN (H.), *Die Bauphasen des Heraions von Olympia,* in *Jahrb.,* LXI-LXII, 1946-1947, pp. 30-54.

148. SEARLS (H.E.) and DINSMOOR (W.B.), *The Date of the Olympia Heraeum,* in *AJA,* XXXXIX, 1945, pp. 62-80.

149. *Olympische Forschungen,* I-IV, Berlin, W. de Gruyter, 1945 et sq.

7. GREEK WEST

150. KOLDEWEY (R.) and PUCHSTEIN (O.), *Die griechischen Tempel in Unteritalien und Sizilien,* Berlin, A. Ascher, 1899.

151. GABRICI (E.), *Per la storia dell' architettura dorica in Sicilia,* in *M. A. Lincei,* XXXV, 1933, col. 137-262.

Syracuse

152. CULTRERA (G.), *L'Apollonion-Artemision di Ortigia in Siracusa,* in *M. A. Lincei,* XLI, 1951, pp. 812 sq.

Megara Hyblaea

153. ORSI (P.), *Tempio greco arcaico,* in *M.A. Lincei,* XXVII, 1921, pp. 109-180.

Agrigentum

154. MARCONI (P.), *Agrigento arcaica.* Rome, Ed. Società Magna Grecia, 1933.

Himera

155. MARCONI (P.), *Himera,* Rome, Ed. Società Magna Grecia, 1931.

Gela

156. ADAMESTEANU (D.) and ORLANDINI (P.), *Gela, scavi e scoperte 1951-1956, Notizie scavi,* XIV, 1960, pp. 67-247.

Selinus

157. GABRICI (R.), *Il santuario della Malophoros a Selinunte,* in *M.A. Lincei,* XXXII, 1927-1928, col. 50 sq.

158. GABRICI (E.), *Acropoli di Selinunte: scavi e topografia,* in *M.A. Lincei,* XXXIII, 1929, col. 61-111.

159. GABRICI (E.), *Studi archeologici selinuntini,* in *M.A. Lincei,* XLIII, 1956, col. 205-408.

Paestum

160. KRAUSS (F.), *Pästum. Die griechischen Tempel,* 2nd ed., Berlin, Gebr. Mann Verlag, 1943.

161. KRAUSS (F.), *Die Tempel von Pästum,* I, *Der Athenatempel,* Berlin, W. de Gruyter, 1959, 2 vols.

162. KRAUSS (F.), *Pästum. Basilika. Der Entwurf des Grundrisses, Festschrift für C. Weickert,* 1955, pp. 99-109.

163. ZANCANI MONTUORO (P.) and ZANOTTI-BIANCO (U.), *Heraion alla foce del Sele,* I, *Il Santuario, Il Tempio della dea,* Rome, Libreria dello Stato, 1951, 2 vols.; II, *Il primo thesauros, ibid.,* 1954, 2 vols.

8. EGYPT-AFRICA

164. PETRIE (W.M. Flinders), *Naucratis,* I and II, London, Trubner, 1886 and 1888.

165. STUCCHI (S.), *Apollonion di Cirene,* Rome, 'L'Erma' di Bretschneider, 1961.

166. PERNIER (L.), *Il tempio e l'altare di Apollo a Cirene,* Series Africa Italiana, Bergamo, 1935.

Sculpture

A — GENERAL WORKS

Handbooks

167. OVERBECK (J.), *Die antiken Schriftquellen zur Geschichte der bildenden Künste bei den Griechen*, Leipzig, Wilhelm Engelmann, 1868.

168. PICARD (C.), *Manuel d'archéologie grecque: La Sculpture*, I, *Période archaïque*, Paris, Ed. Auguste Picard, 1935.

169. CHARBONNEAUX (J.), *La Sculpture grecque archaïque*, Paris, Ed. de Cluny, 1939.

170. KARO (G.), *Greek Personality in Archaic Greek Sculpture*, Cambridge (Mass.), Harvard University Press, 1948.

171. RICHTER (G.M.A.), *Archaic Greek Art against its Historical Background*, New York, Oxford University Press, 1949.

172. LIPPOLD (G.), *Die griechische Plastik*, Munich, C.H. Beck Verlag, 1950.

173. MATZ (F.), *Geschichte der griechischen Kunst*, I, *Die geometrische und die frspace Form*, Frankfurt/Main, V. Klostermann, 1950, 2 vols.

Styles and Periods

174. LANGLOTS (E.), *Frühgriechische Bildhauerschulen*, Nuremberg, E. Fronmann, 1927.

175. MÜLLER (V.), *Frühe Plastik in Griechenland und Vorderasien*, Augsburg, Benno Filser Verlag, 1929.

176. GOTSMICH (A.), *Probleme der frühgriechischen Plastik*, Prague, Adol Otto Czerny, 1935.

177. JENKINS (R.J.H.), *Dedalica. A Study of Dorian Plastic Art in the Seventh Century B.C.*, Cambridge, University Press, 1936.

178. HOMANN-WEDEKING (E.), *Die Anfänge der griechischen Grossplastik*, Berlin, Gebr. Mann Verlag, 1950.

Male and Female Statuary

179. DEONNA (W.), *Dédale ou la statue de la Grèce archaïque*, Paris, E. de Boccard, 1930-1931, 2 vols.

180. BUSCHOR (E.), *Frühgriechische Jünglinge*, Munich, R. Piper & Co, 1950.

181. RICHTER (G.M.A.), *Kouroi. Archaic Greek Youths. A Study of the Development of the Kouros Type in Greek Sculpture*, London, Phaidon Press, 1960.

182. LEVIN (K.), *The Male Figure in Egyptian and Greek Sculpture of the Seventh and Sixth Centuries B.C.*, in *AJA*, LXVIII, 1964, pp. 13-28.

183. RICHTER (G.M.A.), *Korai. Archaic Greek Maidens. A Study of the Development of the Kore Type in Greek Sculpture*, London, Phaidon Press, 1968.

184. TECHNAU (W.), *Die statuarische Gruppe in der griechischen Kunst*, in *Die Antike*, XV, 1939, pp. 277-306.

Decorative Sculpture

185. DEMANGEL (R.), *La Frise ionique*, Paris, E. de Boccard, 1932.

186. LAPALUS (E.), *Le Fronton sculpté en Grèce, des origines à la fin du IVᵉ siècle*, Paris, E. de Boccard, 1947.

187. KÄHLER (H.), *Das griechische Metopenbild*, Munich, F. Bruckmann Verlag, 1949.

Special Studies

188. HEUZEY (J.), *Le Costume féminin en Grèce à l'époque archaïque*, in *GBA*, April 1938, pp. 127-148.

189. POULSEN (V.H.), *Three Archaic Greek Heads in the Ny Carlsberg Glyptothek*, in *From the Collections of the Ny Carlsberg Glyptothek*, II, 1938, pp. 65-112, Copenhagen, Ejnar Munksgaard, 1939.

Technique

190. BLÜMEL (C.), *Griechische Bildhauer an der Arbeit*, 4th ed., Berlin, W. de Gruyter, 1953.

191. REUTERSWÄRD (P.), *Studien zur Polychromie der Plastik. Griechenland und Rom. Untersuchungen über die Farbwirkung der Marmor und Bronzeskulpturen*, Stockholm, A. Bonniers, 1960.

Museum Catalogues

192. PRYCE (F.N.), *Catalogue of Sculpture in the Department of Greek and Roman Antiquities of the British Museum*, I, Part 1, *Prehellenic and Early Greek*, London, printed by order of the Trustees, 1928.

193. SCHEDE (M.), *Griechische und römische Skulpturen des Antikenmuseums (Meisterwerke der türkischen Museen zu Konstantinopel*, I), Berlin-Leipzig, W. de Gruyter, 1928.

194. RICHTER (G.M.A.), *Catalogue of Greek Sculptures. Metropolitan Museum of Art*, Cambridge (Mass.), Harvard University Press, 1954.

195. BLÜMEL (C.), *Die archaisch-griechischen Skulpturen der Staatlichen Museen zu Berlin*, Berlin, Akademie-Verlag, 1963.

Consult the *Enciclopedia dell'arte antica, classica e orientale*, Rome, Istituto poligrafico dello Stato, 1958-1966, for articles on sanctuaries and places where important works of archaic Greek sculpture have been discovered.

B — 1. ATTICA

196. HEBERDEY (R.), *Altattische Porosskulptur; ein Beitrag zur Geschichte der archaischen griechischen Kunst*, Vienna, Helder, Deutsch-Österreichisches Archäologisches Institut, 1919.

197. PAYNE (H.), *Archaic Marble Sculpture from the Acropolis. A Photographic Catalogue by Humfry Payne and Gerard Mackworth Young, Introduction by Humfry Payne*, London, The Cresset Press Limited, n.d.

198. SCHRADER (H.), LANGLOTZ (E.), and SCHUCHHARDT (W.H.), *Die archaischen Marmorbildwerke der Akropolis*, Frankfurt/Main, Klostermann, 1939.

199. SCHEFOLD (K.), *Griechische Plastik*, I, *Die grossen Bildhauer des archaischen Athen*, Basel-Stuttgart, Birkhäuser, 1949.

Kouroi and Korai

200. LA COSTE-MESSELIÈRE (P. de), *Les Corés de l'Acropole*, in *Journal des savants*, 1942, pp. 18-36 and 55-66.

201. BUDDE (L.), *Die attischen Kuroi*, Würzburg, Triltsch, 1939. (Phil. Diss. Berlin.)

202. CAHN (H.A.), *Der Kuros von Cleveland*, in *Antike Kunst*, I, 1958, pp. 75-76.

203. VANDERPOOL (E.), in *AJA*, LXIV, 1960, p. 266. (On the Piraeus kouros.)

204. NIEMEYER (H.G.), *Attische Bronzestatuetten der spätarchaischen und frühklassischen Zeit*, in *Antike Plastik*, III, 1964, pp. 7-31.

205. RAUBITSCHEK (A.E.), *Early Attic Votive Monuments*, in *BSA*, XL, 1939-1940, pp. 17-37.

206. KAROUZOS (Ch.), *Aristodikos. Zur Geschichte der spätarchaisch-attischen Plastik und der Grabstatue*, Stuttgart-Berlin, W. Kohlhammer Verlag, 1961.

Gravestones

207. KÜBLER (K.), *Ein altattisches Grabmal vom Heiligen Tor*, in *AA*, LVIII, 1943, col. 391-444.

208. HARRISON (E.B.), *Archaic Gravestones from the Athenian Agora*, in *Hesperia*, XXV, 1956, pp. 25-45.

209. RICHTER (G.M.A.), *The Archaic Gravestones of Attica*, London, Phaidon Press, 1961.

Votive Inscriptions

210. RAUBITSCHEK (A.E.), *Zu altattischen Weihinschriften*, in *JOEAI*, XXXI, 1938, Beiblatt, col. 21-67.

211. RAUBITSCHEK (A.E.), *Dedications from the Athenian Acropolis. A Catalogue of the Inscriptions of the Sixth and Fifth Centuries B.C.*, Cambridge (Mass.), Archaeological Institute of America, 1949, edited with the collaboration of L. H. JEFFERY.

2. DELOS AND THE CYCLADES

Delos

212. MARCADÉ (J.), *Notes sur trois sculptures archaïques récemment reconstituées à Délos*, in *BCH*, LXXIV, 1950, pp. 181-215. *Sculptures archaïques (additions et corrections)*, in *BCH*, LXXV, 1951, pp. 188-189; LXXVI, 1952, p. 278; LXXVII, 1953, p. 290.

213. GALLET DE SANTERRE (H.), *Délos primitive et archaïque*, Paris, E. de Boccard, 1958.

214. BRUNEAU (P.) and DUCAT (J.), *Guide de Délos*, Paris, E. de Boccard, 1965. École française d'Athènes.

Paros

215. KONTOLEON (N.M.), *Archaic Frieze of Paros. K. Orlandos Miscellany*, Archaeological Society of Athens, 1964, pp. 348-418 (in Greek).

Thera

216. KONTOLEON (N.M.), *Theräisches*, in *AM*, LXXIII, 1958, pp. 117-139.

217. KONTOLEON (N.M.), *Kouroi from Thera*, in *Eph. Arch.*, 1939-1940 (1948), pp. 1-33 (in Greek).

Thasos

218. PICARD (C.), *Colosse criophore de Thasos*, in *BCH*, XLV, 1921, pp. 113-127.

219. LAUNEY (M.), *Un 'Pégase' archaïque de Thasos*, in *Mon. Piot*, XXXV, 1935-1936, pp. 25-48.

220. PICARD (C.), *Une cimaise thasienne archaïque*, in *Mon. Piot*, XXXVIII, 1941, pp. 55-92.

3. DELPHI AND CENTRAL GREECE

Delphi

221. HOMOLLE (T.), *Fouilles de Delphes*, IV, *Monuments figurés: Sculpture*, fascicule 1, *Art primitif, Art archaïque du Péloponnèse et des Iles*, Paris, Fontemoing, 1909.

222. PICARD (C.) and LA COSTE-MESSELIÈRE (P. de), *Fouilles de Delphes*, IV, *Monuments figurés: Sculpture*, fascicule 2, *Art archaïque: les Trésors 'Ioniques,'* Paris, E. de Boccard, 1928.

223. PICARD (C.) and LA COSTE-MESSELIÈRE (P. de), *Fouilles de Delphes*, IV, *Monuments figurés: Sculpture*, fascicule 3, *Art archaïque: Sculptures des temples*, Paris, E. de Boccard, 1931.

224. AMANDRY (P.), *Fouilles de Delphes*, II, *Topographie et architecture, La Colonne des Naxiens et le Portique des Athéniens*, Paris, E. de Boccard, 1953.

225. LA COSTE-MESSELIÈRE (P. de), *Fouilles de Delphes*, IV, *Monuments figurés: Sculpture*, fascicule 4, *Sculptures du Trésor des Athéniens*, Paris, E. de Boccard, 1957.

226. LA COSTE-MESSELIÈRE (P. de), *Au Musée de Delphes; recherches sur quelques monuments archaïques et leur décor sculpté*, Paris, E. de Boccard, 1936.

227. LA COSTE-MESSELIÈRE (P. de), *Sur les Caryatides cnidiennes de Delphes*, in *BCH*, LXII, 1938, pp. 285-288.

228. AMANDRY (P.), *Rapport préliminaire sur les statues chryséléphantines de Delphes*, in *BCH*, LXIII, 1939, pp. 86-119.

229. DARSOW (W.), *Zur Datierung eines delphischen Karyatidenkopfes (Früher Knidierkore)*, in *MDAI*, III, 1950, pp. 119-134.

230. LA COSTE-MESSELIÈRE (P. de), *Corès delphiques*, in *BCH*, LXXVII, 1953, pp. 346-373.

231. RIDGWAY (B.S.), *The West Frieze of the Siphnian Treasury at Delphi: a Rearrangement*, in *BCH*, 1962, pp. 24-35.

232. RIDGWAY (B.S.), *The East Pediment of the Siphnian Treasury: a Reinterpretation*, in *AJA*, LXIX, 1965, pp. 1-5.

Eretria

233. KURUNIOTIS (K.), *Die Hauptstücke vom Giebel des Eretrischen Tempels des Apollo Daphnephoros*, in *Antike Denkmäler*, III, 1914-1915, pp. 15-16.

Boetia

234. GRACE (F.R.), *Archaic Sculpture in Boetia*, Cambridge (Mass.), Harvard University Press, 1949.

4. OLYMPIA

235. FURTWÄNGLER (A.), *Olympia*, IV, *Die Bronzen*, Berlin, A. Asher, 1890.

236. TREU (G.), *Die Bildwerke von Olympia in Stein und Ton. Olympia*, III, *Die Ergebnisse der von dem Deutschen Reich veranstalteten Ausgrabung*, edited by CURTIUS (E.) and ADLER (F.), Berlin, Verlag von A. Asher & Co, 1894.

237. KUNZE (E.), *Neue Meisterwerke griechischer Kunst aus Olympia*, Munich, Filser Verlag, 1948.

238. KUNZE (E.), *Archaïsche Schild-bänder. Ein Beitrag zur frühgriechischen Bildgeschichte und Sagenüberlieferung*, in *Olympische Forschungen*, II, Berlin, W. de Gruyter, 1950.

239. KUNZE (E.), *Ein Bronzejüngling*, in *Olympia Bericht*, V, 1941/1942-1952 (1956), pp. 97-102.

240. KUNZE (E.), *Terrakotta Plastik: Athenagruppe*, in *Olympia Bericht*, VI, 1953-1955 (1958), pp. 169-194.

241. KUNZE (E.), *Zwei archaische Krieger* in *Olympia Bericht*, VII, 1956-1958 (1961), pp. 169-176.

5. CORFU - AEGINA PELOPONNESUS

Corfu

242. RODENWALDT (G.), *Korkyra, archaische Bauten und Bildwerke*. Archäologisches Institut des Deutschen Reiches 1939-1940, I, *Der Artemistempel, Architektur, Dachterrakotten, Inschriften*, revised edition by H. SCHLEIF, K.A. RHOMAIOS, and G. KLAFFENBACH; II, *Die Bildwerke des Artemistempels von Korkyra*, revised edition by G. RODENWALDT, Berlin, Gebr. Mann Verlag, 1939.

243. KUNZE (E.), *Zum Giebel des Artemistempels in Korfu*, in *AM*, LXXVIII, 1963, pp. 74-89. (Study of the central motif in connection with shield-strap reliefs.)

Corinth and Perachora

244. PAYNE (H.G.G.), *Necrocorinthia, A Study of Corinthian Art in the Archaic Period*, Oxford, Clarendon Press, 1931.

245. RICHTER (G.M.A.), *A Greek Terracotta Head and the 'Corinthian' School of Terracotta Sculpture*, in *AJA*, LII, 1948, pp. 331-335.

246. WEINBERG (S.), *Terracotta Sculpture at Corinth*, in *Hesperia*, XXVI, 1957, pp. 289-319.

Aegina

247. PAYNE (H.G.G.), *Perachora, the Sanctuaries of Hera Akraia and Limenia*, Oxford, Clarendon Press, I, 1940; II, edited by T.J. DUNBABIN, 1962.

248. FURTWÄNGLER (A.), *Ägina, das Heiligtum der Aphaia*, with the collaboration of E.R. FIECHTER and H. THIERSCH, Munich, Verlag der K.B. Akademie der Wissenschaften, 1906, 2 vols.

249. WELTER (G.), *Ägina*, Berlin, Archäologisches Institut des deutschen Reiches, 1938.

250. WELTER (G.), *Archaischer Frauentorso*, in *AA*, LIII, 1938, col. 529-530.

Sparta

251. TOD (M.N.) and WACE (A.J.B.), *A Catalogue of the Sparta Museum*, Oxford, Clarendon Press, 1906.

252. DAWKINS (R.M.), *The Sanctuary of Artemis Orthia at Sparta*, in *JHS, Supplementary Papers*, V, London, Macmillan, 1929.

253. KUNZE (E.), *Statuette de Criophore du Péloponnèse du Nord*, in *Musée national d'Athènes. Collection Hélène Stathatos*, III, *Objets antiques et byzantins*, edited by P. AMANDRY and C. ROLLEY, Limoges, Impr. Bontemps et Strasbourg, Amandry, 1963, pp. 50-58.

254. DE LUCA (G.), *Il Kouros di Tenea*, in *Archeologica classica*, XI, 1959, 1, pp. 1-30.

6. SAMOS AND EAST GREECE

Samos

255. BUSCHOR (E.), *Altsamische Standbilder*, I-III, 1934-1935; IV, 1960; V, 1961, Berlin, Gebr. Mann Verlag.

256. VIERNEISEL (K.), *Neue Tonfiguren aus dem Heraion von Samos*, in *AM*, LXXVI, 1961, pp. 25-59.

Various Sites in Asia Minor

257. AKURGAL (E.), *Die Kunst Anatoliens von Homer bis Alexander*, Berlin, W. de Gruyter, 1961.

258. ROBERT (L.) and DEVAMBEZ (P.), *Tête archaïque trouvée à Kéramos*, in *AJA*, XXXIX, 1935, pp. 341-351.

259. ECKSTEIN (F.), *Archaischer Jünglingskopf in Istanbul*, in *Antike Plastik*, I, 1962, pp. 47-57.

260. LAUBSCHER (H.P.), *Zwei neue Kouroi aus Kleinasien*, in *Istanb. Mitt.*, XIII-XIV, 1963, pp. 73-87.

261. HIMMELMANN-WILDSCHÜTZ (N.), *Beiträge zur Chronologie der archaischen ostionischen Plastik*, in *Istanb. Mitt.*, XV, 1965, pp. 24-41.

262. LANGLOTZ (E.), *Die kulturelle und künstlerische Hellenisierung der Küsten des Mittelmeers durch die Stadt Phokaia*, Cologne-Opladen, Westdeutscher Verlag, 1966.

263. DEVAMBEZ (P.), and ROBERT (L.), *Une nouvelle statue archaïque au Louvre*, in *RA.*, n.s., 1966, pp. 195-222.

Assos

264. SARTIAUX (F.), *Les Sculptures et la restauration du temple d'Assos*, in *RA*, XXII, 2, 1913, pp. 1-46; 359-389; XXIII, 1, 1914, pp. 191-222; 381-412.

265. MENDEL (G.), *Musées impériaux ottomans. Catalogue des sculptures grecques, romaines et byzantines*, II, Constantinople, Imperial Museum, 1914, pp. 1-23.

Cyzicus

266. AKURGAL (E.), *Neue archaische Bildwerke aus Kyzikos*, in *Antike Kunst*, VIII, 1965, pp. 99-103.

Didyma

267. WIEGAND (T.), *Didyma*, I, Berlin, Gebr. Mann Verlag, 1941, 3 vols.

268. MÖBIUS (G.), *Archaische Sitzstatue aus Didyma*, in *Antike Plastik*, II, Berlin, Gebr. Mann Verlag, 1963, pp. 23-39.

Ephesus

269. HOGARTH (D.G.), *Excavations at Ephesus. The Archaic Artemisia*, London, The British Museum, 1908.

Xanthos

270. METZGER (H.), *Fouilles de Xanthos*, II, *L'Acropole lycienne*, Paris, Klincksieck, 1963, pp. 93-94.

7. MAGNA GRAECIA AND THE GREEK WEST

271. ORSI (P.), *Daedalica Siciliae*, in *Mon. Piot*, XXII, 1916, pp. 131-162.

272. VILLARD (F.), *Sicile grecque*, Paris, M. Girodias, 1955.

273. LANGLOTZ (E.), *The Art of Magna Graecia. Greek Art in Southern Italy and Sicily*, London, Thames and Hudson, 1965; *Ancient Greek Sculpture of Southern Italy and Sicily*, New York, Abrams, 1965.

Selinus

274. BENNDORF (O.), *Die Metopen von Selinunt, mit Untersuchungen über die Geschichte, die Topographie und die Tempel von Selinunt*, Berlin-Leipzig, W. de Gruyter, 1873.

Silaris Sanctuary

275. ZANCANI MONTUORO (P.) and ZANOTTI-BIANCO (U.), *Heraion alla Foce del Sele*, Rome, Libreria dello Stato, 1951-1954, 4 vols.

Cyrene

276. PARIBENI (E.), *Catalogo delle Sculture di Cirene*, Rome, 'L'Erma' di Bretschneider, 1959. (Statues and reliefs of a religious character.)

Spain

277. GARCIA Y BELLIDO (A.), *Hispania Graeca*, Barcelona, Impr. de la Casa de Caridad, 1948.

| C | MINOR SCULPTURE |

Bronzes

278. LAMB (W.), *Greek and Roman Bronzes*, London, Methuen and Co., 1929.

279. CHARBONNEAUX (J.), *Les Bronzes grecs*, Paris, Presses universitaires de France, 1958.

280. RIDDER (A. de), *Les Bronzes antiques du Louvre*, Paris, E. Leroux, 1913-1915, 2 vols.

281. RICHTER (G.M.A.), *Greek, Etruscan and Roman Bronzes*, New York, The Metropolitan Museum of Art, 1915.

282. NEUGEBAUER (K.A.), *Staatliche Museen zu Berlin. Katalog der statuarischen Bronzen im Antiquarium*, I, *Die minoischen und archaisch-griechischen Bronzen*, Berlin-Leipzig, W. de Gruyter, 1931.

283. JOFFROY (R.), *Le Trésor de Vix*, in *Mon. Piot*, XLVIII, 1954.

284. ROLLEY (C.), *Hydries de bronze dans le Péloponnèse du Nord*, in *BCH*, LXXXVII, 1963, pp. 459-484. (Discussion of production centres of archaic bronze vases decorated with figures in relief or in the round, with recent bibliography.)

Terra-cottas

Several recent catalogues give extensive listings of archaic terracottas and moulded vases:

285. HIGGINS (R.A.), *Catalogue of the Terracottas in the Department of Greek and Roman Antiquities, British Museum*, I-II, London, British Museum, 1954-1959, 3 vols.

286. MOLLARD-BESQUES (S.), *Catalogue raisonné des figurines et reliefs en terre cuite, grecs, étrusques et romains*, I, *Epoques préhellénique, géométrique, archaïque et classique*, Paris, Editions des Musées nationaux, 1954, 2 vols.

287. DUCAT (J.), *Les Vases plastiques corinthiens*, in *BCH*, LXXXVII, 1963, pp. 431-458.

288. DUCAT (J.), *Les Vases plastiques rhodiens archaïques en terre cuite*, Paris, E. de Boccard, 1966.

289. VANDERPOOL (E.), *The Kneeling Boy*, in *Hesperia*, VI, 1937, pp. 426-441. (Attic moulded vase.)

Jewellery, Engraved Gems, Coins

290. COCHE DE LA FERTÉ (É.), *Les Bijoux antiques*, Paris, Presses universitaires de France, 1956.

291. HIGGINS (R.A.), *Greek and Roman Jewellery*, London, Methuen & Co., 1961.

292. BECATTI (G.), *Oreficerie Antiche, dalle Minoiche alle Barbariche*, Rome, Istituto Poligrafico dello Stato, 1955.

293. FILOW (B.D.) and SCHKORPIL (K.), *Die archaische Nekropole von Trebenischte am Ochrida-See*, Berlin-Leipzig, W. de Gruyter, 1927.

294. FURTWÄNGLER (A.), *Die antiken Gemmen*, Berlin-Leipzig, Giesecke & Devrient, 1900, 3 vols.

295. REGLING (K.), *Die antike Münze als Kunstwerk*, Berlin, Schœtz & Parrhysius, 1924.

296. FRANKE (P.R.) and HIRMER (M.), *Die griechische Münze*, Munich, Hirmer Verlag, 1964. C.M. Kraay and M. Hirmer, *Greek Coins*, London, Thames and Hudson, 1966; New York, Abrams, 1966.

Painting and Pottery

| A | GENERAL WORKS |

Handbooks

297. PFUHL (E.), *Malerei und Zeichnung der Griechen*, Munich, F. Bruckmann, 1923, 3 vols.

298. BUSCHOR (E.), *Griechische Vasen*, Munich, R. Piper, 1940.

299. LANE (A.), *Greek Pottery*, 2nd ed., London, Faber & Faber, 1953.

300. RUMPF (A.), *Malerei und Zeichnung* in *Handbuch der Archäologie*, VI, IV, 1, Munich, C. H. Beck Verlag, 1953.

301. VILLARD (F.), *Les Vases grecs*, Paris, Presses universitaires de France, 1956.

302. ROBERTSON (M.), *Greek Painting*, Geneva, Skira, 1959.

303. COOK (R. M.), *Greek Painted Pottery*, London, Methuen & Co., 1960.

304. ARIAS (P. E.) and HIRMER (M.), *A History of Greek Vase Painting*, London, Thames and Hudson, 1961. *A History of 1000 years of Greek Vase Painting*, New York, Abrams, 1962.

305. ARIAS (P.E.), *Storia della ceramica di età arcaica, classica ed ellenistica e delle pitture di età arcaica e classica*, in *Enciclopedia classica*, III, vol. XI, tome V, Turin, Società editrice internazionale, 1963.

Documentary Compilations

306. *The Corpus vasorum antiquorum* now comprises about 150 fascicules published by the principal museums of Europe and America.

307. FURTWÄNGLER (A.) and REICHHOLD (K.), *Griechische Vasenmalerei*, I-III, Munich, F. Bruckmann, 1900-1932.

308. GRAEF (B.) and LANGLOTZ (E.), *Die antiken Vasen von der Akropolis zu Athen*, I-II, Berlin, G. Reimer, 1909-1933.

Sources and Studies of Archaic Painting

309. REINACH (A.), *Recueil Milliet. Textes grecs et latins, relatifs à l'histoire de la peinture ancienne*, I, Paris, Klincksieck, 1921.

310. SALVIAT (F.) and WEILL (N.), *Un plat du VII^e siècle à Thasos: Bellérophon et la Chimère*, in *BCH*, LXXIV, 1960, pp. 352-357. (On the problem of 7th-century polychrome pottery.)

311. VILLARD (F.), *La Céramique polychrome de Mégara Hyblaea*, in *Kôkalos*, Palermo, X-XI, 1964-1965, pp. 603-608.

312. SOTIRIADIS (G.), *Der Apollotempel zu Thermos*, in *Antike Denkmäler*, II, Berlin, G. Reimer, 1902-1908, pl. 50-52.

313. KOCH (H.), *Zu den Metopen von Thermos*, in *AM*, XXXIX, 1914, pp. 237-245.

314. PAYNE (H.G.), *On the Thermon Metopes*, in *BSA*, XXVII, 1925-1926, pp. 124-132.

315. PERNICE (E.), *Tontäfelchen aus Korinth in den K. Museen zu Berlin*, in *Antike Denkmäler*, Berlin, G. Reimer, 1887-1908, I, pl. 8; II, pl. 23-24 and 39-40.

316. ORLANDOS (A.K.), *Pitsa*, in *Enciclopedia dell'arte antica, classica e orientale*, VI, Rome, Istituto della Enciclopedia italiana, 1965, pp. 201-204. (Corinthian paintings on wood.)

317. BOARDMAN (J.), *Painted Funerary Plaques and Some Remarks on Prothesis*, in *BSA*, L, 1955, pp. 51-66. (Attic terra-cotta plaques.)

318. PALLOTTINO (M.), *Etruscan Painting*, Geneva, Skira, 1952.

B 1. ORIENTALIZING WARES

Rhodes

319. RUMPF (A.), *Zu den klazomenischen Denkmälern*, in *Jahrb.*, XLVIII, 1933, pp. 55-83.

320. SCHEFOLD (K.), *Knidische Vasen und Verwandtes*, in *Jahrb.*, LVII, 1942, pp. 124-142.

321. SCHIERING (W.), *Werkstätten orientalisierender Keramik auf Rhodos*, Berlin, Gebr. Mann Verlag, 1957.

322. KARDARA (C.), *Vase Paintings of Rhodes*, in Library of the Archaeological Society, XLIX, Athens, 1963. (In Greek.)

Melos

323. CONZE (A.), *Melische Tongefässe*, Leipzig, Breitkopf & Härtel, 1862.

324. DUGAS (C.), *La Céramique des Cyclades*, Paris, E. de Boccard, 1925, pp. 189-225.

325. PAYNE (H.G.), *Cycladic Vase-Painting of the Seventh Century*, in *JHS*, XLVI, 1926, pp. 203-212.

326. BUSCHOR (E.), *Kykladisches*, in *AM*, LIV, 1929, pp. 142-163.

327. BOCCI (P.), *Ricerche sulla ceramica cicladica*, Rome, 'L'Erma' di Bretschneider, 1962.

Chios

328. PRICE (E.R.), *Pottery of Naucratis*, in *JHS*, XLIV, 1924, pp. 205-222.

329. LAMB (W.), *Excavations at Kato Phana in Chios*, in *BSA*, XXXV, 1934-1935, pp. 158-161.

330. COOK (R.M.), *The Distribution of Chiot Pottery*, in *BSA*, XLIV, 1949, pp. 154-161.

331. BOARDMAN (J.), *Chian and Naucratite*, in *BSA*, LI, 1956, pp. 55-62.

2. BLACK-FIGURE VASE PAINTING

Corinth

332. JOHANSEN (K.F.), *Les Vases sicyoniens*, Paris-Copenhagen, Champion-V. Pio-Paul Brenner, 1923.

333. PAYNE (H.G.), *Protokorinthische Vasenmalerei*, Berlin, H. Keller, 1933.

334. DUNBABIN (T.J.) and ROBERTSON (M.), *Some Protocorinthian Vase-Painters*, in *BSA*, XLVIII, 1953, pp. 172-181.

335. PAYNE (H.G.), *Necrocorinthia*, Oxford, Clarendon Press, 1931.

336. AMYX (D.A.), *Corinthian Vases in the Hearst Collection at San Simeon*, in *University of California Publications in Classical Archaeology*, I, 9, Berkeley, 1943, pp. 207-232.

337. BENSON (J.L.), *Die Geschichte der korinthischen Vasen*, Basel, Benno Schwabe, 1953.

338. BENSON (J.L.), *Some Notes on Corinthian Vase-Painters*, in *AJA*, LX, 1956, pp. 219-230.

Boeotia

339. URE (P.N.), *Boeotian Pottery of the Geometric and Archaic Styles. Classification des céramiques antiques*, XII, Paris, Champion, 1926.

340. URE (A.D.), *Sixth and Fifth Century Pottery from Rhitsona*, Oxford, University Press, 1927.

341. URE (A.D. and P.N.), *Boeotian Vases in the Akademisches Kunstmuseum in Bonn*, in *AA*, XLVIII, 1933, col. 1-26.

Laconia

342. LANE (A.), *Laconian Vase-Painting*, in *BSA*, XXXIV, 1933-1934, pp. 99-189.

343. SHEFTON (B.B.), *Three Laconian Vase-Painters*, in *BSA*, XLIX, 1954, pp. 299-310.

344. ROLLEY (C.), *Le 'Peintre des Cavaliers,'* in *BCH*, LXXXIII, 1959, pp. 275-284.

Chalcidian Pottery

345. RUMPF (A.), *Chalkidische Vasen*, Berlin—Leipzig, W. de Gruyter, 1927.

346. SMITH (H.R.W.), *The Origin of Chalcidian Ware*, in *University of California Publications in Classical Archaeology*, I, 3, Berkeley, 1932, pp. 85-145.

347. VALLET (G.), *Rhégion et Zancle. Histoire, commerce et civilisation des cités chalcidiennes du détroit de Messine*, Paris, E. de Boccard, 1958, pp. 211-228.

Ionian Pottery

Eretria

348. BOARDMAN (J.), *Pottery from Eretria*, in *BSA*, XLVII, 1952, pp. 30-43.

Clazomenae

349. COOK (R.M.), *A List of Clazomenian Pottery*, in *BSA*, XLVII, 1952, pp. 123-152.

350. COOK (R.M.), *Corpus vasorum antiquorum, British Museum*, VIII, 1954, pp. 14-28.

Ionian Cups

351. KUNZE (E.), *Ionische Kleinmeister*, in *AM*, LIX, 1934, pp. 81-122.

Ionian Dinoi

352. VILLARD (F.), *Deux Dinoi d'un peintre ionien au Louvre*, in *Mon. Piot*, XLIII, Paris, Presses universitaires de France, 1949, pp. 33-57.

353. COOK (R.M.) and HEMELRIJK (J.M.), *A Hydria of the Campana Group in Bonn*, in *Jahrbuch der Berliner Museen*, V, 1963, pp. 107-120.

Caeretan Hydriai

354. PLAOUTINE (N.), *Le 'Peintre des hydries' dites de Caeré*, in *RA*, XVIII, 1941, pp. 5-21.

355. DEVAMBEZ (P.), *Deux nouvelles hydries de Caeré au Louvre*, in *Mon. Piot*, XLI, Paris, Presses universitaires de France, 1946, pp. 29-62.

356. SANTANGELO (M.), *Les Nou-velles Hydries de Caeré au Musée de la Villa Giulia*, in *Mon. Piot*, XLIV, Paris, Presses universitaires de France, 1950, pp. 1-43.

357. CALLIPOLITIS (V.), *Les Hydries de Caeré. Essai de classification*, in *L'Antiquité classique*, XXIV, 1955, pp. 384-411.

358. HEMELRIJK (J.M.), *De Caere-taanse hydriae*, Rotterdam, Wege-ling, 1956.

Etruscan Pottery

359. DUCATI (P.), *Pontische Vasen*, Berlin, H. Keller, 1932.

360. DOHRN (T.), *Die schwarzfigurigen etruskischen Vasen aus der zweiten Hälfte des sechsten Jahrhunderts*, Berlin, Triltsch & Huther, 1937.

361. BEAZLEY (J.D.), *Etruscan Vase-Painting*, Oxford, Clarendon Press, 1947, pp. 1-24.

Athens

Technique and Trade

362. RICHTER (G.M.A.), *The Craft of Athenian Pottery*, London, Oxford University Press, 1923.

363. NOBLE (J.V.), *The Technique of Attic Vase-Painting*, in *AJA*, LXIV, 1960, pp. 307-318.

364. NOBLE (J.V.), *The Technique of Painted Attic Pottery*, New York, Watson-Guptill Publications, 1965; London, Faber and Faber, 1966.

365. RICHTER (G.M.A.) and MILNE (M.J.), *Shapes and Names of Athen-ian Vases*, New York, The Metro-politan Museum of Art, 1935.

366. BLOESCH (H.), *Formen attischer Schalen von Exekias bis zum Ende des strengen Stils*, Bern, Benteli, 1940.

367. VILLARD (F.), *L'évolution des coupes attiques à figures noires*, in *REA*, XLVIII, 1946, pp. 153-181.

368. BLOESCH (H.), *Stout and Slender in the Late Archaic Period*, in *JHS*, LXXI, 1951, pp. 29-39.

369. BEAZLEY (J.D.), *Potter and Paint-er in Ancient Athens*, 3rd ed., London, British Academy, Oxford University Press, 1949.

370. VALLET (G.) and VILLARD (F.), *Céramique grecque et histoire éco-nomique*, in *Études archéologiques*, Paris, S.E.V.P.E.N., 1963, pp. 205-217.

371. COOK (R.M.), *Bedeutung der be-malten Keramik für den griechischen Handel*, in *Jahrb.*, LXXIV, 1959, pp. 114-123.

372. AMYX (D.A.), *An Amphora with Price Inscription*, in *University of California Publications in Classical Archaeology*, I, 8, Berkeley, 1941, pp. 179-206.

373. JONGKEES (J.H.), *On Price In-scriptions on Greek Vases*, in *Studia van Hoorn*, Leyden, E.J. Brill, 1951, pp. 66-74.

General Works

374. HASPELS (C.H.), *Attic Black-Figured Lekythoi*, Paris, E. de Boc-card, 1936, 1 volume of text, 1 volume of plates.

375. BEAZLEY (J.D.), *Attic Black-Figure Vase-Painters*, Oxford, Cla-rendon Press, 1956.

376. BEAZLEY (J.D.), *The Develop-ment of Attic Black-Figure*, 2nd ed., Berkeley, University of California Press, 1964.

Early Black-Figure

377. KÜBLER (K.), *Altattische Malerei*, Tübingen, E. Wasmuth Verlag, 1950, pp. 22-30.

378. KAROUZOU (S.), *Vases from Anagyros*, in Library of the Ar-chaeological Society, vol. XLIII, Athens, 1963. (In Greek.)

379. SCHEILBER (J.), *Olpen und Am-phoren des Gorgomalers*, in *Jahrb.*, LXXVI, 1961, pp. 1-47.

Black-Figure Painters after 580.

380. KAROUZOU (S.), *Sophilos*, in *AM*, LXII, 1937, pp. 111-135.

381. JOHANNOWSKY (W.), *Frammen-ti di un dinos di Sophilos da Gortina*, in *Annuario*, XXXIII-XXXIV, 1955-1956, pp. 45-51.

382. GREIFENHAGEN (A.), *Eine at-tische schwarzfigurige Gattung und die Darstellung des Kosmos im VI. Jahrhundert*, Königsberg, Gräfe & Unzer, 1929.

383. BEAZLEY (J.D.), *The Troilos Cup*, in *Metropolitan Museum Studies*, V, 1, 1934, pp. 93-115. (On the C Painter.)

384. BEAZLEY (J.D.), *Amasea, II. The Heidelberg Group*, in *JHS*, LI, 1931, pp. 275-282. (On the Heidelberg Painter.)

385. MINTO (A.), *Il vaso François*, Firenze, Leo S. Olschki, 1960.

386. RICHTER (G.M.A.), *Lydos*, in *Metropolitan Museum Studies*, IV, 2, 1933, pp. 169-178.

387. RUMPF (A.), *Sakonides*, Berlin-Leipzig, H. Keller, 1937. (Actually deals with Lydos.)

388. KAROUZOU (S.), *The Amasis Painter*, Oxford, Clarendon Press, 1956.

389. BOTHMER (D. von), *New Vases by the Amasis Painter*, in *Antike Kunst*, II, 1960, pp. 71-80.

390. SCHAUENBURG (K.), *Neue Am-phoren des Amasismalers*, in *Jahrb.*, LXXIX, 1964, pp. 109-141.

391. BEAZLEY (J.D.), *Little-Masters Cups*, in *JHS*, LII, 1932, pp. 167-204.

392. TECHNAU (W.), *Exekias*, Berlin-Leipzig, H. Keller, 1936.

393. SMITH (H.R.W.), *New Aspects of the Menon Painter*, in *University of California Publications in Classic-al Archaeology*, I, 1, Berkeley, 1929, pp. 1-64. (On Psiax.)

394. BEAZLEY (J.D.), *The Antimenes Painter*, in *JHS*, XLVII, 1927, pp. 63-92.

3. RED-FIGURE VASE PAINTING

Technique and Trade

Same references as for Attic black-figure vase painting (see nos. 362-373).

General Works

395. LANGLOTZ (E.), *Zur Zeitbestim-mung der strengrotfigurigen Vasen-malerei und der gleichzeitigen Pla-stik*, Leipzig, A. Seemann, 1920.

396. RICHTER (G.M.A.), *Attic Red-Figured Vases*, 2nd ed., New Haven, Yale University Press, 1958.

397. BEAZLEY (J.D.), *Attic Red-Figure Vase-Painters*, Oxford, Clarendon Press, 1963, 3 vols.

398. CASKEY (L.D.), and BEAZLEY (J.D.), *Attic Vase Painting in the Museum of Fine Arts, Boston*, I-III, London, H. Milford, Oxford Uni-versity Press, 1941-1963.

399. RICHTER (G.M.A.) and HALL (L.F.), *Red-Figured Athenian Vases in Metropolitan Museum*, New Haven, Yale University Press, 1936.

Painters

400. MARWITZ (H.), *Zur Einheit des Andokidesmalers*, in *JOEAI*, XLVI, 1961-1963, pp. 73-104.

401. BRUHN (A.), *Oltos and Early Red-Figure Vase Painting*, Copenhagen, Nyt Nordisk Forlag, 1943.

402. HARTWIG (P.), *Die griechischen Meisterschalen der Blüthezeit des strengen rothfigurigen Stiles*, Stutt-gart—Berlin, Spemann, 1893.

394

403. KRAIKER (W.), *Epiktetos*, in *Jahrb.*, XLIV, 1929, pp. 141-197.

404. TRENDALL (A.D.), *The Felton Greek Vases*, Adelaide, The Griffin Press, 1958, pp. 13-16. (On the Nikosthenes Painter.)

405. KLEIN (W.), *Euphronios*, Vienna, C. Gerold, 1886.

406. VILLARD (F.), *Deux nouvelles œuvres d'Euphronios au Musée du Louvre*, in *Mon. Piot*, XLV, Paris, Presses universitaires de France, 1951, pp. 1-13.

407. VILLARD (F.), *Fragments d'une amphore d'Euphronios au Musée du Louvre*, in *Mon. Piot*, XLVII, Paris, Presses universitaires de France, 1953, pp. 35-46.

408. VERMEULE (E.), *Fragments of a Symposion by Euphronios*, in *Antike Kunst*, VIII, 1965, pp. 34-39.

409. HOPPIN (C), *Euthymides and his Fellows*, Cambridge (Mass.), Harvard University Press, 1917.

410. GREIFENHAGEN (A.), *Smikros. Lieblingsinschrift und Malersignatur*, in *Jahrbuch der Berliner Museen*, IX, 1967, pp. 5-25.

411. BEAZLEY (J.D.), *Der Kleophrades Maler*, Berlin, H. Keller, 1933.

412. BEAZLEY (J.D.), *A Hydria by the Kleophrades Painter*, in *Antike Kunst*, I, 1958, pp. 5-8.

413. BEAZLEY (J.D.), *Der Berliner Maler*, Berlin, H. Keller, 1930.

414. BEAZLEY (J.D.), *An Amphora by the Berlin Painter*, in *Antike Kunst*, II, 1961, p. 49-67.

415. BEAZLEY (J.D.), *The Berlin Painter*, London, Cambridge University Press, 1964.

416. CAMBITOGLOU (A.), *The Brygos Painter*, Sydney, University Press, 1968.

417. POTTIER (E.), *Douris et les peintres de vases grecs*, Paris, H. Laurens, reprinted 1923.

418. WEGNER (M.), *Duris. Ein künstlermonographischer Versuch*, Münster, Westfälischen Wilhelms—Universität, 1968.

INDEX TO THE BIBLIOGRAPHY

BIBLIOGRAPHY

KUNZE, 237-241, 243, 253, 351.
KURUNIOTIS, 233.
LA COSTE-MESSELIÈRE, 46, 116, 126, 127, 200, 222, 223, 225-227, 230.
LAMB, 278, 329.
LANE, 299, 342.
LANGLOTZ, 174, 198, 262, 273, 308, 395.
LAPALUS, 8, 186.
LAUBSCHER, 260.
LAUNEY, 101, 219.
LAWRENCE, 16.
LEHMANN-HARTLEBEN, 102.
LE ROY, 55.
LETHABY, 75.
LEVIN, 182.
LIPPOLD, 172.
LOEWY, 77.
MARCADÉ, 212.
MARCONI, 154, 155.
MARINATOS, 88.
MARTIENSSEN, 26.
MARTIN, 13, 15, 29, 32, 42.
MARWITZ, 400.
MATZ, 173.
MENDEL, 265.
METZGER, 84, 270.
MILNE, 365.
MINTO, 385.
MÖBIUS, 268.
MOLLARD-BESQUES, 286.
MÜLLER (K.), 137.
MÜLLER (V.), 175.
NAUMANN, 59.
NEUGEBAUER, 282.
NICHOLLS, 72.
NIEMEYER, 204.
NOACK, 111.
NOBLE, 363, 364.
NYLANDER, 45.
Olympia, 149.
ORLANDINI, 156.
ORLANDOS, 17, 316.
ORSI, 153, 271.
OVERBECK, 167.
PALLOTTINO, 318.
PARIBENI, 276.

PAYNE, 129, 197, 244, 247, 314, 325, 333, 335.
PERNICE, 315.
PERNIER, 86, 87, 166.
PERROT, 1.
PERSSON, 135.
PETRIE, 164.
PFUHL, 297.
PHILIPPSON, 12.
PICARD, 167, 218, 220, 222, 223.
PLAOUTINE, 354.
PLASSART, 93.
PLOMMER, 104.
POTTIER, 417.
POUILLOUX, 120.
POULSEN, 189.
PRICE, 328.
PRITCHETT, 30.
PRYCE, 192.
PUCHSTEIN, 150.
RAUBITSCHEK, 205, 210, 211.
REGLING, 295.
REICHHOLD, 307.
REINACH, 309.
REUTERSWÄRD, 191.
REUTHER, 99.
RHOMAIOS, 54, 242.
RICHTER, 171, 181, 183, 194, 209, 245, 281, 362, 365, 386, 396, 399.
RIDDER, 280.
RIDGWAY, 231, 232.
RIEMANN, 37, 38, 44, 108, 131, 147.
ROBERT, 258, 263.
ROBERTSON (D.S.), 19.
ROBERTSON (M.), 302, 334.
RODENWALDT, 130, 242.
ROLLEY, 253, 284, 344.
ROUX, 141.
RUMPF, 300, 319, 345, 387.
SALVIAT, 310.
SANTANGELO, 356.
SARTIAUX, 68, 264.
SAVIGNONI, 90.
SCHAUENBURG, 390.
SCHEDE, 193.
SCHEFOLD, 69, 199, 320.

SCHEILBER, 379.
SCHIERING, 321.
SCHKORPIL, 293.
SCHLEIF, 242.
SCHRADER, 198.
SCHUCHHARDT, 107, 198.
SCRANTON, 9, 27.
SCULLY, 22.
SEARLS, 148.
SHEFTON, 343.
SHOE, 47, 48.
SMITH, 346, 393.
SOTIRIADIS, 113, 312.
STUCCHI, 165.
TECHNAU, 184, 392.
THALLON HILL, 103.
THIERSCH, 112, 248.
TOD, 251.
TRELL, 78.
TRENDALL, 404.
TREU, 236.
URE (A.D.), 340, 341.
URE (P.N.), 339, 341.
VALLET, 347, 370.
VALLOIS, 92.
VAN BUREN, 51, 52.
VANDERPOOL, 203, 289.
VAN EFFENTERRE, 89.
VIERNEISEL, 256.
VILLARD, 272, 301, 311, 352, 367, 406, 407.
VOLLGRAFF, 140.
WACE, 136, 251.
WALDSTEIN, 138.
WEGNER, 418.
WEICKERT, 4, 49.
WEILL, 310.
WEINBERG, 133, 246.
WELTER, 109, 249, 250.
WIEGAND, 81, 105, 267.
WREDE, 6.
WURZ, 34.
WYCHERLEY, 23.
YAVIS, 10.
YOUNG, 63.
ZANCANI MONTUORO, 163, 275.
ZANOTTI-BIANCO, 163, 275.

List of Illustrations

The reference numbers given in parentheses refer to other entries in the List of Illustrations and to the corresponding plates.

In the entries concerning vase painting the inventory number follows the name of the museum.

All dates are B.C.

399

71. Attic Art. **SPATA (Attica). LYDOS.** *Fragment of a black-figure plaque: mourners singing a dirge.* About 560-550. Formerly Vlasto Collection, Athens. Terra-cotta. Height 13 3/4 in. (After J. D. Beazley, *The Development of Attic Black-Figure,* Berkeley, University of California Press, 1964, pl. 19.)

 (J.D. Beazley, ABV, p. 113, no. 84.)

72. Attic Art. **ATHENS.** Signed by NEARCHOS as painter and potter. *Fragment of a black-figure kantharos: Achilles with his team of horses.* About 560-550. National Museum, Athens (Acropolis 611). Terra-cotta. Height of fragment 5 7/8 in. (Arts of Mankind Photo.)

 (J.D. Beazley, ABV, p. 82, no. 1.)

73. Attic Art. **VULCI (Etruria). LYDOS.** *Black-figure amphora, detail: the fall of Troy; Menelaus and Helen; slaying of Astyanax and Priam.* About 550. Staatliche Museen, Berlin (1685). Terra-cotta. Height of vase 18 1/8 in. (After E. Gerhard, *Etruskische und kampanische Vasenbilder des königlichen Museums zu Berlin,* Berlin, Verlag von G. Reiner, 1843, pl. 21.)

 (J.D. Beazley, ABV, p. 109, no. 24.) On the other side: Achilles and Troilus.

74. Boeotian Art. **THEBES.** *Cup in the Subgeometric style.* Mid-6th century. Staatliche Antikensammlungen, Munich (2238). Terra-cotta. Height 8 1/4 in. (Museum Photo.)

75. Boeotian Art. **BOEOTIA.** *Black-figure kantharos with one handle in the form of a boar's snout.* Second quarter or middle of 6th century. Louvre, Paris (CA 577). Terra-cotta. Height 6 3/4 in. (Arts of Mankind Photo.)

76. Corinthian Art. **CAERE (Etruria).** *Black-figure column krater in the late Corinthian style, detail: departure of Amphiaraus.* About 570-560. Formerly Staatliche Museen, Berlin (1655). Terra-cotta. Height 18 1/8 in. (Photo Staatliche Museen, Berlin.)

 On the other side: chariot race in honour of Peleus.

77. Corinthian Art. **CAERE (Etruria). THREE MAIDENS PAINTER.** *Black-figure column krater in the late Corinthian style: wedding procession.* About 560. Museo Etrusco Gregoriano, Vatican City (126). Terra-cotta. Height 16 3/4 in. (Hirmer Fotoarchiv, Munich.)

 On the other side: horsemen.

78. Corinthian Art. **CAERE (Etruria). TYDEUS PAINTER.** *Black-figure amphora in the late Corinthian style: Tydeus slaying Ismene before Thebes.* About 560-550. Louvre, Paris (E 640). Terra-cotta. Height 12 1/2 in. (Arts of Mankind Photo.)

 On the other side: chariot in front view.

79. Corinthian Art. **CAERE (Etruria). DAMOS PAINTER.** *Black-figure hydria in the late Corinthian style, detail: nereids mourning over the body of Achilles.* About 550. Louvre, Paris (E 643). Terra-cotta. Height of vase 17 3/4 in., height of picture 5 1/2 in. (Arts of Mankind Photo.)

80. Corinthian Art. **CORINTH.** *Black-figure plaque: (extracting clay from pit.)* About 580-570. Staatliche Museen, Berlin (F 871). Terra-cotta. Height 4 in. (Museum Photo.)

81. Laconian Art. **TARQUINIA (Etruria). HUNT PAINTER.** *Black-figure cup: returning warriors.* About 550-540. Staatliche Museen, Berlin (3404). Terra-cotta. Diameter 5 7/8 in. (Museum Photo - Jutta Tietz-Glagow.)

82. Laconian Art. **ETRURIA.** *Black-figure cup: Achilles behind the fountain lying in ambush for Troilus.* About 560-550. Louvre, Paris (E 669). Terra-cotta. Diameter 7 1/4 in. (Arts of Mankind Photo.)

 Because of the absence of Troilus, who should appear on horseback to the left of the fountain, this scene was long misinterpreted as representing Cadmus fighting the dragon.

83. Laconian Art. **VULCI (Etruria). ARCESILAS PAINTER.** *Black-figure cup. (Cf. 84, cup tondo.)* About 560. Cabinet des Médailles, Bibliothèque Nationale, Paris (4899). Terra-cotta. Height 7 7/8 in., diameter with handles 15 in. (Arts of Mankind Photo.)

84. Laconian Art. **VULCI (Etruria). ARCESILAS PAINTER.** *Black-figure cup: King Arcesilas II watching his workmen carrying and weighing bales of silphium, among birds, a monkey, a lizard, and a feline. (Cf. 83, outside of cup.)* Cabinet des Médailles, Bibliothèque Nationale, Paris (4899). (Arts of Mankind Photo.)

 It used to be assumed that this scene is set on board a ship embarking cargo. But according to François Chamoux (Cyrène sous la monarchie des Battiades, 1953, pp. 258-263), the absence of masts indicates rather that King Arcesilas is seated on land, under an awning to protect him from the sun, supervising his workmen as they weigh and store away some commodity that can hardly be anything else but silphium (cotton has also been suggested, but for no valid reason).

85. Laconian Art. **CAERE (Etruria). ARCESILAS PAINTER.** *Black-figure cup: punishments of Atlas and Prometheus.* About 550. Museo Etrusco Gregoriano, Vatican City (1298). Terra-cotta. Diameter 8 in. (Photo De Antonis, Rome.)

 According to another interpretation, the scene may represent the punishments of Sisyphus and Tityus in Hades. Both subject and style suffer from a lack of precision.

86. Chalcidian Art of South Italy. **VULCI (Etruria). INSCRIPTION PAINTER.** *Black-figure amphora, detail of the main frieze: Heracles fighting Geryon. (Cf. 87, another detail.)* About 540. Cabinet des Médailles, Bibliothèque Nationale, Paris (202). Terra-cotta. Height of the vase 16 1/8 in., height of frieze 6 1/4 in. (Arts of Mankind Photo.)

 On the shoulder: horsemen.

87. Chalcidian Art of South Italy. **VULCI (Etruria). INSCRIPTION PAINTER.** *Black-figure amphora, detail: Geryon's cattle. (Cf. 86, another detail.)* About 540. Cabinet des Médailles, Bibliothèque Nationale, Paris (202). (Arts of Mankind Photo.)

88. Chalcidian Art of South Italy. **VULCI (Etruria). INSCRIPTION PAINTER.** *Black-figure column krater: Helen and Paris, Andromache and Hector.* About 530. Martin von Wagner Museum, Würzburg (K 160). Terra-cotta. Height 18 3/4 in. (Photo Eberhard Zwicker, Würzburg.)

 On the other side: horsemen.

89. Attic Art. **AGRIGENTUM. TALEIDES PAINTER** (signed by the potter TALEIDES). *Black-figure amphora: weighing goods.* About 540. The Metropolitan Museum of Art, New York (47.11.5). Gift of Joseph Pulitzer. Terra-cotta. Height of the vase 11 5/8 in. (Museum Photo.)

 (J. D. Beazley, ABV, p. 174, no. 1.) On the other side: Theseus and the Minotaur.

90. Chalcidian Art of South Italy. **ETRURIA. INSCRIPTION PAINTER.** *Black-figure psykter amphora, detail: Greeks and Trojans fighting.* About 540. National Gallery of Victoria, Melbourne (1643/4) Terra-cotta. Height of vase 24 1/2 in., height of picture 7 in. (National Gallery Photo.)

 On the other side: men fighting around a chariot.

91. Attic Art. **ETRURIA. AMASIS PAINTER.** *Black-figure amphora, detail: satyrs and maenads accompanying Dionysus.* About 540. Staatliche Museen, Berlin (3210). Terra-cotta. Height of vase 17 1/4 in., height of picture 5 3/4 in. (Museum Photo.)

 (J. D. Beazley, ABV, p. 151, no. 21.)

92. Attic Art. **VARI (Attica). AMA-SIS PAINTER.** *Black-figure lekythos, detail: women spinning. (Cf. 93, another detail.)* About 550. The Metropolitan Museum of Art, New York (31.11.10). Fletcher Fund, 1931. Terra-cotta. Height of the vase 6 3/4 in., height of frieze 2 in. (Museum Photo.)

(J. D. Beazley, ABV, p. 154, no. 57.)

93. Attic Art. **VARI (Attica). AMA-SIS PAINTER.** *Black-figure lekythos, detail: women weaving. (Cf. 92, another detail.)* About 550. The Metropolitan Museum of Art, New York (31.11.10). Fletcher Fund, 1931. (Museum Photo.)

94. Attic Art. **GREECE. AMASIS PAINTER.** *Black-figure lekythos, detail: wedding procession. (Cf. 95, another detail.)* About 550. The Metropolitan Museum of Art, New York (56.11.1). Gift of Walter C. Baker, 1956. Terra-cotta. Height of vase 6 3/4 in., height of frieze 2 in. (Museum Photo.)

95. Attic Art. **GREECE. AMASIS PAINTER.** *Black-figure lekythos, detail: wedding procession. (Cf. 94, another detail.)* About 550. The Metropolitan Museum of Art, New York (56.11.1). Gift of Walter C. Baker, 1956. (Museum Photo.)

96. Attic Art. **VULCI (Etruria). AMA-SIS PAINTER.** *Black-figure cup, detail: balancing tricks in a riding school.* About 530. Private Collection, New York. Terra-cotta. Height of vase 4 1/8 in., height of frieze 2 3/8 in. (Photo Dietrich Widmer, Basel.)

97. Attic Art. **VULCI (Etruria). AMA-SIS PAINTER** (signed by the potter AMASIS). *Black-figure amphora, detail: Dionysus and two maenads.* About 540-530. Cabinet des Médailles, Bibliothèque Nationale, Paris (222). Terra-cotta. Height of vase 13 in., height of picture 6 1/2 in. (Arts of Mankind Photo.)

(J. D. Beazley, ABV, p. 152, no. 25.) On the other side: Athena and Poseidon.

98. Attic Art. **VULCI (Etruria). PHRY-NOS PAINTER.** *Black-figure cup, detail: Ajax carrying the body of Achilles.* About 540. Museo Etrusco Gregoriano, Vatican City (317). Terra-cotta. Height of cup 5 1/2 in., diameter of tondo with border, 4 3/8 in. (Photo De Antonis, Rome.)

(J. D. Beazley, ABV, p. 169, no. 4.)

99. Attic Art. **VULCI (Etruria). PHRY-NOS PAINTER** (signed by the potter PHRYNOS). *Black-figure cup, detail: introduction of Heracles into Olympus.* About 540-530. British Museum, London (B 424). Terra-cotta. Height of cup 7 7/8 in., height of subject 1 5/8 in. (Arts of Mankind Photo.)

(J. D. Beazley, ABV, p. 168.) On the other side: birth of Athena.

100. Attic Art. **VULCI (Etruria).** Signed by the potter TLESON. *Black-figure cup, detail: hunter with hound and game.* About 550-540. British Museum, London (B 421). Terra-cotta. Height of cup 5 1/4 in., diameter of tondo with border 3 in. (Arts of Mankind Photo.)

(J. D. Beazley, ABV, p. 181, no. 1.)

101. Euboean Art. **ERETRIA.** *Black-figure loutrophoros. On the neck: judgment of Paris. On the body: wedding procession.* Mid-6th century. National Museum, Athens (1004). Terra-cotta. Height of vase 34 5/8 in. (Arts of Mankind Photo.)

102. Ionian Art. **CLAZOMENAE.** (Asia Minor.) *Fragment of a black-figure hydria: herald approaching an enthroned couple (Priam and Hecuba receiving the news of Troilus' death?).* About 540. National Museum, Athens (5610). Terra-cotta. Height of scene 3 1/8 in. (Arts of Mankind Photo.)

103. Ionian Art of Italy. **CAERE (Etruria). RIBBON PAINTER.** *Black-figure hydria, detail of the shoulder: sacrifice to Dionysus.* About 530-520. Museo Nazionale di Villa Giulia, Rome. Terra-cotta. Height of vase 17 1/2 in. (Photo De Antonis, Rome.)

On the body: apotheosis of Heracles.

104. Ionian Art. **ETRURIA.** *Black-figure cup: bird-nester between two trees.* Mid-6th century. Louvre, Paris (F 68). Terra-cotta. Height 5 7/8 in., diameter 9 1/4 in. (Arts of Mankind Photo.)

105. Ionian Art of Italy. **CAERE (Etruria). PAINTER OF THE CAERE-TAN HYDRIAI.** *Black-figure hydria. (Cf. 106, detail.)* About 530. Louvre, Paris (E 701). Terra-cotta. Height of vase 17 in. (Arts of Mankind Photo.)

106. Ionian Art of Italy. **CAERE (Etruria). PAINTER OF THE CAERE-TAN HYDRIAI.** *Black-figure hydria, detail: Heracles bringing Cerberus to Eurystheus. (Cf. 105, whole vase.)* About 530. Louvre, Paris. (Arts of Mankind Photo.)

107. Ionian Art of Italy. **CAERE (Etruria). PAINTER OF THE CAERE-TAN HYDRIAI.** *Black-figure hydria, detail: Heracles slaying Busiris.* About 540. Kunsthistorisches Museum, Vienna (3576). Terra-cotta. Height of vase 17 3/4 in., height of scene 6 1/8 in. (Museum Photo.)

108. Etruscan Art. **ETRURIA. PARIS PAINTER.** *Black-figure 'Pontic' amphora, detail: women banqueting.* About 540. The Metropolitan Museum of Art, New York (55.7). Gift of N. Koutoulakis, 1955. Terra-cotta. Height of vase 13 7/8 in., height of frieze 3 1/8 in. (Museum Photo.)

On the other side: Centaur and herald.

109. Attic Art. **VULCI (Etruria). PAINTER OF THE VATICAN MOUR-NER.** *Black-figure amphora, detail: Eos beside the body of Memnon (?).* About 540-530. Museo Etrusco Gregoriano, Vatican City (350). Terra-cotta. Height of vase 17 3/8 in., height of scene 8 1/2 in. (Photo De Antonis, Rome.)

(J. D. Beazley, ABV, p. 140, no. 1.) On the other side: recovery of Helen.

110. Attic Art. **VULCI (Etruria).** Signed by EXEKIAS as painter and potter. *Black-figure amphora, detail: Achilles and Ajax playing draughts. (Cf. 111, another detail.)* About 540. Museo Etrusco Gregoriano, Vatican City (344). Terra-cotta. Height of vase 24 in., height of picture 10 1/4 in. (Hirmer Fotoarchiv, Munich.)

(J. D. Beazley, ABV, p. 145, no. 13.)

111. Attic Art. **VULCI (Etruria).** Signed by EXEKIAS as painter and potter. *Black-figure amphora, detail: return of the Dioscuri. (Cf. 110, another detail.)* About 540. Museo Etrusco Gregoriano, Vatican City (344). (Photo Alinari.)

112. Attic Art. **ETRURIA (?). EXE-KIAS.** *Black-figure amphora, detail: Ajax preparing for his suicide.* About 540. Musée Municipal, Boulogne-sur-Mer (558). Terra-cotta. Height of vase 21 1/4 in. (Photo Henri Devos, Boulogne.)

(J. D. Beazley, ABV, p. 145, no. 18.) On the other side: young men in a chariot.

113. Attic Art. **VULCI (Etruria). EXE-KIAS** (signed by EXEKIAS as potter). *Black-figure amphora: Achilles slaying Penthesilea.* About 530-525. British Museum, London (B 210). Terra-cotta. Height of vase 16 1/4 in. (Museum Photo.)

(J. D. Beazley, ABV, p. 144, no. 7.) On the other side: Dionysus and Oenopion.

114. Attic Art. **ATHENS. EXEKIAS.** *Fragment of a black-figure plaque: funeral procession.* About 530. Staatliche Museen, Berlin (1811-26). Terra-cotta. Height of fragment 8 1/2 in. (Museum Photo—Jutta Tietz-Glasgow.)

(J. D. Beazley, ABV, p. 146, nos. 22-23.)

115. Attic Art. **ATHENS. EXEKIAS.** *Fragment of a black-figure plaque: funeral scene (dead man borne in a chariot drawn by two mules).* About 530. Staatliche Museen, Berlin (1811-26). Terra-cotta. Height of plaque 14 1/2 in. (Museum Photo—Isolde Luckert.)

(J. D. Beazley, ABV, p. 146, nos. 22-23.)

403

247. **POSEIDONIA (Paestum).** *Temple of Athena.* About 500. In situ. Limestone. (Arts of Mankind Photo.)

Hexastyle peripteral temple (6 × 13 columns, 47 ft. 8 in. × 107 ft. 10 in. on the stylobate). External Doric colonnade. Cella with prostyle porch comprising six Ionic columns (4 on the façade and 2 behind, in front on the antae).

248. **POSEIDONIA (Paestum), Temple of Athena, pronaos.** *Ionic capital.* About 500. Paestum Museum. Limestone. Height 29 1/2 in., abacus 45 1/4 in. × 26 1/8 in. (Arts of Mankind Photo.)

249. **POSEIDONIA (Paestum), Silaris Heraion, Temple of Hera.** *Carved mouldings of Ionic type.* About 500. Paestum Museum. Limestone. Height 12 5/8 in. (Arts of Mankind Photo.)

Ornamental course with egg-and-dart and leaf-and-dart mouldings.

250. **POSEIDONIA (Paestum), Silaris Heraion, Temple of Hera.** *Restored entablature.* About 500. (After P. Zancani Montuoro and U. Zanotti-Bianco, *Heraion alla foce del Sele.* I: *Il santuario. Il tempio della dea. Rilievi figurati varii,* Rome, Libreria dello Stato, 1951, pl. XXXVII.)

Unusual here is the absence of a projecting corona. Note the decorative mouldings above and below the frieze.

251. **SELINUS, Marinella Hill, Temple G or Apollonion.** *Ruins. (Cf. 422.)* Late 6th and early 5th century. In situ. Limestone. (Arts of Mankind Photo.)

252. **DELPHI (Marmarja), Temple of Athena.** *Column, detail.* About 500. In situ. Tufa. (Arts of Mankind Photo.)

253. **AEGINA, Temple of Aphaia.** *Overall view.* 500-490. In situ. Limestone. (Arts of Mankind Photo.)

Hexastyle peripteral temple (6 × 12 columns, 45 ft. × 94 1/2 ft. on the stylobate). Recently restored.

254. **AEGINA, Temple of Aphaia.** *Interior of the naos.* 500-490. In situ. Limestone. (Arts of Mankind Photo.)

The naos has two rows of Doric columns in two tiers.

255. **AEGINA, Temple of Aphaia.** *Long south side, after recent restorations. (Cf. 435.)* 500-490. In situ. Limestone. (Arts of Mankind Photo.)

256. **AEGINA, Temple of Aphaia.** *Restored sectional view.* 500-490. (After Ernst R. Fiechter, *Der Tempel der Aphaia auf Ägina,* Munich, 1905, pl. IV.)

257. **AEGINA, Temple of Aphaia.** *Restored cutaway view. (Cf. 435.)* 500-490. (After A. Furtwängler, *Ägina: das Heiligtum der Aphaia,* Munich, 1906.)

258. **AEGINA, Temple of Aphaia.** *Wall of the naos, detail.* 500-490. In situ. Limestone. (Arts of Mankind Photo.)

259. **AEGINA, Temple of Aphaia.** *Southwest corner.* 500-490. In situ. Limestone. (Arts of Mankind Photo.)

260. **AEGINA, Temple of Aphaia.** *Front, after restoration.* 500-490. In situ. Limestone. (Arts of Mankind Photo.)

261. **AEGINA, Temple of Aphaia.** *Capital, detail.* 500-490. In situ. Limestone. (Arts of Mankind Photo.)

262. **AEGINA, Temple of Aphaia,** *Entablature, detail. (Cf. 434.)* 500-490. In situ. Limestone. (Arts of Mankind Photo.)

263. **AEGINA, Temple of Aphaia, west side.** *Foundations and krepis, detail.* 500-490. In situ. (Arts of Mankind Photo.)

264. **DELPHI, Sanctuary of Apollo, Athenian Treasury.** *Façade.* 490-480. In situ. Parian marble. (Arts of Mankind Photo.)

Distyle in antis, 21 ft. 9 in × 31 ft. 9 in.

265. **DELPHI, Sanctuary of Apollo.** *The Sacred Way descending towards the Athenian Treasury.* 490-480. In situ. (Arts of Mankind Photo.)

266. **DELPHI, Sanctuary of Apollo.** *View of the sanctuary from above the theatre.* In situ. (Arts of Mankind Photo.)

267. **DELPHI, Sanctuary of Apollo, Athenian Treasury.** *Capitals and entablature, detail.* 490-480. In situ. Marble. (Arts of Mankind Photo.)

268. **DELPHI, Sanctuary of Apollo.** *Polygonal wall of the terrace of the Alcmaeonid Temple of Apollo.* Last quarter of the 6th century. In situ. Limestone. (Arts of Mankind Photo.)

Fine example of polygonal masonry with curving joints.

269. **DELPHI, Sanctuary of Apollo.** *Southeast corner of the polygonal wall on the Sacred Way.* Last quarter of the 6th century. In situ. Limestone. (Arts of Mankind Photo.)

270. **DELPHI, Sanctuary of Apollo.** *Detail of the polygonal wall with manumission records engraved subsequently on the stones.* Last quarter of the 6th century. In situ. Limestone. (Arts of Mankind Photo.)

271. Attic Art. **VULCI (Etruria). A. D. PAINTER.** *Black-figure hydria, detail: women drawing water at a fountain. (Cf. 349.)* About 510. British Museum, London (B 329). Terra-cotta. Height of vase 22 7/8 in. (Arts of Mankind Photo.)

272. Ionian Art. **ATHENS, Acropolis.** *Kore 682, detail.* 520-510. Acropolis Museum, Athens. Marble. Overall height 71 7/8 in. (Arts of Mankind Photo.)

273. Attic Art. **ATHENS, Acropolis.** *Kore 671. (Cf. 271.)* About 520. Acropolis Museum, Athens. Marble. Height 65 3/4 in. (Arts of Mankind Photo.)

274. Attic Art. **ATHENS, Acropolis.** *Kore 671, detail. (Cf. 273.)* About 520. Acropolis Museum, Athens. (Arts of Mankind Photo.)

275. Attic Art. **ATHENS, Acropolis. ANTENOR.** *Kore 681.* About 520. Acropolis Museum, Athens. Marble. Height with plinth 100 1/2 in. (Arts of Mankind Photo.)

The inlaid eyes suggest that Antenor also worked in bronze (E. Langlotz), which he may have used for the Tyrannicides. The face was mutilated after the murder of Hipparchus (c. 514).

276. Attic Art. **ATHENS, Acropolis, Hecatompedon (Pisistratid Temple of Athena).** *East pediment: Athena attacking a giant, detail.* About 520. Acropolis Museum, Athens. Marble. Overall height 78 1/2 in. (Photo Deutsches Archäologisches Institut, Athens.)

277. Attic Art. **ATHENS, Acropolis, Hecatompedon (Pisistratid Temple of Athena).** *East pediment: a giant.* About 520. Acropolis Museum, Athens. Marble. (Photo Deutsches Archäologisches Institut, Athens.)

278. Attic Art. **DELPHI, Archaic Temple of Apollo.** *East pediment: large kore.* 520-510. Delphi Museum. Marble. Height 45 3/4 in. (Arts of Mankind Photo.)

279. Attic Art. **DELPHI, Archaic Temple of Apollo.** *Acroterium figure: Nike.* 520-510. Delphi Museum. Marble. Height 44 1/2 in. (Arts of Mankind Photo.)

280. Attic Art. **ATHENS, Acropolis.** *Nude male torso 145.* About 510. Acropolis Museum, Athens. Marble. Height 24 3/4 in. (Arts of Mankind Photo.)

Fragment of a group representing Theseus with one of his antagonists.

281. **ERETRIA (Euboea), Temple of Apollo Daphnephoros.** *West pediment: Theseus and Antiope.* 510. Chalcis Museum. Marble. Height 43 1/4 in. (Photo Deutsches Archäologisches Institut, Athens.)

Athena stood in the centre of the group on the west pediment. The torso of an Amazon in the Museo dei Conservatori, Rome, also formed part of this pediment.

282. Peloponnesian Art. **ATHENS, Acropolis.** *Kore 594.* About 500. Acropolis Museum, Athens. Marble. Height 48 1/2 in. (Arts of Mankind Photo.)

283. Attic Art. **ATHENS, Acropolis.** *Kore 670. (Cf. 284.)* About 520. Acropolis Museum, Athens. Marble. Height 45 1/4 in. (Arts of Mankind Photo.)

284. Attic Art. **ATHENS, Acropolis.** *Kore 670, detail. (Cf. 283.)* About 520. Acropolis Museum, Athens. (Arts of Mankind Photo.)

285. Ionian Art of the Islands. **ATHENS, Acropolis.** *Kore 675.* About 520-510. Acropolis Museum, Athens. Marble. Height 21 7/8 in. (Arts of Mankind Photo.)

286. Attic Art. **ATHENS, Acropolis.** *Head of Kore 643, front view. (Cf. 287.)* 520-510. Acropolis Museum, Athens. Marble. Height 6 1/4 in. (Arts of Mankind Photo.)

287. Attic Art. **ATHENS, Acropolis.** *Head of kore 643, side view. (Cf. 286.)* 520-510. Acropolis Museum, Athens. (Arts of Mankind Photo.)

288. Attic Art. **ATHENS, Acropolis.** *Clad figure of a young man 633.* 510-500. Acropolis Museum, Athens. Marble. Height 47 5/8 in. (Arts of Mankind Photo.)

289. Attic Art. **ATHENS, Acropolis.** *Kore 685, three-quarter view.* 510-500. Acropolis Museum, Athens. Marble. Height 49 1/4 in. (Arts of Mankind Photo.)

290. East Ionian Art. *Draped statue of Dionysermos.* About 530. Louvre, Paris. Marble. Height 66 in. (Arts of Mankind Photo.)

291. Attic Art. **ATHENS, Acropolis.** *Bearded head of Hermes 642.* 510. Acropolis Museum, Athens. Marble. Height 4 in. (Arts of Mankind Photo.)

292. Attic Art. **ATHENS (?).** *Fragment of a statue: Athenian horseman in Scythian costume.* 520. Acropolis Museum, Athens. Marble. Height 42 1/2 in. (Arts of Mankind Photo.)

293. Attic Art. **ATHENS, Acropolis.** *Led horse 697.* 520-510. Acropolis Museum, Athens. Marble. Height 44 1/2 in. (Arts of Mankind Photo.)

294. Ionian Art. **ATHENS, Acropolis.** *Torso of a horseman 623.* About 510. Acropolis Museum, Athens. Marble. Height 7 7/8 in. (Arts of Mankind Photo.)

This statue formed part of a group similar to that to which the Rampin Horseman belonged.

295. Thasian Art. **THASOS, Heracleion.** *Forehand of a winged horse: Pegasus* About 515-510. Thasos Museum. Marble. Height of the block 47 3/8 in. (Photo École Française, Athens.)

296. Attic Art. **ATHENS, Acropolis.** *Dog No. 143.* 520-510. Acropolis Museum, Athens. Marble. Length 49 1/4 in. (Arts of Mankind Photo.)

297. Art of Magna Graecia. **CENTURIPE.** *Arula: lion attacking a bull.* Last quarter of the 6th century. Museo Archeologico Nazionale, Syracuse. Terra-cotta. Height 8 in. (Arts of Mankind Photo.)

298. Ionian Art. **MILETUS.** *Recumbent lion.* Last quarter of the 6th century. Staatliche Museen, Berlin. Marble. Height 27 in., length of the base 67 in., width of the base 27 in. (Museum Photo.)

299. Attic Art. **ATHENS, Acropolis.** *Relief 1342: goddess (rather than god) stepping into a chariot.* 510-500. Acropolis Museum, Athens. Marble. Height 47 1/2 in. (Arts of Mankind Photo.)

300. Attic Art. **VELANIDEZA (Attica).** ARISTOCLES. *Gravestone of Aristion.* After 510. National Museum, Athens. Marble. Overall height without base 94 1/2 in. (Arts of Mankind Photo.)

301. Attic Art. **ATHENS, found near the Hephaisteion.** *Hoplitodromos Stele.* 520-510. National Museum, Athens. Marble. Height 40 1/4 in. (Arts of Mankind Photo.)

302. Attic Art. **ATHENS, Themistoclean Wall.** *Statue base: ball game.* About 510. National Museum, Athens. Marble. Height 12 1/2 in., length 32 in. (Arts of Mankind Photo.)

303. Attic Art. **ATHENS, Themistoclean Wall.** *Statue base: dog and cat fight.* About 510. National Museum, Athens. Marble. Height 12 1/2 in., length 32 in. (Arts of Mankind Photo.)

304. Attic Art. **ATHENS, Themistoclean Wall.** *Statue base: hockey game.* About 500. National Museum, Athens. Marble. Height 10 7/8 in. (Arts of Mankind Photo.)

305. Attic Art. **ATHENS, Acropolis.** *Relief 702: Hermes, the Cecropides, and the boy Erichthonius (?).* 510-500. Acropolis Museum, Athens. Marble. Height 15 1/2 in. (Arts of Mankind Photo.)

306. Art of Magna Graecia. **POSEIDONIA (Paestum), Silaris Heraion.** *Metope: two girls running or dancing* 510-505. Paestum Museum. Sandstone. Height c. 33 1/2 in., width 28 1/4 in. (Arts of Mankind Photo.)

307. Art of Magna Graecia. **SELINUS, Sanctuary of Demeter Malophoros.** *Relief: religious dance.* About 510. Museo Nazionale, Palermo. Yellowish tufa. Height 20 in., width 16 in. (Arts of Mankind Photo.)

308. Art of Magna Graecia. **SELINUS, Temple F.** *Metope, detail: head of a dying giant.* About 500. Museo Nazionale, Palermo. Calcareous tufa. Height 32 1/4 in., width 50 in. (Arts of Mankind Photo.)

309. Ionian (?) Art. **Island of ANAPHE (?).** *Kouros known as the Strangford Apollo.* About 500-490. British Museum, London. Marble. Height 39 3/4 in. (Museum Photo.)

310. Attic Art. **ATTICA.** *Statue of Aristodikos, front view. (Cf. 311.)* About 500. National Museum, Athens. Marble. Height 76 3/4 in. (Arts of Mankind Photo.)

311. Attic Art. **ATTICA.** *Statue of Aristodikos, three-quarter view. (Cf. 310.)* About 500. National Museum, Athens. (Arts of Mankind Photo.)

312. Dorian Art of Sicily. **AGRIGENTUM.** *Kouros, back view.* About 500-490. Museo Archeologico, Agrigento. Marble. Height 41 in. (Museum Photo.)

313. Attic Art. **ATHENS, Acropolis.** *Kore 674. (Cf. 315.)* About 500. Acropolis Museum, Athens. Marble. Height 36 1/4 in. (Arts of Mankind Photo.)

314. Attic Art. **ATHENS, Acropolis.** *Head of Kore 696.* About 500. Acropolis Museum, Athens. Marble. Height 10 5/8 in. (Arts of Mankind Photo.)

315. Attic Art. **ATHENS, Acropolis.** *Kore 674, detail. (Cf. 313.)* About 500. Acropolis Museum, Athens. (Arts of Mankind Photo.)

316. Peloponnesian Art. **ATHENS, Acropolis.** *Kore 684.* 500-490. Acropolis Museum, Athens. Marble. Height 46 7/8 in. (Fototecnica, Athens.)

317. Attic Art. **ATHENS, Acropolis.** *Kore 686.* About 490. Acropolis Museum, Athens. Marble. Height 22 3/4 in. (Arts of Mankind Photo.)

318. Attic Art. **ATHENS, Acropolis.** *The Blond Boy 689.* About 480. Acropolis Museum, Athens. Marble. Height 9 5/8 in. (Arts of Mankind Photo.)

319. Corinthian Art. **OLYMPIA.** *Head of Athena.* 490-480. Olympia Museum. Terra-cotta. Height 8 7/8 in. (Arts of Mankind Photo.)

The goddess, wearing the Attic helmet, formed part of a free-standing action group; she may have been watching the fight between Heracles and the three-bodied Geryon.

320. Corinthian or Sicyonian Art. **ALBANIA.** *Priestess of Dodona (?).* 510-500. Louvre, Paris. Bronze. Height 11 in. (Arts of Mankind Photo.)

321. Aeginetan Art. **OLYMPIA.** *Head of Zeus No. 6440.* About 490. National Museum, Athens. Bronze. Height 6 5/8 in. (Arts of Mankind Photo.)

322. Attic Art. **ATHENS.** *Athlete carrying dumbbells.* About 510. National Museum, Athens. Bronze. Height 10 5/8 in. (Arts of Mankind Photo.)

350. Attic Art. **MONTE ABETONE (Etruria), Tomb 610.** PRIAM PAINTER. *Black-figure amphora, detail: women bathing. (Cf. 351.)* About 515. Museo Nazionale di Villa Giulia, Rome. Terra-cotta. Height of vase 15 3/4 in. (Photo De Antonis, Rome.)

On the other side: Dionysus and satyrs gathering grapes in a vine arbour.

351. Attic Art. **MONTE ABETONE (Etruria), Tomb 610.** PRIAM PAINTER. *Black-figure amphora: women bathing, detail. (Cf. 350.)* About 515. Museo Nazionale di Villa Giulia, Rome. Terra-cotta. Height of the picture 5 3/4 in. (Photo De Antonis, Rome.)

352. Attic Art. **ETRURIA.** NIKOSTHENES PAINTER. Signed by the potter NIKOSTHENES. *Black-figure cup, detail: ships.* About 520-510. Louvre, Paris (F 123). Terra-cotta. Height of vase 4 3/8 in., height of band 3 1/4 in. (Arts of Mankind Photo.)

(J. D. Beazley, ABV. p. 231, no. 8.)

353. Attic Art. **PAINTER OF LONDON B 620,** of the Nikosthenes workshop. *Black-figure, white-ground oinochoe: cow suckling her calf.* About 520-510. Hirsch Collection, Cabinet des Médailles, Bibliothèque Royale, Brussels (5). Terra-cotta. Height 11 1/4 in. (Photo Paul Bijtebier, Brussels.)

(J. D. Beazley, ABV, p. 434, no. 4.)

354. Attic Art. **LOCRI (South Italy).** SAPPHO PAINTER. *Black-figure, white-ground column krater: Odysseus escaping from Polyphemus' cave by clinging to the belly of a ram.* About 510-500. Badisches Landesmuseum, Karlsruhe (B 32.) Terra-cotta. Height 13 3/8 in. (Museum Photo.)

(J. D. Beazley, ABV, p. 507, no. 57.) On the other side: Amazons.

355. Attic Art. **ATHENS, Acropolis.** Signed by the painter SKYTHES. *Black-figure plaque: Heracles and Hermes beside the chariot of Athena (?).* About 520-510. National Museum, Athens (Acropolis 2557). Terra-cotta. Height 6 1/2 in. (Arts of Mankind Photo.)

(J. D. Beazley, ABV, p. 352, no. 1.)

356. Attic Art. **ATTICA.** SAPPHO PAINTER. *Black-figure plaque: funeral scene with mourners.* About 500. Louvre, Paris (MNB 905). Terra-cotta. Height 5 3/8 in. (Arts of Mankind Photo.)

357. Corinthian Art. **PITSA (near Sicyon).** *Polychrome plaque: sacrificial scene (copy).* About 540-530. National Museum, Athens. Painted on wood. Height 5 7/8 in. (Arts of Mankind Photo.)

358. Attic Art. **ATHENS, Kerameikos Cemetery.** *Gravestone by Lyseas: Dionysus with a kantharos.* About 510-500. National Museum, Athens (30). Painted marble. Height 76 3/4 in. (After Alexander Conze, *Die attischen Grabreliefs*, I, Berlin, Verlag von W. Spemann, 1893, pl. I.)

359. Attic Art. **ATHENS, Acropolis.** *Painted plaque: running hoplite.* About 520-510. Acropolis Museum, Athens (1037). Painted terra-cotta. Height 25 3/4 in. (Arts of Mankind Photo.)

The name of Megacles, which figured originally on the plaque, was rubbed out and replaced by that of Glaukytes, possibly after the prominent family of the Alcmaeonidae (to which Megacles belonged) were exiled, either towards the end of the Pisistratid tyranny (511-510) or under the oligarchy of Isagoras, which preceded the establishment of the Athenian democracy (508-507).

360. Etruscan Art. **TARQUINIA (Etruria), Tomb of the Leopards.** *Flute player.* About 480-475. Museo Nazionale, Tarquinia. Wall painting transferred to canvas. (Arts of Mankind Photo.)

361. Attic Art. **CAERE (Etruria).** OLTOS (the vase is signed by the potter PAMPHAIOS). *Red-figure stamnos, detail: Heracles and Achelous.* About 520. British Museum, London (E 437). Terra-cotta. Height of the vase 10 7/8 in., height of the scene 4 1/2 in. (Arts of Mankind Photo.)

(J. D. Beazley, ARV, p. 54, no. 5.) On the other side: satyr and maenad.

362. Attic Art. **MONTE ABETONE (Etruria), Tomb 610.** OLTOS. *Red-figure cup, detail: Heracles and Nereus.* About 510-505. Museo Nazionale di Villa Giulia, Rome. Terra-cotta. Height of the cup 64 1/4 in. (Photo De Antonis, Rome.)

On the inside of the cup: young man holding a cock. On the other side: procession going to sacrifice.

363. Attic Art. **TARQUINIA (Etruria).** OLTOS. *Red-figure cup, detail: deities in Olympus (Zeus, Ganymede, and Hestia).* About 510. Museo Nazionale, Tarquinia (RC 6848). Terra-cotta. Height of vase 8 7/8 in., diameter 20 1/2 in. (Arts of Mankind Photo.)

(J. D. Beazley, ARV, p. 60, no. 66.) Inside: a warrior. On the other side: Dionysus mounting a chariot, with his thiasos.

364. Attic Art. **ETRURIA.** OLTOS (the vase is signed by the potter PAMPHAIOS). *Red-figure amphora, detail of the neck: nude girl tying on her sandals.* About 520-510. Louvre, Paris (G 2). Terra-cotta. Height of vase 15 1/8 in., height of detail 4 3/8 in. (Arts of Mankind Photo.)

(J. D. Beazley, ARV, p. 53, no. 2.) On the body: satyrs and maenads.

365. Attic Art. **VULCI (Etruria).** Signed by EPIKTETOS. *Red-figure cup, detail: Theseus and the Minotaur.* About 510. British Museum, London (E 37). Terra-cotta. Height 4 1/4 in., diameter 11 5/8 in. (Arts of Mankind Photo.)

(J. D. Beazley, ARV, p. 72, no. 17.) Inside: reclining banqueter. On the other side: comos.

366. Attic Art. **CAERE (Etruria).** Signed by SKYTHES. *Red-figure cup, detail of the inside: lyre player.* About 520-510. Museo Nazionale di Villa Giulia, Rome (20760). Terra-cotta. Height 3 in., diameter 7 3/4 in. (Photo De Antonis, Rome.)

(J. D. Beazley, ARV, p. 83, p. 14.) On the outside: exploits of Theseus.

367. Attic Art. **VULCI (Etruria).** Signed by EPIKTETOS. *Red-figure plate, detail of the tondo: revellers.* About 520-510. British Museum, London (E 137). Terra-cotta. Diameter 7 3/8 in. (Museum Photo.)

(J. D. Beazley, ARV, p. 78, no. 95.)

368. Attic Art. **ETRURIA.** NIKOSTHENES PAINTER (signed by the potter PAMPHAIOS). *Red-figure cup, detail: Heracles and Alcyoneus.* About 510-500. National Gallery of Victoria, Melbourne (1730/4). Terra-cotta. Height 4 7/8 in., diameter 12 7/8 in. (Photo Ritter-Jeppesen, Melbourne.)

On the inside: silenus running with a goatskin bottle. On the other side: Dionysus and his thiasos.

369. Attic Art. **CAERE (Etruria).** Signed by EUPHRONIOS. *Red-figure calyx-krater, detail: Heracles and Antaeus.* About 515. Louvre, Paris (G 103.) Terra-cotta. Height 18 1/8 in., height of picture 7 7/8 in. (Arts of Mankind Photo.)

(J. D. Beazley, ARV, p. 14, no. 2.) On the other side: musical contest.

370. Attic Art. **CAPUA (Campania).** EUPHRONIOS. *Calyx-krater: young men oiling and grooming themselves. (Cf. 371.)* About 510. Staatliche Museen, Berlin (F 2180). Terra-cotta. Height 13 3/4 in. (Museum Photo—Jutta Tietz-Glagow.)

(J. D. Beazley, ARV, p. 13, no. 1.)

371. Attic Art. **CAPUA (Campania).** EUPHRONIOS. *Calyx-krater, detail: young men oiling and grooming themselves. (Cf. 370.)* About 510. Staatliche Museen, Berlin (F 2180). Terra-cotta. Height of the detail 6 in. (Museum Photo.)

372. Attic Art. **VULCI** (Etruria). EUPHRONIOS. *Red-figure amphora, detail: banqueting reveller.* About 510. Louvre, Paris (G 30). Terra-cotta. Height of the detail 2 3/4 in. (Arts of Mankind Photo.)

(J. D. Beazley, ARV, p. 15, no. 9.)

373. Attic Art. **VULCI** (Etruria). Signed by EUPHRONIOS as painter and by KACHRYLION as potter. *Red-figure cup, detail: Heracles and Geryon. (Cf. 374, another detail.)* About 510-500. Staatliche Antiken-sammlungen, Munich (2620). Terra-cotta. Diameter 16 7/8 in. (Museum Photo.)

(J. D. Beazley, ARV, p. 16, no. 17.)

374. Attic Art. **VULCI** (Etruria). Signed by EUPHRONIOS as painter and by KACHRYLION as potter. *Red-figure cup, detail of the tondo: youth on horseback. (Cf. 373, another detail.)* About 510-500. Staatliche Antikensammlungen, Munich (2620). (Museum Photo—Max Hirmer.)

375. Attic Art. **VULCI** (Etruria). Signed by EUTHYMIDES. *Red-figure amphora: Hector arming, between Priam and Hecuba. (Cf. 376, another detail.)* About 510-500. Staatliche Antikensammlungen, Munich (2307). Terra-cotta. Height 23 5/8 in. (Hirmer Fotoarchiv, Munich.)

(J. D. Beazley, ARV, p. 26, no. 1.)

376. Attic Art. **VULCI** (Etruria). Signed by EUTHYMIDES. *Red-figure amphora, detail: dancing revellers. (Cf. 375, other side.)* About 510-500. Staatliche Antikensammlungen, Munich (2307). Terra-cotta. Height of the picture 9 in. (Museum Photo.)

377. Attic Art. **VULCI** (Etruria). Signed by EUTHYMIDES. *Red-figure amphora, detail: Helen carried off by Theseus.* About 510. Staatliche Antikensammlungen, Munich (2309). Terra-cotta. Height of vase 22 5/8 in., height of picture 10 in. (Hirmer Fotoarchiv, Munich.)

(J. D. Beazley, ARV, p. 27, no. 4.) The names of Helen and her attendant Korone have been interchanged by the painter. But the carrying off of the youthful Helen by Theseus is unanimously vouched for by ancient tradition.

378. Attic Art. **VULCI** (Etruria). PHINTIAS. *Red-figure amphora, detail: Leto carried off by Tityus.* About 520-510. Louvre, Paris (G 42). Terra-cotta. Height of vase 25 1/2 in., height of picture 8 5/8 in. (Arts of Mankind Photo.)

(J. D. Beazley, ARV, p. 23, no. 1.) On the other side: athletes.

379. Attic Art. **TARQUINIA** (Etruria). Signed by PHINTIAS. *Red-figure amphora, detail: Heracles carrying off Apollo's tripod.* About 520-510.

Museo Nazionale, Tarquinia (RC 6843). Terra-cotta. Height of the vase 26 in., height of the detail c. 8 in. (Arts of Mankind Photo.)

(J. D. Beazley, ARV, p. 23, no. 2.) On the other side: Dionysus and his thiasos. (Cf. 380.)

380. Attic Art. **TARQUINIA** (Etruria). Signed by PHINTIAS. *Red-figure amphora, detail: satyr embracing a maenad.* About 520-510. Museo Nazionale, Tarquinia (RC 6843). Terra-cotta. Height of vase 25 in., height of detail c. 2 in. (Arts of Mankind Photo.)

On the other side: dispute of Heracles and Apollo over the Delphic tripod. (Cf. 379.)

381. Attic Art. **ETRURIA.** Signed by SMIKROS. *Red-figure stamnos, detail: reveller and flute girl.* About 520-510. Musées Royaux d'Art et d'Histoire, Brussels (A 717). Terra-cotta. Height of vase 15 1/8 in., height of detail 6 3/4 in. (Photo copyright A.C.L. Institut royal du patrimoine artistique, Brussels.)

(J. D. Beazley, ARV, p. 20, no. 1.) Apart from the signature, the name Smikros is also used to designate the reveller with his head thrown back.

382. Attic Art. **VULCI** (Etruria). Signed by the potter SOSIAS. *Red-figure cup, detail of the tondo: Achilles bandaging Patroclus' wound.* About 500. Staatliche Museen, Berlin (2278). Terra-cotta. Height 4 in., diameter of the cup tondo 7 in. (Museum Photo.)

(J. D. Beazley, ARV, p. 21, no. 1.) On the outside: Heracles entering Olympus.

383. Attic Art. **VULCI** (Etruria). Signed by PEITHINOS. *Red-figure cup, detail: amorous couples. (Cf. 384, another detail.)* About 500. Staatliche Museen, Berlin (2279). Terra-cotta. Height 5 in., diameter 13 3/8 in. (Arts of Mankind Photo.)

(J. D. Beazley, ARV, p. 115, no. 2.)

384. Attic Art. **VULCI** (Etruria). Signed by PEITHINOS. *Red-figure cup, detail of the tondo: Thetis and Peleus. (Cf. 383, another detail.)* About 500. Staatliche Museen, Berlin (2279). Terra-cotta. Diameter of the tondo 8 5/8 in. (Museum Photo—Jutta Tietz-Glagow.)

385. Attic Art. **TARQUINIA** (Etruria). KLEOPHRADES PAINTER. *Red-figure calyx-krater, detail: athletes.* About 500. Museo Nazionale, Tarquinia (RC 4196). Terra-cotta. Height of vase 17 3/4 in., height of detail 8 1/2 in. (Arts of Mankind Photo.)

(J. D. Beazley, ARV, p. 185, no. 35.)

386. Attic Art. **NOLA** (Campania). KLEOPHRADES PAINTER. *Red-figure hydria, detail: the fall of Troy (Iliupersis), with Ajax and*

Cassandra. About 480. Museo Nazionale, Naples (2422). Terra-cotta. Height of vase 16 1/2 in., height of band 5 7/8 in. (Arts of Mankind Photo.)

(J. D. Beazley, ARV, p. 189, no. 74.)

387. Attic Art. **VULCI** (Etruria). KLEOPHRADES PAINTER. *Red-figure amphora: athletes (on the neck) and Dionysus with sileni and maenads (on the body). (Cf. 388, detail.)* About 500. Staatliche Antikensammlungen, Munich (2344.) Terra-cotta. Height 22 in. (Photo Hans Hinz, Basel.)

(J. D. Beazley, ARV, p. 182, no. 6.)

388. Attic Art. **VULCI** (Etruria). KLEOPHRADES PAINTER. *Red-figure amphora, detail: dancing maenad. (Cf. 387, whole vase.)* About 500. Staatliche Antikensammlungen, Munich (2344). Terra-cotta. Height of the detail c. 5 in. (Hirmer Fotoarchiv, Munich.)

389. Attic Art. **NOLA** (Campania). BERLIN PAINTER. *Red-figure amphora, detail: cithara player.* About 490. The Metropolitan Museum of Art, New York (56.171.38). Fletcher Fund, 1956. Terra-cotta. Height of vase 16 1/2 in., height of figure 8 1/2 in. (Museum Photo.)

(J. D. Beazley, ARV, p. 197, no. 3.) On the other side: umpire.

390. Attic Art. **VULCI** (Etruria). BERLIN PAINTER. *Red-figure amphora, detail: Heracles carrying off the Delphic tripod.* About 500. Martin von Wagner Museum, Würzburg (500). Terra-cotta. Height of the vase 20 3/8 in., height of the figure 10 1/2 in. (Museum Photo.)

(J. D. Beazley, ARV, p. 197, no. 8.) On the other side: Apollo.

391. Attic Art. **ETRURIA. BERLIN** PAINTER. *Red-figure amphora: Athena.* About 490. Antikenmuseum, Basel. Terra-cotta. Height of vase (with lid) 31 1/8 in. (Museum Photo—Claire Nigli.)

Athena is about to pour out some wine for Heracles, who appears on the other side.

392. Attic Art. **ORVIETO** (Etruria). ONESIMOS. *Red-figure cup, detail of the tondo: discus thrower.* About 500. The Museum of Fine Arts, Boston (01.8020). H.L. Pierce Fund. Terra-cotta. Diameter of the cup 10 1/8 in. (Museum Photo.)

(J. D. Beazley, ARV, p. 321, no. 22.) On the outside: athletes.

393. Attic Art. **VULCI** (Etruria). ONESIMOS (signed by EUPHRONIOS as potter). *Red-figure cup, detail: Heracles and Eurystheus. (Cf. 394, another detail.)* About 500-490. British Museum, London (E 44). Terra-cotta. Height of cup 5 in., diameter 13 1/4 in. (Arts of Mankind Photo.)

(J. D. Beazley, ARV, p. 318, no. 2.)

Glossary-Index

Unless otherwise indicated, all dates in the Glossary-Index referring to the ancient world are B.C.

ABACUS. Slab either square (Doric) or rectangular (Ionic) that forms the upper member of the capital of a column and on which rests the architrave. In the Ionic order the edge of the abacus is decorated with a smooth or carved moulding (egg-and-dart or leaf-and-dart), *p.* 174-175, 189, 196, 203.

ACHAEANS. Inhabitants of Achaea, an ancient country located in the north part of the Peloponnesus. They first achieved a loose political unity by forming the Achaean League of twelve Achaean cities, *p.* 101.

ACHELOUS. River god, son of Oceanus and Tethys, and Heracles' rival for the hand of Deianira. Metamorphosed into a bull, he wrestled with Heracles for her; Heracles broke off one of his horns, and Achelous admitted defeat, *p.* 317; *fig.* 361.

ACHILLES. Legendary Greek hero and central figure of the *Iliad.* Son of a mortal, Peleus, and the sea goddess Thetis. During the Trojan War he ambushed and killed Troilus, Priam's youngest son, and avenged the death of his companion Patroclus by killing Hector, whose body was ransomed by Priam. He also killed Memnon and the Amazon Penthesilea. With his friend Ajax he was playing draughts in his tent when the Trojans attacked the Greek camp. After his death Ajax brought back his body, *p.* 44, 61, 63, 67, 74, 76, 80, 90, 100, 102, 122, 304, 333, 349, 353; *fig.* 48, 69, 72, 79, 82, 98, 110, 113, 347, 382, 400, 405.

ACROCORINTHUS. Acropolis of Old Corinth (1,886 feet high), crowned with fortifications. Remains of a temple of Aphrodite have been found on the summit, *p.* 175.

ACROPOLIS. Upper part of an ancient Greek town, fortified and serving as a citadel. It was generally the centre of important civic cults. Most famous is the Acropolis of Athens, very early the site of the city's sanctuaries, etc. *p.* 4, 40, 61, 65, 107-108, 110, 114, 116, 143, 157-

158, 161, 175-176, 180, 187, 190, 215, 233, 235, 239, 245, 252, 254, 256, 259, 262, 268, 270, 276, 279-280, 284, 310, 312, 329; *fig.* 117.

ACROTERIUM. Statue or ornament (volutes, foliated scrolls, acanthus leaves) placed on the apex of a pediment or at either end of it, *p.* 107, 112, 176, 192, 239, 284; *fig.* 173, 193, 218, 230, 279.

ACTIUM. Promontory and former seaport in southern Epirus (Gulf of Arta) on the Ionian Sea. Two kouroi found at Actium are in the Louvre. Temple of Apollo Actios, *p.* 128; *fig.* 146; *map* 441.

ADRIA (Venetia, Italy), *maps* 441, 443.

ADRIATIC SEA, *p.* 16; *maps* 441-444.

ADYTON. Inner sanctuary, holy of holies. Applied especially to that part of a temple where the oracle was consulted (Delphi, Claros, etc.), *p.* 16, 181, 212-214.

AEGEAN SEA, *p.* 20, 31, 170, 175, 201, 357; *maps* 441-444.

AEGINA. Island in the Saronic Gulf, southwest of Athens, to which it was hostile in the archaic period. Famous for its bronze founders and its temple of Athena Aphaia, *p.* 20, 48, 50, 52, 217-226, 228, 276, 279, 288, 291; *fig.* 187, 253-263, 323, 332-337, 434, 435; *maps* 441-442, 444.

AENEAS. Trojan hero, son of Anchises and the goddess Aphrodite. Escaped from Troy and sailed to the west. The departure of Aeneas, carrying his aged father on his back, is a frequent theme on Attic black-figure vases found in Etruria; it was also adopted in Etruscan art, *p.* 338; *fig.* 386.

AEOLIC. Type of capital in which the volutes spring up vertically from the shaft, *p.* 173-175, 357; *fig.* 210-213.

AEOLIS. Region on the northwest coast of Asia Minor, colonized by the Aeolian Greeks, lying between the Troad and Ionia, *p.* 158, 174.

AESCHYLUS (c. 525-456). Attic tragic poet, born at Eleusis. He fought at Marathon and Salamis. Seven of his plays are extant, *p.* 267-268, 291.

AETOLIA (northern Greece), *p.* 32; *map* 442.

AGAMEMNON. Homeric hero, king of Mycenae, and leader of the Greek armies in the Trojan War, *p.* 145.

AGRIGENTUM (Agrigento). Greek city (Akragas) on the southwest coast of Sicily, founded in 580 by colonists from the neighbouring city of Gela. Famous for its temples, in which the Doric style attained one of its highest expressions, *p.* 176, 180, 211, 266-267; Olympieion, *p.* 20; *fig.* 312; *maps* 441, 443-444.

AIAKES. The man who dedicated a seated statue from Samos. He was the father of Polycrates, *p.* 251.

AJAX. Son of Telamon, companion and friend of Achilles, whose body he rescued from the hands of the Trojans. Committed suicide in a fit of madness because the arms of Achilles were awarded not to him but to Odysseus, *p.* 61, 63, 90, 100, 102, 288; *fig.* 69, 98, 110, 112.

AJAX. The Locrian Ajax, leader of the Locrian forces in the Trojan War, who violated Cassandra, *fig.* 386.

ALALIA (Corsica), *maps* 441, 443-444.

ALCAEUS. Lyric poet, born in Lesbos about 630, who became involved in the struggle against the tyrant Pittacus. Some of the extant fragments of his poems reflect these political disputes. He also wrote hymns and scolia (short lyrical poems sung after dinner), *p.* 107.

ALCMAEONIDAE or ALCMAEONIDS. Noble Athenian family whose most famous members were Megacles and Cleisthenes. The Alcmaeonids completed the rebuilding of the Temple of Apollo at Delphi (late 6th century), which had been destroyed by fire, *p.* 153-154, 175, 216-217, 231, 235, 239.

ALCYONEUS. Giant who is represented in vase painting as the herdsman of Geryon. Athena put him to sleep with the aid of Hypnos; Heracles then killed him in his sleep before attacking his master, the king, *p.* 320; *fig.* 368.

AL MINA (northwest Syria), *maps* 441, 443.

AMASIS PAINTER. Attic black-figure painter (third quarter of 6th century), who worked for the potter Amasis. Some 110 works by his hand are known, nine of which are signed by Amasis as potter, *p.* 59, 87-89; *fig.* 91-97.

AMAZONS. Legendary nation of female warriors said to have lived in Pontus (Asia Minor). No men were allowed among them, but once a year they visited the men of a neighbouring tribe to prevent their race from dying out. They were fought by Heracles, Theseus, and Achilles; the latter killed their queen Penthesilea under the walls of Troy, *p.* 102, 239, 284, 298, 304; *fig.* 343.

AMORGOS (Cyclades), *map* 442.

AMPHIARAUS. Seer and king of Argos. Forced by his wife Eriphyle, who had been bribed with the gift of a necklace, to take part in the expedition of the Seven against Thebes, which he knew would be disastrous and would cost him his life, *p.* 71-72; *fig.* 76.

AMPHORA. Large earthenware vessel used for holding wine, oil, honey, and fruits (see also Psykter), *p.* 46, 63, 67-68, 74, 81-82, 85, 87-88, 99-100, 102, 297-298, 306, 308, 323, 326-327, 329, 331, 338, 340, 356; *fig.* 50, 73, 78, 86-87, 89-91, 97, 108-113, 339-343, 350-351, 364, 372, 375-380, 387-391, 408.

AMYCLAE. City in Laconia, south of Sparta. Site of Amyklaion (sanctuary of Apollo Amykleios), possessing the 'throne' of Apollo by Bathycles of Magnesia, *p.* 116; *map* 441.

ANAPHE (Cyclades), *fig.* 309.

ANATOLIA (Asia Minor), *p.* IX, 126, 132, 135, 357.

ANAVYSSOS. Locality in southern Attica, where a kouros was found (National Museum, Athens), *p.* 154.

ANCHISES. Trojan hero beloved of Aphrodite, by whom he had a son, Aeneas. After the fall of Troy Aeneas carried his aged father out of the burning city on his shoulders, *p.* 338; *fig.* 386.

ANDOKIDES PAINTER. Probable inventor of the red-figure technique. Only a few of his works are known (fourteen in all), dating from about 530 to 515. The black-figure scenes on some of his vases were executed by another anonymous artist, the Lysippides Painter, who, like him, worked for the potter Andokides (who signed eight vases), *p.* 297-298, 300, 315, 317; *fig.* 339, 341-343.

ANDROMACHE. Wife of Hector and mother of Astyanax. One of the finest characters in Homer, distinguished by her affection for her husband and child. After the fall of Troy, she became the captive of Neoptolemus, son of Achilles, *p.* 82, 351; *fig.* 88, 401.

ANDROS (Cyclades), *maps* 441-444.

ANTA. Slightly projecting pilaster strip terminating the side walls of the cella of a Greek temple. Crowned by a capital with a character of its own, *p.* 3-4, 6, 14, 176, 189, 212-214, 221; *fig.* 6.

ANTAEUS. Giant of Libya, son of Poseidon and Gaia. An invincible wrestler, for he derived fresh strength from contact with his mother earth. Heracles lifted him into the air and crushed him to death, *p.* 320-321; *fig.* 369.

ANTEFIX. Upright ornament, painted or carved, masking the ends of the covering tiles along the edge of a roof, *p.* 16, 107, 176.

ANTENOR. Brother-in-law and counsellor of Priam. An advocate of peace before and during the Trojan War, he was spared by the Greeks, *fig.* 68.

ANTENOR. Attic sculptor (last quarter of 6th century), who carved the first group of the Tyrannicides— Harmodius and Aristogiton—set up by the Athenians after the expulsion of the Pisistratids, but carried off by the Persians. Sculptor of Kore 681 from the Acropolis and possibly of the pedimental sculptures of the Alcmaeonid temple at Delphi, *p.* 165, 235, 239, 251, 260, 262, 276, 280; *fig.* 275.

ANTIMACHIDES. Athenian architect in the service of the Pisistratids. According to Vitruvius (VII, 160, 15), he worked with Porinos, Antistates, and Callaeschros on the great temple of Olympian Zeus, designed as a Doric structure, then continued later in the Corinthian style by Cossutius, *p.* 216.

ANTIMENES PAINTER. Attic black-figure painter (last quarter of 6th century). Decorated chiefly hydriai, amphorae, and a few kraters (136 works known in all), *p.* 305; *fig.* 348.

ANTIOPE. Amazon carried off by Theseus during the legendary war between the Greeks and the Amazons. Pediment of the temple of Apollo Daphnephoros at Eretria, *p.* 239, 284; *fig.* 281, 328.

ANTIS, IN. Latin term designating a plan in which the side walls end in antae, with columns (generally two) between them. Traditional plan of the porch of Greek temples, *p.* 14, 189, 214, 221; *fig.* 6.

ANTISTATES. See ANTIMACHIDES.

APHAIA. Name of the mysterious primitive divinity who gave her epithet to Athena in the sanctuary of Athena Aphaia at Aegina, where the famous Doric temple was built (c. 500-490), *p.* 217-226, 288-289; *fig.* 253-263, 332-337.

APHARIDAE. Idas and Lynceus, the sons of Aphareus, who with Castor and Polydeuces stole cattle in the course of the Argonaut expedition, *fig.* 128.

APHRODITE. Goddess of love. By the judgment of Paris, she was awarded the prize for beauty over her rivals Hera and Athena, *p.* 145, 161, 164, 351, 352; *fig.* 167, 175, 206, 402.

APOLLO. One of the most important of the Olympian divinities, son of Leto and Zeus, and twin brother of Artemis. Sun god and patron of the Muses and the arts. His chief sanctuary was at Delphi, *p.* 15-16, 20, 24, 116, 126, 135, 138, 154, 156, 164, 173, 175-176, 184, 188, 192-195, 201, 213, 215-217, 231, 235, 238-239, 267-268, 283-284, 331, 340; *fig.* 14-15, 33-34, 199, 215, 222, 239, 251, 264, 266-270, 278-279, 281, 325, 327, 378-379; Apollo Ismenios. Epithet of Apollo in his sanctuary at Thebes, *p.* 156; *fig.* 193; Apollo Philesios. Epithet of Apollo in his sanctuary at Miletus, *p.* 276.

APOLLONIA (Epirus), *maps* 441-443.

APOLLONIAN TRIAD. Apollo, Leto, and Artemis, *p.* 239.

APOLLONION. Temple of Apollo, *p.* 214-215.

APSIDAL PLAN. Design combining the rectilinear elements of the quadrangular plan with an apse, usually placed on the short side opposite the main front, *p.* 4, 6, 190; *fig.* 414.

ARCADIA (Peloponnesus), *p.* 157.

ARCESILAS II. King of Cyrene (c. 565-550), *p.* 76, 78, 80; *fig.* 84.

ARCHERMOS OF CHIOS. Sixth-century sculptor who worked in Lesbos and Delos. Said to have been the first to represent the winged Victory (Nike), *p.* 143, 152.

ARCHILOCHUS (c. 712-c. 664). Lyric poet born at Paros. Took part in the colonization of Thasos. The surviving iambic fragments are marked by vehemence and energy, *p.* 19.

ARCHITRAVE. The lowest member of the entablature, resting on the capitals of the columns. Also called epistyle, *p.* 6, 11-12, 158, 175, 196, 198, 202, 204, 210; *fig.* 198.

ARES. Greek god of war, son of Zeus and Hera, *fig.* 204.

ARGONAUTS. The band of heroes under Jason who went in quest of the Golden Fleece, *p.* 14.

ARGOS. City in Argolis and the leading power in the Peloponnesus after the fall of Mycenae, until challenged by Sparta. Famous in the 6th and 5th centuries for its sculptors, chiefly in bronze (Polycleitos), *p.* 4, 6, 14, 24, 31, 112, 131, 276; *maps* 441-444.

ARISTAEUS. Son of Cyrene and Apollo, protector of fields and flocks, venerated chiefly at Ceos, *p.* 154.

ARISTION. The hoplite carved by Aristocles on an Attic gravestone (National Museum, Athens), *p.* 259; *fig.* 300.

ARISTOCLES. Attic sculptor of the 6th century who signed the Aristion stele (National Museum, Athens), *p.* 259.

ARISTODIKOS. An Athenian represented as a kouros (c. 500), *p.* 249, 267-268; *fig.* 310-311.

ARISTOPHANES (c. 445-c. 386). The greatest Athenian poet of comedy; author of some forty plays, eleven of them extant, *p.* 147.

ARKHADES. Site of an ancient town (Arkadia) in central Crete, *p.* 196; *maps* 441, 444.

ARMENIA, *p.* x.

ARTAKE. Town on the Asiatic shore of the Sea of Marmara (Turkey) near Cyzicus, *p.* 127.

ARTEMIS. Daughter of Zeus and Leto; twin sister of Apollo. Mistress of wild animals, virgin huntress, and moon goddess, she is one of the great Olympian divinities, *p.* 16, 26, 63, 113, 145, 171, 176, 192-195, 239, 331; *fig.* 16-17, 24, 69, 378; Artemis Brauronia. She was venerated under this name in the sanctuary of Brauron near the east coast of Attica and in a sanctuary on the Acropolis of Athens, *p.* 256; Artemis Daidaleia, *fig.* 177; Artemis Orthia. Epithet of Artemis in her sanctuary at Sparta, *p.* 147.

ARTEMISION. Sanctuary of Artemis. The most famous was at Ephesus, *p.* 158, 169-171, 198, 201, 203, 213; *fig.* 208-209.

ARULA. Latin name (diminutive of *ara*) for a small altar decorated with reliefs on the front, sometimes on all four sides. Found chiefly in the cemeteries and sanctuaries of Rome, Magna Graecia, and Sicily, *fig.* 297.

ARYBALLOS. A bottle with short neck, single handle, and globular body, used especially for holding oils or ointments, *p.* 322; *fig.* 326.

ASIA MINOR, *p.* 6, 12, 93-94, 135, 137, 158, 169-171, 190, 198, 203, 211, 216, 256.

ASSOS. Ancient town in the Troad, whose ruins stand near the hamlet of Behramkale, 15 miles southwest of Ayvalik. Famous for its Temple of Athena (6th century), *p.* 12, 158, 175; *fig.* 198; *maps* 441, 444.

ASSYRIA, *p.* 158, 174.

ASTRAGAL. A moulding of half-round profile, generally associated in the Ionic order with the upper part of the column shaft, the abacus of the capital, or other mouldings in the adornment of walls, *p.* 192, 198.

ASTYANAX. Son of Hector and Andromache, slain in the fall of Troy. With his dead body Neoptolemus struck down Priam, the boy's grandfather, *p.* 338, 351; *fig.* 62, 386, 401.

ATHENA. (See also PROMACHOS.) Greek goddess of wisdom and counsel, patroness of the arts of peace and war. Her father was Zeus, from whose forehead she sprang fully armed. Patroness of Attica, her chief sanctuary being the Parthenon in Athens, *p.* 11, 48, 52, 59, 110, 113-114, 161, 174-176, 195, 203, 210-212, 215, 217, 226, 231, 235, 238, 245, 249, 251, 276, 280, 284, 287-289, 297, 301, 305, 338, 340; *fig.* 51, 56, 61, 124-127, 205, 233, 235, 247-248, 252, 276, 319, 324, 331, 335, 339-340, 355, 368, 391; Athena Chalkioikos. Epithet of Athena in her temple at Sparta, *p.* 116.

ATHENIS OF CHIOS. Sculptor (second half of 6th century), son of Archermos of Chios, and brother of Boupalos, *p.* 152.

ATHENS, *p.* 20, 24, 31, 40, 44, 46, 52, 61, 65, 68, 71, 82, 87-88, 93-94, 104, 107, 114, 116, 127, 143, 147, 151, 154, 158, 165, 176, 180, 190, 215-217, 231, 233, 245, 249, 251, 254, 261-262, 265, 267-268, 276, 280, 284, 288, 291, 295, 298, 312, 356; *fig.* 18-19, 117-127, 139, 187-190, 216, 272-277, 280, 282-289, 291-294, 296, 299, 301-305, 313-318, 322, 324, 425; *maps* 441-444.

Acropolis, *p.* 4, 40, 61, 65, 107-108, 110, 114, 116, 143, 157-158, 161, 176, 190, 215, 231, 233, 235, 239, 245, 252, 254, 256, 259, 263, 268, 270, 276, 279-280, 284, 310, 312, 329; *fig.* 117, 216; Agora, *p.* 231; Dipylon, *p.* 20, 46; Fountain houses, *p.* 231, 305; Hecatompedon of Pisistratos, *p.* 114, 215; Kerameikos, *p.* 259; Mint, *p.* 231; Parthenon, *p.* 113, 116, 176, 213, 221, 249, 254, 259, 284; Pinacotheca, *p.* 31; Prytaneum, *p.* 231; Stoa Poikile, *p.* 31; Temple of Athena Polias, *p.* 215; Temple of Olympian Zeus, *p.* 215-216.

ATLAS. Giant who after the failure of the revolt of the Titans was condemned by Zeus to hold up the sky on his shoulders, *p.* 76, 80; *fig.* 85.

ATTICA. Peninsula of central Greece around Athens, bounded on the north by Boeotia and on the west by Megaris, *p.* 20-22, 24, 29, 46-52, 56-69, 71, 74, 80-82, 85, 87, 90, 93-94, 98-99, 107, 112-113, 126-128, 131, 145, 152-154, 161, 168, 198, 233, 245, 249, 252-253, 256, 259, 266, 268, 276, 280, 284, 287, 295, 297, 306, 310, 335, 354, 356-357; *fig.* 20, 49, 57, 109, 271, 300, 310-311, 358-359; *map* 442.

BACCHYLIDES OF CEOS. Greek poet (early 5th century), a contemporary of Pindar and, like him, a writer of victory odes and lyrical poems, *p.* 24.

BATHYCLES OF MAGNESIA. Ionian architect and sculptor from Magnesia ad Maeandrum (second half of 6th century). At Sparta he made the monumental 'throne' of Apollo, adorned with reliefs and figures in the round, for the sanctuary of Apollo at Amyclae, *p.* 145.

BATHYLLOS. Cithara player and favourite of Polycrates, tyrant of Samos, *p.* 158.

BERLIN PAINTER. Painter of large red-figure Attic vases (first quarter of 5th century). Most of the 245 vases attributed to him are amphorae, *p.* 340, 343, 354; *fig.* 389-391.

BITON. See CLEOBIS.

BLACK-FIGURE. Painting technique invented in the early 7th century, most probably by Corinthian vase painters. Figures and ornaments were painted in black silhouette to come up, after firing, black on the natural clay surface, with incised details and touches of added white and red, *p.* 31-32, 39-40, 42, 44, 46-52, 55-56, 59, 63, 69, 71, 75-76, 78, 82, 87, 93-94, 98-99, 295, 297-298, 300-301, 305-306, 308, 310, 312, 317, 320, 357.

BLACK SEA, *p.* 357.

BLOND BOY, *p.* 276, 279-280; *fig.* 318.

BOCCANERA SLABS. Series of painted terra-cotta plaques, found in 1874 by the Boccanera brothers in the Banditaccia necropolis at Caere (Etruria) and now in the British Museum. Before being placed in the small chamber tomb, in which they were discovered, they probably decorated the walls of a civil or religious edifice in the town, *p.* 34; *fig.* 35-36.

BOEOTIA. Region in central Greece north of Attica, essentially rural; capital, Thebes. The Boeotians were regarded by the Athenians as dull-witted clods, *p.* 20, 68-69, 154; *fig.* 74-75; *maps* 441-444.

BOREADS. Calais and Zetes, twin sons of Boreas, the north wind, and Oreithyia. In the course of the Argonaut expedition they drove off the Harpies who were tormenting Phineus, *p.* 48; *fig.* 52.

BOULEUTERION. The Greek senate house or council hall (Olympia), *fig.* 432.

BOUPALOS. Architect and sculptor (second half of 6th century), son of Archermos of Chios and brother of Athenis, *p.* 152.

BRANCHIDAE. Priestly clan serving the sanctuary of Apollo at Didyma, near Miletus. Their statues lined the sacred way of the sanctuary. Also another name for Didyma, *p.* 138, 251; *fig.* 169.

BRYGOS PAINTER. One of the most prolific Attic red-figure cup painters of the first quarter of the 5th century. He worked for the potter Brygos. Out of some 230 works by his hand, fourteen bear the signature of Brygos, *p.* 335, 346, 349, 351, 356; *fig.* 396-401.

BUSCHOR (Ernst). German archaeologist (1886-1967), *p.* 132.

BUSIRIS. Legendary king of Egypt, who every year sacrificed a foreigner to Zeus. Heracles, seized and about to be sacrificed, burst his bonds and slew Busiris and his attendants, *p.* 98; *fig.* 107.

BYZANTIUM, *p.* 192; *maps* 441-443.

C PAINTER. Attic black-figure painter (second quarter of 6th century), who decorated chiefly cups. His work numbers some 130 items, *p.* 59, 68; *fig.* 56, 61-62.

CAERE (CERVETERI). One of the leading cities of Etruria, some 35 miles northwest of Rome. Very prosperous during the archaic period. Many Greeks, including potters, settled at Caere and its port Pyrgos, and Corinthian and above all Attic vases were imported in large quantities, *p.* 94, 98, 190, 345; *fig.* 210, 229; *maps* 441, 443-444.

CALATHOS. Literally, 'basket.' Designates in architecture a type of high, elongated capital, particularly the bell or core of the Corinthian capital round which the acanthus leaves are grouped, *p.* 196.

CALF-BEARER (Moschophoros), *p.* 107, 112, 249; *fig.* 117.

CALLAESCHROS. See ANTIMACHIDES.

CALLIOPE. The muse of epic poetry. Like her sisters, daughter of Zeus and Mnemosyne (or Harmonia), *p.* 63.

CALLON. Aeginetan sculptor (6th century), who worked at Troezen, Amyclae, and Athens, *p.* 276.

CALYDON. Town in Aetolia, scene of the Calydonian boar hunt, which was led by Meleager, accompanied by other heroes (Castor and Polydeuces, Theseus, Jason, Peleus, Amphiaraus, and others), *p.* 61, 107, 112, 176; *maps* 441, 444; Temple A, *p.* 176; *fig.* 217-218; Temple C, *fig.* 417.

CAMEIROS (Rhodes), *maps* 441-442.

CAMPANIA (South Italy), *p.* 116; *maps* 441, 443-444.

CANACHOS. Sculptor of Sicyon (late 6th to early 5th century), who worked chiefly in bronze. His masterpiece was the Apollo Philesios at Miletus, *p.* 201, 276.

CANALIS. See CHANNEL.

CANOPY. A sheltering structure, supported by columns, standing over a statue or votive offering, *p.* 4, 11, 14, 174, 195, 225.

CARIA. Region of southwestern Asia Minor, between the Maeander and the Indus, *p.* 126; *maps* 442-444.

CARPATHOS (Dodecanese), *maps* 441-444.

CARTHAGE (North Africa), *maps* 441, 443-444.

CARYATID. Sculptured female figure used as a column supporting an entablature, *p.* 143, 161, 196, 198, 233, 270; *fig.* 174, 201, 231.

CASSANDRA. Daughter of Priam and Hecuba, given the gift of prophecy by Apollo. At the fall of Troy she sought refuge under the protection of the statue of Athena, but was torn from it and ravished by Ajax the Locrian, *p.* 338; *fig.* 386.

CASTOR. See DIOSCURI.

CECROPS, CECROPIDES. Cecrops was the first king of Attica and umpire in the dispute between Poseidon and Athena for the possession of Attica; he decided in favour of the goddess. The Cecropides were the descendants of Cecrops, *p.* 263; *fig.* 305.

CELLA. The principal room of a Greek temple, in which the cult statue stood, *p.* 4, 6, 14, 16, 170, 176, 181, 187, 203-204, 206, 211-216, 221, 225.

CENTAURS. A race of beings half man, half horse. They attacked Heracles, guest of the centaur Pholus, but the hero routed them. At the marriage of Pirithous, they tried to abduct his bride but were driven off by the Lapiths, *p.* 44, 61-63, 189; *fig.* 47, 65, 132.

CENTURIPE. Town in eastern Sicily, near Catania, founded by the Sicels and plundered by the Roman praetor Verres, *fig.* 297; *map* 441.

CEOS. Small island in the Cyclades where a kouros was found (National Museum, Athens), *p.* 154; *fig.* 191; *maps* 441-442.

CEPHALLENIA (Ionian islands), *maps* 441-444.

CERBERUS. Three-headed dog who guarded the entrance to Hades. Captured and brought to the upper world by Heracles, *p.* 98; *fig.* 106.

CERCOPES. The two sons of the Oceanid Theia. Notorious robbers, they were first punished by Heracles, then transformed into monkeys by Zeus, *p.* 184; *fig.* 135-136.

CERVETERI. See CAERE.

CHALCIDIAN. The same distinctive alphabet was used by the town of Chalcis in Euboea (45 miles north of Athens) and by all its colonies in South Italy and Sicily, so its use on Chalcidian vases proves only that they originated in a Chalcidian town, not necessarily in Chalcis itself. In fact, all the Chalcidian vases have been found in the west, and none in Greece, so they must be of colonial origin, *p.* 76, 80-82, 85; *fig.* 86-88, 90.

CHALCIS. Chief city of ancient Euboea, separated from Boeotia by the Strait of the Euripus. In the west and in the north Aegean (Chalcidice), it founded many colonies, which long preserved its institutions, language, and alphabet, *maps* 441-443.

CHANNEL. Central element of the Ionic capital (canalis), separating the echinus, or cymatium, from the abacus and ending in the spirals of the volutes, *p.* 203.

CHARITES or GRACES. Aglaia, Thalia, and Euphrosyne, daughters of Zeus and Eurynome, personifications of beauty and charm. Friends of the muses and companions of Apollo, Dionysus, and Aphrodite, *p.* 239.

CHERAMYES. Samian personage who dedicated a statue of Hera (Louvre), *p.* 135; *fig.* 163.

CHERSIPHRON. Cretan architect from Knossos, who with his son Metagenes built the great Ionic temple of Artemis at Ephesus (Croesus temple, c. 560). Chersiphron is supposed to have carried the work to the top of the columns, Metagenes to have added the entablatures, *p.* 169, 171.

CHERSONESE (TAURIC). Ancient name of the Crimea, colonized chiefly from Miletus. It acted as intermediary between the Greeks and the tribes of South Russia, *p.* IX.

CHIGI VASE. Proto-Corinthian olpe found at Formello, near Veii (Etruria), on the estates of Prince Chigi, and now in the Villa Giulia Museum, Rome, *p.* 31-32, 40, 44, 50, 59; *fig.* 30, 31.

CHIOS. Rich Ionian city on the island of the same name off the Asia Minor coast. Famous for its wine, widely exported even in the archaic period, much more so than its painted pottery, *p.* 39-40, 143, 152, 245; *fig.* 39, 41; *maps* 441-444.

CHITON. Long, transparent, finely pleated tunic; the principal undergarment, chiefly of women, in the Ionian cities and in Athens, *p.* 298, 338, 343, 352, 354.

CHIUSI (Etruria), *maps* 441, 443.

CHRYSAOR. Son of Poseidon and the Gorgon Medusa, from whose trunk he sprang, with Pegasus, when her head was cut off by Perseus. Father of Geryon and Echidna, *p.* 26, 128.

CHRYSAPHA. Locality near Sparta, in Laconia, *p.* 148; *fig.* 183; *map* 441.

CHRYSELEPHANTINE. Composed of or adorned with gold and ivory, *p.* 20.

CLADEOS. Tributary of the river Alpheus, running along the west side of the sanctuary of Olympia, *p.* 231.

CLAZOMENAE (URLA). Greek city on the Asia Minor coast, in northern Ionia, 30 miles west of Izmir (Smyrna). Though not yet excavated systematically, it has yielded a quantity of painted pottery and sarcophagi, all of them presumably local products, *p.* 93-94, 168, 195-196; *maps* 441-442.

CLEOBIS. Son of a priestess of Hera. He and his twin brother Biton drew their mother's chariot from Argos to Delphi, where she was to perform a sacrifice; they died of exhaustion on arrival at the sanctuary. Statues dedicated by the Argives at Delphi, *p.* 24, 112, 131; *fig.* 23.

CLEISTHENES. Athenian statesman (second half of 6th century), grandson of the tyrant of Sicyon. After the fall of the Pisistratids, he reestablished the Solonian constitution and made democratic reforms, *p.* 231, 233, 268.

CLEOMENES, *p.* 16.

CLEONAE (Peloponnesus), *maps* 441-442.

CNIDUS. Ancient city of Caria in southwestern Asia Minor, on Cape Krio; one of the cities of the Dorian Hexapolis. It dedicated a treasury at Delphi; the head of the caryatid attributed to this treasury does not in fact belong to it, *p.* 143, 196-198, 233; *fig.* 232; *maps* 441-443.

COFFER. An ornamental panel deeply recessed in a soffit or ceiling. Often decorated with a carved or painted design, sometimes of metal (rosettes), *p.* 211.

COIGNING or QUOINS. Dressed stones used to strengthen the corners or doorways of structures built of low-resistance materials (pisé, brick, rubble). Their function may be emphasized by rustication, *p.* 3.

COINS, *p.* 135, 153; *fig.* 152-162.

COLONY. Town founded by Greek settlers from a mother city in mainland Greece or Ionia, for the exploitation of natural resources or trading purposes, *p.* 15, 26, 81, 128, 175-176, 188.

COLUMN (ENGAGED). Column of less than circular section (half or three-quarters of its circumference) set flat against a vertical surface, *p.* 187.

COMAST. Reveller, *p.* 56, 319, 323, 333, 336, 351; *fig.* 57, 63, 367, 372, 376, 381, 396.

COMOS. Revel or company of revellers, often in connection with Dionysus (satyrs, maenads), *p.* 87, 326-327, 331, 356; *fig.* 381.

CONCHITIC. Composed of or containing many shells, *p.* 187, 217.

CORCYRA (KERKYRA). Greek island in the Ionian Sea, off the coast of Albania and Epirus. Colonized from Eretria, then occupied by Corinth in 733. Three miles south of the town of Corfu are the ruins of a temple of Artemis with important sculptures, including the so-called Introduction pediment (Palaeopolis, Corfu Museum), *p.* 16, 22, 26, 107, 113-114, 128, 148; *fig.* 16-17, 24, 415-416; *maps* 441-444.

CORFU. Anglicized name of Corcyra.

CORINTH. Isthmus city between mainland Greece and Peloponnesus, an important centre of trade and handicrafts with two ports, one on the western gulf, the other opening on the Aegean. In the early 7th century a paved road *(diolkos)* was built, enabling ships to be hauled across the isthmus from one sea to the other. From the mid-8th to the second half of the 6th century, Corinth exported painted pottery in large quantities throughout the Mediterranean world. The ruins of ancient Corinth lie 4 miles from the modern city, *p.* 6, 15-16, 22, 24, 26, 28-29, 31-32, 34, 39-40, 42-48, 52, 56, 59, 71-75, 78, 80-81, 85, 93, 112-113, 116, 128, 131, 148, 156, 175-176, 182, 195, 215-216, 221, 276, 312, 340, 349; *fig.* 30-31, 43-48, 76-80, 357, 431; *maps* 441-444.
Temple of Apollo, *p.* 175-176, 215; *fig.* 215.

CORONA. Projecting part of the cornice, crowning the entablature. Its lower edge is undercut to help in the drip of rain water, *p.* 12, 17, 175, 183, 192, 195, 197, 211, 213.

COS (Dodecanese), *map* 442.

CRETE. Large island in the centre of the eastern Mediterranean, seat of the most important of the pre-Hellenic civilizations. It played an outstanding part in the rise of Daedalic sculpture in the 7th century, *p.* 4, 12, 20, 22, 29, 141, 169, 196; *maps* 441-444.

CRITIOS. Athenian sculptor who, with Nesiotes, in 477-476, executed statues of the Tyrannicides to replace those by Antenor, which had been carried off to Persia by Xerxes. A marble boy is also attributed to him (Acropolis Museum), *p.* 280.

CROESUS. Last king of Lydia (561-546), famous for his wealth and felicity. Defeated and dethroned in 546 by Cyrus, *p.* 135, 171, 173, 280, 356; *fig.* 408.

CROISOS, *p.* 154.

CRONION. Hill overlooking the Altis or sacred grove at Olympia, *p.* 231.

CROTALA. Castanets used to accompany dancing, *fig.* 176.

CROTON (South Italy), *maps* 441, 443-444.

CUMAE. Greek city in Campania, north of the Gulf of Naples, a Chalcidian colony founded in the 8th century; it maintained relations with Etruria during the archaic period, *p.* 59; *maps* 441, 443.

CUP. Wide-mouthed drinking vessel presenting a great variety of types in overall proportions and design of foot and lip, especially in Attic pottery. The evolution of cup shapes is helpful in working out a precise chronology, *p.* 40, 59, 69, 76, 78, 80, 87-90, 96, 106, 308, 315, 317, 319-320, 325, 333, 335-336, 340, 343, 345-346, 349, 351, 353-354, 356; *fig.* 63, 74, 81-85, 96, 98-100, 104, 116, 352, 362-363, 365-366, 368, 373-374, 382-384, 392-396, 398-399, 401-402, 404-405, 407, 409.

CURETES. Daemons associated with several divinities, chiefly Zeus but also Apollo, *p.* 239.

CURVATURE. As an aesthetic refinement a subtle convex curve was sometimes given to the platform of a colonnade in order to break up the horizontality of the design, *p.* 176.

CYBELE. Goddess worshipped in Asia Minor, *p.* 173.

CYCLADES. Group of Aegean islands clustering around Delos. Seat of a flourishing civilization both in early pre-Hellenic times and in the early Greek archaic period, *p.* 4, 6, 39, 131, 137, 196, 211; *fig.* 40; *maps* 441-444.

CYCNUS. Son of Ares, the god of war. Killed by Heracles despite his father's intervention, *p.* 287, 301; *fig.* 330, 345.

CYMATIUM. See LESBIAN CYMATIUM.

CYPRUS, *p.* 174; *maps* 441, 443-444.

CYPSELIDS. Dynasty of tyrants (Cypselus, Periander, Psammetichus) who ruled Corinth for three-quarters of a century, in the second half of the 7th and the first half of the 6th

century. Their rule marked the apogee of the city's political power, but the beginning of its economic decline, *p.* 40.

CYRENE. Greek colony in North Africa, on the Libyan plateau, founded about 630 by Spartans from Thera. It long preserved monarchical institutions, *p.* 20, 76, 78, 126, 192; *fig.* 418-419; *maps* 441, 443-444.

CYTHERA (Ionian islands), *maps* 441-444.

CYZICUS. Milesian colony founded in 675 on the south shore of the Sea of Marmara, *p.* 127, 158; *fig.* 197; *map* 441.

DAEDALIC STYLE. Early archaic style of sculpture following the Geometric period. Named after the legendary sculptor Daedalus, an Athenian exiled to Crete, *p.* x, 20, 22, 110, 126, 141.

DEINAGORAS. Naxian who dedicated a statuette to Apollo (c. 520), *p.* 283; *fig.* 326.

DELOS. Island in the Cyclades, famous for its sanctuaries of Artemis and Apollo. Religious centre of the Delian amphictyony, it gradually came under the influence of Athens during the 6th century, *p.* ix, 4, 12, 14, 20-21, 132, 143, 174, 192, 198, 203; *fig.* 173; *maps* 441, 443-444.
Oikos of the Naxians, *p.* 12, 198.

DELPHI. Locality in Phocis, seat of the Delphic oracle, *p.* ix, 4, 11, 22, 116, 118, 123, 143, 161, 174-175, 192, 195-196, 198, 216-217, 226, 228, 231, 233, 235, 238, 245, 251, 270, 276, 284, 340; *fig.* 23, 130, 138, 174, 231, 266, 268-270, 425; *maps* 441, 444; Athenian Colonnade, *p.* 231; Athenian Treasury, *p.* 118, 226, 228, 231, 284, 287; *fig.* 264-265, 267, 328-331; Marmaria terrace, *p.* 11, 195, 217; *fig.* 233, 235, 252, 427-428; Monopteros of Sicyon, *p.* 11, 195, 198; *fig.* 10; Sicyonian Treasury, *p.* 11, 116, 195; *fig.* 8-10, 128, 429; Siphnian Treasury, *p.* 161-168, 196-198, 245, 251; *fig.* 199-207, 232, 234, 236-237; Temple of Apollo (Alcmaeonid), *p.* 175, 216-217, 231, 235, 238; *fig.* 278-279; Temple of Apollo (4th century), *fig.* 430; Temple of Athena (first), *p.* 11; Temple of Athena (second), *p.* 217; *fig.* 252; Tholos on Marmaria terrace, *fig.* 430; Tholos (old), *p.* 11, 195; *fig.* 7.

DEMETER. Daughter of Cronus and Rhea; goddess of agriculture (especially of grain) and fertility. Particularly venerated, with her daughter Persephone, in the Eleusinian mysteries and in Sicily, *p.* 265; *fig.* 307.

DENTILS. A row of small projecting rectangular members on the Ionic entablature above the frieze, simulating the beam-ends of a ceiling, *p.* 198, 202.

DIACRIA. Region of Attica north of Athens, *p.* 22.

DIDYMA. Large sanctuary of Apollo some 12 miles south of Miletus. Also called Branchidae from the name of its priestly caste. The town was taken by Miletus in the mid-6th century. Now the Turkish village of Yenihisar, *p.* 4, 138, 171, 173, 201-202, 213, 251; *fig.* 168-169, 239, 424; *maps* 441, 444.

DIDYMEION. The sanctuary of Apollo at Didyma, near Miletus, administered by the family of the Branchidae. The archaic temple was burned by the Persians in 494; *p.* 138, 158; *fig.* 168.

DIKE. Greek goddess of justice; daughter of Zeus and Themis, *p.* x, 107.

DINOS. Cauldron-shaped krater without handles, placed on a metal or terra-cotta stand. A common vase shape till about the mid-6th century, *p.* 31-32, 52, 56, 65, 96; *fig.* 32, 37, 53, 55, 58-60, 70.

DIONYSERMOS. The man represented in the draped statue in the Louvre, *p.* 251; *fig.* 290.

DIONYSUS. Son of Zeus and Semele. God of the vine, wine, and mystical frenzy, generally attended by his thiasos: his wife Ariadne and satyrs and maenads. The cult of Dionysus was extremely popular in Attica from the time of Pisistratos on, and the god is represented on many Attic vases from 560, *p.* 63, 88, 106, 325, 331, 338, 351; *fig.* 97, 103, 116, 358, 387, 404, 406.

DIOSCURI. Castor and Polydeuces (Pollux), sons of Leda; the first by Tyndareus, king of Sparta, the second by Zeus. These two heroes took part in the Argonaut expedition and in the Calydonian boar hunt. They carried off the Leucippides, who were betrothed to the sons of Aphareus, Idas and Lynceus, *p.* 101, 116; *fig.* 111, 128, 134.

DIPTERAL. Designates a type of Ionic temple having a peristyle with a double row of columns (Samos, Ephesus), *p.* 170, 203, 215.

DIPYLON. Name of a gate on the northwest side of ancient Athens. Near the Dipylon Gate in early archaic times was a cemetery in which fragments of the oldest Attic statue have been found (National Museum, Athens), *p.* 20-22, 46, 127, 259, 270; *fig.* 18-19.

DISTYLE. Of a portico with two frontal columns.

DODONA. Town in Epirus, in the country of the Molossians, south of Janina. Site of a temple and oracle of Zeus, *p.* 148; *fig.* frontispiece, 186, 320; *maps* 441-442.

DORIANS. People who invaded Greece from the north in the 12th century and settled in the Peloponnesus and certain islands (Crete, Rhodes), and also in Doris on the southwest coast of Asia Minor, *p.* 6, 15, 22, 24, 28, 110, 131-132, 141, 145, 158, 175, 203, 263, 268, 276, 279, 357.

DORIC. One of the great orders or styles of Greek architecture, characterized by the fluted column with no base, the capital with a smooth echinus, and an entablature with a frieze of triglyphs and metopes, *p.* 4, 6, 11-12, 15-17, 19, 114, 116, 158, 161, 175-176, 182, 187-190, 195, 198, 203-216, 225-226; *fig.* 221.

DORYCLEIDAS. Spartan sculptor (early 6th century), trained by Cretans, and brother of Medon, *p.* 26.

DOURIS. Prolific Attic red-figure cup painter (first quarter of 5th century). Nearly 300 works by him are known, 39 of them signed, *p.* 352-354; *fig.* 405-407.

DREROS. Site of an archaic town in Crete, *p.* 4, 12; *maps* 441, 444.

ECHINUS. The convex moulding that forms the transition between the column shaft and the abacus carrying the architrave, *p.* 11, 17, 174-175, 189, 205, 210, 215.

EGG-AND-DART. Carved or painted ornament on the Ionic cymatium, *p.* 174-175, 196, 198, 202-203, 210, 212.

EGYPT. Country of northeastern Africa watered by the Nile, one of the cradles of civilization. Relations with archaic Greece, *p.* IX, 3-4, 12, 20, 94, 98, 107, 126, 169, 174-175, 196; *maps* 441, 443-444.

EKPHANTOS. Corinthian painter of the 7th century. According to Pliny (*Natural History*, XXXV, 16), he was the first to colour his drawings, using pigments made from powdered potsherds, *p.* 29.

ELEA or VELIA (South Italy), *map* 443.

ENDOIOS. Athenian sculptor and painter (second half of 6th century), known from several signatures and written references to him. A seated Athena, badly damaged, is probably his work (Acropolis Museum), *p.* 251.

ENNEASTYLE. Designates a peripteral temple with nine columns at the front, *p.* 206.

ENTABLATURE. The superstructure of the temple carried by the columns. It consists of three parts: architrave, frieze, and cornice, *p.* 11-12, 14, 16-17, 171, 176, 183, 187, 189-190, 195, 198, 202-204, 206, 210, 212, 216; *fig.* 236, 239, 250, 262, 267.

ENTASIS. The slight convex curve given to the Doric column to correct the optical illusion that would result if its sides were perfectly straight. The column tapers upward so that the reduction of diameter is most marked in the upper third of the shaft, *p.* 204, 210.

EOS. Personification of Dawn; sister of Helios and Selene. By Tithonus she had a son, Memnon, king of the Ethiopians, who died at Troy, *p.* 99, 354; *fig.* 109, 407.

EPHESUS. City of Ionia on the Aegean, at the mouth of the Cayster, which flourished in the archaic period. It maintained good relations with Croesus, who in the mid-6th century contributed to the erection of the Temple of Artemis, one of the largest in the Greek world, designed by Cretan architects, *p.* 135, 158, 169-171, 173-174, 196, 198, 201-203, 213; *fig.* 164; *maps* 441-442, 444; Artemision, *p.* 158, 169-171, 198, 201, 203, 213; *fig.* 208-209, 425.

EPICLES, *p.* 16.

EPICTETOS. Painter of Attic red-figure cups and plates (last quarter of 6th century). About 100 works have been identified, 40 of them signed. He was above all the painter of young men, *p.* 317, 319-320; *fig.* 365, 367.

EPIDAMNUS. Town in Illyria (Roman Dyrrhachium, modern Durazzo), *p.* 192.

EPISTYLE. See ARCHITRAVE.

ERETRIA. Coast town of Euboea. Site of the temple of Apollo Daphnephoros, whose west pediment is extant (Amazonomachy, last quarter of 6th century), *p.* 93, 239, 245; *fig.* 281; *maps* 441-444.

ERGASTINAI. Girls of noble Athenian families who wove the peplos offered to Athena every four years during the Panathenaic festival. They are represented on the Parthenon frieze, *p.* 249.

ERGOTIMOS. Attic potter (second quarter of 6th century). Seven signed works are known, including both large vases and cups, *p.* 61, 63; *fig.* 6, 64-69.

ERICHTHONIUS or ERECHTHEUS. Early Attic hero, son of Hephaestus and Gaia, brought up by Athena. With Cecrops he was umpire in the dispute between Poseidon and Athena for the possession of Attica. He was worshiped on the Acropolis in the Erechtheion, which housed his tomb, *p.* 263; *fig.* 305.

ERIPHYLE. Wife of the seer Amphiaraus. Bribed by Polynices with the necklace of Harmonia, she forced her husband to take part in the expedition of the Seven against Thebes, although he knew it would prove fatal to him, *p.* 71.

ETRURIA. Ancient land of western Italy, which traded extensively with the Greeks in the archaic period, *p.* 34, 52, 71, 81, 93-94, 96, 98, 173, 190, 306, 308, 315; *fig.* 35-36, 108; *maps* 441, 443-444.

EUBOEA. Greek island off Boeotia and Attica, *p.* 93, *fig.* 101; *maps* 441-444.

EUMARES. Athenian painter (6th century) who introduced more variety in the attitudes of men and women, *p.* 29.

EUPHORBUS. Trojan hero killed by Menelaus, *p.* 36; *fig.* 38.

EUPHRONIOS. One of the most prolific of Attic red-figure artists of the severe style. He had a long career, first as a vase painter in the last two decades of the 6th century (80 vases of all types, 15 with his signature), then as a master potter throughout the first quarter of the 5th century (10 vases by him are signed as potter), *p.* 320-327, 329, 331, 333, 343; *fig.* 369-374.

EURIPIDES (c. 480-406). Athenian tragic poet who wrote nearly 100 plays; 18 are extant, and the titles of 74 are known, *p.* 145.

EUROPA. Daughter of Agenor, king of Phoenicia. Zeus, in the form of a white bull, carried her off while she was playing on a beach with her attendants. Mother of Minos, Sarpedon, and Rhadamanthus, *fig.* 131.

EURYSTHEUS. King of Tiryns and Mycenae, chosen by the Pythia to set the tasks Heracles had to perform as a purification for shedding his children's blood. Eurystheus lived in fear of the return of his mighty cousin, *p.* 98, 345; *fig.* 106, 393.

EURYTION. Geryon's herdsman. With bow and arrow Heracles killed first him, then his master, *p.* 82.

EURYTIOS or EURYTOS. King of Oechalia in Thessaly, father of Iole, with whom Heracles fell in love. He taught the hero to use the bow, *p.* 42, 349; *fig.* 44.

EUTHYDIKOS. Man who dedicated Kore 686 on the Acropolis of Athens (c. 590), *p.* 270, 276; *fig.* 317.

EUTHYMIDES. Attic vase painter. About 20 large red-figure vases by him are known, ranging in date from about 520 to 500; seven bear his signature as painter, *p.* 326-329, 331, 333, 336; *fig.* 375-377.

EXEDRA. A semicircular or rectangular recess with a bench, standing on a platform with one or two steps. The bench may also serve as a socle for statues, *p.* 6.

EXEKIAS. Perhaps the most characteristic Attic black-figure vase painter in the third quarter of the 6th century. Both painter and potter (11 vases bear his signature as potter); 23 vases of various shapes were decorated by him (only two are signed). He influenced an important group of painters of large vases (Group E), *p.* 68, 87, 99-106, 297, 300, 302, 304, 325-326, 354; *fig.* 110-116.

EXERGUE. Space on coin or medal, usually on the reverse below the central part of the design.

FASCIAE. Plain horizontal bands on the front of the Ionic architrave, *p.* 196, 198, 202.

FILLET. Narrow, decorative raised band serving as a division between larger mouldings, *p.* 174, 189, 203.

FOUNDRY PAINTER. Attic red-figure cup painter (c. 480), in the manner of the Brygos Painter. His work comprises 38 items, *p.* 356; *fig.* 409.

FRANÇOIS VASE. Attic volute krater, the work of Ergotimos and Kleitias, discovered in 1845 A.D. near Chiusi (Etruria) by the painter Alessandro François, *p.* 59-65, 71, 74, 87, 113; *fig.* 6, 64-69.

FRIEZE. Central division of the entablature, between architrave and cornice, consisting of alternating metopes and triglyphs (Doric order) or a carved or moulded course (Ionic order), *p.* 6, 11-12, 17, 52, 56, 59, 63, 65, 67, 71-72, 81, 85, 107, 113, 158, 161-165, 168, 175-176. 183-184, 187, 189-190, 192, 195, 197-198, 202, 210-213, 215-216, 245, 251, 259, 284, 353; *fig.* 13, 198-200, 202-207, 221, 225.

GANYMEDE. Son of Tros and Callirrhoe, a beautiful Trojan boy. Carried off by Zeus, who had taken the form of an eagle, he became cup bearer to the gods in Olympus, *p.* 317; *fig.* 363.

GAUL, *p.* ix.

GEISON. Projection of the corona protecting a Doric or Ionic entablature, *p.* 192.

GELA. Greek city in Sicily with a treasury at Olympia, *p.* 187, 192, 198; *fig.* 230; *maps* 441, 443-444.

GENELEOS. Samian sculptor, a contemporary of the anonymous sculptor of the Hera dedicated by Cheramyes (c. 560). He carved a family group for the sanctuary of Hera, Samos, *p.* 135, 157.

GERYON. Three-headed, three-bodied monster, grandson of Poseidon, son of Chrysaor and Callirrhoe. King of the island of Erytheia in the stream of Ocean and owner of herds of cattle, which Heracles drove off after he had killed Geryon, *p.* 82, 85, 325; *fig.* 86-87, 373.

GIANTS. Sons of Uranus (Heaven) and Gaia (Earth), vanquished by the Olympians, whose power they sought to usurp, *p.* 114, 163, 235; *fig.* 204, 276-277, 308.

GIGANTOMACHY. Legendary battle between the gods of Olympus and the giants, children of Gaia (Earth). One of the favourite subjects of Greek art: vase paintings, frieze of the Siphnian Treasury at Delphi, decoration of the Hecatompedon on the Acropolis of Athens, *p.* 114, 162-164, 235, 238, 256; *fig.* 202-204.

GORDION. Ancient city of Phrygia on the Anatolian plateau. Its ruins stand near the village of Yassihöyük, some 30 miles southwest of Ankara, *p.* 175, 198; *maps* 441, 444.

GORGON. There were three Gorgons — Stheno, Euryale, and Medusa — daughters of a sea god. Only Medusa was mortal, and she is generally referred to as the Gorgon. With Athena's help Perseus cut off her head; from her trunk sprang Chrysaor and the winged horse Pegasus. This theme is represented on the pediment of the Temple of Artemis, Corfu, and on the metopes of Temple C, Selinus, and of the Silaris temple, *p.* 17, 26, 32, 48, 52, 63, 114, 148, 176, 184, 187, 202; *fig.* 16, 53, 133, 184.

GORGONEION. Carved or painted mask of the Gorgon's head, in terra-cotta or stone, *p.* 16, 148, 176, 187; *fig.* 185.

GORGON PAINTER. Painter of large black-figure Attic vases (first quarter of 6th century). Some 30 works are attributed to him, *p.* 52; *fig.* 53, 55.

GORTYN (Crete), *map* 441.

GRAVE MONUMENTS, *fig.* 189-190, 358.

GRIFFIN. A fabulous animal having the head and wings of an eagle and the body and hind quarters of a lion, *fig.* 26, 130.

GUTTAE. Droplike, cone-shaped ornaments decorating the Doric architrave and the underside of the corona. See MUTULE, *p.* 12, 183, 211.

HADRIAN. Roman emperor (A.D. 117-138), *p.* 216.

HAGELADAS. Sculptor of Argos, whose career began at the end of the 6th century. He was considered in antiquity as the master of Pheidias, Myron, and Polycleitos, *p.* 276.

HALICARNASSUS. Dorian city in Caria (Asia Minor) on the north side of the Ceramic Gulf. Birthplace of Herodotus, *p.* 287; *maps* 441, 444.

HARPIES. Two winged genii, tormentors of King Phineus, the host of the Argonauts. The harpies were driven off and rendered powerless by the Boreads, *p.* 48; *fig.* 52.

HEADER. In masonry, a stone laid with its end toward the face of the wall, *p.* 196.

HECATOMPEDON. Greek term for any temple measuring 100 feet in length, *p.* 4, 14, 114, 215, 254, 259, 268; *fig.* 276-277.

HECTOR. Son of Priam and Hecuba, husband of Andromache, and the leading Trojan warrior. He was finally slain by Achilles, who left his body unburied until Priam prevailed on him to yield it up, *p.* 82, 326-327, 349; *fig.* 38, 88, 375, 400.

HECUBA. Wife of Priam and mother of (among others) Hector, Paris, Cassandra, and Troilus, *p.* 327; *fig.* 375.

HEIDELBERG PAINTER. Decorator of about 60 Attic black-figure cups between 570 and 550, heralding the style of the Amasis Painter, *p.* 59, 86; *fig.* 63.

HELEN. Daughter of Zeus and Leda, she was the most beautiful woman in Greece. First carried off by Theseus and his friend Pirithous. After marrying Menelaus, she was induced by Paris to flee with him to Troy. After the fall of Troy, her beauty disarmed her husband's anger, *p.* 82, 85, 329, 331, 352; *fig.* 88, 377, 403.

HELLADIC PERIOD. The pre-Hellenic period of culture in mainland Greece (c. 2700-1100 B.C.), *p.* 4.

HEPHAESTUS. God of fire, son of Zeus and Hera. Cast out of Olympus, he was brought back by Dionysus, who had made him drunk, *p.* 63.

HERA. Sister and wife of Zeus, queen of Olympian gods. She pursued with vindictive hatred the women beloved of Zeus and the children born of his intrigues, particularly Heracles. She sided against the Trojans because, in the beauty contest with Athena and Aphrodite, Paris did not award the prize to her, *p.* 6, 9, 12, 14, 24, 26, 44, 113, 118, 126-127, 135, 137, 157, 169-170, 187-188, 192, 198, 202-204, 212, 231, 251, 265, 270; *fig.* 1, 4-5, 25, 124, 163, 230, 238, 240-246, 249-250, 306.

HERACLES. Greatest of Greek heroes, son of Zeus and Alcmene, forced to execute twelve labours imposed by Eurystheus. Most often represented in archaic art are his exploits with the Nemean lion, the Lernean hydra, the Erymanthian boar, the hind of Ceryneia, the Stymphalian birds, the Cretan bull, Cerberus, and Geryon. In the course of these adventures he defeated the Centaurs, friends of Pholus; killed Cycnus,

son of Ares; forced Nereus to show him the way to the garden of the Hesperides; crushed the giant Antaeus, son of Earth; killed the king Busiris; and delivered Prometheus. He also captured the Cercopes; struggled with Apollo for the Delphic tripod; and killed the centaur Nessos, which led to his death. But he was admitted to the ranks of the gods and introduced into Olympus by his patroness, Athena, *p.* 24, 39-40, 44, 46, 48, 52, 82, 98, 113-114, 118, 158, 161, 164, 184, 189, 192, 284, 287-288, 301, 317, 320, 325, 331, 340; *fig.* 39-40, 44, 47, 50, 86, 99, 106-107, 124-125, 135-136, 198-199, 295, 329-330, 334, 337, 339-340, 345, 355, 361-362, 368-369, 373, 379, 390, 393.

HERAION. Sanctuary of Hera, at Olympia in particular. See HERA.

HERMES. Son of Zeus and Maia, messenger of Zeus, and god of shepherds and flocks. Stone pillars surmounted by his bust, called herms, stood in ancient times on street corners or on the wayside, *p.* 157, 252, 263; *fig.* 194, 204-205, 291, 305, 355.

HERODOTUS. Greek historian (c. 485-420), called the Father of History, born at Halicarnassus. His work covers the archaic period and deals with the relations of Greece with the East, *p.* 24, 276.

HESIOD. Greek poet of Boeotia (late 8th century), author of the *Theogony* and the *Works and Days, p.* x.

HESTIA. Goddess of the hearth, daughter of Cronus and Rhea; sister of Zeus and Hera, *fig.* 363.

HEXAPOLIS (DORIAN). Association of six Dorian colonies: Halicarnassus, Cnidus, and Cos on the southwestern coast of Asia Minor, and Ialysos, Lindos, and Cameiros on the island of Rhodes, *p.* 28.

HEXASTYLE. Of a portico with six frontal columns.

HIMATION. Garment draped over the chiton or, in the case of men, often worn next to the skin, *p.* 99, 101.

HIMERA (Sicily), *p.* 82; *maps* 441, 444.

HIPPIAS. Elder son of Pisistratus, he succeeded his father as tyrant of Attica in 528, till forced into exile in 510. Died in 490, *p.* 151, 249.

HIPPOKLEAS, *p.* 268.

HIPPOLYTUS. A play by Euripides featuring Phaedra, a worshipper of Aphrodite (goddess of love), and Hippolytus, who is attached to the cult of Artemis (goddess of chastity), *p.* 145.

HIPPONAX. Greek poet of Ephesus (mid-6th century), author of satirical poems, *p.* 152.

HIP ROOF. The roof at the far end of a rectangular plan, opposite the pediment, *p.* 6, 190.

HOMER. Greatest of epic poets, generally thought today to have been a native of one of the Ionian towns and to have lived in the 9th century B.C. He gave final shape to the epic poems traditionally ascribed to him, *p.* IX, 52, 56, 65, 126, 135, 289.

HOPLITES. Citizens of any town who possessed sufficient resources to equip themselves at their own expense and serve in the heavy infantry. The panoply of the hoplite included the bronze helmet, breastplate, and greaves, and shield, spear, and sword. The hoplites fought in serried ranks and formed a phalanx, *p.* 31-32, 59; *fig.* 30, 359.

HOPLITODROMOS. Runner armed as a hoplite, represented on an Athenian votive stele or gravestone, *p.* 259-260, *fig.* 301.

HORAE. Divinities associated with the four seasons, daughters of Zeus and Themis. They ensured the keeping of the divine order and acted in Olympus as attendants of the greater gods, *p.* 74.

HYDRA. Hydra of Lerna, a monster killed by Heracles. This exploit is represented on the oldest pediment from the Acropolis of Athens, *p.* 113; *fig.* 216.

HYDRIA. Three-handled water pot. Attic black-figure hydriai between 530 and 510 often represent women going to the fountain with their hydriai, *p.* 74, 94, 96, 98, 300, 302, 304-305, 336, 345; *fig.* 79, 102-103, 105-107, 271, 344-349, 386.

HYMN. Poem or choral lyric in honour of gods or heroes. See STESICHORUS.

HYPNOS. Sleep personified, twin brother of Thanatos, Death. Represented in the form of a winged genius, *p.* 320; *fig.* 368.

IBERIA. Ancient name of Spain, *p.* IX.

ICARIA (Sporades), *maps* 441-442.

ICTINOS. Athenian architect whom Pericles and Pheidias entrusted with the design of the Parthenon. He also worked at Eleusis and perhaps at Bassae (Temple of Apollo), *p.* 176.

ILIAD. Greek epic poem traditionally attributed to Homer, telling of the anger of Achilles and its consequences during the Trojan War, *p.* 128, 145, 162-163.

ILIUPERSIS ('Sack of Troy'). Lost poem of the epic cycle forming a sequel to the *Iliad*. The fall of Troy inspired some dramatic compositions from Attic vase painters, who concentrated on certain episodes: the slaying of Priam by Neoptolemus, the violence done to Cassandra, the flight of Aeneas, and the meeting of Helen and Menelaus, *p.* 68, 336, 349, 351; *fig.* 73, 386, 401.

IMBRASOS. Stream in Samos beside which stood the Heraion (south of the present-day town of Tigani), *p.* 14.

IMBROS (North Aegean), *map* 442.

INSCRIPTION PAINTER. Initiator of the Chalcidian wares at Rhegium. Some 30 works are attributed to him, painted between about 550 and 530, all of outstanding quality, *p.* 85; *fig.* 86-87, 90.

INTRODUCTION PEDIMENT. See CORCYRA.

IOLE. Daughter of Eurytus, king of Oechalia. Heracles fell in love with her and, when her father would not let him have her, carried her off, thus arousing the jealousy of Deianira, *fig.* 44.

IONIAN. Designating the inhabitants or arts of Ionia (Ionian islands and central part of the west coast of Asia Minor), *p.* X, 15, 26, 28, 82, 85, 87, 89-90, 93-99, 101-102, 110, 112, 123-148, 158, 161, 169-170, 173, 175, 188, 203, 215-216, 233, 235, 245, 249-251, 254, 263, 265-266, 268, 270, 297-298, 305, 317, 329, 345, 357; *fig.* 102-108.

IONIANISM. Designating the character of Ionian art, *p.* 132, 135, 214, 233, 245, 266, 268, 279.

IONIC. One of the great orders of Greek architecture, characterized by the fluted column on a moulded base and the capital with horizontal volutes, *p.* 4, 12-15, 19, 158, 171, 173-175, 189, 195, 198, 203, 206, 211-213, 215-216, 221, 259, 357; *fig.* 248.

IOS (Cyclades), *map* 442.

IPHITUS. Son of Eurytus, brother of Iole and friend of Heracles, *fig.* 44.

ISMENE. Daughter of Oedipus and Jocasta, and sister of Antigone. Killed by Tydeus who surprised her with her lover during the expedition of the Seven against Thebes, *p.* 74; *fig.* 78.

ISTHMUS. Neck of land 4 miles wide between the Saronic and Corinthian gulfs, cut by a canal accessible to small ships. Famous for the sanctuary of Poseidon, where the Isthmian games were celebrated every two years, *p.* 175.

ISTRIA. Milesian colony on the Black Sea, south of the mouths of the Danube, founded about the middle of the 7th century, *p.* 126; *maps* 441, 443-444.

ITALY, *p.* IX, 81, 94, 116, 173, 175-176, 188, 211; *fig.* 103.

ITHACA (Ionian Islands), *map* 442.

JACOBSEN (Carl) (1842-1914). Founder of the Ny Carlsberg Glyptothek in Copenhagen; his name is linked with a kouros head in this museum, *p.* 153, 280; *fig.* 188.

KANTHAROS. Drinking cup with two vertical handles rising well above the brim. Probably an imitation of a metal original, it is often represented in the hands of Dionysus, *p.* 65, 69, 340; *fig.* 72, 75, 358.

KAROUZOS (Christos). Greek archaeologist (1926-1967), *p.* VII, 267.

KAVALLA (Thrace), *maps* 441, 444.

KERAMEIKOS. The potters' quarter of Athens, *p.* 112, 123, 256.

KERAMOS (Asia Minor), *p.* 126.

KITION (Cyprus), *maps* 441, 444.

KLEITIAS. One of the finest Attic black-figure vase painters of the second quarter of the 6th century. Only 16 works by him are known, *p.* 61-63, 65, 68, 90; *fig.* 6, 64-69.

KLEOPHRADES PAINTER. The most original painter of large redfigure Attic vases in the first quarter of the 5th century. One of the 107 vases attributed to him bears the signature of Epictetos, doubtless this artist's real name (Epictetos II), the same as that of the cup painter of the previous generation. He also decorated a series of black-figure Panathenaic amphorae, *p.* 336, 338, 340, 346; *fig.* 385-388.

KLOPEDHI. Site of an ancient town in the island of Mytilene (Lesbos), whose ruins stand near the centre of the island, 2 miles from Kaloni, p. 173; maps 441, 444.

KNOSSOS. Chief city of ancient Crete, p. 12.

KORE (plural, KORAI). Term designating either the goddess Persephone, daughter of Zeus and Demeter, or the draped female statues of the archaic period, p. 19, 110, 112, 143, 145, 161, 196, 202, 233, 235, 239, 249, 266, 268, 270, 276, 280, 329; Delphi kore, fig. 278; Kore 594, fig. 282; Kore 643, p. 249; fig. 286-287; Kore 670, p. 245, 249, 270; fig. 283-284; Kore 671, p. 233, 251; fig. 273-274; Kore 673, p. 254; Kore 674, p. 270, 280; fig. 313, 315; Kore 675, p. 245; fig. 285; Kore 679 (Peplos kore), p. 108-110, 112, 127, 145, 152, 245; fig. 119-120; Kore 681 ('Antenor kore'), p. 235; fig. 275; Kore 682, p. 233; fig. 272; Kore 684, p. 276; fig. 316; Kore 685, fig. 289; Kore 686, p. 270, 276; fig. 317; Kore 696, p. 270, 276; fig. 314; Lyons kore, p. 110, 143; fig. 121.

KOUROS (plural, KOUROI). Term designating the statues of nude youths in sanctuaries and cemeteries of the archaic period, p. 19-20, 22, 112, 126-128, 131, 154, 156, 158, 233, 245, 249, 251, 267-268, 270, 283; fig. 309, 326; Actium kouros, p. 128; fig. 146; Agrigentum kouros, p. 267; fig. 312; Ceos kouros, p. 154; fig. 191; Melos kouros, p. 132; fig. 150; New York kouros, p. 22; fig. 20; Paros kouros, p. 132; fig. 151; Ptoion kouros, p. 156; fig. 192; Samos kouroi, p. 126-127; fig. 141-143; Sounion kouroi, p. 131; fig. 21-22; Tenea kouros, p. 128, 131; fig. 147-148; Thasos kouros, p. 132; fig. 149; Thera kouros, p. 126; fig. 140; Volomandra kouros, p. 127-128, 131-132, 233; fig. 144-145.

KOUROTROPHOS. See MOTHER GODDESS.

KRATER. Fairly large vase in which wine was mixed with water at meal times, p. 42, 50, 52, 67, 71-72, 148; fig. 40, 49, 54, 184; Calyx krater. Krater with a wide, flaring mouth, which appears in Attic pottery about 530, p. 39, 72, 106, 320-323, 327, 329, 336, 340; fig. 39, 41, 369-371, 385; Column krater. Narrow-necked krater with small columnar handles. This shape is of Corinthian origin, p. 42, 72, 74, 82, 85, 308, 310, 349; fig. 44, 46, 76-77, 88, 354;

Spouted krater, p. 48, 50, 52; fig. 51-52; Volute krater. Krater of tall, slender proportions, with upright handles ending in volutes. The earliest example is the François Vase. This shape reappears in Attica after 530, p. 61, 65, 71, 74; fig. 64-69.

KREPIS. The stepped platform on which the temple stands, p. 16, 175-176, 210; fig. 14, 215, 235, 263.

LABYRINTH. An intricate structure or maze, from the complex design of the Cretan palace where Theseus, seeking out the Minotaur, would have lost his way but for the clue of thread provided by Ariadne, p. 169.

LACONIA. Southern part of the Peloponnesus, centring on the valley of the Eurotas (capital Sparta), p. 40, 148; map 442.

LACONIAN. Designating the art or region of the southern Peloponnesus ruled by Sparta, p. 22, 26, 76-81, 116, 145, 147-148; fig. 42, 81-85.

LA COSTE-MESSELIÈRE (Pierre de). French archaeologist (born 1894), p. 284.

LAPHRION. Sanctuary of Artemis Laphria on the territory of the town of Calydon (Aetolia). Its ruins lie 8 miles east of Missolonghi, on the Gulf of Corinth, p. 176; fig. 217-218.

LAPITHS. A mythical people of Thessaly. At the marriage of the Lapith Pirithous, they were attacked by the Centaurs, who had also been invited. In the fight that ensued, the Centaurs suffered heavy losses, p. 63; fig. 65.

LARISA. Ancient town in Aeolis (Asia Minor), situated on an acropolis overlooking the valley of the Hermos. Site of archaic buildings that have yielded a rich series of architectural terra-cottas. Its ruins lie 27 miles northwest of Izmir (Smyrna), p. 173-174, 198; fig. 211, 213; maps 441, 444.

LEAGROS GROUP. A group of over 300 Attic black-figure vases of 520-510, chiefly hydriai, also amphorae, and a few lekythoi, showing a marked stylistic kinship. They may have been produced by a single workshop employing several painters, p. 262, 302, 304; fig. 346-347.

LEAVES. Decorative element in Ionic mouldings, which also appears in the Aeolic capital and the palm capital, p. 174, 192, 196, 210, 212, 215.

LEKANIS. A rather shallow bowl with a lid, p. 59; fig. 62.

LEKYTHOS. A small, narrow-necked, cylindrical vase for oil or perfumes. It appears in Attic pottery in the second quarter of the 6th century, but was most widely diffused after 530, p. 87-88, 310; fig. 92-95.

LEMNOS (North Aegean), map 442.

LEONIDAS. King of Sparta, who commanded the small force of Spartan soldiers at Thermopylae (480). The statue to which his name was given (fig. 338) is actually earlier, p. 145.

LESBIAN CYMATIUM. The cyma reversa moulding carved with leaf-and-dart, p. 198, 202-203, 210.

LESBOS. See MYTILENE.

LETO. Daughter of the Titans Coeus and Phoebe. Loved by Zeus and persecuted by Hera, she gave birth to Apollo and Artemis in the island of Delos, which thus became a sacred island (Homeric Hymn to the Delian Apollo), p. 239, 329, 331; fig. 378.

LEUCADIA (Ionian Islands), maps 441-444.

LEUCIPPIDES. Phoebe and Hilaeira, daughters of Leucippus, king of Messenia. They were carried off by the Dioscuri, Castor and Polydeuces, fig. 134.

LIBATION TABLE. Altar slab on which drink offerings were poured out as a ritual act, p. 12.

LIBYA (North Africa), p. 20, 126; maps 441, 443.

LITTLE MASTER CUPS. A special type of black-figure cup with miniature decoration, p. 87-90, 317; fig. 98-100.

LOCRI. Ancient city of South Italy, founded in the early 7th century by Greeks from Locris. Neighbouring towns were Croton and Sybaris. Its ruins lie 2 miles southwest of present-day Locri, p. 175, 203; maps 441, 443-444.

LOTUS FLOWER. Used with the palmette as a characteristic ornamental motif of the Ionic style, p. 189, 197, 203; fig. 175, 234.

LOUTROPHOROS. Tall ritual (wedding or funerary) vase with high neck and flaring mouth, *p.* 46, 93; *fig.* 101.

LYDIA. Kingdom of Asia Minor (capital Sardis), between Mysia and Caria, bounded on the west by the Aegean. Flourished under the dynasty of the Mermnadae until the Persian conquest (546), *p.* 28, 135, 169, 171, 356; *maps* 441, 443-444.

LYDOS. Attic black-figure painter (active c. 570-540). His work includes over 85 items, of uneven quality; only two vases bear his signature, *p.* 67-68, 104; *fig.* 71, 73.

LYGDAMIS. Tyrant of Naxos (c. 545-525), ally of Polycrates of Samos and Pisistratos, whom he helped to return to Athens, *p.* 151.

LYSEAS GRAVESTONE, *p.* 312; *fig.* 358.

LYSIPPIDES PAINTER. Painter of large Attic black-figure vases (last quarter of 6th century). Out of 23 known works, seven were executed in collaboration with the Andokides Painter, *p.* 297; *fig.* 340.

MACRON. Attic red-figure cup painter (first quarter of 5th century). His large output (nearly 350 items) shows a certain monotony; only a skyphos and a pyxis bear his signature. He worked constantly for the same potter; 26 of his works are signed by the potter Hieron, *p.* 335, 351-352; *fig.* 402-404.

MADRID PAINTER. Only eight works are attributed to this excellent painter of large black-figure Attic vases (last quarter of 6th century), *p.* 301; *fig.* 345.

MAENADS. The female attendants of Dionysus, possessed by an orgiastic frenzy, *p.* 88-89, 331, 338, 340, 346, 349-351; *fig.* 97, 380, 387-388, 397-398, 404.

MAGNA GRAECIA. Name given to the Greek colonies in South Italy, *p.* 81, 116, 122, 148, 176, 252, 263; *maps* 441, 443-444.

MALOPHOROS. Epithet of Demeter, goddess of fertility, one of the principal divinities of Selinus. She had a sanctuary near that city, *p.* 265; *fig.* 307.

MALTA, *maps* 441, 443-444.

MARATHON. Plain on the northeast coast of Attica, where the Athenians won their first great victory over the Persians (490), *p.* 226, 276, 284, 351.

MARINELLA. Village to the east of Selinus (Sicily), *p.* 176.

MASSALIA or MASSILIA. Greek colony founded by the Phocaeans (c. 600) on the site of present-day Marseilles, *p.* 196-197, 203; *fig.* 232-233, 235; *maps* 441, 443-444.

MAZI. Village in Attica, *p.* 145; *fig.* 177.

MEANDER. The Greek fret or key pattern. An ornamental design with many windings, formed by broken lines at right angles to one another. So called by analogy with the windings of the river Maeander in Asia Minor (present-day Menderes), *p.* 189, 192; *fig.* 227.

MEDITERRANEAN, *p.* IX, 357.

MEDMA. Greek city founded by the Locrians, near the present-day village of Rosarno (Calabria), *fig.* 172; *map* 441.

MEDON. Brother of Dorycleidas and one of the Spartan sculptors who worked at Olympia in the first half of the 6th century, *p.* 26.

MEGACLES. Member of the Athenian family of the Alcmaeonids, whose name may have figured on an Attic gravestone (c. 530), *p.* 123, 153; *fig.* 189.

MEGARA. Greek town on the isthmus of Corinth, *p.* 192; *fig.* 32.

MEGARA HYBLAEA. Dorian colony in Sicily, north of Syracuse. The current excavations have shown that the city flourished in the 7th century, thus accounting for the development of an interesting local art. It was then that settlers from Megara Hyblaea founded Selinus; *p.* 31-32, 141; *fig.* 170, 171; *maps* 441, 443.

MEGARON. Term used by Homer for the main hall of a palace. Used by modern archaeologists to designate the room with a hearth in Mycenaean palaces and any room plan with vestibule and façade on the short side, as distinguished from a plan with the entrance on the long side, *p.* 4, 213.

MEGIDDO (Palestine), *p.* 174; *maps* 441, 444.

MELOS (MILO). Island in the southern Cyclades, peopled by the Dorians of Laconia. The origin of Orientalizing pottery of the so-called 'Melian' style, the finest examples of which have been found on Melos, is still uncertain (Naxos? Paros?), but it is unlikely to have been made on Melos itself, *p.* 39, 89, 132; *fig.* 150; *maps* 441-443.

MEMNON. Son of Eos (Dawn) and Tithonus, and brother of Priam. King of the Ethiopians, he came to the aid of the Trojans but was killed by Achilles. His body was retrieved by Eos, *p.* 99, 354; *fig.* 109, 407.

MENELAUS. Homeric hero, king of Sparta, son of Atreus and Aerope, brother of Agamemnon and husband of Helen, *p.* 145, 351; *fig.* 38, 403.

MESOGEIA. Southern district of Attica where several kouroi have been found, *p.* 22, 267.

MESOPOTAMIA, *p.* 4.

MESSAPIANS. Captive women from Messapia (present-day Calabria and Apulia in South Italy), subject of a votive monument of the Tarentines at Delphi, executed about 490 by Hageladas of Argos, *p.* 276.

METAGENES. See CHERSIPHRON.

METAPONTUM. Greek city of South Italy on the Gulf of Tarentum, *p.* 118, 192; *maps* 441, 443-444.

METOPE. Square or rectangular panel between the triglyphs on a Doric frieze, first decorated with paintings, then with relief carvings, *p.* 6, 9, 11, 17, 32, 88, 107, 114, 116, 118, 158, 176, 183-184, 189-190, 212-213, 215, 265-266, 284, 312; Delphi, Athenian Treasury, *p.* 284; *fig.* 328-331; Delphi, Sicyonian Treasury, *p.* 11, 116; *fig.* 128; Poseidonia, Silaris Treasury, *p.* 189-190, 212; *fig.* 132, 134-135, 137, 306; Selinus, Temple C, *p.* 118, 183-184; *fig.* 131, 133, 136, 221-222; Selinus, Temple E, *p.* 266; Selinus, Temple F, *p.* 213, 266; *fig.* 308; Thermon, Temple of Apollo, *p.* 107, 312; *fig.* 33-34; Thermon, Temple C, *p.* 6, 32, 107, 312; *fig.* 3.

METROON. Temple of the Mother of the Gods (Olympia), *fig.* 432.

MIKON. Athenian painter and sculptor (active c. 470-440). His painting of the Battle of Marathon in the Stoa Poikile in Athens was famous. He collaborated with Polygnotos in decorating the Theseion, *p.* 31.

MILETUS. One of the leading Ionian cities on the west coast of Asia Minor, on the Latmic gulf, near Didyma. Taken and destroyed by the Persians (494), *p.* 126-127, 132, 137-138, 158, 173, 175, 201, 251; *fig.* 298; *maps* 441-444.

MILO. See MELOS.

MINOAN. Designates the Cretan civilization of the second millennium, symbolized by the palace of Minos at Knossos, *p.* 12.

MINOTAUR. Cretan monster with the body of a man and the head of a bull, the offspring of Pasiphae, wife of Minos. Shut up in the Labyrinth, he devoured every year seven Athenian youths and seven maidens, until he was killed by Theseus, *p.* 61, 317; *fig.* 365.

MONODENDRI. Cape in Asia Minor, west of the peninsula of Mycale, north of Miletus, *p.* 175; *fig.* 214.

MONOLITHIC. Designates any architectural member carved from a single block of stone (column, entablature, etc.), *p.* 16, 175, 188.

MONOPTEROS. Temple of circular or rectangular plan having a roof supported by a single colonnade, but with no cella, *p.* 11, 195, 198; *fig.* 10.

MOSCHOPHOROS. See CALF-BEARER.

MOTHER GODDESS, *p.* 141; *fig.* 170, 171.

MUTULE. Thin flat rectangular slab adorning the underside of the Doric corona and carrying three rows of guttae (4, 5, or 6 guttae in each row), *p.* 12, 183, 211.

MYCENAE. Ancient city of Argolis (Peloponnesus), centre of the Mycenaean civilization of Bronze Age Greece, *p.* IX, 4, 6, 29; *maps* 441, 444.

MYLASA. Capital of ancient Caria (Asia Minor), *p.* 126.

MYRON. Attic sculptor whose career began about 450. Said to have been a pupil of Hageladas of Argos, *p.* 276.

MYSON. Painter of large red-figure Attic vases (first quarter of 5th century). His signature, as painter and potter, appears on only one of the 83 works attributed to him, *p.* 356; *fig.* 408.

MYTILENE. Chief city of Lesbos, its name often designating the whole island. Birthplace of the poets Sappho and Alcaeus and the lawgiver Pittacus, *p.* 107, 173-174; *maps* 441, 443-444.

NAISKOS. Small edifice, generally votive or funerary, designed like a miniature temple or given a temple façade, *p.* 201.

NAOS. The part of the temple enclosed by the peristyle, consisting of porch, cella, and opisthodomos, *p.* 181; *fig.* 254, 258.

NAPLES, *maps* 441, 443-444.

NAUCRATIS. Trading station founded in the 7th century by the Milesians on the Canopic mouth of the Nile, near Sais (present-day Kom Gaef), *p.* x, 126, 169, 175; *maps* 441, 443-444.

NAXOS. The largest island of the Cyclades. Marble quarried here was used in large quantities in the archaic period, *p.* 12, 20-21, 123, 132, 143, 151, 154, 174, 198, 283; *fig.* 138, 326; *maps* 441-444.

NEANDRIA. Town in the Troad, about 30 miles south of Troy, known for its archaic temple (early 6th century) with a central colonnade and Aeolic capitals, *p.* 6, 173-174; *fig.* 212; *maps* 441, 444.

NEARCHOS. Athenian painter and potter (second quarter of 6th century). Only five of his vases are known, all of very fine workmanship; three bear his signature as potter. He was the father of the potter Tleson, *p.* 65, 67-68; *fig.* 72.

NEAR EAST, *p.* IX, X, 12, 94, 110, 173, 356.

NECKING. Part of the Doric capital connecting the echinus with the shaft of the column, sometimes forming a leaf moulding, *p.* 17, 203, 215.

NEOPTOLEMUS. Son of Achilles and Deidameia. After his father's death he joined the Greeks at Troy and took part in the sack of the city, when he killed young Astyanax, *p.* 353; *fig.* 62, 405.

NEREIDS. Sea divinities, the fifty daughters of Nereus and Doris, and sisters of Thetis, *p.* 74; *fig.* 79, 198.

NEREUS. Sea god, the 'Old Man of the Sea', having the gift of metamorphosis, *fig.* 362.

NESIOTES. Sculptor who with Critios executed the second group of Tyrannicides (after 480), *p.* 283.

NESSOS. Centaur who tried to assault Deianeira and was killed by her husband, Heracles. He was the cause of Heracles' death, *p.* 46, 48; *fig.* 50.

NESTOR. Homeric king of Pylos in the Peloponnesus. Represented in the *Iliad* and the *Odyssey* as the type of old man with ripe experience and wise counsel, *p.* 145.

NETTOS PAINTER. Thirteen vases, mostly large ones, are attributed to this typical representative of the Late Proto-Attic style (last quarter of 7th century). His name piece is the large amphora in Athens showing the fight between Heracles and Nessus (Nessos in Greek, Nettos in Attic dialect), *p.* 46, 48, 50, 52; *fig.* 50-52, 54.

NIKANDRE. Naxian lady who at Delos in the 7th century dedicated a statue of Artemis (National Museum, Athens), *p.* 21.

NIKE. Greek name of the goddess of victory, *p.* 143, 239; *fig.* 173, 279.

NIKOSTHENES. Athenian potter (active c. 530-500) who made a large number of amphorae of a peculiar type, much appreciated by the Etruscans, and many cups. At least 112 vases bear his signature as master potter, *p.* 308; *fig.* 352, 353, 368.

NIKOSTHENES PAINTER. Attic red-figure cup painter who, between 520 and 500, worked for the potters Nikosthenes and Pamphaios. About 35 works are attributed to him, *p.* 320; *fig.* 352, 353, 368.

NOLA (South Italy), *maps* 441, 443.

ODYSSEUS. Son of Laertes, king of Ithaca, famous for using his wits and his resourcefulness, which enabled him to make his way home from Troy after ten years' wandering. Shut up in the cave of Polyphemus, he contrived to escape. Cf. POLYPHEMUS, *p.* 310, 353; *fig.* 354, 405.

ODYSSEY. Epic poem attributed to Homer, describing the adventures of Odysseus after the fall of Troy, until his return to Ithaca, *p.* x, 108.

OIKOS. Designates any building of small size or the main room of a house. Cf. DELOS, *p.* 12, 14, 198.

OINOCHOE. Standard wine jug, with a round or (usually) trefoil mouth and an upright handle, *p.* 87, 308, 340; *fig.* 353.

OLBIA. Black Sea colony of Miletus, founded in the mid-7th century at the junction of the Dnieper and the Bug. A connecting link between the Greeks and Scythians, *p.* 126.

OLPE. Elongated wine jug, usually with a round mouth. This type of vase is most common at Corinth, *p.* 40, 87; *fig.* 30, 31, 43.

OLTOS. Attic red-figure painter (last quarter of 6th century) who decorated some 140 vases of various shapes, but mostly cups; two of them are signed, *p.* 315, 317, 320; *fig.* 361-364.

OLYMPIA. Sanctuary of Zeus in Elis, where other cults were also celebrated, notably that of Hera. Here, every four years, the Olympic games brought delegations from all over the Greek world; the traditional date of their foundation is 776 B.C., *p.* IX, 4, 6, 9, 20, 26, 137, 145, 147, 187, 192, 198, 231, 270, 276, 291; *fig.* 25, 129, 167, 178-181, 319, 321, 432; Temple of Hera, *p.* 6, 9, 26, 192; *fig.* 1, 4-5, 433; Treasuries, *p.* 187, 192, 198; *fig.* 230.

OLYMPIEION. Temple of the Olympian Zeus (Olympia, Athens, Agrigentum, *p.* 20, 187, 215.

OLYMPUS. Mountain range in Thessaly, in Greek mythology the home of the gods, *p.* 63, 113; *fig.* 99, 124.

ONATAS. Aeginetan sculptor (first half of 5th century), famous as a bronze caster, *p.* 276.

ONESIMOS. Attic red-figure cup painter whose large output is datable to 500-480. At least 137 works have been identified, only one of them signed. He worked for Euphronios after the latter had set up as a master potter; eight cups by Onesimos bear the signature of Euphronios as potter, *p.* 343, 345; *fig.* 392-395.

OPISTHODOMOS. In the Greek temple the closed space behind the cella, separated from it by the extension of the walls and, usually, two columns *in antis*, *p.* 16, 176, 212, 214, 221.

ORESTEIA. Story of Orestes, son of Agamemnon and Clytemnestra, a subject treated in a poem of the Epic Cycle, the *Nostoi* ('Returns'). Title of a trilogy by Aeschylus, produced in 458, *p.* 122.

ORIENTALIZING PERIOD. Period of Greek art (8th and 7th centuries) when the Geometric style gave place to works showing Oriental influence, *p.* x, 4, 19, 31, 34, 36, 40, 44, 52, 55, 63, 70, 88, 113.

ORNITHE. Name of a girl represented in a group of statues by Genelaos of Samos, *fig.* 165.

ORTHOSTATS. Large slabs forming the first course of a classical wall, higher and more massive than the following courses of headers and stretchers, *p.* 3; *fig.* 235.

ORTYGIA. Island in the harbour of Syracuse (Sicily) where the original Greek colony was founded (8th century), *p.* 12, 15.

ORVIETO (Central Italy), *maps* 441, 443.

PAESTUM. See POSEIDONIA.

PAINTER OF ACROPOLIS 606. Painter of large black-figure Attic vases (second quarter of 6th century). Seven works are attributed to him, *p.* 65; *fig.* 70.

PAINTER OF THE CAERETAN HYDRIAI. Ionian painter working in Etruria, who decorated over 30 hydriai, nearly all found at Caere, with a great variety of themes. His work is datable to between about 535 and 510, *p.* 96, 98; *fig.* 105-107.

PALAESTRA. School for wrestling and other sports, gymnasium, *p.* 259, 262-263.

PALMETTE. Conventionalized palm-leaf ornament, *p.* 39, 63, 70, 153, 173, 175, 189, 196-197, 203, 340; *fig.* 234.

PAPHLAGONIA (Asia Minor), *p.* 174; *maps* 441, 444.

PARAPET. Low protecting wall at the edge of a platform, *p.* 12, 198, 213.

PARIS. Youngest son of Priam and Hecuba, chosen as judge in the beauty contest between Aphrodite, Athena, and Hera. He gave the prize to Aphrodite, and she rewarded him with the love of Helen of Sparta, whom he carried off to Troy, *p.* 82, 161, 351; *fig.* 88, 101, 205-206, 402.

PAROS. Ionian island of the Cyclades, whose quarries provided ancient Greek sculptors with their finest marble. Art centre and home of the lyric poet Archilochus, *p.* 20, 132, 168, 215, 267; *fig.* 151; *maps* 441-442, 444.

PARTHENON. The most famous temple of Athens, built on the Acropolis between 447 and 432 and richly decorated, *p.* 113, 116, 176, 213, 221, 249, 254, 259, 284.

PATROCLUS. Friend of Achilles, slain by Hector before Troy. Funeral games were held in his honour, in which all the Greek leaders took part, *p.* 56, 61, 333; *fig.* 58, 362.

PAUSANIAS. Greek traveller and geographer (2nd century A.D.) whose *Description of Greece* is a valuable source book for topography and monuments, *p.* 9, 145, 192.

PAYNE (Humfry). English archaeologist (1902-1936). With G. M. Young, he produced the first large, carefully illustrated publication of the archaic marbles discovered on the Acropolis of Athens, *p.* 108; *fig.* 118, 122.

PAZARLI. Ancient town of eastern Phrygia (Asia Minor), known for the painted terra-cotta revetments of its buildings, *p.* 175, 198; *maps* 441, 444.

PEDIMENT. The triangular space forming the gable of a building, limited by the sloping sides of the roof and the horizontal line of the entablature, *p.* 6, 17, 26, 107, 113-114, 116, 158, 175-176, 187, 190, 192, 215, 226, 235, 238-239, 245, 256, 262, 268, 279, 284, 288-289, 291, 336; Aegina, Temple of Aphaia, *p.* 226, 279, 288-289, 291; *fig.* 332-335, 337; Athens, Acropolis, *p.* 158, 176, 235; *fig.* 124, 216; Athens, Hecatompedon, *fig.* 276-277; Athens, old Temple of Athena, *p.* 114, 215; *fig.* 125-127; Corcyra, Temple of Artemis, *p.* 17, 26, 107, 113-114, 148; *fig.* 16, 24; Delphi, Siphnian Treasury, *fig.* 199; Delphi, Temple of Apollo, *fig.* 278; Eretria, Temple of Apollo, *fig.* 281.

PEGASUS. Winged horse born of Poseidon and the Gorgon at the same time as Chrysaor, *p.* 26.

PEITHAGORAS. Tyrant of Selinus (early 6th century), *p.* 213.

PEITHINOS. Attic red-figure cup painter (late 6th century). Only two cups bear his signature, *p.* 335; *fig.* 383-384.

PELEUS. A mortal, Peleus overcame the resistance of the sea goddess Thetis and made her his wife. All the gods (except Eris) attended the wedding of Peleus and Thetis, who later gave birth to Achilles, *p.* 56, 61, 63, 74; *fig.* 59-60, 67, 384.

PELOPION. Tomb or site of the tomb of Pelops in the sanctuary of Zeus at Olympia, *p.* 231.

PELOPONNESUS. Mountainous peninsula forming the southernmost part of mainland Greece, below the isthmus of Corinth. Most of it, in the south and east, was peopled by the Dorians, *p.* 6, 20, 141, 148, 157, 252, 276, 283; *maps* 441-444.

PENTELIC. Marble from Mount Pentelicus, Greece, *p.* 154.

PENTHESILEA. Queen of the Amazons, daughter of Ares. Helping the Trojans in the Trojan War, she was killed by Achilles, who fell in love with her just as he struck her down, *p.* 102, 304; *fig.* 113, 347.

PEPARETHOS (Aegean island), *maps* 441-442.

PEPLOS. A 'Dorian' garment worn by women. It was a large rectangular piece of drapery fastened over the shoulders by two clasps (fibulae), *p.* 110, 127, 145, 152, 245; *fig.* 119-120.

PEPLOS KORE. See KORE.

PERACHORA. Peninsula facing Corinth, site of a temple of Hera, *p.* 4; *maps* 441, 444.

PERGAMON. Ancient city in Mysia, near the west coast of Asia Minor, *p.* 251.

PERIANDER. Tyrant of Corinth (c. 625-585), *p.* 16.

PERIPTERAL. Designates a temple whose naos is surrounded by an outer colonnade consisting of a single row of columns, in contradistinction to dipteral, *p.* 6, 14-15, 170, 176, 204, 210, 212-213, 215.

PERISTYLE. The outer colonnade surrounding a temple, *p.* 4, 6, 14, 16, 170, 187-188, 201-203, 206, 210, 213-215, 221; *fig.* 220.

PERSEUS. Son of Zeus and Danae. He attacked the Gorgons and killed the only one of the three sisters who was mortal. The other two pursued him, but he escaped and brought the Gorgon Medusa's head to his protectress, Athena, *p.* 32, 48, 52, 184; *fig.* 33-34, 51, 53, 133.

PERSIA. The Persian empire founded by Cyrus in the mid-6th century stretched from the Aegean Sea to the Indus and from Thrace to Egypt. It threatened the very existence of Greece, of Athens in particular, in the reigns of Darius and Xerxes (Ionian revolt, 499-494, and first and second Persian wars, 490 and 480-478), *p.* 94, 201, 203, 233, 262, 267, 276, 356-357.

PHAEDRIADES. The two cliffs that tower above the sacred precinct at Delphi, *p.* 231.

PHAISTOS (Crete), *p.* 12.

PHARSALUS. Town in southeastern Thessaly, 41 miles north of Lamia. One of the great centres of the region in the archaic period, *p.* 56; *maps* 441-442.

PHEIDIAS. The greatest Greek sculptor of the 5th century. A friend of Pericles, he is said to have exercised a general supervision over the building of the Parthenon, *p.* 20, 113, 276.

PHILIPPEION. Monument dedicated by Philip of Macedon in the sanctuary at Olympia, *fig.* 432.

PHINTIAS. Painter of large red-figure Attic vases (last quarter of 6th century). His work, of excellent quality, is not very well known: only 14 of his vases are preserved, six with his signature as painter (three of these he also signed as potter), *p.* 329, 331, 333; *fig.* 378-380.

PHOCAEA. Greek city on the west coast of Asia Minor, *p.* 174; *maps* 441-444.

PHOENICIANS. Race of western Semites who settled on the coast of Syria, *p.* x, 174; *maps* 441, 443-444.

PHOENIX. King of the Dolopians, who had acted as Achilles' tutor and became his counsellor during the Trojan War, *p.* 145.

PHOLUS. Kindly Centaur, son of Silenus, who invited Heracles into his cave and gave him meat and wine. The other Centaurs, attracted by the smell of the wine, attacked the hero, who drove them off. Pholus was accidentally killed in the fight, *p.* 44, 189.

PHRYGIA. Region of central Asia Minor, extending from the Sangarios to the Halys, *p.* x, 169, 174; *maps* 441, 444.

PHRYNOS PAINTER. Highly talented artist of Little Master cups who worked for the potter Phrynos (c. 550-530). Six black-figure vases by him are known, *p.* 87, 90; *fig.* 98-99.

PILASTER. An engaged pillar projecting only slightly from a wall, *p.* 173-174.

PINACOTHECA. The building forming the north wing of the Propylaea on the Acropolis of Athens and decorated with paintings on wooden panels, the work of the best artists of the 5th century, *p.* 31.

PINDAR (518-438). The great lyric poet of ancient Greece, born near Thebes (Boeotia), known chiefly for his triumphal odes celebrating athletic victories at the Panhellenic games, *p.* 24, 267-268.

PIRAEUS. The port of Athens, on the Saronic gulf, built originally by Themistocles (mid-5th century) and linked with Athens by the Long Walls, *p.* 283-284; *fig.* 325, 327.

PISÉ. Beaten earth mixed with pebbles and chopped straw, used for building, *p.* 3.

PISISTRATIDS. Sons or descendants of Pisistratos, *p.* 154, 216, 233-234.

PISISTRATOS. Tyrant of Athens, born in Athens in the early 6th century. He gained power in 560. Twice expelled by the aristocrats, he re-established himself in power about 542 (?) with his two sons Hippias and Hipparchus, and died in 527. He built roads and public buildings and encouraged art and literature, *p.* 114, 151, 153-154, 215, 298.

PITHOS. Large terra-cotta jar, half buried and used for storage. Eurystheus took refuge in a bronze pithos, *p.* 98, 345; *fig.* 106, 393.

PITSA. Locality west of Sicyon (Peloponnesus) near the south coast of the Gulf of Corinth, some 30 miles west of Corinth. Among the votive offerings discovered here in a cave were some painted wooden panels, one of them dedicated to the nymphs, *p.* 312; *fig.* 357.

PITTACUS (c. 650-c. 560). Lawgiver of Mytilene in Lesbos in the early 6th century. Numbered with his contemporary Solon among the Seven Sages of Greece, *p.* 107.

PLATFORM. See KREPIS.

PLINY THE ELDER (A.D. 23-79). Latin author of an encyclopaedic *Natural History* in 37 books (Book xxxv deals with the history of painting in antiquity). In command of the Roman fleet at Misenum in A.D. 79, he was killed at Stabiae in the great eruption of Vesuvius that overwhelmed Pompeii and Herculaneum, *p.* 29, 42, 169.

POIKILE. The Stoa Poikile (Painted Portico) was built about 470 on the north side of the Agora of Athens and decorated by the best painters of the day with large compositions on wooden panels fastened to the walls, *p.* 31.

POLOS. High cylindrical headdress worn by certain goddesses or their priestesses. Refers in particular to the headdress of the caryatids of Delphi, which is better termed calathos ('basket'), *p.* 270; *fig.* 29.

POLYCLEITOS. Sculptor of the school of Argos (second half of the 5th century), *p.* 24, 268.

POLYCRATES. Tyrant of Samos who gained power about 533, with the help of Lygdamis of Naxos, against the Samian aristocracy. He surrounded himself with poets, musicians, and artists. Treacherously captured by Oroetes, Persian governor of Lydia, and put to death by crucifixion in 522. He sponsored the building of the second great temple of Hera (c. 530-525), *p.* 20, 151, 157-158, 202-203, 215; *fig.* 240.

POLYDEUCES (POLLUX). See DIOSCURI.

POLYGNOTOS. Greek painter from Thasos, son of Aglaophon. Settled in Athens and painted large compositions (c. 470-440). He was honoured with Athenian citizenship. He also decorated the Lesche of the Cnidians at Delphi, *p.* 31.

[POLY]MEDES OF ARGOS. Argive sculptor who carved the Argive twins Cleobis and Biton, dedicated at Delphi about 580. The first half of his name, broken off in the inscription, is restored [Poly], *p.* 24.

POLYPHEMUS. Man-eating Cyclops, son of Poseidon and the nymph Thoosa, who shut up Odysseus and his companions in his cave, devouring several of them each day. The survivors blinded him and made their escape by clinging to the bellies of the sheep he let out to pasture, *p.* 310; *fig.* 354.

'PONTIC' VASES. Group of black-figure vases of Ionian style, so called by a 19th-century archaeologist because some of them show figures in Asiatic costumes similar to those of the Scythians around the Black Sea (Pontus Euxinus). Actually these are Etruscan vases of the third quarter of the 6th century (chiefly amphorae and oino-

choai), produced under the influence of Ionian vase painters established in Etruria, *p.* 98; *fig.* 108.

PONTUS EUXINUS. Greek name for the Black Sea, *p.* 126.

PORINOS. Architect who worked with Antistates and Callaeschros on the Temple of Olympian Zeus in Athens, *p.* 216.

POROS. A soft limestone quarried in the southern part of the Gulf of Corinth (Corinth, Sicyon), *p.* 3, 11, 195.

POSEIDON. One of the leading gods of Olympus, son of Cronus and Rhea, brother of Zeus, and god of the sea and of water generally. He had a sanctuary at Cape Sounion in Attica, where fragments of colossal kouroi have been found, *p.* 22, 175; *fig.* 214, 242.

POSEIDONIA (PAESTUM). Ancient Greek city in South Italy (Lucania). See also SILARIS, *p.* 6, 118, 176, 188-190, 192, 203-213, 266; Silaris Heraion, *p.* 212, 265-266; *fig.* 249-250, 306, 436-437, 439; Silaris Treasury, *p.* 6, 12, 118, 187-190, 198, 212-213; *fig.* 132, 134-135, 137, 224-228, 440; Temple of Athena, *p.* 176, 210-212; *fig.* 247-248; Temple of Hera I ('Basilica'), *p.* 204-210; *fig.* 238, 242-246, 438; Temple of Hera II ('Temple of Poseidon'), *p.* 263, 266; *fig.* 242.

PRIAM. Last king of Troy, son of Laomedon, husband of Hecuba and father of (among others) Hector, Paris, Cassandra, and Troilus. An old man when Troy fell and was sacked, he was killed by Neoptolemus, son of Achilles, *p.* 59, 63, 68, 327, 338, 349; *fig.* 62, 68, 375, 386, 400.

PRIAM PAINTER. Black-figure painter in Athens (last quarter of 6th century) who decorated about 30 amphorae and hydriai, sometimes using original themes, *p.* 306; *fig.* 350-351.

PRINIAS. Present name of a site in central Crete with small 7th century temples; carvings from them are now in the Herakleion Museum. The ancient name was Rhyzenia, *p.* 4, 12, 107; *fig.* 11-13; *maps* 441, 444.

PROMACHOS. Epithet of Athena in her role as a warrior, *p.* 280; *fig.* 324.

PROMETHEUS. Son of the Titan Iapetus who gave fire to mankind

against the will of Zeus. In punishment he was chained to a rock in the Caucasus, where every day an eagle devoured his liver (every night it grew again). He was released by Heracles, *p.* 52, 76, 80; *fig.* 85.

PRONAOS. The porch or anteroom of a Greek temple, giving access to the cella. It is closed off on the sides by the extension of the cella walls; in front it usually has two columns *in antis*, *p.* 6, 14, 16, 161, 170, 176, 181, 192, 203, 212-213, 221.

PROPYLAEUM. Entrance gateway to building or enclosure (usually temple precincts), *p.* 231.

PROSTYLE. Designates a temple porch whose columns, instead of being between the antae (i.e. *in antis*), are set forward in front of them, *p.* 211, 213-214.

PRYTANEUM or PRYTANEION. The official headquarters of the administrative organization of a Greek city, *p.* 231; *fig.* 432.

PSIAX. Attic painter of black-figure (25 works) and red-figure vases (13 works), active in the years 530-510. Two of his red-figure vases bear his signature as painter, *p.* 300; *fig.* 344.

PSYKTER. A wine cooler: a small krater shaped like a top, filled with snow or ice water and placed in a large krater full of wine. In some amphorae with double walls (psykter amphorae), the outer compartment fulfilled the same purpose, *p.* 85, 353; *fig.* 90, 406.

PTERON. Peripteral colonnade, *p.* 214.

PTOION. Sanctuary and oracle of Apollo Ptoios in Boeotia, north of Thebes. Several kouroi have been found here, *p.* 20, 154, 156, 245; *fig.* 192; *map* 441.

PYGMIES. Mythical tribe of small men living in the south of Egypt, *p.* 63.

PYTHIAN GAMES. Games held at Delphi every four years in honour of the Pythian Apollo. One of the four great Panhellenic contests. Pindar's Pythian odes were written in honour of the winners of these games, *p.* 108.

PYXIS. Cylindrical or spherical terracotta box with a lid. This vase shape was most popular with Corinthian potters, who gave it a great variety of forms, *p.* 59, 164; *fig.* 61.

QUADRIGA. A chariot drawn by four horses harnessed abreast; especially as represented in sculpture or on coins, *p.* 52, 72, 184, 239; *fig.* 199, 205, 207, 222, 344.

RADIATING SCHEME. Timber roof frame in which the rafters form a circular pattern round a crownpiece, *p.* 190; *fig.* 229.

RAMPIN (Georges). French diplomat of the 19th century, who in 1896 bequeathed to the Louvre the horseman's head that bears his name. The corresponding body (Acropolis Museum, Athens) was identified by Humfry Payne, *p.* 107-108, 110, 112, 127, 254; *fig.* 118, 122.

RAMPIN MASTER, *p.* 108-110, 127, 145, 152, 156-157, 235, 253, 268; *fig.* 118, 122.

RED-FIGURE. Painting technique invented by Attic vase painters about 530, possibly by the Andokides Painter: the background was painted in black, and the figures were reserved in the red colour of the clay ground, *p.* 89, 106, 259, 295-298, 300-301, 305, 310, 312, 315, 320, 333, 351, 357.

RESERVED. In vase decoration, when a figure or detail is left in the colour of the clay, unpainted, it is said to be reserved, *p.* 96.

RHEGIUM. Chalcidian colony in South Italy (present-day Reggio di Calabria), on the Strait of Messina, founded in the 8th century. Chalcidian vases were no doubt made there in the second half of the 6th century, *p.* 81, 148; *maps* 441, 443.

RHODES. Aegean island, largest of the Dodecanese, colonized by the Dorians, *p.* 28, 36-39, 126; *fig.* 37-38; *maps* 441-444. Jewellery, *p.* 28; *fig.* 26-28.

RHOIKOS. Architect, engineer, sculptor, and bronze founder of Samos who, with Theodoros, built the first large dipteral temple in the Heraion (first half of the 6th century), *p.* 127, 169, 202; *fig.* 241.

[RH]OMBOS. The man who dedicated the statue of the Calf-Bearer on the Acropolis of Athens. The first two letters of the name (Greek P = RH) have been restored, *p.* 112.

RIDGE POLE. The top horizontal member of a sloping roof, against which the upper ends of the rafters are fixed, *p.* 190.

ROME, *p.* 128, 135; *maps* 441, 443.

ROSETTE. Conventionalized circular floral motif, *p.* 81, 171, 189, 196, 211; *fig.* 26.

SABOUROFF HEAD. Archaic head (Berlin Museum) taking its name from a former owner, *p.* 151-153; *fig.* 187.

SALAMIS. Island in the Saronic gulf, west of Piraeus, where the Greeks won their great naval victory over the Persians (480), *p.* 276, 351, 357.

SAMOS. Large Ionian island off the coast of Caria (Asia Minor), famous for its sanctuary of Hera: Ionic temple rebuilt under the tyrant Polycrates and many sculptures, *p.* 4, 12, 14, 20, 126-127, 135, 137, 143, 145, 151, 157-158, 169-171, 196, 202-203, 205, 213, 215, 251; *fig.* 141-143, 163, 165-166, 195-196; *maps* 441-444; First Hecatompedon, *p.* 14; Second Hecatompedon, *p.* 4; *fig.* 410; Rhoikos Temple, *p.* 202; *fig.* 241, 411, 425; Polycrates Temple, *p.* 157, 215; *fig.* 240, 412-413, 425-426; Stoa, *p.* 14; *fig.* 410.

SAMOTHRACE (Aegean island), *map* 442.

SAPPHO. Lyric poetess of Lesbos (late 7th—early 6th century), *p.* 19, 107, 249.

SAPPHO PAINTER. Attic black-figure painter (early 5th century), who decorated about 60 small vases, mostly lekythoi, *p.* 308-310; *fig.* 354, 356.

SARDIS. Capital of Lydia (Asia Minor), seat of the kings of Lydia, famous for its Temple of Cybele and the remains of archaic Lydian civilization revealed by excavations. Now the Turkish village of Sari, 58 miles east of Izmir (Smyrna), *p.* 173, 175; *maps* 441, 444.

SARONIC GULF, *p.* 217.

SCOTIA. A concave moulding which, set between two torus mouldings, gives its characteristic profile to the Attic Ionic column base, *p.* 171, 196.

SCYROS (Aegean island), *map* 442.

SEKOS. Greek term for the cella of a temple. See CELLA.

SELENE. Sister of Helios, she personifies the moon, riding across the heavens in a silver chariot drawn by two horses, *p.* 349; *fig.* 399.

SELEUCIDS. Line of kings (312-64 B.C.) who reigned in the Near East and Asia Minor, *p.* 216.

SELINUS. Greek city on the south coast of Sicily (present-day Selinunte), founded by settlers from Megara Hyblaea (c. 628), *p.* 12, 16, 118, 176, 180-181, 184-189, 192, 211, 213-216, 263, 265-266; *fig.* 131; *maps* 441, 444; Demeter Malophoros sanctuary, *p.* 265; *fig.* 307; Temple C, *p.* 12, 176, 180-184, 187-189; *fig.* 133, 136, 220-223, 421; Temple D, *p.* 12, 118, 187, 211; Temple E, *p.* 266; Temple F, *p.* 213, 266; *fig.* 308, 423; Temple G (Apollonion), *p.* 213-216; *fig.* 251, 422.

SICELS or **SICULI.** An indigenous people of Sicily.

SICILY. Largest island in the Mediterranean, colonized by the Greeks from the 8th century on, *p.* 15-16, 20, 31, 81, 116, 141, 175-176, 180-182, 187, 192, 211-213, 215, 266, 357.

SICYON. Ancient Greek city in the northern Peloponnesus, on the Asopus, west of Corinth. Home of the sculptors Canachos and Aristocles of Sicyon, *p.* 29, 42, 157, 192, 195, 198, 201, 276, 312; *fig.* 7, 9-10, 194; *map* 441; Treasury at Delphi, *p.* 11, 116, 195, 198; *fig.* 8, 128.

SILARIS. Ancient name of the present river Sele in Campania (South Italy). At the Foce del Sele (mouth of the Silaris), some 6 miles from Paestum, an archaic sanctuary of Hera was discovered in the 1930's, *p.* 6, 12, 118, 184-189, 198, 212, 265-266; Heraion, *p.* 6, 12, 118, 187-188, 198, 212, 265-266; *fig.* 249-250, 306; Temple, *p.* 212; *fig.* 249-250; Treasury, *p.* 6, 12, 118, 184-190, 198, 212; *fig.* 132, 134-135, 137, 224-228.

SILENOMACHY. Name given to a mythological episode represented only on two west metopes of the 'first treasury' at the mouth of the Silaris, and treated perhaps by the poet Stesichorus: Hera pursued by the Sileni and defended by Heracles, *p.* 122.

SILENUS. Minor woodland deity associated with Dionysus, *p.* 88; *fig.* 387, 406.

SIMA. The rain gutter at the edge of the roof, forming the upper part of the entablature above the corona, *p.* 176, 215; *fig.* 217.

SIMONIDES. Greek lyric poet, native of the island of Ceos (born c. 556). He was a friend of the Pisistratid Hipparchus and wrote paeans, victory odes, dirges, and epigrams, *p.* 154.

SINOPE (Asia Minor), *maps* 441, 444.

SIPHNOS. Ionian island of the Cyclades, whose city dedicated a famous treasury at Delphi between 530 and 525, *p.* 161, 164, 168, 196-198, 245, 251, 253; *fig.* 199-207, 232, 234, 236-237.

SKYPHOS. A drinking cup, circular and deep, with two horizontal handles. This shape, of Corinthian origin, was taken up by Attic vase painters, who, however, usually preferred a shallower cup, *p.* 44, 56, 319, 346, 349, 351; *fig.* 45, 47, 54, 57, 397, 400, 403.

SKYTHES. Attic red-figure cup painter (last quarter of 6th century), with 25 known works, four bearing his signature, *p.* 310, 319, 340; *fig.* 355, 366.

SMIKROS. Painter of large red-figure Attic vases (c. 520-500). Seven works have been identified, three with his signature, *p.* 333; *fig.* 381.

SMILIS. Sculptor of Aegina, said to have worked also in Samos and at Olympia (second half of 6th century), *p.* 20.

SMYRNA. Greek city of Asia Minor (present-day Izmir, Turkey), *p.* 174; *maps* 441, 444.

SOFFIT. The underside of any architectural element, *p.* 197, 211.

SOLON. Athenian poet and statesman (c. 640-c. 560/559). Elected archon in 594-593, he reformed the Athenian constitution. Numbered among the Seven Sages, *p.* x, 52, 107, 113.

SOPHILOS. The first Attic vase painter whose name we know. Between about 590 and 570 he decorated some 40 black-figure vases, chiefly amphorae and kraters (notably dinoi); three of them are signed, *p.* 56-59, 61, 65; *fig.* 58-60.

SOSIAS PAINTER. A remarkable artist, known only from two fine red-figure cups (late 6th century), who worked for the potter Sosias, *p.* 333; *fig.* 382.

SOUNION or SUNIUM. Cape at the southern extremity of Attica, where there stood a sanctuary of Poseidon, *p.* 22, 127, 131; *fig.* 21-22.

SPARTA. Chief city of Laconia and the most powerful state in the Peloponnesus. A flourishing art centre in the archaic period, *p.* 22, 24, 26, 28, 40, 76, 78, 116, 145, 147-148, 157; *fig.* 175-176, 338; *maps* 441-444; Temple of Artemis Orthia, *p.* 147; Temple of Athena Chalkioikos, *p.* 116.

SPATA (Attica), *maps* 441-442.

SPHINX. For the Greeks, a fabulous monster with wings, a lion's body, and a woman's head, *p.* 21, 34, 40, 63, 112, 123, 153, 156, 175-176; *fig.* 36, 49, 138-139, 189-190, 193, 218.

SPINA (Emilia, Italy), *map* 443.

SPORADES (Aegean), *maps* 441-442, 444.

STAMNOS. Ovoid krater with two lateral handles. This shape appears chiefly in Attic pottery after 530, *p.* 317; *fig.* 361, 381.

STELE. An upright slab used as a gravestone or as a votive offering in the sanctuaries, *p.* 123, 153, 259-261, 310, 312; *fig.* 123, 183, 189-190, 300-301, 358.

STESICHORUS. Greek epic poet, a native of Himera in Sicily. About 600 he wrote the *Geryoneis*, telling of Heracles' exploits in the western part of the Mediterranean world, *p.* 82, 122, 135.

STOA. A building one of whose long sides is open, the wall being replaced by a row of columns, *p.* 14, 31; *fig.* 410, 432.

STRANGFORD (Percy Smythe, Viscount). English diplomat and collector (1826-1869). The kouros formerly owned by him is in the British Museum, *p.* 267-268; *fig.* 309.

STRETCHER. Masonry block placed lengthwise in a course. Coupled stretchers are characteristic of Ionian masonry, *p.* 196.

STYLOBATE. The top step of the platform, or krepis, on which the columns of the peristyle rest, *p.* 6, 14, 170, 181, 203, 215.

SYBARIS and SYBARITES. The opulent Greek city of Magna Graecia and its inhabitants. The Achaeans founded the city in 720 in the plain of the river Crathis (Crati) in Lucania, on the Gulf of Tarentum. It was destroyed by its neighbour, Croton, in 510. Some of its inhabitants sought refuge in the region of Paestum, southeast of Neapolis (Naples), *p.* 192, 266; *maps* 441, 443.

SYRACUSE. Greek colony in eastern Sicily, founded by Corinth in 733. It became the most powerful of the Sicilian cities and was adorned with fine monuments by its successive tyrants, *p.* 12, 15-16, 22, 26, 148, 175, 180, 183, 187, 192, 203; *fig.* 185, 219; *maps* 441-442, 444. Temple of Apollo (Ortygia), *p.* 12, 15-16, 175, 188; *fig.* 14-15, 420; Temple of Olympian Zeus, *p.* 187.

SYRIA, *p.* x, 174; *map* 443.

SYRIA (NEO-HITTITE). After the downfall of the Hittite empire in Anatolia at the end of the 13th century, Hittite civilization flourished anew from the 9th to the 7th century in Syria, *p.* x.

SYROPHOENICIAN ARCHITECTURE. Orientalizing style of architecture whose first manifestations occur in Syria and Phoenicia in the early first millennium, *p.* 3.

TAENIA. A smooth projecting band or fillet forming the upper termination of the architrave, *p.* 210.

TALEIDES PAINTER. Painter of black-figure amphorae and hydriai, but in a style akin to the Little Masters. He decorated about 20 vases, ten of them bearing the signature of the potter Taleides, *p.* 85, 87, 88; *fig.* 89.

TANAGRA. Village in Boeotia famous for its terra-cotta figurines, *p.* 20.

TARENTUM (Taranto). Spartan colony founded in South Italy in 708 on the gulf of the same name. Tarentum was a busy and prosperous seaport in the archaic period, handling Corinthian, Attic, and Laconian imports in considerable quantities, *p.* 40, 148, 276; *fig.* 182; *maps* 441, 443-444.

TARQUINIA. Etruscan city on the coast of Etruria, about 55 miles northwest of Rome. Closely connected with Corinth, according to ancient tradition (Demaratus of Corinth is said to have settled there and been the ancestor of the dynasty of the Tarquinii), it also imported much Attic pottery, especially after the mid-6th century. An important local school of painting developed under Greek influence; some of its late 6th- and early 5th-century tomb paintings number among the masterpieces of ancient art, *p.* 315, 317, 331, 336, 340; *fig.* 360; *maps* 441, 443.

TELAMONES. Figures of giants carrying the architrave in the intercolumniations of the Olympieion at Agrigentum, *p.* 20.

TEMENOS. The sacred precinct, whose limits were marked by boundary stones or an enclosure, *p.* 171, 176, 187, 201, 203.

TENEA. Locality near Corinth where a famous kouros was found, *p.* 128, 131; *fig.* 147, 148.

TENOS (Cyclades), *map* 442.

TERRA-COTTA PLAQUES, *p.* 6, 31-32, 34, 55, 75, 104, 175, 187-188, 190, 192, 198, 210, 310, 312; *fig.* 35-36, 71, 80, 114-115, 355-357, 359.

TERRACE. Terrace architecture has its origins in the layout of certain archaic sanctuaries. It reached its full development in the 4th and 3rd centuries, *p.* 176, 192, 195.

TEUCER. Homeric hero, son of Telamon and Hesione, and brother of Ajax, with whom he took part in the Trojan War. He was considered the most skillful bowman among the Greeks, *p.* 288.

THALES OF MILETUS. Greek philosopher, mathematician, and astronomer (first half of 6th century), a native of Miletus. He was numbered among the Seven Sages, *p.* 141.

THASOS. Island in the northern Aegean, off the coast of Thrace, colonized in the early 7th century by the Parians. Several archaic statues have been found there, also marble and terra-cotta reliefs, which decorated the gates and sanctuaries of the chief town, also called Thasos, *p.* 4, 20, 132, 174, 254; *fig.* 149, 295; *maps* 441-444.

THEBES. One of the chief cities of Boeotia and one of the oldest. Nearby stood the Temple of Apollo Ismenios, *p.* 71, 154, 156, 195, 267; *fig.* 76, 78, 192-193; *maps* 441-442.

THEMISTOCLES. Athenian statesman (c. 525-459). An influential political leader between 490 and 480, he made Athens a sea power by fitting up the harbours of Piraeus and building triremes. He forced the Greek fleet into battle at Salamis (480) and began the construction of the Long Walls, *p.* 112, 267; *fig.* 123.

THEODOROS. Architect, engineer, sculptor, and bronze founder who, with Rhoikos, built the first dipteral temple of Hera in Samos. A specialist in laying foundations in marshy ground, he was called in to lay those of the Artemision at Ephesus, *p.* 127, 145, 169.

THERA. Volcanic island of the southern Cyclades, colonized by the Spartans in the 9th century. Several archaic statues have been found there, *p.* 20, 126; *fig.* 140; *maps* 441-443.

THERMON. City in Aetolia, north of the Gulf of Corinth, famous chiefly for its sanctuary of Apollo, which flourished from the Geometric period down to the 3rd century, when it became the seat of the Aetolian League, *p.* 14, 32, 107, 312; *fig.* 3, 414; *maps* 441-442, 444; Megara, *p.* 4, 6; Temple of Apollo, *p.* 6, 32; *fig.* 33-34.

THESAUROS. See TREASURY.

THESEUS. Athenian hero, son of Poseidon and Aethra. After passing his boyhood at Troezen, he returned to Athens, ridding the country of various nuisances on the way. He killed Periphetes, Sinis, Sciron, Cercyon, and Procrustes. He also killed the Crommyonian sow, the bull of Marathon, and the Cretan Minotaur. On the way home from Crete he stopped at Delos, where the young Athenians celebrated their deliverance with joyful dances. He also defeated the Amazons, who had invaded Attica, and with his friend Pirithous carried off Helen while she was still a girl, *p.* 61, 63, 239, 245, 254, 284, 287, 317, 319, 329, 331; *fig.* 66, 281, 328, 331, 365, 377.

THETIS. A sea goddess, daughter of Nereus and Doris. She married a mortal, Peleus, and gave birth to Achilles, whom she twice provided with arms, *p.* 61, 63, 74; *fig.* 67, 384.

THIASOS. The revel-rout of mythical figures accompanying Dionysus: his wife Ariadne, the satyrs, and the maenads, *p.* 63, 338; *fig.* 387.

THISBE. Village in Boeotia, *fig.* 29; *map* 441.

THOLOS. A circular building, used for religious or funerary purposes, *p.* 11, 195; *fig.* 7, 233.

THREE MAIDENS PAINTER. Corinthian vase painter (second quarter of 6th century) who often represented three girls side by side or grouped under the same veil, *p.* 74; *fig.* 77.

THYREA. Town in Thyreatis (Peloponnesus), a region between Argos and Sparta, to which it belonged during the second half of the 6th century, *p.* 117.

TIMONIDAS. Corinthian painter (first half of 6th century) whose signature appears on a small vase and a terra-cotta plaque, *p.* 44; *fig.* 48.

TITYUS. A giant, son of Zeus, who tried to assault Leto and was killed by her children, Apollo and Artemis, *p.* 329; *fig.* 378.

TLESON. Athenian potter, son of the painter and potter Nearchos. About 60 Little Master cups, datable to about 550-530, bear his signature; some have no figure work. Then there are about 50 black-figure cups decorated by a single artist, the so-called Tleson Painter, who also decorated some of the cups signed by Tleson as potter, *p.* 87, 90; *fig.* 100.

TONDO. Circular painting, as on the inside bottom of a vessel, *p.* 76, 90, 319, 325, 333, 343, 346, 349, 354.

TORUS. Smooth or fluted convex moulding, of ellipsoidal profile, which enters into the composition of the Ionic column base and adorns the base of Ionic walls, *p.* 171, 196, 203.

TREASURY. (Greek, THESAUROS.) A small templelike structure erected in the great Panhellenic sanctuaries by various cities in token of gratitude to the divinity, *p.* 11, 116, 118, 137, 158, 164, 187-188, 192, 195-198, 212, 231.
Delphi, Athenian, *p.* 118, 226, 228, 231, 284; *fig.* 264-265, 267, 328-331; Cnidian, *p.* 196-198; *fig.* 232; Massalian, *p.* 196-197; *fig.* 232-233, 235; Sicyonian, *p.* 11, 116, 195; *fig.* 8, 10, 128; Siphnian, *p.* 161, 164, 168, 196-198, 245, 251, 253; *fig.* 199-207, 232, 234, 236-237.
Olympia, Treasury of Gela, *p.* 187, 192, 198; *fig.* 230.
Poseidonia, Silaris Treasury, *p.* 6, 12, 118, 187-190, 212; *fig.* 132, 134-135, 137, 224-228.

TRIGLYPH. Characteristic element of the Doric frieze, a thick block divided into three smooth vertical bands by two complete and two half grooves, and adorned at the top by a smooth horizontal band. The triglyphs alternate with the metopes, *p.* 6, 9, 11, 17, 176, 183, 189, 190, 210, 212, 213; *fig.* 221, 225.

TRIPOD-PYXIS. See PYXIS.

TRITON. Son of Poseidon and Amphitrite, human from the waist up, fish-shaped from the waist down. His fight with Heracles was represented several times in archaic art, *p.* 114, 158; *fig.* 125-127, 198.

TROAD. Territory surrounding the city of Troy, *p.* 175.

TROILUS. Youngest son of Priam and Hecuba. While taking his horses to a fountain, he was ambushed and killed by Achilles, *p.* 44, 61, 63, 76; *fig.* 48, 82.

TROY. City in northwestern Asia Minor near the Hellespont (Dardanelles). It was captured by the Achaeans after a siege of ten years, about 1200 B.C. Its site on the mound of Hissarlik was identified by Heinrich Schliemann in 1871, *p.* 63, 68, 85, 101, 122, 288, 291, 336, 349, 352; *fig.* 68, 73, 90, 386, 403.

TUFA. The commonest Roman building stone, formed from volcanic dust; it is porous and grey, *p.* 176, 192, 217; *fig.* 173.

TYDEUS. Aetolian hero who joined Polynices in the expedition of the Seven against Thebes. During the siege he killed Ismene, sister of Eteocles and Polynices, whom he surprised with her lover Theoclymenus, *p.* 74; *fig.* 78.

TYMPANUM. The area between the lintel of a doorway and the arch above it, *p.* 192, 226, 235, 245.

TYNDAREUS. Lacedaemonian hero, father of one of the Dioscuri, Castor, and of Clytemnestra. But Castor's brother Polydeuces (Pollux) and his sister Helen, though fathered by Zeus, are also considered the children of Tyndareus, the Tyndarides, *p.* 101; *fig.* 111.

TYRANNICIDES. Name applied to the two Athenians, Harmodius and Aristogiton, who killed Hipparchus, son of the tyrant Pisistratos. After the fall of the Pisistratid tyranny in 510, Antenor made statues of the Tyrannicides. These were carried off by the Persians in 480 and replaced by a second group executed by Critios and Nesiotes, *p.* 235, 262, 280.

TYRTAEUS. Lyric poet who lived at Sparta in the second half of the 7th century and wrote martial elegies, *p.* 145.

URARTU. Ancient region mentioned in Assyrian texts, corresponding to present-day Armenia on both sides of the Caucasus. Here a highly original civilization flourished from the 9th to the 7th century, *p.* x.

VARI. Locality in Attica, about 12 miles south of Athens. Site of an aristocratic cemetery whose grave goods include large black-figure vases dating to the last quarter of the 7th and the early 6th century, *p.* 50; *maps* 441-442.

VEII (Etruria), *maps* 441, 443.

VITRUVIUS. Roman engineer and architect (first century A.D.), author of the only complete treatise on architecture to survive from antiquity, *p.* 12, 169, 214-215.

VIX. French village on the upper Seine, 3 miles from Châtillon-sur-Seine (Côte-d'Or), where in January, 1953, a very large, richly decorated bronze krater was found. It was probably made at Tarentum in Magna Graecia, *p.* 148; *fig.* 184.

VOLOMANDRA. Site in Attica where a kouros was found (National Museum, Athens), *p.* 127-128, 131-132, 233; *fig.* 144-145.

VOLUTE. Spiral scroll on Ionic capital, *p.* 171, 173-175, 196, 202-203, 211, 259.

VOTIVE TEMPLES. Small models of temples offered as votive offerings in the sanctuaries (Heraion of Argos, Perachora, Samos), *p.* 4, 14; *fig.* 2.

VULCI (Etruria), *maps* 441, 443.

XANTHOS (Asia Minor), *map* 441.

ZANCANI MONTUORO (Paola). Italian archaeologist (born 1901), *p.* 188.

ZANOTTI BIANCO (Umberto). Italian archaeologist (born 1889), *p.* 188-189.

ZACYNTHOS (or ZANTE), *maps* 441-444.

ZEUS. Supreme god of Olympus, son of Cronus and Rhea. His most important sanctuary was at Olympia, *p.* 26, 59, 98, 113, 164, 187, 215-216, 231, 235, 279, 291; *fig.* 124, 321, 363.

Maps

THE MEDITERRANEAN BASIN

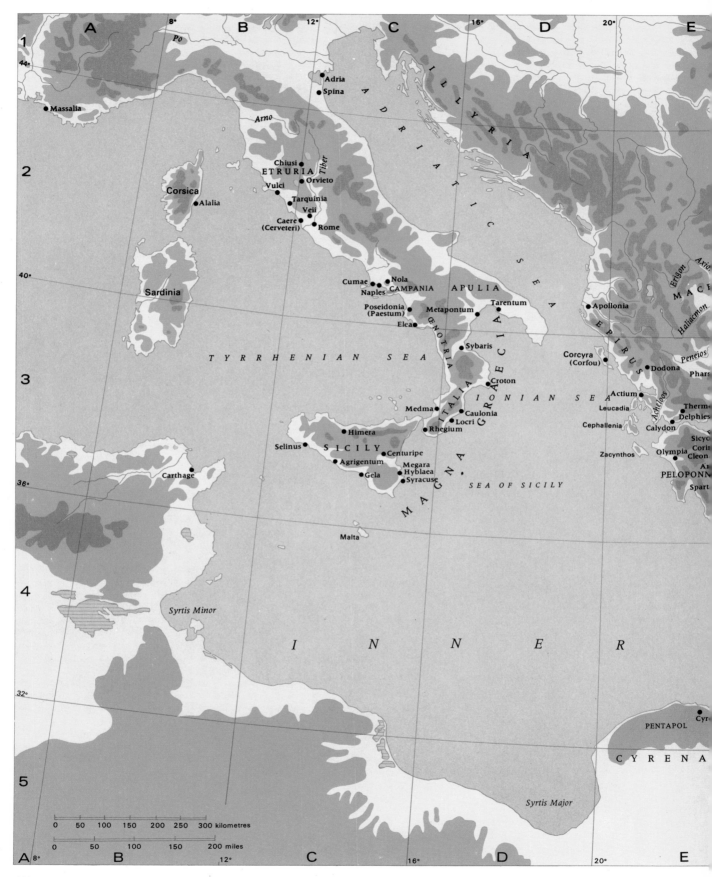

Map labels:

Po
A 1 8°
B 12°
C 16°
D 20° E 1
44°

●Adria
●Spina

●Massalia

Arno

ILLYRIA

A D R I A T I C S E A

Chiusi●
ETRURIA
Orvieto●
Vulci●
Tiber
Tarquinia●
Veii●
Caere●
(Cerveteri) ●Rome

A 2 Corsica

Alalia●

40°

Sardinia

Cumae● ●Nola
Naples● CAMPANIA APULIA
Poseidonia● ●Metapontum ●Tarentum
(Paestum)
Elea● ●Apollonia
ŒNOTRIA
MAC
●Sybaris

Erigon
Axio

Haliacmon
Corcyra● Peneios
(Corfou) ●Dodona Phars
EPIRUS

T Y R R H E N I A N S E A

I O N I A N S E A

Croton●
●Actium
Medma● Leucadia
Caulonia● Therm
●Locri Delphies
Rhegium● Cephallenia Calydon
Himera●

Selinus● S I C I L Y Zacynthos Olympia● Sicyo
Cori
Centuripe● Cleon
Agrigentum● Megara PELOPONN
Gela● Hyblaea
●Syracuse SEA OF SICILY Spart

Carthage●
36°

Malta●

Syrtis Minor

I N N E R

32°
PENTAPOL ●Cyr

C Y R E N A
A 5 B C D E

Syrtis Major

0 50 100 150 200 250 300 kilometres
0 50 100 150 200 miles

A 8° B 12° C 16° D 20° E

441. THE MEDITERRANEAN BASIN.

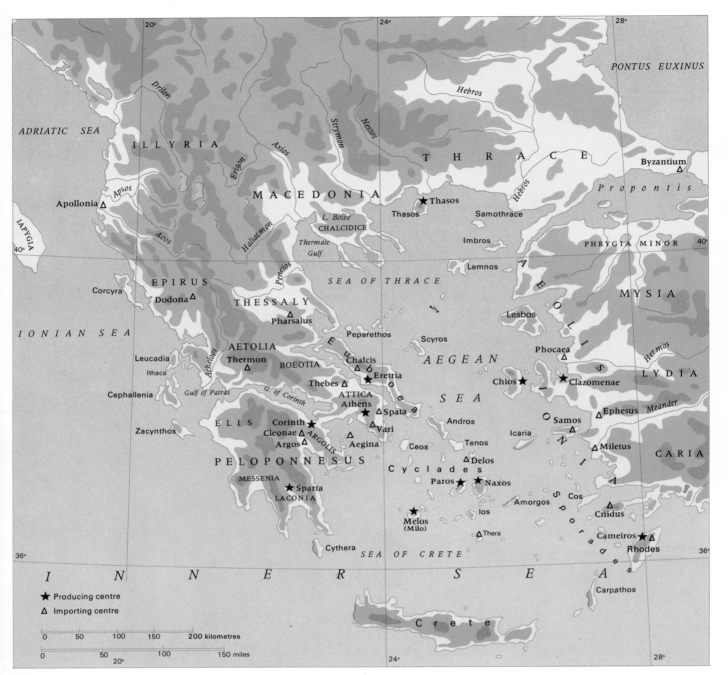

442. MAIN PRODUCING AND IMPORTING CENTRES OF GREEK POTTERY (DETAIL).

MAIN PRODUCING AND IMPORTING
CENTRES OF GREEK POTTERY

Adria	C 1	Elea (Velia)	C 2	Phocaea	F 3
Agrigentum	C 3	Eretria	E 3	Poseidonia (Paestum)	C 2
Alalia	B 2	Euboea (island)	E 3 - F 3		
Al Mina	H 3			Rhegium	C 3
Andros (island)	F 3	Gela	C 3	Rhodes	F 3 - G 3
Apollonia	D 2			Rome	C 2
Argos	E 3	Istria	G 1		
Athens	E 3			Samos (island)	F 3
		Lesbos (island)	F 3	Sparta	E 3
Byzantium	G 2	Leucadia (island)	E 3	Spina	C 1
		Locri	D 3	Sybaris	D 3
Caere (Cerveteri)	C 2			Syracuse	C 3
Carpathos (island)	F 4	Malta (island)	C 4		
Carthage	B 3	Massalia (Marseilles)	A 2		
Cephallenia (island)	E 3	Megara Hyblaea	C 3	Tarentum	D 2
Chalcis	E 3	Melos (Milo)	F 3	Tarquinia	B 2
Chios	F 3	Metapontum	D 2	Thasos (island)	F 2
Chiusi	C 2	Miletus	F 3	Thasos	F 2
Cnidus	F 3	Milo (Melos)	F 3	Thera	F 3
Corcyra (island)	D 3				
Corinth	E 3	Naples	C 2		
Croton	D 3	Naucratis	G 5	Veii	C 2
Cumae	C 2	Naxos (island)	F 3	Vulci	B 2
Cyrene	E 4	Nola	C 2		
Cythera (island)	E 3				
Delos	F 3	Orvieto	C 2	Zacynthos (island)	E 3

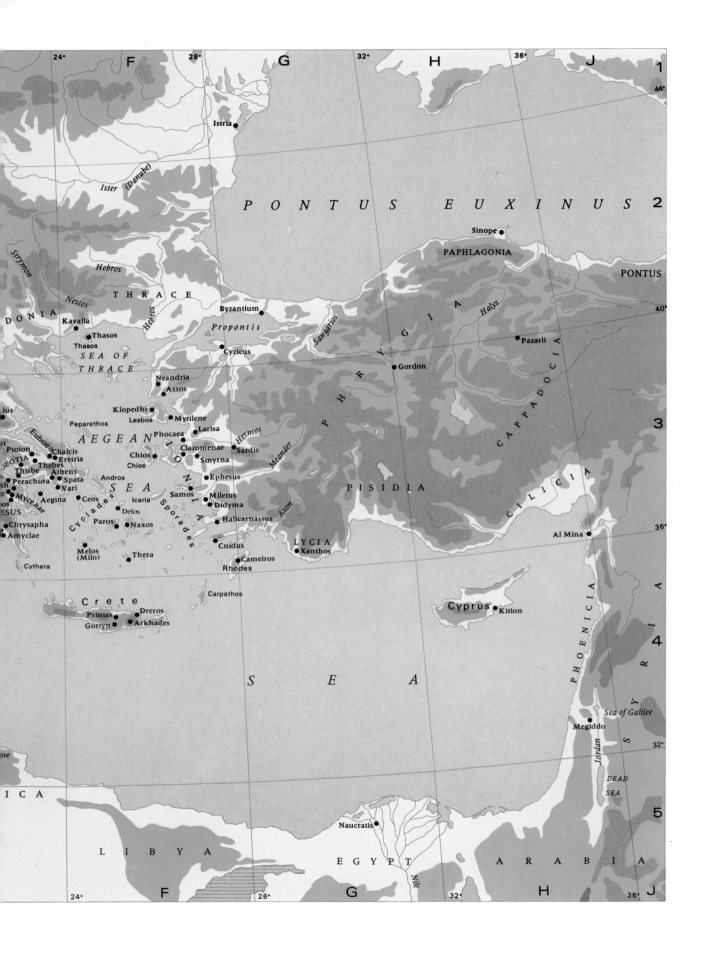

F · 24° · 28° · G · 32° · H · 36° · J · 1

44°

PONTUS EUXINUS 2

Sinope ·

PAPHLAGONIA

PONTUS

Istria ·

Ister (Danube)

Strymon

Hebros

THRACE

Nestos

Hebros

DONIA

Kavalla ·
· Thasos
Thasos

SEA OF THRACE

Propontis

Byzantium ·

Cyzicus ·

Sangarios

Halys 40°

Pazarli ·

CAPPADOCIA

Gordon ·

P · H · R · Y · G · I · A

Neandria ·
· Assos

Klopedhi ·
Lesbos
· Mytilene

Hermos

Larisa ·

AEGEAN

Peparethos

lus

Ptoion
Euboea
Chalcis
BEOTIA · Eretria
Thisbe · Thebes
Perachora · Athens
Spata
Vari
Mycenae · Aegina · Ceos
ESUS
Chrysapha
Amyclae

Phocaea ·

Chios ·
Chios

Clazomenae ·
· Sardis
· Smyrna

Meander

SEA

Andros

Cyclades

Paros
Melos
(Milo)

Icaria
Samos ·
· Ephesus
· Miletus
· Didyma

Sporades

Delos
· Naxos
· Thera

· Halicarnassus

Axon

PISIDIA

CILICIA

Cythera

· Cnidus

LYCIA
· Xanthos

Al Mina · 36°

Cameiros ·
Rhodes ·

Carpathos

Crete

Prinias ·
Gortyn ·
· Dreros
· Arkhades

Cyprus
· Kition

PHOENICIA

SYRIA

Sea of Galilee

Megiddo · 32°

Jordan

DEAD SEA

S E A

5

ne

I C A

L I B Y A

Naucratis ·

E G Y P T

Nile

A R A B I A

24° · F · 28° · G · 32° · H · 36° · J

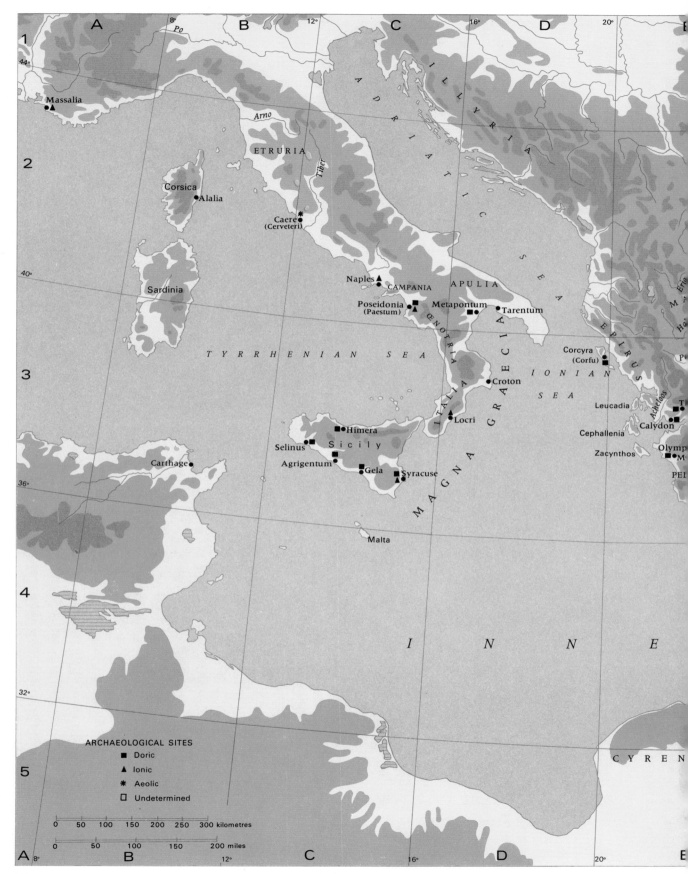

ARCHAEOLOGICAL SITES

■ Doric
▲ Ionic
✳ Aeolic
□ Undetermined

0 50 100 150 200 250 300 kilometres

0 50 100 150 200 miles

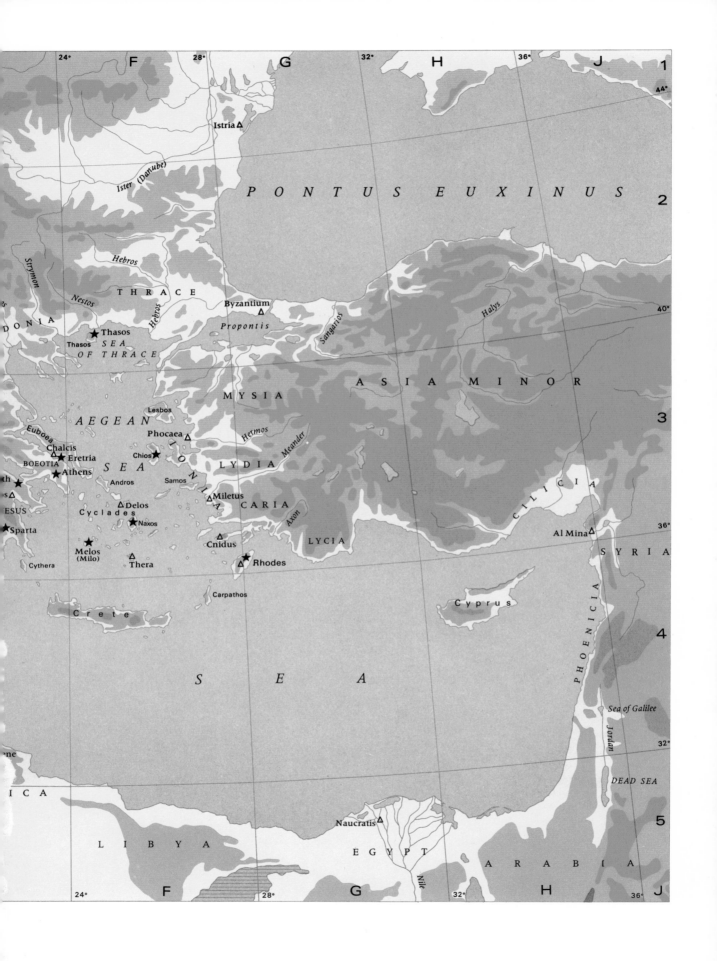

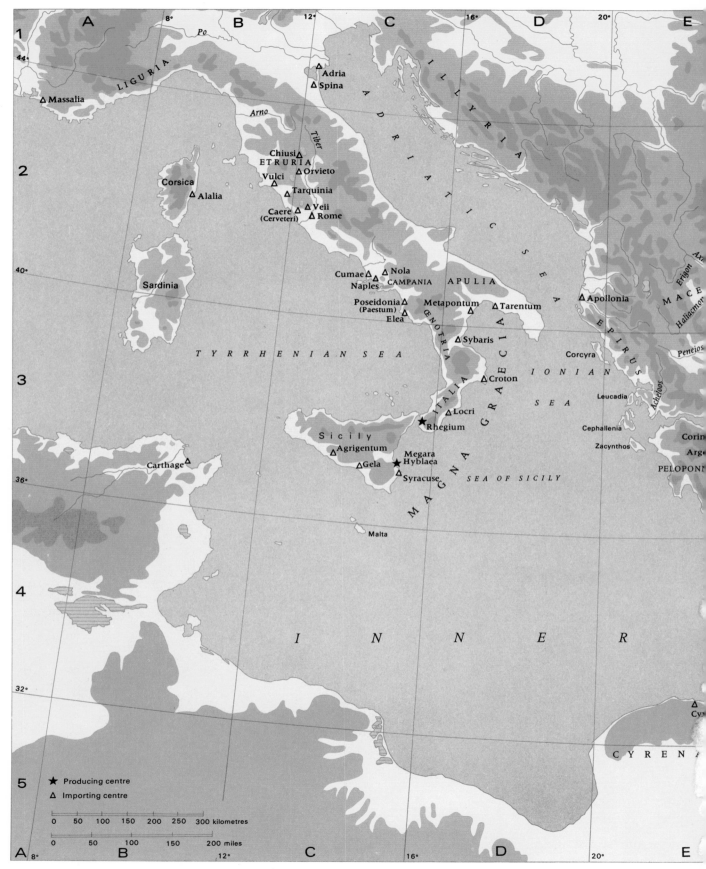

443. MAIN PRODUCING AND IMPORTING CENTRES OF GREEK POTTERY.

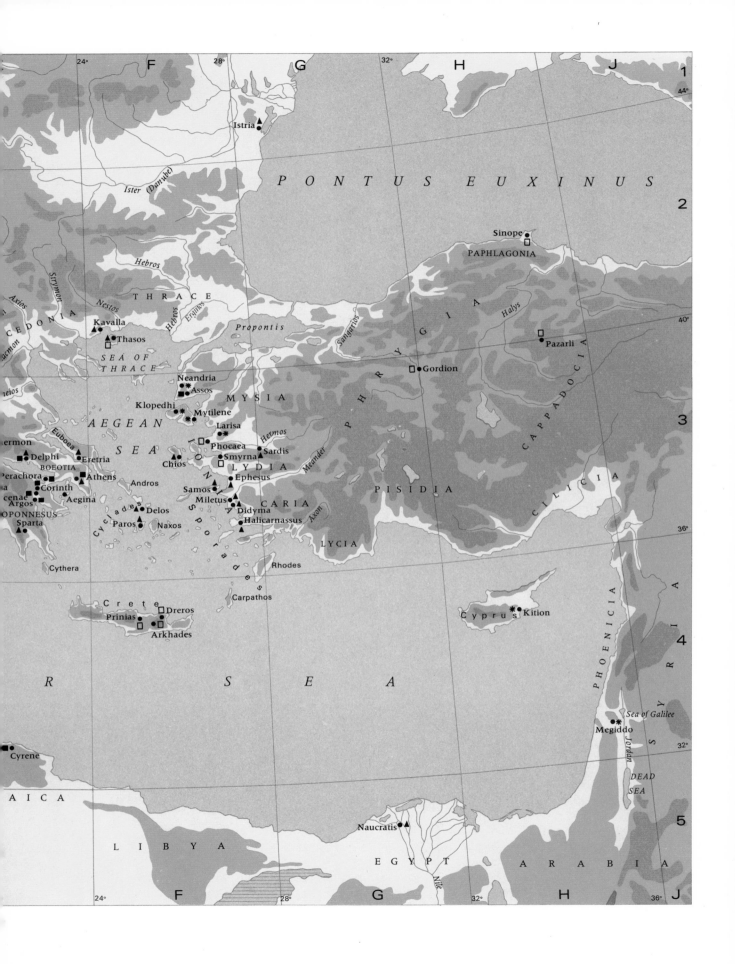

ARCHAEOLOGICAL SITES

Aegina E 3
Agrigentum C 3
Alalia B 2
Andros (island) F 3
Arkhades F 4
Argos E 3
Assos F 3
Athens E 3

Caere (Cerveteri) C 2
Calydon E 3
Carpathos (island) F 4
Carthage B 3
Cephallenia (island) E 3
Chios F 3
Corcyra (Corfu) D 3
Corinth E 3
Croton D 3
Cyrene E 4
Cythera (island) E 3

Delos F 3
Delphi E 3
Didyma F 3
Dreros F 4

Ephesus F 3
Eretria E 3
Euboea (island) E 3 - F 3

Gela C 3
Gordion G 3 - H 3

Halicarnassus F 3
Himera C 3

Istria G 1

Kavalla F 2
Kition H 4
Klopedhi F 3

Larisa F 3
Leucadia (island) E 3
Locris D 3

Malta (island) C 4
Massalia (Marseilles) A 2
Megiddo H 4
Metapontum D 2
Miletus F 3
Mycenae E 3
Mytilene F 3

Naples C 2
Naucratis G 5

Naxos (island) F 3
Neandria F 3

Olympia E 3

Paros F 3
Pazarli H 2 - H 3
Perachora E 3
Phocaea F 3
Poseidonia (Paestum) C 2
Prinias F 4

Rhodes (island) F 3 - G 3

Samos (island) F 3
Sardis G 3
Selinus C 3
Sinope H 2
Smyrna F 3
Sparta E 3
Syracuse C 3

Tarentum D 2
Thasos F 2
Thermon E 3

Zacynthos (island) E 3

Maps drawn by Jacques Person.

THIS, THE FOURTEENTH VOLUME OF 'THE ARTS OF MANKIND' SE-
RIES, EDITED BY ANDRÉ MALRAUX AND ANDRÉ PARROT, HAS BEEN
PRODUCED UNDER THE SUPERVISION OF ALBERT BEURET, EDITOR-
IN-CHARGE OF THE SERIES, ASSISTED BY JACQUELINE BLANCHARD.
THE BOOK WAS DESIGNED BY MICHEL MUGUET, ASSISTED BY
SERGE ROMAIN. THE TEXT AND THE PLATES IN BLACK-AND-WHITE
WERE PRINTED BY LES ÉTABLISSEMENTS BRAUN ET CIE, MULHOUSE-
DORNACH; PLATES IN COLOUR BY L'IMPRIMERIE DRAEGER FRÈRES,
MONTROUGE; PLANS AND MAPS BY L'IMPRIMERIE GEORGES LANG,
PARIS. THE BINDING, DESIGNED BY MASSIN, WAS EXECUTED BY
BABOUOT, GENTILLY.